ITALIAN
RENAISSANCE
PAINTING

ITALIAN RENAISSANCE PAINTING

James Beck

ICON EDITIONS

HARPER & ROW, PUBLISHERS

New York

Cambridge	London
Hagerstown	Mexico City
Philadelphia	São Paulo
San Francisco	Sydney

1817

Grateful acknowledgment is made for permission to reproduce works from the following: National Gallery, London; The Fitzwilliam Museum, Cambridge, England; The Courtauld Institute, London; Victoria and Albert Museum, London; Ashmolean Museum, Oxford, England; The British Museum, London; National Gallery of Scotland, Edinburgh; The Louvre; Musée des Beaux Arts, Lille; National Gallery of Art, Washington; Philadelphia Museum of Art; The Metropolitan Museum of Art, New York; The Art Museum, Princeton University; National Gallery of Canada, Ottawa; National Gallery of Victoria, Melbourne; Villa I Tatti, Florence; Museo Diocesano, Cortona; Uffizi, Florence; The Vatican, Rome; Instituto Poligrafico della Stato, Florence; Staatliche Museum, Berlin; Kaiser Friedrich Museum, Berlin; Städelsches Kunstinstitut, Frankfurt; Alte Pinakothek, Munich; Staatliche Gemäldegalerie, Dresden; Kupferstichkabinett, Berlin; Kunsthistorisches Museum, Vienna.

Library of Congress Cataloging in Publication Data

Beck, James.
 Italian Renaissance painting.
 (Icon editions)
 Bibliography: p.
 Includes index.
 1. Painting, Italian. 2. Painting, Renaissance—Italy. I. Title.
ND615.B35 1981 759.5 80-8640
ISBN 0-06-430382-9
81 82 83 10 9 8 7 6 5 4 3 2 1

ISBN 0-06-430082-x pbk.
81 82 83 10 9 8 7 6 5 4 3 2 1

CONTENTS

Acknowledgments vii

PART I. INTRODUCTION

Chapter 1. A Stylistic Framework for Italian Renaissance Painting 9

Chapter 2. Origins of the Emerging Renaissance Style 25

PART II. THE FIRST GENERATION

Chapter 3. The Lyric Current 55
 Fra Angelico 55
 Paolo Uccello 67
 Antonio Pisanello 76
 Francesco Squarcione 84
 Jacopo Bellini 87
 Sassetta 92

Chapter 4. The Monumental Current 101
 Masaccio 101
 Fra Filippo Lippi 112
 Domenico Veneziano 124
 Piero della Francesca 130
 Andrea del Castagno 146

PART III. THE SECOND GENERATION

Chapter 5. The Lyric Current 160
 Andrea Verrocchio 160
 Sandro Botticelli 165

Filippino Lippi 176
Francesco di Giorgio 186
Pietro Perugino 190
Pinturicchio 200
Cosmè Tura 206
Gentile Bellini 213
Vittore Carpaccio 216

Chapter 6. The Monumental Current 223
Andrea Mantegna 223
Giovanni Bellini 239
Antonello da Messina 250
Melozzo da Forlì 256
Antonio del Pollaiuolo 260
Domenico Ghirlandaio 265
Luca Signorelli 276
Leonardo da Vinci 285
Piero di Cosimo 304

PART IV. THE THIRD GENERATION

Chapter 7. The Monumental Current 318
Fra Bartolommeo 318
Michelangelo 325
Giorgione 344
Titian 352
Sebastiano del Piombo 367
Raphael 373
Andrea del Sarto 391

Chapter 8. The Lyric Current 402
Lorenzo Lotto 402
Correggio 411
Domenico Beccafumi 421
Rosso Fiorentino 426
Jacopo Pontormo 434

Appendix 451

Bibliography 453

Index 461

Numbers in brackets in the text refer to the illustrations.
Height precedes width in all dimensions given.

ACKNOWLEDGMENTS

Among the many friends and colleagues who have assisted me, first place goes to Howard Hibbard, who early on read the entire manuscript, making numerous and wide-reaching suggestions. At a last stage Janet Cox-Rearick went through the text, with helpful results. Others who provided emendations were Pellegrino D'Acierno, David Alan Brown, Harry Cloudman, Everett Fahy, Jonathan B. Riess, David Rosand, Jeffrey Ruda, and Craig Hugh Smyth. Graduate students who had a share in the preparation of this book include Perry Brooks, Patricia Emison, Eloise Quiñones Keber, Adrienne von Lates, Frances Preston, and Joel Silverstein. I would also like to thank Fiorella Superbi and Anna Terni at Villa I Tatti and Herbert Keutner, Director of the Kunsthistorisches Institut in Florence.

Elinor Richter saw to the awesome and often frustrating task of obtaining the photographs; she also prepared the bibliography.

Joanne Greenspun edited the manuscript with enormous care, dedication, thoughtfulness, and enthusiasm, making significant improvements in every chapter. I am especially indebted to her.

I am also grateful to various Superintendencies of Fine Arts in Italy, particularly those of Florence, Siena, Milan, and Rome, whose photographs form the bulk of the illustrations for this book. In addition, I would like to thank the following museums or institutions for their cooperation: Berlin–Dahlem, Staatliche Museen; Budapest, Museum of Fine Arts; Cambridge, Fitzwilliam Museum; Chantilly, Musée Condé; Dresden, Staatliche Gemäldegalerie; Edinburgh, National Gallery of Scotland; Florence, I.D.E.A., Villa I Tatti; Frankfurt, Städelsches Kunstinstitut; Hampton Court,

Royal Collection; Lille, Musée des Beaux–Arts; London; British Museum, Courtauld Institute, National Gallery, Victoria and Albert Museum; Melbourne, National Gallery of Victoria; Munich, Alte Pinakothek; New York, Metropolitan Museum of Art; Oxford, Ashmolean Museum; Paris, Louvre; Philadelphia, Philadelphia Museum of Art; Princeton, University Museum; Rome, Vatican Pinacoteca; Vienna, Kunsthistorisches Museum; and Washington, National Gallery.

Finally, Cass Canfield, Jr., was supportive of this project from its inception, back in 1975, and he continued to inject sensible suggestions for all aspects of the book, from the preparatory stages to the actual production. I warmly acknowledge his contributions and those of Carol E. W. Edwards and C. Linda Dingler.

J.B.

New York
December 1980

PART I
INTRODUCTION

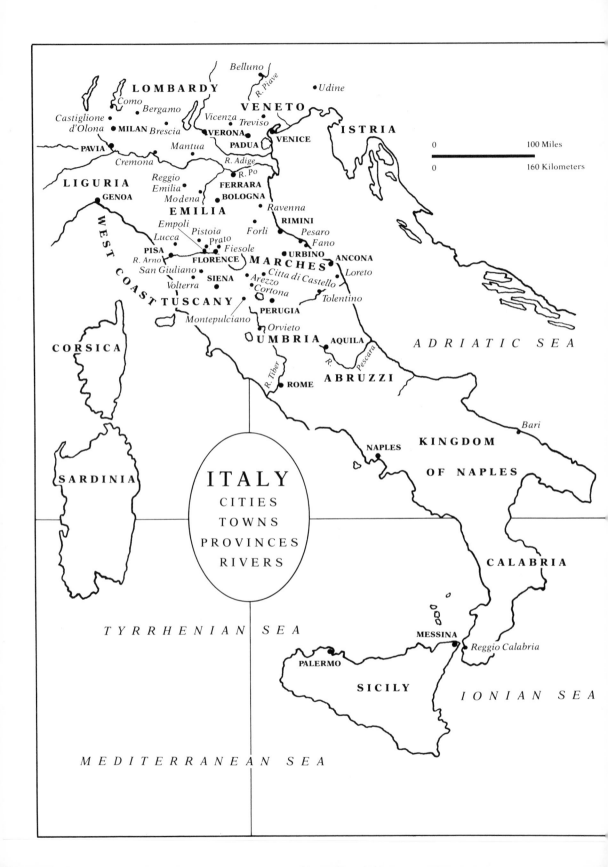

The beginning of the Italian Renaissance as manifested in painting is marked by momentous international events and political factors which, if they did not create the new style in art, favored it and allowed for a rapid growth. Early in the fifteenth century the papacy was in deep crisis, with three claimants to the throne. A world council called by Sigismund, king of Hungary and Roman emperor, was held in Constance (Switzerland) beginning in 1414. By 1417 a new universal pope, Martin V, had been elected, and for all practical purposes the schism was over. The papacy was finally restored to Rome by Martin, who was himself a Roman of the Colonna family. Often regarded as the first Renaissance pope, although by no means a humanist, Martin began the endless task of rebuilding a Rome left abandoned for half a century. Nor is it entirely irrelevant that Martin spent over a year (1419–20) in Florence, the unrivaled center of the artistic explosion during the first part of the fifteenth century, before establishing himself in Rome.

The word Renaissance, the French translation of the Italian word *rinascita*, meaning rebirth, was already applied during the period itself, although it did not consciously refer specifically to an artistic style. One component of the Renaissance is certainly that of a re-awakening of the appeal of classical antiquity together with a self-conscious imitation of Greco-Roman art. We find a flurry of interest among artists in the preserved Roman monuments that are scattered about Italy—buildings and sculptures, especially in the form of carved sarcophagi—just as humanist writers were seeking out classical texts throughout Europe. This is not to say that in previous periods, before the fifteenth century,

artists were not interested in ancient art forms; such concerns were persistent, and several specific renascences occurred in Western Europe, during the time of Charlemagne at the beginning of the ninth century and under Frederick II in the thirteenth, based on imperial, propagandistic motives. However, the broader intellectual community was not prepared to accept such a revival for long. The climate was not yet right.

In addition to a revival of interest in antiquity among artists and writers during the Renaissance, there was also an intensification of inquiry into the physical world of nature. It was a period of experimentation and exploration and has been described as "the age of discovery of the world and of man." If the distinctions with the previous, the late medieval or Gothic, period are often drawn too sharply, we do find a deeper commitment to examining the natural world, in which man was conceived of as the center. This was in opposition to the more otherworldly overtones of the Middle Ages. One can easily imagine that there will continue to be debates about the definition of the Renaissance both as a concept and as an historical period, but for the arts it is distinguished by the collective production of those masters we are studying, as well as the art of the sculptors and architects who worked alongside them.

The painters had a somewhat different task than did the sculptors and architects with respect to antiquity. There were classical sculptures and ancient buildings, but there were no examples of Roman painting for early Renaissance painters, except for an occasional Greek or Etruscan painted vase, uncovered by chance. Early Christian mosaics and, to a lesser extent, fresco painting in Rome and in Ravenna are notable exceptions, but they were not representative of the finest productions of antiquity by classical standards, and were for the most part inferior to the very pictures these Renaissance painters were then producing. Consequently, painters had to re-create ancient painting; they could not imitate it. If a statue by Donatello or Michelangelo could be described by contemporaries as equal or even superior to examples from the classical past, there were surviving works that permitted such a comparison. Not so with painting, although quite typically fifteenth- and sixteenth-century writers said that Pisanello, Jacopo Bellini, Titian, and others actually surpassed the ancients, which was the highest possible praise. For painting, descriptions of Greek and Roman pictures as they were found in books by Pliny, Lucian, and others served as the yardstick.

In addition to seeking insights from the ancient world, Renaissance painters began to look systematically at their surroundings in their quest to understand the physical world. A painting came to be regarded as a window looking out on the world, and a growing naturalistic spirit resulted. Not surprisingly, then, from the 1420s to the 1450s, painters, as they had not done in more than

a thousand years, devoted themselves to rendering landscape, the careful depiction of trees, flowers, plants, and cloud-filled skies. They studied how light functions out-of-doors and how the eye perceives elements within a landscape, some near, some at great distance from the spectator. Most painters of the early Renaissance were aware of landscape elements in a way altogether unknown to painters of the Gothic past, when landscape was treated symbolically, a conception that is still found in Lorenzo Monaco. The shift already appears in Gentile da Fabriano and in Masolino and was successfully sustained by Fra Angelico.

Man-made objects and articles from everyday life, such as fruit, flowers, and vegetables, also came increasingly under examination by painters early in the Renaissance. Throughout the entire period, however, these still-life elements never became the exclusive subject matter of a painting, as finally happened in the Baroque period. Rather, they were used to embellish or explain a subject and were also a mark of a painter's skill. Here the model of antiquity was held up, since excellent ancient painters were reputed to be skilled at "fooling the eye" *(trompe l'oeil)* of the beholder so successfully that a painted object appeared to be real. Paintings were said to have been so realistic that they could even deceive a dog. Leonardo da Vinci, who elaborates on this theme in his notebooks, tells of seeing flying swallows try to light upon painted bars before the windows of buildings.

Independent portraits were also being made for the first time during this same moment. They became an increasingly important genre constituting a means of income for painters throughout the Renaissance, and to be sure, in the centuries that followed. Earlier, there were certain likenesses painted, especially in the guise of donors and princes, but the portrait as an independent picture in its own right was initiated first by painters like Uccello, Domenico Veneziano, Piero della Francesca, and their contemporaries in North Italy—Jacopo Bellini and Pisanello—perhaps as early as the 1430s but certainly by the 1440s. In the sixteenth century, we find a substantial number of portraits by Titian, Lorenzo Lotto, Sebastiano del Piombo, and Raphael.

The subject that permitted the painter to achieve the most profound and complete expression was, according to Renaissance theory, the history or narrative picture *(istoria),* which offered possibilities beyond paintings devoted to single figures, portraits, or icons. Leon Battista Alberti (1404–1472), the humanist, writer, and architect, had some direct experience with painting and sculpture and was a frequent associate of artists. He fully stated the importance of narrative painting by 1435, when he wrote *On Painting,* a treatise largely based on a combination of what he was able to glean from ancient writers and his own observations of painting that was then being produced. Alberti described a fine

narrative as one so charming and attractive as to hold the eye of the learned and the unlearned spectators for a long while with a certain sense of pleasure. It must have plenty of variety, for novel things delight us, he said. A painting is richly varied if it contains a properly arranged mixture of old men, youths, boys, matrons, maidens, and children, domestic animals, buildings, views; but, he added, not more than nine or ten figures should be included, for a picture must remain full of dignity and modesty. In such pictures the artist could demonstrate all of his skills and the depth of his understanding of the human condition.

While Christian themes and representations, with the Madonna and Child always popular and ubiquitous, continued to dominate the interest of Renaissance painters, there was also a proliferation of purely lay and sometimes pagan subject matter. The myths of the ancient gods of Greece and Rome were frequently painted for the *cognoscenti,* and astrological and alchemical elements became more commonly depicted and drawn. Pictures illustrating stories taken from ancient writers, particularly Ovid, and re-interpretations of the moderns, including Petrarch and Poliziano, became more common in the late fifteenth and early sixteenth centuries. Festivals and pageants required the participation of painters, and staged entrances of distinguished persons were celebrated with splendid decorations, though they are for the most part lost to us.

Painters during the Renaissance were heavily patronized by religious institutions, much as they had been during the Middle Ages. Churches, convents, and monasteries needed frescoes for their walls and panel pictures for altars. Chapels in the large churches, which belonged to families, also required suitable painted decoration, and even when contracts were given out by private individuals, administrators of the church had their say. The papacy was a particularly powerful patron (see page 7): prestigious decorative programs in Rome were undertaken in the fifteenth and sixteenth centuries. These included paintings for the side walls and ceiling of the Sistine Chapel and the rooms and the *logge* (open, partially exposed galleries or passageways) of the Vatican Palace. Members of the papal court and wealthy and powerful cardinals and other clerics also employed artists.

Local governments of the many city-states into which Italy was splintered were another important source for artistic commissions. Town halls and other civic buildings needed painted embellishments. In the case of princely states like Ferrara, Mantua, Milan, and Naples, the ruling houses were anxious to outdo one another in the splendor of their painted rooms, perhaps the most imposing being the Camera degli Sposi by Mantegna, in Mantua [186]. During the fifteenth century the Medici maintained political domination over Florence

List of Popes during the Renaissance

POPE	FAMILY	ORIGIN	DATES AS POPE
Martin V	Oddone Colonna	Rome	1417–1431
Eugenius IV	Gabriele Condulmer	Venice	1431–1447
Niccolas V	Tommaso Parentucelli	Sarzana	1447–1455
Callistus III	Alfonso de Borgia	Valencia	1455–1458
Pius II	Aeneas Silvius Piccolomini	Siena	1458–1464
Paul II	Pietro Barbo	Venice	1464–1471
Sixtus IV	Francesco della Rovere	Savona	1471–1484
Innocent VIII	Giovanni Battista Cibo	Genoa	1484–1492
Alexander VI	Rodrigo de Borgia	Valencia	1492–1503
Pius III	Francesco Todeschini-Piccolomini	Siena	1503
Julius II	Giuliano della Rovere	Savona	1503–1513
Leo X	Giovanni de' Medici	Florence	1513–1521
Adrian VI	Adrian Florensz Dedal	Utrecht	1522–1523
Clement VII	Giulio de' Medici	Florence	1523–1534
Paul III	Alessandro Farnese	Canino (Viterbo)	1534–1549
Julius III	Giovanni del Monte	Rome	1550–1555
Marcellus II	Marcello Cervini	Montepulciano	1555
Paul IV	Gian Pietro Caraffa	Naples	1555–1559
Pius IV	Giovanni de' Medici	Milan	1559–1565
St. Pius V	Antonio Ghislieri	Bosco Marengo (Turin)	1566–1572
Gregory XIII	Ugo Buoncompagni	Bologna	1572–1585

but still kept within the framework of a Republican system. They were notable patrons of the arts, like the elected doges of Venice, and employed some of the finest painters available.

Not only were the rulers prepared to spend vast sums on painting, but private citizens, usually merchants and bankers, also participated in the patronage of the arts. Giovanni Rucellai, a wealthy Florentine who had the good sense to use Alberti as his architect, bragged about how he had obtained the services of the best masters. Not only were frescoes and altarpieces supplied, but also *cassone* (chest) frontals, cupboard and bedstead pictures, painted marriage plates, birth salvers, and portraits.

The Renaissance was a period of enormous excitement, with new forms expressed in poetry, music, political theory, and scientific experimentation. But painting, sculpture, and architecture underwent dramatic changes of such magnitude that we often think of the Renaissance first as it manifested itself in art. The encompassing style becomes easily distinguishable from the previous medieval style, more easily than the change in government or in the use of language, so that Renaissance painting in particular is a basic measure for a coherent impression of the period as a whole.

A STYLISTIC FRAMEWORK FOR
ITALIAN RENAISSANCE PAINTING

Renaissance painting remains the basis of all subsequent Western art despite the shattering innovations of the past hundred years. The formulas for image-making that were perfected in the fifteenth and sixteenth centuries, particularly in Italy, are those that painters still rely upon and, more significantly, that have conditioned the way most of us continue to see and even to photograph the world. The purpose of this book is to present the painting that is usually called Italian Renaissance within an easily understandable framework based on style. No such system for the modern viewer is readily available, although Renaissance art criticism began in the middle of the sixteenth century. The painter-architect Giorgio Vasari (1511–1574) wrote his account by presenting artistic biographies of the life and works of each artist deemed worthy of a place in his *Lives* (first edition, 1550; second edition, greatly enlarged, 1568). His spotlighting of the individual is characteristic of the Renaissance, and the intimate interrelation between work and maker found in Vasari is still an effective approach to Italian Renaissance art. But there are also drawbacks. The controllable facts of each artist's life, even of birth and death, let alone whether he was married or not, where he was trained and by whom, are usually unknown for masters of the fifteenth and sixteenth centuries—not to mention the more elusive aspects of his personal and emotional life. In addition, insights into a particular painter's ideas about his art, such as might be revealed in letters or memoirs, which are commonly accessible for later artists, are rare in the Renaissance.

To make the critic's and historian's task still more difficult, a substantial

portion of the art of individual masters has been lost, destroyed, or, in the case of frescoes, covered over. The paintings that are preserved have suffered from time, weather, mutilation, repainting, and restoration. We are inevitably dealing with incomplete oeuvres that are not necessarily indicative of the originals. Most of the works that have been preserved are undated and undatable by contemporary documentation. Consequently, the biographical approach has built-in deficiencies. Often our knowledge is too limited to devise anything like a convincing reconstruction. But even when a relatively complete corpus of pictures and data is available, separate biographies in themselves do not offer the possibility of revealing a comprehensive view of the period.

One might instead proceed by moving decade by decade, clustering important monuments around their proper moment of manufacture; then, if considered desirable, the political, social, economic, and intellectual circumstances could be so interlaced that painting might be studied within the context of the society in which it was produced. A purely chronological treatment of Italian Renaissance painting, which constructs phases from "early" to "high" and "late" has been widely used, but with variations and shifting terms. This approach seems to imply first a rise, and then an inevitable decline and fall. The work of artists like Masaccio, Uccello, and Pisanello in the first rumblings of the new artistic epoch (the reasoning might go) leads to a more systematic and rigorous art by Mantegna, Antonio Pollaiuolo, and Giovanni Bellini. Their achievements are inevitably followed by the productions of the next generation, who raise the art of painting to celestial levels. This phase, referred to as the "high" Renaissance, is considered the finest hour of the entire epoch. Here one would find the names Leonardo da Vinci, Raphael, and Correggio, and the masterpieces of the "divine" Michelangelo. Following this apex, of course, there must be a decline. The disintegration has been associated with a phase or period called Mannerism. Painters at the beginning of this phase—Pontormo, Rosso, and Beccafumi—despite modern re-evaluation of their individual merits, are somehow relegated to an inferior status. Such divisions of the Renaissance are more comprehensive than a collection of independent biographies, but the inherent bias for progress is so strong that critical judgment is hampered. The periods leading up to the classic moment are, by definition, only a prelude to something better, and once the best is reached the rest is anticlimax.

A somewhat different program for treating Renaissance painting gives priority to an arrangement of artists according to "schools." Frequently we encounter labels in museums describing pictures as Florentine, Venetian, Lombard, or Umbrian. This method is now favored in scholarly circles. Specialists usually have little difficulty in recognizing the qualities of a school or combination of schools, even when they are unable to isolate the master who painted a given picture. Such categorization is particularly effective for Sienese art, but

it is less useful as a principal division for other schools, where greater cross-fertilization from one local center to another occurred. Frequently a master from one place worked for long periods in other centers, absorbing qualities characteristic of these "schools." Such a painter may well have affected the artistic style of his new center of activity, and consequently altered its character as an independent school to some extent.

Leonardo da Vinci offers an example of the inherent ambiguity in this method. Born and trained in Florentine territory, he went to Milan when he was about thirty, stayed there for nearly twenty years, and returned there for another stretch later in his life. His art had an enormous effect on the painters working in Lombardy. At the same time, his own style took on characteristics of the artistic qualities typical of Milan. Usually labeled Florentine, Leonardo is occasionally termed Milanese, and copies of his paintings are almost inevitably of the "Lombard" school.

Furthermore, the concept of schools does not mesh with accepted historical and stylistic episodes (from late medieval to Renaissance, and to post-Renaissance [that is, Mannerist] and Baroque art) since these schools span the centuries. No precise boundary is provided in Florentine painting between the period of Cimabue and Giotto and that of Masaccio and Michelangelo and even up through Carlo Dolci, that is, from the late thirteenth century through the mid-seventeenth and even beyond. It would be shortsighted to underestimate the power of local habits and preferences, but for a broadly based treatment of Italian Renaissance painting, division into schools can be overly limiting. Artists traveled widely; virtually every major painter of the period moved from his place of birth and training, that is, from his "school," to accept assignments elsewhere. Such interchange took place in many directions constantly, often obliterating the "school" as a center of style.

Two other orientations—aesthetic and iconographic—should be mentioned. Every art work is an independent object with its own identity, integrity, and rules. The beauty, rightness, and success of a painting can be studied formally, outside the historical, stylistic, or even biographical conditions in which it was created. However, aesthetic analysis does not contribute substantially to the construction of a framework for Renaissance painting, which is the object of this book. Iconography—that is, the subject matter and meaning of paintings—and the cultural conditions that help explain the works of art and their patronage are of great interest. Such investigations share ground with cultural history and the history of ideas and are fundamental to an understanding of the period. But an approach of this kind is less useful for establishing a broad stylistic framework in which the art may be studied.

This book organizes the main exponents of Italian Renaissance painting according to the generation in which each artist was born. The cohesive quali-

ties of each generation, including broad intellectual currents, considered as given and irrevocable facts, are stressed over differences between one city and another or one region and another. Hence the Venetians, Paduans, Umbrians, Romans, Sicilians, and Tuscans are treated together within their appropriate generation, although an awareness of local origins must always remain a factor. The organization into generations is based on birth dates, whether confirmed or approximate, rather than on the basis of dates of known activity—even if large segments of an artist's career are unknown.

Using this generational guideline, we are reminded that Michelangelo (born 1475) and Titian (probably born 1477) are true contemporaries of Giorgione (born about 1477) and Raphael (born 1483) despite the fact that Titian lived more than half a century after Giorgione's death in 1510 and Michelangelo outlived Raphael by forty-four years. It is my contention that the formation of painters, their experience in the period of training and early independence, the connections they had with teachers and other constructive sources in their development, together with the artistic environment of the same moment, significantly locate them historically and indelibly mark their expression. The political, economic, and cultural conditions are shared by all members of their generation, whether painters or not. I am also suggesting that a painter, or for that matter any artist, cannot effectively move out of the circumstances established by his training and youthful experience, although the boundaries need not be sharply drawn. Consider, for example, Masolino (ca. 1384–1443?), a painter deeply taken with the potentialities of perspective and the systematic organization of the spatial properties of a painting, concepts that were being developed around 1420 by Filippo Brunelleschi. However much he tried, Masolino could not make effective use of them the way his younger contemporaries could, including Masaccio (1401–1428) and Filippo Lippi (1406/7–1469). And if Correggio's art has been described as looking forward to Baroque solutions, perhaps it would be more accurate to assert that certain Baroque decorators looked back to Correggio.

One could ask what effect trauma, either personal or collective, might have had on the style of any given artist. Would the loss of a spouse or parent, a disappointing love affair, serious financial difficulty, severe illness, a war, famine, a plague, or a political uprising have a decisive effect on an artist's style? The evidence, incomplete as it is, seems to indicate that it would not, but it might instead affect the subject matter, what aspects might be emphasized, inherent optimism or pessimism, the choice, quantity, and balance of colors. But an artist's basic artistic inclinations remain unaffected.

The birth dates of the principal painters of the Italian Renaissance do not fall neatly into acceptable units, but it is still possible to organize them into

three generations that roughly span the period. The first generation consists of those masters born in an arc of years around 1410, that is, who emerge as independent painters in the 1420s and 1430s when the artistic vocabulary in Italy was expanding radically in the hands of sculptors and architects. The second generation is made up of painters born around 1445, and the third generation of artists was born around 1480. In every case as many as fifteen years on either end of the central dates are sometimes needed to round out each generation. Nearly all of the painters whose works will be examined in this book were born during the *quattrocento* (fifteenth century), although in many cases their entire adult lives were spent in the *cinquecento* (sixteenth century).

A certain leeway is required in locating those artists born on the edges of the generational structure, and a cluster of dates must be used. Sometimes arbitrary decisions are necessary, as in the case of Andrea del Castagno (born about 1419) or Piero della Francesca (born about 1420 or 1422), both of whom I have placed in the first generation, while putting Mantegna (born 1431) and Giovanni Bellini (born about 1432) among painters of the second generation. Because of the length of any given generation, about thirty-five years, a master and his pupils can easily belong to the same one, as do Leonardo (born 1452), and his teacher Verrocchio (born about 1435).

Since the yardstick for establishing the three generations is birth dates, controllable starting points are easily achieved, once a decisive generational starting point is determined. This, in turn, is arrived at by conventional estimates and contemporary evidence within the period. The generation of Masaccio as making a new and different contribution was recognized already in the fifteenth century, most clearly by Alberti in *On Painting.* On the other hand, the years when each generation ends chronologically are irregular, as is the date of the end of the Renaissance itself. As already affirmed, Titian and Michelangelo continued to be active well into the second half of the sixteenth century, so, with regard to them, some material in this book dates as late as the 1560s and 1570s. With their generational contemporaries, Giorgione and Raphael, it ends much earlier. The main body of material presented, however, was produced in the hundred years that began in the 1420s, with notable exceptions on either side of the boundary.

Renaissance painting begins with the emergence of Masaccio, which follows on the heels of the innovations of sculptors from a slightly earlier moment, Brunelleschi (1377–1446), Nanni di Banco (1385?–1421), and Donatello (1386–1466). It is necessary to make a distinction between what happens in painting and what happens in sculpture: the sculptors (and architects) were more precocious in developing certain concepts associated with the Renaissance vocabulary than were the painters early in the fifteenth century, but seem to fall

behind in invention by the end of the century, with, of course, the notable exception of Michelangelo.

Toward the final years of the Italian Renaissance, in the 1520s, the stylistic language changes significantly under the leadership of a new generation of painters born shortly after 1500, whose appearance coincides with several momentous historical events: the death of the Medici pope Leo X (1521), an extravagant patron of the arts; the gradually expanding threat to the church from the reformatory forces after 1517; and finally the sobering Sack of Rome in 1527 by German and Spanish mercenaries. In a letter to Michelangelo of February, 1531, Sebastiano del Piombo, the Venetian painter who had settled in Rome, admitted: "I do not feel like the same Sebastiano that I was before the Sack."

·⊢·

Besides organizing Renaissance painters into three separate generations, I have divided them between two general categories or tendencies: monumental and lyric. As we shall see, these two stylistic labels are only relatively meaningful, like the analogous terms classic and romantic. Just as no single artist represents the absolute monumental current in every respect, although Masaccio, Piero della Francesca, Raphael, and Titian come the closest, no single painter fits completely within the lyric category, although Pisanello, Botticelli, and Pontormo are candidates. The monumental and lyric currents in Italian Renaissance painting should be thought of as parts of a continuum, with the painters of the period standing at different points on it, some masters resting more decisively at the extremities, others, like Leonardo, clustered toward the center. Subdivisions of the categories could also be made, lyric monumental and monumental lyric, between the main groupings, much as in nineteenth-century art criticism one refers to romantic classicism and classical romanticism; but such refinements should be used cautiously.

While it is undesirable to overly refine and exaggerate the characteristics that make up lyric and monumental painting, certain qualities recur with enough frequency to sketch distinctions between the two currents. Within the larger context of a Renaissance style, in lyric painting we find an emphasis on gracefulness, elegance, and refinement of forms; complex, often curvilinear, design patterns related closely to, or on, the surface; and an excitement of contours. Frequently there is a strong commitment to naturalistic detail, to landscape elements, as well as a concentration on decorative features. The proportions of the figures may be attenuated, with long, lithe bodies and smallish heads; the limbs, especially the hands and feet, are tapered. In the monumental current, there is a gravity of forms, a volumetric three-dimensional insistence in which the figures take up space in a convincing stage-like environ-

ment. Usually there is an organization that emphasizes horizontal and vertical stresses; a full front view or a sharp profile for figures is preferred. Color is used less for its own sake than as a vehicle to produce readability. In its extreme, monumental pictures become cold, mechanical, and rigid; lyric pictures become precariously decorative, capricious, and overrefined.

One can imagine situations in which individual painters change, becoming at times more or less monumental or lyric as they seek to resolve specific pictorial problems, or even iconographic ones. Artists may accommodate themselves to some extent to the desires or expectations of a patron and modify their basic impulses; or they may have to adjust their own habits to a pre-existing situation. Filippino Lippi, decidedly a lyric master, when completing the Brancacci Chapel frescoes left unfinished by Masaccio, tried to reconcile his own inclinations with Masaccio's monumental language, so that his share would not appear out of place within the fresco decoration [140, 141]. The small figures in predella scenes, often painted at the bases of altarpieces, reveal a different formula from the large proportions of the main field or in a large fresco, for painters are often flexible in their response to pictorial challenges.

Yet a premise of this book, leaving room for occasional exceptions, remains that certain painters of the Italian Renaissance are innately monumental, others lyric, and that the set of stylistic choices open to them is conditioned by their basic propensity. Although landscape, still life, and the depiction of architecture have an important function, Renaissance painting is primarily devoted to the human figure, so that in ascertaining the identification within the monumental-lyric continuum, the treatment of the figure by the various painters is the most revealing, if not the only, measure.

Since I am seeking a trustworthy account of Renaissance painting, the controllable factual data that have been conserved form the principal criterion for developing the analyses of individual painters throughout the book. Heresay and anecdotal material, however engaging, have been omitted. I have begun every treatment of an artist with an introductory portion that reviews the known facts about that artist and his work. After the reader has some insight into the artist's career as a whole, I then treat a select group of his works. The works discussed, necessarily limited in number, were chosen because of certain characteristics that help in establishing a total view of the painter under examination. In many cases, alternates could just as easily have been selected, especially when a painter's oeuvre is particularly large. Whenever feasible, only those pictures and frescoes that are documented for or securely associated with a given master are discussed. Problematic pictures and those that are poorly preserved are usually set aside. Merely because a painting is signed is not always a guarantee that it was actually executed by that master, and might only mean

that it came from his workshop. In such cases, qualitative judgments should be made.

Reconstructions of phases in an artist's career unconfirmed by documentary evidence have been avoided for the most part. Usually, when little or nothing is known of a particular situation, the temptation is to fall back on Vasari's account, although Vasari is not particularly reliable when treating *quattrocento* painters. When he writes about artists closer to his own time, on the other hand, his observations are more authoritative.

Very little is known with certainty about the details of the life and fixed points in the art of such a famous and influential Venetian painter as Giovanni Bellini before he was over fifty years old. Numerous paintings have been associated with him that purport to date from the previous decades, even from extreme youth, attributions based on certain assumptions about his training and his relation to Andrea Mantegna. Nor are such lacunae uncommon for Renaissance artists: in the same family, there are also large gaps in our knowledge of his father Jacopo and his brother Gentile, both famous painters who are also discussed in this book.

I have chosen to discuss only the more prestigious and influential masters of each generation. The measure for estimating the importance of a painter is usually taken as the effect his pictures had on contemporaries and immediate successors. Consequently, masters like Masaccio, Giovanni Bellini, Mantegna, Botticelli, Leonardo, Raphael, Michelangelo, and Titian loom particularly large. Sometimes artists whose imagery was especially innovative although not specifically influential have been included, perhaps because they could not be left out; Sassetta and Lotto fall into this category.

No special effort has been made to create a balanced coverage among painters from Italy's various regions. A situation of natural selection gives Tuscany, and especially its main center, Florence, a decided edge over other places during the time when the first generation flourished. Much as the Florentine dialect became the literary language of Italy by the fifteenth century, so the artists of Florence—sculptors and architects as much as painters—had an unmistakable impact upon the entire peninsula. No representatives from Milan are to be found in this book, although it was the capital of Lombardy, a region of immense wealth and political and military power. That region failed to produce a painter of first rank. Nor have the number of representatives from the lyric and monumental currents been artificially equalized.

Whenever possible, the career of each painter is arranged according to three phases: early, middle, and late; or first, second, and third. Typically there is a certain pattern that can be ascertained for most Renaissance painters. After a period of training (a prephase, as it were), when the artist is inseparably

identified with his teacher, the early phase begins, characterized by an outburst of invention. At this time, a clarification of the painter's natural inclination toward monumental or lyric solutions evolves. Beginning at the point of artistic independence and for a span of time that varies markedly from master to master, the active, inspirational first phase may be closely observed. New solutions of all sorts—compositional, coloristic, figural, and spatial—are worked out, and they serve as raw material for the remainder of a career. In the second or middle phase, there is elaboration, modification, intensification, and reconstruction. The third or late phase is one of expansion, facility, and magnification.

While training and under the strict guidance of a teacher, the youthful *garzone* (shop boy), who usually joined the workshop around the age of thirteen, is a long way from achieving a definable identity and a personal statement. He concentrates on imitating his master's manner and to the degree that he is successful, the work in which he participates, or even actually executes, is but an extension of his master's style; the pupil is an extra arm of the master without a true artistic personality of his own. Even the greatest of painters, such as Raphael, assimilated the manner of his teacher (Perugino) so skillfully that one is hard pressed to separate passages by the young painter within a painting by the older one. For a period of time during his apprenticeship, and spilling over for a year or so thereafter, Raphael was, for all practical purposes, Perugino and not yet Raphael. Even as late as 1504, when Raphael was twenty-one, he continued to paraphrase the idiom of his teacher, and the prominently signed and dated *Marriage of the Virgin* [323], for example, is heavily Peruginesque in facial types, figural proportions, and in coloration. During the training period, then, even the natural inclination of the student may be sublimated, so that Raphael, the monumentalist par excellence, appears to be the reverse. A year or two later, even in such a little painting as the *Three Graces* [324], Raphael's monumental language emerges. Later on we find a similar situation among Raphael's own gifted pupils. Raphael was able to impose on them his own vision with great success, although to the degree that he failed to have a direct and constant role in any given project, the younger painters edged toward greater stylistic independence, and after the master's death they were free to pursue their own instincts.

The length of the three phases in a painter's career varies, and not all artists even lived long enough to have participated in all phases. Masaccio, for example, died when he was not yet twenty-seven years old, never having moved beyond his first phase; Giorgione also died so early that it is difficult to decide if he lived long enough to have moved into a middle period. Raphael, too, died young, at age thirty-seven, and it would certainly be incorrect to think of his last works as truly "late." The *Transfiguration* [340], unfinished at his death, is

a high point of his second phase, not his third. Furthermore, we are often poorly informed about the training and even the early period of many Renaissance painters. Fra Angelico is nearly thirty before we can begin to single him out; Filippo Lippi is also close to thirty, if not more; and Verrocchio is not easy to isolate as a painter at all, let alone to understand in terms of phases. And so it goes with scores of Renaissance painters. There are, to be sure, artists for whom we are better informed, and special attention can be given to their development. Michelangelo is one of the best documented, and since he did not paint constantly, his career can be more easily treated within the established pattern. With Raphael, where dated works abound, one can also follow the situation. Titian's paintings are also well documented, but not his training and youth, which remain something of a mystery, although close ties with Giovanni Bellini and Giorgione are commonly assumed.

Returning to Raphael, we can see something of how the pattern operates. After he freed himself from a strict imitation of Perugino, he began to become open to other strong impulses as he sought to identify his own artistic nature. He found inspiration in the examples of Michelangelo, Leonardo, and Fra Bartolommeo, all of whom he could have known once he settled in Florence by 1505. To be sure, Raphael had probably been in Florence earlier with his master and already knew some of the works of these artists, but he would not have been able to absorb what they had to offer within the context of his pupil-master relationship with Perugino. During the next few years, from 1505–8, he articulated his characteristic language, and by the time he was finishing the frescoes in the Stanza della Segnatura, around 1511, aged about twenty-eight, his first phase was complete. During the next decade, which was all that he was granted, Raphael perfected what he had previously set forth.

Leonardo da Vinci, on the other hand, does not appear to have attained full artistic independence from his master until he began to paint the *Adoration of the Magi* [245] in 1481, when he was fully twenty-nine years old. Leonardo remained in Verrocchio's shop well beyond the age when most painters had struck out on their own. We do not know precisely when he left, but he appears to have been attached to the workshop style for a long time, to an extent disguising his own fundamental inclinations. Once he began to work on the *Adoration*, with its complex spatial construction, its subplots, including even a battle scene, and its wide range of figural types and poses, most of the artistic solutions that Leonardo was to elaborate for the rest of his career are discernible, even though this painting was never finished. Leonardo's early phase, which was late in arriving, is highlighted by the *Last Supper* [248]. The second phase is signaled by the drawings and the cartoon for the *Battle of Anghiari* [252], begun in 1504. As for a third or late phase, the situation is more clouded;

Leonardo painted less and less as he grew older, moving to a whole range of other interests. In the handful of paintings that are late, none has come down to us in sufficiently good condition or is of the compositional richness necessary to make a valid assessment of the third phase of his art.

Michelangelo is something of an exception to the suggested pattern of the painter's evolution because he did not stay long in a workshop with a particular master, and he never submitted himself to close imitation or copying of their manners. After an abbreviated apprenticeship with Ghirlandaio that lasted two years, from age thirteen to fifteen, he began to work more or less independently in the Medici gardens, shifting from fresco and tempera to marble and perhaps bronze. Michelangelo should be considered as a partial autodidact who very quickly unleashed his personal language. By the time he produced the *Battle Relief* [275] and the *Madonna of the Stairs* (Florence, Casa Buonarroti), both relief sculptures, while still in adolescence, the deck was cleared for such fundamental first-phase works as the *Battle of Cascina* [273], begun in 1504 but never finished and known only through copies and drawings. In the Sistine ceiling [278], completed in 1512, we can observe the shift from the first to the second phase. Here, he is modifying, elaborating, and, in a way, fulfilling the discoveries made earlier. In a final phase, after a span of more than twenty years when he painted very little, if at all, Michelangelo completed the frescoes for the altar wall of the Sistine Chapel by painting the *Last Judgment* [289] and the frescoes in the Pauline Chapel [290, 291], also in the Vatican, which reflect enormous self-confidence and facility, the fruit of long experience.

This system of dividing an artist's career is conventional and follows, or is parallel to, the traditional notion of the ages of man, with infancy and childhood as preludes to youth, middle age, and old age. There is no implication of a rise and decline, however. Just as the youthful moment is one of immense, exuberant discovery, the old-age style or the third phase might be characterized by deep self-knowledge and a magnification of vision together with a reduction to essentials. Think of late Titian (or late Rembrandt). Because of the lack of data, the differences in life-spans, and the variations that occur within the patterns of individual masters, the structure suggested here need not and cannot be rigidly applied for each artist; it may be thought of as providing additional guideposts that can be used, where applicable, for understanding the flow of certain careers.

The three-part division of an artist's career, following an introductory or learning phase, may also be transposed into the larger divisions of the period and hence of this book. The discussion of the origins of Renaissance painting, the generation immediately preceding the first generation of Renaissance painters, may be seen in relation to the apprenticeship phase of an individual

style. The sculptors were more precocious in their experimentation and in dealing with issues that became important for the first generation of painters, including a careful evaluation of ancient models. The first generation embodies that outburst of originality and the innovative solutions typical of the first phase of a great artist's career. The second is characterized by an assessment, elaboration, and perfection of the new forms, with a certain element of rejection of the solutions of the immediate predecessors. The third is revealed by a magnification and even institutionalization of the Renaissance ideas already set forth, and by a renewed interest in the innovations of the first generation, but now with all the tools and skills accomplished in the second.

·⊦·

The organization of Renaissance painting into three generations has the effect of giving equal weight to each generation. There is thus a shift in emphasis away from the third generation, which is traditionally awarded the highest honors. We do not need to diminish the achievements of Giorgione, Michelangelo, Raphael, Titian, and Correggio. Their contributions were exceptional for the entire history of painting. On the other hand, to call Masaccio, Filippo Lippi, and Pisanello "primitive," as has been done until fairly recently, seems to represent an enormous misunderstanding of the entire Renaissance. Nor should the contributions of the middle generation, of Verrocchio, Pollaiuolo, Mantegna, Perugino, and Giovanni Bellini, be sandwiched into a critical limbo.

Masaccio, Fra Filippo Lippi, Jacopo Bellini, Pisanello, Domenico Veneziano, Piero della Francesca, and the other first generation painters represent in their art a period of spectacular discoveries at a decisive moment in the history of Western culture. Mathematical or linear perspective, first used by painters in the 1420s, became essential for the whole Renaissance and for much of Western painting up to modern times. The treatment of landscape is hardly less important for the following generations. In the area of figure painting, the proportional systems used by first generation painters were vital, as was the handling of anatomy and the nude. Portraiture was developed for its own sake; and narrative painting became the cornerstone of official painting for the next four centuries. The art of the first generation gave rise to Renaissance theory, stated magisterially around 1435 by Alberti.

The first generation painters were basically on their own in inventing the new pictorial language. They were able to look back to the achievements of the late medieval masters, especially Giotto, from Florence, and Duccio and his fellow Sienese, the Lorenzetti brothers and Simone Martini. These artists are often thought of as proto-Renaissance because of their precocious approach to many of the pictorial problems explored by later painters. Their reputations

were still very much alive in the early fifteenth century, and they continued to have a certain vitality for the next century. But it was not until nearly two generations after these *trecento* (fourteenth century) giants had died that the artists of the Renaissance emerged.

In the years after 1420 daring innovators exhibited the exuberance and strength of youth; they took risks and in so doing were unprepared to hide their weaknesses. Think of Masaccio's understanding of human anatomy in the Adam or the Eve from the Brancacci Chapel frescoes or Paolo Uccello's exaggerated exercises in perspective or in color. The painters of the first generation will be particularly admired by those who appreciate pure invention, although the technical skills sometimes lagged behind.

In the second generation, like middle age, the painters cast a more calculated and critical eye on what had been discovered. They began to analyze and refine the new linear and aerial perspectives; they more systematically and doggedly studied human anatomy; they modified and combined inventions of the previous decades and sought more rigorous solutions to problems raised during the first generation. Artists like Giovanni Bellini, Andrea Mantegna, and Antonio Pollaiuolo were able to ingest the innovations of their predecessors and not only elaborate upon them, but also operate with them more easily within a balanced system. For example, the theme of the *sacra conversazione*, altarpieces containing groups of saints in the presence of and in the same space as the Virgin and Child, first enunciated by first generation masters such as Fra Angelico and Domenico Veneziano (who in turn had precedents in the *trecento*), was raised to a convincing reality, with narrative rather than iconic implications. The spatial explorations of Mantegna and Melozzo da Forlì, especially for the treatment of wall or ceiling decorations and the relationship of the spectator to the represented scene, were of enormous ingenuity and reveal the strictest discipline. Surely this phase cannot in any way be called inferior to that which went before or that which followed.

The third generation reflects a tendency to return to solutions reminiscent of the first generation. Since the use of oil paint as a substitute for tempera gradually becomes more common in Italy during the 1470s and 1480s, the third generation painters are more exclusively dependent upon that medium except, of course, when making frescoes. With oil paint came canvas as a more common means of support, and its potentialities were exploited by third generation painters. In addition, the use of a heavy weave by Venetian painters, notably Titian, had an important effect on how the paint was applied. The anatomy of Masaccio's Adam is approximate, with the legs a little too long and the torso a little too short; Raphael's or Titian's nudes, based on a more direct study and understanding of the figure, have a new visual justice which was, in turn,

predicated upon the experience and the anatomical investigations of the second generation painters. This equation for narrative painting would liken Raphael's *School of Athens* [332] to Masaccio's *Tribute Money* [77]. The final generation of Renaissance painting hardly needs advocates.

The third generation painters were better prepared to evaluate and to put to use the lessons of antiquity because of new discoveries of major sculpture from the ancient world as well as a confirmed awareness of the power of the architecture of ancient Rome, and even the discovery of Roman mural decorations. These painters are typically confident of their artistic language, having had the advantage of experience: the body of works produced by two generations of talented painters.

<div align="center">⊹⊹</div>

Although the designation of schools has not been stressed in this book, the value of such labels should not be underestimated. Giovanni Bellini is a Venetian painter whose visual orientation is marked not only by the local artistic tradition that characterized the city, including a Byzantine medieval overlay exemplified by the glittering mosaics that cover the walls of San Marco, but also by the physical aspects of the city: the architecture, unique because of the special problems connected with its site, the canals, the sea, and the resulting qualities of light all had an effect upon the vision of artists raised in Venice. We could hardly expect a different scenario. Just as the spoken dialect of Venetian Italian has its own cadences unique unto itself, so the art produced there has certain qualities singularly Venetian.

The same is true of Florence, where it would be unrealistic to forget that Masaccio or Verrocchio, much less Michelangelo, were "Florentine." The local habits—visual, intellectual, political, and linguistic—affected all the sons of the city just as Brunelleschi's dome of the Cathedral *(duomo)* cast its shadow over the entire population of Tuscany, as Alberti suggests. Florence lies in a flat valley punctuated by the Arno River, which flows to the sea some fifty miles away. Behind Florence are the Apennines, which rather quickly rise to the north, providing a natural barrier to Lombardy and offering some respite from the hot summers. The mountains have also served as a stylistic wall between Tuscany and North Italy. The land around Florence is mean and dry, but with determination renders its splendid grapes, olives, and grain.

Quite diverse from either Florence or Venice is Siena, a hill town with narrow, winding streets, a natural citadel, with high walls for defense. Views of the lowlying, rolling countryside nearby are available from almost anywhere in the city, not unlike hill towns in Umbria, the main example being Perugia, a reasonably important art center during the Renaissance. Just as one can charac-

terize the particular features of one town over another, so too the traditional labels can and should be used, once their limitations are appreciated.

·ɪ·

No special consideration has been given to the art of the rest of Europe during the period of the Renaissance in Italy. Just as there were frequent exchanges between one city and another in Italy, and between one region and another, so too was there interchange between Italy and other nations. Together with the active trade that was common among the countries of Europe, art works and artists moved readily, although national styles retained their independence. Italian artists and patrons were acquainted with Netherlandish painting of the fifteenth century, and in the area of landscape and still-life painting as well as in portraiture, we must assume that the Italians were indebted to their Northern contemporaries. There must have been influences from many directions; we know, for example, that Dürer's prints had a significant impact on many Italian painters.

·ɪ·

The stylistic integrity of each painter, beyond the shared qualities of every generation and the broad affinities of a lyric or monumental sort, is always an irreducible component of Renaissance painting. The purely personal quotient was consciously cultivated, functioning as an unofficial trademark for each painter's shop. The style of a master like Castagno is and always was easily recognized. In locating this painter within the overall framework of the Renaissance, we can see him as a first generation painter, a Florentine, pertaining to the monumental current. On the more strictly personal level, his style exhibits an insistent, thick line; an intensity of figural expression; and a harshness or at least a directness in establishing his forms. As another example we can take Correggio. He stands chronologically within the third generation, is Emilian, and tends toward an adherence to the lyric current. His soft, atmospheric treatment of figures and landscape details, the refined, sensual personalities in his pictures, their small heads and features, the thick excited bravura passages in his oil paintings, are all aspects of a personal style.

The importance of powerful individual artists in determining broad stylistic qualities of a generation has been suggested from time to time and is inherent in my approach. One must wonder whether Renaissance painting as we know it could have occurred without some of the dominant personalities: Masaccio, Mantegna, Giovanni Bellini, Raphael. Or, reversing the situation, whether the personal styles or individual solutions of such painters did not go a long way toward making a Renaissance language, which lesser geniuses

tended to consolidate. There are so many gifted and original masters of Renaissance painting operating simultaneously that what occurred seems at least partially inevitable, but it was the brightest stars who cast their light upon the entire stylistic landscape.

The situation is somewhat different for the period immediately following the third generation, those painters born in the period from about 1495 to 1525, who were trained at the beginning of the Protestant Reformation (1517). These painters, including Parmigianino (1503–1540), Giulio Romano (1499?–1546), Perino del Vaga (ca. 1500–1547), Bronzino (1503–1572), Tintoretto (ca. 1518–1594), and Giorgio Vasari (1511–1574), have a different orientation to painting than did the artists who preceded them. The issues are still difficult to define, and one should remember that the concept of Mannerism as a period style is a critical construct of the twentieth century. This is not the place to explore the complex issues or to examine the pictures produced by these artists. They seem to have been more specifically derivative, more deeply committed to the manner of one or another or a combination of the masters from the previous generation; Parmigianino to Correggio (and some movement vice versa), Giulio Romano and Perino del Vaga to Raphael, Tintoretto to Titian and Michelangelo, Bronzino to Pontormo and Michelangelo, Vasari to Michelangelo and Raphael.

It is not my purpose here to treat Mannerism as a stylistic occurrence in *cinquecento* Italy, much less in other European centers. There is no question that it derives from the manners of the third generation painters. There is a winding down of the kind of artistic energy that had characterized the Renaissance. The decisive generation for a new robust style occurs some time later and is marked by the emergence of the Carracci in Bologna and Caravaggio in North Italy, who set into motion an entirely new style called Baroque.

ORIGINS OF THE
EMERGING RENAISSANCE STYLE

By isolating two broad stylistic currents, lyric and monumental, within the context of Italian Renaissance painting, and by organizing the artists according to generations, certain problems inherent in other divisions of the material disappear. Usually, for example, Masolino (ca. 1384–1443?) and Masaccio (1401–1428) are treated together, and Masolino inevitably becomes the foil: he was a more conservative and, to a certain extent, even backward-looking master who, despite being seventeen years Masaccio's senior, became his somewhat awkward and ineffectual imitator, the reasoning goes. They did collaborate on at least one major commission, the Brancacci Chapel in Santa Maria del Carmine in Florence. Since it is the single most influential cycle of frescoes painted in the early Renaissance, even though it was unfinished at Masaccio's death, the interdependence of Masaccio and Masolino has been exaggerated. The fact that these two painters were in close contact need not mean that they were working within the same formal language or that the obvious differences between them were principally questions of skill, genius, or modernity. Masolino belongs to an earlier generation and tradition in the evolution of Italian art, one that places him more comfortably with slightly older contemporaries such as Lorenzo Monaco (1370?–1425) and Gentile da Fabriano (1370?–1427) than with Masaccio, who was born in the *quattrocento.* Masolino's nearly precise contemporaries were the sculptors Lorenzo Ghiberti (1378–1455), Donatello (1386–1466), Nanni di Banco (1385?–1421), and Filippo Brunelleschi (1377–1446).

The three painters, Lorenzo Monaco, Gentile da Fabriano, and Masolino, belong to a moment that precedes the first generation of Renaissance painters.

They had their artistic apprenticeship and training before 1400; and their formation was predicated upon different cultural, artistic, political, and economic conditions from those masters who belong to the first generation even if we are unable to fully reconstruct their careers, especially the early phases. Their work opened the way for the innovations of their pupils and followers.

The career of Maso or Tommaso di Cristofano Fini, known as Masolino (da Panicale), is particularly baffling to reconstruct because he is not actually documented until 1423. In that year he is inscribed in the guild in Florence to which the painters were attached, the Medici e Speziali, that is, doctors and druggists, which will be referred to throughout this book as the painters' guild. The date of his birth (ca. 1384) derives from a statement by his father in a tax return of 1427, in which Masolino was described as forty-three years old and then in Hungary.

Masolino's work can be effectively studied from the mid-1420s through the 1430s, when he was active in Florence, Rome, Todi, and finally Castiglione Olona. As a result of his activities in both central and northern Italy, Masolino's style had a particularly wide diffusion. In Florence he was working on frescoes of the Brancacci Chapel and elsewhere in the Church of Santa Maria del Carmine, presumably just before his departure for Hungary in 1425 and after his return in mid-1427.

Paintings by Masolino produced in Rome include a cycle dealing with the lives of Sts. Ambrose and Catherine of Alexandria for the Chapel of the Sacrament in San Clemente. An elaborate but undated altarpiece for Santa Maria Maggiore, perhaps still unfinished in 1432, is at least in large part his. He left Rome in 1432, when he painted a Madonna in fresco for San Fortunato in Todi and soon afterward was at work in Castiglione Olona, a small Lombard center north of Milan, where he was engaged on two complex fresco cycles. Masolino died sometime between 1440 and 1447, perhaps in 1443, the year Vasari erroneously gives for Masaccio's death.

Before examining Masolino's art, a look at his Florentine contemporaries is instructive since Florence at this moment in history was the dominant artistic center in Italy for the emerging Renaissance style, which first manifested itself in sculpture and in architecture and then in painting. The three most prestigious artistic personalities in Florence during the first years of the fifteenth century were not painters; all were trained as goldsmiths and to varying degrees worked as sculptors. The oldest, Filippo Brunelleschi, became the most original and influential architect and engineer of his generation and was, besides, the inventor of linear perspective, the *sine qua non* for Renaissance narrative painting, around 1420. The system was utilized in painting by Masaccio a few years later, perhaps under the direct guidance of Brunelleschi,

whose architectural style, first enunciated in such buildings as the Hospital of the Innocents [18] and the Church of San Lorenzo in Florence, was based on ancient classical forms coupled with elements of the Tuscan Romanesque period.

Lorenzo Ghiberti, Brunelleschi's keenest adversary in Florence, remained more exclusively devoted to sculpture throughout his lifetime, much of which was spent producing two sets of bronze doors for the Florentine Baptistry. The second (east) doors, usually called the *Gates of Paradise,* are opposite the façade of the Cathedral. In the course of work on the doors, Ghiberti wielded immense power because of his capacity to employ a large staff. Artistically, he developed scores of compositions and hundreds of figural combinations and poses, making it quite easy to isolate his stylistic and natural preferences.

Ghiberti's figures and their poses reflect a continuation of earlier models, especially those set forth by Giovanni Pisano and translated and re-elaborated during the *trecento.* These were types that had spread throughout Europe toward the end of the century and were especially favored by goldsmiths. The style they represent is often described as the International Gothic, the Courtly Style, or simply the International Style. The work of Lorenzo Monaco, Gentile da Fabriano, and Masolino shares a close relationship with this style. The International Style refers to the current that flourished from about 1380 onward in Western Europe and Bohemia, characterized by fluid, curvilinear forms of elegance and refinement that drew upon Gothic art. In a lyric-monumental continuum Ghiberti's art unmistakably falls on the lyric side, and it may have been his innate preferences that first drew his attention to the International Style. If this current had impulses from the earlier period, especially Sienese painting before the Black Death (1348), there was also a strong desire for a careful, direct observation of the natural world together with a highly refined taste. As Ghiberti matured, he remained committed to a lyric current at the same time that he took full advantage of perspective, and enthusiastically shared with the younger, progressive artists a keen interest in ancient art.

Ghiberti's slightly younger contemporary, Donato di Niccolò di Betto Bardi, known as Donatello, is an outstanding example of the monumental current. He even worked briefly with Ghiberti on the first bronze doors, following an association with Brunelleschi, but soon turned more exclusively to monumental sculpture in marble and bronze. In his youth Donatello was not impervious to the appeal of the International Style—witness the marble *David* [1] of 1408–9—although by the time he carved the St. Mark [2] (about 1414), he emerges as a practitioner within a monumental current with few equals.

It is instructive to examine the *St. Mark* alongside Ghiberti's *St. John the Baptist* [3] (1415–17), nearly contemporary, over-life-size statues made for the

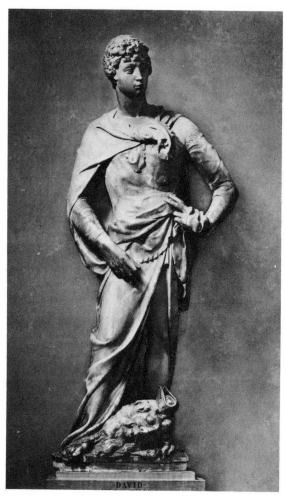

1. Donatello. *David*, 1408–9. Marble, h. 191 cm. (including base). Florence, Bargello.

exterior niches on Orsanmichele (Florence), to distill features of the lyric and monumental currents immediately before the appearance of the first genera-tion of painters. Both statues are imposing, even dominating images, although Ghiberti's is cast in bronze and Donatello's carved from marble. The way in which the two bearded saints are posed dramatically reflects the different tendencies the works represent. *Mark* stands easily on the petrified pillow within a system of *contrapposto* first developed by Greek sculptors in the fifth century B.C. His right leg bears most of the weight, a function underscored by the striations carved into the columnar drapery that covers the leg; the right arm hugging the body's contour repeats and accentuates the vertical thrust. The left leg is bent and the left arm is slightly raised, making the shoulders

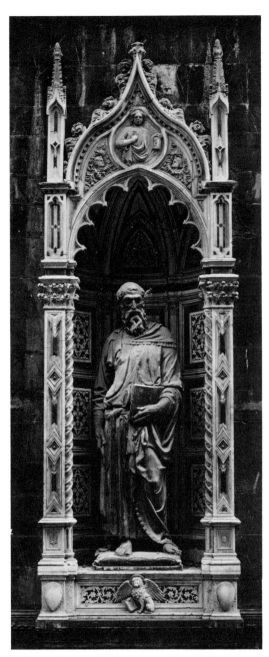

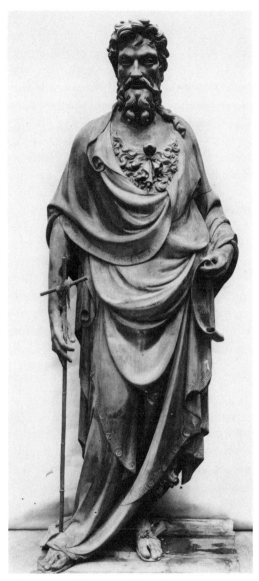

3. Lorenzo Ghiberti. *St. John the Baptist*, 1415–17. Bronze, h. 254 cm. Florence, Orsanmichele.

2. Donatello. *St. Mark*, ca. 1414. Marble, h. 236 cm. (including cushion and plinth). Florence, Orsanmichele.

comply with the arrangement. The mighty head stares off to the spectator's right, breaking the axiality of the frontally oriented figure.

In Ghiberti's interpretation of the standing figure, the distribution of weights is less specifically arranged, and the drapery moves within broad arcs and sweeping curves—an elegance of design and movement not found in Donatello's statue. The volume of the *St. John* is stressed less, in favor of an active flattened-out surface where areas set into deep shadow are juxtaposed with strongly highlighted segments. Both are dignified, majestic images with restrained gestures, although Donatello's *Mark* displays greater intensity of expression, and his appearance more directly recalls Roman prototypes. Ghiberti relies on the late medieval discoveries of Giovanni and Andrea Pisano in the appearance of the saint, that is, on Tuscan *trecento* prototypes. He is more attuned to the effects of surface than is Donatello, and the arrangement of John's beard or the patterns of his hairy shirt have a visual appeal independent of their function. The treatment of silhouettes or edges in the two statues has similar diversity, as do the other elements. By its very mass, Donatello's statue occupies the space of the niche without compromise. Ghiberti's has an excited boundary that struggles with the surrounding space, stretching it and intruding upon it.

The art of these two masters has its own particular rhythm of development, and at times Ghiberti is more inclined to experiment with typically monumental solutions. But he never moves into a monumental current, which was antithetical to his natural predilections. The same holds true in reverse for Donatello. Even though he was temporarily attracted to the elegant, non-classical modulations of artists like Ghiberti and at different stages of his career turned toward an atmospheric handling of surfaces, especially in narrative reliefs—stylistic elements more in harmony with the lyric taste—Donatello never lost control of the monumental qualities.

Donatello and Ghiberti can hardly be overestimated in the effect they had upon the painters who followed them chronologically. If Fra Angelico (1399?–1455) is artistically a natural parallel to Ghiberti and owes him a good deal, Masaccio (1401–1428) could not have developed his art without the example and, perhaps, collaboration of Donatello (and Brunelleschi). The sculptors were about half a generation in advance of the painters at the beginning of the fifteenth century, a lead that shifts later in the century in favor of the painters. During the years shortly after 1400, Ghiberti, Brunelleschi, Donatello, and others, notably Nanni di Banco, were working in an idiom that has spatial and figurative qualities which are inseparably tied to our notion of Renaissance art.

Nanni di Banco's career was an abbreviated one; he can be documented only for the thirteen-year period from 1408 until 1421, when he died. But he did

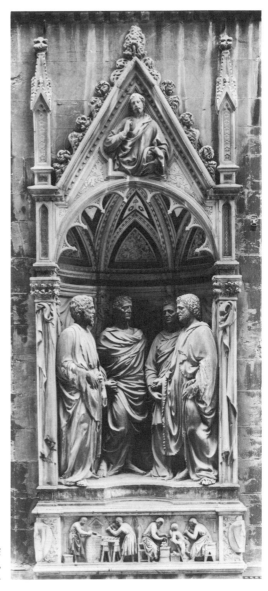

4. Nanni di Banco. *Quattro Santi Coronati*, 1411–15. Marble. Florence, Orsanmichele.

leave his mark in the form of imposing statues for Orsanmichele, along with those by Ghiberti and Donatello. His *Quattro Santi Coronati* [4], the four patron saints of stone carvers, are arranged spatially in a semicircle that may have given Masaccio insights for the composition of the central group in his *Tribute Money* [77] from the Brancacci Chapel, while the dignified, imitation Roman figural types also have an echo in the painter's work.

Among the painters who were Brunelleschi's, Ghiberti's, and Donatello's

precise contemporaries and whose work falls at the threshold of the Renais-
sance, there is not a single important representative of the monumental cur-
rent. Rather, the three most influential painters, Lorenzo Monaco, Gentile da
Fabriano, and Masolino, all fall into the lyric category. Their later work overlaps
the careers of such first generation masters as Fra Angelico, Jacopo Bellini,
Uccello, and Pisanello, and they left a strong impact on the evolution of these
first generation painters. Gentile's contributions, especially his works of the
1420s when he was active in Siena, Florence, Orvieto, and finally Rome, are
enormous, since he often transcended local schools. He was a Marchigan by
birth, worked in Venice and the Veneto for about a decade, and is often thought
of as belonging to the Venetian school. He was not impervious to innovations
wherever he went, and especially those he found in Florence, like Ghiberti's
first doors, already cast though not yet installed. He seems to have been aware
of the newest research in the development of perspective, and if he was not
fully prepared to employ it in his paintings, he came close.

The birth date of Gentile di Niccolò da Fabriano is unknown but is usually
taken to be as early as 1370, although he is first documented only in 1408, in
Venice. Before that he must have painted in his native region around Fabri-
ano, including the magnificent *Polyptych of Valle Romita* (Milan, Brera). He
painted an important fresco for the Venetian government in the Doges' Palace
depicting a naval battle, but it was destroyed in a fire during the sixteenth
century. Recorded in Lombardy in the years after 1414, Gentile was invited to
work for the newly elected pope, Martin V. He was in Florence in 1420, when
he rented a house, and he was matriculated in the painters' guild in there in
1422. The *Adoration of the Magi,* commissioned by Palla Strozzi perhaps as
early as 1420 for the sacristy of Santa Trinita, is signed and dated 1423. Two years
later he signed the *Quaratesi Altarpiece* for a chapel in San Niccolò sopr'Arno;
in Siena he painted the *Madonna dei Notai* (lost). At the end of 1425, in Orvieto,
Gentile painted a *Madonna and Child Enthroned* in the Cathedral and then
proceeded to Rome, where he died in 1427 while working on frescoes for San
Giovanni in Laterano (destroyed in the seventeenth century).

<div align="center">┼┼</div>

To grasp Gentile's art within the context of Renaissance painting, we must
study his two major commissions in Florence. The *Adoration of the Magi* [5]
is composed of a central field with three round arches showing the *Adoration;*
below, the *Adoration of the Child,* the *Flight into Egypt,* and the *Presentation
of the Child in the Temple* (Florence, Uffizi, except for the *Presentation* in
Paris, Louvre) make up the predella. In the late Gothic gables above are reclin-
ing prophets and in roundels an *Annunciation* and a *Blessing Christ,* in a

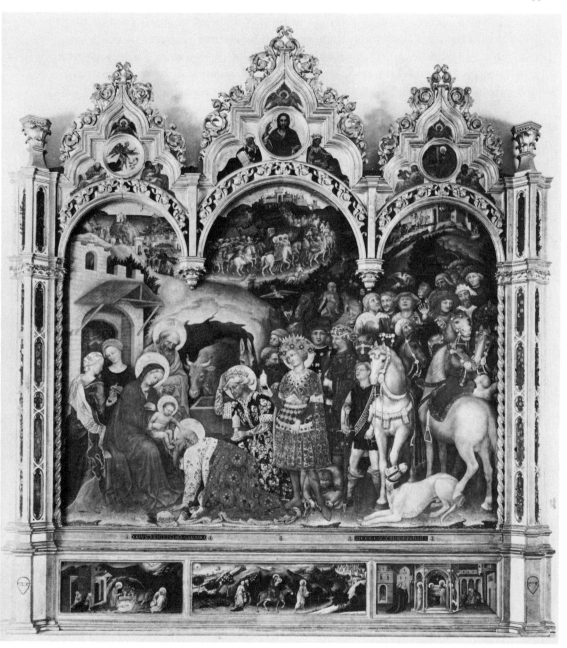

5. Gentile da Fabriano. *Adoration of the Magi (Strozzi Altarpiece)*, 1423. Wood panel, 303 × 282 cm. Florence, Uffizi.

different scale, larger than the figures in the predella scenes, but smaller than those in the front plane of the main panel. The corner pilasters of the frame contain painted flowers in lozenges executed with elegance, refinement, and naturalistic verve. We may assume that Gentile worked about two years on the intricate altarpiece and that he had a staff to help him, numbering in this *bottega* (workshop), perhaps, Jacopo Bellini (see Chapter 3).

Panoramic rather than iconic, the *Adoration of the Magi* is literally jammed with figures and objects of all kinds for the spectator to ponder. The scene unfolds at the lower left, where Mary and the Child with attendants and Joseph accept the gifts and homage of the three kings. They comprise the essential personages of the story and might have been sufficient for some masters and some patrons but not for Gentile and not for the wealthy Palla Strozzi. The retinue of the kings, which fills nearly half the picture, and the distant subscenes under the arches that depict the journey of the Magi show that Gentile is interested in all features of the social and natural environment; he parallels and perhaps reflects the advanced Netherlandish painters of the same time. A virtual zoo may be found in the picture: horses, a mastiff, an ox and an ass (traditional for the theme), camels, monkeys, a deer, a leopard, birds of different species. Landscape elements abound: diverse and exotic trees, including pomegranates, the fruit of which symbolizes the Resurrection, and flowers and plants of all kinds. This interest in the natural world is one shared by many painters who came after Gentile. It is an important aspect of Renaissance art that was inherited from the previous Gothic past.

The figures in their lavish costumes and elaborate headdresses, old and young, men and women, in different attitudes, particularly claim the viewer's attention. Gentile relishes decorative patterns and an extended spectrum of high color—strong blues and bright reds set against off-whites and, of course, gold leaf spread abundantly around the picture, sometimes acting as background, occasionally as lights. The desire for naturalistic detail, characteristic of Gentile, is combined with the joy of richly decorated objects.

Gentile's figures are elegant and swaying, with small heads and dainty facial features, regardless of their social class. The heads are modeled softly and easily by means of light and shade without emphasis upon volume and show little dramatic intensity or narrative power. The three-dimensional qualities of the figures, whose flesh, bones, and muscles do not usually form a part of this artist's commitment, are de-emphasized, while the drapery takes precedence over the body it covers.

The predella scenes are more novel. The *Flight into Egypt* [6], for example, might be thought of as a landscape with figures (in comparison to the *Adoration* above, which is a figure painting with a landscape background), and

6. Gentile da Fabriano. *Flight into Egypt* (predella panel, *Strozzi Altarpiece*), 1423. Wood panel, 25 × 88 cm. Florence, Uffizi.

as such could lay claim to being among the earliest landscapes painted in the fifteenth century. It has a specific topographic look reminiscent of the country-side around Siena or Umbria. The sun is ingeniously composed of actual gold leaf and gold paint, and the sunlight refracts against the tops of low hills from the far left, finally striking the geometric planes of the city wall on the right and functioning as the unifying logic of the composition in which thin, naturalistic clouds drift across the sky.

The large altarpiece for the Quaratesi family has been dismembered (central section *Madonna Enthroned,* Hampton Court; side saints, Florence, Uffizi; predella panels in the Vatican, Pinacoteca, and Washington, National Gallery). The picture in Washington [7] shows the interior of a Romanesque church with the tomb of St. Nicholas of Bari to which cripples have been brought; the man in the left foreground holds crutches on his shoulders as he strides out, healed. The sources of light are confused, but the created space, although lacking the precision and unity of Brunelleschi's method, is functionally convincing and descriptive. Gentile, an artist of demanding visual sensibilities, recorded as accurately as possible what he saw in all its complexity. He left a strong impression upon painters working in Florence at the time of his stay there, from about 1422 through 1425, including Masolino, as well as some of the younger generation, most notably Fra Angelico and Masaccio. Lorenzo Monaco, on the other hand, was so deeply invested in the style he had developed for himself that by the 1420s he appears to have been less susceptible to Gentile's innovations. If Gentile had a significant impact upon both first generation monumental and lyric painters in Florence (and Siena), he was also instrumental in the formation of the Venetian Jacopo Bellini and of Pisanello, from Verona, both of whom were connected with his workshop and were prominent exponents of the lyric current in the first generation of Renaissance painting.

⁘

Lorenzo Monaco was probably trained as a miniaturist or manuscript painter, and his art is more stylized than either Gentile's or Masolino's. He retains connections with late-fourteenth-century conventions of his native Siena. Born Piero di Giovanni around 1370, he was given the name Lorenzo when he took orders, hence Lorenzo Monaco (meaning monk). By 1391 he was in Florence, where he joined the Camaldolese. He appears to have left the order, or at least changed his status within it, about ten years later. In 1402 Lorenzo enrolled in the painters' guild in Florence. Relatively little is known about his life and his commissions, although a number of signed and dated works permit a reconstruction of his development and chronology. At the end of his life he was painting an important fresco cycle in Santa Trinita.

Lorenzo's importance for the development of Renaissance painting is marginal, despite the intrinsic beauty of his pictures. The aspects of the International Style that most appealed to him—an abstract and anti-naturalistic color, extreme elongation of figures, unrealistic draperies with little relation to the human figure beneath them, as well as bare symbolic landscapes and miniaturized architecture, as in the *Adoration of the Magi* [8]—had few immediate echoes in the mainstream of *quattrocento* painting. A nearly exact contemporary of Gentile, Lorenzo Monaco can be appreciated as a rare and delicate master who represents a refined late *trecento* style, but one who had neither the wide experience nor inclusive appeal of Gentile. His art does bring to mind

7. Gentile da Fabriano. *Pilgrims at the Tomb of St. Nicholas of Bari* (predella panel, *Quaratesi Altarpiece*), 1425. Wood panel, 36 × 35 cm. Washington, National Gallery (Kress Collection).

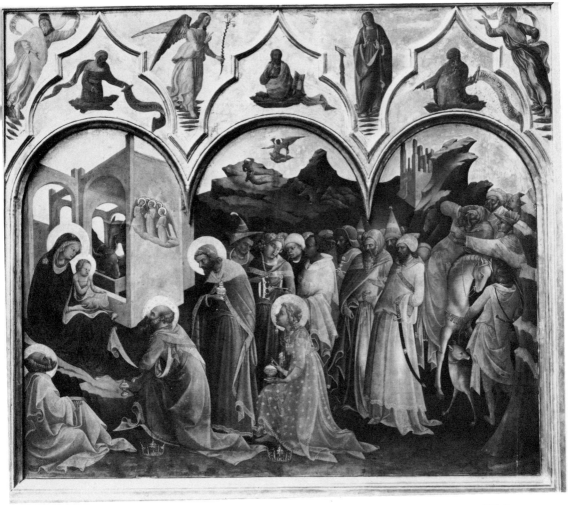

8. Lorenzo Monaco. *Adoration of the Magi*, 1420–22(?). Wood panel, 144 × 177 cm. Florence, Uffizi.

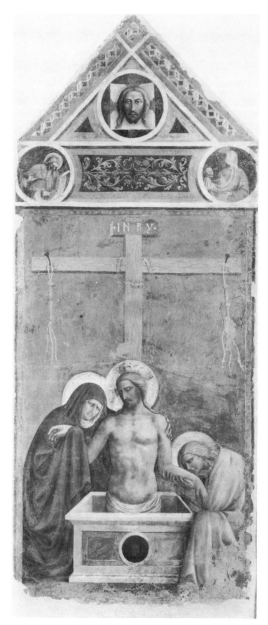

9. Masolino. *Pietà*, 1424. Fresco, 280 × 118 cm. Empoli, Museum of the Collegiata.

certain sixteenth-century painters who consciously sought to reject the real in favor of an ethereal, unnatural world, and whose abstract color and elongated figures have an analogous effect. But these connections are fortuitous and unspecific, not so much based on a conscious revival of Lorenzo Monaco's art as a general nostaglia for Gothic forms.

✛

Masolino, finally, continued to work long after the death of Gentile da Fabriano and became one of the most influential painters in Italy. Around 1424 Masolino painted an important cycle of frescoes in Empoli depicting the *Story of the True Cross,* but only the *sinopie* (that is, underdrawing on the rough wall) have survived; and in the same town he did a *Pietà,* also in fresco [9]. He sought realism in details, such as the woodgrain of the Cross or the marble of the tomb, but the handling of light is uncertain and the perspective tentative. The figures, Mary, John, and especially Christ, are built up with decisive areas of light and dark; the nude torso is treated schematically. Bodies are substantial, but the heads smallish, their features tightly painted.

The combination of a somewhat heavy and elongated figure with a small head is repeated in the fresco of the *Fall* from the entrance arch of the Brancacci Chapel in Santa Maria del Carmine, Florence, which is universally agreed

10. Florence, Santa Maria del Carmine, Brancacci Chapel. Plan of the frescoes by Masaccio, Masolino, and Filippino Lippi.

A. *The Calling of Sts. Peter and Andrew* (?), destroyed (Masolino?)
B. *St. Peter Denying Christ* (?), destroyed (Masolino?)
C. *The Shipwreck of the Apostles* (?), destroyed (Masolino?)
D. *Expulsion* (Masaccio) [75]
E. *Tribute Money* (Masaccio) [77]
F. *St. Peter Preaching* (Masolino) [13]
G. *St. Peter Baptizing the Neophytes* (Masaccio) [14]
H. *Resurrection of Tabitha and the Healing of a Cripple* (Masolino) [12]

I. *Fall* (Masolino) [11]
J. *St. Paul Visits St. Peter in Prison* (Lippi)
K. *Raising of the Son of Theophilus and St. Peter Enthroned* (Masaccio and Lippi) [140]
L. *St. Peter Healing with His Shadow* (Masaccio) [73]
M. *People Giving Their Goods to St. Peter and the Death of Ananias* (Masaccio) [74]
N. *Judgment and Martyrdom of St. Peter* (Lippi) [141]
O. *Angel Delivering St. Peter from Prison* (Lippi)
a.b.c.d. Evangelists, destroyed (Masolino?)

to be part of Masolino's share of these famous frescoes [10, 11]. Here, Masolino's style can surely be seen, despite the enormous problems related to the division of labor between him, Masaccio, and Filippino Lippi. The most satisfactory explanation is that Masolino obtained the commission for the chapel from Felice Brancacci around 1424 and that he then painted the vaults and the uppermost tier on the walls, all of which were destroyed in a fire during the eighteenth century. By September of 1425 Masolino went off to Hungary on a particularly

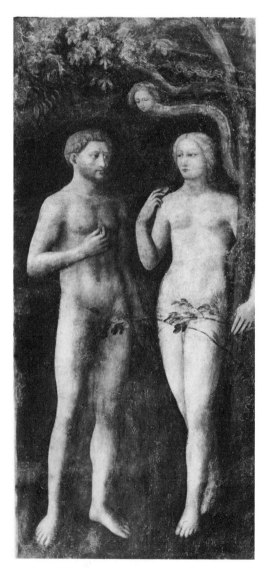

11. Masolino. *Fall*, 1427/28. Fresco, 208 × 88 cm. Florence, Santa Maria del Carmine, Brancacci Chapel.

lucrative assignment, and work in the chapel presumably stopped. After about a year the patron turned to Masaccio, perhaps recommended by Masolino himself before his departure, or more likely by the Carmelites, for whom Masaccio had been working in Pisa. Masaccio began work in earnest on the frescoes early in 1427. He must have made wholly new designs for the entire project below the lunettes. Late in 1427, however, Masolino was back in Florence. Masaccio left for Rome in 1428 and died there in the same year; Masolino also seems to have left Florence, perhaps also for Rome. Since the frescoes had not been completed, and since there is nothing in the lowest zone by Masolino, even within the unfinished fresco of the *Raising of the Son of Theophilus and St. Peter Enthroned* [140] (the lowest zone is normally the last executed), the evidence seems to indicate that Masolino left work on the chapel before Masaccio. This scenario is perhaps as close as we can come to a chronology, although it must be considered hypothetical.

If Masaccio was responsible for the second phase of the decoration (all of the surviving frescoes), Masolino was obliged to accommodate his share to Masaccio's new program and to those parts already painted by Masaccio. Indeed, Masolino here becomes more Masaccesque than ever before or again. Nevertheless, the qualities that make him a significant exponent of the lyric current are amply demonstrated, as we notice in the *Fall,* and in the frescoes representing the *Resurrection of Tabitha and the Healing of a Cripple* [12] (1427/28), which are united within a single compositional field, balancing Ma-

12. Masolino. *Resurrection of Tabitha and the Healing of a Cripple,* 1427/28. Fresco, 255 × 598 cm. Florence, Santa Maria del Carmine, Brancacci Chapel.

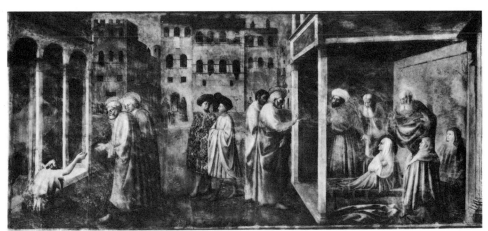

13. Masolino. *St. Peter Preaching*,
1427/28. Fresco, 255 × 162 cm.
Florence, Santa Maria del Carmine,
Brancacci Chapel.

saccio's *Tribute Money* on the opposite wall. Obvious gesturing, colorful inci-
dental details—especially the superb cityscape in the background—the tiny
daintily rendered hands and feet of his actors, and extensive decorative ele-
ments are all characteristic of Masolino. The color, too, is in a high key in
contrast to the more somber tones of Masaccio's frescoes, although the condi-
tion of the entire cycle makes final conclusions, especially concerning color,
difficult. Masolino's perspective is hesitant when compared with Masaccio's
Trinity [66] of late 1425: the buildings on both the left and right are spatially
ambiguous, and the relation of the figures to the architecture is puzzling.
Masolino seems to have been incapable of mastering Brunelleschi's discovery,
and betrays the same difficulty in later works in Rome and Castiglione Olona
—despite the fact that he was particularly fascinated by the pictorial possibili-
ties of perspective.

The modeling of the heads in the frescoes, especially the two elegant young
men in the center, who were apparently added for compositional reasons,
reveals a debt to Gentile da Fabriano. Masolino seems to have included portraits

14. Masaccio. *St. Peter Baptizing the Neophytes*, 1427/28. Fresco, 255 × 162 cm. Florence, Santa Maria del Carmine, Brancacci Chapel.

of contemporaries in the frescoes and especially in his *St. Peter Preaching* [13], where the monks to the right of St. Peter may be portraits of members of the Carmelite order; the laymen to the left probably represent the family of the patrons, shown here in three-quarter view; Masaccio has similar figures in the matching *St. Peter Baptizing the Neophytes* [14], but in sharp profile.

Once Masolino left Florence in 1428, apparently for good, his art is, if anything, more thoroughly lyric, as if a distance from Masaccio's work liberated his style, which could now take its more natural course. The altarpiece for Santa Maria Maggiore (central panel, Naples, Capodimonte Museum; side panels, Philadelphia Museum of Art [23] and London, National Gallery) depicts the *Founding of Santa Maria Maggiore* [15] and, on the other side, the *Assumption of the Virgin,* with paired saints. The figures in the *Founding* are rendered with greater delicacy than those Masolino painted in the Brancacci Chapel, in part because of the medium, tempera. The more elegant and refined figures have miniaturized features produced by tight modeling, while the impulse to create three-dimensional volume has diminished. The distant landscape is especially

16. Masolino. *Annunciation*, 1428–30 (?). Fresco. Rome, San Clemente, Cappella del Sacramento.

effective, and the composition is one of Masolino's finest. Pope Liberius traces the outlines of the new church on the fresh snow, which has fallen miraculously in August. Numerous bystanders, arranged in two parallel rows, recede into a larger group of witnesses. The buildings on either side reinforce the movement into the center of the picture, which shows Christ and Mary on an axis above, placed in a circular halo of bright colors.

 Scholars have studied the frescoes in the Roman church of San Clemente, a vast cycle that includes episodes in the lives of Sts. Catherine and Ambrose and a large Crucifixion, in hopes of finding signs of a collaboration with Masaccio; the results have not been convincing. On the other hand, there is a greater interest in perspective, in space, and in the depiction of architecture than we find in Masolino earlier, and although his efforts are not fully successful, these frescoes are among the first in which the new perspective methods were used in Rome. We can only imagine the furor they must have caused in the late 1420s. In an *Annunciation* [16] over the great arch of the chapel the viewer looks from below into the coffered ceiling, through an open loggia of fine Ionic columns.

 The same fascination with perspective in rendering architecture is found

15. Masolino. *Founding of Santa Maria Maggiore (Santa Maria Maggiore Altarpiece)*, late 1420s (?). Wood panel, 144 × 76 cm. Naples, Capodimonte Museum.

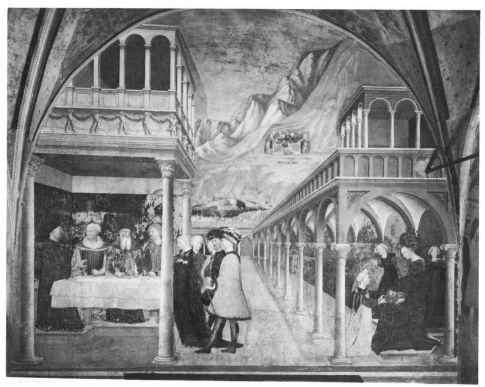

17. Masolino. *Feast of Herod*, 1435. Fresco, 380 × 473 cm. Castiglione Olona, Baptistery.

18. Filippo Brunelleschi. Hospital of the Innocents, Florence, c. 1420.

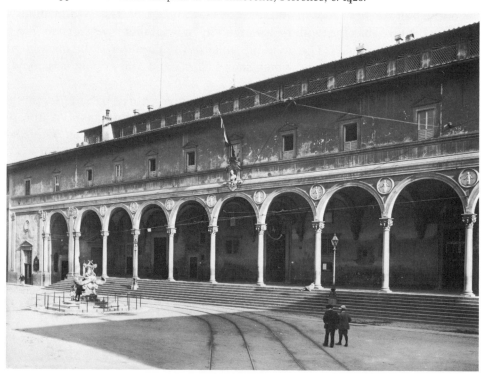

in Castiglione Olona, where Masolino was taken by his Roman patron, Cardinal Branda, who came from there and who sought to make it into a model town in the newest Tuscan style. Masolino composed his subjects on the narrow ribs of irregular, curved vaults in the frescoes for the Collegiata, which illustrated stories from the life of the Virgin; and if he did not always succeed in rendering the space convincingly, such problems were not completely resolved until the sixteenth century. Masolino's interests can be surveyed in the frescoes for the Baptistery in Castiglione Olona, which deal with the life of St. John the Baptist. These bear the date 1435 and were probably finished before those in the Collegiata.

In the *Feast of Herod* [17] several scenes are included in consecutive fashion within the same composition, as had already been done in the Brancacci Chapel and, for the same subject, by Donatello (Siena, Baptistry). On the left is the banquet; on the right the severed head of John is brought before the queen. Masolino sets the action in buildings imagined in the new Renaissance style based on Brunelleschi [18]. The one on the left has a frieze of *putti* (small nude boys) in imitation of marble sculpture, a precocious use of the antique motive. Also adventuresome is the landscape or mountainscape, a reminder that from Castiglione Olona the mighty Alps can be seen. If the *Feast of Herod* comes to grips with many of the salient problems that paintings would deal with in the coming decades, and if Masolino is not successful, in the final analysis his attempts are bold and the work he left is meritorious.

PART II
THE FIRST GENERATION

Among those painters born between about 1395 and the early 1420s, from Fra Angelico and Squarcione to Andrea del Castagno, we find a group who, collectively, established numerous innovations that are associated with all Renaissance painting. They did not, however, depart radically from the technical procedures in common practice during the *trecento*. Their principal medium for altarpieces and independent pictures was still tempera, and the most usual support was a carefully prepared wood surface. Even in mural decoration, true *(buon)* fresco continued to be favored. In this method, pure pigments are mixed with water and applied to a freshly plastered wall; once dry, the pigments become unified with the wall. The wall was first prepared with a coat of rough plaster *(arriccio)* upon which some very sketchy notations of the planned painting were sometimes lightly drawn. Then a more detailed drawing was brushed in with a reddish-ocher paint, called from the place of its origin, *sinopia*. The final, smoother layer *(intonaco)* was applied in small areas one day at a time, just enough for that day's work. Thus, a careful examination of the surface of a fresco can often show the outline of each day's work, and it is now fairly easy to calculate how many working days *(giornate)* were required to produce a given painting.

In recent times, with the frequent removal of frescoes from the walls for purposes of preservation and restoration, the layer containing the *sinopia* [19] has been unveiled, offering the modern viewer an opportunity to follow the evolution of a fresco. Besides insight into the graphic style of masters for whom no independent drawings have survived, changes that may have taken place

19. Paolo Uccello. *Creation of the Animals* and the *Creation of Adam*, ca. 1432–36. Sinopia, 210 × 425 cm. Florence, Santa Maria Novella, Green Cloister.

between the preparation of the wall and the final painting can now be ascertained. Beginning during the second half of the fifteenth century, there was a gradual movement away from a dependence on the *sinopia* method in favor of detailed, full-scale cartoons on paper, and by the time Raphael and Michelangelo were making important frescoes in the early sixteenth century in Rome, the earlier approach was abandoned altogether. Similarly, the use of tempera as a medium had been all but entirely replaced by oil-based paints, and there was a parallel shift away from wood, to canvas, as the preferred support.

In the use of color, the painters of the early Renaissance still adhered to the traditional approach in which broad areas of single colors were applied rather schematically in bright hues. It was the consciousness these painters had of how light operates in a picture that was novel and decisive in creating the new style. Lightened passages were used in opposition to shadowed or dark ones to model forms, to give them the appearance of convincing *relievo* (relief), seemingly projecting from the flat surface. Painting became praised to the degree that it approached sculpture.

The artists of the first generation tended to establish their figures by mixing the dominating color of, say, drapery with black or another deep tone on one side of the forms represented, and with white on the other, producing a range

from light to dark *(chiaroscuro)* that implies three-dimensionality. Such light-
ing of each individual figure in a picture was made consistent, or nearly so, by
using the same light source or sources throughout the entire work. In the case
of chapel decoration, the whole fresco cycle was adumbrated by a single main
light source, possibly the actual one, as Masaccio had done in the Brancacci
Chapel. Added to this system, early Renaissance masters, as distinct from their
predecessors, became deeply conscious of translating all of the real world into
pictorial compositions. They began to employ cast shadow and made light and
atmosphere important components in painting for the first time. In so doing
these artists developed what has been called aerial or atmospheric perspective
in their landscape backgrounds, in which objects become less distinct as they
are distant from the viewer, and where the colors become increasingly less
intense and paler as they approach the horizon in the extreme distance.

I have already referred to probably the most influential single innovation
of the period, mathematical or "artificial" perspective, based on the discoveries
of Brunelleschi and Alberti. The use of perspective, in which all the objects and
buildings in a picture were organized within a system of a single vanishing
point, further served to permit highly unified, centrally oriented pictures that
were similar to looking out at the world through a window. All the objects and
figures in a painting began to have proportional relationships to one another
and to the whole, depending, of course, on the degree to which a particular
painting followed the system. It is also valuable to remember that painters at
this time did not paint directly from nature but re-created the world inside, in
their studios.

<p style="text-align:center">✢</p>

In this section, the lyric masters are presented before the monumental ones, not
because they occupy a preferential position during the early Renaissance, but
because they follow Gentile da Fabriano, Lorenzo Monaco, and Masolino quite
comfortably, continuing features of the International Style and the other Gothic
solutions of the immediate past. They made notable discoveries in the area of
landscape and in the use of linear and aerial perspective, and they were com-
mitted to the study of antique forms, although their goal was not necessarily
imitation.

On the other side of the coin, one could very well begin with Masaccio and
the monumental painters. Masaccio's name is almost interchangeable with the
first phase of the Renaissance, and his example is inevitably cited to illustrate
the conditions of progressive painting at the time. Due to his early death and
to a certain lag in time between his startling pictures, their acceptance, and the

perpetuation of his ideas by other painters, including Filippo Lippi, Domenico Veneziano, and Piero della Francesca, little is lost by studying his contributions with other monumental painters with whom he shared many common features. These artists concentrated on the representation of the human figure (often in an architectural setting) with an integrity and dignity found in ancient statuary, in Donatello's and Nanni di Banco's sculptures, and, looking back, in Giotto's frescoes in Florence and Padua [20].

Any division of the material will cause some inconveniences. What should be recognized is that Masaccio, Fra Angelico, and the other leading painters of the first generation, whether characterized as lyric or monumental, were together responsible for the first phase of Renaissance painting. Some of the artists were simply greater, more imaginative, or painted pictures that were more beautiful than some of the others.

20. Giotto. *Lamentation*, ca. 1305. Fresco, 185 × 200 cm. Padua, Arena Chapel.

CHAPTER 3

THE FIRST GENERATION:
THE LYRIC CURRENT

*Fra Angelico, Paolo Uccello, Antonio Pisanello, Francesco
Squarcione, Jacopo Bellini, Sassetta*

FRA ANGELICO

The path that Gentile da Fabriano and
Masolino had opened was broadened and fully
developed by masters of the first generation.
The style was fueled, as we have seen, by the
example of an artist of extraordinary powers,
Lorenzo Ghiberti. His two sets of bronze doors
for the Florentine Baptistry were among the
most influential and admired works produced
in the first half of the fifteenth century. In fact,
the three older masters—Gentile, Masolino,
and Ghiberti—were principal influences on
the Florentine Fra Angelico (1399?–1455), who
may be viewed as the lyric counterpart of his
near Florentine contemporary, the more
monumentally oriented Fra Filippo Lippi.

The birth date of Fra Giovanni Angelico
(born Guido di Pietro and given the name Gio-
vanni when he became a Dominican monk,
perhaps around 1420) is unknown, but since his
first commission (lost) was undertaken to-
gether with an older, established painter in
1417, he was, presumably, born around 1399,
supposedly in Fiesole, a few miles from Flo-
rence. He joined the Confraternity of St. Luke

in 1417 and painted in the Gherardini Chapel
in Santo Stefano al Ponte (destroyed) in 1418.
In 1423 Angelico was paid for a cross in Santa
Maria Nuova (lost). The earliest preserved and
documented painting is the smallish *St. Peter
Martyr Altarpiece* [21], which was mentioned
as finished in a document of 1429. By 1433 An-
gelico had obtained the commission to paint
an altarpiece for the Arte dei Linaiuoli, the
linenworkers' guild, which has a marble frame
designed by Lorenzo Ghiberti and carved in
his workshop [22]. Angelico began the altar-
piece for San Domenico in Perugia (Perugia,
Galleria Nazionale dell'Umbria) in 1437, and
he was recorded in Cortona, where he worked
on several projects, in 1438. No documents sur-
vive for his work as a painter in the Convent
of San Marco (Florence) until 1447, when An-
gelico was also painting in Rome, in the Vati-
can; presumably he had begun frescoing the
cells and hallways of the convent some time
earlier. In 1447 he was also contracted to paint
in the San Brizio Chapel of the Orvieto Cathe-
dral but finished only the vaults; the rest was
painted by Luca Signorelli more than a half-

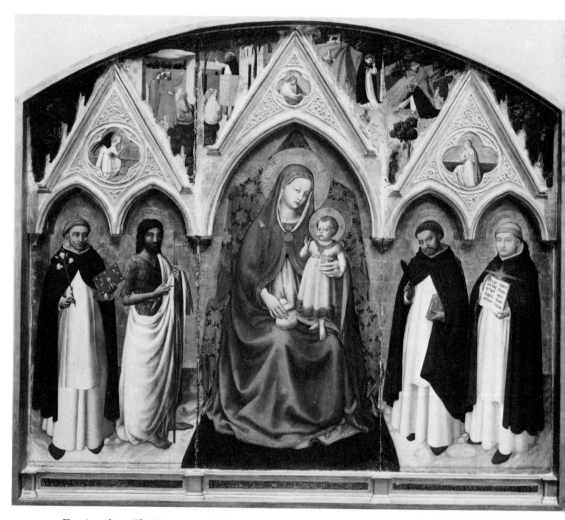

21. Fra Angelico. *The Virgin and Child with Sts. Dominic, John the Baptist, Peter Martyr, and Thomas Aquinas (St. Peter Martyr Altarpiece)* 1427/28. Wood panel, 137 × 168 cm. Florence, Museum of San Marco.

century later. In 1448 Angelico painted the Chapel of Nicholas V and the pope's study (destroyed) in the Vatican. During his final years, the officials of Prato Cathedral offered him the decoration of the choir, but he refused the assignment, which was then turned over to Fra Filippo Lippi. Angelico died in Rome in 1455 and was buried in Santa Maria sopra Minerva. As we can see from the sketch of his activity, Fra Angelico was active in Umbria and Rome as well as in his native Florence.

·÷·

Because of the paucity of documents, problems related to the dating of Fra Angelico's works abound; questions of his training, stylistic development, and the identification of his teacher or teachers are vexing. He seems to be closest to Masolino once we can securely isolate his work, and a dependence upon him persists in the 1430s. Another puzzling aspect of Angelico's art is that in many paintings that appear to belong to the same period in his development, there is a demonstrable diversity of handling, drawing, and color, from which we can only assume that he turned over commissions or parts of commissions almost indiscriminately to his shop assistants. Sometimes they appear to be gifted and original painters, and a few critics believe that the presence of Piero della Francesca and Domenico Veneziano might even be detected. This situation may have reflected Angelico's own character as much as external factors. Objectives of fame and fortune that motivated most Renaissance artists may well have been indifferent to him, considering his remarkable temperament and deep religious conviction. His principal goal seemed to be to produce well-crafted work in which the execution was suitable to the content. Whether he himself or one of his coworkers actually painted a particular section, even a crucial one, was of no importance to him.

Critical reconstruction and evaluation of Angelico's art are hampered by the apparently slow progress of his first fifteen years of activity, along with a failure to react quickly to new changes that were occurring during the 1420s, including aerial and linear perspective, the naturalistic rendition of landscape, the use of controlled light sources, the empirical study of the structure of the human figure, and so on. The *St. Peter Martyr Altarpiece* [21] was painted before 1429 and appears to date to about 1427/28, precisely when Masolino and Masaccio were working in the Brancacci Chapel, and shortly after Gentile had died in Rome. No one could have guessed on the basis of this conventional and uninspired triptych that Angelico, then presumably about thirty years old, would shortly become one of the leading painters in Italy and a participant in the most advanced innovations of the period. He appears here still close to the formal style of a conservative contemporary like Bicci di Lorenzo, although the Madonna reflects a type found in Arcangelo di Cola da Camerino, active in Florence in the early 1420s. Bicci, son of a successful painter, was *capomaestro* (head of works) at Sant'Egidio, the church connected with the Hospital of Santa Maria Nuova, when Angelico had a commission (lost) there in 1423. In the *Linaiuoli Altarpiece* [22] the next documented work, a persistent adherence to the conventional language can still be detected, although the overall effect is more modern, especially in the predella scenes. The tight modeling, which is combined with a more confident use of light to build form, especially on the shutters, depicting life-size saints on both sides, is still related to Masolino's style and calls to mind specifically the side saints for his *Santa Maria Maggiore Altarpiece,* divided between London and Philadelphia [23].

One would look in vain here or in his other paintings for reflections of Masaccio's art.

22. Fra Angelico. *Linaiuoli Altarpiece*, commissioned 1433. Wood panel, 330 × 260 cm. Florence, Museum of San Marco.

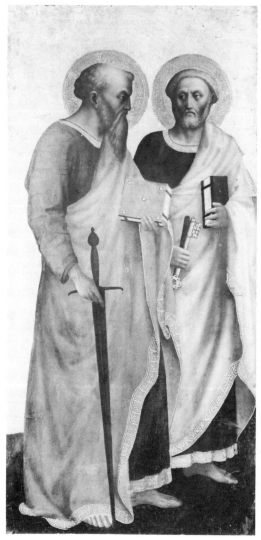

23. Masolino. *Sts. Peter and Paul* (side panel, *Santa Maria Maggiore Altarpiece*), ca. 1430. Wood panel, 109 × 53 cm. Philadelphia Museum of Art (Johnson Collection).

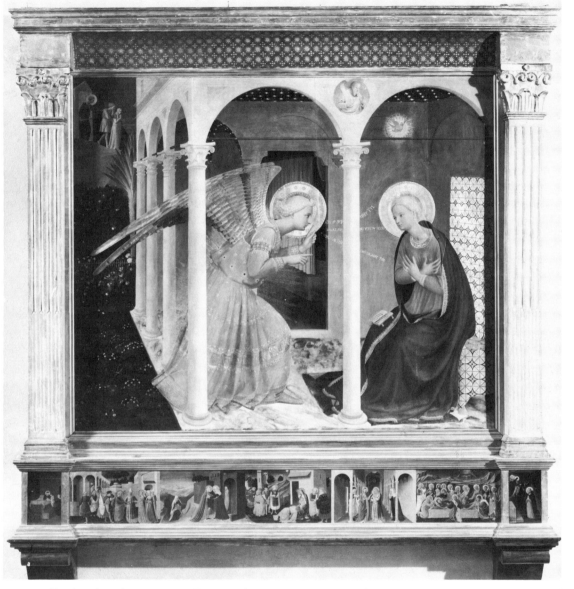

24. Fra Angelico. *Annunciation (Cortona Altarpiece)*, ca. 1438. Wood panel, 175 × 180 cm. (central scene). Cortona, Museo Diocesano.

Donatello, too, seems to have little appeal for Angelico, and he shows few indications of a specific commitment to antiquity. Angelico's pictorial requirements are so much a part of his religious makeup that there seems to be no compulsion to be up-to-date, and he acquired from the newest painting only those devices that suited his artistic goals. The sanctity of Fra Angelico's life (he is also known as Beato, that is, the Beatified Angelico) and his humility are commonly mentioned when discussing his art.

As has been pointed out, we known nothing of Angelico's training, although his first preserved works indicate that he emerged late as an artistic personality, when in his thirties, at about the time of the *Linaiuoli Altarpiece,* where the predella scenes in particular reveal for the first time the beginning of a personal, characteristic expression. His stylistic development is thus compressed into the next twenty years, and demarcations are difficult to isolate.

By the mid-1430s and throughout the 1440s, Angelico participated effectively in the discoveries of his progressive contemporaries and produced some of his finest works. The *Cortona Altarpiece* has an *Annunciation* [24] set above a predella containing scenes from the life of the Virgin and stupendous landscape passages, one beside the other without separate frames. The composition of the *Annunciation* (datable to about 1438) and, to a certain extent, the figural poses are related to Masolino, but Angelico's benign world with its frank, unaffected manner gives the ever present decorative elements—the extensive use of gold, the pale, elegant, unnatural figures— a convincing justice. The Adam and Eve who appear in the upper left background, expelled from Paradise, are more earthly representations. The *Annunciation* occurs within a contemporary loggia, although cramped and miniaturized; outside, an array of flowers punctuates the enclosed garden, symbolic of Mary's virginity.

The *Deposition from the Cross* [25, 26], of uncertain date but finished, perhaps, around 1440, was begun for Palla Strozzi presumably by Lorenzo Monaco, who would have painted only the pinnacles and the side saints before his death in 1425; after a considerable lapse of time, the project for the sacristy of Santa Trinita was taken up again by Fra Angelico, who painted the main field. Angelico organized the composition around the pre-existing tri-arched frame but used the entire central space for the depiction of Christ being lowered tenderly to the ground. Coloristically the painter seems to have taken a cue from Lorenzo Monaco: the off-pinks, whites, and a stupendous pale green in the standing figures on the extreme right interact with the more usual full reds and Angelico's favorite blue.

Among the figures on the right side are a group of pious onlookers, including portraits of contemporaries, perhaps members of the Confraternity of Santa Maria della Croce al Tempio, as well as *beati* (the beatified), whose halos are of thin golden rays instead of the solid opaque ones Angelico reserved for saints. Under the left arch are holy women, including the Magdalen, who kisses Christ's feet, and Mary, her hands clasped in resignation. The scene takes place in a landscape, for the first time on a large scale; here Angelico gives us a naturalistic light and crisp airiness. The action occurs in the second plane, producing a tangible distance from the viewer, traversed by the kneeling figure, whose left hand is caught in sunlight. The *Deposition* is a painting of intense drama and pathos, made all the more powerful by its placement in the brightly lighted landscape. Yet none of the tragedy, ranting, or outbursts of anguish that the subject has provoked in other masters is found here. Instead, a silent inevitability reigns. The walled city on the left has cubic forms that offer eternal solidity underscored by a hilly landscape on the opposite side, broken only by superbly rendered trees of all kinds, as if the

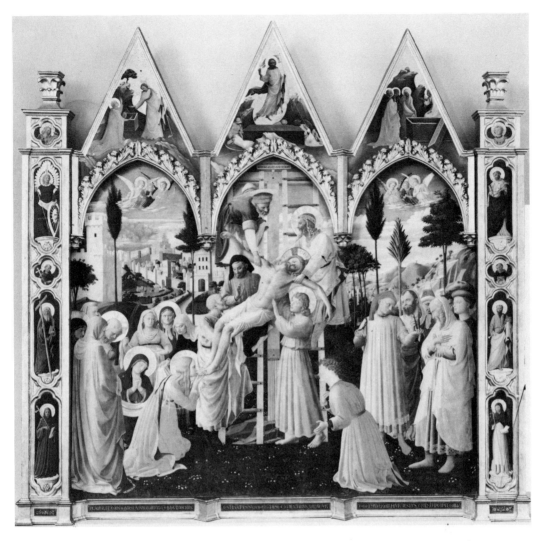

25. Fra Angelico. *Deposition from the Cross*, ca. 1436–40. Wood panel, 176 × 185 cm. Florence, Museum of San Marco (side saints and pinnacles by Lorenzo Monaco).

26. Fra Angelico. Detail of 25.

backgrounds in Ghiberti's relief panels from the *Gates of Paradise* had come to life [282]. Unity is achieved by the light and by clouds that streak across the sky.

If Angelico has intensified the power of nature in which the scene takes place, he has also de-emphasized the volume and the weight of the figures. They do not stand in easy *contrapposto,* attached inevitably by gravity to the earth, but lightly and elegantly they take their place within the painted world. The lyric current, of which he is an outstanding example, was the appropriate vehicle for his spiritual posture. Angelico never painted subjects that did not have a religious content, no independent portraits, *cassoni,* or marriage plates—in other words, none of the normal range of works that a secular painter's shop produced at the time.

The *San Marco Altarpiece* [27], dedicated to Sts. Cosmas and Damian, was a Medici com-

27. Fra Angelico. *The Virgin and Child Enthroned with Angels and Sts. Cosmas and Damian, Lawrence, John the Evangelist, Mark, Dominic, Francis, and Peter Martyr (San Marco Altarpiece),* ca. 1438–40. Wood panel, 220 × 227 cm. Florence, Museum of San Marco.

mission for the main altar of San Marco and appears to have been ordered about 1438 and completed by 1440; its elaborate predella has been separated from the main panel and is divided among a number of public collections. Like the *Deposition,* the composition is predicated on an open, figure-free zone with attention given to the Virgin and Child placed back within the pictorially created stage. The figures of the patron saints, the doctors *(medici)* Cosmas and Damian, lead the viewer into the space; St. Cosmas, believed to be a veiled portrait of Cosimo de' Medici, gestures in the direction of the enthroned central group, but looks out directly at the spectator, providing a point of entry into the painting. An oriental carpet modulates the composition, but the figures of Sts. Lawrence, John the Evangelist, and Mark on the left, and of Dominic, Francis, and Peter Martyr on the right, are not effectively incorporated into the perspective construction, so that the strong space-creating elements within the painting, once formulated, are undermined.

Even in situations where he effectively used perspectival devices, Angelico is never completely devoted to spatial illusionism. He rarely foreshortens the halos of his sacred figures; they are large disks of incised gold, larger than those of his contemporaries, and he lays them out flatly on the surface. The *trompe l'oeil* picture-within-a-picture of the *Crucifixion* at the lower edge on the central axis relates as a visual device to Fra Filippo's *cartellino* (painted label) in the *Tarquinia Madonna* [82]; both serve to accentuate spatial interest by affirming the picture's surface and what occurs on the planes behind it. Fra Angelico's ingenious representation is a substitute for a small crucifix, necessarily on the altar table, functioning to combine the actual space in front of the picture with the painted space—a daring innovation and one that had a long following after this, its first appearance.

28. Fra Angelico. *Annunciation*, ca. 1440. Fresco, 187 × 157 cm. Florence, Convent of San Marco (cell three).

As we have already seen, Fra Angelico was a master of landscape, and in the *San Marco Altarpiece* the thick forest of trees offers glimpses of the terrain below and the mysterious golden sky above. (The entire surface of the painting has been seriously abraded, and its original appearance is obscured.) The figures, not permitted to take command of the painting, act out their functions along with all the other elements, the finely conceived Renaissance throne, the still-lifes, including the garland of flowers, the golden curtains, and the hangings on the low wall that separates the sacred scene from the out-of-doors.

Another aspect of Angelico's activity, and one that appears to have been fully developed in the same years as the *San Marco Altarpiece,* is his extensive contribution as a fresco painter, concentrated in the decoration of the Convent of San Marco in Florence, for much of the time his home, and in the Vatican Palace.

The Convent of San Marco was rebuilt by the architect Bartolommeo Michelozzo under Medici patronage after 1437, and it has been assumed that as sections of the cloister were constructed, Fra Angelico and his co-workers began decorating the corridors and the cells with frescoes. Hence, the rough dating of the frescoes begins around 1438 and continues to about 1450, which also overlaps the period when Angelico was in Rome. If the chronology of these wall paintings offers problems, separating the various hands at work here is no less difficult. One can safely assert, however, that the entire cycle represents Angelico's language and style, although he did not design, much less execute, all of it. The finest paintings are of high quality and unusual simplicity, although one should be aware that they were produced for the contemplation and edification of the Dominican monks and not for laymen. In the *Annunciation* [28] (cell three) of about 1440, the composition represents a shift

from the *Cortona Altarpiece.* Here we are close to the figures; the angel stands erect, looking down sweetly at the Virgin, and the pictorial space is an extension of the actual corridors of the cloister beyond the cell. Instead of the restricted porch of the Cortona picture, the space has been opened out, and the figures stand comfortably within. Light enters the vaults and the columns from the courtyard on the left, falling on the left side of Gabriel and the forehead and bodice of Mary and finally striking the end wall. Standing on a patch of green is Peter Martyr, a thirteenth-century Dominican saint, who looks on the scene as if he were a monk in the cloister. In this fresco Angelico's remarkable handling of light and his pale colors and high tones are similar to Domenico Veneziano's treatment of about the same date (compare the *St. Lucy Altarpiece,* [92]).

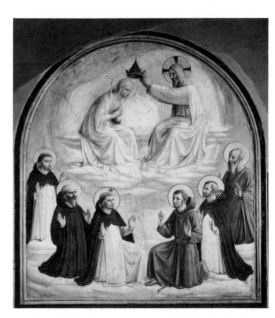

29. Fra Angelico. *Coronation of the Virgin,* ca. 1442. Fresco, 189 × 159 cm. Florence, Convent of San Marco (cell nine).

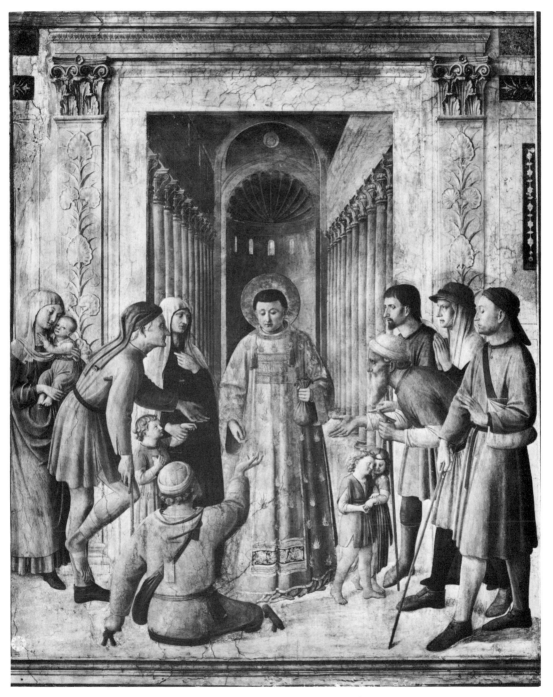

30. Fra Angelico. *St. Lawrence Distributing Alms to the Poor and the Infirm,* ca. 1447–50. Fresco. Rome, Vatican, Chapel of Nicholas V.

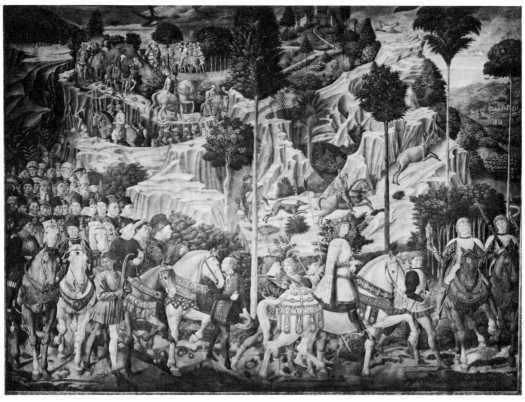

31. Benozzo Gozzoli. *Adoration of the Magi* (detail), 1459. Fresco. Florence, Medici-Riccardi Palace.

Another demonstration of Angelico's gifts as a composer is the *Coronation of the Virgin* [29] (cell nine), where the painted field is made up of a rectangle adjoined to a semicircular segment of wall set into a frame. In it Angelico continues the circular movement by the placement of the six saints underneath: Thomas, Benedict, Dominic, Francis, Peter Martyr, and Mark, resting on clouds. In the lunette area the whites of the central group, which functions like a circle-within-a-circle, glow hauntingly—more, even, than the gold of the halos and the crowns.

Angelico's frescoes in the Vatican for the private chapel of Nicholas V were presumably executed between 1447 and 1450, and once again the participation of assistants must have been considerable. In the humanistic Roman ambiance of the pope, Fra Giovanni Angelico, perhaps unconsciously, sought an increasingly aulic approach to these scenes from the lives of the deacon saints, Stephen and Lawrence, by imbuing them with trappings that were not compatible with his natural inclinations. The architectural backgrounds related to Alberti's practice are self-consciously up-to-date, but the figures never move easily within the space; they are lined up, frieze-like, close to

the picture plane, so that implied spatial thrusts become uneasy scenographic backdrops, as in the *St. Lawrence Distributing Alms to the Poor and the Infirm* [30]. The details of the fine Albertian portal and the incidental aspects within the group who gather around the saint are carefully studied and informative, but are uninspired and haphazard; what is lacking here is the spiritual integrity of Angelico's works in Tuscany and Umbria. The pressure of the situation appears to have ill-suited the painter, or perhaps he turned over an increasingly greater share of responsibility to assistants; the leading personality among them was Benozzo Gozzoli (1420–1497), who became an influential painter in his own right, and carried certain aspects of Angelico's language well into the second half of the fifteenth century [31].

PAOLO UCCELLO

The fame of Paolo di Dono, commonly known as Paolo Uccello (1397–1475), is attached to a legendary dedication to perspective. He entered Ghiberti's shop around 1413, presumably to learn the goldsmith's trade, but by 1415 he was inscribed in the painters' guild. As with so many of his contemporaries, little can be ascertained from the extant documents about his life and work; information about his early development and his youthful painting style, as in the case of Fra Angelico, is not available. Uccello is known to have gone to Venice in 1425, where he was employed as a mosaicist at San Marco and where he made a *St. Peter* (not identified), but no works from Venice can be convincingly ascribed to him. Uccello had returned to Florence by 1431, but it is only five years later that a datable work can be isolated, the *Sir John Hawkwood* [35] fresco in the Ca-

thedral, commissioned and completed in a matter of months during 1436. Consequently, we are dealing here with Uccello at about forty years of age, with a whole career behind him for which nothing is definitely known. The study of Uccello's style thus begins, as it were, in his middle period.

In 1443 Uccello was paid by the Cathedral officials in Florence for painting the clock face on the inner façade of the church, and in the same year he supplied them with cartoons for stained-glass windows. Uccello went to Padua for an undetermined period in the 1440s, where he painted a much-admired series of giants (lost). No dated works survive until many years later, when, following a preliminary trip, Uccello undertook the predella of an important altarpiece in Urbino, for which he produced scenes of the *Profanation of the Host* [40, 41] in 1467–68. Back in Florence in 1469, he complained to tax officials that he was old and without means of livelihood, though he is known to have painted some pictures for insertion into furniture.

⁜

The two outstanding groups, his masterpieces, the three Battle of San Romano paintings [36, 37, 38] and the frescoes from the so-called Green Cloister of Santa Maria Novella, are undocumented and open to divergent datings. Indirect evidence shows Uccello to have been associated with Santa Maria Novella at the latest by 1434, a date that corresponds with the general opinion that Uccello's frescoes of the *Creation of the Animals*, the *Creation of Adam and Eve*, and the *Fall* [32], which are full of figural and technical inventions, may be dated to 1432–36, that is, before he undertook the *Hawkwood*. In them and in others for the same location treating the life of Noah, probably done a few years later, Uccello comes closest to giving a sturdy weight and physical pres-

32. Paolo Uccello. *Creation of the Animals, Creation of Adam, Creation of Eve,* and the *Fall* (partial view), ca. 1432–36. Fresco (transferred), upper scene 210 × 425 cm.; lower scene 244 × 478 cm. Florence, Santa Maria Novella, Green Cloister.

ence to his figures, approaching the monumental current of Masaccio. On the other hand, the elongated proportions and the general sway of the figures in the creation scenes with their small, refined heads are closely related to Ghiberti's Genesis panel from the *Gates of Paradise* (modeled by about 1429) and also reflect Masolino's approach, especially in the *Fall* [11] from the Brancacci Chapel. Uccello's experience in North Italy may be detected in an assimilation of Gentile da Fabriano's art in Venice and certain features that parallel Pisanello.

The poorly preserved frescoes, exposed in a cloister at Santa Maria Novella for centuries, are painted in a virtual monochrome; only in the *Flood and the Recession of the Waters* [33] and in the *Sacrifice of Noah and the Drunkenness of Noah* [34] is a bit more color used, although the tones are completely unnaturalistic and fanciful. In referring to another fresco cycle by Uccello that is now barely visible (Florence, San Miniato al Monte), Vasari noted: "He did not carefully observe a proper consistency in the employment of colors, for he made his fields blue, his city red, and his buildings of various hues according to his fancy."

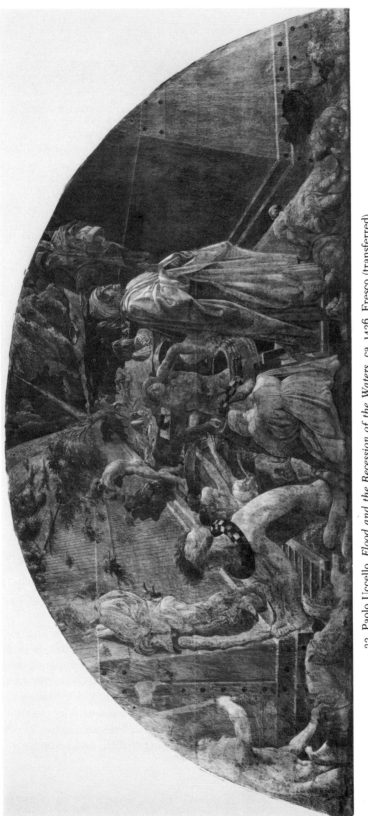

33. Paolo Uccello. *Flood and the Recession of the Waters*, ca. 1436. Fresco (transferred), 215 × 510 cm. Florence, Santa Maria Novella, Green Cloister.

34. Paolo Uccello. *Sacrifice of Noah and the Drunkenness of Noah* (detail), ca. 1436. Fresco (transferred), 277 × 540 cm. (whole). Florence, Santa Maria Novella, Green Cloister.

The *Flood and the Recession of the Waters,* composed in a lunette, combines within a single field the storm, the winds, and the drama created by the rising waters on the left and the damage and release of the receding waters on the right. Noah's ark is shown twice, exposing different sides of a gigantic pyramid. The pictorial imagery is as rich and inventive as any painted in the *quattrocento.* The sculpturesque figure that stands in the right foreground, whose legs are grasped by a drowning man, dominates the scene; nevertheless, he is difficult to identify. Since the figure has no halo and no beard, as he does in another scene nearby, by Uccello, he could hardly be Noah, as is sometimes claimed; perhaps he represents the fresco's unidentified patron. The wealth of detail completely overshadows sensible figural and spatial composition, although the rushing orthogonals formed by the sides of the ark at least provide a context for readability.

The individual elements are justifiably admired: the horseman on the left vainly challenging the rising flood, the people hopelessly clinging to the side of the ark, the sturdy nude holding a club in the middle distance, the excitement of the trees bent by cyclonic winds, the leaves and branches flying everywhere, the lightning striking and setting afire a tree.

35. Paolo Uccello. *Sir John Hawkwood*, 1436. Fresco (transferred), 732 × 404 cm. (without frame). Florence, Cathedral.

On the right side the dead child, whose belly is realistically bloated by water, is symptomatic of the wealth of sharply observed natural phenomena that are noteworthy. Among the cadavers placed in sudden foreshortening is a large raven, shown plucking out the eye of a dead man, a detail no longer fully visible but known to us from an early-nineteenth-century engraving after the fresco. The power of this scene and the other Noah stories by Uccello which are beneath it was such as to provide Michelangelo with ideas for his own treatment of the Noah scenes on the Sistine ceiling.

Before turning to the battle paintings, the *Sir John Hawkwood* [35], a work of noble dignity, should be examined particularly since it is a firmly dated painting, among the few in Uccello's output. The English soldier of fortune, known to Italians as Giovanni Acuto,

died in 1394, and Uccello's fresco was made to replace an older painted monument. Uccello created an important equestrian funerary type that was later used by Castagno in his *Niccolò da Tolentino* [119] and realized in sculpture by Donatello for his *Gattamelata* [120]. The heavily restored work has been transferred from the wall to canvas, and the wide border is a later addition; but, notwithstanding these alterations, the *Hawkwood* survives as a powerful image in which Uccello's perspectival interests are united with ideas about reality. Parts are shown in foreshortening, taking into account the spectator's vantage point, but the massive horse and rider are conceived as seen head-on. His painting is not so much a portrait of a warrior as a portrait of an imagined bronze monument.

The paintings of the Battle of San Romano

36. Paolo Uccello. *Battle of San Romano*, late 1440s (?). Wood panel, 182 × 319 cm. London, National Gallery.

37. Paolo Uccello. *Battle of San Romano*, late 1440s (?). Wood panel, 182 × 322 cm. Florence, Uffizi.

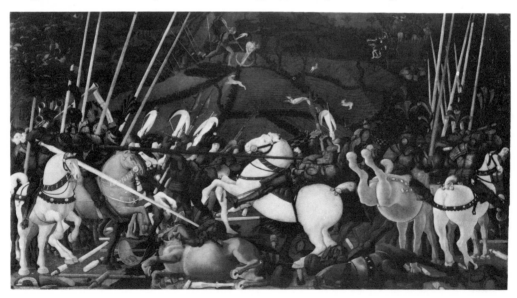

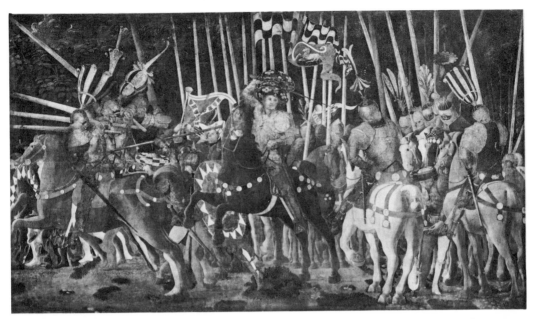

38. Paolo Uccello. *Battle of San Romano*, late 1440s (?). Wood panel, 180 × 316 cm. Paris, Louvre.

together formed part of a unified decorative scheme for a room in the Medici Palace, referred to as the bedroom of Lorenzo de' Medici ("Il Magnifico") in an inventory of 1492 [36, 37, 38]. The subject has Medici overtones because the battle actually took place in 1432, just before the temporary exile of the family. Although these works are undated, a consensus among specialists places them around 1456; a case can be made, however, for their execution in the late 1430s through the late 1440s on the basis of proximity to the event and the costumes of the participants, as well as Masolinesque characteristics. The traditional dating is based on the celebration in fresco of the condottiere Niccolò da Tolentino, completed in 1456 by Andrea del Castagno in the Cathedral as a pendant to the *Hawkwood*, and the assumption that since these pictures commemorate the same condottiere, in some way

they belong to a similar program and date. Considering the complexities of Uccello's pictures, the amount of detail, and their ample size, they must have been worked on over a period of years, perhaps through the late 1440s.

The Battle of San Romano was a struggle resulting in the victory of the Florentines over the Sienese, who were then allied with the Milanese. A festive rather than a martial air dominates these pictures (unlike, for example, Leonardo's *Battle of Anghiari* [252]), and at least one older source refers to them as representing jousts. The three panels apparently depict different incidents in the battle and are composed so that the movement flows from the left-hand panel (London), which shows Niccolò da Tolentino leading the Florentines into the fray. The more centralized middle panel showing the unhorsing of the Sienese

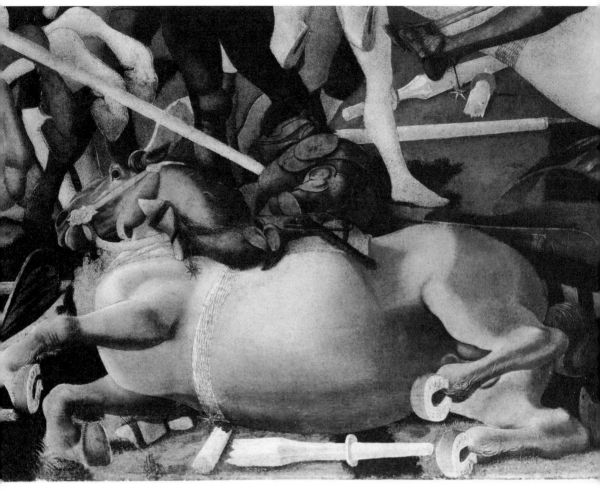

39. Paolo Uccello. Detail of 37.

general Bernardino della Ciarda (Florence) is signed by Uccello on a *trompe l'oeil* ribbon on the lower left. Finally, Micheletto da Cotignola is shown attacking the enemy forces from the rear (Paris).

In comparison to the Genesis stories from the cloister of Santa Maria Novella, the battle pictures are far more decorative. In the Uffizi picture [37], the horses appear to have been based on miniature three-dimensional models that the artist constructed in his studio and which he then moved around to suit his needs;

sometimes they are in sharp foreshortening, sometimes tilted over on the ground. The painting provides an example of a perspective system applied to a subject where there is no architecture. The broken lances on the ground establish a grid upon which a linear arrangement in space has been plotted. And whenever possible, and sometimes even when not possible, Uccello foreshortens figures, as he had done in the Noah scenes [39].

The spatial structure in the foreground, where a major confrontation takes place, can

40. Paolo Uccello. *Profanation of the Host* (predella panel, showing a woman redeeming her cloak at the price of the consecrated Host and the attempted destruction of the Host), 1467–68. Wood panel, h. 42 cm. Urbino, Galleria Nazionale delle Marche.

be reconstructed, but the transition from the front plane to the middle ground and distance defies logic, a fact not necessarily disturbing in itself, but with a master like Uccello, who is so taken with the potentialities of spatial rendering with mathematical perspective, the results are incongruous. He is able to establish volume for the figures and especially the horses, but of what kind? They virtually float, hovering above the ground, bloated like over-filled rubber balloons painted with fairyland colors. The impression is neither realistic nor naturalistic, but a proto-surreal fantasy with individual details given meticulous attention. Begin-

ning at the extreme left, the trumpet players with their long horns accompany the battle, providing the tempo for the mock encounter that is led by warriors on white and reddish horses. Seen again from behind, they move off the picture space on the right, as one of the horses seems to be giving the world of the spectator a mighty irreverent kick. The armor of the fighters—and especially their helmets and hats—is painted with the rigor of an expert still-life painter, but it functions as superb decoration as much as it does as object.

Uccello's late works place him firmly in the lyric current. In the predella for Justus van

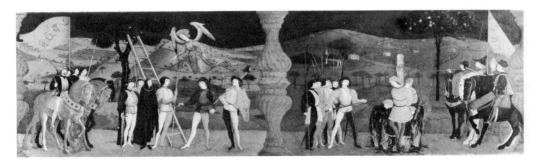

41. Paolo Uccello. *Profanation of the Host* (predella panel, showing the execution of the repentant woman and the Jew and his family being burned), 1467–68. Wood panel, h. 42 cm. Urbino, Galleria Nazionale delle Marche.

Ghent's *Consecration of the Host* (Urbino, Ducal Palace), for example, note Uccello's lithe, delicate figures with their small, thin faces and tiny, spiky hands and feet and the unvolumetric treatment of bodies that function more like silhouettes than three-dimensional figures [40, 41]. Painted in 1467–68, they represent the continuation of a figure style found in the background of the Uffizi battle picture, painted at least twenty years earlier. The loosely painted landscape in the predella is more effective than before, and the sweeping view of the countryside has an Umbrian cast. These delicate scenes, treating episodes in a medieval legend of the *Profanation of the Host,* are of great beauty, refinement, and sensitivity. They are painted with the ease and knowledge of nearly half a century of experience, yet still retain a connection with *trecento* traditions. Perspective has become less obsessive and more empirical in the late paintings, although one still finds that here, as in earlier works, Uccello—fanciful and always imaginative—hovers precariously between high genius and eccentricity.

ANTONIO PISANELLO

An artist of great fame in his own time and much in demand, the widely traveled Antonio Pisanello (ca. 1395–1455) was born in Verona, which came under Venetian rule early in the fifteenth century. Apparently trained locally, perhaps by Stefano da Verona (who was actually French in origin), he painted alongside Gentile da Fabriano in the Doges' Palace in Venice before 1422. (The fresco was replaced later in the fifteenth century.) Pisanello was documented in Mantua in 1422 and worked there for the Gonzaga on and off until 1426; he does not seem to have accompanied Gentile to Florence, although reflections of Gentile's Tuscan paintings occur in Pisanello's art. During the years 1424–26 he painted an *Annunci-*

ation [42, 43] and other decorations for the Brenzoni Monument in Verona, which was sculptured by the Florentine Nanni di Bartolo, called Il Rosso, once a collaborator of Donatello's. When Gentile da Fabriano died in Rome in 1427, Pisanello inherited the workshop equipment, and by 1431 he was himself in Rome, where he continued frescoing San Giovanni in Laterano until 1432 (destroyed). During 1433 Pisanello worked for the Este in Ferrara and continued to have contact with them over the next decade or more. In 1438 he was still in Ferrara when the council between the Eastern and Western churches was held, and he may have proceeded to Florence, where the council moved in 1439. During the same period he is also documented in Mantua at which time he apparently painted an enormous fresco (recently rediscovered), and in 1440 he was in Milan. In a drawn-out legal controversy Pisanello was convicted by the Venetians of siding with their enemies in Verona, but the case was eventually dropped. He seems to have remained in Ferrara until 1447, but he continued to maintain a house in Verona and must have been there on and off. In 1449 the painter was summoned to the court of Alfonso I of Aragon in Naples; he died in Verona six years later.

⁜

As with so many artists of the fifteenth and sixteenth centuries, a sharply defined chronology of works cannot be established despite the many documents that have been uncovered relating to Pisanello's life. His artistic productions are swelled beyond the paintings and frescoes by a significant number of preserved drawings, more than for any member of his generation with the exception of Jacopo Bellini, and by a group of cast bronze medals, many of which are dated. Pisanello was the most important and innovative medalist of his time, although curiously enough when signing

his medals he described himself as *pictor* (painter). Critics have often pointed out that Pisanello was favored by the aristocratic courts rather than the republics of Italy; in any case his style does continue aspects of the Courtly or International Style of the previous decades.

An artist particularly aware of Roman antiquity, having made drawings after ancient models, Pisanello was also taken with the discoveries of scientific perspective later in his career. His lyricism may be understood in relation to Gentile's style, and he certainly also knew the Roman works of Masolino. On the other hand, there is a transalpine Franco-Flemish quotient inherent in his art.

The earliest surviving datable and signed work by Pisanello is the *Annunciation* that forms part of the decoration of the Brenzoni Monument [42, 43]. The monument, which combines sculpture and frescoes, was executed in the years from 1424 to 1426 in the Veronese church of San Fermo Maggiore. Pisanello must have had a share in the overall design, collaborating closely with Il Rosso, who had participated in the progressive currents developing in Florence. Such interchanges of Tuscan and North Italian elements

42. Antonio Pisanello. *Annunciation* (detail of Gabriel), 1424–26. Fresco. Verona, San Fermo Maggiore.

43. Antonio Pisanello. *Annunciation* (detail of Virgin), 1424–26. Fresco. Verona, San Fermo Maggiore.

45. Antonio Pisanello. *St. George, the Princess, and the Dragon*, ca. 1436–38. Fresco (right side). Verona, Sant'Anastasia.

44. Antonio Pisanello. *St. George, the Princess, and the Dragon*, ca. 1436–38. Fresco (left side). Verona, Sant'Anastasia.

47. Antonio Pisanello. *Study of Head*, ca. 1436. Silverpoint on parchment. Paris, Louvre.

were common during the Renaissance. In the *Annunciation* fresco, which is damaged, the painter is in complete command of his personal pictorial expression, one that is controlled by decorative, linear elements, even within the figures. The entire body of the profile angel is composed of sweeping curves, reinforced formally by wings which are constructed three-dimensionally with painted stucco; Mary sits stiffly as she turns toward the viewer, hands clasped in prayer. The convincing painted architecture is not rendered in a systematic linear perspective but in the empirical manner of *trecento* local masters, especially Altichiero, the leading Veronese painter of the later fourteenth century, so that the Virgin appears to be in front of the bedroom rather than in it. A particularly successful feature of the fresco is the group of naturalistic birds at the lower left, which relate to the tradition of animal illustrations that developed in manuscript illumination in North Italy and especially Milan around the beginning of the fifteenth century. The modeling in the faces

and hands of the figures is similar to Gentile's. But Pisanello is more prone to idealization and stylization than Gentile, as in the reverently tilted profile of the angel. Color, perhaps because there is so much loss, appears secondary in importance to the design, the drawing, and the controlled modeling.

A second major Veronese enterprise datable to 1436–38 includes *St. George, the Princess, and the Dragon* for the great arch that leads into the Pellegrini Chapel in Sant'Anastasia [45]. The fresco was conceived in conjunction with the terra-cotta relief sculpture within the chapel by another Tuscan collaborator, Michele da Firenze. This is Pisanello's most famous work. Its subject was a perfect vehicle, allowing him to give free rein to his imagination and skill. The dragon on the left [44] is like some monstrous flying reptile of prehistory, crouched in readiness for the battle that is in preparation on the other side of the painting. Beneath him are the bones of previous victims; above, wild animals frolic innocently in the landscape, much of which has

46. Donatello. *St. George and the Princess*, ca. 1419. Marble relief, 39 × 120 cm. Florence, Bargello.

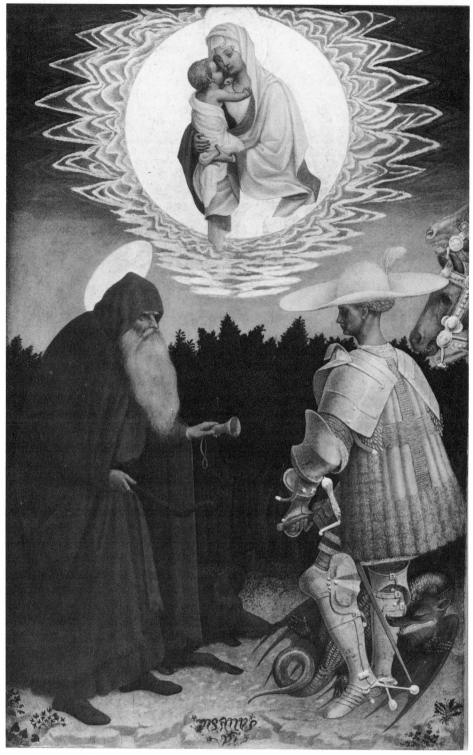

48. Antonio Pisanello. *Apparition of the Madonna to Sts. Anthony Abbot and George*, 1445 (?).
Wood panel, 47 × 29 cm. London, National Gallery.

been destroyed. The princess, in uncompromised profile, will be sacrificed save for the intervention of St. George, presented in sharp foreshortening as he prepares to mount his horse, furtively glancing in the direction of the enemy. The subject is usually rendered by portraying the combat between St. George and the dragon or the actual defeat of the beast, as in Donatello's famous relief on the St. George niche from Orsanmichele in Florence [46]. Pisanello instead builds up the spectator's anxiety by presenting the moment of preparation rather than the actual conflict. The front plane is occupied by the principals of the drama but the viewers have much more to enjoy than the main action alone.

The secondary figures, especially the group to the left of St. George and the hanged men above, are distinctive, although their meaning in the context of the painting is unclear. Drawings and studies for these figures, among the earliest preparatory examples from the Renaissance, have survived, and I suspect that implicit are political references, including the "Tartar" with the long straight hair, curved hat, and sweeping moustache, a type Pisanello may have observed firsthand on the docks of Venice [47]. The quality of specificity and the practice of drawing from life made him an excellent portraitist, one of the finest in the *quattrocento.* The landscape and cityscape in the *St. George,* however, are emblematic, removed from the direct study of nature that Fra Angelico embraced in the very same years. Much of the surface of the fresco, which was transferred from the wall to canvas in modern times, has been lost, although it can be partially reconstructed. The magnificent costume of the princess must have been extremely elegant; she appears in a watercolor drawing that could be a study for the painted figure (Chantilly, Musée Condé).

The signed *Apparition of the Madonna to Sts. Anthony Abbot and George* [48], perhaps

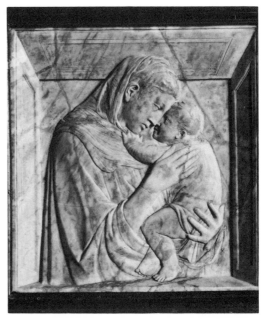

49. Donatello. *Pazzi Madonna,* c. 1420. Marble, 74 × 69 cm. Berlin-Dahlem, Staatliche Museen.

of 1445, is a smallish painting for private devotion. The elegance of St. George—his silhouette, with his broadbrimmed hat, his impeccably refined suit of armor, his person, and his pose—is differentiated from the hoariness of St. Anthony. Above, Mary and the Child, in attitudes that derive from Florentine sculptured models [49], are set in a halo composed of a perfect circle that spills out onto the sky, appearing like a painting within the overall painting.

Frequently praised by his contemporaries, Pisanello was the subject of poems in which he is described as having surpassed Zeuxis and Apelles, reputed to be the greatest painters of Greece, and having been influential in a rebirth of art, that is, a Renaissance. The humanist Guarino Veronese, for example, discusses him as the artist who, after the death of art, supervises its return to life, like a phoenix; another writer happily greeted Pisanello's con-

50. Antonio Pisanello. *Drawing of a Horse*, ca. 1445. Pen and black charcoal, 19.5 × 26 cm. Paris, Louvre.

tributions like sweet April after winter. He was able to render humans and animals and was valued for his ability to depict horses [50]. The portrait of *Lionello d'Este* [51], probably painted in 1441, was held to be second best to a competing portrait made at the same time by Jacopo Bellini (lost); it is a profile likeness of the then thirty-four-year-old nobleman who was shortly to take over the rule of Ferrara from his father. Lionello was fond of fine objects, tapestries, brocades. His name, which means little lion or little cat, gave rise to con-

ceits, and on the reverse of one of Pisanello's bronze medals of him, there is a seated lynx who is blindfolded, a family emblem [52]. The profile head of the animal—with a straight line stretching down the forehead and the flat nose and interrupted by a slight indentation for the bridge of the nose—finds a close analogy with the painted profile of Lionello by Pisanello. There is a subtlety of interpretation coupled with a confident elegance that makes Pisanello one of the most widely appreciated painters of the first generation.

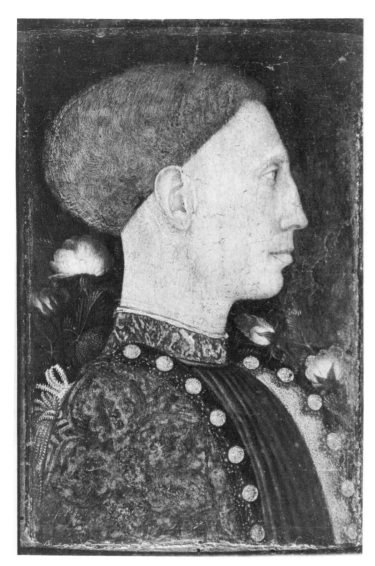

51. Antonio Pisanello. *Lionello d'Este*, 1441 (?). Wood panel, 28 × 19 cm. Bergamo, Accademia Carrara.

52. Antonio Pisanello. *Medal of Lionello d'Este* (reverse), 1444. Bronze, diameter 6.7 cm.

FRANCESCO SQUARCIONE

The personality of Francesco di ser Giovanni Squarcione (1397?–1468) and the impact of his contributions cannot be ignored, despite a severely limited number of preserved works. His fame is now based largely on his capacity as a teacher; his pupils included Mantegna, the most illustrious, but also Niccolò Pizolo, Marco Zoppo, Carlo Crivelli, and Giorgio Schiavone. He was apparently the dominant local artistic personality in his native Padua for nearly half a century. Squarcione, first trained as a tailor and embroiderer, was a member of the painters' guild by at least 1423, and in a document of 1426 he is called a painter. Possibly self-taught in painting, he restricted his movements to Padua, then an important cultural center with a major European university, and the area nearby; he had a brief residence in Venice in the early 1460s. Recorded together with Fra Filippo Lippi on a committee to evaluate a painting by another master in 1434, Squarcione was certainly acquainted with Tuscan art. Paolo Uccello's painting must have served as an example, as did the Florentine sculpture produced in Padua during the first half of the *quattrocento.* The greatest of these sculptors, Donatello, had been active in the Church of Sant'Antonio (commonly called Il Santo) on the high altar and in the nearby piazza on the statue of *Gattamelata,* from 1443 to 1454, at which time Squarcione had direct contacts with him.

<center>+++</center>

The Paduan painter is often misplaced as a contemporary of Mantegna and his other pupils. Once seen within his proper generation, along with Pisanello from neighboring Verona and Jacopo Bellini of Venice among the North Italian painters, his contributions, even in their existing fragmentary form, are impressive. He was an admired expert in perspective and foreshortening, as were the other two masters. Squarcione had drawings by other artists as well as a collection of art ob According to a sixteenth-century source, he had 137 pupils; even taking into account a healthy dose of exaggeration, he must have had many, and they came from far and wide.

Of the two certain paintings that survive, a *Madonna and Child* [53] and the *De Lazara Altarpiece* [54], the first is signed; the second is well documented (1449–52) and is usually considered to be slightly later. Given this situation, Squarcione's known works were produced after he was fifty years of age. Thus we are presumably beginning (and ending) with his late period, without a clue to his training or earlier phases of his style, and it is foolhardy to speculate about the nature of his previous work without new evidence. One should be reminded, however, that Padua had a vigorous *trecento* tradition, exemplified by Altichiero and Giusto de' Menabuoi, not to mention Giotto's masterpiece, the Arena Chapel [20], that must have colored his vision. Gentile da Fabriano had been active in Lombardy and the Veneto at a time when Squarcione would have been developing his skills. Furthermore, connections with Northern Europe, especially Austria and Germany, were strong in Padua and may have had an effect upon his development.

One of the added difficulties when considering Squarcione and these two works is the question of how much even here is actually autograph, that is, by his own hand, and conversely how much may have been farmed out to his pupils, especially when one considers the diversity between the two. We will probably never know the answer, but ultimately what counts is that Squarcione left a unique imprint upon a host of other painters that ultimately spread throughout much of Italy, and that these two pictures are a product of his

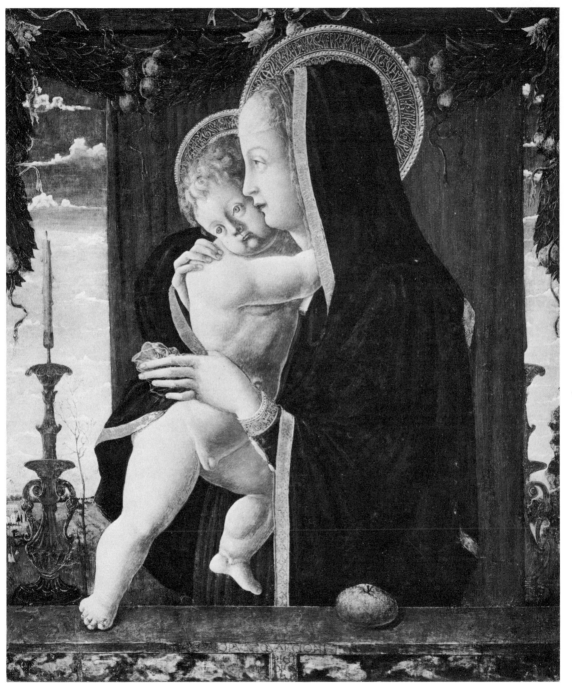

53. Francesco Squarcione. *Madonna and Child*, ca. 1448. Wood panel, 80 × 68 cm. Berlin-Dahlem, Staatliche Museen.

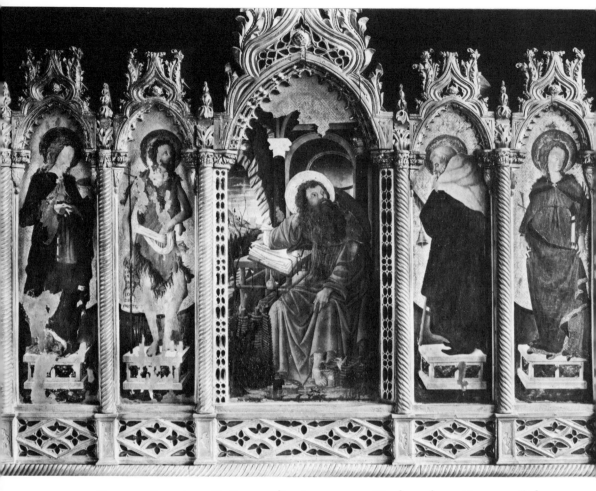

54. Francesco Squarcione. *De Lazara Altarpiece*, 1449–52. Wood panel, 175 × 220 cm. Padua, Museo Civico.

creativity and offer the best insight available into his own contribution.

The altarpiece made for the De Lazara family chapel in the Carmine church of Padua is a polyptych with five separate compartments in an elaborate frame. A seated St. Jerome occupies the central section; the width of this panel is about double that of the other four, which depict Sts. Lucy, John the Baptist, Anthony Abbot, and Justina, so that the entire altarpiece can be divided into thirds of equal size. The proportions of the figures are not consistent between the central figure and the side saints. Jerome, overpoweringly large, denies effectively any implication of rapport between them. He sits in a naturalistic setting with a distant landscape on the left, while the side saints, realistically rendered with descriptive color, stand on marble bases against an abstract background; they appear more like painted statues than real people, and the disjunction between them and the central image is puzzling, not to say old-fashioned for the middle of the fifteenth century. The space created for St. Jerome, with a vista set obliquely to the left distance and a view into an apsidal chapel slightly to the right of center, is oddly unmeasured. Judging from this picture, despite its sparkling ingenuity, Squarcione could hardly have taught more than the craft to the precocious Mantegna, who emerged as an independent master precisely in the years of the De Lazara painting.

The figures in the *De Lazara Altarpiece* are not only disconnected in their relation to the central section with St. Jerome, but they turn left or right apparently without plan or pattern, while Jerome looks up and to the right, forcing the observer to follow his gaze far outside the pictorial field. Squarcione's individuality produced singular situations—bizarre foreshortenings, as in the hand of St. Lucy, or the unexpected spatial manipulations in the Jerome panel, all of which demonstrate an engaging expressionism.

The other painting invariably connected with Squarcione is the signed *Madonna and Child* in Berlin [53], often associated with Donatello and particularly with a tiny detail of a bronze relief he finished about 1450 of the *Miracle of the Speaking Babe* for Il Santo. The *Madonna*, which has a demonstrable dependence upon Florentine sculpture, has been dated to this period and it, too, may have been commissioned by the De Lazara family. On the other hand, the style of the picture reflects Filippo Lippi's *Tarquinia Madonna* of 1437 [82]. Not only is the Child's aggressive pose almost identical, but the chubby face and small features suggest a connection, raising the possibility that Squarcione's picture is closer in date to the Lippi (which is dated) than is usually believed. The power of the painting derives from the incongruous juxtaposition of the Child seen full-face beside the insistent profile of the Mother.

In the landscape, an enormous pair of candlesticks, the one on the right only partially discernible behind the curtain, once more raise questions of size and scale. There is a blatant rejection of symmetry in favor of the unexpected, the eccentric. An oversized but flattened-out apple, seemingly extracted from the garland above, finds its place on the ledge that separates the viewer from the subject. This arrangement of a still-life element and the Madonna becomes standard during the second half of the fifteenth century and is particularly favored by Giovanni Bellini. The Berlin *Madonna*, engaging and even witty, gives an indication of a personal style that had such a strong appeal for many painters of the next generation.

JACOPO BELLINI

It is convenient to discuss Jacopo di Niccolò Bellini (ca. 1400–1470/71) in close context with Pisanello and Squarcione as the three stand at

the foundation of the Renaissance style in North Italy, and their activities intersected frequently. Head of a family of painters, Jacopo Bellini dominated the field in his day, as his sons Gentile and Giovanni did in theirs, during the following generation. What makes the evaluation of his art frustrating is the virtual absence of painted works, certainly chief works, upon which his fame was based. Venetian by birth, he was a pupil of Gentile da Fabriano's, as he attested when signing a *Crucifixion* in fresco (lost) for the Cathedral of Verona in 1436. He was probably in Florence and Rome during the 1420s with his master, whose name he gave to his presumed firstborn son, Gentile. Jacopo was already married by 1429, and among his children was a daughter, Nicolosia, who married Andrea Mantegna in 1453.

The first independent painting by Jacopo of which we have knowledge is a *San Michele* (destroyed) for a church in Padua, completed in 1430. In 1437 he was a member of the Scuola Grande di San Giovanni Evangelista, one of the many *scuole* (religious confraternities for laymen) in Venice, where he became a deacon in 1441, the year of a competition with Pisanello for a portrait of Lionello d'Este of Ferrara. Pisanello's picture has been discussed; Jacopo's does not survive. By 1444 he delivered the *Annunciation* for Sant'Alessandro in Brescia [55], which is still in that church together with a predella by other painters. The *Madonna and Child* in the Brera [56] is signed and dated 1448 by a post-Renaissance inscription on the frame, which was probably copied from a genuine one that was obliterated. In 1456–57 Jacopo Bellini painted the Tomb of Beato Lorenzo Giustiniani (lost), and in 1460 he signed an altarpiece with his sons for the Gattamelata Chapel in Il Santo, Padua, which has not been preserved.

The small number of extant documented works is supplemented by an unusually large body, actually hundreds, of drawings, mostly conserved in two books, one in the British Museum and the other in the Louvre. In his will, Jacopo left the drawings to his wife, who in turn passed the much-prized inheritance on to Gentile, at whose death they went to Giovanni. Bellini's sketchbooks contain drawings for different purposes, ranging from exercises in perspective to studies after the antique, compositions for paintings, designs for statuary, and notations of figural ideas. The quality varies decisively among them, and it is a challenge to isolate those entirely by him from those in which his sons and others in the shop may have had a share, either in conception or by having gone over the lead point with ink to enliven and sharpen the effects. Furthermore, accurate dating of the drawings is problematic; considering their number and diversity, they were probably executed over a considerable span of time beginning around 1430 and continuing to the 1450s.

⊹⊹⊹

Several patterns emerge that help explain Jacopo's art. He was much taken with the new perspective that had been worked out in Florence, and was famous among his contemporaries for perspectival skills. Nevertheless, he was unable fully to integrate figures into his created stages when difficult foreshortenings were involved, and his approach recalls Masolino's efforts, not Masaccio's. He was committed to the study of ancient reliefs, sculptures, and inscriptions, sharing that interest with contemporaries like Pisanello and Squarcione.

A limited insight into the reasons for the wide admiration Jacopo's art inspired may be obtained from the *Annunciation* in Brescia [55], which was once erroneously attributed to Fra Angelico. The overwhelming control of the decorative qualities of materials is impressive—the draperies, the wall hangings, the ori-

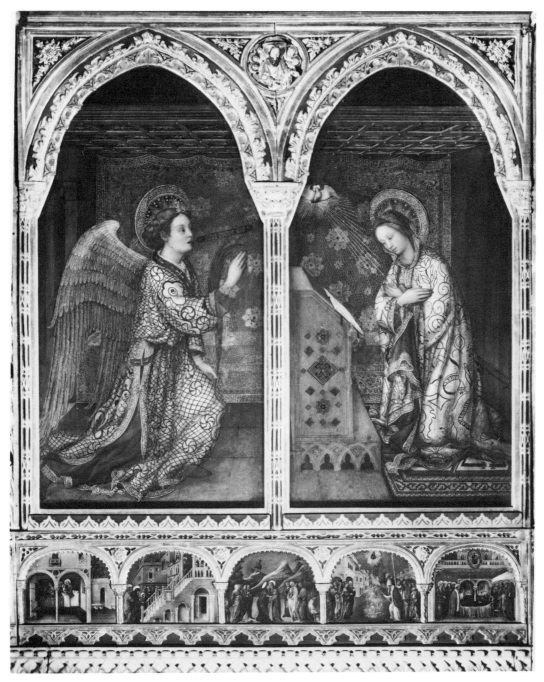

55. Jacopo Bellini. *Annunciation*, 1444. Wood panel. Brescia, Sant'Alessandro.

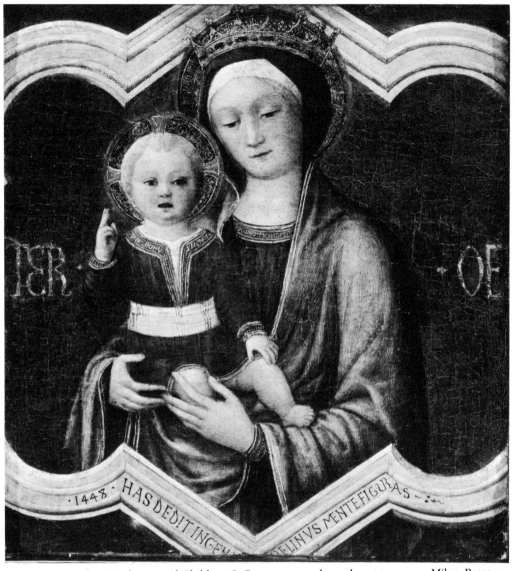

56. Jacopo Bellini. *Madonna and Child*, 1448. Canvas on wood panel, 45 × 50.2 cm. Milan, Brera.

ental carpet upon which the Virgin kneels, the brocade-like wings of Gabriel. These sumptuous qualities recall and even surpass such magnificent *trecento* examples as Simone Martini's in the Uffizi and must have offered undeniable appeal to Jacopo's patrons, who had a centuries-old awareness of Byzantine art. His knowledge of perspective is well expressed in the ceiling with wooden coffers into which are set foreshortened stars. The elaborate halos are also located obliquely in the shallow space, which opens out at the edges. The figural tra-

dition expressed is that developed by his teacher, Gentile da Fabriano, parallel to Masolino's and carried on by Jacopo's rival, Pisanello. The modeling of the faces and hands, rather understated, delicate, and without dramatics, is consistent with a certain flattening-out of the pictorial composition. Jacopo's is a direct, uncluttered, if busy, world; the mannerisms of Stefano da Verona or the exaggerations of Pisanello are absent. The *Annunciation*, a work of his middle career, is complex, decorative, and satisfying but it left no imprint upon later painters, nor did the

various Madonnas connected with Jacopo (like the *Madonna and Child*, [56]) have a lasting appeal.

The drawings, on the other hand, often expose the more forward-looking aspects of Jacopo's art despite the inherent questions of chronology and attribution. One of these drawings that has not been retouched, the *Lamentation* [57], was made on two sheets. A panoramic landscape with three crosses, now empty, ladders used to take down the bodies, and low hills receding in the distance is on the left; the heavy cover of the tomb is in the

57. Jacopo Bellini. *Lamentation* (sketchbook, folios 57b–58a), 1440s. Pen, 42.7 × 58 cm. Paris, Louvre.

foreground. The figural subject on the right includes the grieving followers who surround the dead Christ, while in a plane behind there is a live and a dead tree of obvious symbolic intention. The figures and their expressions recall Donatello's reliefs at Il Santo, although Jacopo's actors reveal a greater restraint in their emotional reactions. The *Lamentation* appears to have been useful to Jacopo's sons and perhaps to his son-in-law, Mantegna.

SASSETTA

Siena had strong ties with a Gothic style throughout the Renaissance. The most representative and at the same time most original painter of the first generation in Siena was Stefano di Giovanni di Consolo (ca. 1400–1450), known as Sassetta, a made-up name that first appears in the eighteenth century. Sassetta, who seems to have been born in Cortona, par-

58. Sassetta. *'Bene scriptisti de me, Thomas'* (predella panel, *Arte della Lana Altarpiece*), 1423–26. Wood panel, 25 × 28.5 cm. Rome, Vatican Pinacoteca.

ticipated in the new interest in landscape, the organization of spatial effects, and the daring foreshortenings exemplified by Gentile da Fabriano and Masolino. The signed altarpiece for the Sienese Arte della Lana, the woolwork-ers' guild, datable on the basis of documenta-tion to 1423–26, has disappeared, except for the predella panels, which are divided among various public collections. In the 1420s Sassetta had a share in designing a scene for the his-toriated mosaic pavement of the Cathedral of Siena. In addition, he made a scale design of the baptismal font for the Baptistry, where he had an opportunity to study at close hand the works of Donatello and Ghiberti, who had contributed to the monument, as well as the sculptures by his Sienese compatriot, Jacopo della Quercia.

In 1430 Sassetta received the commission to paint the altarpiece known as the *Madonna of the Snow* [59] for the San Bonifazio Chapel in the Sienese Cathedral, finished two years later. The controversial altarpiece for the Os-servanza, a church outside the city of Siena, is dated 1436 but not signed, and is now usually assigned to another master. In 1437 Sassetta contracted to produce an elaborate altarpiece for San Francesco in Borgo San Sepolcro (now divided among various collections), which he finished in 1444, after having produced a painting for nearby Cortona a few years be-fore. In 1440 the painter was married, and in the same year he was once again employed by the Cathedral of Siena, this time to supply de-signs for stained-glass windows, which were never made. Sassetta died ten years later. Dur-ing the intervening decade he had conducted an active shop, where he produced many works for local consumption as well as a large fresco of the *Coronation of the Virgin* (de-stroyed).

⊹

From the surviving predella scenes of the *Arte della Lana Altarpiece* we can see that Sas-

setta's participation with Gentile da Fabriano and Masolino in modeling figures, in the rend-ering of landscapes, and in the depiction of architecture is more than casual. One need not seek documentary proof of a Florentine experience for Sassetta, since Siena is so close that inevitably he must have at least briefly visited there. Besides, Gentile had painted in Siena. As for Sassetta's progressive treatment of figures within an architectural space, one should recall that Sienese *trecento* painters, including Simone Martini and Ambrogio and Pietro Lorenzetti, very nearly stumbled on the discovery of one-point perspective a cen-tury before Brunelleschi formulated the sys-tem around 1420.

The predella scene, '*Bene scriptisti de me, Thomas*' [58] was located on the far right, as is evidenced by the convergence of orthogonals in an area deep in the picture at the left (rather than at a single point in the distance!). Spatial considerations are foremost. The open rooms, leading one into another, are close to Gentile's treatment of space, although the strongest derivation comes from the great Sie-nese masters of the past.

The *Madonna of the Snow* [59, 60], of which at least the main panel is extremely well preserved, permits a study of Sassetta's art at a high level of achievement in a large format and, since it is datable (1430–32), has value for sketching Sassetta's chronological develop-ment. The name of the picture derives from the fresh snow, fallen miraculously in August, held by the angels.

In a predella panel [61] one sees the pope plotting out the ground plan of the Church of Santa Maria Maggiore in Rome, the subject, it will be recalled, of Masolino's altarpiece now in Naples [15]; the building of the church is illustrated in the adjacent scenes. The han-dling of details in the main field, the insistence on filling the available space to the fullest, and an advanced sense of design distinguish the painting. The altarpiece is conceived as a trip-

59. Sassetta. *Madonna of the Snow Altarpiece*, 1430–32. Wood panel, 241 × 223 cm. Florence, Pitti Palace.

60. Sassetta. Detail of 59.

tych with pairs of saints: Peter and John the
Baptist, Francis and Paul under narrow
Gothic arches, with Mary and the Child given
wider berth under a central semicircular arch.
There is, however, the implication of a unified
space that one associates with a *sacra conver-
sazione.* The brocaded, gilded, and embossed
surface and the wealth of color, demanding

blues and reds, make for extravagant decora-
tive effects. The Virgin's throne has com-
pletely disappeared beneath the draperies,
while the tight modeling of the faces and
hands and the insistent drawing create an un-
settling divergency of effects. Clearly Sassetta,
an impeccable craftsman, emphasizes the sur-
face plane of the painting as well as the skin of

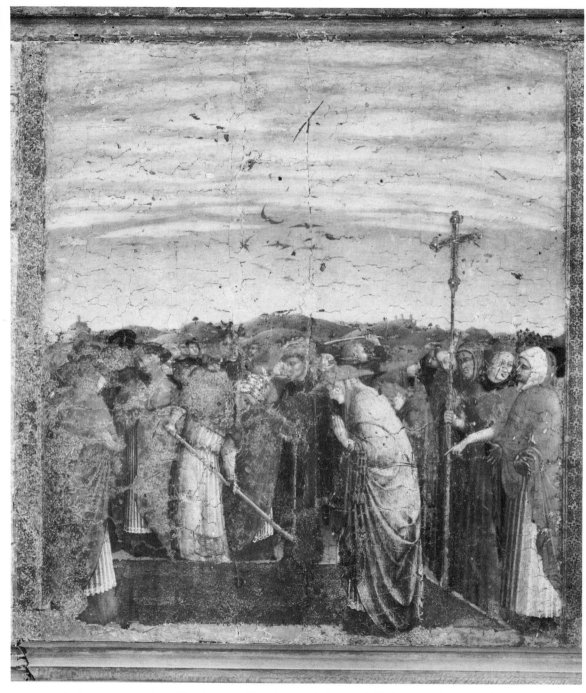

61. Sassetta. *Founding of Santa Maria Maggiore* (predella panel, *Madonna of the Snow Altarpiece*), 1430–32. Wood panel, 33 × 29 cm. Florence, Pitti Palace.

62. Sassetta. *St. Francis in Ecstasy*, 1444. Wood panel, 190 × 122 cm.
Settignano, Villa I Tatti.

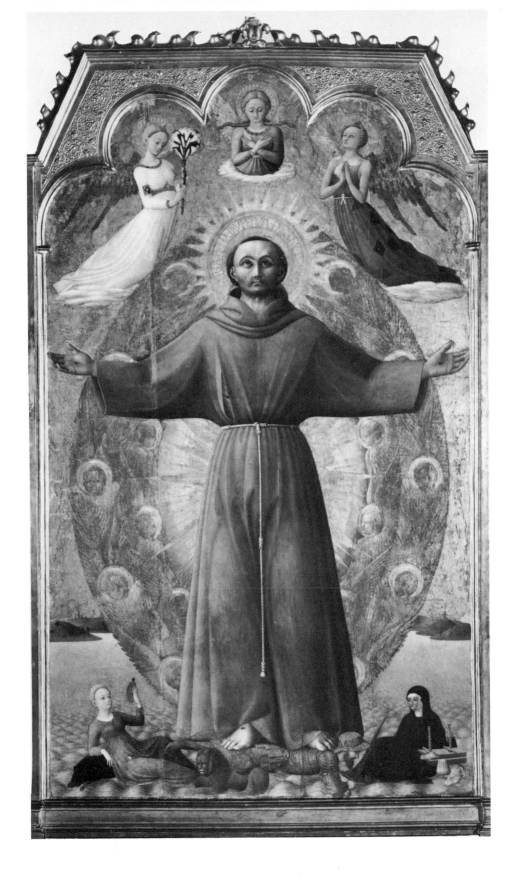

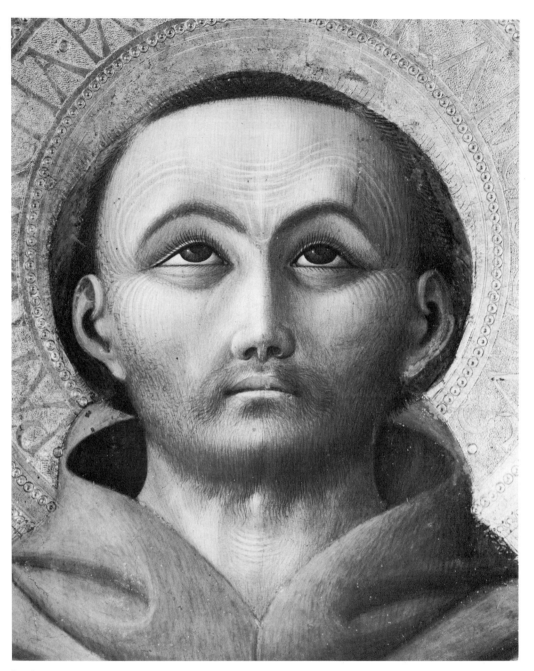

63. Sassetta. Detail of 62.

objects, creating a flattening quality that mitigates deep spatial implications and volumetric conviction.

The predella scenes for the *Madonna of the Snow* are far more anecdotal than the formal scene above. Here Sassetta appears less eccentric in his figural types and in greater harmony with the progressive directions in Italian art of the moment, including the treatment of light and naturalistic landscape. We may even assume that the flatter decorative representations, arranged formally on the main field, are motivated by an iconographic or even traditional requirement, while in the shadows at the base of the altarpiece the artist felt freer to participate in the less familiar (to his Sienese audience) approach.

Sassetta, at least in the 1430s, does not stand far from Fra Angelico in style, and the two probably worked in Cortona in the same years. Furthermore, Sassetta's system of modeling and his use of light in building up the figures for the Franciscan altarpiece in Borgo San Sepolcro (central panel, [62]) permit speculation concerning the possibility of an interchange with Domenico Veneziano, on the one hand, and Piero della Francesca, on the other. Piero had his origins in Borgo San Sepolcro, and if he was already a trained painter by the time Sassetta's altarpiece was delivered from Siena to Borgo in·1444, it does not obviate the possibility that Piero found qualities to admire in the smooth, pearly light and in the abstraction of the figures and the unnaturalistic colors [63]. Temperamentally and stylistically they were far apart, but Piero must still have recognized that the altarpiece, painted on both sides with many auxiliary scenes by Sassetta, was the most impressive modern work in town, and in establishing his local reputation he was obliged to come to terms with it.

THE FIRST GENERATION:
THE MONUMENTAL CURRENT

Masaccio, Fra Filippo Lippi, Domenico Veneziano, Piero della Francesca, Andrea del Castagno

MASACCIO

Few painters have had a greater impact upon later art than did Masaccio (1401–1428). He alone virtually set the tone for much of Renaissance painting, and when one considers that he lived less than twenty-seven years with a working span that barely amounted to a decade, his feat becomes even more extraordinary. Although he had no immediate predecessors for the direction in which he was to take the art of painting, certain aspects of his style can be traced to Giotto, who flourished a century before. Masaccio's importance for Florentine and Italian painting was recognized by Leonardo, who paid homage to him in his notebooks; by Michelangelo, who studied his frescoes; and by Vasari, who gave him high praise.

Tommaso di ser Giovanni, nicknamed Masaccio, which translates as "slovenly" or "big" Tom and probably had an endearing implication, was born in 1401 in the provincial town of Castel San Giovanni (now San Giovanni Valdarno), about thirty miles south of Florence in the Arno River valley. He may have moved to

Florence when he was about sixteen and probably worked in the shop of Bicci di Lorenzo, a successful but somewhat pedestrian painter who maintained one of the busiest workshops in Florence. In 1422 Masaccio enrolled in the painters' guild, and in the same year he finished and dated his earliest surviving work, the *San Giovenale Altarpiece* [64]. In 1424 he joined the Confraternity of St. Luke, composed mainly of painters. Notices concerning Masaccio survive from the year 1426, when he was in Pisa preparing an elaborate altarpiece for the Carmelite church there. In 1427 Masaccio filed his *catasto* (income tax), describing sizable debts. He appears to have gone to Rome by the middle of 1428 and died there soon after. His most famous works, the frescoes of the Brancacci Chapel and the *Trinity* in Santa Maria Novella, both in Florence, are not documented.

⁘

The earliest paintings, the *San Giovenale Altarpiece* of 1422 [64] and the *Madonna and Child with St. Anne* of about 1423 [65], both

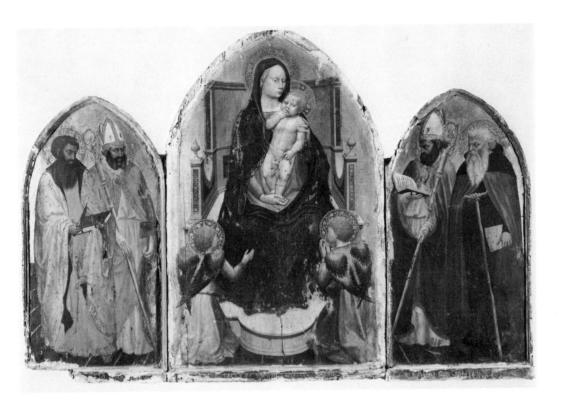

64. Masaccio. *San Giovenale Altarpiece*, 1422. Wood panel, central scene 108 × 65 cm.; side panels 88 × 44 cm. Florence, Fortezza di Basso (temporarily).

undocumented, need not detain us for long. The single most significant fact that might be deduced from them is the recognition that the young painter had carefully meditated on forms and solutions which Donatello had been evolving in his in-the-round sculpture and his reliefs, which he superimposed on the late Gothic style of his teachers. Of all the painters of the period, Masaccio stood closest stylistically to Donatello, who was his personal friend, as was Brunelleschi. These early pictures reveal Masaccio on the verge of establishing a confident, personal style.

Three works permit an assessment of Masaccio's art: the *Trinity* fresco in Santa Maria Novella, the *Pisa Altarpiece* (central panel in London, National Gallery; smaller panels in various collections), and the Brancacci Chapel

frescoes in Santa Maria del Carmine. The earliest is the *Trinity* [66], probably painted at the end of 1425, followed by the *Pisa Altarpiece*, documented in 1426, and finally Masaccio's share of the Brancacci frescoes, apparently done in 1427 and early 1428. Debates about the chronology of Masaccio's paintings revolve around a span of merely six years or less, and within an overview of the Renaissance are hardly crucial. The paintings are unique among themselves and collectively form the earliest statement of the new style expressed within a monumental idiom.

The *Trinity* includes at the base a human skeleton resting on a painted sarcophagus that refers to the temporal and fleeting nature of man's life on earth and contains the ominous inscription: IO FU GIA QUEL CHE VOI SETE, E

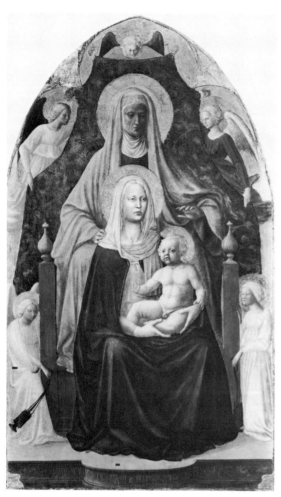

65. Masaccio with assistants. *Madonna and Child with St. Anne*, ca. 1423. Wood panel, 175 × 103 cm. Florence, Uffizi.

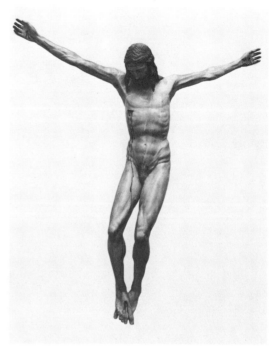

67. Filippo Brunelleschi. *Crucifix*, 1402 (?). Wood. Florence, Santa Maria Novella.

QUEL CHE SON VOI ANCO SARETE (I was once as you are, and you also shall be as I am). Within the created space but outside the sanctuary are the kneeling donors, perhaps Lorenzo Lenzi, in the habit of Gonfalonier of Justice, and his wife. The two most remarkable features of the *Trinity* are the architectural setting and the majestic conception of the subject. Filippo Brunelleschi, then engaged on the construction of the dome of the Florentine Cathedral as well as the rebuilding of the Church of San Lorenzo, apparently supplied Masaccio with technical advice for the intricate and innovative perspective. The carved wooden crucifix by Brunelleschi in the same church (Santa Maria Novella), dated about 1402, may have served Masaccio as a model for his own Christ, but he added the flavor of Donatello to the pose [67]. The massive pilasters and the weighty entablature frame the sa-

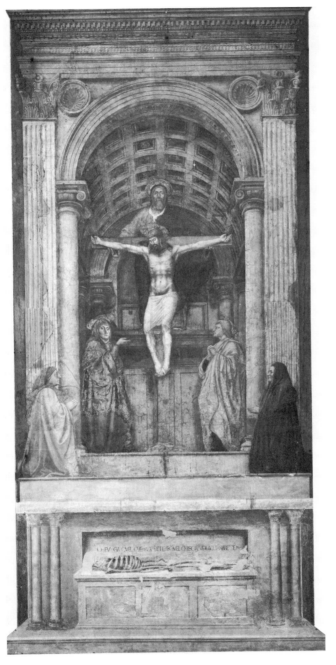

66. Masaccio. *Trinity*, late 1425 (?). Fresco, 667 × 317 cm. Florence, Santa Maria Novella.

68. Masaccio. Detail of 66, showing gridwork.

cred scene and serve to separate the donors from the Crucifixion. Between the pilasters appears a barrel vault, and at the back the wall has fictive marble incrustations, a device found on contemporary Florentine wall tombs such as one by Donatello for Pope John XXIII in the Baptistry. In addition to obvious analogies with Brunelleschi's architecture, the niche by Donatello and Michelozzo for the Parte Guelfa (subsequently Mercanzia) on Orsanmichele [2] provided Masaccio with important insights for adumbrating the space.

In the fresco the gridwork used to establish proportions and develop the space is still visible [68], but there remains a basic though perhaps inevitable ambiguity, manifested by the unclear spatial relationship between God the Father, the crucified Christ, and the back wall. The central theme is actually a conflation of two motives: the Holy Trinity, consisting of God the Father, Christ, and the Dove; and the Crucifixion, shown with Mary and John beneath the Cross. The figure of Christ is consequently the central element in both subjects and unifies the two themes and the two separate compositions, one superimposed upon the other.

The light in the fresco is diffused over the whole surface, functioning to establish the lights and darks necessary to model three-dimensional form. It falls on Christ's body from the front but on the architectural ele-

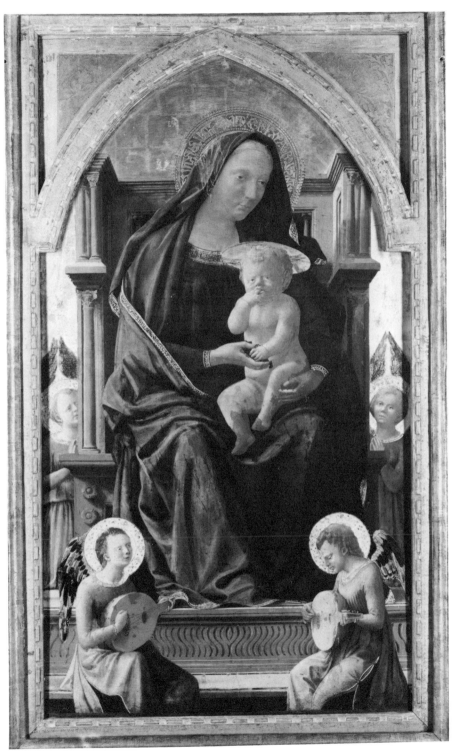

69. Masaccio. *Madonna and Child Enthroned (Pisa Altarpiece)*, 1426.
Wood panel, 135 × 73 cm. London, National Gallery.

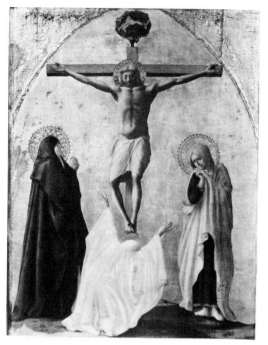

70. Masaccio. *Crucifixion* (upper panel, *Pisa Altarpiece*), 1426. Wood panel, 83 × 63 cm. Naples, Capodimonte Museum.

ments from the left, that is, from the direction of the portals of the church that also provide a principal source of natural illumination for the wall, where the fresco is located. By consistently being shown as emanating from the same sources, light has a strong unifying function, much the same as the readily understandable proportions of the figures and the architecture serve to tightly structure the painting. In the *Trinity,* for the first time in *quattrocento* art, we find a world in which the figures, the architecture, and the stage-like created space are in harmony with one another and within the rational grasp of the spectator. The figures are rendered with a seriousness and a restraint that became a standard for many of Italy's leading painters, a quality that is best studied in the Brancacci frescoes.

Nearly the entire year 1426 was taken up with the execution of the intricate altarpiece, a polyptych, for the Carmelite church in Pisa, which once consisted of numerous panels, including predella scenes beneath the larger *Madonna and Child Enthroned* [69], paired standing saints (lost), small standing saints and bust-length figures, and a *Crucifixion* [70] as well as other subjects, some lost, for the pinnacles. The precise appearance of the original, dismantled and cut up in the eighteenth century, is not certain, but we know that it was designed and produced by a Sienese woodworker before Masaccio even obtained the commission. The *Madonna* in London, the central element, has suffered serious damage to the surface. Mary's face is almost devoid of the top layers of paint and now appears misleadingly flat and unmodeled. Still a marvelous image, this massive figure must have dominated the entire altarpiece. Her throne is decorated with single and paired Corinthian columns of archaeological exactitude, illusionistically painted, for like Donatello and Brunelleschi, Masaccio admired the architectural and sculptural forms of antiquity.

Light and cast shadow function more decisively than in the *Trinity,* due perhaps to the fact that Masaccio had become more deeply aware of their use by Gentile da Fabriano. The light coming behind the left shoulder of a spectator facing the Madonna flickers at the back of the throne on the right, playing against the surface. The realistically portrayed Child sucking his fingers is set against the more delicate and somewhat playful angels peering out from behind the throne and with those below, making music. All the parts of this section, which was cut down, are interrelated, and even the Christ Child's halo is shown in sharp foreshortening in contrast to those for the other sacred figures, which are flattened out, parallel to the picture plane. The singular use of the foreshortened halo

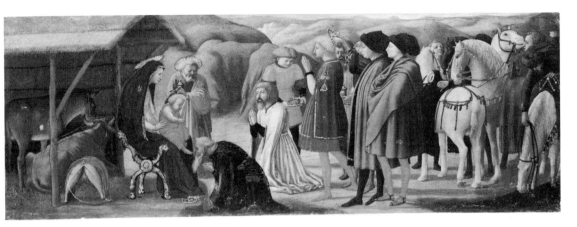

71. Masaccio. *Adoration of the Magi* (predella panel, *Pisa Altarpiece*), 1426. Wood panel, 21 × 61 cm. Berlin-Dahlem, Staatliche Museen.

cannot easily be explained; the halo of the Christ from the *Crucifixion* [70], originally on the upper zone of the altarpiece, is not in perspective while in the *Trinity,* on the other hand, all the halos are foreshortened.

A further dimension of Masaccio's powers is illustrated by the *Adoration of the Magi* [71], once the middle scene of the predella. The picture can be conveniently compared with Gentile's *Adoration* [5], which, however, was conceived as the main subject of an imposing altarpiece with a predella of its own, as we have seen. Their purposes were as different as their shapes, resulting in radically diverse compositions. Masaccio has severely reduced the number and the magnificence of the participants; his humble, more modestly dressed, kings are less graceful than Gentile's Magi. The solemnity of the event, rather than the festive qualities, is stressed. As with the *Trinity,* patrons are included but instead of being isolated in a separate zone, they are now integrated into the composition in the same space, as participants in the event. They are shown in sharp profile to preserve a distinction between the sacred and the profane. These tiny figures dressed in notary's costume have a solidity and presence unknown in earlier painting belonging to the same family as the massive Child from the central panel above.

The monumentality of the figures and the rigorous spatial compositions found in the panels of the *Pisa Altarpiece* are given grander format in Masaccio's frescoes for the Brancacci Chapel in Santa Maria del Carmine, Florence. As already mentioned (see Chapter 2), the decoration of the chapel with frescoes was first undertaken in about 1425 by Masolino and finished only a half-century later by Filippino Lippi [10]. Masaccio's share in the chapel can be dated 1427/28, that is, immediately following the completion of his work in Pisa, when he must have taken over the decoration while Masolino was away from Florence. He then designed all of the remaining parts according to his own vision, based as it was on a commitment to perspective, landscape, and light. Around the middle of 1427, Masolino returned from Hungary and apparently joined Masaccio in painting the still unfinished cycle, this time in a somewhat secondary capacity, having now to follow the program and plan established by Masaccio.

In addition to a system of narrow pilasters

72. View of the Brancacci Chapel, Santa Maria del Carmine, Florence.

and stringcourses painted to appear like marble, which give an architectural organization to the frescoes, there are formal relationships from one side of the chapel to the other and from one scene to another [72]. For example, on the altar wall on either side of the window are *St. Peter Preaching* (Masolino) [13] and *St. Peter Baptizing the Neophytes* (Masaccio) [14]. Both are shown within a landscape, and in each the natural light from the chapel window (which has been raised higher on the wall since Masaccio's day) provides the direction of light in the paintings, although in Masolino's the light source is inconsistently understood. All the frescoes in the Brancacci Chapel follow the pattern of acknowledging the actual light, so that in the scenes to the left of the window, light comes into the pictures from the right;

on the right side, light comes from the left. This system coordinates the entire mural cycle.

Besides the light, in the two scenes on the lowest zone of the altar wall, *St. Peter Healing with His Shadow* [73] and the *People Giving Their Goods to St. Peter and the Death of Ananias* [74], both by Masaccio, perspective is used to construct the space, with the buildings also a unifying element; they share a vanishing point located within the window area. Such subtleties are not uncommon in the Brancacci cycle. For example, the upper two scenes of *St. Peter Preaching* and *St. Peter Baptizing*, and the other two scenes on the same level in the chapel, the *Tribute Money* and the *Resurrection of Tabitha* on the side walls, are twenty-five centimeters higher than the frescoes on the lowest zone of the chapel. This adjustment was probably made to compensate for the apparent diminution in size because of the greater distance from the spectator standing on the chapel floor. Another example of Masaccio's encompassing refinements should suffice to make the point: the figures of Adam and Eve in the *Expulsion* on the inner wall of the entrance arch [75], the first seen from the nave as one approaches the chapel, are placed obliquely in space, drawing the viewer into the chapel and its frescoed decoration, although in the usual left to right reading, one would expect the Fall before the *Expulsion*.

The scene of the *Expulsion* is one of the most successful figural inventions of the Renaissance; Michelangelo, over eighty years later in a very different artistic climate, was able to rely heavily upon it for his own *Expulsion* on the Sistine ceiling [76]. The angel who hovers overhead, sword in hand, banishes the pair from Paradise, whose sharply foreshortened gate is on the left. Masaccio's tangible, present, thick, muscular, three-dimensional treatment of the human body is clearly demonstrated here. Adam and Eve, and the nudes

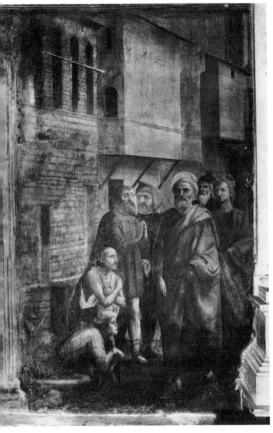

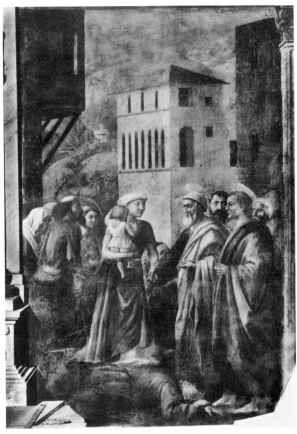

73. Masaccio. *St. Peter Healing with His Shadow,* 1427/28. Fresco, 230 × 162 cm. Florence, Santa Maria del Carmine, Brancacci Chapel.

74. Masaccio. *People Giving Their Goods to St. Peter and the Death of Ananias,* 1427/28. Fresco, 230 × 162 cm. Florence, Santa Maria del Carmine, Brancacci Chapel.

from *St. Peter Baptizing the Neophytes,* are by no means accurate in an anatomical sense, nor are they based on countless studies after models or after corpses, as became the practice among second generation masters. Masaccio's conception of the figure is largely empirical and slightly deficient by later standards; the proportions of Adam, when measured, reveal a short torso, a somewhat awkward right leg, truncated arms, and enormous feet. Errors abound, but the overall effect is visually convincing and tactilely satisfying.

The *Expulsion* is also distinguished for its

psychological interpretation. Eve reacts to being driven from Eden with a hollow shriek that pierces the barren landscape; Adam, teeth clenched, buries his face in his hands, despairingly. Both take long steps forward, the movement of the legs being reversed. Color in this narrow scene and generally throughout the cycle is not remarkable, although it acts to maintain a clarity of reading and purpose. Warm earth tones predominate, operating to define the forms they represent. On the other hand, a thorough cleaning of these precariously preserved frescoes would probably show

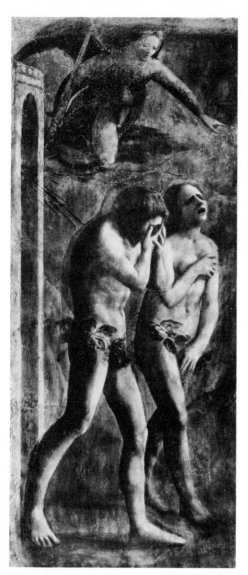

75. Masaccio. *Expulsion*, 1427/28. Fresco, 208 × 88
cm. Florence, Santa Maria del Carmine, Brancacci
Chapel.

76. Michelangelo. *Temptation and Expulsion*, 1508–
12. Fresco. Rome, Vatican, Sistine Chapel.

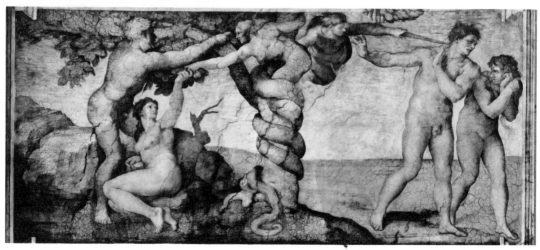

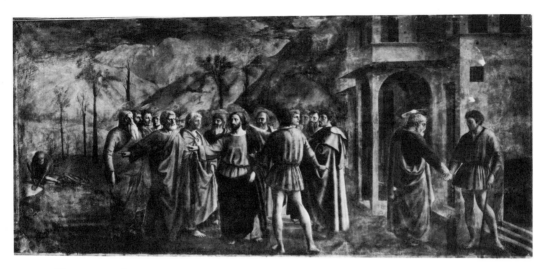

77. Masaccio. *Tribute Money,* ca. 1427/28. Fresco, 255 × 598 cm. Florence, Santa Maria del Carmine, Brancacci Chapel.

78. Masaccio. Detail of 77.

a brighter and higher tonality that is closer to Masolino's and Gentile's color than now appears.

St. Peter Baptizing the Neophytes exemplifies several other aspects of Masaccio's art, including the attention he directed to nature, with its extraordinary bird's-eye view of the mountainous landscape. This element is still more readily studied in what is unquestionably the most famous fresco of the series, the *Tribute Money* [77, 78]. Three different episodes based on biblical passages are included, with emphasis located in the center, where Christ, in the company of the Apostles, is approached by the tax collector at Capernaum. He gesticulates to Peter, apparently ordering him to go to the water, "cast an hook, and take up the fish that first cometh up" (Matt. 17: 27). On the left, in the middle ground, Peter is taking a coin from the fish, and in a third scene, in the right foreground, Peter gives the coin to the tax collector, represented twice in the fresco. Peter, the main subject of the entire cycle, is here shown three times. The figures in the principal group are arranged in

space within a centralized configuration and echo Early Christian usage as well as Giotto's majestic compositions at Santa Croce (Florence).

Christ says that he need not pay the tax but pays it so as not to give offense. The meaning has been associated with another familiar passage: "Render therefore unto Caesar the things which be Caesar's, and unto God the things which be God's" (Luke 20: 25). These scenes, and indeed the whole cycle, may express the desire of Pope Martin V through the Carmelites for harmony between the church and civil authorities.

Two kinds of perspective operate in the *Tribute Money:* linear perspective, in which buildings are set obliquely into space with the orthogonals tending to converge around the head of Christ; and aerial perspective, in which the mountains recede into the distance by lightening the tones and diminishing the sharpness of the contours. Hence, Masaccio has produced an accessible and believable world with man as its measure.

In his brief life, Masaccio altered the history of European painting. He participated in the discoveries of the champions of early Renaissance classicism in sculpture, Donatello and Nanni di Banco, and he shared ideas with the most ingenious personality of his time, Filippo Brunelleschi, who effectively contributed to Masaccio's formation. But Masaccio translated and applied to panels and walls what these older masters had presented him; he transformed notions of the figure that were conceived for three dimensions onto two-dimensional surfaces and in so doing altered the language to suit his medium and his artistic constitution. He also incorporated the new perspective into his own art, making it an indispensable tool for painters for the next five hundred years. The justice of his compositions and the nobility and self-confidence of his dignified figures, whose poses and expressions

have a measured restraint and appropriateness, established a standard for later artists. His sense of unfolding narrative, exemplified in the *Tribute Money* and echoing similar compositions by Donatello and Ghiberti, must have provided Alberti with some of his theoretical ideas about narrative painting, which, in turn, had an enormous impact on later art theory and practice. Masaccio's bold, forthright interpretation of the human drama continued to exert its vitality for the next hundred years and more, and generations of Florentine painters came to draw from the Brancacci Chapel frescoes.

Masaccio never had a middle or a late style; what we have is all early. As hopeless as it might be to predict what his art would have looked like had he lived another twenty or thirty years, perhaps the mature works of Domenico Veneziano, such as the *St. Lucy Altarpiece* [92] may provide a clue.

FRA FILIPPO LIPPI

Fra Filippo Lippi and Domenico Veneziano were the most important practitioners of the monumental style immediately following the premature death of Masaccio. Although they both belong to a generation that coincides with Masaccio's, virtually nothing is known of their work in the 1420s. As a young man Lippi (Filippo di Tommaso di Lippo, 1406/7–1469) was under the shadow of Masaccio (and Masolino) at the Convent of Santa Maria del Carmine in Florence, where he became a friar in 1421. Unlike Masaccio he had a long, productive artistic career, exerting a broad influence over a substantial period of time. He traveled to North Italy (Padua) in the mid-1430s, where he disseminated the latest Florentine discoveries and, at the same time, was open to the stylistic currents he found there.

Nothing is known of Lippi's artistic origins and early style. The first information that can

be offered falls into the 1430s. In 1432 Lippi probably painted a fresco in the cloister of Santa Maria del Carmine, the so-called *Rules of the Carmelite Order* [79], and in the same year he apparently left the convent permanently. Lippi was in Padua in 1434 and perhaps earlier, where he was recorded together with Francesco Squarcione, the local painter and powerful personality who has already been discussed. Back in Florence, he signed and dated the *Tarquinia Madonna* in 1437 [82] and obtained an important commission for an altarpiece, the *Madonna Enthroned with Saints* for the Barbadori family chapel in Santo Spirito [83], which he apparently finished during the following year. Lippi's art, and probably this painting, are warmly praised by Domenico Veneziano in a letter of 1438 to Piero, son of Cosimo de' Medici, with whom Fra Filippo had close dealings. In 1442, with Medici support, Pope Eugenius IV awarded him an important benefice. A large payment was made in 1447 for *St. Bernard's Vision of the Virgin* (London, National Gallery), produced for the Palazzo della Signoria, as well as final payments for the *Coronation of the Virgin* [84], made for Sant'Ambrogio, which was commissioned in 1441.

Fra Filippo began to fresco the enormous choir of the Cathedral of Prato in 1452 (after Fra Angelico had turned down the assignment). He was aided by his chief assistant of the period, Fra Diamante; the work dragged on for years. In Prato Lippi also obtained a number of other assignments and purchased a house there in 1455. About two years later Filippino was born, his son by Lucrezia Buti, a nun in Prato. By 1458 he completed a painting for the king of Naples, a commission negotiated by the Medici, for whom Filippo produced an *Adoration of the Child* in 1459. Filippo probably married Lucrezia in 1461, and their ecclesiastical vows were revoked. By 1466 he had put the finishing touches on the

frescoes in Prato; in the previous year negotiations had been underway for him to fresco the choir of the Cathedral of Spoleto in Umbria. The actual painting began in 1467 with the assistance of Fra Diamante, who completed the work about the time of Lippi's death in 1469. Despite the wishes of the Florentines, who wanted him to be interred in his native city, Fra Filippo was buried in Spoleto, where there is a monument dedicated to him in the Cathedral with an inscription by the humanist poet Angelo Poliziano.

The *Rules of the Carmelite Order* [79], probably frescoed in 1432, is preserved only in fragmentary form and has undergone considerable damage. This fresco is neither documented nor signed, and its assumed authorship is based on stylistic and circumstantial evidence. Enough of it remains to locate it within the ambiance of Masaccio's Brancacci Chapel frescoes and, of course, it was only a few yards away physically; furthermore, it permits the assumption of Lippi's direct apprenticeship with Masaccio. In the *Rules* the Frate demonstrates insistent reduction of details, especially in the impressive landscape into which several separate episodes are placed; the artist accomplished a well-conceived interaction of natural landscape, architecture, and figures. The actors, mostly friars, are broadly modeled, and their proportions are inconceivable without Masaccio's example. It should be understood, of course, that there must have been a stylistic prehistory for this fresco in Lippi's evolution; even though we have no evidence, it is tempting to see him as an assistant of Masaccio's in Pisa and in the Brancacci Chapel. A small cut-down painting of a *Madonna and Child with Saints* [80] has good claim to predate the *Rules of the Carmelite Order* and to be Lippi's. The picture is notably Masaccesque, recalling to a certain ex-

79. Fra Filippo Lippi. *Rules of the Carmelite Order* (detail),ca. 1432. Fresco. Florence, Museum of Santa Maria del Carmine.

tent the central section of the *Pisa Altarpiece* [69], upon which Lippi may even have worked.

An artist who requires mention, if only parenthetically, when considering the early Lippi and the first echoes of Masaccio's art is the Sienese Domenico di Bartolo (ca. 1401–1447), who, according to Vasari, although unconfirmed by other sources, spent a period of time in Florence and had even worked in the Carmine church, where he is said to have painted the main altar (lost). Whatever may

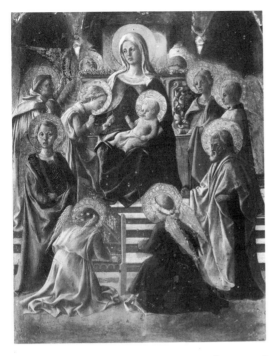

80. Attributed to Fra Filippo Lippi. *Madonna and Child with Saints*, ca. 1430. Wood panel, 43.7 × 34.3 cm. Empoli, Museum of the Collegiata.

Returning to Filippo Lippi, the first securely dated painting is the *Tarquinia Madonna* [82], which bears a *cartellino,* the earliest in Italian art, with the year 1437 in Roman numerals. Elements apparently derived from contemporary Netherlandish art, including an attentive focus on detail, the closely modulated modeling, and the interior scene itself, are reflected in this picture. Although no paintings by Northern artists can be documented in Italy before about mid-century, smaller easily portable works, including miniatures, must have found their way there. Lippi painted this work after his return from North Italy, where more consistent contacts with French, German, and Netherlandish painting can be assumed.

The figures are substantial, especially the

have been his early training (and I suspect a part in it for the sculptor Jacopo della Quercia), his *Madonna of Humility* [81] is signed and dated 1433 and is one of the earliest truly Masaccesque paintings for which we have a firm date. Like the paintings of Fra Filippo Lippi of apparently the same years, the coherent and rational light of Masaccio is not fully understood, but the massive figures and an interest in robust bodily proportions and in the nude provide a strong link to Masaccio. The motive of the Child sucking his fingers occurs in Masaccio's *Pisa Altarpiece.* In Domenico's art following the *Madonna of Humility,* he becomes progressively removed from Florentine examples, and in the frescoes he painted in the mid-1440s for the Pellegrinaio of the Hospital of Santa Maria della Scala he tends toward caricature and illustration.

81. Domenico di Bartolo. *Madonna of Humility,* 1433. Wood panel, 93 × 59.5 cm. Siena, Pinacoteca.

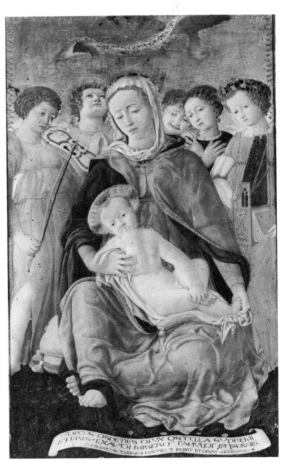

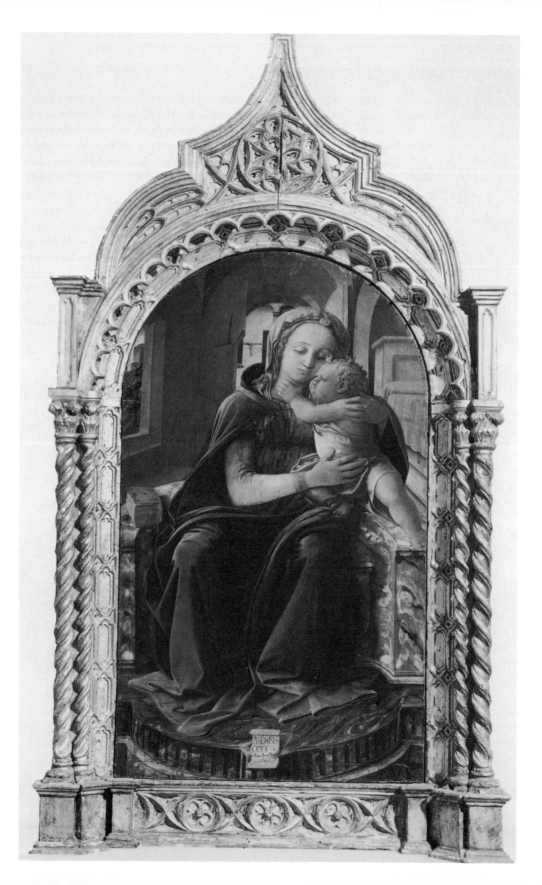

Child, whose large head, thick limbs, and heavy trunk are almost grotesque, as is the Child's inexplicable pose. The Madonna, with her nearly round head, a characteristic type for Lippi, her rigid right arm and squarish, stumpy hands with short fingers, and the ponderous, almost exaggerated draperies continue in his art. The perspective is also somewhat forced, but the sharply foreshortened upper shutter of the window is adventurous. Another effective feature of the painting is the vigorous light and shadow used both for building forms and for illumination within the interior space,

although the source of light is not consistently distributed.

Close in concept, but more successful as an artistic enterprise, is the *Barbadori Altarpiece* for Santo Spirito [83], begun in the same year (1437). The space is fully developed, very much like a well-conceived theatrical stage; the assortment of architectural furniture, related to Donatello, is fanciful and engaging. The Virgin, whose pose is related to carved figures of the standing Madonna, towers over the kneeling saints, Frediano and Agostino, as if she belonged to another set of proportions;

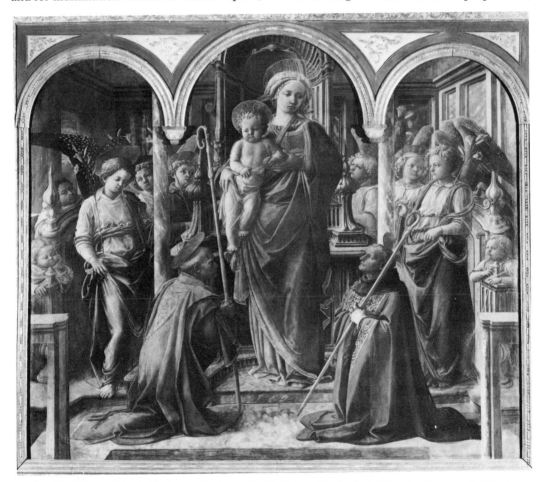

83. Fra Filippo Lippi. *Madonna Enthroned with Saints (Barbadori Altarpiece)*, 1437–38. Wood panel, 217 × 244 cm. Paris, Louvre.

82. Fra Filippo Lippi. *Tarquinia Madonna*, 1437. Wood panel, 114 × 65 cm. Rome, Galleria Nazionale at the Palazzo Barberini.

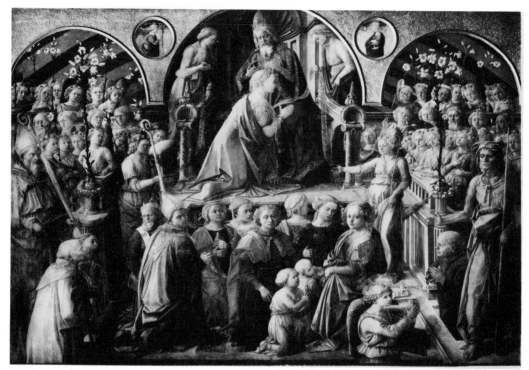

84. Fra Filippo Lippi. *Coronation of the Virgin,* 1441–47. Wood panel, 200 × 287 cm. Florence, Uffizi.

86. Donatello. *Cavalcanti Annunciation,* ca. 1440. Limestone with gilt, 297 × 274 cm. Florence, Santa Croce.

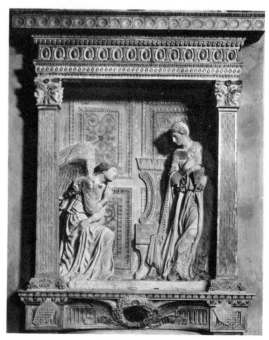

consequently, one is reluctant to call this a *sacra conversazione* in the strict sense, since the rapport between Mary and the side saints is incomplete.

In the *Coronation of the Virgin* [84], begun about 1441 and finished in 1447 for the main altar of Sant'Ambrogio in Florence, the huge figures of Sts. Ambrose and John the Baptist on the extreme left and right frame the somewhat confusing composition. They have little convincing relationship in size with the sacred figures in the central field located beneath the Coronation of Mary. The apparently indiscriminate mixture of sacred figures and contemporaries (including the donors), some in

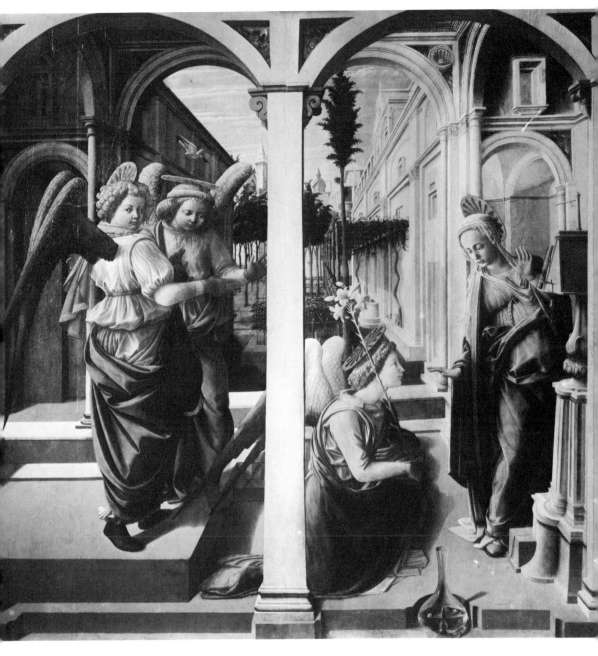

85. Fra Filippo Lippi. *Annunciation*, mid-1440s. Wood panel, 175 × 183 cm. Florence, San Lorenzo.

the guise of saints, further disrupts a rational reading of the scene. Even the artist himself peeks out, half hidden, from the left foreground of this altarpiece, as he does in the Barbadori picture. The Uffizi *Coronation,* despite certain inconsistencies, is a visual treat, the more so since a recent cleaning has unveiled a wealth of vigorous although unnaturalistic color. Here is a beatified world without conflict or blemish; the participants are untroubled, heavenly creatures undisturbed by self-doubts. Lippi's handsome figures, constructed sumptuously and optimistically, are much like their sculptured counterparts by Luca della Robbia, a temperamentally similar artist to whom Filippo Lippi owes a debt.

The *Coronation* exhibits important innovations: the Baptist, gesturing toward the Virgin on the painting's central axis, introduces the spectator to the action. Behind him, still in the foreground, is the donor, while from below an angel enters the scene, a device that will find an echo later, in the art of Andrea Mantegna and in the frescoes of Domenico Ghirlandaio in the Sassetti Chapel of Santa Trinita. Little is left that specifically recalls Masaccio's solutions in these large paintings. Lippi, who falls toward the center of the lyric-monumental continuum, is never fully taken with the structure of his figures: the flesh, bones, and muscles, the forms beneath the draperies; rather, he is intent on rendering surface appearances.

Still above the altar in the Martelli Chapel for which it was made in the Church of San Lorenzo, the *Annunciation* [85] is among the most successful paintings of Lippi's middle period, with a daring balance of figures, architecture, and landscape. The artist is in firm control of the light in this painting, which was not the case for either the *Coronation* or the *Barbadori Altarpiece;* although the light sources are multiple and diffused, the *Annunciation* appears to utilize the natural sources within the church itself, which was designed by

Filippo Brunelleschi. The perspective as well as the light are unifying elements, with the orthogonals meeting in an area slightly to the right of the central axis, at the end of the grape arbor. If the pose of the Virgin owes something to Donatello's *Cavalcanti Annunciation* [86], the well-defined forms are gently modeled in a continuation of a personal style already articulated in the *Tarquinia Madonna.* The *trompe l'oeil* vase with the marvelously delineated lilies, symbols of the Virgin's purity, is a reminder of the Netherlandish component in Lippi's art.

Many critics have presumed an interlude during the late 1440s when Fra Filippo was strongly attracted to the painting of Fra Angelico to such a point that a direct collaboration between the two masters has been postulated for the *Adoration of the Magi* [87], a *tondo* (a picture with a circular shape) rich in detail and incidentals, not consistent with Filippo's secure works. One would be hard pressed to imagine a situation when these two leading Florentine painters, during full maturity and fame, would have collaborated in this way. I would eliminate this beautiful painting from Lippi's oeuvre altogether, leaving it in the limbo of a cooperative effort between Angelico and his workshop of the late 1430s.

By withholding any part whatsoever for Lippi in the *Adoration,* a so-called Angelesque phase becomes less convincingly sustainable and should probably be discarded. Certainly in his late works, best seen in the Prato frescoes when he was at the summit of his powers, Fra Filippo betrays no debt whatsoever to Angelico, rather, reiterating in a monumental idiom his Masaccesque origins.

The frescoes in the choir of the Cathedral in Prato represent a long drawn-out but major effort by the master, and they seem to have been produced slowly and sporadically between 1452 and 1466. The enormous scale of the choir and consequently the painted sub-

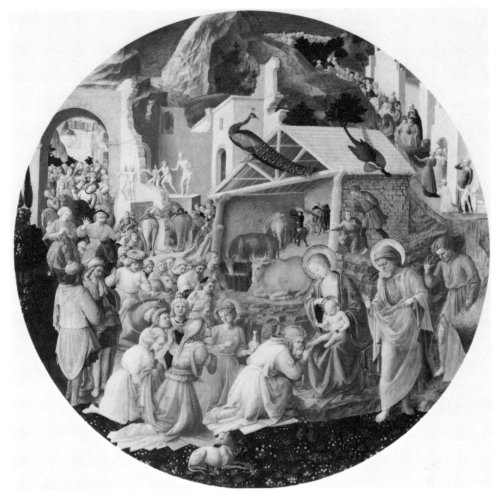

87. Fra Angelico and workshop. *Adoration of the Magi*, ca. 1438. Wood panel, diameter 137.2 cm. Washington, National Gallery.

jects, a far cry from the intimate frescoes of the Brancacci Chapel, must be taken into account for an effective evaluation. The wall space and the vaults are vast, and the distance from the spectator at the pavement level is considerable; a comparison with the Sistine ceiling is even possible [277]. The *Four Evangelists* painted in the vaulting are well over life-size and serve as proof of Filippo's mas-

tery, in which he shows renewed concern for the structure of the figures. The cycle in Prato has been restored recently, revealing powerful yet sensitive images produced with verve and facility during a late period in his development. The *St. Luke* [88], with his hand resting on his chin and his elbow on his raised knee, belongs to a sculptural tradition that can be found in the early *quattrocento* with Nanni di

88. Fra Filippo Lippi. *St. Luke*, ca. 1454. Fresco. Prato, Cathedral.

Banco and Donatello and is carried on in painting to Michelangelo's Sistine Prophets. Because of the great distance, Lippi was forced to put aside a certain amount of petty detail and abandon his sometimes idiosyncratic light for a more single-minded approach, in this his *ultima maniera*.

The Prato frescoes were both an artistic and a physical challenge for the aging painter, and, particularly in the large scenes on either side of the choir with stories of St. John the Baptist and St. Stephen, an ample share of the execu-

tion may be attributed to workshop assistants. In the lowest zone, which is the last part painted according to usual practice, the *Funeral of St. Stephen* [89] is signed and dated 1460. The narrative takes place within the nave of a Renaissance church, vaguely Brunelleschian, with its façade removed. At the side are figures in a landscape spilling over to part of another scene, the *Stoning of St. Stephen*, which begins there. The well-organized perspective leads the eye to the altar and the cross on it, reiterated by its slim shadow on the apse

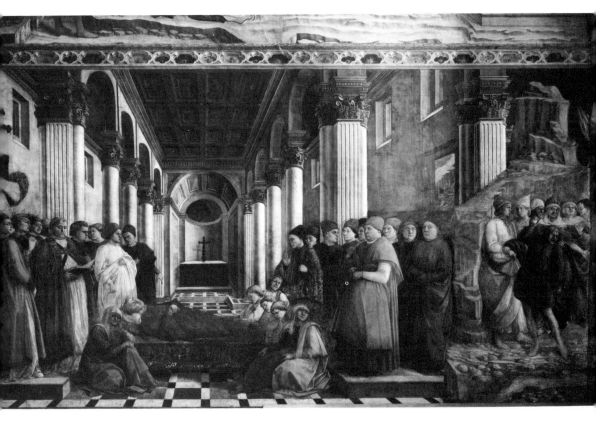

89. Fra Filippo Lippi. *Funeral of St. Stephen*, 1460. Fresco. Prato, Cathedral.

wall. The handsome deacon saint is laid out on a carpeted bier with his hands gently resting on his chest, eyes closed in final sleep, an image that recalls effigy figures by contemporary sculptors, including Bernardo Rossellino and Desiderio da Settignano [90]. The entourage surrounding the deceased is dignified, the reactions of the individual bystanders restrained and unemotional. They are almost certainly portraits of local dignitaries, with the massive Carlo de' Medici given a principal position on the right side. In works such as this, Lippi shows great breadth and vitality.

Few would place Filippo Lippi at the highest level in the pantheon of monumental artists of the Renaissance, which would include Masaccio, Piero della Francesca, Mantegna, Raphael, and Titian. Perhaps he lacked a sufficient commitment to the structure of his figures and the rationality of the architecture he constructed in his paintings. His vision is less engaging to the intellect, nor does it stand up to sustained scrutiny the way Domenico Veneziano's or Piero della Francesco's ab-

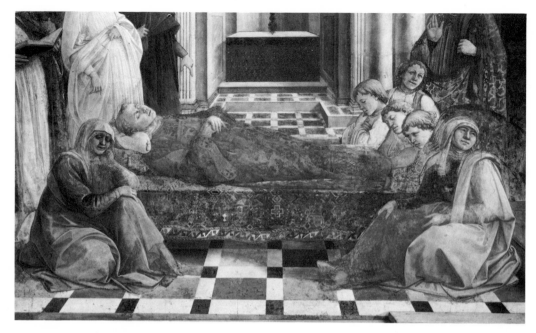

90. Fra Filippo Lippi. Detail of 89.

stractionism does. Filippo Lippi was not dedicated to the study of nature firsthand; instead, he depended largely upon painted and sculptured prototypes, and his figures are often inorganic and unanatomical, rendered without an ultimate conviction for their three-dimensional presence. Nor was Filippo deeply motivated by a desire to imitate antiquity; there are remarkably few paraphrases from ancient sculpture, and when isolated, they appear to have been achieved indirectly, filtered through Donatello or Luca della Robbia. For the most part his painted architecture, the buildings he invented, cannot even vaguely be reconstructed. Like Fra Angelico, Fra Filippo Lippi was taken with landscape, and he was successful in this genre in the backgrounds of many pictures; but his world is predominantly fantasy, accentuated by an unnaturalistic palette. Lippi, however, had moments of the greatest power, like the frescoes in Prato, which stand among the finest and most elequent statements of the age.

DOMENICO VENEZIANO

Domenico di Bartolommeo, known as Domenico Veneziano (ca. 1410–1461), belongs very close to Filippo Lippi chronologically and shares with him a preference for monumental forms. He was either Venetian by birth or by family origin, but nothing whatsoever is known about his training or his development, not even the place or year of his birth. Historically he is first known from a letter he wrote from Perugia, in 1438, to Piero di Cosimo de' Medici, seeking employment in Florence. He compares himself to the best Florentine painters, Fra Angelico and Fra Filippo, implying that he had been in Florence previously and demonstrating that he was acquainted with the art of these two painters. Following a very

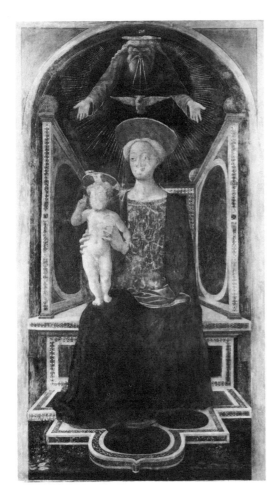

91. Domenico Veneziano. *Carnesecchi Madonna*, ca. 1433. Fresco (transferred), 241 × 120 cm. London, National Gallery.

come down to us, and one of them, the so-called *Carnesecchi Madonna* [91], a fresco from an outdoor tabernacle in Florence, has suffered considerable damage. The other painting, the signed *St. Lucy Altarpiece* (main panel, Uffizi; predella, divided among several public collections) is well preserved [92]. Neither work is datable through documents or inscriptions so that anything approaching a reliable chronology for Domenico is impossible.

What is known about Domenico may be summarized in a few lines: following the letter to Piero de' Medici, but not necessarily as a result of it, Domenico obtained an important commission to fresco the choir of Sant'Egidio in Florence, depicting scenes from the life of the Virgin, a project that was eventually continued by Castagno and Baldovinetti. These paintings have been all but entirely destroyed, leaving no way to obtain an idea of their appearance. The documents from Sant'Egidio inform us that his active participation in the work was stopped in 1445 and that furthermore he was assisted early on by Piero della Francesca, who was living at his house in Florence. Payments to Domenico for *cassoni* have been found, although actual examples have not been convincingly identified. In 1455 Domenico was still in Florence, where he is recorded as renting a house, and in 1457 he served as an arbiter for evaluating an altarpiece partially painted by Pesellino. Domenico died in Florence in 1461.

✛

youthful connection with Gentile da Fabriano, according to some critics, he may even have worked within the shop of Fra Angelico as an independent master at some point in the 1430s. From his art he appears to have had virtually no cultural contact with Venetian art and was probably trained in Umbria under the influence of Sienese masters, including Sassetta. Only two unquestionable works have

Any account of Domenico Veneziano must center around the two secure works, together with a small number of others that are connected with them. Since the *Carnesecchi Madonna* [91] reveals an inflexible, exaggerated perspective and a thin, brittle architecture (in the throne), I believe that it can be dated to the early 1430s, slightly earlier, that is, than Filippo Lippi's *Tarquinia Madonna*. The work

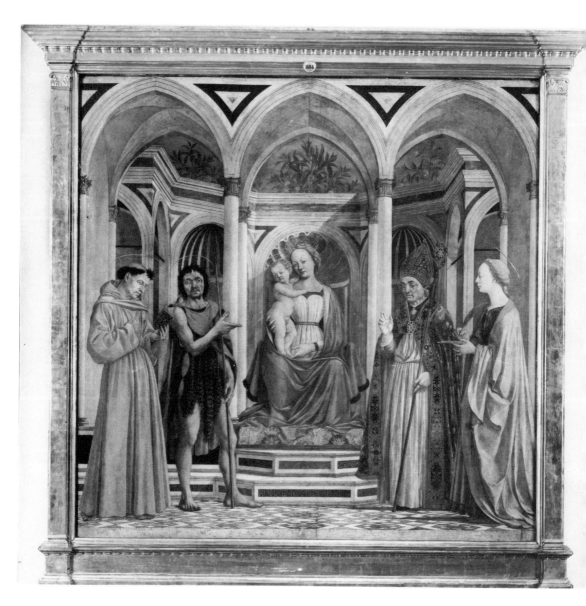

92. Domenico Veneziano. *Madonna and Child with Saints (St. Lucy Altarpiece)*, predella now dispersed, 1440s. Wood panel, 209 × 216 cm. (central scene). Florence, Uffizi.

must fall into the first phase of Domenico's career, following an apprenticeship in some unidentified workshop. Vasari refers to the fresco as an early work, but his account of Domenico's life is not accurate and includes a long episode about how he had been murdered by Andrea del Castagno, who sought from Domenico the secrets of oil painting. The incident Vasari recounts is chronologically impossible because Castagno died four years before Domenico; nor do we have any evidence that Domenico ever used oil paint. The condition of the *Carnesecchi Madonna*, really a Trinity combined with the Madonna enthroned, painted in fresco but transferred to canvas in the nineteenth century, allows for little insightful stylistic analysis. It was signed and so has important documentary value. The conception of space is far less convincing than in the *St. Lucy Altarpiece* and consequently is dated some years earlier. The columnar neck and oval head of the Virgin in the fresco, and the robust, alert Child already locate Domenico within the monumental current, which is confirmed by the *St. Lucy Altarpiece* [92].

That large panel picture with predella scenes, painted for the Florentine church of Santa Lucia dei Magnoli, is one of the finest Renaissance paintings. The central field is nearly a square, producing a geometric strength further developed within the design of the architecture. The monumental Virgin and Child are descendants of Masaccio's figures from the *Pisa Altarpiece* [69]. The picture is usually dated around 1445 but was probably painted over a period of several years and perhaps much longer, for Domenico seems to have worked very slowly, judging from the time he needed to paint the frescoes in Sant'-Egidio (he actually left the work unfinished) and the paucity of other works attributable to him. The pale, blond tonalities, strongly imbued with direct yet filtered light, dominate the field of vision, which has an outdoor light recalling, if anything, Fra Angelico's *Deposition* [25]; the understated modeling of the heads has points in common with Sassetta.

Each of the figures is framed by an arch or segment of an arch in the loggia behind; the Virgin, as expected, is given the most elaborate space. The saints, on either side, are paired by framing arches in the middle ground, with Mary isolated by the raised platform in a zone set slightly deeper in space. The picture belongs to the category of *sacra conversazione*, a convention that has a fuller elaboration later in the fifteenth century and especially in the sixteenth. Domenico has worked out every detail, each element, both artistically and thematically; nothing has been left to accident or whim. Quite unlike Fra Filippo's altarpieces of about the same time, crowded with figures and incidentals, the *St. Lucy* picture is spare, the relationships between one segment and other measured. In Domenico's picture the arches of the middle ground are slightly pointed in the loggia where the saints stand, but rounded in the zone of Mary and the Christ Child to set them apart.

The figures emphatically affirm the monumental qualities of the painter's style. St. John the Baptist is extremely muscular, with powerful limbs and thick extremities; he looks out of the painted space at the spectator, who is, in turn, drawn by John's gesture toward the enthroned Madonna. Mary and the Child turn back toward John, who is presented in full face. The other saints demonstrate different possibilities, proving Domenico's insistence on variety. Lucy is shown in sharp and magnificent profile on the extreme right, while Zenobius turns easily in three-quarter view, balancing John in importance, for both are patron saints of Florence. Finally, Francis is in nearly complete profile. Shadow is used rather sparingly in building up forms within limited

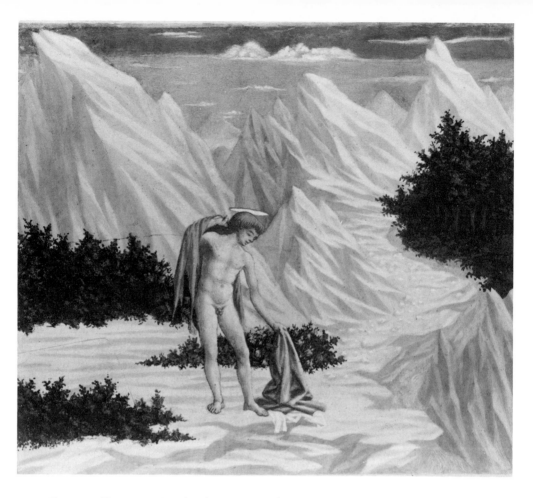

94. Domenico Veneziano. *St. John the Baptist in the Desert* (predella panel, *St. Lucy Altarpiece*), 1440s. Wood panel, 28 × 32 cm. Washington, National Gallery (Kress Collection).

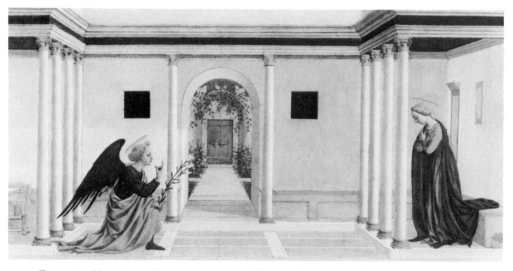

95. Domenico Veneziano. *Annunciation* (predella panel, *St. Lucy Altarpiece*), ca. 1445. Wood panel, 27.3 × 54 cm. Cambridge, England, Fitzwilliam Museum.

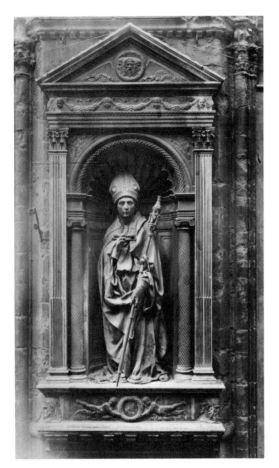

93. Donatello. *St. Louis of Toulouse*, ca. 1422–25. Gilt bronze. Florence, Museum of Santa Croce.

of the figures fall. Most important, these figures stand gracefully but unequivocally, often in easy *contrapposto*, like the Baptist or the chunky, naked Child.

The predella scenes include a *St. John the Baptist in the Desert* [94] and an *Annunciation* [95] and other panels treating incidents in the life of each of the saints. Unlike the placement of the vanishing point on the central axis in the main field of the altarpiece, in the *Annunciation* Domenico located it significantly to the left, mitigating the thrust into space that might otherwise draw attention away from Gabriel and Mary. The iconographic and visual elements are judiciously integrated: the foreshortened, closed, and heavily bolted garden, a reference to Mary's virginity, and the actual Annunciation itself in the foreground. The architecture is in the new Renaissance style of Brunelleschi and Michelozzo. Both figures are in rigorous profile, unlike Fra Angelico's practice for the same subject. Domenico has paid particular attention to the abstract geometry of the composition, but his approach in this direction is more intuitive than the parallel one in Piero della Francesca's art. Light continues to play a crucial role in the *Annunciation,* entering from the right, as in all of the predella scenes and in the main panel, an indication that it was integrated with the natural light source in the church.

A small number of *cassone* panels, portraits, and Madonnas have been associated with Domenico with greater or lesser conviction, in addition to the controversial *tondo* of the *Adoration of the Magi* [96], which does not easily fit into any chronology that one might devise for Domenico and which, in my opinion, is not by him. A fresco showing Sts. John the Baptist and Francis in Santa Croce is his and dates to a period after the *St. Lucy Altarpiece.* The marvelous *Madonna and Child* in the Berenson Collection [97] is also surely his work and

areas. Three-dimensional conviction is established by means of the close range of tones from lights to medium darks. Veneziano also emphasized forms by outlining the main elements. The figures have a strong presence, revealing a vital connection with contemporary sculpture, probably the most obvious being the relationship between St. Zenobius and Donatello's *St. Louis of Toulouse* [93] of twenty years earlier. A low horizon produces the rapid foreshortening of the highly complex inlaid floor, upon which the thin shadows

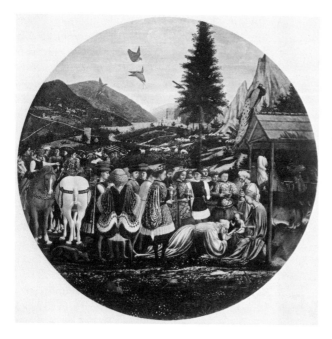

96. Attributed to Domenico Veneziano. *Adoration of the Magi*, ca. 1455. Wood panel, diameter 84 cm. Berlin-Dahlem, Staatliche Museen.

is closely related to the *St. Lucy Altarpiece* and perhaps dates to about 1440. The oval shape of the Virgin's head, the powerful neck, the alert Child, combined with an attraction to patterned although unfussy decoration that forms the curtain behind, make it an appealing example of Domenico's personal style, which has an important echo in the art of Piero della Francesca.

PIERO DELLA FRANCESCA

The most outspoken master of the monumental current following the death of Masaccio was Piero della Francesca (or Piero di Benedetto Franceschi, ca. 1420/22–1492). Piero first appears in documents only in 1439, as we have seen, in Florence with Domenico Veneziano, assisting him on the frescoes in the choir of Sant'Egidio. He received his first recorded commission in 1445 in his native Umbrian town of Borgo San Sepolcro, which only a few years earlier had been placed under Florentine control. The *Altarpiece of the Misericordia* [98] was to have been finished in three years, but ten years later, in 1455, Piero still had not quite completed it; he was obliged by a new contract to do so by Lent of that year. Most of the work on the *Misericordia* picture must already have been completed before 1450. Around the same time (ca. 1450), Piero painted frescoes in Ferrara, which have not survived but seem to have been crucial for the emergence of a new painting style in Ferrara. Also at mid-century he signed and dated a painting of *St. Jerome* (Berlin-Dahlem, Staatliche Museen), which, while it is an autograph work, is rather uninformative for his development.

After this time, however, a better grasp of Piero's whereabouts may be ascertained. A fresco showing St. Sigismond and Sigismondo Pandolfo Malatesta, ruler of Rimini, is signed and dated 1451 [99]. In 1452 Bicci di Lorenzo, a long-active Florentine painter, died, leaving

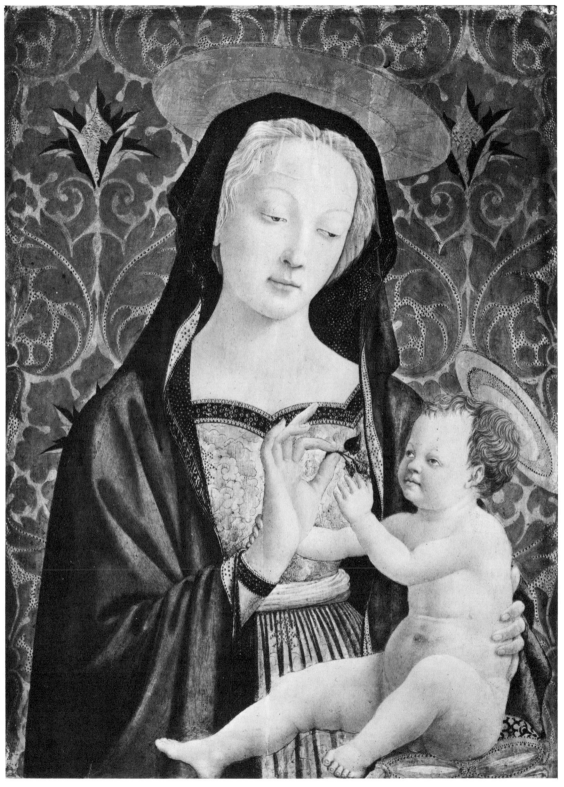

97. Domenico Veneziano. *Madonna and Child*, ca. 1440. Wood panel, 86 × 61.5 cm. Settignano, Villa I Tatti.

a fresco cycle for the choir of San Francesco in Arezzo scarcely begun. Piero took over the commission at an unknown time, but presumably soon after Bicci's death. Toward the end of 1454 he obtained another important and well-paid commission, a polyptych for Sant'-Agostino in Borgo San Sepolcro. Piero is known to have worked in Rome for Pope Pius II in 1459 (and probably the year before), but nothing survives. The frescoes in Arezzo are mentioned as finished by 1466, but that is merely an extreme *terminus ante quem;* they were probably completed sometime earlier and in any case represent the artist at the height of his powers at mid-career. He was brought to Urbino in 1469 for the purpose of supplying a painting for the Confraternity of Corpus Domini, for which Uccello had already made the predella, but Piero apparently refused the assignment, which was passed on to the Fleming Justus van Ghent. During most of his later life Piero is regularly recorded in Borgo San Sepolcro, although he retained a connection with the court of Urbino.

.¦..

Unlike Masaccio, who died very young, or Domenico Veneziano, who apparently worked slowly and in any case for whom few works survive, Piero has left abundant examples of his art, covering a variety of subjects in several media, as well as books on perspective and mathematics that contributed to his fame. He was also reputed to have been an architect. Also from Borgo, Luca Pacioli, a mathematician and scientist who was a collaborator with Leonardo da Vinci, called Piero the "monarch of painting" in his time. After a curious decline in the estimation of his art from the sixteenth through the later nineteenth century, Piero's reputation and the appreciation of his art have undergone an explosive rise in popularity, making him today one of the most admired painters of the Renaissance.

Piero seems to have been Domenico Veneziano's pupil at some stage, and both of them participated in aspects of Fra Angelico's art of the mid-1430s. The possibility that one or another of them was employed in Angelico's shop for a short period cannot be dismissed. Piero worked for church dignitaries, lay religious confraternities in Arezzo and in Borgo, and influential patrons in Ferrara, Urbino, and Rimini. The *Altarpiece of the Misericordia,* with its many parts, has been reconstructed and offers a view of the artist at the beginning of his known career. The central scene, the *Madonna della Misericordia* [98], which can be dated to the later 1440s, is conventionally treated by showing Mary with her mantle protecting the members of the confraternity kneeling around her. On a much smaller scale, they are arranged in a circular formation like an enormous base for the columnar Mary; they are in two groups of four men and four women of different ages. The low point of sight, which recalls Domenico Veneziano, allows for a tightly knit grouping of figures close to the picture plane. Light has a crucial function in Piero's work as it does in the painting of Fra Angelico and the Sienese artist Sassetta, whose *San Francesco Altarpiece* was delivered to Borgo San Sepolcro just one year before the *Misericordia* commission. The light, which is, to be sure, unatmospheric, explains the figures and even rivals them. Piero succeeds in treating the gilded background not as a flat reflective surface but as a light-generating and light-participating plane, fully coordinated with the pictorial elements of the subject.

The *St. Sigismond and Sigismondo Pandolfo Malatesta* [99] of 1451, in the Tempio Malatestiano in Rimini, remodeled by Alberti, has suffered considerable loss of surface and consequently does not permit deeper insights into Piero's stylistic evolution beyond demonstrating his familiarity with a progressive architectural vocabulary. Piero's early figural

98. Piero della Francesca. *Madonna del Misericordia (Altarpiece of the Misericordia* mostly late 1440s. Wood panel, 134 × 91 cr Borgo San Sepolcro, Pinacoteca Communal

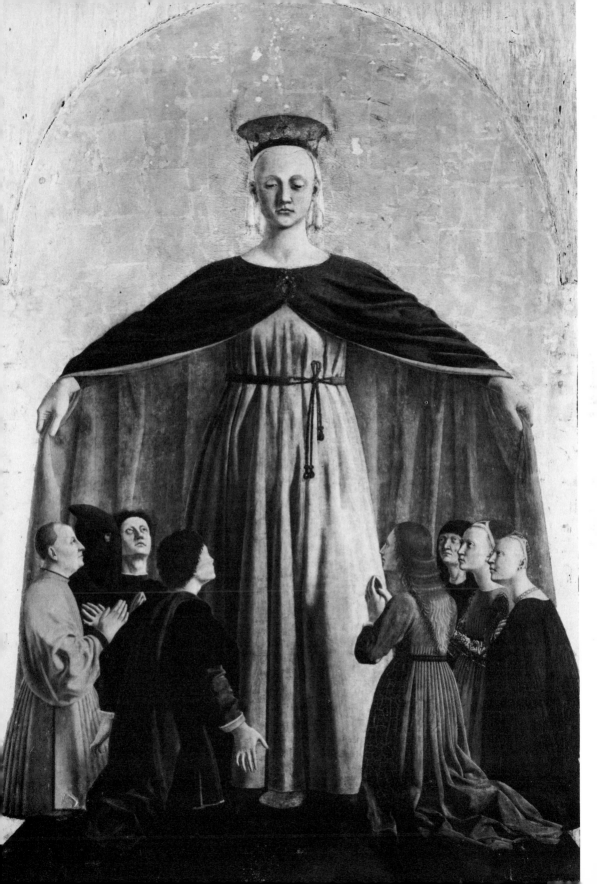

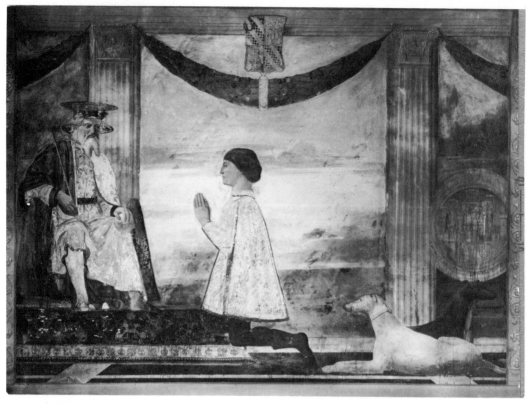

99. Piero della Francesca. *St. Sigismond and Sigismondo Pandolfo Malatesta*, 1451. Fresco, 257 × 345 cm. Rimini, Tempio Malatestiano.

style is better studied in the *Baptism of Christ* [100], undated but apparently about contemporary with the Riminese fresco. Christ stands architectonically, like the Mary of the *Misericordia* picture or, for that matter, like the tree nearby. His nearly nude body is modeled unfussily with broad, somewhat schematic shadows on the left side, as if designed with the experience of intarsia in mind. The anatomy within the silhouetted contours is generalized and barely delineated. The insistent imposition of the painter's iron will over nature, one that seeks out formalistic, abstract, and design qualities organized into a harmony that is an unnatural perfection, becomes the dominant attribute of Piero's ecological balance between figure and landscape. He transforms

the white Holy Dove that hovers above the erect Christ into a spreading horizontal, like the clouds, countering the measured, insistent verticals of the figures and trees. The horizontal and vertical confrontation is finally resolved by the semicircularity of the frame at the top, filled with leaves. The picture's demanding centrality is offset by the more casually placed angels on the left, who are in the same spatial plane with Christ and St. John the Baptist. There is no slavish paraphrasing of antique sources in Piero's uncompromising approach, although the drapery on the middle angel does have a relation to classical sculpture, whereas the facial types recall Luca della Robbia.

If Masaccio's masterpiece is the Brancacci

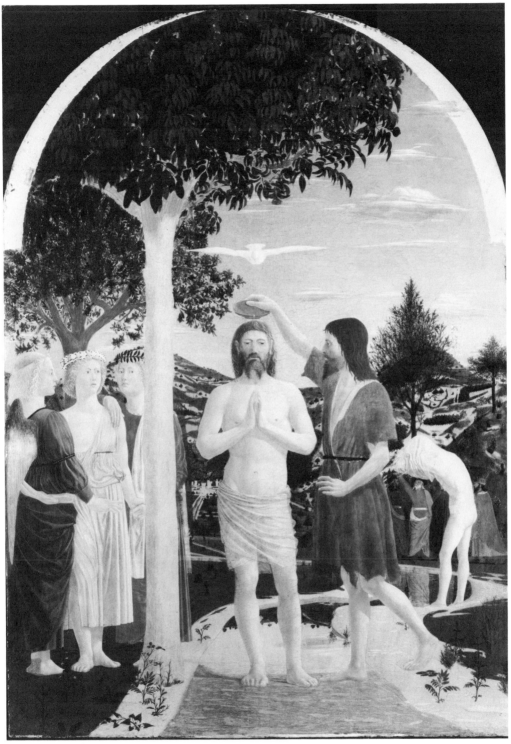

100. Piero della Francesca. *Baptism of Christ,* ca. 1451. Wood panel, 167 × 116 cm. London, National Gallery.

101. View of the choir, San Francesco, Arezzo.

102. Arezzo, San Francesco, Choir. Plan of the frescoes by Piero della Francesca
A. *Death of Adam* [104]
B. *Adoration of the Wood by the Queen of Sheba and the Meeting of the Queen of Sheba and Solomon* [105]
C. *Burial of the Wood* [103]
D. *Annunciation* [106]
E. *Dream of Constantine*
F. *Constantine's Victory over Maxentius*
G. *Torture of the Jew*
H. *Helena's Discovery and Proof of the Cross*
I. *Victory of Heraclius over Chosroes*
J. *Heraclius Restores the Cross to Jerusalem*
K. Unidentified Prophet
L. Unidentified Prophet

Chapel frescoes, Filippo Lippi's the choir of the Prato Cathedral, and Domenico Veneziano's the *St. Lucy Altarpiece,* Piero's is unquestionably the fresco cycle of the *Story of the True Cross* for the choir of San Francesco in Arezzo [101, 102], probably painted during the 1450s and more likely from 1452 to 1458, falling, that is, into the middle phase of Piero's career.

The Gothic vaults of the choir and a small amount of other decoration had already been done by Bicci di Lorenzo by 1452. Piero must have been presented with the program, at least in broad outline, including what scenes were being planned. In recent studies the meaning of the cycle has been associated with liturgical considerations, on the one hand, and with the local presence of sacred relics, on the other. Broadly speaking, the events depicted derive from Jacopo di Voragine's *Golden Legend,* where the accounts of the story of the True Cross are given in several places, and which had already given rise to earlier painted cycles, including those by Agnolo Gaddi and Masolino. There are parallels between one side of Piero's chapel and the other, and a rela-

103. Piero della Francesca. *Burial of the Wood*, mid-1450s. Fresco, 356 × 190 cm. Arezzo, San Francesco.

tionship between the Old Testament and post-Christian events depicted in a Christological context: for example, the *Burial of the Wood* [103] refers to Christ carrying the Cross, at least pictorially. The two lunette scenes take place within a landscape; the scenes from the middle register have more processional emphasis and occur also within a landscape together with buildings. In the bottom zone are battle scenes. Piero stresses a horizontal read-

ing, with robust cornices between each zone. Several events are included in each compartment, a usage that had become common in the *quattrocento*, especially following Ghiberti's panels for the *Gates of Paradise*, but also found in Masaccio's *Tribute Money*, as has been noted.

The narrative begins in the upper right lunette with the *Death of Adam* [104], where three different events unfold from right to left. Most of the figures on the front plane are close to the picture's surface, similar to Mantegna's Eremitani Chapel frescoes of about the same date. Adam, near death, is shown with the ancient Eve supporting his head. He asks his son Seth, who is also quite old, to obtain the promised oil of the tree of mercy from the angel at the gates of Paradise. This event, with Seth and the angel, is shown in the distance behind the nude whose back is toward the spectator. The death of Adam is illustrated on the left side of the fresco and has many features in common with representations of the lamentation over the dead Christ, who was considered as the second Adam. Seth appears for the third time (like St. Peter in Masaccio's *Tribute Money*) beside Adam, who is placed obliquely in daring foreshortening; instead of the oil, a sprig, given by the angel, is put into Adam's mouth before burial. From it eventually grows the mighty tree (now much obliterated) that fills the center of the painting. This tree will yield the wood of the True Cross, the protagonist of the cycle. The clouds in the sky are perspectively arranged to increase the spatial movement toward the low horizon in the distance.

Despite losses and damage to the fresco's surface, the *Adam* remains a powerful narrative. The variety of poses and gestures, the range of forms from nude youths to aged men and women, and the vigorous movements juxtaposed with the reclining figures constantly engage the viewer. Piero is interested in the

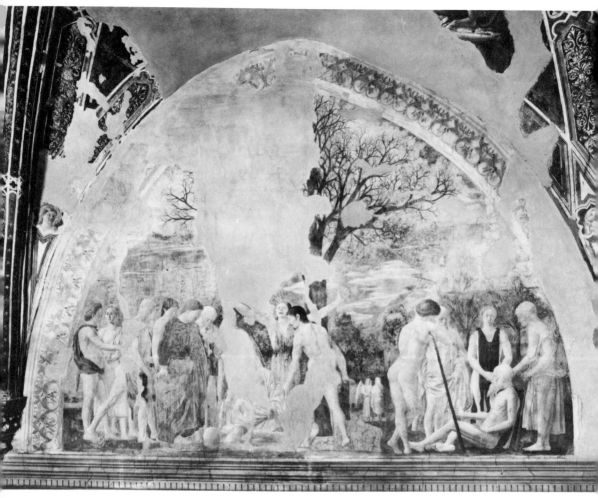

104. Piero della Francesca. *Death of Adam,* mid-1450s. Fresco, 390 × 747 cm. Arezzo, San Francesco.

human body and its potential for physical expression; his actors, silent and independent, are psychologically unrelated to one another: their interconnections are formal and iconographic. Classical borrowings are infrequent, and when isolated are more generic types than specific sources. No trip to Rome need be projected for the formal solutions in the Arezzo frescoes, as is sometimes claimed, since ancient examples were abundant in Tuscany and Umbria. An awareness of Greek vase painting and of Etruscan art is likely, as seen, for example, in the man striding toward the dead Adam on the extreme left. The color is dominated by magical, pale flesh tones accentuated by the bright reds and blues of the scanty garments, making the action readable from the distant floor below. Pure profile and full frontal figures are often set beside one another: the old Adam and Eve on the right, with the young woman, perhaps a grandchild, behind them looking out blatantly at the viewer. But Piero varies his formula: the relaxed nude man with his legs crossed leaning on a staff and the bearded Seth are less insistently located in relation to the picture plane.

Piero, like figural artists of every period, reused his own inventions time and again. The lively and engaging woman at the left, who looks intently at the man next to her, is identical to the middle angel of the London *Baptism,* only she is turned in the other direction. Piero created a group of figure types, frequently repeated, that has led iconographers astray when trying to identify given figures as recognizable portraits. In the scene immediately below the Adam and chronologically close in date of execution, the *Adoration of the Wood by the Queen of Sheba and the Meeting of the Queen of Sheba and Solomon* [105], a more consistent re-use of figures and heads is readily discernible. The two attendants of the queen in the center left come from the same

cartoon which, in turn, is merely reversed and slightly modified to obtain the two women on the right, standing once more behind their queen at the encounter. The woman who looks straight out is identical with the one on the opposite side of the composition, and the profile head of the Queen of Sheba comes from the same model, reversed. Piero used the technique of transfer called *polverello* to reproduce his cartoons onto the wall, that is, the outlines of the figures were pricked with a pin and a dark powder was dusted through the holes onto the plaster wall. The resulting dots on the wall were then connected to re-create the original contours of the drawing, which could quite easily be reversed or repeated whenever desired.

If little workshop participation is recognizable in the *Adam* lunette fresco, a somewhat greater share by assistants appears in the *Queen of Sheba,* including, for example, the horses and their attendants on the extreme left as well as the subordinate groups on both ends of the composition. On the other hand, the work as a whole is so clearly Piero's in conception and expression that shop intervention is an insignificant component for the final result.

As the story unfolds, the wood of the tree that had grown out of Adam's mouth has been cut down and used as a bridge. The Queen of Sheba, a prefiguration of Mary and of the New Covenant, journeys to Jerusalem and on the way adores the wood (typologically close to the theme of Mary Adoring the Child) that will become the Cross of Christ's Crucifixion, as is shown on the left. Within a majestic loggia, backed by enormous slabs of colored marble, Solomon and the queen clasp hands, joining symbolically, as it were, the Old and the New Law, the Law of Moses and the Law of Christ. In this picture Piero della Francesca has created an ideal type, especially in his women, with long, thick necks, oval faces, strong chins,

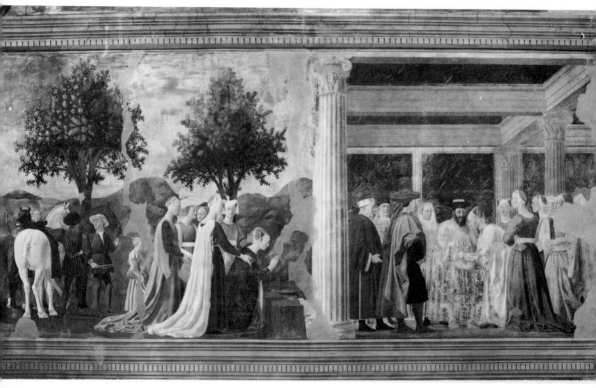

105. Piero della Francesca. *Adoration of the Wood by the Queen of Sheba and the Meeting of the Queen of Sheba and Solomon,* mid-1450s. Fresco, 336 × 747 cm. Arezzo, San Francesco.

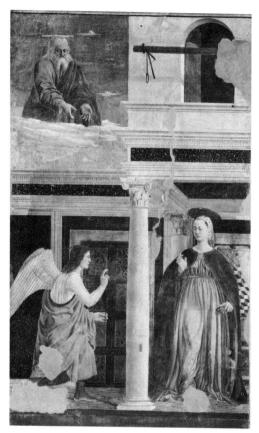

106. Piero della Francesca. *Annunciation*, mid-1450s. Fresco, 329 × 193 cm. Arezzo, San Francesco.

full mouths, prominent noses, large ears, long, narrow eyes, and straight foreheads. The coloring of the flesh is subdued, the modeling understated; movement is potential not actual, and there is a prevailing absence of expression.

In the subsequent scenes of the *True Cross* cycle there is a leap in time to after the Crucifixion, when the wood had been lost only to be found again by St. Helena centuries later, when it produced miracles. Only the *Annunciation* on the altar wall [106], somewhat in-

congruously placed together with three scenes from the legend, is overtly taken from the New Testament. All the scenes on the apse wall are located uneasily next to those on the side walls without any architectural framing. The Crucifixion, obviously the climax in the history of the wood of the Cross, is not illustrated in the painted cycle at all, although it does appear, of necessity, on the actual altar and is implied throughout the cycle by the appearance of crosses, wood, and cruciform compositions.

The portraits of *Federigo da Montefeltro*, duke of Urbino, and his wife, *Battista Sforza*, were made as a diptych in the Netherlandish manner [107, 108]. On the reverse are *Triumphs* [109, 110], whose landscape backgrounds are nearly continuous, but in their present nineteenth-century Neoclassical frames they have been separated. The paintings may date from as late as 1474, since the inscription on the back of Federigo's portrait says he is equal to the most elevated duke, a title he obtained only in that year. In this case Battista's is a posthumous portrait (she died in 1472) based on either a death mask or an existing painted portrait. Many critics believe the portrait pair belong to the middle or late 1460s, in which case the inscription would have been added later or at least changed; in any event it is nearly always difficult to date Piero's paintings since his style does not change radically from one decade to another. Stylistically the paintings reaffirm Piero's unmistakable seriousness and the finality of his interpretations. The handling of the landscape on both sides witnesses a new commitment on his part to greater atmospheric qualities in which light, air, and mist work almost with an Impressionist's awareness; touches of bright color pick up and suggest the forms he wishes to include [frontispiece]. In the distance the low mountains of Umbria, seen from a bird's-eye view, recede into infinity, becoming in-

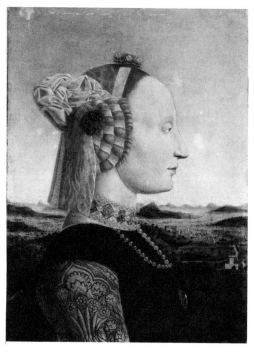

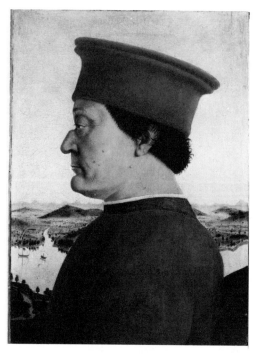

107. Piero della Francesca. *Battista Sforza*, ca. 1470. Wood panel, 47 × 33 cm. Florence, Uffizi.

108. Piero della Francesca. *Federigo da Montefeltro*, ca. 1470. Wood panel, 47 × 33 cm. Florence, Uffizi.

creasingly less distinct and less colorful in a system that would later be advocated by Leonardo da Vinci.

With the portraits of *Federigo da Montefeltro* and *Battista Sforza* Piero announces a late phase when his art moved in the direction of a softer, more diffused surface and to a more mysterious, freer modeling that echoes a gradual shift already noticeable in the *Triumphs.* The unmistakable profile of the duke, with its broken nose, is found again, this time when he is depicted kneeling as a donor in the so-called *Brera Altarpiece* [111]. Datable to 1472–74, this *sacra conversazione* may have been painted for the Church of San Bernardino in Urbino. Besides Federigo, a famous condottiere shown in full armor, although the helmet and the arm

pieces have been removed in reverence to the Virgin and Child, six saints are arranged around the enthroned pair, with four angels on a step behind. There are various elements in this altarpiece of special merit, including the egg painted with cool precision hanging from the inverted conch shell, usually identified as an ostrich egg, which is a reference to the virgin birth. The Christ Child is fully nude and asleep on Mary's lap, a symptomatic prediction of His derision and death. The noble architectural setting of this extraordinary painting, which is neither signed nor dated, includes a monumental arch with a barrel vault containing rosettes. We seem to be in the crossing of an *all'antica* Renaissance church, rich in colored marble and fine classical deco-

ration. The figures stand as firmly and as solidly as columns, and in spirit are aloof and self-absorbed.

The *Nativity* (really an Adoration of the Child) was found among Piero's belongings at his death; the nearly square picture is either unfinished or has undergone considerable loss through overcleaning [112]. The subject, visualized as a narrative, is taken from Northern art, but it had long since entered Italy. Piero locates the action in a landscape, and the figures are set well into the fictive space, unlike the characteristic frieze-like arrangements near the picture surface of the Arezzo frescoes. Light is once again a determining element, but now shadow functions with greater expressive power, and the light-to-dark range has been noticeably expanded; the head of the Virgin, delineated by a few strokes

of dark tones and by a deep shadow under her chin, is in full sunlight. The same interplay occurs in the singing angels, among the most unforgettable pictorial inventions of the Renaissance. There is also an emotional factor, an intensity in the expression of the angels, that is new in Piero's art. The interplay of light and dark is also found in the masonry shed, where the side wall on the left is brightly lit from the upper front left, and light strikes part of the inside wall; next to it is the corner in deep shadow. The landscape on the left is noteworthy, as the path rises easily, then descends sharply, only to be followed once more in its meandering course in the deep distance. The figures, slightly more elongated than we have been accustomed to in Piero's art, have smaller, less geometrically insistent heads, but they are still silently aloof. Piero never aban-

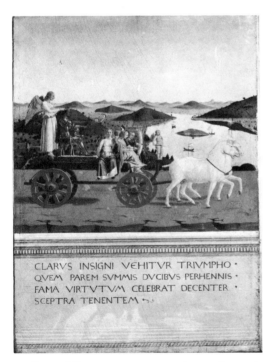

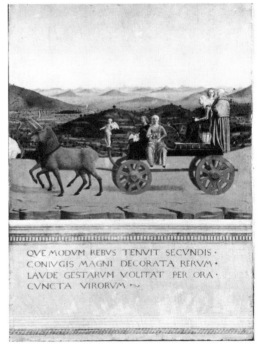

109. Piero della Francesca, *Triumph of Federigo da Montefeltro* (reverse of 108).

110. Piero della Francesca. *Triumph of Battista Sforza* (reverse of 107).

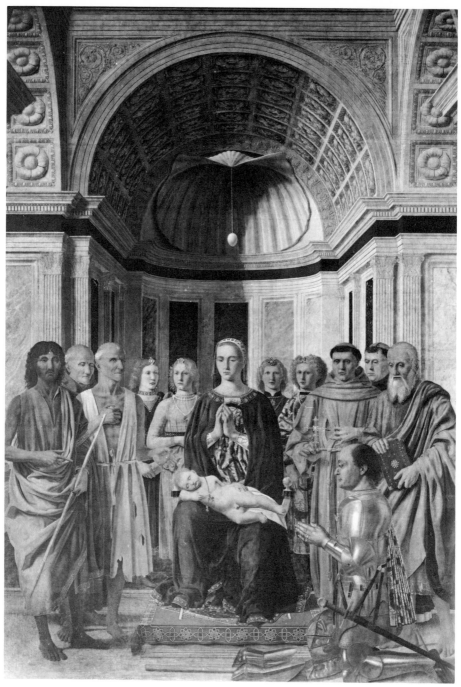

111. Piero della Francesca. *Madonna and Child with Saints, Angels, and Duke Federigo da Montefeltro (Brera Altarpiece)*, 1472–74. Wood panel, 248 × 170 cm. Milan, Brera.

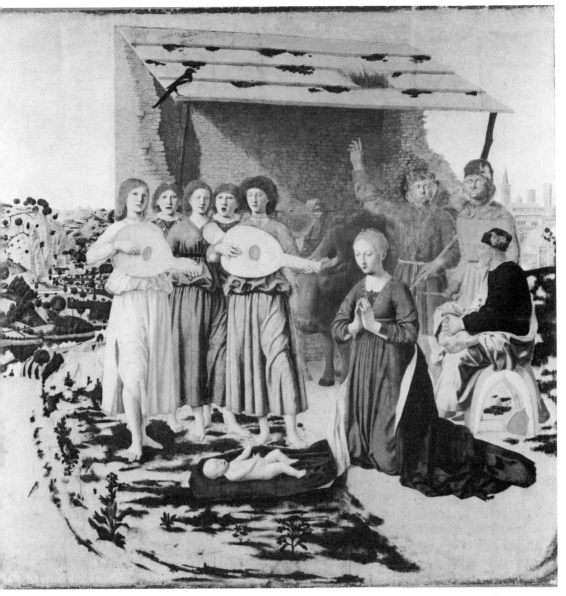

112. Piero della Francesca. *Nativity,* ca. 1480. Wood panel, 124.5 × 123 cm. London, National Gallery.

dons a volumetric approach to form, even in this, one of his last works before blindness set in. Painted in oil (as are the Uffizi portraits), the *Nativity* is an example of Piero's gradual shift in medium away from tempera; actually, in this instance, we are very likely dealing with a combination of oil and tempera. Oil did open up new possibilities to Piero even late in his career.

Piero lived longer than most members of the first generation and witnessed changes in the course of painting, with the emergence of the new generation in the sixties and seventies (and even earlier with the precocious Mantegna), on whom his own contributions had a significant impact. Besides leaving his mark on the Ferrarese painters, there must have been an interchange with Antonello da Messina. Piero was the teacher of Luca Signorelli, and he had at least an indirect influence on Leonardo, both for his painting and his thought. Raphael grew up in the court of Urbino and must have known well Piero's pictures there.

ANDREA DEL CASTAGNO

Placing Andrea di Bartolo (ca. 1419–1457), usually called Andrea del Castagno or merely Castagno, within the first generation and Mantegna in the second may appear arbitrary, especially since their works overlap in the 1450s and since they share stylistic preferences. But Mantegna was then very young and at the start of his long career, whereas Castagno was at the end of his. Born in a mountainous region on the northeastern border of Tuscany and the Romagna, Castagno was presumably trained in Florence, perhaps by Domenico Veneziano. He was nicknamed Andreino degli Impiccati (little Andrea of the Hanged Men) because, according to a legend reported by Vasari, after the Battle of Anghiari, which took place in 1440, he painted effigies of the enemy leaders (long-since lost) on

113. Andrea del Castagno. Vault of the San Tarasio Chapel, San Zaccaria, Venice, 1442. Fresco, h. of figures 176 cm.

commission from the victorious Florentine government. Frescoes in the old choir of San Zaccaria in Venice [113], dated 1442 with an inscription that "Andrea da Florentia" (and another painter) had made them, are an example of the constant interchange between the various regions of Italy, and they also represent his earliest identified painting.

Andrea had gone off to make his career abroad before being fully accepted at home, much as had Uccello and Filippo Lippi. In 1444 Andrea is documented in Florence, where he matriculated in the painters' guild. In the same year he designed a stained-glass window of the *Pietà* for the Cathedral, along with similar projects by Ghiberti, Donatello, and Paolo Uccello. In the following year Castagno painted a posthumous portrait (lost) of the humanist and long-time chancellor of Florence Leonardo Bruni for the Giudici e Notai, the guild of judges and notaries. He was commissioned to paint an altarpiece for San Miniato fra le Torri (now in Berlin-Dahlem, Staatliche Museen) in 1449, which was finished in the following year. For several months in 1454, Castagno was known to have been painting in the Vatican Library, Rome. The famous

fresco of *Niccolò da Tolentino* [119], a companion to Uccello's *Hawkwood*, was commissioned from Castagno in 1455 and finished in the following year. Still in his mid-thirties, he frescoed a *Last Supper* (lost), perhaps similar to the undocumented one in Sant'Apollonia, for the Hospital of Santa Maria Nuova in the year of his death, 1457.

·:·

The vault of the original choir (now transformed into the chapel) of San Zaccaria, Venice, was painted when Castagno was about twenty-one, in 1442 [113]. The frescoes are painted on narrow, sharply curved compartments between the ribs and consequently are particularly hard to photograph effectively. The style reflects a careful study by the young painter of Donatello's sculpture—especially the *Zuccone* and *Jeremiah*—with its broad treatment of sturdy figures with puffy draperies, its intensity of expression, and even such secondary details as *putti*. Features from Uccello may also be detected, but the most important pictorial force acting upon Castagno seems to have been the example of Domenico Veneziano, whose participation in the same fresco program has been suggested. Back in Florence, Castagno may have assisted Domenico in the frescoes for Sant'Egidio alongside Piero della Francesca, his exact contemporary. The notion of having three such powerful painters working side by side is speculative especially since the frescoes no longer exist, but paintings by Castagno reflect a knowledge of the styles of both Domenico Veneziano and, to a lesser extent, Piero della Francesca. Nor should such a situation preclude some exchange in the other direction, that is, from Castagno to Domenico and Piero, given the forceful expressionism of Andrea's art and the power of his inventions.

Important changes of style are difficult to isolate among Castagno's more firmly attributable works; his career, after all, was short and only a small number of panel pictures can be associated with him. What is left are mostly frescoes, often in poor condition, as are those in Venice, while many others have been moved, at which time they suffered some losses. Three projects should suffice to delineate the essential features of his art. The first, a group of works made for the Monastery of Sant'Apollonia, a female order of Benedictines, appear to have been painted between 1447 and 1449: scenes from the Passion of Christ surmount a *Last Supper* for the refectory, which has now been transformed into a museum dedicated to Castagno's art [114]. The upper zone, divided by two large windows and now removed from the wall to expose the *sinopie*, is no longer clearly readable due to water damage from a leaky roof. The three episodes, the *Crucifixion* in the center, with the *Resurrection* on the left and the *Deposition* on the right, are arranged within a unified panoramic composition. A fine landscape, the six massive angels, the arms of the Cross, and the outline of the horizon against the sky form a powerful horizontal that harmonizes these scenes with the *Last Supper*.

The treatment of the human figure places Castagno in the forefront of monumental painters of the period, and he has often been described as a continuation of the spirit if not of the actual style of Masaccio, although he is more brutal, as is demonstrated by the *sinopie* for these and other frescoes [116]. Castagno, whose forms are established with extreme economy, seems to have worked fast and efficiently (unlike Domenico Veneziano), knowing exactly what he wished to accomplish at a given moment, and was prepared to change from the original plan even radically, as we learn from other works.

The *Last Supper* [115], placed rather low on the wall, is better preserved than the Passion scenes. Located between fictive brick walls

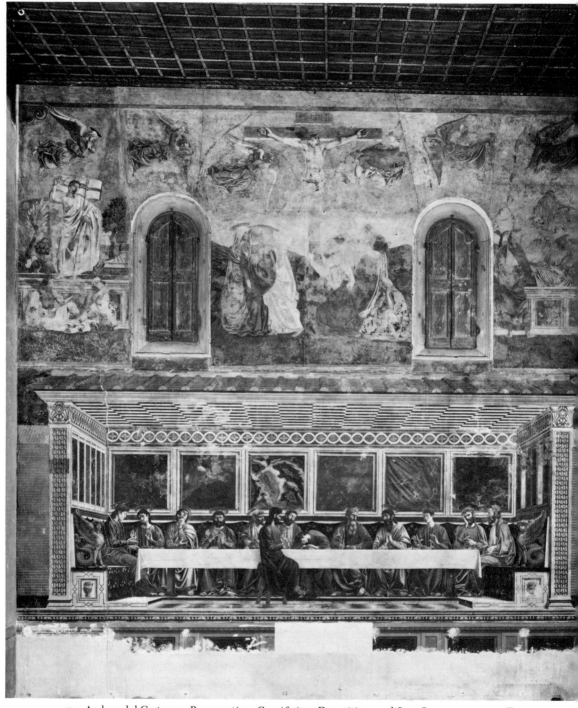

114. Andrea del Castagno. *Resurrection, Crucifixion, Deposition,* and *Last Supper,* 1447–49. Fresco, 920 × 980 cm. (total area of painted wall). Florence, Cenacolo of Sant'Apollonia.

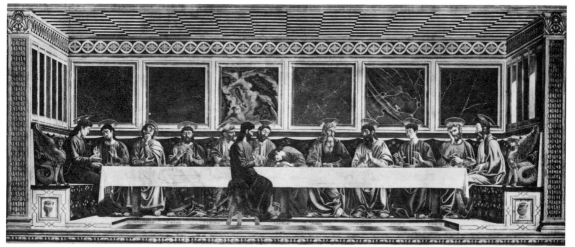

115. Andrea del Castagno. *Last Supper* (detail), 1447–49. Fresco. Florence, Cenacolo of Sant'Apollonia.

116. Andrea del Castagno. *Deposition*, ca. 1452. Sinopia, 285 × 330 cm. Florence, Cenacolo of Sant'Apollonia.

and a tiled roof that abuts the actual side walls, the building appears to have been cleanly sliced open·to present a boxlike stage for the action. The interior is a fanciful room *all'antica* with coloristic decorations, including bronze sphinxes at the edges, a checkerboard ceiling, and varied marble on the walls. The slab behind Christ, who is placed slightly off-center to the left, seems a prelude to the Crucifixion, with its great splash of deep red. Painted windows on the right side provide much of the pictorial light that falls on the figures, although this light is not insistent; by contrast, the brightly lit scenes above receive their illumination from the actual windows of the large room.

The painting, usually studied within the context of other illustrations of this subject, including those by Ghirlandaio, Leonardo, and Andrea del Sarto, appears stiff and programmatic, and possibly even old-fashioned. But the low horizon, a preference also found in Domenico Veneziano's *St. Lucy Altarpiece* [92] and in Castagno's own *Madonna and Saints* for the Casa Pazzi of about 1443 (Florence, Pitti Palace), provides a directness in approaching the figures, which are effectively integrated into the architectural stage. What adds to the general harshness is the total absence of atmosphere in the space between the spectator and the scene, making the *Last Supper* almost too vivid, the contours too untem-

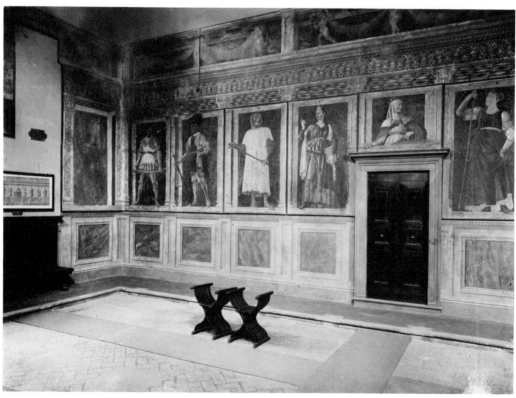

117. Andrea del Castagno. *Famous Men* cycle from the Villa Carducci, Legnaia, ca. 1450. Fresco (transferred). Florence, Uffizi.

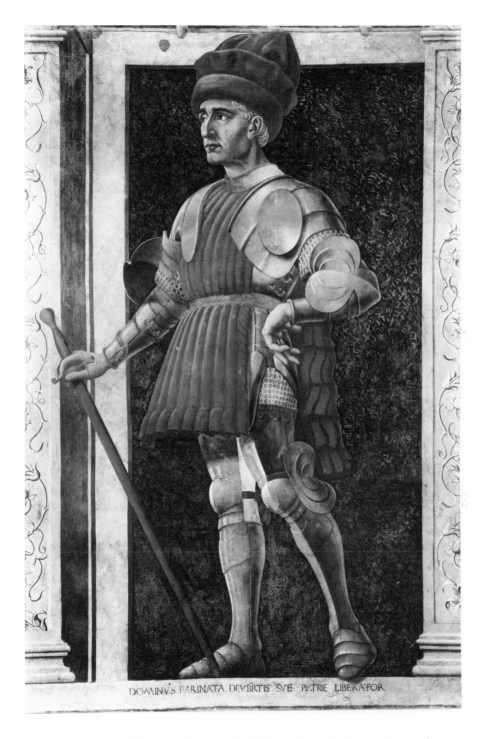

DOMINVS FARINATA DEVBRTIS SVE PATRIE LIBERATOR

118. Andrea del Castagno. *Farinata degli Uberti*, from the *Famous Men* cycle, ca. 1450. Fresco, ca. 245 × 165 cm. Florence, Uffizi.

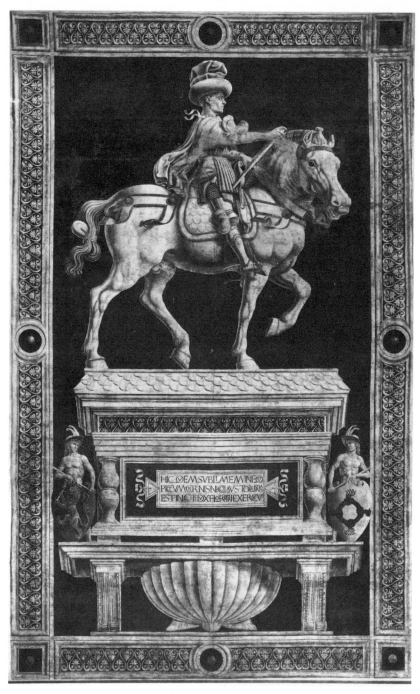

119. Andrea del Castagno. *Niccolò da Tolentino*, 1455–56. Fresco (transferred), 833 × 512 cm. Florence, Cathedral.

120. Donatello. *Gattamelata*, 1447–53. Bronze, h. ca. 340 cm. Padua, Piazza del Santo.

pered and uncompromising. Castagno's language of expression is almost crude and certainly inelegant. The reactions of the Apostles are reserved without exaggeration of gesture, but their stereotypical facial types and features create difficulties for the viewer in establishing rapport with these nearly ugly, aloof, and somewhat swollen images, frozen in their actions. The somber color suits the seriousness of the mood.

The *Famous Men (uomini famosi)* cycle that Castagno painted in the Villa Carducci (Legnaia, just outside Florence; frescoes now in Florence, Uffizi) permits him to be ranked as one of the most progressive decorators of the fifteenth century [117]. This project, painted around 1450, predates the more complex program of the Camera degli Sposi by Mantegna, in Mantua [186], but is no less extraordinary, since it was destined for a private citizen in a country villa rather than for the rulers of

an independent state. Already singled out for praise by Albertini in his *Memoria di Florentia* of 1510, the frescoes were removed first to Sant'Apollonia during the nineteenth century and more recently to the Uffizi, except for some fragments still *in situ,* making a thorough reconstruction of the original state difficult. The long wall had three groups of three figures in niches: Florentine politico-military personalities (Pippo Spano, Farinata degli Uberti, and Niccolò Acciaiolo); Florentine poets (Dante, Petrarch, and Boccaccio); and famous women from history (the Cumaean Sibyl, Queens Esther and Tomyris), the first such grouping I know suggesting the patron was a woman. On the one short wall that can be studied, Adam and Eve flank a central niche that contains, over an actual door, a *Madonna and Child* in a lunette. There is an optical extension of space with a vigorously foreshortened coffered ceiling and a very low

horizon, similar to that in the *Last Supper.*

Unlike the famous heroes on the long wall which look colorfully real, Adam and Eve are rendered in monochrome as imitation statues with bases, creating an engaging play among different levels of fictive reality. Above is a frieze of *putti* with wreaths or garlands, motives popularized by contemporary sculptors, who borrowed the device from Roman sarcophagi. *Farinata degli Uberti* is a massive, self-confident, swaggering soldier in easy *contrapposto,* his left wrist resting on his hip as he balances the long sword with his other hand [118]. The inscription below calls Farinata the liberator of his country. He stands in front of the niche—which is broken by an expansive hat—more than in it, and his left foot punctures the picture plane, enhancing the realism of the depiction. These *uomini* (and *donne*) *famosi* have dignity and bearing worthy of their persons and accomplishments.

The *Niccolò da Tolentino* fresco [119] must be included in any examination of Castagno's art. Made to commemorate the general who led the Florentines to victory in the Battle of San Romano (celebrated, as we have seen, in three paintings by Uccello), the fresco is painted in monochrome to simulate a marble equestrian monument, which the Florentines had actually planned to erect. It makes an engaging match with Uccello's nearby fresco of *Hawkwood,* which imitates bronze [35]. The *Tolentino* fresco has been transferred from the wall to canvas and has undergone numerous restorations, already begun in the sixteenth century. The wide, painted border with a palmette design, taken from a frieze on the sarcophagus beneath the statue, is not part of the original painting. The coat of arms of the condottiere, which shows the knot of Solomon on the right and the rampant lion, symbol of Florence, on the left, appears on the shields held by finely wrought, muscular youths, who turn toward each other. They are related, once again, to contemporary sculpture, this time to Desiderio da Settignano's Marsuppini Tomb in Santa Croce.

The principal feature is, of course, Castagno's horse and rider. The rider, composed, self-assured, majestic, concentrates on the action of his enemies ahead, making an image of military dignity that rivals even Donatello's *Gattamelata* [120], which had been finished in Padua a few years earlier, and Verrocchio's *Colleoni* [122], made a generation later. *Niccolò da Tolentino* represents a high point of monumental painting at mid-century with its convincing form and a measured balance between realism and idealism.

PART III
THE SECOND GENERATION

Most of the first generation painters treated in the previous section had achieved fame and reputation during their own lifetime. The Florentine sculptor (creator of the bronze doors of Old St. Peter's in Rome) and architect Antonio Filarete (ca. 1400–ca. 1469) wrote a *Treatise on Architecture* (early 1460s) in which we find a list of painters whom he hypothetically would hire to decorate an ideal city. He mentions Masolino, Masaccio, Fra Angelico, Domenico Veneziano, Andrea del Castagno, and Paolo Uccello, all of whom were Florentine, like Filarete, or else closely associated with Florence. Notably, he does not mention the important Venetian or North Italian painters such as Jacopo Bellini, Pisanello, and Squarcione, but he does include two outstanding "Northerners," Jan van Eyck and Rogier van der Weyden, who were much admired in Italy. These two Netherlandish painters are also listed in a long rhymed poem, ostensibly extolling the military activities of Federigo da Montefeltro, duke of Urbino, by Giovanni Santi (1439?–1494). Giovanni, a painter and majordomo at the court of Urbino, never earned a place of his own in the history of Italian Renaissance painting, at least on the basis of artistic merit, although he will long be remembered as the father of Raphael.

Several passages of Santi's long poem are of particular value since they are devoted to listing the best painters in Italy around 1480. In this regard, Giovanni exhibits a more cosmopolitan point of view than his contemporary Florentine commentators. His slate of artists, many of whom I have grouped among the first generation, is remarkably complete in terms of what subsequent criticism has judged to be the most important painters of the time. Santi mentions, in the following order, Fra Angelico, Pisanello, Fra Filippo Lippi, Francesco Pesellino

(a Florentine also included in Filarete's *Treatise,* although he died young and left few works), Domenico Veneziano, Masaccio, Castagno, Uccello, and Piero della Francesca. While not altogether representative of every region, Santi's selections do include an Umbrian (Piero della Francesca), a North Italian (Pisanello), a Venetian (Domenico Veneziano), as well as the usual number of Florentines.

Among those belonging to the second generation, Santi's register is even more complete and continues to be without bias toward local origin. We find Antonio and Piero del Pollaiuolo ("very great draftsmen"), Leonardo da Vinci, Perugino ("a divine painter"), Ghirlandaio, Filippino Lippi, Botticelli, Signorelli ("inventive and of wandering spirit"), Antonello da Messina, Giovanni and Gentile Bellini, Cosmè Tura, Ercole de' Roberti, Andrea Verrocchio, Francesco di Giorgio, and, lastly, Melozzo da Forlì, who was Santi's special friend. According to the author, the painter who deserved the highest praise was Andrea Mantegna, who surpassed both the ancients and the moderns. With the exception of Ercole de' Roberti (whose known production is quite limited), all these painters are discussed in the following chapters and only three others had to be added to Santi's list. Significantly, all three, Carpaccio, Pinturicchio, and Piero di Cosimo, were born just late enough to have escaped Santi's notice.

For the second generation we now have representatives from all the main regional schools of painting at the time: the Venetian (the two Bellini, now augmented by Carpaccio); the Florentine (the Pollaiuolo brothers, Leonardo, Botticelli, Ghirlandaio, Filippino Lippi, Verrocchio, and Piero di Cosimo); the Umbrian (Perugino, Signorelli, and Pinturicchio); and the Emilian (Tura, Ercole de' Roberti, and Melozzo). In Santi's list it is clear that the Florentine painters were the dominant group among artists of the first generation. In the second, a shift occurs that allows for the greater representation of painters from other regions. Venice begins to emerge as a leading Italian artistic center, with Giovanni Bellini as the dominant figure. Bellini, as we shall see, was instrumental in forming an articulate Venetian style that would rival and actually surpass the Florentines by the beginning of the next century.

A third contemporary source offers confirmation concerning the leading painters of the period. In a draft of a report to Duke Ludovico Sforza ("Il Moro") of Milan written by his agent in Florence, datable to the mid-1480s, four painters active in the city are discussed. Perhaps the intention was to hire one or more of them to work in Milan or Pavia. We have three Florentines included— Botticelli, Filippino Lippi, and Ghirlandaio—plus one Umbrian, Perugino. Leonardo da Vinci is noticeably absent from the list, but he was already in Milan. Moreover, the note may even have been dictated by him or, at the very least, reflect his own evaluations. All of the artists mentioned worked in the Sistine Chapel and, with the exception of Filippino, they were all employed at the

Medici villa at Spedaletto, near Volterra (no longer identified). According to the writer, Botticelli is given the most praise, although the choice is nearly even.

Second generation painters betrayed a greater scientific interest in the world around them than their predecessors. They were not satisfied with simply approximating the appearance of the natural world or of the human figure. Beginning in the 1450s and 6os, and in a thoroughly devoted way in the 1470s, painters began to study human anatomy. Furthermore, they participated in dissections so that not only would the outward appearance be known to them, but also the inner structure, the skeleton, the bones and the muscles, which were analyzed as never before. One finds this interest both in Tuscany and in the North, but at the start painters including Verrocchio and Antonio del Pollaiuolo were leaders in anatomical study. Their efforts culminated in the anatomical drawings of Leonardo da Vinci.

In a similar way, the insights made in the area of perspective by first generation artists became more self-conscious and codified among second generation painters. The effect of atmosphere on landscape, the results of changing light, the operation of colors in different environments were studied, and, once again, the most thorough research was done by Leonardo, who had planned a *Treatise on Painting* for the use of other painters. It would be a mistake to think that these interests, so well expressed by Leonardo, were not shared by his contemporaries. The demanding analysis of landscape, found in Giovanni Bellini and other Venetian painters, should be seen as part of the desire for a greater penetration and understanding of the world, as were the efforts of Antonello da Messina in the depiction of still-life objects or Melozzo da Forlì in the area of perspective. This somewhat rigid scientific search tends to disappear with the emergence of third generation artists.

The city of Rome and all that it inspired, both for the classical tradition and as the modern seat of the papacy, always held an appeal for painters. As we have seen, some first generation masters, as well as their predecessors, notably Masolino, Masaccio, Gentile da Fabriano, and Pisanello, worked in Rome. By the 1470s and 1480s, contemporary with work on the Sistine Chapel, Rome became an increasingly attractive place for painters (and sculptors). It is easier to cite those leading painters who did not, or probably did not, go to Rome at some point in their careers than to list those who did. In this respect, the crucial distinction between second and third generation painters is that while the earlier ones went to Rome for a specific assignment, only to return directly to their home cities or other centers, many third generation artists tended to remain in the papal city permanently, or at least for longer stretches of time. Consequently, while it is hard to speak about a Roman style in the *quattrocento*, third generation painters such as Raphael become, as it were, "Roman."

THE SECOND GENERATION:
THE LYRIC CURRENT

Andrea Verrocchio, Sandro Botticelli, Filippino Lippi, Francesco di Giorgio, Pietro Perugino, Pinturicchio, Cosmè Tura, Gentile Bellini, Vittore Carpaccio

ANDREA VERROCCHIO

Trained as a goldsmith, the Florentine Andrea di Michele di Francesco di Cioni, called Verrocchio (ca. 1435–1488), was among the most influential artists of his generation, and his workshop was a training ground for many distinguished painters. As far as we know, his early career was entirely occupied with metalwork. Then he became a sculptor of stone and terra-cotta as well as monumental bronzes, including the over-life-size *Christ and St. Thomas* [121], made to replace Donatello's *St. Louis of Toulouse* on Orsanmichele. The project dragged on for many years but appears to have been first undertaken in 1464. The Tomb of Giovanni and Piero de' Medici in San Lorenzo was completed in 1472. In that year Verrocchio's name occurs as a member of the Confraternity of St. Luke, which was largely, although not exclusively, composed of painters. Verrocchio continued to receive important sculptural commissions, including the Forteguerri cenotaph in 1474 for the Cathedral of Pistoia (which he never finished). His masterpiece, the *Colleoni* [122], situated out-

side the Venetian church of Santi Giovanni e Paolo, required the artist's presence in Venice, where he moved in 1483 and where he died five years later.

If Verrocchio's career as a goldsmith and sculptor can be reconstructed with some confidence, his career as a painter is much more difficult to follow, although his impact on other painters was considerable. No dated painting or altarpiece can be unequivocally attributed to him. The only documentary notice that occurs during his lifetime and that refers to an extant picture is a *ricordo* (brief written record) of 1485 saying that the altarpiece commissioned from Verrocchio for the Cathedral of Pistoia would have long since been finished had the officials not been so slow in their payments. Verrocchio never completed the picture, still in the Cathedral, which was turned over to his shop for execution. Lorenzo di Credi was apparently responsible for a significant share.

The most famous painting associated with Verrocchio is the *Baptism of Christ* [123], but no documentary evidence for the work has turned up. The artist is also known to have

121. Andrea Verrocchio. *Christ and St. Thomas,* begun 1467. Bronze, h. of Christ 230 cm. Florence, Orsanmichele.

122. Andrea Verrocchio. *Colleoni,* begun 1483. Bronze, h. of horse and rider 395 cm. Venice, Campo Santi Giovanni e Paolo.

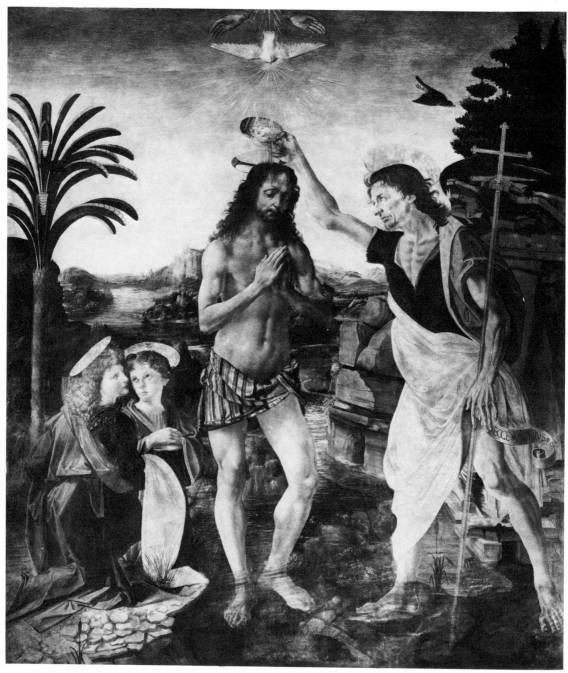

123. Andrea Verrocchio. *Baptism of Christ,* ca. 1470–73. Wood panel, 177 × 151 cm. Florence, Uffizi.

painted some banners for a joust organized by the Medici, but these have long since disappeared. From an inventory of property in Verrocchio's estate we learn that he made and painted masks, presumably for festivals and theatrical performances. Verrocchio (along with Antonio del Pollaiuolo and Leonardo da Vinci) was not included in the lucrative commission to paint the walls of the Sistine Chapel because he was either already too occupied with other projects in his busy workshop to leave Florence, although he did leave for Venice soon afterward, or because he had no experience with fresco.

<center>⁘</center>

The *Baptism of Christ* [123, 124] made for the Vallombrosian monastery of San Salvi, just outside the walls of Florence, has a particular fame because of Vasari's report that Leonardo, while in Verrocchio's shop, painted one of the angels, which all experts agree is the one on the extreme left. The date and the extent to which Verrocchio conceived and painted the *Baptism* are open to debate. Judging from the evidence we have—a remarkably small number of drawings and his documented sculptures—a dating of 1470–73 seems reasonable, with Verrocchio leaving the greatest share of the actual painting to his talented assistants, although he probably developed the overall composition and the design. It may be fruitless to seek Verrocchio's independent personality as a painter in one part or another in this picture or in any of the ones associated with his name. Rather, one should consider the workshop itself as a creative entity that had a style and produced paintings like the *Baptism,* in which we can find passages not only by Leonardo but also some that may be by Botticelli as well as still other assistants. Undoubtedly Verrocchio was the mastermind and prime mover of this workshop style, the legally responsible person and the guiding spirit.

The *Baptism of Christ* is painted with mechanical insistence and is more a sum of its parts, a montage, than an organic, tightly unified composition. It has a vertical thrust, as can be expected from the requirements of the theme, which is treated rather traditionally. The figures of Christ and St. John the Baptist are handled like representations of pigmented statues, frozen in movement, and without inner life or emotion. The proportions of the figures are sturdy, and Verrocchio shared with his contemporaries a fascination with bones, muscles, tendons, and veins, as exemplified by the left arm of the Baptist or the drawing for Christ's left foot. The figures are arranged to stress the central axis—the Holy Dove at the top, the cup of water, and Christ's body. All are shown close to the surface of the picture and appear rather two-dimensional despite insistent modeling in *chiaroscuro.* Each segment—an arm, a hand, a head—remains iso-

124. Andrea Verrocchio. Detail of 123.

125. Andrea Verrocchio and workshop. *Madonna with Sts. John the Baptist and Donatus,* ca. 1475–83. Wood panel, 189 × 191 cm. Pistoia, Cathedral.

lated. At the same time, the outer edges of forms, the silhouettes, overcome the limited modeling to produce a flattened image. The landscape elements operate with the same irregularity. The rocky ledge on the right and the miniaturized palm on the left, which it balances, are incongruous with the figures, with one another, and with the distant vistas. Even the group of two angels by Leonardo and another shop assistant (Credi or Botticelli?) is more satisfying as a detail than as a vital part of a whole and appears almost as an irrelevant intrusion. What is most appealing in the painting are the heavy risks which the artist has taken within a pictorial system in which the world can be divided up, studied with intensity bit by bit, from drapery folds to locks of hair (as on the Baptist), and be put back together.

Another product of Verrocchio's shop is the altarpiece of the *Madonna with Sts. John the Baptist and Donatus* for the Cathedral of Pistoia [125], probably designed and begun around 1475 and completed as much as ten years later by the *bottega* assistants. The setting, an unspecific open loggia with contemporary Renaissance architecture, is organized with only apparent mathematical and spatial rigor. The foreground, dominated by the saints close to the picture plane, is established by the fringes of a luxurious carpet. In the second plane Mary is seated in a raised niche with the nude Child sitting unconvincingly on her lap. One has the impression that the Child was carefully worked out in drawing independently of the mother and then superimposed on the composition. In the distance spreads a landscape reminiscent of the flat Arno Valley near Pistoia. Although each section and each element, as in the *Baptism,* has been studied with independent concentration, the whole lacks spontaneity, a sense of the accidental. The result is a frozen and academic product.

Yet Verrocchio's manner was quickly and enthusiastically imitated. What were the reasons? Intense study through drawing became a common method of planning a picture, offering uniformity and continuity. The small number of physical types that Verrocchio developed were particularly admired and had a widespread following, even among such important and influential painters as Botticelli, Ghirlandaio, and Perugino. The tight modeling and precise drawing are so finished that they come to have the appeal of being unchangeable and essentially correct. Verrocchio's system of dividing up the problems —studying a figure and the drapery that clothes it separately, for example—is essentially an academic system of instruction removed from nature in which art can be learned step by step.

SANDRO BOTTICELLI

One of the most powerful painters of the lyric current was the Florentine Sandro (Allesandro) di Mariano Filipepi (1445–1510), called Botticelli, a nickname meaning "little barrel" that was first applied to his brother. Botticelli may have been trained by a goldsmith, but he transferred to the shop of Filippo Lippi, presumably when the latter was still at work on the choir of Prato Cathedral; possibly Botticelli went with Lippi to Spoleto. We know with certainty that in 1470, when Botticelli was twenty-five, he was commissioned to paint *Fortitude* [126] for the Mercanzia (merchants' court), one in a series of allegories, the remainder being assigned to Piero del Pollaiuolo. In the early seventies, he may also have been associated with the Verrocchio shop, as we have seen. Sandro was in Pisa in 1475 to make a fresco for the Cathedral (lost), and in 1478 he painted effigies of the Pazzi conspirators in Florence (destroyed), an assignment similar to one that Castagno had some years before. Botticelli frescoed a *St. Augustine in His Study*

[130] in direct confrontation with Ghirland-aio's *St. Jerome* in the Ognissanti church in 1480 [219]. In the following year these two masters, together with Perugino and Cosimo Rosselli, were in Rome, where they painted frescoes for the Sistine Chapel. Work proceeded quickly there, and Botticelli was back in Florence in 1482, where he obtained an assignment from the Signoria, the governing officials of the city, that was never actually produced. In 1485 there are payments for the *Bardi Altarpiece* for Santo Spirito (Berlin-Dahlem, Staatliche Museen).

During 1491 he was appointed to a committee, along with Ghirlandaio, Perugino, and Lorenzo di Credi, to evaluate projects for the façade of the Florentine Cathedral. Early in 1501 Botticelli signed and dated the *Mystic Nativity* [134], the only signed work in his entire extant oeuvre. In 1502 he was mentioned in a letter by Isabella d'Este's agent in Florence, and in the same year was anonymously accused of sodomy, but not prosecuted. In 1504 Botticelli was a member of a commission of artists who deliberated over the appropriate placement of Michelangelo's marble *David*. Botticelli died in 1510; the last years of his career were not rich in commissions, and his art may have slipped entirely out of fashion. In an unusual bit of biographical evidence for the period, his father laments in a tax return of 1487 that his son Sandro, who then lived with him, was a painter but worked only when he felt like it.

+‡+

The sketch of Botticelli's life gives very little direct evidence for a chronology of his work, and any pattern of stylistic evolution among his paintings must be largely based on secondary sources and guesswork. His two most famous paintings, among the most renowned of the entire Renaissance, are both undated and undatable on documentary grounds. We do know from contemporary sources that he was very highly regarded at the height of his activity and was patronized by Lorenzo de' Medici ("Il Magnifico") and by the other important branch of the Medici family.

Fra Filippo's influence was essential to Botticelli's development, but there is reason to believe that after Lippi died, or when Botticelli left his shop, he was also influenced by Verrocchio. In Verrocchio's workshop he may have first encountered his slightly younger contemporary Leonardo da Vinci, with whom he seems to have been on close terms. The earliest documented work, the *Fortitude* [126], already represents a fully articulated early phase, although Botticelli may have been affected here by the requirements of the assignment, since he had to make his work compatible with the other pictures in the series. In the *Fortitude* Botticelli shows himself a skilled master of perspective, which he uses comfortably in placing his figure in the shallow space. He creates an intricate but engaging throne, but unlike Piero del Pollaiuolo, Botticelli plays down modeling in establishing the physical presence of the figure. The head of *Fortitude* recalls both Lippi and, more directly, Verrocchio in its dependence on outlining. A precisely stated edge produces convincing form without a reliance on *chiaroscuro* modeling. This stress on line is typical of Botticelli throughout his career and increased as his style achieved full definition.

The smallish *Adoration of the Magi* [127], one of several Adorations by Botticelli, was painted for a private chapel in Santa Maria Novella. Here the proportions of the figures are elongated, and as one looks upward the natural foreshortening is accentuated. The colors are somber, deep, and somewhat monotonous, but are still within the framework of Fra Filippo's style, although the painting should probably be dated to about 1475, long after Botticelli's association with him had

126. Sandro Botticelli. *Fortitude*, 1470. Wood panel, 124 × 64 cm. Florence, Uffizi.

the right edge of the picture looking out at the spectator. Many other contemporaries have been identified among the figures, making this a kind of *uomini famosi* of the Medici household. In general, caution should be used in accepting such proposed identifications—for this and for most Renaissance pictures—unless the evidence is strong. Nevertheless, in 1435 Alberti wrote of the appeal for the viewer of seeing familiar personalities in a painting. The inclusion of portraits in religious paintings appears to have been common, and some early sources do mention portraits in this work.

The attraction of the *Adoration of the Magi* lies in the treatment of the subject and the innovative composition. The central event, the kings paying homage to the newborn Christ, takes place within a humble wooden shelter built on the ruins of a classical marble structure. The architectural symbolism repeated throughout the picture is explicit: the victory of the new faith of Christ over the ancient, pagan religions, the once mighty buildings of which are being eroded by time. Mary, the Child, and Joseph, who rests his head upon the massive rock behind (perhaps representing the church), are raised high above the horizon and placed deep in space, removed from the confusion of the numerous participants. The central axis is emphasized by the placement of the sacred figures and the golden rays. The Virgin, with her small features and triangularly shaped head, and the tiny Child both reflect the style of Verrocchio or, more precisely, Verrocchio's shop.

Botticelli exposes a contradiction between the spatial thrusts he devises, including a powerful wedge into depth relatively free of figures in the middle, and the silhouetting of individual images, which serves to accentuate the surface. This flattening of forms, only implicitly found in the *Adoration*, becomes a salient feature of the *Primavera* [128], which, with the *Birth of Venus* [129], is Botticelli's

ended. The *Adoration* is frequently discussed because of the wealth of presumed portraits in the picture, including a posthumous profile likeness of Cosimo de' Medici ("Il Vecchio") (founder of the Medici de facto rule of Florence) in the guise of the oldest king, and that of his grandson, Lorenzo, also in profile on the left. The painter himself seems to be shown on

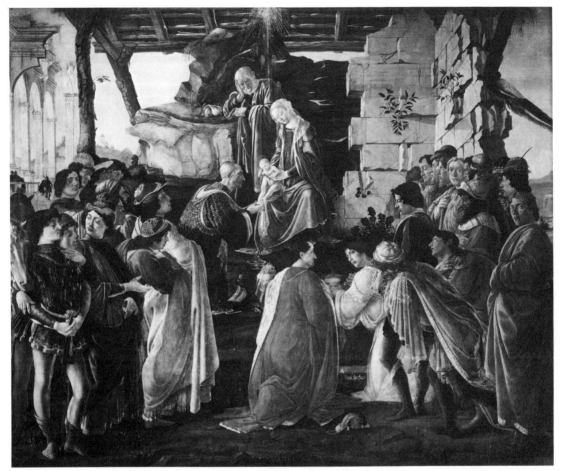

127. Sandro Botticelli. *Adoration of the Magi*, ca. 1475. Wood panel, 111 × 134 cm. Florence, Uffizi.

most admired work. The two pictures, both painted in tempera, do not belong to the same program and appear not to have been painted at the same time, despite certain common features. They are part of a small but significant group of paintings by Botticelli depicting classical mythological subjects. The *Primavera* (Spring), unanimously considered the earlier of the two, is composed freely, without a strict symmetrical balance. The central figure is framed by an arch composed of trees and leaves with a bower of laurel that creates a dark tonality behind her. Above, a blindfolded cupid aims an arrow at one of the three thinly clad Graces. The figures seem to float gracefully on the surface without a formalized harmony. The painting is almost oppressively dominated by the presence of the actors, who are very close to the spectator's space despite the wealth of spatially unintegrated landscape

elements. The ubiquitous flowers on the ground are emblems of the woman standing next to the draped Venus, who looks out of the picture almost arrogantly, her person overshadowed by the blossoms that she distributes from a vast supply. She is Flora or Primavera from whom the painting has obtained its name. Beside her is Zephyr and perhaps Flora in another guise; Mercury on the extreme left completes the cast of characters. But if the identifications are clearly established, the meaning of the *Primavera* has been the subject of countless, often conflicting, interpretations and remains something of a riddle.

The overall effect of the painting, with its flat colors and silhouetted forms, is that of a tapestry of exceptional decorative power. The figure style falls decisively within a lyric approach. Flora, a tall, elongated image in a nongravitational stance, is close to the picture plane, and her richly embroidered dress challenges the implication of her physical presence. Modeling as a means to create volumetric form is kept to a minimum. Instead, the figures are created mainly by the edges of the form and by color. The *Primavera* was presumably painted in the late 1470s or in the early 1480s, immediately before Botticelli went to Rome, but a date following his return is also possible. Renaissance artists like Botticelli often had several stylistic modes that they used at the same time, depending upon the category of subject matter, the destination of the work, or the requirements of the patron. Hence the style of a religious piece like the *Adoration* may be quite different from, say, that of the *Primavera*, although the two may be close in date.

The *Birth of Venus* betrays, if not a shift in style, a further refinement in Sandro's formal

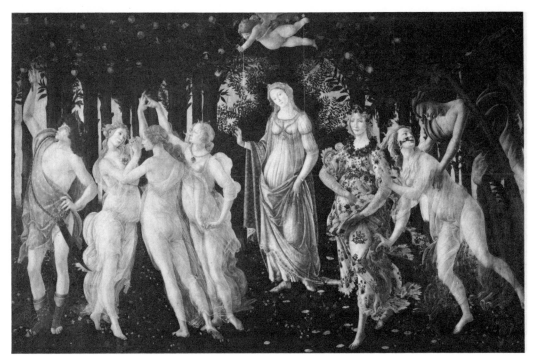

128. Sandro Botticelli. *Primavera*, 1479–81(?). Wood panel, 203 × 314 cm. Florence, Uffizi.

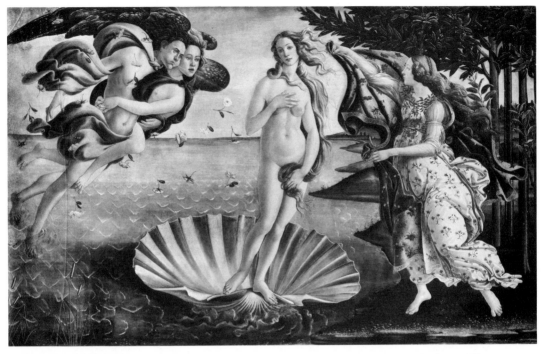

129. Sandro Botticelli. *Birth of Venus*, 1483(?). Canvas, 172.5 × 278.5 cm. Florence, Uffizi.

expression. It was painted in tempera, like the *Primavera*, but on canvas instead of on a wood panel. The two paintings also differ in size, although the *Birth of Venus* may have been cut down at the top. The subject is hardly obscure, and complex allegorical significance has been detected. As with the *Primavera*, the painter eschews a purely axial composition, shifting an apparently centralized organization slightly away from the center. The rejection of three-dimensional volume is now nearly complete. The figures are established almost exclusively by the magnificent, heavily drawn outlines, and they function like cutouts pasted on a schematized, make-believe background. Naturalistic representation has given way to a cerebral, distilled, slow-moving dream world of unmatched attraction. Although Venus is posed like the Venus pudica

of ancient art [325], the effect here is romantically fanciful and sentimentally engaging, in contrast to the classical, sculptured source. An illustration of Venus, with her golden hair blown by the wind, is a familiar but haunting image. Her form has been laid out flatly, resulting in a complex set of ornamental surface patterns.

The *St. Augustine in His Study* [130] is securely dated 1480 and consequently may fall chronologically between the two mythological pictures just examined, although it diverges from them considerably in style and in medium, being fresco. Here, for example, attention is paid to specific detail to such a degree that one can read some parts of the writing in the open book on the shelf above the saint's head. In the conception of the figure, Botticelli has moved toward the monumental,

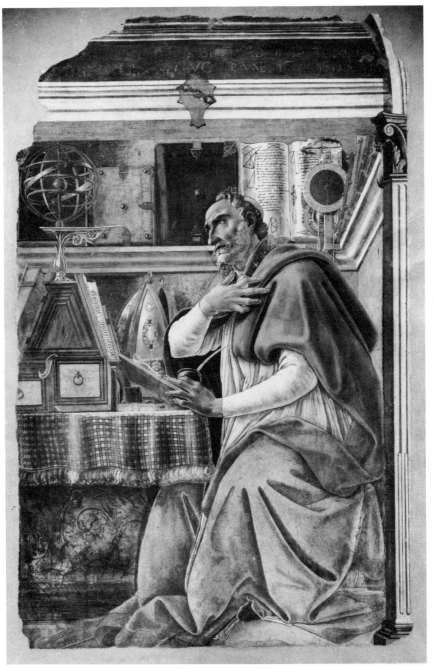

130. Sandro Botticelli. *St. Augustine in His Study,* 1480. Fresco, 152 × 112 cm. Florence, Ognissanti.

quite unlike his lyrical figures in the *Prima-vera.* The divergence in style with the *Prima-vera* may be ascribed in part at least to the competition with the more monumentally ori-ented Ghirlandaio, who did the companion fresco, and to the nature of the subject matter, together with the requirements of the monks of the Ognissanti church [219]. Nevertheless, even here a flattening of forms may still be detected, as in the drapery or in the way the monstrous right hand is laid on a plane close to the surface and parallel to it, much the same as the hand of Venus is arranged in the *Birth of Venus.*

The three narrative scenes Botticelli painted in the Sistine Chapel include two epi-sodes in the life of Moses and the *Temptations of Christ* [148]. These were done rapidly and, we must assume, with considerable assistance;

consequently, they do not show Botticelli at his best. Furthermore, the scenes apparently had to conform to an overall plan conceived by the director of the entire fresco project (Pietro Perugino?). The colors are rather pon-derous, specific, and descriptive. The land-scape is realistic, and the spatial staging con-vincing. In the amorphous compositions the figures tend to be weightless; as types they are unmistakably "Botticellian," notably the women at the well in *Moses in Egypt and Midian* [131].

Botticelli painted the traditional range of commissions, producing in addition to frescoes for religious and private patrons, large altar-pieces, occasional portraits, and a number of Madonnas. The *Madonna del Magnificat* [132] displays a figural composition within the for-mat of a *tondo,* with the vertical axis displaced

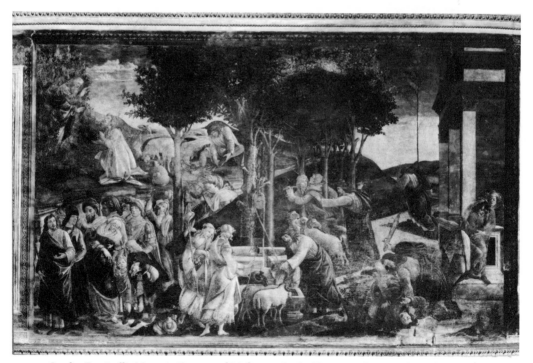

131. Sandro Botticelli. *Moses in Egypt and Midian,* 1481–82. Fresco, 348.5 × 558 cm. Rome, Vatican, Sistine Chapel.

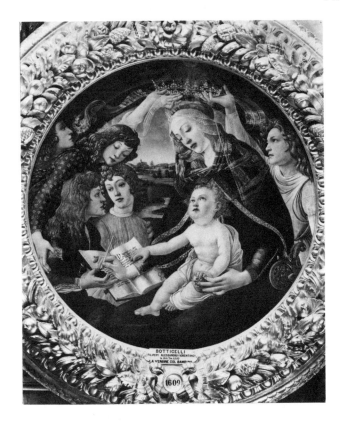

132. Sandro Botticelli. *Madonna del Magnificat,* 1485(?). Wood panel, diameter 118 cm. Florence, Uffizi.

slightly off-center by a landscape. The four angels are balanced pictorially by the rays of the Holy Spirit, the gold crown of Mary, and the Child; the heraldic angel on the right was perhaps based on the likeness of a studio *garzone.* Full, warm colors dominate the intricately established surface of intersecting curvilinear forms in this painting, which appears to date to the mid-1480s.

In his late works, which are increasingly unconventional, particularly those with religious themes, Botticelli turned to an ever more personal style. His outlook may have been affected by the preaching of the fiery Dominican friar Savonarola and the vivid controversy that surrounded his preaching in Florence. The *Lamentation* [133], presumably painted

in the 1490s, was at one time in the Florentine church of Santa Maria Maggiore. The intricate composition is constructed vertically from the diminutive body of the dead Christ on the lap of Mary, creating a subtheme of the Pietà. The Maries, in contorted poses, surround the central group, with the Virgin swooning in the awkward embrace of St. John. Above is Joseph of Arimathea, who hieratically holds instruments of the Passion, the crown of thorns and three nails. The bodies of the figures and their poses are constructed without regard for human anatomy and actual physical possibilities of movement; Botticelli favors instead an expressive geometry where the rules of naturalism and scale no longer apply. Mary Magdalen, at the feet of Christ, her head turned inex-

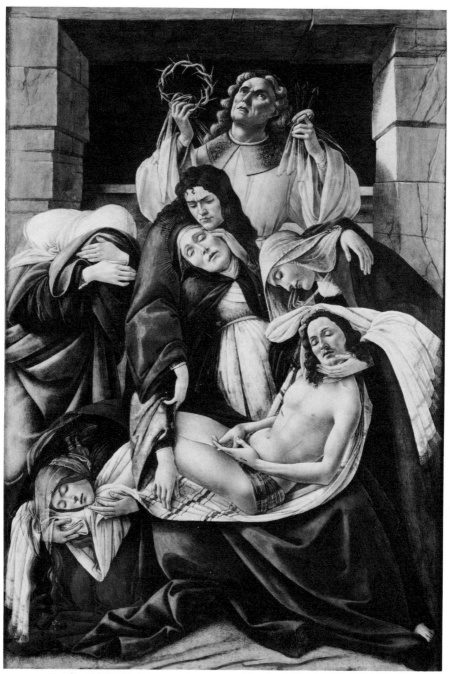

133. Sandro Botticelli. *Lamentation*, 1490s. Wood panel, 107 × 71 cm. Milan, Poldi-Pezzoli.

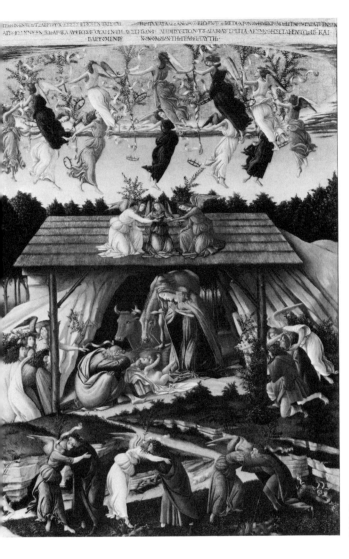

134. Sandro Botticelli. *Mystic Nativity*, 1501. Canvas, 108.5 × 75 cm. London, National Gallery.

plicably, is a stirring image of absolute despair. The intertwining of the forms laid out on the surface produces ambiguities of pose, scale, and visual logic that lead in the direction that third generation lyric painters, like Pontormo and Rosso Fiorentino, will move in the next twenty years.

During the last decade of his life, Botticelli seems to have had fewer commissions. The *Mystic Nativity* [134] was apparently painted for himself and not a client, shortly after 1500.

The style is similar to the *Lamentation*, although the small London picture has a miniature-like quality. It is intimate, with many figures, devotedly individualized and keenly personal.

Perhaps there was a falling off in demand for Botticelli's services once Michelangelo began to emerge as an independent artist, Leonardo had returned to Florence, and the young Raphael began to build his reputation. Botticelli must have felt ill at ease with the booming

force of Leonardo and Michelangelo, actively competing in Florence, and the converts they were making to their figural styles, which were entirely contrary to Botticelli's fragile temperament.

FILIPPINO LIPPI

Filippino Lippi (ca. 1457–1504), son of the painter Fra Filippo Lippi, maintained a dominant position among Florentine painters of his generation. He is first mentioned in 1467, when he was with his father at Spoleto, presumably doing minor chores in the shop. In 1469 his name again occurs in Spoleto, shortly after old Filippo's death. We know that he was enrolled in the Confraternity of St. Luke in Florence in 1472, where he is mentioned in the company of Botticelli, who apparently took over his education. Filippino is known to have been outside of Florence in 1480 (perhaps first in Lucca and then in Rome with Botticelli). By the end of 1482 he had received an independent and significant commission, replacing Perugino, for a mural painting in the Palazzo della Signoria (never executed).

In 1483 he received an assignment for the *Annunciation* in San Gimignano [137, 138], and in 1486 Filippino dated an altarpiece for the Palazzo della Signoria (Florence, Uffizi). The following year he obtained an important contract from Filippo Strozzi to decorate his family chapel in Santa Maria Novella, but the cycle, finished in 1502, seems to have been begun in earnest only about 1500. In 1488 Lippi received a commission from Cardinal Caraffa in Rome for a family chapel in Santa Maria sopra Minerva, but Filippo was also in Florence and Spoleto that same year. The Caraffa Chapel frescoes were finished in 1492. In the meantime Lippi participated in the competition to design a façade for the Florentine Cathedral along with other leading painters and architects. The *Adoration of the Magi,*

painted for the monks at San Donato a Scopeto, is signed and dated 1496 [143]. Records show that Filippino was again involved with work on the Florentine Cathedral, this time in repairing the lantern of the dome. The signed *Marriage of St. Catherine* (Bologna, San Domenico) is dated 1501. His last works include an altarpiece for the town hall of Prato in 1503 (Galleria Communale). In the final year of his rather abbreviated activity, he was a member of the commission to decide on the placement of Michelangelo's *David.* Filippino's known career as a painter spans only about twenty years, during which time he traveled to Rome for extended stays and to the surrounding towns in Tuscany. He left a deep impression on Tuscan painting that lasted well into the sixteenth century.

⁘

Although Filippino had the advantage of being the son of a distinguished painter, he could have had only the barest instruction from his father, who died when he was about twelve. His education was presumably taken over first by Fra Diamante, his father's long-time collaborator and chief assistant, and then by Sandro Botticelli. No early works by Filippino can be identified. An altarpiece that lays claim to a date of about 1483 (based on indirect evidence and stylistic judgments) is the *Four Saints Altarpiece* [135], a curious composition because it looks like a *sacra conversazione,* but without the Virgin and Child. Sts. Roch, Sebastian (not shown nude, as was usual), Jerome (with the lion, his attribute, peeking out from behind his right leg), and Helen (leaning on the Cross) are oddly independent, each apparently oblivious to his neighbors. Only Sebastian looks pathetically toward St. Roch. Filippino's figures are not as intimately tied to Botticelli's manner as one might expect, but they, too, are elongated, with little commitment to naturalistic, structural proportions or

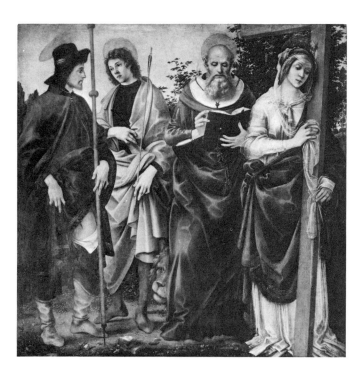

135. Filippino Lippi. *Four Saints Altarpiece*, ca. 1483. Wood panel. Lucca, San Michele.

136. Antonio del Pollaiuolo. *St. James Between Sts: Vincent and Eustace*, 1467–68. Wood panel, 172 × 179 cm. Florence, Uffizi.

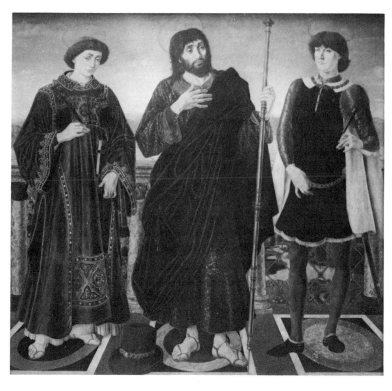

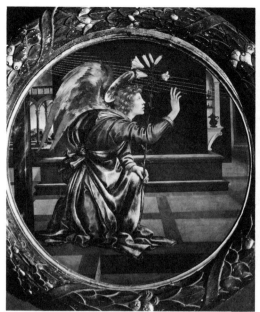

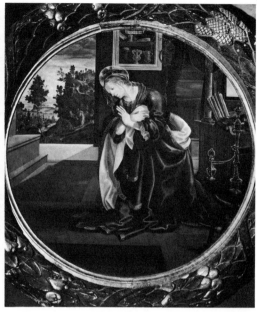

137. Filippino Lippi. Gabriel from the *Annuncia-tion*, ca. 1483–84. Wood panel, diameter 110 cm. San Gimignano, Museo Civico.

138. Filippino Lippi. Virgin Annunciate from the *Annunciation*, ca. 1483–84. Wood panel, diameter 110 cm. San Gimignano, Museo Civico.

to volume. The beautifully drawn faces and hands do reveal connections with Botticelli, but also with the Pollaiuolo shop, which had produced an altarpiece with three isolated saints for the Chapel of the Cardinal of Portugal in San Miniato fifteen years earlier [136]. Filippino, like many of his contemporaries, was receptive to Netherlandish influences, especially in the handling of light and the textures of surfaces, seen here in the head and beard of St. Jerome.

The *Annunciation* for San Gimignano is his earliest documented work, although the actual painting could have been delayed after the commission was awarded early in 1483 [137, 138]. Using the *tondo* form often favored by both Fra Filippo and Botticelli, Filippino has isolated Gabriel and Mary in separate panels, their bodies well concealed by weighty and complex garments. The space around them is full of objects, within an involved architecture and landscape. Lippi's figures have

no volume or discernible anatomical structure. Instead, he concentrates on the surface excitement of the draperies and on marvelous details, including a picture-within-a-picture in the panel devoted to Mary.

The high point of the early phase of Lippi's development is the *Vision of St. Bernard* [139], one of the finest lyric pictures of the entire Renaissance. St. Bernard of Clairvaux, seated at a desk with his pen poised, experiences a vision of the Virgin, who regularly had been the subject of his writings. The confrontation takes place out-of-doors (rather than in his study or in a church), enframed ingeniously by an outcropping of rock that creates a natural bench and bookshelves for the scholar. Behind Bernard, in the dark reaches of the rock, are two chained demons, while in the zone above, Cistercian monks converse or look heavenward in front of their fine Renaissance abbey. Still higher in the composition, a sick old man is being carried down toward the

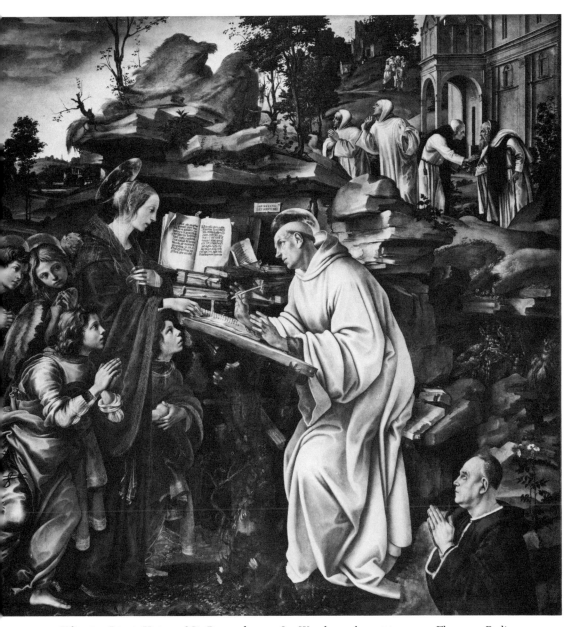

139. Filippino Lippi. *Vision of St. Bernard,* ca. 1485. Wood panel, 210 × 195 cm. Florence, Badia.

140. Filippino Lippi and Masaccio. *Raising of the Son of Theophilus and St..Peter Enthroned*, ca. 1428 and ca. 1484. Fresco, 230 × 598 cm. Florence, Santa Maria del Carmine, Brancacci Chapel.

141. Filippino Lippi. *Judgment and Martyrdom of St. Peter*, ca. 1484. Fresco, 230 × 598 cm. Florence, Santa Maria del Carmine, Brancacci Chapel.

building. On the other side, a sweet landscape sweeps the eye into the distance.

The format of the main figural group is echoed by the stony backdrop which, roughly speaking, forms a pyramid. Also included are the donor, Francesco del Pugliese, matched pictorially on the other side by the blond angel, leaning inward, hands clasped in prayer. The colors are confident, bright, and direct, adding to the exceptional visual excitement of the painting. Mary hovers above the ground facing Bernard. Her elegant form and finely silhouetted head are not dependent upon vigorous light-to-dark juxtapositions or even, as with Botticelli, a felicitously found, heavily accented line, but rather on the operation of fragile edges. The same is true for the

figure of the saint, where light, color, and lustrous paint, presumably oil, combine to produce the desired effect. The landscape is rather flat, despite all the implications of deep space. The painting, although not dated, may have been finished by 1485, the approximate completion date for another project of considerable importance, the Brancacci Chapel frescoes [10].

In this commission Filippino was able to submerge his lyric proclivities to a considerable extent to accommodate his style to that of Masaccio. He finished the scene of the *Raising of the Son of Theophilus and St. Peter Enthroned* [140], abandoned by Masaccio in 1428, with Lippi's share apparently limited to the standing figures and the nude youth in the

142. Filippino Lippi. *Virgin in Glory*, ca. 1489–90. Fresco. Rome, Santa Maria sopra Minerva, Caraffa Chapel.

center and the figures to the extreme left. The completed fresco is so homogeneous in style that critics are still not in complete agreement as to which parts were painted by Lippi and which were painted fifty years before, surely a remarkable achievement. On the opposite wall of the Brancacci Chapel he created a narrative entirely *ex novo*, the *Judgment and Martyrdom of St. Peter* [141], that is spatially more ambiguous and has less monumentally conceived figures. The various parts of this poorly preserved fresco are more successful than the work in its entirety.

To see Filippino as a fresco painter wholly on his own, one must turn first to the Caraffa Chapel in Santa Maria sopra Minerva in Rome, where the murals give full measure to his gifts as well as to an elaboration of his style. This work announces the onset of his middle period, which is even more imaginative, bizarre, and anecdotal than the early phase. The frescoes, finished in 1493, display the artist's new visual experiences, including an awareness of Melozzo da Forlì's art. Analogous daring foreshortenings are found in Lippi's *Virgin in Glory* [142] for the massive altar wall of the chapel. Filippino's music-making angels are skillfully incorporated into the curve of the wall, and their joyful celebration is appropriate to the occasion. There is no single point of sight for these images; some are seen sharply from below, others are nearly perpendicular to the surface plane. As a result, an implication of celestial movement into space is first established and then denied. The angels have sweeping, agitated draperies that indicate movement, but emphasis is placed on the edges of forms so that they appear flat and linear rather than three-dimensional. Although the limbs of the figures are monumentalized to some extent, the total impression remains decidedly lyric. Mary, standing on a cloud bank, is heavily draped, and the presumed weight-free left leg emerges beneath the swells of the garment, in a shift from normal gravitational logic.

The impact of Filippino's stay in Rome upon his artistic vocabulary was confined largely to details: architectural backgrounds, decorative motifs, still life, and antique conceits. His figural style remained basically unaffected, and poses taken from classical sources, so readily available to him in Rome, rarely appear. The Roman works do mark a period in which the ideas and visual experiences of his youth were elaborated and expanded, which became especially noticeable after his return to Florence. Once home he produced the *Adoration of the Magi* for the monks of San Donato a Scopeto in 1496, a commission originally awarded to Leonardo da Vinci some fifteen years earlier [143]. Leonardo had left his work unfinished when he set out for Milan at the end of 1482 or 1483 [245] but the monks apparently waited a good while before re-assigning the picture. Lippi, in turn, created an entirely new work rather than taking over Leonardo's partially finished panel; moreover, he did not base his composition closely on Leonardo's. Instead, he seemed to have had Botticelli in mind when planning the composition [144].

The central area is left void of action, but just barely, since Filippino tends to fill the available space with figures or painted objects. Mary holds the Child, who twists away from the old Magus who would kiss His foot. Together with St. Joseph, leaning on his staff, the figures are stacked up along the central axis. Above and slightly behind are the modest shed and the sweeping landscape, which contains scenes illustrating the journey of the Magi, as seen earlier with Gentile da Fabriano's famous version of the subject [5]. Portrait likenesses abound; the kneeling man in profile on the left and the standing figure gesticulating on the right are clear-cut examples, being perhaps benefactors of the monastery. Furthermore, if we are to believe Vasari, the

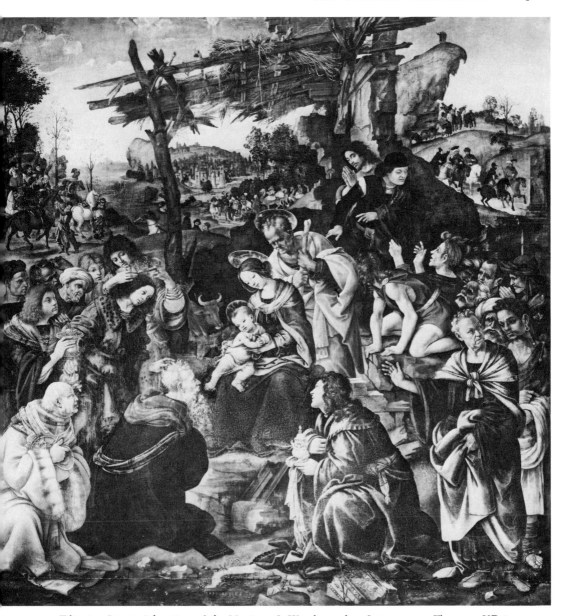

143. Filippino Lippi. *Adoration of the Magi*, 1496. Wood panel, 258 × 243 cm. Florence, Uffizi.

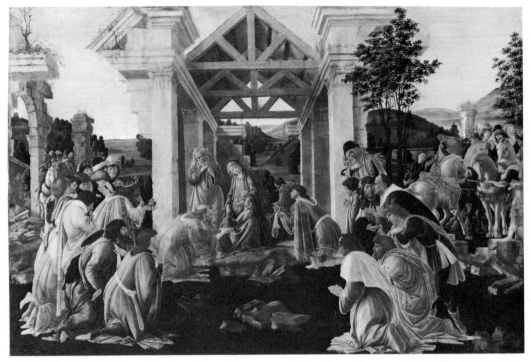

144. Sandro Botticelli. *Adoration of the Magi*, ca. 1482. Wood panel, 70 × 104 cm. Washington, National Gallery (Andrew Mellon Collection).

young kneeling king has the features of Lorenzo de' Medici.

A reverence for incidental detail and for outlandish costumes occurs throughout Filippino's art. These tendencies are especially seen in his second major fresco cycle, that in the Strozzi Chapel of Santa Maria Novella, painted between 1500 and 1502. The scenes, which deal with events in the lives of Sts. Philip and John the Evangelist, are located near Ghirlandaio's frescoes in the vast choir, done a few years earlier. Far less severe, Lippi's paintings are daring in color. Bright tones are used in broad expanses punctuated by strong yellows and greens. The architecture in the paintings, continuing a usage already unveiled in Rome, is more self-con-

sciously patterned after temporary settings for theatrical performances or for carnival displays than on real structures, revealing Filippino's vast inventive capacities.

The story of *St. Philip Driving the Dragon from the Temple* [145], recounted in the *Golden Legend*, is filled with imaginative elements consistent with Filippino's originality. St. Philip, who happened to be the painter's name saint, had been seized by pagans in Scythia; they sought to compel him to offer sacrifice to a statue of Mars. Suddenly a dragon issued forth from the foot of the altar and killed the son of the attendant priest. A noxious odor emanated from the beast, as indicated by the gesture of the woman on the left, who holds her nose. Philip succeeded in

145. Filippino Lippi. *St. Philip Driving the Dragon from the Temple*, 1500–1502. Fresco. Florence, Santa Maria Novella, Strozzi Chapel.

ordering the demon back to the desert, and the Apostle will shortly restore the dead and convert the whole community.

In Filippino's open, unstructured composition, with the fragile altar ensemble, he worked with a full arsenal of classical motifs based on a study of ancient decorations combined with a creative and witty attitude toward archaeological data. The arrogant Mars, a bronze image on an elaborate pedestal, is within a curved niche covered with trophies

and heightened by marble herms that appear to come alive and move freely, disengaging themselves from their architectural prisons. The decisive, unnaturalistic color emphasizes a tongue-in-cheek dimension of this, one of his finest works. The figures, in elaborate and exotic costumes and of different physical and ethnic types, retain the elegance, refinement, and proportions that characterize all of Filippino's paintings. His emphasis on elongated proportions, self-conscious gestures, and deco-

rative surface excitement, together with a personal interpretation of emotional reactions, strongly appealed to some of the younger painters then emerging in Florence, especially those associated with the lyric current soon after the beginning of the sixteenth century.

FRANCESCO DI GIORGIO

Francesco di Giorgio Martini (1439–1501) belongs to a select group of Renaissance practitioners, including Brunelleschi, Alberti, Michelangelo, Peruzzi, and, of course, Leonardo da Vinci, who excelled in several of the arts at the same time. A native of Siena, he may have been trained by Vecchietta (1410–1480), both a successful painter and sculptor. Francesco di Giorgio's early career, however, is too poorly documented to make any definitive judgments. He appears in extant records for the first time in 1464, when he produced a wooden sculpture of *St. John the Baptist* (Siena, Museo dell'Opera del Duomo). In 1469 Francesco was charged with overseeing the intricate aqueduct system of Siena for a three-year period, and similar assignments as an engineer and architect continued to come for the remainder of his life, both in Siena and in other centers. His fellow Sienese painter Neroccio de' Landi (1447–1500) became his partner, perhaps as early as 1469, until litigation abruptly dissolved the relationship in 1475. In the 1470s Francesco painted two different versions of the *Coronation of the Virgin,* one in fresco for the ancient Hospital of Santa Maria della Scala, done in 1471 (destroyed), and another, originally for the Benedictine abbey church outside Siena at Monte Oliveto, which appears to have been painted in 1472 [146]. Francesco signed a *Nativity* [147] that was commissioned in 1475.

By the mid-1470s, Francesco di Giorgio's other skills were in strong demand, and in 1477 he was already in the service of the famed Federigo da Montefeltro of Urbino, primarily as a military engineer and architect. He also designed relief sculpture, intarsia decorations, medals, and war machines for his patron. Francesco di Giorgio was in Naples in 1479 and in 1480. In 1484 he began his most famous building, the centrally designed Church of the Madonna del Calcinaio outside Cortona. Returning to Siena from time to time during the same period, he continued to receive various official commissions, including the bronze angels for the high altar of the Sienese Cathedral (finished in 1498), but no paintings are recorded later in his career. Francesco, summoned to Milan to give advice on how to design the dome of the Cathedral, came into contact with Leonardo da Vinci, who later owned and annotated one of Francesco's manuscripts.

The Sienese artist, along with important Florentines and a few other "foreigners," participated in a competition for designing a façade of the Cathedral of Florence. Back in Naples during the 1490s, he continued to be active in Urbino. In 1498 he finally returned to Siena for good when he was made *capomaestro* of the works at the Cathedral. Francesco died in Siena toward the end of 1501, leaving behind, in addition to the works already mentioned, a series of manuscripts of the greatest importance devoted to architecture and engineering. No documentation confirms that he continued to paint after the *Nativity,* although critics usually assume later activity, including the magnificent newly discovered frescoes in the Bichi Chapel of Sant'Agostino in Siena which have been attributed to him (erroneously, in my opinion).

⁙

The altarpiece depicting the *Coronation of the Virgin* [146] was painted for the Chapel of Sts. Sebastian and Catherine of Siena at Monte

146. Francesco di Giorgio. *Coronation of the Virgin*, ca. 1472(?). Wood panel, 341 × 200 cm. Siena, Pinacoteca.

Oliveto, hence the prominence of those two in the lowest zone of the picture. Considering Francesco di Giorgio's activity as an architect, it is surprising that there is so little convincing structure to the composition and that the spatial relationships are so difficult to decipher. No single, consistent optimal point of sight where the perspective operates effectively seems to have been planned. As a result, while one might expect to see the two kneeling saints from above or the central group of Christ and Mary from below, they are all seen almost straight on. Christ, the dominant image on the central axis, is in the act of crowning the kneeling and proportionally somewhat smaller Mary. His left arm, thrust across the body, forms a wedge below the nearly diamond-shaped head. A swirling God the Father, surrounded by zodiacal signs and angels, supervises the uppermost zone.

Mary and Christ rest upon a flat cloud bank shown in sharp foreshortening (although the figures themselves are not foreshortened). On a ledge in the same zone, seated figures—including St. John the Baptist cross-legged on the left and crowned King David holding his lyre on the right—and handsome angels imply a semicircular distribution in space, a compositional innovation that will find reverberations in the following decades. Along the sides, hosts of saints are piled up in the narrow vertical strips, recalling a Sienese tradition that goes as far back as Duccio di Buoninsegna's *Maestà* of the early *trecento*. The spaces are hard to reconstruct; the surfaces are overcrowded; the color strong although unnatural.

Francesco had his artistic and cultural roots in Siena, as a look at Sassetta's elongated figures, with their elegant limbs and miniaturized facial features, tends to confirm. But just as Sassetta experienced outside, that is to say, non-Sienese influences, so too did Francesco di Giorgio. His personal style was modified and molded by impulses from two North Ital-

ian painters active in Siena, Girolamo da Cremona and Liberale da Verona, both of whom reflected Mantegna's innovative formal style. In addition, Francesco di Giorgio was keenly aware of what was unfolding in nearby Florence. Critics often point out the influence of Filippo Lippi and of Verrocchio, as well as that of the Pollaiuolo shop. Donatello and Ghiberti had left works in Siena which are also reflected by Francesco di Giorgio. The twisting, winged, nude *putti* of the *Coronation*, who help support the cloud bank, are modifications of Donatello's tiny music-making angels in the Sienese Baptistry.

Francesco di Giorgio constantly disregards the structure of figures or their anatomy. Bodies are usually heavy, arbitrary, and abstract, without special attention to the light sources; for example, the St. Dorothy standing on the extreme right edge of the picture with the flowers gathered in her garment. Her long face, accentuated by a strong chin and a wide-eyed expression, is curiously personalized, suggesting deep intensity and even an affliction, often found in Francesco's somewhat melancholy vision. Like Botticelli, his world consists more of fantasy and imagination than of a demanding observation of nature. In the *Coronation of the Virgin* the unity of the picture is sacrificed to an abundance of detail.

In the short time between the *Coronation* and the *Nativity* [147], more properly an Adoration of the Child, commissioned in 1475 and presumably finished a year later, we see a shift that may signal a new phase in Francesco's development. But the number of paintings that can be attributed to him, much less dated or datable ones, is so small that his evolution as a painter is virtually impossible to define. The *Nativity* is a more confident and less crowded composition than the *Coronation*. The radically twisted St. Joseph in the center, with his active movement, is an ambitious restatement of the Christ from the earlier picture. The sa-

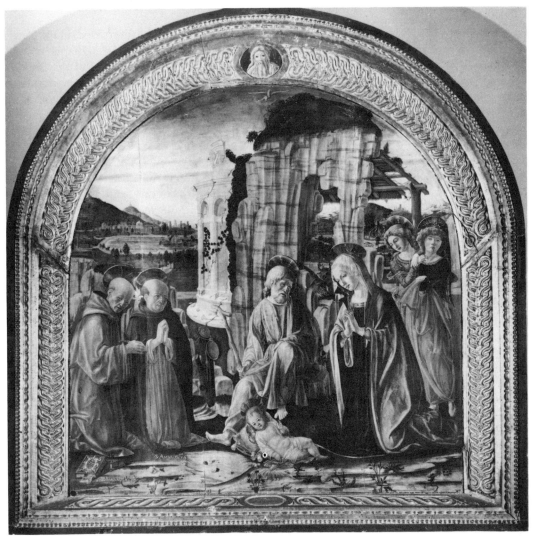

147. Francesco di Giorgio. *Nativity*, 1475. Wood panel, 198 × 104 cm. Siena, Pinacoteca.

cred figures, including St. Bernard and St. Thomas (not Sts. Bernardine and Ambrose, as their embossed inscriptions added in the nineteenth century would have it) with Joseph and Mary, form a flattened arc in space around an alert, open-eyed Child who rests His head on a pillow, which is formally related to the picture frame. Francesco's treatment of the drapery gives the impression of having been based on careful studies, particularly noticeable in the figure of St. Bernard. The figures, all on the same plane, are preceded by a bit of bare terrain. Directly behind the manger, a simple lean-to is attached to an outcropping of rock, with a segment of a classical building in a decaying state. Still further in the distance is a well-articulated landscape with a local Sienese flavor. The two angels standing casually

on the right are tall, weightless images enrapt in their own dreams.

Late in life Francesco di Giorgio may have turned to painting again, following work done in bronze relief, but the attributions made for a late period are full of problems since Sienese painting toward the end of the fifteenth century has not yet been carefully studied. Outsiders begin to dominate the local scene. Perugino, Pinturicchio, and Signorelli, all active in Siena, overshadowed Francesco as a painter. It is fair to conclude that he was, in fact, more interesting as an architect and sculptor than as a painter.

PIETRO PERUGINO

Pietro di Cristofano Vannucci, known as Pietro Perugino (1452?–1523), was born in an Umbrian town near Perugia called Città della Pieve at an uncertain date, perhaps in 1452, since a reliable contemporary source (Giovanni Santi) describes him as being the same age as Leonardo. He is mentioned in his native town in 1469 but by 1472, if not earlier, he was in Florence, where he had enrolled in the Confraternity of St. Luke. From this point on Perugino was often on the move during a career that lasted over half a century, traveling from Florence to Perugia and Città della Pieve as the main points of his activity, but also to Venice, Cremona, Pavia, Fano, Pisa, Siena, Orvieto, and Rome. He was clearly a painter in demand, and one who left his mark over a large part of Italy. Older sources suggest that Perugino may have had some training in Verrocchio's *bottega*. In 1481–82 Perugino worked together with a group of painters in the Sistine Chapel [148], although he had already painted there a year or two earlier, when he seems to have frescoed two scenes on the altar wall and the altarpiece itself, all of which gave way to Michelangelo's *Last Judgment*. Even before that, in 1479, Perugino had painted the Cap-

pella della Concezione (destroyed) in the Vatican Palace. It is often suggested that he was in charge of the overall program of the Sistine Chapel frescoes for Sixtus IV. Although no confirmation has been found to support this theory, he undoubtedly had the largest share, and he had been on the spot before the others had been called in.

The frescoes on the walls of the Sistine Chapel are among the most important painted in the fifteenth century, and no study of Renaissance painting can possibly ignore it. Two documents verify that there were four masters involved in Sixtus IV's project in the early stage: Perugino, and the Florentines Botticelli, Ghirlandaio, and Cosimo Rosselli. Although the contributions of these painters can be identified on the basis of stylistic comparisons and with the help of Vasari's descriptions, problems connected with the collaboration of workshops have arisen. The names of other artists who may have worked on the project have been suggested, including Filippino Lippi, Signorelli, Pinturicchio, Biagio di Antonio, and Piero di Cosimo. The program consists of eight scenes each from the life of Moses and the life of Christ, typologically paralleling one another. Those on the altar wall by Perugino were destroyed; those on the entrance wall were thoroughly repainted in the sixteenth century, leaving twelve representative works of 1481–82 by leading masters.

Perugino was still in Rome in 1484, when he worked on the decorations for the festivities in honor of the coronation of Innocent VIII. During the following year, he was awarded Perugian citizenship. In 1486 he was again in Florence, where he was in a fight for which he paid a steep fine. In 1489 negotiations began between Perugino and the officials of the Cathedral of Orvieto with the purpose of having him complete the frescoes for the San Brizio Chapel, barely begun by Fra Angelico. After a ten-year period of drawn-out exchanges, the

148. Vatican, Sistine Chapel. Plan of the wall frescoes

A. Perugino. *Assumption of the Virgin* (destroyed)
B. Perugino. *Finding of Moses* (destroyed)
C. Perugino. *The Circumcision of Moses' Son*
D. Botticelli. *Moses in Egypt and Midian* [131]
E. Rosselli(?). *The Crossing of the Red Sea*
F. Rosselli(?). *The Giving of the Law* and the *Adoration of the Golden Calf*
G. Botticelli. *The Punishment of Corah and the Sons of Aaron;* the *Stoning of Moses*
H. Signorelli(?). *The Last Acts and Death of Moses*
I. Perugino. *Nativity* (destroyed)
J. Perugino. *Baptism of Christ*
K. Botticelli. *Temptations of Christ* and the *Old Testament Sacrifice*

L. Ghirlandaio. *Calling of Peter and Andrew* [221]
M. Rosselli. *The Sermon on the Mount*
N. Perugino. *Christ Handing the Keys to St. Peter* [149]
O. Rosselli. *The Last Supper*

Frescoes on the entrance (east) wall (not shown):

Signorelli (?). *Archangel Michael Defending the Body of Moses from the Devil* (repainted, sixteenth century)

Ghirlandaio. *Resurrection and Ascension of Christ* (repainted, sixteenth century by Matteo da Lecce)

commission went instead to Luca Signorelli.

During 1491 Perugino is recorded in Rome and Florence, and again in Rome in the following year. He signed and dated an altarpiece of the *Madonna Enthroned with Sts. John the Baptist and Sebastian* for San Domenico in Fiesole [151] in 1493, the same year in which he married the daughter of Luca Fancelli, a Florentine architect who was active in northern Italy. Perugino obtained an

important commission for the Doges' Palace in Venice in 1494 and was there the following year, although he apparently never even began the frescoes. Back in Perugia he received the commission for the altarpiece in San Pietro in 1495, and the Cambio, the bankers' guild, awarded him the important assignment to decorate their small hall in 1496, work that he completed in 1500. In the years between, he signed an altarpiece in Fano (1497)

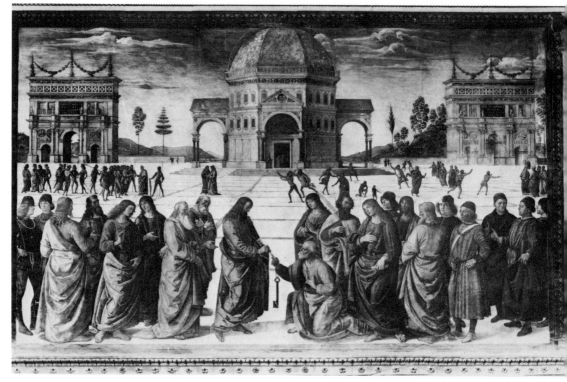

149. Pietro Perugino. *Christ Handing the Keys to St. Peter*, 1481–82. Fresco, 335 × 550 cm. Rome, Vatican, Sistine Chapel.

and was also active in Florence. A correspondence begun with Isabella d'Este in 1500 resulted in the *Battle of Love and Chastity* [159] for her Mantuan *studiolo* (private study).

Perugino was commissioned by the wealthy Chigi family to paint an altarpiece for them in Sant'Agostino in Siena in 1502. He was a member of the committee to decide on the placement of Michelangelo's *David* in Florence in 1504. In 1505–8 the painter was active in Perugia and Città della Pieve, and in 1508 he was once more in Rome to fresco the ceiling of the Vatican Stanza dell'Incendio, whose walls Raphael painted a few years afterward. Over the span of the next decade Perugino continued the pattern of intense movement between Florence and Perugia. In 1521 he

signed a fresco in Spello (Umbria); two years later he died in a small town near Perugia. He had been a productive, well-appreciated, and well-traveled painter.

⊹⊹

In constant demand during most of his life, Perugino produced much of his huge output with help from an active workshop, perhaps more than one, working simultaneously in different cities. He seems to have been willing to take on whatever commissions came his way wherever they turned up if the price was right. Works that he made or had a share in making vary in quality and in the power of invention. Although not strictly speaking early, the frescoes Perugino undertook for the

Sistine Chapel offer the first firmly established indication of his art. He was then nearly thirty (or even older if the date of his birth is taken as 1445, as is sometimes done) and a master of authority.

Among his frescoes in the Sistine Chapel the *Christ Handing the Keys to St. Peter* [149] is stylistically the most instructive, although even here considerable collaboration may be assumed. The main figures are organized in a frieze in two tightly compressed rows close to the surface of the picture and well below the horizon. The principal group, showing Christ handing the gold and silver keys to the kneeling St. Peter, is surrounded by the other Apostles, including Judas (fifth figure to the left of Christ), all with halos, together with portraits of contemporaries, including one said to be a self-portrait (fifth from the right edge). The flat, open piazza is divided by colored stones

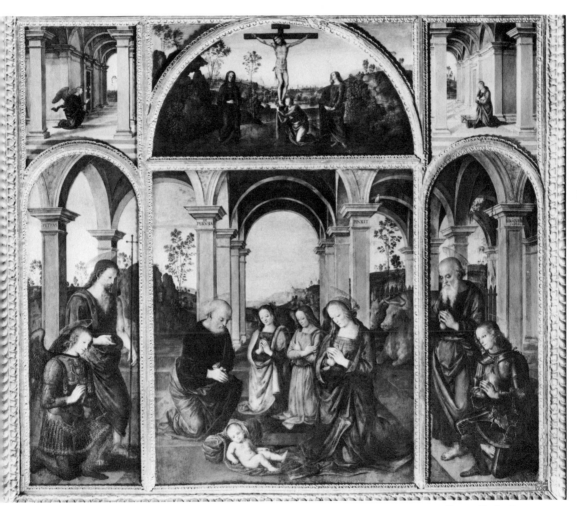

150. Pietro Perugino. *Albani Torlonia Polyptych*, 1491. Wood panel, 138 × 151 cm. Rome, Torlonia Collection.

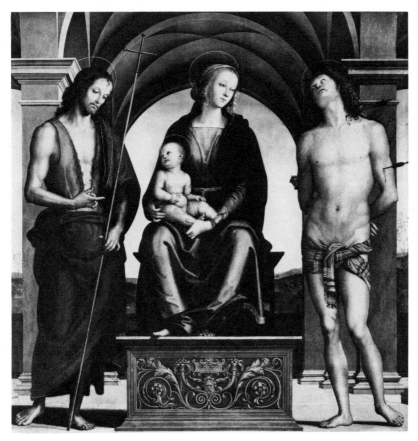

151. Pietro Perugino. *Madonna Enthroned with Sts. John the Baptist and Sebastian*, 1493. Wood panel, 178 × 164 cm. Florence, Uffizi.

into large foreshortened rectangles, although they are not used in defining the spatial organization. Nor is the relationship between the figures and the felicitous invention of the porticoed Temple of Solomon that dominates the picture effectively resolved. The triumphal arches at the extremities appear as superfluous antiquarian references, suitable, one must suppose, for a Roman audience. Scattered in the middle distance are two secondary scenes from the life of Christ, including the Tribute Money on the left.

The style of the figures is dependent upon Verrocchio. The active drapery, with its massive complexity, and the figures, particularly several Apostles including St. John the Evangelist, whose beautiful features, long flowing hair, elegant demeanor, and refinement recall St. Thomas from Verrocchio's bronze group on Orsanmichele [121]. The poses of the actors fall into a small number of basic attitudes that are consistently repeated, usually in reverse from one side to the other, signifying the use of the same cartoon. They are graceful and elegant figures who tend to float on the balls of their feet rather than to

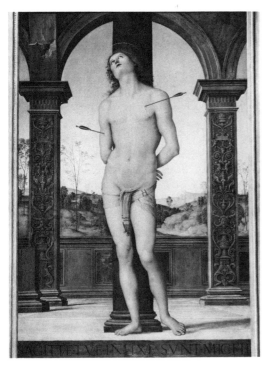

152. Pietro Perugino. *St. Sebastian*, ca. 1495. Wood panel, 170 × 117 cm. Paris, Louvre.

153. Pietro Perugino. *Mary Magdalen*, ca. 1500. Wood panel, 47 × 34 cm. Florence, Pitti Palace.

stand firmly on the earth. Their heads are smallish in proportion to the rest of their bodies, and their features are delicately distilled with considerable attention to minor detail. Perugino's figures fall unmistakably within the lyric current and are synonymous with it.

The octagonal temple with its ample porches that dominates the central axis must have had behind it a project created by an architect, but Perugino's treatment is like the rendering of a wooden model, painted with exactitude. The building with its arches serves as a backdrop in front of which the action unfolds. Perugino has made a significant contribution in rendering landscape. The sense of an infinite world that stretches across the horizon is stronger than in almost any other work of his

contemporaries, and the feathery trees against the cloud-filled sky with the bluish hills in the distance represent a solution that later painters would find instructive, especially Raphael.

As demonstrated in the biographical sketch, there is a lacuna among the firmly datable paintings of nearly a full decade until the signed and dated *Albani Torlonia Polyptych* of 1491 [150] and a number of works from 1493, including the *Madonna Enthroned with Sts. John the Baptist and Sebastian* [151]. Perugino tended to re-use compositions like this one, with the Virgin sitting on a classicized base. Undoubtedly Perugino turned out such pictures in large numbers, and they were popular. The saccharine expressions of the figures,

the tiny, refined features, the closely modeled flesh treated with the same mechanical attention as the architectural elements, and the open expansive landscapes with a low horizon are part of a formula Perugino repeated in many of his paintings. The figures sometimes become banal, revealing an absence of artistic invention.

Perugino seems to have taken the easy road in his career, and was frequently content to repeat and re-use what had worked for him previously. He lifts the St. Sebastian from this altarpiece for Fiesole for an independent painting depicting that saint [152], probably done about the same time or a few years later. Hardly altering the figure at all, he nonetheless created a moving image, possibly the result of deeper concentration and firmer commitment. His modeling is precise, and the expression here overcomes a purely automatic

sweetness. The architecture takes on the reality of still-life painting with a broken segment in the upper left, a menacing feature within an otherwise tranquil, airy landscape.

Another picture in which Perugino freed himself from obvious and lazy solutions to achieve a powerful image is the bust-length *Mary Magdalen* [153], which can be dated about 1500, when Perugino's reputation was at its peak. The painter makes use of the expressive potentialities of the hands gently resting one over the other. The painting, presumably produced for private devotion, is treated much like a portrait. The type Perugino favored here has a nearly oval head, a pathetic expression, close modeling, delicate features, and flowing, wavy hair rendered with warm red-oranges dominating. In an actual portrait, that of *Francesco delle Opere* [154], which is dated 1494 on the back, the hands also have a

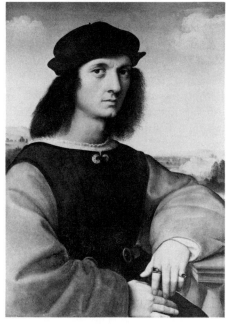

154. Pietro Perugino. *Francesco delle Opere*, 1494. Wood panel, 52 × 44 cm. Florence, Uffizi.

155. Raphael. *Angelo Doni*, ca. 1506. Wood panel, 63 × 45 cm. Florence, Uffizi.

major expressive function. The precise treatment of the head, slightly tilted, the intensely expressive face, and the integration of the figure with the landscape are particularly successful. Bold, daring color has been revealed by a recent cleaning of the picture. Perugino presents a direct interpretation of the sitter that compares favorably with Raphael's portrait of *Angelo Doni* [155], painted more than a decade later.

Perugino, once he emerged as an independent master, hardly altered his formula for image-making. Even toward the end of his protracted career, he perpetuated a personal style developed in the 1470s and 1480s that brought him wealth and fame. The Cambio frescoes were finished by 1500 and show the painter in full control of all the technical means to produce a major statement at the height of his maturity [156]. When sufficiently challenged he was ready for the occasion. Calling upon his own previous pictorial inventions for compositional and figural solutions, Perugino was also able to summon up suitable new motives for this prestigious cycle. The Cambio was a banking institution as well as an organization for the distribution of funds for Perugia's needy. It also served as a court for mercantile litigation. Perugino's frescoes, made in conjunction with a humanist who was called in for consultation, embody the various functions of the Cambio.

The decoration is composed of a ceiling with a simulated architectural framework and contains a variety of subjects including *putti*, satyrs, grotesques, and other classical devices, as well as astrological references. Compared to the earlier Camera degli Sposi, Perugino's solution is more directly derived from antiquity than Mantegna's, whose masterly *trompe l'oeil* and style itself are more classical in spirit. Perugino's personal involvement seems to be confined more to the walls than to the ceiling. He left a vigorous self-portrait in a feigned painting within a frame and an inscription, a daring device quickly picked up by Pinturicchio. The walls contain a somewhat unexpected combination of Christian and Greco-Roman themes. *Uomini famosi* from the ancient world are placed alongside Virtues, Prophets, and Sibyls [157], as well as traditional religious scenes including the *Adoration of the Child* and the *Transfiguration*. In the wall fresco showing *God the Father with Prophets and Sibyls* [158] the figures are in two compressed rows strung across the horizon with what remains of a developed landscape. Here again Perugino follows his practice of re-using figures or parts of figures: Solomon and the Tiburtine Sibyl were painted from the same cartoon, which also served, in reverse, for the lower portion of the bearded Moses and the Cumaean Sibyl.

In Perugino's world conflicts, disruptions, and doubts are never present; an optimistic aura is certainly part of its appeal. One is tempted to see an actual share in these frescoes for the Cambio by the young Raphael, who was seventeen in 1500, but the isolation of his hand is virtually impossible. As a pupil and assistant, he worked so closely within the manner of his teacher that their efforts can hardly be distinguished. The system of spatial division in the Cambio, the relationship of one part to another, was unquestionably known to Raphael, but when faced with an analogous problem for the decoration of the Stanza della Segnatura only a few years later, Raphael chose a different solution.

One more work should be mentioned, which is interesting because of its failure rather than achievement, and because of the lengthy documentation that has survived concerning it. The *Battle of Love and Chastity* [159], made for Isabella d'Este's *studiolo,* was apparently painted only in 1505, although the commission was arrived at somewhat earlier. Perugino sought to accommodate his work to

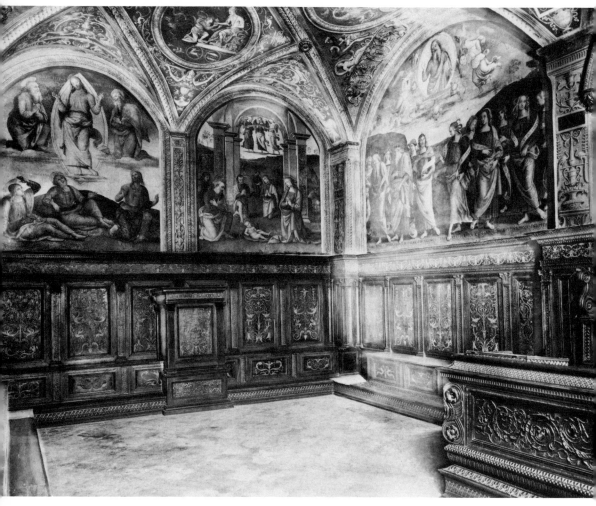

156. General view of the Collegio di Cambio, Perugia.

157. Pietro Perugino. *Fortitude, Temperance, and Ancient Heroes*, 1496–1500. Fresco, 291 × 400 cm. Perugia, Collegio di Cambio.

158. Pietro Perugino. *God the Father with Prophets and Sibyls*, 1496–1500. Fresco, 229 × 370 cm. Perugia, Collegio di Cambio.

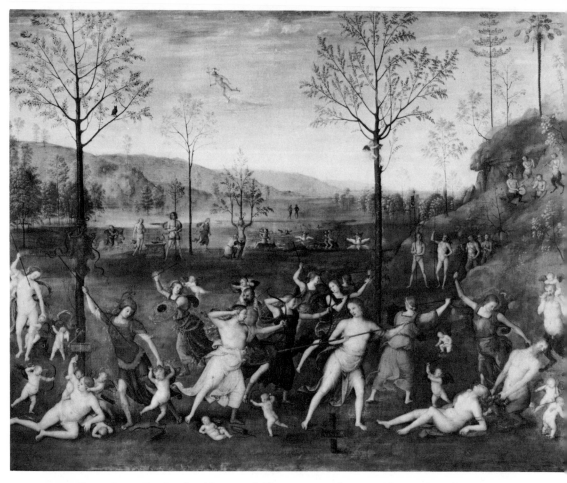

159. Pietro Perugino. *Battle of Love and Chastity*, 1505. Canvas, 156 × 129 cm. Paris, Louvre.

Mantegna's *Parnassus* in dimension and effect, but Mantegna had used oil paint whereas Perugino used tempera, automatically creating jarring differences. Furthermore, Perugino's picture appears stiff, the composition unfocused, the figures repetitive and uneasy. Still, the power of his landscape is impressive. He seems to have developed the picture as a landscape, a spacious valley with soft trees that break against a bright sky, into which he placed the small, rather ill-conceived figures. Consequently, if Perugino does not fully succeed in the busy, confused composition of figures, the picture does look ahead to pure landscape painting. Despite the absence of organic conviction in his figures, their elegance, the softly modeled flesh, the

sweet expressions on youthful, nearly oval heads are memorable and are Perugino's personal property. He had a wide influence, not only on direct pupils like Raphael and Pinturicchio, but also on Giorgione in Venice and Lorenzo Costa and Correggio in Emilia, not to mention a Florentine following.

PINTURICCHIO

Bernardino di Betto (Benedetto), called Il Pinturicchio (ca. 1460–1513), was, like Perugino, a native of the district around Perugia and consequently open to the artistic currents common to the Umbrian region. His training and early career are completely unknown; even his date of birth is a matter of speculation.

Usually considered to have been born around 1454 on the basis of ambiguous data given by Vasari, he was more likely born a few years later. He was thought by his contemporaries to have been a pupil of Perugino and to have had a share in Perugino's frescoes in the Sistine Chapel in the early 1480s. Critics have also assigned to him several paintings of a series depicting events in the life of St. Bernardine of Siena (Perugia, Pinacoteca), firmly datable to around 1473. This attribution is impossible on chronological grounds if the correct date of his birth is about 1460. The first actual notice for Pinturicchio is his inscription in the painters' guild in Perugia in 1481. There is another Perugian notice of 1481 concerning a work no longer extant. In the following year he received payments for a lunette in the Palazzo dei Priori in Perugia, his first securely datable work, although it is modest and uninformative stylistically.

The important frescoes for the Bufalini family in the Roman church of Santa Maria in Aracoeli are not documented, but may date from the late 1480s. They were produced for an Umbrian patron from Città di Castello and depict scenes from the life of St. Bernardine. Only with the decorations of the so-called Borgia apartments in the Vatican Palace, made for the Borgia pope Alexander VI (1492–1503) soon after the pope took office and probably finished by 1495, do we have another firmly dated work. In 1492 Pinturicchio was frescoing in the Cathedral of Orvieto (works no longer extant), where he was active over the next few years. By the 1490s, then, his life

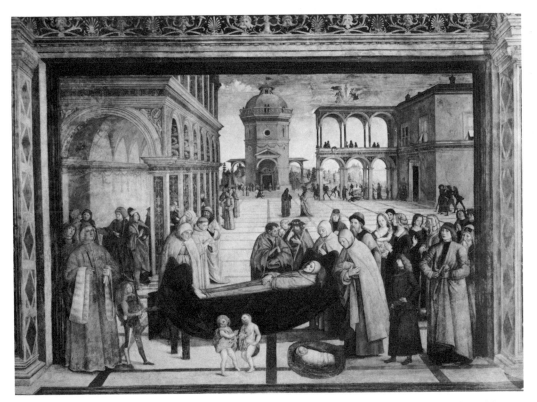

160. Pinturicchio. *Death of St. Bernardine*, late 1480s. Fresco. Rome, Santa Maria in Aracoeli, Bufalini Chapel.

and work are more thoroughly traceable. In 1501 he frescoed the Baglioni Chapel in Santa Maria Maggiore in his native town of Spello; in that year he also held political office in Perugia. By 1502 Pinturicchio had obtained the commission to fresco the Piccolomini Library, a large appendage to the Sienese Cathedral. The actual painting took place between 1505 and 1507. In Siena—where he finally settled, married, had children, and died—he had other important commissions for the Cathedral, for the Church of San Francesco, and for Pandolfo Petrucci, the chief citizen of the city. Throughout his life, Pinturicchio was never recorded in Florence. Although we might easily assume a brief trip or trips there, a sympathy for the progressive art occurring in the

Tuscan capital is completely absent from his work. In this respect, he is unlike other leading Umbrian painters, such as Piero della Francesca, Perugino, Signorelli, and Raphael, who were open to such influences.

⊹⊹

The Bufalini Chapel frescoes in the Aracoeli require special mention because they are so characteristic of Pinturicchio and because they represent a high degree of accomplishment. He treats here a fairly new iconography, the life of St. Bernardine, who was coincidentally his name saint. The *Death of St. Bernardine* [160] has a spatial stage that opens out onto a deep, irregularly shaped piazza. The architecture throughout is thoroughly up-

161. Vault of the Borgia apartments, ca. 1493–95. Fresco. Rome, Vatican.

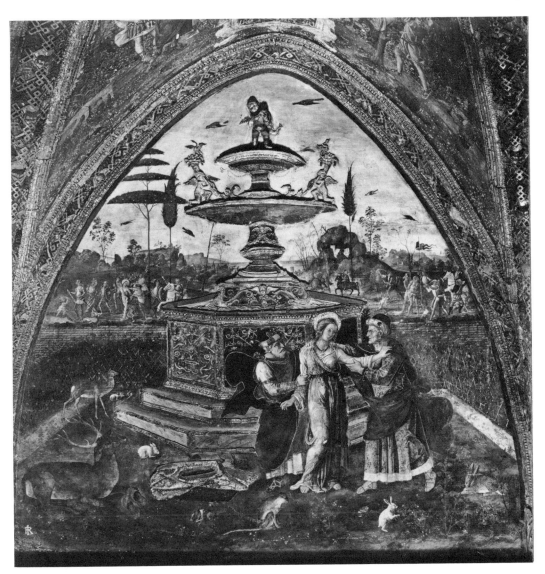

162. Pinturicchio. *Susanna and the Elders*, 1493–95. Fresco. Rome, Vatican, Borgia apartments.

to-date and elegant, recalling Perugino's treatment in *Christ Handing the Keys to St. Peter* from the Sistine Chapel [149]. The arrangement of the figures is uncontrived, almost accidental, with subscenes scattered throughout in the receding planes. Incidental naturalistic detail offers visual amusement, with the landscape in the distance treated with particular effectiveness. Pinturicchio had few peers among his contemporaries in integrating bright diversified vistas with his figures.

More firmly datable (ca. 1493–95), the frescoes for Pope Alexander VI in the Borgia apartments, consisting of many rooms, are more problematic in degree of workshop participation. For the vast enterprise, presumably done rapidly, the painter had a number of collaborators, although the overall style, the taste, and the program must have been Pinturicchio's responsibility. The busily elaborated ceilings with motifs *all'antica* and numerous classical references [161], coupled with constant allusions to the Borgia, are definitely from Pinturicchio's hand. He appears to be aware of the latest interests among the intellectuals at the papal court in terms of archaeological reconstructions and typological landscapes but without the kind of commitment and conviction we see in Mantegna, for example. His is a style of safe modernity that quickly became old-fashioned. Overly rich surfaces are apparent in the best of the scenes, like *Susanna and the Elders* [162], where one has the typical impression of having too much of everything. The fountain, partially modeled in low relief with real stucco, competes with the purely two-dimensional painted elements and overpowers them.

The recently restored Piccolomini Library frescoes reveal no dramatic shift in Pinturicchio's style, and the cycle is, if nothing else, a rare example of a unified decoration of the early sixteenth century. Well suited to Pinturicchio's skills and to a somewhat provincial Siena, his lyric style fits comfortably into the medieval setting of the Cathedral—as the young Michelangelo's statues for the Piccolomini altar that is located a few yards away do not. The subject matter concerns incidents in the life of Aeneas Silvius Piccolomini, the Sienese pope (Pius II) and humanist, an unusually complete program for someone neither a saint nor a ruler.

The narratives are illustrated with descriptive clarity, the figures precisely drawn, the unatmospheric landscape bright and sharply defined. For the *Aeneas Silvius Piccolomini Departs for Basel* [163], the first and among the most inventive, there is a preparatory drawing [164], frequently attributed to the young Raphael. In the fresco the elegant manner of Pinturicchio's style is especially discernible in the central figure, that of the youthful Aeneas Silvius, heroically set upon a white horse placed obliquely in space. The lad turns sharply to face the spectator. His refined features and modish garments and the delicate hound, highbred and quivering, reflect a set of choices that can be traced back to artists like Pisanello and Sassetta in the previous generation. Seen through a high arch with decorative devices carried down from the fully articulated ceiling which Pinturicchio must have worked on first, the landscape takes up more than half the available space. A special bonus is included, a tour de force and one not provided in the drawing: a storm at sea and a rainbow in the sky. These daring naturalistic inclusions are examples of the originality that crops up in this cycle. Significant stylistic breaks with his earlier works, however, do not occur.

Another engaging detail is found in the slightly earlier fresco cycle in Spello where, as a means of signing the work, Pinturicchio has included his own self-portrait on the right side of the *Annunciation* [165], but not as is usually done in *quattrocento* examples, in among the

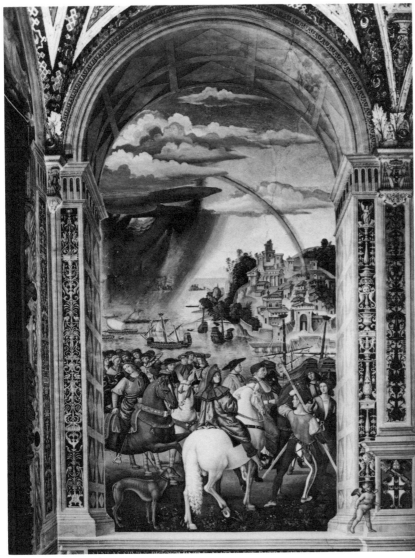

163. Pinturicchio. *Aeneas Silvius Piccolomini Departs for Basel,* ca. 1506. Fresco. Siena, Cathedral, Piccolomini Library.

164. Raphael(?). Preparatory drawing for *Aeneas Silvius Piccolomini Departs for Basel,* ca. 1505. Pen, bister, and white lead, 70.5 × 41.3 cm. Florence, Uffizi, Gabinetto di Disegni e Stampe degli Uffizi.

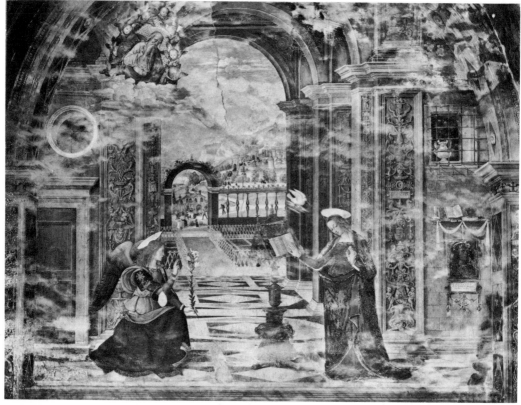

165. Pinturicchio. *Annunciation* (with self-portrait), 1501. Fresco. Spello, Collegiata di Santa Maria Maggiore, Baglioni Chapel.

spectators, peering out of the scene represented. Instead, following a similar image by Perugino in the Cambio frescoes in Perugia, he has made his portrait as a bust within a painted marble frame on a wall. Under it in clear bold lettering is his name on a plaque. Pinturicchio was a successful portraitist, and there are a large number of portraits attributed to him. In them and in his art generally, what is absent is a soaring artistic spirit. He lacked the poetry of Perugino's best works and the rigor and the genius of his fellow pupil, Raphael.

COSMÈ TURA

Among the Ferrarese, Cosmè di Domenico Tura (ca. 1430–1495) holds a special place due

to his extraordinary originality. He is first mentioned as painting banners attached to trumpets for the court of his native Ferrara in 1451, and in the following year he is documented as having painted a processional flag. Next mentioned in Ferrara again in 1456 and in 1457, he was employed by Borso d'Este, who named him court painter in 1458. After occasional work for the Este, the rulers of Ferrara, he painted ten panels for the Pico della Mirandola (lost) in 1465, and in 1467–68 he painted an altarpiece for San Domenico in Ferrara (lost). Along with other works Tura was paid for painting the organ shutters for the Cathedral of Ferrara in 1469 [166, 167], which are his earliest extant and firmly datable works, presumably begun a year or two before.

Tura undoubtedly had a share in the famous

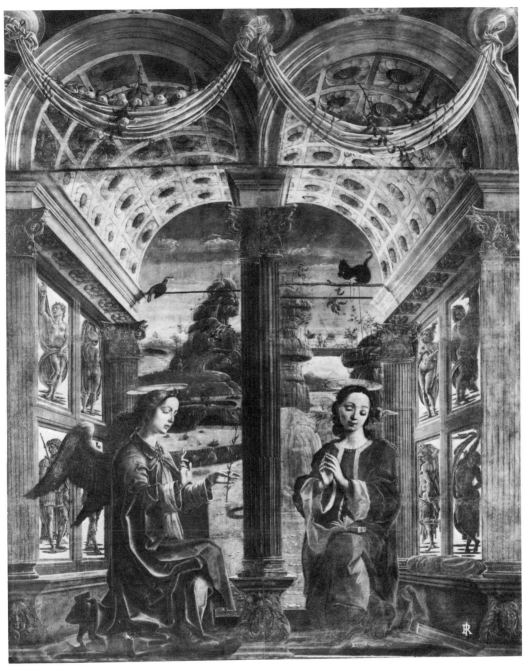

166. Cosmè Tura. *Annunciation* (organ shutter, interior, left and right wings), 1469. Canvas, 413 × 338 cm. Ferrara, Museo del Duomo.

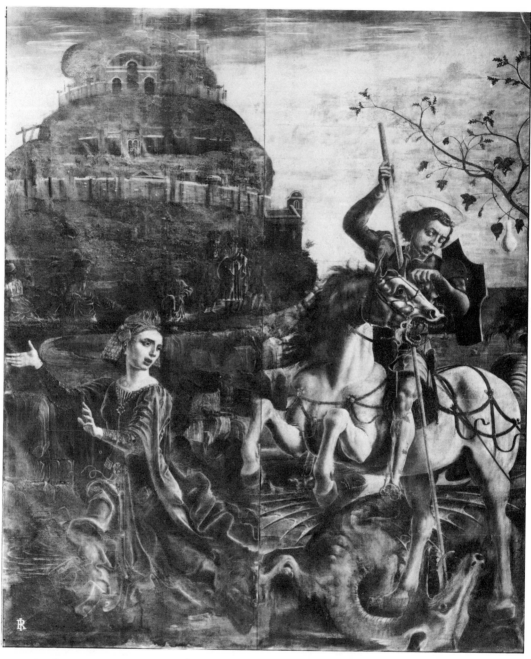

167. Cosmè Tura. *St. George and the Princess* (organ shutter, exterior, left and right wings), 1469. Canvas, 413 × 338 cm. Ferrara, Museo del Duomo.

frescoes depicting the months in the Schifa-noia Palace, which were undertaken in the early 1470s. Ercole d'Este continued to employ him after his brother Borso died in 1470, and for Ercole he designed silver and gold vases, tapestries, and furniture ornaments. In the next decade and beyond he was frequently called upon for portraits of the ducal family, but very few have survived, none without attribution questions. Likenesses of Isabella d'Este, who married Francesco Gonzaga of Mantua, and her sister Beatrice d'Este, who married Ludovico Sforza of Milan, are mentioned in contemporary sources. In 1486 Cosmè left the service of the court and seems to have worked independently until his death in 1495. From what we know Cosmè traveled little during his lifetime, concentrating his activities in his native city, where he was instrumental in giving rise to a vigorous pictorial tradition.

<div align="center">✢</div>

The organ frontal for the Cathedral must serve as an introduction to the painter, although he was about thirty-nine years old when it was finished and obviously a fully formed painter. On one side was an *Annunciation* [166] and on the other *St. George and the Princess* [167], now shown on four separate canvases. These works were painted with tempera, although Tura seems frequently to have employed oils as well. They are emotionally charged, full of movement and intense expressionism. In the *St. George* Tura's lyric treatment of forms has features common to other second generation lyric painters, stated with his special brand of imaginative and even eccentric forms. The frightened princess, placed close to the picture plane, moves swiftly to the left of the single canvas she occupies. Her fluttering, irregular draperies with decisive hills and valleys are carefully studied, but they do not follow the structure of her body or even her pose, becoming instead alive

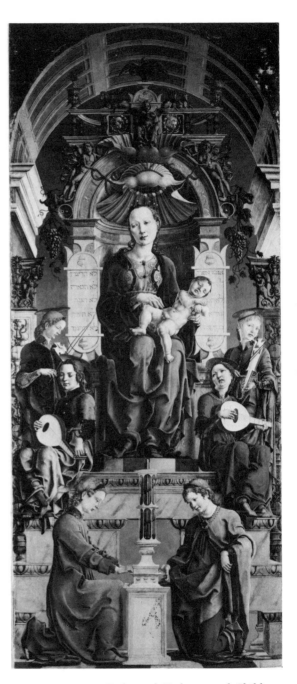

168. Cosmè Tura. *Enthroned Madonna and Child with Angels (Roverella Altarpiece),* ca. 1475–80. Wood panel, 239 × 102 cm. London, National Gallery.

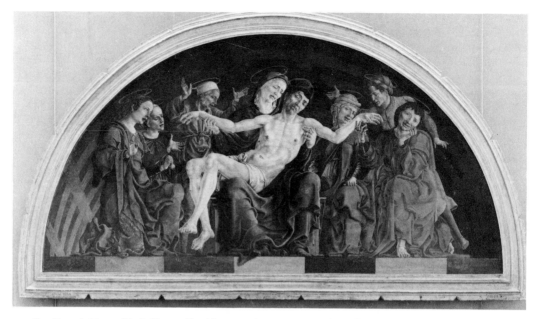

169. Cosmè Tura. *Pietà (Roverella Altarpiece)*, ca. 1475–80. Wood panel, 132 × 267 cm. Paris, Louvre.

and rebelliously independent of the forms they hide.

Light is effectively rendered as an expressive device without becoming a particularly naturalistic component, striking here and there, helter-skelter, although a certain concentration on the left may be isolated. Highlights are also found on the right-hand edges of forms, especially in the canvas showing St. George impaling the dragon. Color is equally anti-naturalistic. The tight-fitting leather costume of the saint is outlined, pale maroon against a golden sky. His gray horse, ferociously participating in the confrontation, is accentuated by a calligraphic arrangement of thin red straps. There are strong echoes of Mantegna, perhaps in part filtered through Squarcione, in motives like the rendering of the winding trail with figures on the hill behind the princess and a tight application of paint, which permits abundant minuscule detail. Critics have called attention to connec-

tions with later Donatello, especially with his reliefs made for nearby Padua. These are difficult to isolate within the personal expressive idiom of the St. George, except for the shared intensity in treating sacred figures and narratives.

Tura's chief work was probably the now dismembered *Roverella Altarpiece,* made for that family's chapel in the Ferrarese church of San Giorgio fuori le mura between 1475 and 1480. Parts of the complex work are preserved in various collections, with the central panel of the *Enthroned Madonna and Child with Angels* in London [168] and the massive lunette showing the *Pietà* in Paris [169]. These are superior examples of Tura's art, which did not undergo decisive shifts, at least among the documented works or believable attributions. He was the first Ferrarese genius of the Renaissance. In his formation as an artist, Tura seems to have responded to impulses from Verona and Padua, as I have mentioned.

Locally there were frescoes by Piero della Francesca and paintings by Rogier van der Weyden and other Netherlandish masters (both groups have disappeared). Nearby, Bologna had close cultural ties with Ferrara, and the *quattrocento* sculptural tradition that flourished there had a share in the evolution of Tura and other Ferrarese painters. Niccolò dell'Arca, who is close in temperament and expression to Tura, with interest in bizarre detail and unusual juxtapositions, must have had an influence on Tura and the others.

In the *Pietà*, located in a sharply foreshortened vaulted space, the sad scene unfolds among the mourners. The three-dimensional qualities of the figures are understated in favor of surface configurations. The studied draperies and the closely observed anatomical details participate in similar interests among Tura's Florentine and Paduan contemporaries, although in Tura's treatment the active, expressive edges, as in the excited elongated hands, overcome the forms they delineate.

Space is compromised in favor of a busy agitated surface in the *Enthroned Madonna*, where a convincing illusionistic stage is nearly created by the architecture only to be undermined by the curvilinear excitement close to the surface. The artist uses daring foreshortening and perspective devices with flair as other progressive masters were doing, but Tura was too idiosyncratic to embrace these techniques unqualified by his own expressionistic instincts, which were molded by the special qualities of Ferrarese humanism and the Ferrarese court. The Christ Child on the left arm of Mary is asleep, predicting the final sacrifice, a theme popular in North Italy. The surrounding architecture is remarkably unarchitectonic, and any resemblance to a measurable mathematical logic is absent from the picture. The color, dominated by a sharp green carried even into the architecture and the figures, is jarring but engaging. The distribution of

weights and the combination of painted architecture and bronze decorations with fruit, drapery, and flesh provide a striking contrast to Mantegna's working method. Tura's is a melancholic vision of an afflicted world in which the beauty of his figures, their refinement, exaggerated *contrapposto*, and decadent elegance contain seeds of their self-destruction.

The painters who created the frescoes of the Schifanoia Palace are not fully documented, and questions of convincing attribution remain to be resolved. Nor do these extraordinary frescoes appear to have had the impact upon later painting that their originality warrants. Had they been executed in a city such as Florence, Venice, Rome, or even Milan, their influence would surely have been far greater. They are so handsome and so well reflect the humanistic ambience of Ferrara— with its court attuned to the arts of painting and music—that they should be considered in a book on Renaissance painting.

The cycle, done mostly in 1470 and 1471, was divided into twelve compartments (nearly half have perished), one for each month; these in turn were subdivided into three sections horizontally, with the middle portion devoted to symbols of the months and decans. Above are narratives representing scenes of classical mythology; below, activities typical of the seasons are depicted. In the tripartite representation for the month of *April* [170], effectively attributed to the local painter Francesco del Cossa (ca. 1436–1478), we see a courtly elegance of figure, costume, and pose and elaborate decoration, together with a complete disregard of relative proportions within each segment and from segment to segment. Although there are reflections from Mantegna's decorations in the Ducal Palace in nearby Mantua, in the Ferrarese cycle the spectator can enjoy the complex and superbly drawn images and the clever integration of the sen-

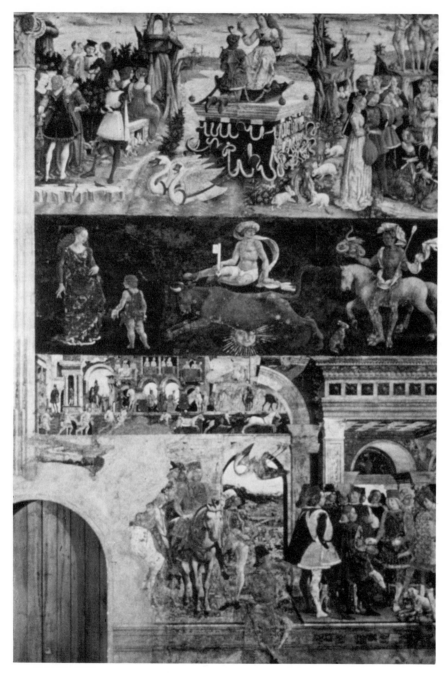

170. Francesco del Cossa. *April*, ca.
1470. Fresco. Ferrara, Schifanoia Palace, Sala dei Mesi.

sual subject and the classical references, including the *Three Graces* on the upper right, but he never participates in the illusion, nor is he fooled by the spatial devices. The surface plane is not fully pierced, and in the middle section the flattish, sharply silhouetted forms rest on the dark ground like cutouts.

Tura was almost certainly Francesco del Cossa's teacher, and many believe that he planned and designed the Schifanoia frescoes with the advice of a local humanist, although passages actually executed by him are difficult to isolate. He is often credited with being the founder of the vigorous school of Ferrarese fifteenth-century painters, who included not only Cossa but also Ercole de' Roberti. This school continued to have a significant following well into the next century.

GENTILE BELLINI

Among the Venetians who are best located within a lyric current in the second generation, Gentile (ca. 1429–1507), son of Jacopo Bellini, ranks among the finest. Perhaps two or three years older than his brother Giovanni, who will be treated in the next chapter, Gentile probably received his name from that of his father's teacher, Gentile da Fabriano. The entire early career of Gentile Bellini, like that of his brother's, is undocumented. Consequently we are completely ignorant of his early style, although the assumption that he was trained by his father and remained connected with his shop is persuasive. Both Gentile and Giovanni, whose formal backgrounds must have been about the same, were still with Jacopo as late as 1460, as attested to by an inscription for a now lost altarpiece in Padua.

The first securely identifiable and datable painting by Gentile is the signed *Beato Lorenzo Giustiniani* [171] of 1465. This damaged work has been frequently repainted, making it difficult to assess. In 1466 Gentile

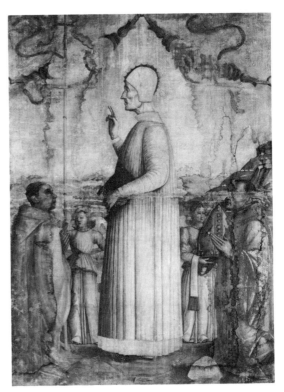

171. Gentile Bellini. *Beato Lorenzo Giustiniani,* 1465. Canvas, 221 × 155 cm. Venice, Accademia.

was commissioned to paint two large canvases (called *teleri* in Venice) for the Scuola Grande di San Marco, which have not survived. They were to have been done, according to the requirements of the contract, in the manner of similar ones made by his father Jacopo for the Scuola Grande di San Giovanni Evangelista, at an unspecified time previously. Gentile, who had been given the title of Count Palatine by Emperor Frederick III, painted *Cardinal Bessarion and Two Disciples* as part of a reliquary for a venerable fragment of the True Cross (Vienna, Kunsthistorisches Museum), apparently in 1472. Two years later he was placed in charge of the fresco restorations in the Sala del Gran Consiglio in Venice's Doges' Palace, and at that time he was referred to as a distin-

guished and excellent painter. He was also made official painter of the Republic so that he could paint portraits of the doges.

Gentile Bellini designed a marble pulpit and spiral staircase in 1476 for the Veronese sculptor Antonio Rizzo for the Scuola Grande di San Marco; they were destroyed by a fire in 1485 along with Gentile's paintings for the same lay institution. Gentile was sent to Constantinople by the Venetian government to make portraits of the sultan in 1479, and his brother Giovanni was placed temporarily in charge of the works in the Sala del Gran Consiglio. A dated painting (London, National Gallery), although poorly preserved, certifies his trip to the Middle East. Upon his return to Venice, Gentile took up the charge at the Doges' Palace, where he executed large canvases that were destroyed in a fire in 1577. Some years later, in 1492, Gentile with his brother volunteered to carry out a new set of paintings for the Scuola Grande di San Marco to replace those that had burned, work that

dragged on for a long time. Gentile, along with other painters including the much younger Carpaccio, worked on histories for the Scuola Grande di San Giovanni Evangelista, which can be dated 1496–1501. The year 1504 saw the beginning of the *St. Mark Preaching in Alexandria* for the Scuola Grande di San Marco [173]. In his will of 1507, made shortly before his death, Gentile left his brother their father's book of drawings, with the provision that he complete the work started by Gentile for the Scuola Grande di San Marco. The hundreds of drawings were clearly considered the family's prize possession, either as models for a *bottega,* or by this time, I suspect, for their sentimental value.

⁜

Gentile's stylistic dependence upon his father seems to have been sustained at least as late as 1465, when he was in his mid-thirties, in the painting of *Beato Lorenzo Giustiniani* [171], of that year. Despite its poor preservation, the

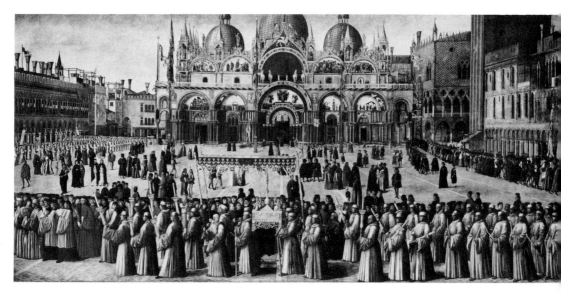

172. Gentile Bellini. *Procession of the Reliquary of the Cross in Piazza San Marco,* 1496. Canvas, 323 × 430 cm. Venice, Accademia.

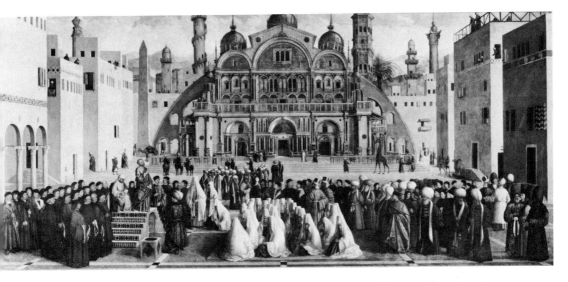

173. Gentile Bellini (later finished by Giovanni Bellini). *St. Mark Preaching in Alexandria*, begun 1504. Canvas, 770 × 347 cm. Milan, Brera.

Giustiniani recalls the tight manner of his father, but Jacopo's style, as we have seen, is not easily isolated, so that not much can be concluded even at such a relatively advanced point in Gentile's career.

The *Procession of the Reliquary of the Cross in Piazza San Marco* [172] is a large-scale history painting that offers the most complete introduction to Gentile's art. Signed and dated 1496, it falls into what should normally be considered a late phase, painted well past his sixtieth year. Since no pictures of similar compass by him have come down to us from his early or middle periods, the pattern of his unfolding style is impossible to reconstruct. The exceptional invention exemplified in this painting explains the high esteem of his city and the honors he received. It also allows us to examine his artistic style, which is so different from that of his brother. This enormous painting, rivaling in size the frescoes more common to Tuscany and Umbria, appears to be formal and solemn, but an undercurrent of casual nonchalance permeates the city view, giving

it the quality of genre. For example, the members of the confraternity in the front plane march in an organized procession, but the candlesticks they hold are haphazardly set at various angles so that what appears to be geometrical and rigid is humanized in the details.

The scene illustrated is the procession held on the feast of Corpus Domini when the Confraternity of San Giovanni Evangelista exhibited a relic of the True Cross, here shown in its golden glory. The procession winds its endless way, ultimately passing before the spectator, who has the best possible seat directly in front of the picture plane, parallel to the façade of Basilica of San Marco. The remarkable perspective, with a central line into space marked off on the pavement and a vanishing point located in the lunette of the main portal of that church, establishes a satisfying format for the complex showpiece with its hundreds of figures and massive yet colorful architectural monuments, familiar and consequently engaging to the Venetian public. It is precisely by means of the rigorous spatial construction that

Gentile manages to maintain legibility in a composition that threatens to become hectic and confusing. Light, which comes in from the left front, assists in unifying the diverse elements in the painting.

Gentile's treatment of the human figure tends to be schematized, without special attention to anatomy, structure, or weight, although the figures seem convincing due to a consistent, empirically grounded proportionality. The actors in the foreground, including presumed portraits of the painter and his brother to the right of the reliquary, are more formally posed than those in the center of the piazza in the middle distance. These stand easily, either singly or in groups, and in appearance and treatment inspired some eighteenth-century Venetian painters.

Connections with Flemish art might be appropriately cited for Gentile's pictures since by the end of the fifteenth century Netherlandish painting was long since known and widely admired throughout Italy. The scale, however, is entirely different. Instead of small altarpieces created with a rigorous and unbending realism and a tightly controlled application of paint on wood, Gentile, like Carpaccio, whose art will be examined next, used a freer application of paint on an immense linen ground. Occasionally Gentile operates with loose impasto strokes of oil paint, creating a vibrant surface when observed close at hand. One can hardly escape the excitement and scintillation of such a sumptuous, complete, and particularized world. Venice is painted with a descriptive fidelity that captures the city's magical attraction. The façade of San Marco is treated like portraiture, a category in which Gentile was particularly skilled. This is exemplified by the characterizations on the front plane, which show specific, apparently readily identifiable personages of all ages, bearded and clean-shaven, with intense expressions and rather hard facial features. A

natural successor in these encompassing panoramic city views was Vittore Carpaccio.

VITTORE CARPACCIO

Nearly thirty years separate the births of Gentile Bellini and Vittore di Pietro Carpaccio (ca. 1460–1525), yet both Venetians belong to the second generation and both adhere to lyric sensibilities. In the case of Carpaccio, late in his life he seems to have been influenced by third generation painters, notably Giorgione. The first secure information that pertains to Carpaccio's career is from 1490, when he signed and dated the *Arrival of St. Ursula in Cologne* [174], part of a series devoted to scenes from her life painted in the 1490s. The bulk of fixed points in the artist's life are derived from dated pictures, a practice common to Carpaccio, rather than from preserved documents, letters, contracts, or tax reports. Even such pictures are not without chronological problems, however, because one may assume that the date refers to the time when the work was finished. We do not know how long he may have spent on his pictures, which for the most part are large, even gigantic, *teleri*. Judging from signed and dated paintings, he seems to have worked within several slightly different modes at one and the same time, changing the scale of his figures in relation to the architectural or landscape environment, making them sometimes dominating, sometimes small. Furthermore, in Renaissance painting a signature does not necessarily mean that the master painted without assistance. Some critics even claim that a work very prominently signed could indicate heavy shop participation: the master signed the work so that the patron or client would pay a higher price.

In 1501 and 1502 Carpaccio received payments for work in the Doges' Palace; in 1502 he signed the *Calling of St. Matthew*, painted

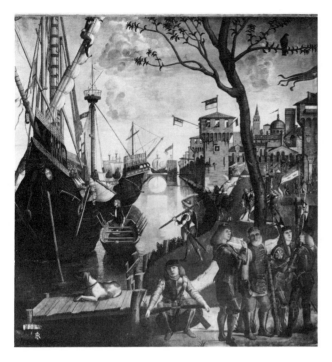

174. Vittore Carpaccio. *Arrival of St. Ursula in Cologne*, 1490. Canvas, 280 × 255 cm. Venice, Accademia.

for the Scuola di San Giorgio degli Schiavoni, which is still *in situ.* In 1507 Carpaccio was active along with Giovanni Bellini in making pictures for the Sala del Gran Consiglio in the Doges' Palace (destroyed by fire in 1577). Under Giovanni's direction Carpaccio and two other painters were charged with setting a price for Giorgione's façade frescoes at the Fondaco dei Tedeschi in 1508. In 1511 he wrote to the marchese of Mantua concerning a large picture—a view or map of Jerusalem—then in his studio (untraced). He worked on decorations for the Scuola degli Albanesi from 1504 to 1508 and for another *scuola,* that of Santo Stefano, from about 1511 to 1520. In 1522–23 payments were made to Carpaccio for work he produced for Antonio Contarini. From what little we know, the painter did not establish himself in any other center, and apparently stayed close to Venice all his life.

❖

Since in the first datable picture, from the St. Ursula cycle, Carpaccio appears as a fully mature, independent, and original painter, his training and the identification of his teacher or teachers remain guesswork. Any number of suggestions have been brought forth, ranging from Jacopo Bellini (which is chronologically impossible), Gentile Bellini, or Alvise Vivarini among the Venetians, to Mantegna from Padua and, further afield, Perugino, Ghirlandaio, and Signorelli. A possible youthful trip to Ferrara has also been suggested. This confusion concerning Carpaccio's artistic origins reflects difficulties that can occur when the lines among the "schools" of Italian painting are rigidly drawn. Carpaccio shared many qualities with his contemporaries from different regions, including a devotion to linear perspective and the pictorial possibilities of daring

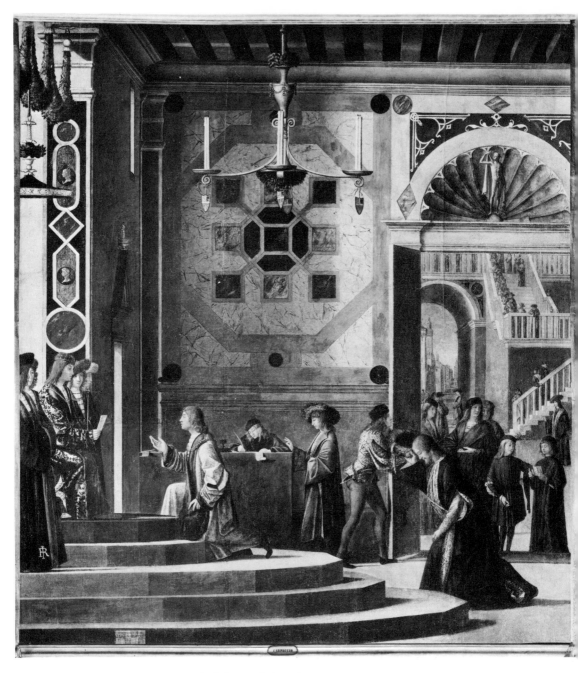

175. Vittore Carpaccio. *Dismissal of the English Ambassadors,* ca. 1492. Canvas, 280 × 253 cm. Venice, Accademia.

solutions achieved by Antonello da Messina, a gifted southerner who had a singular influence in Venice, and whose art we shall examine in the next chapter, but Carpaccio was certainly not Antonello's pupil.

In the canvas of 1490, the *Arrival of St. Ursula in Cologne* [174], the scope of interest is amply revealed: landscape and seascape elements, figures and animals, city views and a passion for still-life details. The figures, set into planes with the main groups close to the picture surface, are somewhat stiffly and ambiguously posed, the only uneasy aspect of the painting. Light, a dominant element in Carpaccio's art, as it is such an ever-present feature of the Venetian scene, acts effectively here upon sky, clouds, and water. In another

picture from the same series, the *Dismissal of the English Ambassadors* [175], the function of light has a dramatic importance, becoming an essential feature of the narrative. The scene shows the king of Brittany receiving two representatives of the king of England, who had come to obtain Ursula, daughter of the king of Brittany, as wife for the English king's son. Ursula had set down certain conditions, and they are being passed along to the ambassadors. In the center, in the middle ground, a scribe takes dictation from a member of the court; we see behind an elaborate staircase, a distant view through the arch. This picture brings to mind both Jan van Eyck and Vermeer, since these masters had a parallel interest in the potentialities of such elements as

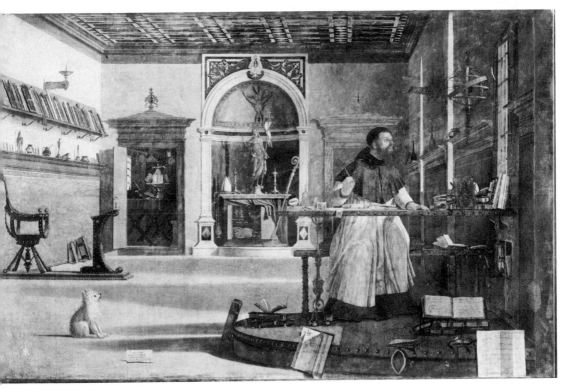

176. Vittore Carpaccio. *St. Augustine in His Study (Vision of St. Augustine),* 1502–7. Canvas, 144 × 208 cm. Venice, Scuola di San Giorgio degli Schiavoni.

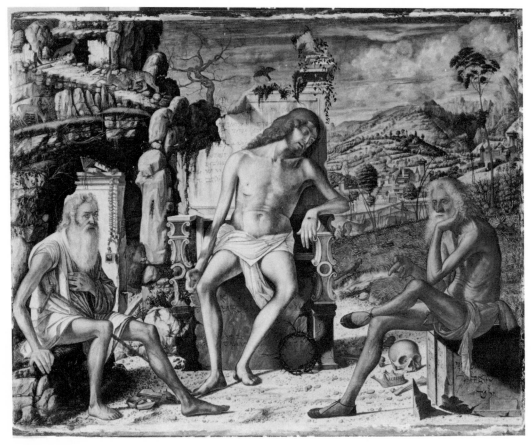

177. Vittore Carpaccio. *Meditation on the Passion of Christ*, ca. 1505. Wood panel, 70 × 86 cm. New York, Metropolitan Museum of Art.

chandeliers, but the true common denominator is the poetry of the light as it breathes life into the figures. All three are "genre" painters who scrupulously rendered specified details from the world they experienced daily, but they injected into the wealth of objects a metaphysical dimension bordering on abstraction. Obviously Carpaccio was much taken with contemporary architectural decoration and intarsia, features prominently visible in this picture, which is among his most memorable.

The paintings in the St. Ursula series are large (nearly nine feet high) and, like similar

teleri by Gentile Bellini, are equivalents to the frescoes favored in central Italy. Their very size points to Carpaccio's ability to transcribe elaborate narratives, usually relegated to predella scenes or small-scale independent paintings, onto a monumental setting. The spatial organization is strongly planar, but the divisions are loosely geometric, musical, and intuitive, so that the picture cannot be subdivided into smaller, matching units. The color is rich, winning, and descriptive but kept in restraint; the unvolumetric figures perform their roles in the drama without gravity. In these pictures, Carpaccio demonstrates his skill as a his-

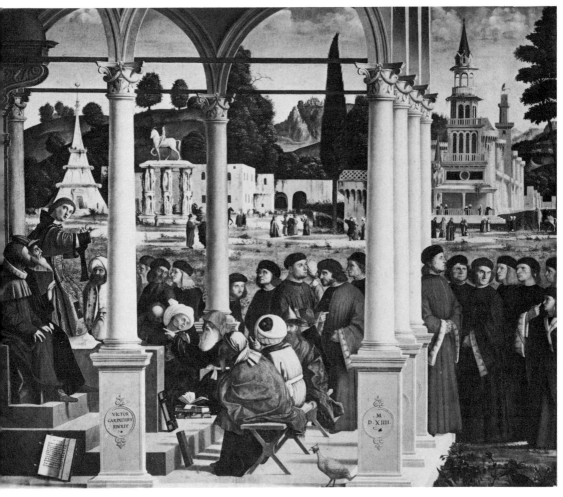

178. Vittore Carpaccio. *Disputa of St. Stephen*, 1514. Canvas, 147 × 172 cm. Milan, Brera.

tory painter, often manipulating scores of figures in a range of poses within the same composition, but he is devoted more to appearance than to structure. Carpaccio was hardly the keen student of anatomy that he was of perspective.

In a series produced for still another *scuola*, that of San Giorgio degli Schiavoni, painted between 1502 and 1507, Carpaccio produced one of his most admired works, *St. Augustine in His Study* [176], more commonly called the

Vision of St. Augustine. The fine interior with its wealth of objects documents the life of a Venetian prelate-scholar around the turn of the century. As can well be imagined, books and manuscripts dominate, cluttering the desk and the floor and lining a shelf on the left. Musical manuscripts also have a prominent position, reflecting the importance of music in Venetian life. Although the orthogonals of the perspective, best seen in the coffered ceiling, lead to the saint and more specifically to his

upraised writing hand, the actual center is occupied by a bronze statue of the resurrected Christ on an altar in the distant niche, which has a mosaic decoration in the apse. On a stringcourse beneath the bookshelf is a miscellany of objects, including small bronzes and other antiquities. The light, entering the scene from the sharply foreshortened window on St. Augustine's left, has an iconographic as well as an aesthetic function, representing a vision that transfixes the saint and even his little dog.

The *Meditation on the Passion of Christ* [177] is of approximately the same period, datable to about 1505. In it Carpaccio comes closest to Mantegna, to whom, in fact, the picture had been attributed until Carpaccio's signature was detected a few decades ago. Although still alive and active in the Mantuan court, Mantegna was quite old and isolated from the mainstream but must have had an enormous reputation. In these very years his art seems to have had a strong appeal among North Italian painters, including not only Carpaccio but those who belong to the following generation, Lotto, Titian, and Correggio. The landscape in the *Meditation*—the rocky cliff, the dead tree on the left of the decaying throne, the more distant fertile hills, and the tree breaking the horizon on the right—might be confused with Mantegna's style of half a century earlier were it not for the more facile handling of the light as it flickers on the surface of the rocks or as it hits the buildings in the village. Carpaccio here has also studied Giovanni Bellini's approach to the figure, especially in the sleeping Christ. The seated figure on the left is recognizable from the lion behind as St. Jerome, but his bearded counterpart in a pose of reflection, less easily identified, may be Job, who had an ample cult in Venice.

A signed and dated work from the following decade (1514), the so-called *Disputa of St. Stephen* [178], was once part of a cycle treating the life of that saint and is now divided among various European museums. The principal action takes place on a plane close to the surface, as was usual in Carpaccio's pictures, although the young protagonist is placed off to the extreme left somewhat above the turmoil. In addition to the exponents of other faiths, distinguished by their oriental costumes, a group of contemporaries appear, presumably portraits of the confraternity members who commissioned the series to which the painting belongs. On a technical level the skillful application of oil paint on canvas and the softened light and atmosphere that tend to break rigid edges relate Carpaccio's art to Giorgione's. One can only guess about a situation in which Giorgione as a developing painter learned much from Carpaccio in the 1490s only to offer the older master insights later on, as seems to be the case for the cowled figure with a soft white beard directly beneath a column, who gestures toward the deacon saint.

Carpaccio's attraction to fantastic architecture and to landscape continued to flourish, and specified details abound. The marble equestrian on a high base is not unlike the monuments Carpaccio would have known, especially Verrocchio's *Colleoni* in Venice. But one does not find a deep archaeological interest in his work: he tends to invent his objects and his architecture, using specific sources only as a springboard, and his figures are removed from prototypes based on ancient, classical examples. Carpaccio was a disciplined master of considerable inventive power who secularized his religious narratives but eschewed direct borrowing from antiquity. He never lost his elegance and sharpness of vision, or the musicality of his rhythmic panoramic compositions.

THE SECOND GENERATION:
THE MONUMENTAL CURRENT

Andrea Mantegna, Giovanni Bellini, Antonello da Messina, Melozzo da Forlì, Antonio del Pollaiuolo, Domenico Ghirlandaio, Luca Signorelli, Leonardo da Vinci, Piero di Cosimo

ANDREA MANTEGNA

The most famous monumental painter of the generation following Masaccio's and coming close on the heels of Castagno and Piero della Francesca was Andrea Mantegna (1431–1506). Eulogized by poets and writers during his lifetime, Mantegna was given the highest place among all painters, ancient or modern, by Giovanni Santi, court painter in Urbino and the father of Raphael, as we have already seen. Giovanni Bellini, his brother-in-law, is the only contemporary who rivals Mantegna's dominant position, at least among those born before 1450 and certainly among those from North Italy, although Bellini emerges as an independent, definable master only after a long period of maturation, unlike the precocious Mantegna. Mantegna quickly assimilated innovations of the progressive first generation masters, insights into the use of linear perspective and a system of organizing the pictorial field within a unifying, controlled order. He benefited from the example of Donatello, who was Mantegna's senior by nearly half a century. The Florentine sculptor

was in his sixties while working on the main altar of Il Santo and other projects in Padua, including the monumental equestrian statue of *Gattamelata*, at precisely the time that Mantegna was artistically defining his personality.

Donatello's activity in Padua served to reinforce and enlarge the Florentine innovations already known through works by Lippi, Uccello, and Castagno in the Veneto. Piero della Francesca, who had been active in Ferrara (and possibly in Bologna) just before 1450 is also significant in Mantegna's formation, and Piero's style is reflected as well by two of Mantegna's early co-workers, Bono da Ferrara and Ansuino da Forlì. Mantegna's rigorously organized compositions, uncompromising and graceless, together with his conception of the figure, his hard-edged drawing, harsh color, and the elimination of atmosphere and accident are all part of a personal style.

Mantegna's teacher, Francesco Squarcione (see Chapter 3), had an active and influential school in Padua. He habitually "adopted" his pupils, as was the case with Mantegna, who was able to free himself only after considera-

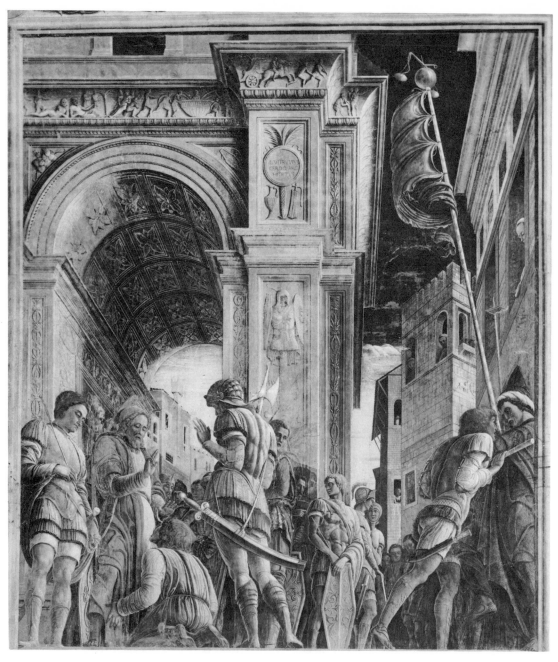

179. Andrea Mantegna. *St. James Led to Execution* (destroyed), ca. 1453–55. Fresco. Padua, Eremitani, Ovetari Chapel.

ble legal maneuvering. Unlike most painters born in the fifteenth century, Mantegna's career is reasonably well documented, even for his earliest efforts. We know that by his seventeenth year he had signed an important altarpiece (destroyed in the seventeenth century) for the Paduan church of Santa Sofia. Proof of his remarkable ability at a very young age is found in the frescoes for the Ovetari Chapel of the Eremetani church in Padua [179, 181] on which he worked with various partners and collaborators between 1450 and 1457. Shortly after, he undertook the painting of the altarpiece for the Church of San Zeno in nearby Verona, which was finished in 1460 and had enormous influence. By 1458 Mantegna was already under contract to Ludovico Gonzaga, lord of Mantua, but settled in that city only in 1460. He remained there for the rest of his life except for short periods in Tuscany and Rome. His work in Mantua included fresco decoration for the Gonzaga palaces and castles in and around Mantua, portraits and panel pictures for the family, and designs for pageants and even costumes.

He was already influential in the development of printmaking, and was one of the first Renaissance engravers. He also designed sculpture and may have modeled terra-cotta figures. Judging from inscriptions, the frescoes in the Camera degli Sposi in the Gonzaga's ducal palace, begun in 1465, were not completed until 1474 [186]. Mantegna is known to have been in Florence in 1466, in Pisa in 1467, and more than two decades later, in 1489–90, in Rome working on Pope Innocent VIII's chapel (destroyed). Following the Battle of Fornovo, a campaign in which Ludovico's son, Francesco Gonzaga, played a leading role, Mantegna painted the *Madonna della Vittoria* [192] in 1496. Ten years later, rich and famous, Mantegna died, still under the patronage of the Gonzagas.

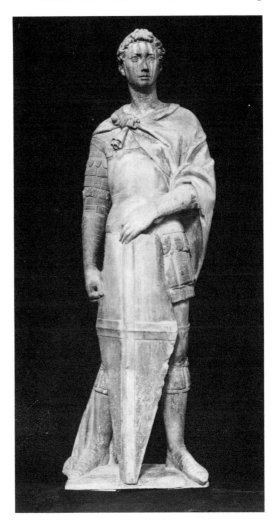

180. Donatello. *St. George*, ca. 1412. Marble, h. 209 cm. Florence, Bargello.

✠

Because of the well-documented evolution of his art, Mantegna's career can be spelled out neatly in three phases. His prehistory as an artist, that is, the training period, is less clear, but appears to have been short in any case. Once he attained artistic independence Mantegna moved far beyond anything his master

Squarcione would aspire to. The frescoes for the Ovetari Chapel and the *San Zeno Altarpiece* mark the high points of his early maturity. The fresco cycle represents scenes from the lives of Sts. James Major and Christopher. The Ovetari Chapel suffered a direct hit from a bomb in 1944, and most of the frescoes were shattered to bits (except several that had been removed for restoration), and despite piece-by-piece reconstruction only small parts were salvaged from the rubble. For the purpose of evaluating this first phase of Mantegna's style, two scenes suffice: *St. James Led to Execution* and the *Execution of St. James,* paired in the lowest zone of the left side of the chapel and painted between 1453 and 1457. They are both shown in sharp foreshortening, as seen from below *(di sotto in su),* although not from the same level in each fresco, probably indicating that they were not painted at the same time.

In the earlier *St. James Led to Execution* [179] the perspective and the architecture dominate, as though Mantegna proceeded by first establishing a theatrical stage-like space and then filling it with actors. The soldier of fiery appearance who rests on his shield, located in the middle ground near the central axis, is a paraphrase of Donatello's *St. George* [180], evidence of an artistic rapport with the sculptor that permeates Mantegna's art. The figures are decisively and unambiguously posed with pronounced *contrapposto* and occupy a zone that is less than half the height of the pictorial field, which is otherwise filled with an imposing triumphal arch on the left and an irregular, palace-lined street on the right. Every portion of the surface has painted decoration; no broad area of blue sky offers repose to the eye. The main action is framed by the arch at a point where the saint pauses on his way to his beheading to bless or, perhaps, to cure a supplicant. A turbaned patriarchal figure at the lower right is being forcefully pushed aside by a soldier, while people peer out from the windows of the building above in order to follow the excitement.

The arch shows Mantegna's dedication to the antique, which ranges from direct copying through generalized archaeological reconstruction of classical artifacts to pure invention within a classical mode. More than any other artist of the period, Mantegna was attracted by antiquity: he collected objects and carefully observed inscriptions and ancient coins, often including such elements in his pictures. At the same time, Mantegna's attention to naturalistic detail, his insistence on depicting everything that is visible, and the importance he often gives to landscape indicate at least a second-hand experience with Northern and especially Netherlandish art.

The *Execution of St. James* [181], perhaps painted after an interval of several years, has fewer participants and is markedly more dramatic than the previous scene. Now there are only a handful of foot soldiers, two equestrians, and an Eastern attendant, in addition to the horrifying executioner, whose bodily force concentrates on the blow the mallet is about to strike upon the blade that will behead the saint. James is stretched out on the ground obliquely, very close to the picture plane. The implication of this positioning is that the head, once severed, will topple into the spectator's space in the chapel. (No wonder that centuries ago a believer gouged out the eyes of an executioner!) The skillful use of foreshortening and the daring treatment of pictorial space are exceptional and recur in Mantegna's pictures. Mantegna engages the spectator by bringing the action and the forms close to the picture plane. Occasionally he has the figures break through, to encroach upon the viewer's space —potentially in the case of the soon-to-be-severed head of St. James, actually in that of the warrior who leans over the fence toward the spectator.

Probably the most striking feature of the

181. Andrea Mantegna. *Execution of St. James* (destroyed), ca. 1455–57. Fresco. Padua, Eremitani, Ovetari Chapel.

182. Andrea Mantegna. *San Zeno Altarpiece*, 1456–60. Wood panel, 480 × 450 cm. Verona, San Zeno.

Execution is the vast landscape composed of a distant, constantly rising hill on the left, which is covered with ancient buildings, contrasted on the right by a fragment of an elegant classical structure much in ruin. The action of the scene takes place in front of this majestic physical world with figures, as before, set close to the picture's surface. Only the three soldiers in the middle distance and some tiny, barely visible people on the path are actually in the landscape rather than in front of it. Obscure symbolic references abound within the picture, including the thin young oak tree, the same type from which the fence is made. A branch of the oak is broken and dying; at the right, an owl sits on a dead branch protruding from the disintegrating ruins. The painting's color is dominated by the greens of the landscape, which are brought into relation with tones used in the foreground figures, mixtures of pale violets and softer blues; but color is in the service of the overpowering forms. Little attention is given to atmospheric effects in the landscape; the figures' actions and interactions provide the drama.

If the Ovetari Chapel offers a key to Mantegna's early manner in fresco, a style that did not radically change later on, the *San Zeno Altarpiece* in Verona serves as a key to his panel painting [182, 183], on a scale that varies from slightly under-life-size figures in the main field to minuscule images in the predella, which may well reflect Mantegna's experience as an illuminator. Within a single pictorial space, the altarpiece is composed of three compartments, thus maintaining a traditional triptych format, with a predella scene for each of the main sections. The design of the frame, with four massive, engaged, wooden columns, painted and gilded, supporting an extravagantly decorated entablature and pediment, may relate to Donatello's altar design for Il Santo in Padua. Mantegna's imposing stage *all'antica* is constructed with robust piers, interior friezes, and a coffered ceiling that relate to the structure of the frame. A cloud-filled sky serves to unite all three sections as does the multicolored marble floor.

The levels of reality in the altarpiece and the associations that the spectator is expected

to make with the world of the painting are more complicated than in the frescoes in Padua and lead to further exploration in this direction in the Camera degli Sposi. The real, projecting three-dimensional frame of the altarpiece is a link between the actual and the painted world. The spatial realms are also interlaced by a consistent light source, shown in the painting as coming from the right and provided by an actual opening in the choir of the Romanesque church that was apparently made to better illuminate the painting. The saints are arranged in rows that follow the piers at the sides, with St. Zeno on the left and St. Benedict on the right of the enthroned Madonna.

The interrelating of illusionistic elements may be read within the swags or garlands found in the picture. They are composed of naturalistically rendered leaves, fruits, and vegetables in color and are attached by *trompe l'oeil* hooks at about the center of each section of the triptych, resting almost on the picture plane, between the actual columns and the painted piers visually closest to the surface. The frieze that runs along the entablature of the room has imitation marble garlands analogous to the "real" ones. Similarly, the angels accompanying the Madonna and Child have marble relatives in the frieze.

The figures are rendered with a physical integrity like those in Masaccio's *Tribute Money* and in Donatello's sculptures in Padua. For example, the mighty image of St. Peter on the extreme left, who gestures with his key into the compositional space, has a heavy drape over his tunic like the *St. Louis of Toulouse* from the altar of Il Santo. Mantegna avoids simple, sweeping forms in favor of patiently rendered ones, on this level differing significantly from Castagno, whose figure style nevertheless has much in common with Mantegna's and whose example could have played a part in his development. Light functions sub-

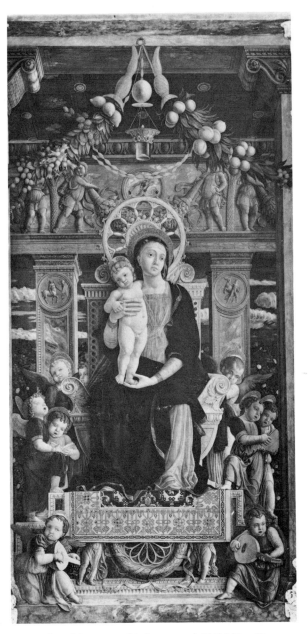

183. Andrea Mantegna. *Madonna and Child (San Zeno Altarpiece)*, 1456–60. Wood panel, 220 × 115 cm. Verona, San Zeno.

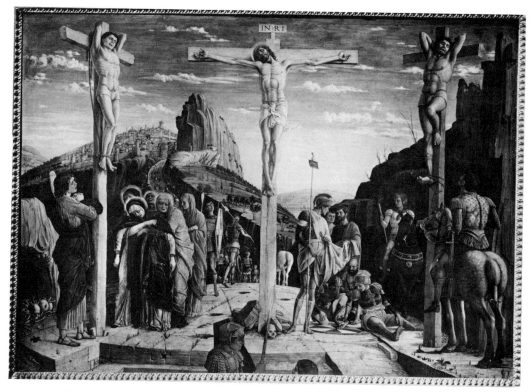

184. Andrea Mantegna. *Crucifixion* (predella panel, *San Zeno Altarpiece*), 1456–60. Wood panel, 67 × 93 cm. Paris, Louvre.

tly when Mantegna models flesh, as in the nude Christ Child or the smooth face and neck of Mary, and the close range of tones reveals an acquaintance with the art of Piero della Francesca.

In the three predella scenes, the *Agony in the Garden*, the *Resurrection* (both in Tours, Musée des Beaux-Arts), and the *Crucifixion* [184], which were separated from the altarpiece during the Napoleonic conquest of Italy, we can see Mantegna's remarkable ability to change scale without any loss of power. The proportions of the figures are slightly more elongated in the smaller, more horizontal format of the predella. If Mantegna reveals an awareness of Piero, Castagno, and even Filippo Lippi in the main field, in the *Crucifix-*

ion Jan van Eyck and Netherlandish prototypes seem more important. The side crosses are set diagonally into the foreground space of the plateau, which suddenly drops out of sight only to rise again in the distance with a city "portrait" and softened landscape still farther from the spectator. The mourners on the left, in their bitter despair, are juxtaposed with the soldiers on the right, who are intent upon the dice that will decide the winner of Christ's garments. The small painting evokes diverse human emotions; at the same time the variety of the natural world, though it is hardly free from puzzling elements, also engages the viewer's attention. An intent warrior whose specific head is in profile, possibly a self-portrait, rises from steps cut into the hill in the

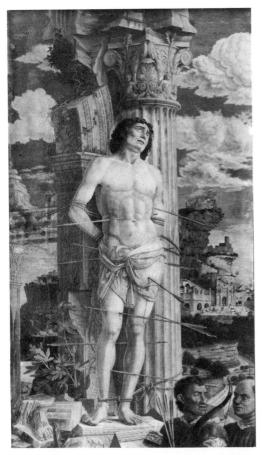

185. Andrea Mantegna. *St. Sebastian*, ca. 1480. Wood panel, 257 × 142 cm. Paris, Louvre.

186. General view of the Camera degli Sposi, 1465–74. Frescoes. Mantua, Ducal Palace.

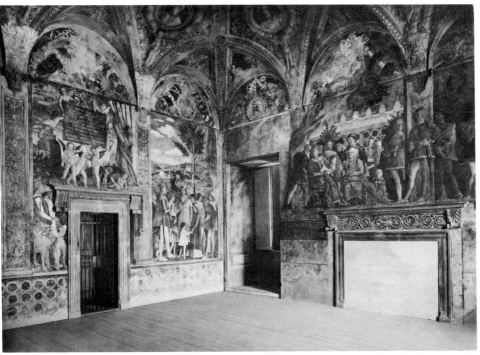

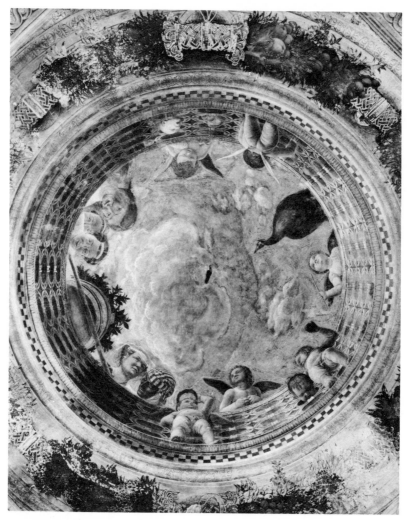

187. Andrea Mantegna. Oculus, 1465–74. Fresco. Mantua, Ducal Palace, Camera degli Sposi.

foreground. Stylistically and intellectually the *Crucifixion* sums up the entire altarpiece, revealing Mantegna as a rare artist who, in a spectacular burst of creative energy, possessed all the necessary skill to render what his mind invented during these youthful years.

The same mark of genius may be found in his other religious paintings, like the *St. Sebas-*

tian [185] of about 1480, which belongs to a second phase, that of elaboration of inventions already achieved. The saint is shown middle-aged, rather than as the customarily handsome youth. The grotesque executioners down below, placed close to the beautifully articulated classical column and capital, and a menacing world with a castle on a distant, jag-

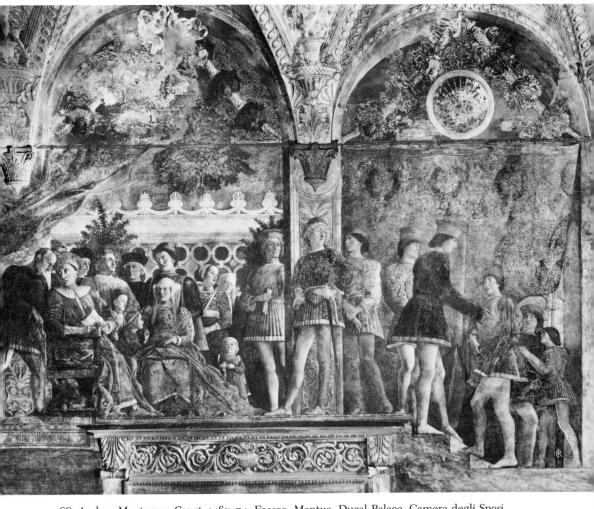

188. Andrea Mantegna. *Court*, 1465–74. Fresco. Mantua, Ducal Palace, Camera degli Sposi.

189. Andrea Mantegna. *Servants with Horse and Dog*, 1465–74. Fresco. Mantua, Ducal Palace, Camera degli Sposi.

ged cliff, form surreal juxtapositions with other enigmatic elements, including the young fig tree growing amidst the ruins and the fragmentary foot from a classical statue that blatantly resembles the foot of the saint. The saint is not shot with arrows from the front as he is conventionally shown, but from both sides, obliquely.

Mantegna's culminating achievement falls into this middle period in his development: the decoration of the Camera degli Sposi in the Ducal Palace at Mantua. The room, twenty-five feet square, occupied the artist from 1465 until 1474, a long time for a fresco decoration [186]. Work proceeded slowly because of known interruptions and the program's complexity, as well as the degree of detail required. The space of the room is essentially a cube, and in it Mantegna has created a monumental architectural reality by means of ribs on the ceiling connecting with pilasters on the walls, which are in turn supported by a marble socle. In the center of the ceiling is the much-admired oculus [187], opening onto a painted sky. The interplay of levels of reality elaborates ideas already set forth in his art. Only the corbels are actually stone; the highly worked ribs, the garlands that encircle the eight busts of emperors supported by *putti*, and the ensembles in decorative lozenges are painted to simulate marble so convincingly that even the modern viewer is sometimes fooled. In the triangular spaces at the edges of the ceiling are twelve mythological scenes of Orpheus, Orion, and Hercules with backgrounds of simulated mosaics, a device that Raphael was to use in the ceiling of the Stanza della Segnatura.

The overall design and various details of the ceiling permit an assessment of Mantegna's precocity in the creation of the room's decoration, which opened the way for the illusionistic painting of Pinturicchio, Raphael, Michelangelo's Sistine ceiling, and beyond to later six-

190. Andrea Mantegna. *Inscription with Putti*, 1465–74. Fresco. Mantua, Ducal Palace, Camera degli Sposi.

teenth-century *quadratura* (perspective architectural wall and ceiling painting). Only two of the walls have figurative narrations: the north wall with a scene that is usually called the *Court* [188] and the west wall, divided into three scenes, *Servants with Horse and Dog* [189], the *Inscription with Putti* [190], and the *Meeting* [191]. The remaining two walls are painted with imitation leather draperies that encroach upon the other sides as well to create the fiction that there were curtains before all four walls and on two sides they had been opened up to reveal the events depicted. The various layers of reality demand a willingness on the part of the spectator to participate in the visual metaphors by taking optimum positions in the room where the spatial play operates (especially true for viewing the oculus). The exercise is visual, but the overtones are intellectual.

Although the meaning of the frescoes has not been fully explained, one can safely say that the central subject is Ludovico III Gonzaga, his wife, his children, and his court. A closed letter held by Cardinal Francesco Gonzaga in the *Meeting* seems to be the same one, now opened, that Ludovico, seated majestically, holds in the *Court*, and must be considered important for understanding the paintings. The style of the frescoes is similar to Mantegna's previous works. The compositions are dominated by the narrative elements, with the figures set frieze-like, close to the picture plane within a narrow spatial shelf in front of a landscape or architectural setting. The arrangements are formalized and measured, and I suspect that Mantegna may have had a renewed encounter with the art of Piero della Francesca between the time he painted the *San Zeno Altarpiece* and the Camera degli Sposi. If anything, the organization of the surface is more harmonic and measured than before.

Lifted from the overall narrative context

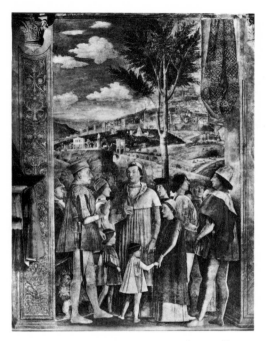

191. Andrea Mantegna. *Meeting*, 1465–74. Fresco. Mantua, Ducal Palace, Camera degli Sposi.

and considered as a family group portrait, the *Court* must rank among the finest examples of that genre, rivaling those by Velázquez and Goya. Unfortunately, the fresco has suffered from humidity, injury, and poor restoration so that the polished refinement of the original can only be partially appreciated today. The magnificent details of the ceiling and some of the busts and scenes, however, might offer insight into how Mantegna's original surfaces originally looked. They stand among the most convincing *trompe l'oeil* passages of the entire Italian Renaissance.

Mantegna worked over a long period, from about 1480 to 1495, on a series of nine paintings known collectively as the *Triumphs of Caesar* (Hampton Court). Any thorough evaluation of these large canvases, which serve to introduce Mantegna's late style, is seriously hampered

by their generally poor condition and inept restoration. Furthermore, we may assume heavy participation by his assistants in their original execution. Even the actual purpose of the series remains obscure, although they were known to have been used for theatrical performances. Here, once again, no radical shift in Mantegna's monumental style may be detected: a frieze-like arrangement of figures on a plane close to the surface, with a background of either architectural or landscape motives, although deep space is somewhat suppressed.

Among the important late works are the *Madonna della Vittoria* [192] and two mythological subjects painted for Isabella d'Este, the Ferrarese wife of Francesco Gonzaga and a remarkable patron of the arts. The *Madonna* in the Louvre was painted to celebrate Francesco's military victory of 1495, and the picture, which reveals facility of invention and execution, was completed a year later. The altarpiece, a *sacra conversazione*, also encompasses a Madonna della Misericordia type (which was the requirement of an earlier commission for the chapel in Mantua) in which Mary protects the company with her cloak (compare Piero della Francesca's *Madonna della Misericordia* [98]).

The woman holding the rosary at the lower right is probably St. Elizabeth, since she is close to the little St. John the Baptist, her son, and was also the patron saint of Isabella d'Este. The imaginatively conceived space, the wealth of engaging details, including the bower of fruit and vegetables filled with diverse birds, the rather shallow circular arrangement of figures, and the general closeness of the scene to the picture plane are all characteristic and familiar in Mantegna's art. His vision was always dominated by the human figure and by the potentialities of dramatic illustration. Objects exist only in relation to the actors on the stage Mantegna has

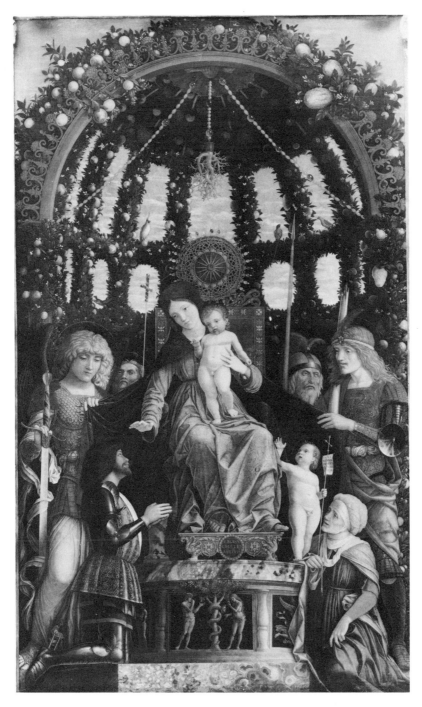

192. Andrea Mantegna. *Madonna della Vittoria*, 1496. Wood panel, 280 × 166 cm. Paris, Louvre.

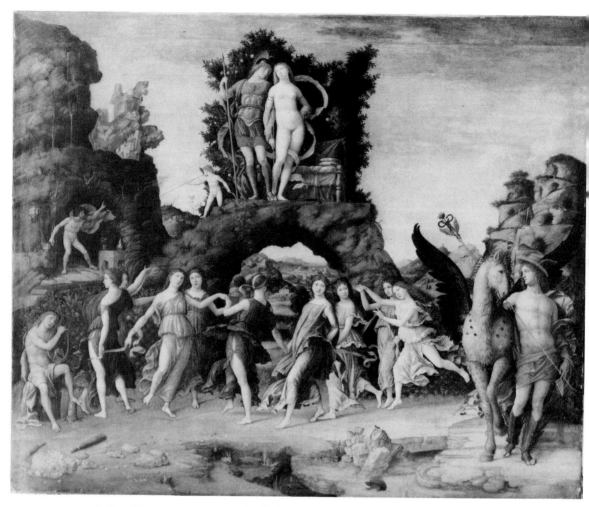

193. Andrea Mantegna. *Parnassus,* finished 1497. Wood panel, 160 × 192 cm. Paris, Louvre.

created, and the narration begins, as does the history of man, with original sin, shown in a feigned bronze relief on the marble base of the Virgin's throne. Within the sacred space, Francesco, the donor, is set off from the other figures by being portrayed in sharp profile—the only figure in the painting so rendered—and may reflect an awareness of Piero's *Brera Altarpiece* in which Federigo da Montefeltro, also in armor, is similarly placed [111]. In Mantegna's picture Sts. Michael, Andrew, Longinus, and George all have a military air.

Around 1495 Isabella d'Este planned to have the most famous painters of her time contribute pictures for her *studiolo;* she was unsuccessful in obtaining pictures from Leonardo (although he drew her portrait) and Giovanni Bellini, but not for want of trying. Mantegna, her court painter, and Lorenzo Costa, Mantegna's successor, each completed two canvases and Perugino one. Mantegna's so-called *Parnassus* [193], completed by 1497, is one of his finest works, much discussed and admired, although the exact meaning of the allegory remains elusive. As a painter dedicated to the study of antiquity and ancient archaeology, it is fitting that Mantegna should have produced a masterpiece with a classical theme. The main participants are Venus and Mars, their hands and feet interlocked, in the center on a raised platform, where Venus's bed is located. Her husband Vulcan, nude, is represented as a cuckold; he gestures toward his wife and her lover. Seated below him playing the lyre is either Orpheus or Apollo. In the center are the nine Muses, who seem to be in poses taken from dance, while at the right are Mercury and the winged horse Pegasus. Mantegna has integrated the landscape elements with the figures, using rocky cliffs as foils, while the central arch permits a deep vista into the rolling landscape. In this late work Mantegna has maintained a monumental approach to human figures. Stocky and heavy-limbed, they plant their weight solidly in easy *contrapposto.*

In the landscape the edges or contours of his figures have been softened, and some critics have suggested that Mantegna was now adopting effects that were part of the vocabulary of his brother-in-law, Giovanni Bellini.

Mantegna's paintings have a constant, heroic quality, and, notwithstanding a devotion to minor details, he never loses the geometry of the whole. He invented compositions and individual figure types that continued to have meaning for Raphael, Giorgione, Correggio, and Titian. Although or perhaps because Mantegna became more isolated working in a secondary center, he maintained a consistency of vision which fed upon the enormous inventive energy that he had first demonstrated so many years before.

GIOVANNI BELLINI

Our knowledge of Giovanni di Jacopo Bellini's training, early style, and even the works of his middle years is less clear than for any other Renaissance artist of his stature. The first five decades of the life of Giovanni Bellini (ca. 1432–1516), also known as Giambellino, are practically unsupported by contemporary data. Even his birth date and whether he was legitimate or not are unknown, although a date of about 1432 seems to be a reasonable suggestion for his birth, making him younger than his brother Gentile, also a famous painter (see Chapter 5) with whom he collaborated. Presumably both Giovanni and Gentile were trained by their father Jacopo. Giovanni, it is commonly believed, was subsequently swayed in his artistic development by the powerful example of his gifted brother-in-law Andrea Mantegna, who married Giovanni's sister Nicolosia in 1453. But since Jacopo's oeuvre is poorly documented and since the influence of Mantegna in an early phase is not supported by dated works, a reconstruction of much of Giovanni's career is hypothetical.

The earliest works that can be ascribed to

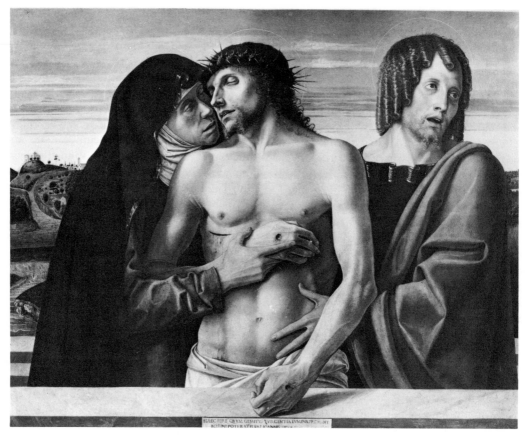

194. Giovanni Bellini. *Dead Christ with Mary and John*, ca. 1470. Wood panel, 86 × 107 cm. Milan, Brera.

Giovanni Bellini which are unquestionably datable fall only into the 1480s, when he was presumably in his fifties. Scores of paintings have been attributed to him for the time before firmly documented works can be isolated, including the *Fugger Portrait* (Pasadena, California, Norton Simon Collection), which once had a date of 1474 on the back though it was unsigned. But no matter how strong a case may be made for attributing one or another work to Giovanni during the span of years from the 1450s to the 1480s, it must still be regarded as part of a sweeping critical construct. Included within this group are some of the most impressive pictures considered to be by the master, and they need not be challenged; and, to be sure, some of them are signed and can be dated by stylistic criteria. A body of Mantegnesque works of high quality that are definitely not by Mantegna, being somewhat softer, more atmospheric, and less rigid, have been widely accepted as Bellini's and even discussed chronologically according to dates that relate to Mantegna's models; but this is a risky procedure since Mantegna's panel pictures of the 1450s and 1460s are them-

selves not easily datable. The moving *Dead Christ with Mary and John* [194] is an earlier signed painting without question by Bellini, dated to the 1460s or early 1470s.

The first mention of Giovanni Bellini in an artistic context is in an inscription on a lost altarpiece of 1460 for the Gattamelata Chapel in Il Santo, Padua, where Jacopo Bellini affirms that it had been made by him and his sons. According to local contemporary sources, after his father's death in 1470 or 1471, Giovanni collaborated with Gentile on certain decorations of the Doges' Palace in Venice (no longer extant). In 1483 Giovanni was made official painter to the state and was exempted from some taxes. He seems to have been married soon after, for in 1485 his wife's dowry is mentioned. In 1487 Giovanni signed and dated the *Madonna degli Alberetti* [201] the first such work among his paintings, and consequently his first extant dated picture. In the following year he completed the triptych in the Frari (Venice), depicting an enthroned Madonna and Child with paired saints in separate compartments on either side. Isabella d'Este of Mantua sought through her agent to obtain a work by Bellini for her *studiolo,* and Giovanni finally produced a *Madonna and Child* for her (lost) in 1504.

Giovanni signed and dated the altarpiece for San Zaccaria in Venice in 1505, and a year later he was described in a letter by Albrecht Dürer as the best painter in Venice despite his advanced age, a statement that may have resulted from Bellini's responsiveness to Dürer's art. Gentile died in 1507, and Giovanni inherited their father's drawings. He signed and dated a *Madonna* (Detroit, Art Institute) in 1509 and another [202] in 1510. In 1513 Giovanni completed the altarpiece for San Giovanni Crisostomo in Venice, and in 1514 he signed and dated the *Feast of the Gods* [199]. He was actively painting during the final years of his long life and signed several pictures,

including the *Fra Teodoro da Urbino* [203] and the *Woman with a Mirror* (Vienna, Kunsthistorisches Museum).

‡‡

If the earlier part of his career is full of unanswered questions, the final years present difficulties concerning Giovanni's relationship to the most important Venetian masters of the following generation, Giorgione, Titian, and Sebastiano del Piombo. Giovanni seems to have traveled relatively little, unlike most of the artists discussed in this book, from Masaccio and Masolino to Mantegna and Piero della Francesca, all of whom, for example, had spent some time in Rome. This fact leads to a further consideration concerning Giovanni's position as *caposcuola* (head) of the Venetian School. Venetian Renaissance painting, as the term is usually used, refers to an approach toward drawing and toward the use of color and light that actually coincides well with Giovanni's later works. Hence the question arises whether these "Venetian" qualities, continued in the art of Giorgione and Titian, are not more accurately described as "Bellinesque." Parallels may be drawn with Masaccio's place in Florentine art or Piero della Francesca's in Umbrian. The force of the genius who imprinted a personal vocabulary and discoveries upon an ample following affected and sometimes actually created a local tradition, and Giovanni's long and productive career and his nearly constant presence had an understandably powerful impact upon Venetian painters. In other words, his personal style becomes what is usually considered to be "Venetian."

The superb *Pesaro Altarpiece* [195], which was made for the Church of San Francesco, is a signed work. Secondary evidence points to a date in the mid-1470s but recent study suggests that it may be earlier, about 1470. Whether Giovanni painted the work in Pesaro

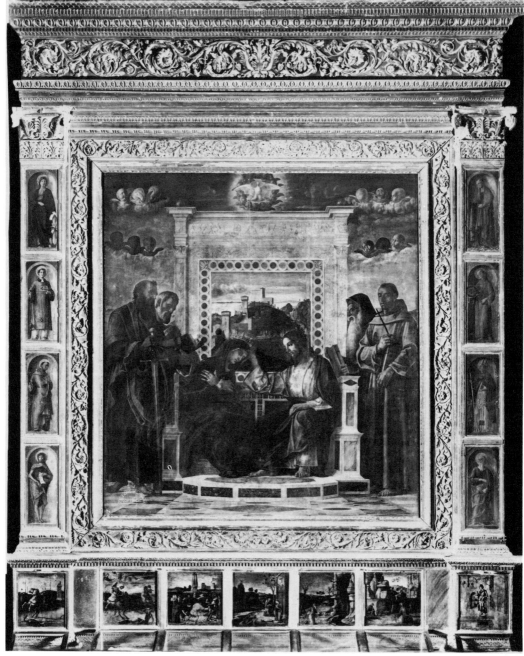

195. Giovanni Bellini. *Coronation of the Virgin (Pesaro Altarpiece)*, mid-1470s. Wood panel,
262 × 240 cm. Pesaro, Museo Civico.

or made it in his Venetian studio and sent it down by ship together with its elaborately carved frame is not known; but he must have been to Pesaro at some time, at least for the installation if not for the commission itself, and since the city had close cultural ties with Urbino, Giovanni must have become acquainted with works by Piero della Francesca. Indeed, two distinct influences on Bellini's painting that are in themselves related have been noted: the example of Piero and that of Antonello da Messina, whose art we shall examine next. The central panel of the *Pesaro Altarpiece* shows the Coronation of the Virgin in a breezy landscape; the enthroned central group surrounded by Sts. Paul, Peter, Jerome, and Francis is in a style recalling Mantegna's *San Zeno Altarpiece* [196]. The composition within its squarish format has a low horizon,

inducing a rapid recession. A pervasive geometric insistence dominates: rectangular stresses, like the framed landscape behind the throne, including the colorful inlaid tiles and the encrusted marbles, mitigate the formality. The interdependence of light and color, essential components, recall Piero and Antonello.

This painting is the first by Giovanni on a monumental scale using the oil medium, traditionally associated with Antonello, instead of tempera, although the transition between the two media was gradual in the later *quattrocento*. Artists combined oil and tempera, and the modern observer cannot easily distinguish the precise combinations that may have been used. Modeling with an oil-based paint permits softer, more delicate tonal transitions, "poetic" effects characteristic of Bellini's later painting as well as of Giorgione's. Seemingly,

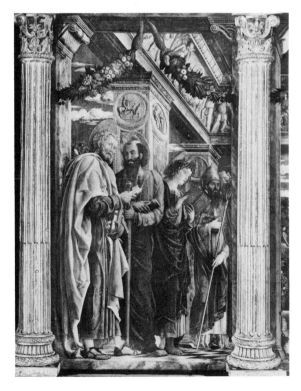

196. Andrea Mantegna. Detail of 182.

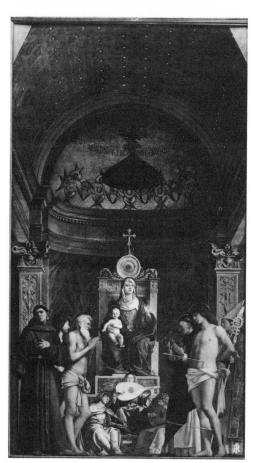

197. Giovanni Bellini. *San Giobbe Altarpiece*, ca. 1485–87. Wood panel, 471 × 258 cm. Venice, Accademia.

198. Giovanni Bellini. *San Zaccaria Altarpiece*, 1505. Canvas (transferred), 500 × 235 cm. Venice, San Zaccaria.

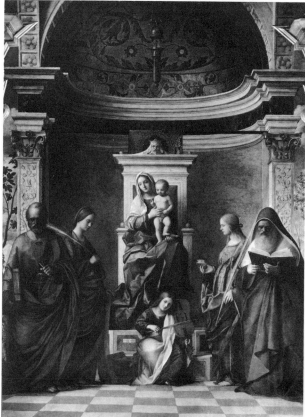

too, oil provides the possibility of more vivid, sunnier, and more atmospheric landscape renderings. The importance of oil as a medium in the later fifteenth and sixteenth centuries should not be underestimated. Giovanni did not immediately take the next step of using oil paint on canvas, but for some time he continued with the more traditional wood supports; and he never took the final step, the use of rougher-textured linens favored by masters of the following generation, most notably Titian.

The *San Giobbe Altarpiece* [197], datable to about 1485–87, is a grand composition that places Giovanni Bellini squarely within a pan-Italian monumental current. The Madonna is set on a high throne well above the accompanying figures, reflecting a type elaborated by Antonello's *San Cassiano Altarpiece* [207] (and perhaps a lost earlier example by Giovanni himself) which was perpetuated at least through Giorgione's *Castelfranco Altarpiece* [293]. The easily posed figures preserve their physical integrity in a vaulted architecture that occupies over half the picture space. The interplay between the painted architecture and the original frame, now separated, is distinctive, serving to intensify the illusionism of the scene. A pervasive golden light emanates partially from the apsidal mosaic and is refracted by the marble barrel vault. In this way a unifying envelope wraps the self-possessed figures, remote and internally absorbed, in an invisible fabric, like the music of the strings produced by the angels below Mary. The smooth unblemished nude body of the aged Job, seen in profile, and the handsome youthful Sebastian on the right are related to the contemporary sculpture of Pietro Lombardo, who in Venice functioned as *caposcuola* in sculpture much as Bellini did for painting.

The low horizon relates the painted figures to us, the spectators, since the fictive space seems to flow naturally from outside the frame. Bellini's approach to modeling differs from that of Mantegna, Piero, and Antonello because he increasingly forgoes the edges of his forms. Rather than drawing the outside surface and then filling in the modeled parts from the silhouette, he modeled with light and shadow from the inner core outward, gradually arriving at the contours. Color does not exercise a decisive function in the establishment of the forms but is used with confidence and flair to enhance the appeal of the elaborate construction.

The qualities found in the San Giobbe picture are apparent in the much later *San Zaccaria Altarpiece* [198] of 1505, by which time we can truly speak of a late phase in his art. The overall scheme in the San Zaccaria painting is also similar to the *San Giobbe Altarpiece*, although the horizon is somewhat higher. The increased distance between the viewer and the painted figures reduces communication. Although the picture is another *sacra conversazione*, interaction among the sacred figures is minimal as well. There is a completely untamed landscape and clouds at the edges of the picture. The figures are arranged rather formally, with the central axis decisively accented by the hanging lamp and the single viol player, instead of the three angels in the San Giobbe painting. Matched pairs of male and female saints are in a measured relationship: the old Peter and Jerome full face set in front of pilasters, Catherine and Lucy in nearly pure profile, Mary and the Child seen frontally. The picture, painted when Bellini was over seventy, is a sign of his continually expanding perception and complete command of the technical tools of his art.

In his last works Bellini shows how even at a very advanced age he was able to participate in the most novel artistic tendencies that the younger painters were developing. To a larger extent than most painters, and especially in comparison with his brother-in-law Mantegna, Bellini was prepared to adjust his style. His

199. Giovanni Bellini (later reworked by Titian). *Feast of the Gods*, 1514. Canvas, 170 × 188 cm. Washington, National Gallery.

pupils and assistants included those painters of exceptional talent already mentioned, Giorgione, Titian, and Sebastiano, and the degree of collaboration on works emanating from his studio is very difficult to determine, as is the interrelationship between these masters during these years.

The *Feast of the Gods* in Washington [199] is among Bellini's small number of purely non-Christian secular works, apart from portraits, and he seems to have approached the lusty subject matter with a certain reserve. The figures occupy hardly a third of the pictorial field; the rest is landscape, whose surface Titian overpainted, especially on the left, as has been revealed by X rays. Spatial and contextual relationships of figures to landscape must have been entirely Bellini's. The figures are arranged along a horizontal band in an irregular pattern without the aid of an architectural or geometrical order, an accidental and intuitive arrangement which gives this *poesia* (po-

etic subject) a particularly advanced appearance. The central axis is unstressed, and the figures, usually conceived in pairs in Bellini's pictures, are arranged in unmatched groupings so that the composition retains an unexpected freshness and facility. Although individual poses and types are sometimes dependent on ancient prototypes, the overall effect of the figural composition, which could easily have become coldly frieze-like, is irregular, casual, and enticing. The modeling is obtained by light and dark, with color primarily an accessory to the drawing, poses, draperies, and gestures. This picture was painted for Alfonso d'Este's *camerino* (small chamber) in his castle in Ferrara and is signed and dated (1514) on a little *cartellino* attached to a wooden tub on the lower right-hand side of the painting.

The *Feast of the Gods* is painted on canvas, thus combining the medium of oil with the support of canvas, which becomes the typical arrangement for Venetian painting. Bellini had already used canvas for the large altarpiece now in Murano (San Pietro Martire) dated 1488, but its poor state of preservation does not permit an analysis of the interaction of medium, technique, and support. In the *Feast* the physical existence of the paint itself, which became an attribute of Titian's style, demonstrates Bellini's forward-looking approach at the end of his life.

The difficulty of literal interpretation of the *Feast of the Gods,* a subject based on Ovid's *Fasti,* may also be found in a religious painting of much smaller dimensions and somewhat earlier—contemporary with the *San Zaccaria Altarpiece*—the enigmatic *Sacred Allegory*

200. Giovanni Bellini. *Sacred Allegory,* ca. 1505. Wood panel, 73 × 119 cm. Florence, Uffizi.

201. Giovanni Bellini. *Madonna degli Alberetti*, 1487. Wood panel, 74 × 58 cm. Venice, Accademia.

202. Giovanni Bellini. *Madonna and Child*, 1510. Wood panel, 85 × 115 cm. Milan, Brera.

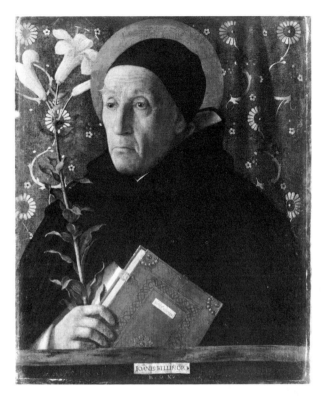

203. Giovanni Bellini. *Fra Teodoro da Urbino*, 1515(?). Canvas, 63 × 49.5 cm. London, National Gallery.

[200]. Hidden within the rocky landscape are figures, animals, buildings, and castles that surely relate to the main subject below. A proper reading should include the realization that the enthroned Mary, usually seen directly facing the spectator in devotional pictures and altarpieces, is arranged in profile and that an axis runs from her to the infant, the potted tree, and Sts. Job and Sebastian parallel to the horizon, at about the middle of the picture. The perspective, best seen in the floor, has orthogonals meeting in the general area of the cave, where a shepherd is seated. The meaning remains obscure in spite of recent explanations that have associated the principal theme with an allegory of Charity.

Two *Madonnas* can represent the substantial body of smaller private commissions Bellini made during his career: the *Madonna degli Alberetti* [201] and the Brera *Madonna and Child* [202]. The earlier picture of 1487 has softly modeled, golden flesh tones lighted from the front left with the Child standing cross-legged on a parapet and looking out at the viewer while Mary is absorbed in her Child. The two sacred images are isolated from the background by a green hanging attached without explanation or logic; at the edges we look into narrow bands of landscape. The proportions are massive; the anatomy is generalized. In the later picture, of 1510, there is a similar cloth, but because of the horizontal orientation of the panel, the landscape is prominent and the natural light takes on a deeper meaning. The strong shoulders of Mary are echoed in the interrupted hill behind her.

Giovanni Bellini, whose art can be accurately charted only in the last thirty years of his life, was able to expand his artistic horizon,

more so than any of his contemporaries, through a shift in medium and support, on the one hand, and through the powerful stimulation of brilliant young pupils and associates like Giorgione, Sebastiano del Piombo, and Titian, on the other.

ANTONELLO DA MESSINA

Antonio di Giovanni, known as Antonello da Messina (1431?–1479), was unquestionably the most renowned Sicilian artist of the Renaissance and one of the most influential painters of the entire second generation. His date of birth is uncertain, but the fact that his parents were still alive at the time of his death and that his son Jacobello was married in 1479 suggest a date of about 1431. The earliest preserved notice for Antonello is from 1457, when he was contracted to paint a banner in Reggio Calabria, and when he is known to have taken on a pupil. In 1460 Antonello is documented again in Calabria on his way back to Messina (from Naples?), where in the following year his brother Giordano became his apprentice. He obtained assignments in 1463 in Messina, where he purchased a house a year later. The *Salvator Mundi* [204] is dated 1465 and was probably painted in Messina. The *Ecce Homo* (New York, Metropolitan Museum of Art) may once have had the date 1470, together with a signature. Antonello did a number of versions of this subject that can be dated to the same decade.

The painter finished a polyptych for the Monastery of Santa Maria alle Monache, called San Gregorio, in Messina, which is signed and dated 1473 [205]. In the same year he received payments for another important commission, this time at Caltagirone, which does not survive. A letter of 1475 tells us that Antonello was in Venice painting an altarpiece for San Cassiano. The following year, when the masterly Venetian altarpiece was all but com-

plete, his services were requested in Milan as court painter. Antonello does not appear to have gone to Milan at this time, although he may have been in the Lombard capital in the 1450s. In any case, he was back in Messina by the end of 1476. Less than three years later, Antonello made his last will and testament, presumably at the age of about forty-eight, and died shortly thereafter.

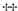

Although the year of Antonello's birth and the conditions of his training are uncharted, we can reconstruct a chronology of dated and documented works in the years following 1465, the date of the *Salvator Mundi* [204]. This painting supports what early (although not contemporary) sources relate, that the painter's training and development were closely tied to Netherlandish art. His awareness of Northern art was not only the result of his acquaintance with paintings by Jan van Eyck and Rogier van der Weyden, available to him in Italy and especially in Naples, but also through the example of his apparent teacher, the Neapolitan Colantonio, who painted in the Flemish manner. Antonello is sometimes credited with having actually studied in the Lowlands. Although this claim is unlikely, Antonello's importance in propagating Northern stylistic traits and exploring the potentialities of oil paint, as opposed to the more commonly used tempera in Italy, is easily demonstrated.

In the London *Salvator Mundi,* the image of Christ appears in absolute formal frontality, close to but behind a low wall. His left hand is shown resting on the parapet, while the right hand is raised in a gesture of blessing. *Pentimenti* (repainted passages by the artist himself as he ponders his picture) can be observed even in reproduction. They show that Antonello lowered the hand to allow it to rest on the ledge. In addition, he altered the edge of Christ's shirt, giving it in the final version a

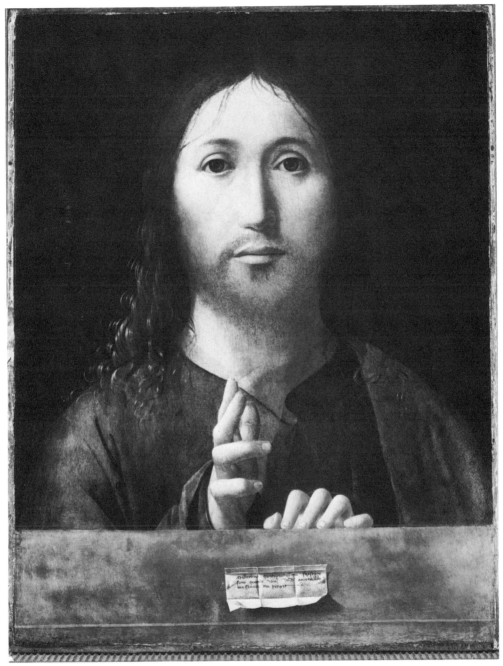

204. Antonello da Messina. *Salvator Mundi*, 1465. Wood panel, 39 × 29.5 cm. London, National Gallery.

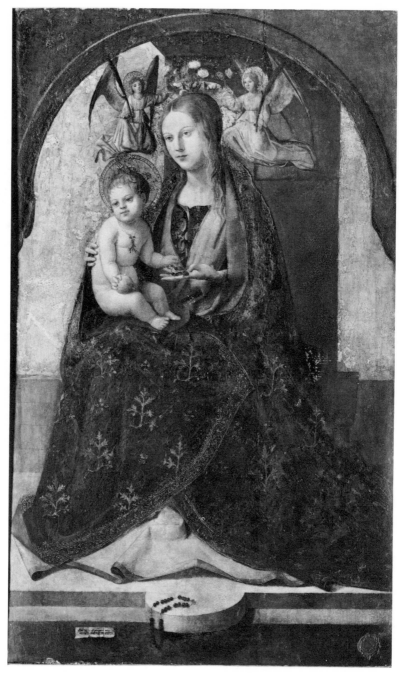

205. Antonello da Messina. *Madonna and Child (San Gregorio Polyptych)*, 1473. Wood panel, 129 × 76 cm. Messina, Museo Nazionale.

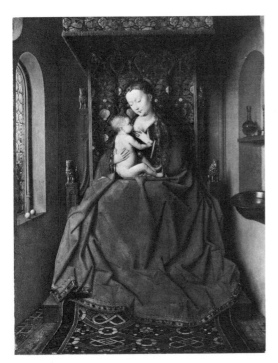

206. Jan van Eyck. *Lucca Madonna*, ca. 1436. Wood panel, 65.5 × 49.5 cm. Frankfurt, Städelsches Kunstinstitut.

which the light dances over the unfolded scrap of paper with the inscription is a symptomatic *trompe l'oeil* demonstration.

The next securely dated work, leaving aside the problematic *Ecce Homo* in New York, is the much damaged *San Gregorio Polyptych*, whose central panel contains a Madonna and Child [205]. Between 1465 and 1473 Antonello must have executed numerous paintings, including small religious subjects and portraits, a genre in which he excelled, but positive identification and dating are lacking. The central panel of the Madonna and Child from Messina continues to display Flemish connections, ones that revert back to the generation of the Master of Flémalle and Jan van Eyck [206] rather than to members of Antonello's own generation, as if he were only acquainted with similar early examples from the first half of the fifteenth century. Mary sits easily on her throne, fully engulfed by her majestic garment and slightly turned in space. In her long, horizontally extended left hand she holds cherries, which the strapping Christ Child touches. The nude Child, with coral hanging from His neck, looks idly off to the left beyond the picture space, while clutching an apple with His other hand. These are open-eyed, handsome creatures who exhibit a directness that brings to mind Raphael's *Sistine Madonna* [336] or even the *Madonna of the Chair* (Florence, Pitti Palace). The soft modeling of the Child or of the head of Mary does not belie the monumentality of the figures. A string of beads rests precariously below, near the omnipresent *cartellino*. No existing documentation links Antonello with Piero della Francesca, but the affinities between them are so strong that a direct exchange is often assumed, one that could have taken place in Rome in the late 1450s when Piero is known to have been working there.

sweeping loop rather than the more austere collar it had earlier. These changes demonstrate his method of work, and the constant revisions show Antonello to be a perfectionist, who even at a late stage in the evolution of an image was prepared to alter what he had done to fulfill formal requirements. The image and the tight modeling have strong Flemish qualities. The painted *cartellino* loosely attached to the wall, which bears the date and Antonello's name, is also associated with Northern painting although its first known use occurs in Filippo Lippi's *Tarquinia Madonna* [82]. Antonello favors this device in his paintings. Most noteworthy and symptomatic are Antonello's use of light in building convincing form and rendering details. Although the surface of the *Salvator Mundi* has suffered, the manner in

The most influential painting by Antonello was the *San Cassiano Altarpiece* [207], which

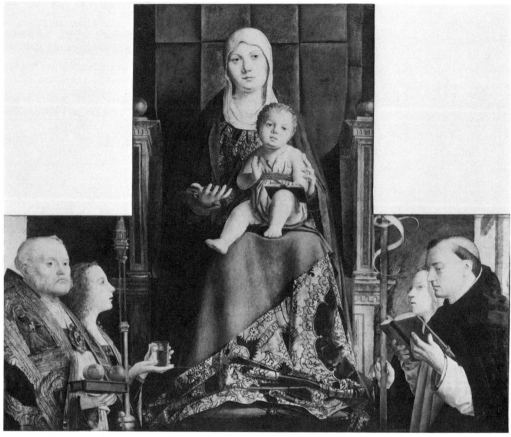

207. Antonello da Messina. *San Cassiano Altarpiece* (surviving sections), 1475–76. Wood panel,
115 × 65 cm. (Madonna and Child). Vienna, Kunsthistorisches Museum.

has been cut up and can be reconstructed only
hypothetically. Painted soon after the *San
Gregorio Polyptych,* it has an overall monu-
mentality which, if anything, is aggrandized.
The painting had a pervasive impact on origi-
nal Venetian painters as varied as Alvise
Vivarini, Cima da Conegliano, Giovanni Bel-
lini, and Giorgione, who were able to make
good use of certain aspects of Antonello's in-
ventions. Chronological questions have been
raised by those who assume that Giovanni Bel-
lini provided the basis for Antonello's painting
rather than vice versa: partisans of Venetian
art are reluctant to have an "outsider" change

the course of their school style. Similarly, An-
tonello is often found listed under the rubric
of the Venetian School. Yet he appears to have
spent barely two years in the city and appar-
ently earned the position by having strongly
influenced Venetian art rather than being par-
ticularly taken with it.

The original appearance of this *sacra con-
versazione* can be reconstructed from three
fragments now joined together in Vienna, an
enthroned Madonna and Child and two pairs
of saints (cut down) that belong to the lower
zone, and from old, partial copies. The ar-
chitectural setting that was part of the back-

ground may relate to Piero della Francesca's *Brera Altarpiece,* completed a year or two before [111]. Unlike Piero, Antonello has placed the enthroned group high above the accompanying saints, a solution found in Giorgione's *Castelfranco Altarpiece* painted nearly a generation later [293]. The Madonna and Child are positioned in front of deep violet and green curtains of honor; Mary's simple blue cape partially conceals a magnificent brocaded dress. The seriousness and directness of the frontally posed figures recall once more Piero and even hark back to Masaccio's *Pisa Altarpiece* [69], although here Antonello's Child is clothed. A book balances precariously on Christ's raised left leg, a symptom of Antonello's ever-present taste for realistic details.

Of the surviving saints, Nicholas of Bari with his attributes, the three balls, and Mary Magdalen, who holds a transparent water glass, are on the left; Ursula, barely visible, and Domenic are on the right. These figures have been truncated above the waist, now appearing, not altogether unsatisfactorily, as busts, although they were originally full-length standing figures. The variety of their attitudes and particularly of their expressions is proof of the painter's psychological power. Nicholas looks out directly to meet the spectator's gaze, as do Mary and the Child. The insistent profile of the Magdalen is contrasted with the bright-eyed Ursula and Domenic, both turned ever so slightly in space. The missing figures were a warrior saint, probably George, and St. Sebastian attached to a column, plus two other female saints, the fragmented profile of one still visible behind St. Domenic.

Although Antonello's training and his first phase can only be sketchily defined, we can assume that this painting and its prelude, the *San Gregorio Polyptych,* represent Antonello at the height of his second phase, when he had overcome any sign of provincialism. Also falling within this phase of development is the

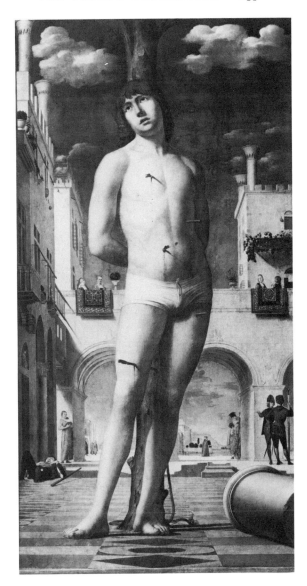

208. Antonello da Messina. *St. Sebastian,* ca. 1476. Wood panel, 171 × 85 cm. Dresden, Staatliche Gemäldegalerie.

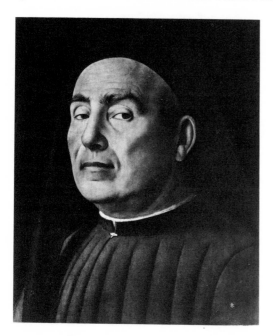

209. Antonello da Messina. *Trivulzio Portrait*, 1476. Wood panel, 36.5 × 28 cm. Turin, Museo Civico.

stupendous *St. Sebastian* [208], painted in Venice as part of a larger complex (lost) that included sculpture and thus datable to about 1476. The easily posed, nearly nude, athletic Sebastian, the low horizon, and the foreshortened elements, including the broken column on the right and the man lying on the carefully demarcated pavement, recall Mantegna, Antonello's exact contemporary, although the sunny, unatmospheric environment still has connections with the art of Piero della Francesca. The calibrated *contrapposto* of the principal figure and his powerful body prove Antonello's place within the monumental current. He seems to have studied the human form directly from the model without relying on either anatomical investigation or ancient examples. Consequently, his nude is without harshness or sculpturesque rigidity, unlike the nudes of Pollaiuolo or Mantegna. The compo-

sition is a remarkable balance between a geometric and a harmonic orientation.

Among a number of signed and dated portraits, the so-called *Trivulzio Portrait* [209], named for the Milanese collection to which it once belonged, has been judged a self-portrait because of its directness. The inscription—1476 ANTONELLUS MESSANEUS PINXIT—analogous to others on the ever-present *cartellino*, makes no such claim. In the genre of portraiture Antonello appears to be particularly close to Netherlandish masters in the exacting, closely controlled modeling, the masterful use of light, and the convincing, unprettified likeness. Unlike their Northern counterparts, Antonello's portraits are not dramatic; they understate spotlighting in favor of a diffused, evenly distributed illumination. Moreover, the bit of torso that he includes implies greater three-dimensionality and the existence of a powerful body.

Antonello is one of the most heterogeneous Italian painters of his generation, little intimidated by localism. He is a product, perhaps more than any other contemporary, of the broadest range of personal and regional school influences, which even transcend Italy itself. He succeeded in achieving a profound personal art from such divergent sources as his own native Sicilian background, Netherlandish painting, and, as has been suggested frequently, Piero della Francesca, and to a lesser extent Mantegna, without being impervious to what he saw in the artistically thriving Venice of the later *quattrocento*.

MELOZZO DA FORLÌ

Nothing is known about the training and early career of Melozzo (1438–1494; perhaps a nickname for Michele), who was born in the Emilian town of Forlì, not far from the Adriatic coast, although he was renowned during his lifetime and had been richly patronized by

Pope Sixtus IV. Most of Melozzo's works have not survived, and those few that have rarely give a true impression of their original appearance, which impedes a just evaluation of his quality as a painter and his impact upon other artists who succeeded him. After 1460, following his apprenticeship, Melozzo is frequently mentioned in local documents and is specifically known to have been in Forlì from 1461 to 1464, although absent in 1465. Such information does not mean that he was uninterruptedly in Forlì during this span of years. He may have been in Rome, where later on he produced his best work, as early as the 1460s, and he seems to have been in Urbino at some time during the decade, although firm evidence is lacking. Melozzo appears to have been painting in Tivoli near Rome in 1475. He is further documented as having finished a painting in the Vatican Library for Sixtus IV in 1477. Begun in 1475, the *Sixtus IV Appointing Platina as Prefect of the Vatican Library* [210] is Melozzo's most admired work.

He was in Rome in 1478 at the time of the formulation of regulations for the painter's Confraternity of St. Luke, which in the next century evolved into the Roman Academy, and he is documented as working in the Vatican Library again in 1480, this time in partnership with the local master Antoniazzo Romano. During these years, from 1478 to 1480, he probably frescoed the apse of Santissimi Apostoli in Rome, fragments of which are now divided between the Quirinal Palace and the Vatican Pinacoteca. This assignment was also commissioned by Sixtus IV, who made Melozzo his official painter; however, he was excluded from a share in the lucrative and prestigious Sistine Chapel wall frescoes, perhaps because he was occupied with other work. In the 1480s Melozzo painted in the Santa Casa of Loreto, in the Marches not far from Forlì, where he is specifically documented in 1484. Melozzo was back in Rome at

the latest by 1489; later he worked on the decoration of the town hall at Ancona and the frescoes for the cupola of San Biagio in Forlì, where he died in 1494.

÷÷

Melozzo's reputation rested heavily on his ability to handle perspective, and he went beyond Mantegna in daring foreshortenings and difficult views *di sotto in su.* Consequently, he falls within the tradition of Uccello, Castagno, and Mantegna, which is later perpetuated in the fresco decoration of Correggio and *quadratura* painters of the later sixteenth and seventeenth centuries. Even Michelangelo explored some of the potentialities of spatial manipulations, especially in the Sistine ceiling. Given Melozzo's interests and the nearness of Forlì to both Mantua and Padua, his training or at least his early visual experiences must have included an awareness of if not a direct rapport with the slightly older Mantegna.

The group portrait *Sixtus IV Appointing Platina* [210], which includes other personages, probably all relatives of the Della Rovere pope, is an extension of Mantegna's portrait frescoes in the Camera degli Sposi, completed shortly before. In Melozzo's painting, as in Mantegna's, the figures are placed in planes closest to the onlookers in the room. The pope is seated in noble profile; the humanist writer Platina, bibliophile and biographer of popes, is kneeling with dignity. His features are impeccably drawn, and again the treatment is similar to Mantegna's, although light operates more specifically, picking out the strands of hair and softly defining the facial features. Architecture occupies the greater part of the picture space: huge piers that support a ceiling with finely wrought coffers, seen sharply from below, appear worthy of a dedicated archaeologist. This conception of a group portrait on a memorable scale but raised to the level of narrative or history painting is a daring solution,

210. Melozzo da Forlì. *Sixtus IV Appointing Platina as Prefect of the Vatican Library*, 1475–77. Fresco (transferred), 370 × 315 cm. Rome, Vatican Pinacoteca.

211. Melozzo da Forlì. *Blessing Christ* (fragment), ca. 1478–80. Fresco. Rome, Quirinal Palace (formerly Rome, Santissimi Apostoli apse).

and one must think ahead to Raphael's *Pope Leo X with Two Cousins* [342] or Titian's *Pope Paul III and His Grandsons* [315] for parallels. Melozzo has a flair for depicting individual likenesses as well as an insight into personality. For Platina's portrait we must assume that Melozzo made earlier studies directly from life.

The other works that demonstrate Melozzo's abilities, which place him clearly within the monumental current among second generation masters, are the fragmentary frescoes from Santissimi Apostoli, which have now been framed, somewhat incongruously, as separate, independent paintings. The main section is a *Blessing Christ* [211] surrounded by angels, where once more we see Melozzo's concern for difficult foreshortenings. Christ seemingly holds his massive right hand out over the spectator's space in a sweeping ges-

ture, echoed by the other hand. The expansive quality of the outstretched arms diagonally enframes the mighty head of Christ; the overall effect is one of restrained yet majestic self-control. The multitude of jubilant angels, subdivided into more comprehensible groups and isolated figures in varied pious attitudes, is entirely subservient in its movement to Christ.

The small chapel in the Santa Casa, matching one by Signorelli, was executed for a member of the Della Rovere family. It continues to demonstrate Melozzo's devotion to spatial complexities, although it does not add anything to our understanding of his art. Melozzo remains an undefined master, his development elusive; nevertheless, he stands as an adventuresome and progressive painter of stature.

ANTONIO DEL POLLAIUOLO

The devotion to antiquity found in the art of Mantegna is also representative of Antonio del Pollaiuolo (ca. 1431–1498), who was not exclusively a painter. Antonio's fame rests more extensively on his works as a goldsmith and sculptor, although the small group of paintings that can be assigned to him demonstrate his skill as a two-dimensional artist. In all of these media Antonio excelled as a designer and draftsman. His ideas were registered in drawings that were then executed in paint, sometimes by him, but frequently by his younger brother and chief assistant Piero (1443–1496). Piero was more exclusively a painter, and despite the close working relationship between the two, apparently first as master and pupil, they did not have the same stylistic inclinations: Piero's works fall within the lyric current, Antonio's within the monumental.

Antonio di Jacopo Benci, known as del Pollaiuolo because his father was a chicken merchant, was born in Florence. Nothing is known of his early life except that he was trained as a goldsmith, possibly by Ghiberti, who was working on the *Gates of Paradise* at the time when Pollaiuolo was an apprentice. His first recorded activity was work on a silver cross (Florence, Museo dell'Opera del Duomo) for the Florentine Baptistry in 1457 along with two other goldsmiths. According to his own testimony he made three large canvases around 1460 illustrating the feats of Hercules for Piero di Cosimo de' Medici (lost), known through small versions of the same subjects.

Antonio continued to undertake commissions as a painter and as a goldsmith simultaneously for the next two decades, although he seems to have painted only sporadically, much as Verrocchio did. He began to supply designs to embroiderers for vestments used in the Baptistry (Florence, Museo dell'Opera del Duomo) in 1466, the same year he enrolled in the Arte della Seta, that is, the silk guild (to which the goldsmiths were attached). Antonio contributed to the decorations for a tournament for Lorenzo de' Medici in 1468 along with Verrocchio and Botticelli, and in the following year he visited Rome, stopping on the way to see Fra Filippo Lippi in Spoleto. In 1478 he was allotted a share in the Silver Altar of the Baptistry, for which he produced the *Birth of St. John the Baptist* in 1480 (Florence, Museo dell'Opera del Duomo). Following the death of Sixtus IV in 1484, Pollaiuolo was occupied in Rome with his tomb in St. Peter's over the next ten years and then with the Tomb of Innocent VIII, also in St. Peter's, which was completed in 1498, the year of the artist's death in Rome.

✛

While Antonio Pollaiuolo presumably painted from about 1460 to 1484, no firm dates can be applied to his extant works. Besides their small number, two other problems surround a critical examination of Antonio's paintings: the virtual impossibility of establishing any sort of chronology based on external evidence; and the difficulty of isolating Piero's hand from that of his brother. He seems to have abandoned painting once he was in Rome working on the two papal tomb projects, which were bronze monuments of complexity and originality.

An example of a collaboration in which the main role must have been Antonio's is the *Martyrdom of St. Sebastian* [212], made for the Pucci Chapel in the Santissima Annunziata (Florence). It was emphatically claimed by Vasari to have been finished in 1475 and therefore tentatively datable 1473–75, that is, approximately contemporary with Verrocchio's *Baptism of Christ*, with which it shares stylistic features. It is among the outstanding paintings of the entire *quattrocento*. Few doubts arise concerning Antonio's domi-

212. Antonio del Pollaiuolo. *Martyrdom of St. Sebastian*, ca. 1473–75. Wood panel, 292 × 203 cm. London, National Gallery.

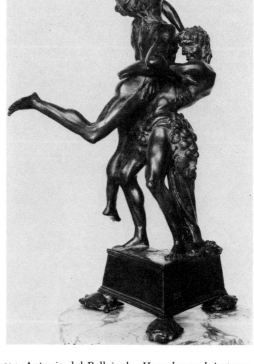

214. Antonio del Pollaiuolo. *Hercules and Antaeus,* 1475(?). Bronze, h. 45 cm. Florence, Bargello.

213. Antonio del Pollaiuolo. *Hercules and Antaeus,* 1470(?). Wood panel, 16 × 10.5 cm. Florence, Uffizi.

nant role as the inventor of the composition and of the figure types, although it appears likely that passages, including, for example, the archers who shoot at the saint from behind and large portions of the landscape, belong to Piero. The physically convincing foreground figures, the decisive fashion in which they plant their feet on the ground, their sturdy bodies, massive forearms and hands, and the muscles under energetic stress are typical of Antonio, as is the carefully studied anatomical structure with the bodies shown in frozen action. Antonio is an enthusiastic observer of ancient art, as evidenced by his frequent utiliza-

tion of figural poses and types borrowed from classical sculpture.

In the *St. Sebastian* the horizon has been placed high, and the young saint's head towers over the scene, located at the apex of an isosceles triangle formed by his executioners at the base, resulting in a strongly vertical thrust accentuated by the tree to·which the saint is tied. Furthermore, by crowding the figure at the top edge of the panel, Pollaiuolo produces a monumental effect that is common in his paintings, as if the figures seek to expand beyond the confines of the picture itself.

Pollaiuolo was a sculptor, and even for

215. Antonio del Pollaiuolo. *Dancing Nudes* and other wall decoration, 1470s. Fresco. Arcetri, Villa della Gallina.

rider, probably related to a sculpted small model, is also repeated. The detailed landscape is articulated by a river that meanders into the distance, where low mountains break the horizon.

The *St. Sebastian* is Antonio's surviving masterpiece as a painter, but it was undoubtedly preceded by significant works, some of which have been lost, most notably the feats of Hercules to which he referred in a letter decades later. The tiny but magnificent *Hercules and Antaeus* [213] presumably reflects one of the canvases he did for the Medici and is an autograph work. The mythological subject, in which Hercules crushes the giant Antaeus once he is lifted from the earth, from which he obtains his strength, is also rendered by Antonio in his finest bronze statuette [214]. Pollaiuolo uses the theme to study the human

paintings such as this the individual figures appear to be based on three-dimensional models in wax or clay which he made for the purpose and which could have been moved around easily. The archers in front at the left and right as well as one behind Sebastian are derived from a single model. They share an intent, demeanor, and a flat-footed stance with legs apart (similar to his sculpture of *David* in Berlin) and are differentiated from the corresponding, less decisive variant in the middle at the left. In the same way, the two soldiers in the front center are from the same bending model, one turned inward, the other facing outward; this fine nude surely is the result of life studies and proves the power of outline in his method of creating convincing form. In the distance a rearing horse with a

216. Antonio del Pollaiuolo. *Putto*, detail of 215.

body under extreme physical exertion, and he examines the full range of reactions from bursting muscles to the agonizing pain expressed by Antaeus.

What is left of the decoration from a room by Pollaiuolo in the Villa della Gallina on the outskirts of Florence is derived from classical prototypes. The principal subjects are *Dancing Nudes* set above a fictive architecture with perspective views based on Greek vase painting, perhaps as reinterpreted by the Etruscans [215, 216]. The modeling within the figures, if there was any, has disappeared, leaving such successfully and accurately conceived flat silhouettes that the outlines are sufficient to define the monumental figures in convincing movement and joyful attitudes. These images

are a tour de force, showing Antonio's control of form through contours. Even in his more carefully modeled figures, like the archers in the foreground of the *St. Sebastian* or the *Hercules and Antaeus,* the edge, active and changing, defines the form; muscles and sinews are superimposed almost as an afterthought.

In other words, he conceives the figure from the outside in, as is clearly revealed in his drawings and engravings, including the large *Battle of Ten Nudes,* the most important work of its kind made in the fifteenth century [217]. The figures, disposed in a variety of poses and movements, in foreshortening and in profile, show a carefully rendered internal structure, with muscles given emphasis (too much for

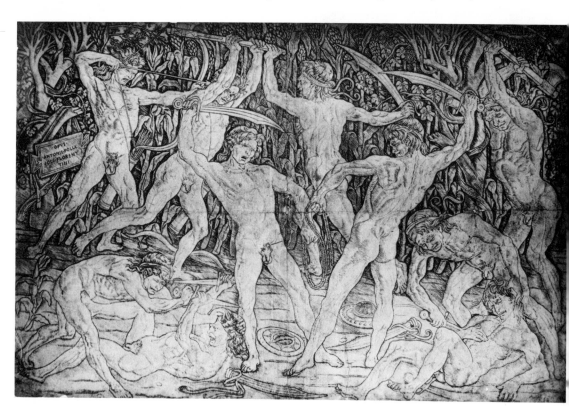

217. Antonio del Pollaiuolo. *Battle of Ten Nudes,* 1470s. Engraving, 428 × 618 cm.

Leonardo, who wrote that such figures appeared like "a sack of walnuts"). Their genius lies in the contours, and if the busy modeling within them is thought away, the effect is like the *Dancing Nudes*. The meaning of the print, other than a battle, has yet to be explained, but it served as a pattern for other artists.

DOMENICO GHIRLANDAIO

The quality of artistic invention found in the paintings by the Florentine, Domenico di Tommaso di Currado (1449–1494), commonly known as Domenico Ghirlandaio, varies greatly. In fact, an assessment of Ghirlandaio's art is made difficult because of his extensive reliance on assistants and collaborators, including his brothers Davide (1451–1525) and Benedetto (1458–1497) as well as his brother-in-law Bastiano Mainardi (1460–1513). Domenico is first mentioned in 1475 in Rome, where he and Davide were working for Sixtus IV's library in the Vatican. Back in Tuscany in 1476–77, he and his shop assistants painted a *Last Supper* for a monastery in Passignano near Florence, a fresco that has suffered from overpainting. Other documented works of the late 1470s include poorly preserved altarpieces of 1479, for the Badia a Settimo a few miles down the Arno from Florence and the *Last Supper* and *St. Jerome in His Study* [219], both for the Ognissanti church in Florence and dated 1480. Ghirlandaio was summoned back to Rome, where he did several frescoes including the *Calling of Peter and Andrew* (1481–82), still intact in the Sistine Chapel [221] along with works by Botticelli, Perugino, and Cosimo Rosselli. He then worked in the Sala dei Gigli of the Palazzo della Signoria in Florence together with assistants, as was the practice of his shop, from 1482 to 1485.

He painted a story of Vulcan (no longer extant) for Lorenzo de' Medici's villa outside Volterra at Spedaletto, in company with other masters, including Botticelli, around 1485. In that year he finished and dated the *Adoration of the Shepherds*, an altarpiece for the Sassetti Chapel in Santa Trinita in Florence [223], along with extensive frescoes there, done by 1486. Ghirlandaio had contracted with the Tornabuoni family in 1485 to decorate the choir of Santa Maria Novella and began replacing the *trecento* frescoes there in the following year. The vast cycle was finished in 1490. Among his assistants Ghirlandaio employed Michelangelo Buonarotti, who had been apprenticed to him in 1488 at the age of thirteen. Domenico completed the large *Adoration of the Magi* for the Hospital of the Innocents in 1488 (commissioned in 1485), and he continued to have important assignments in Florence in the early 1490s until his death, including mosaic decorations for the Cathedral. Ghirlandaio's shop continued to function, first under his brother Davide and then under his son Ridolfo (1483–1562), well into the sixteenth century.

✢

Domenico achieved an important place among painters, especially those directed toward a monumental style, thanks to a directness in rendering narratives and in placing convincing figures in understandable compositions; he was a natural continuator of the approach typified by Masaccio and before him by Giotto. Ghirlandaio's specific artistic origins are not known, and, given the rather late appearance of extant documented works by him, they can only be suggested. Alesso Baldovinetti (ca. 1425–1499), a well-known local painter, may have been his teacher, although Ghirlandaio's earliest works betray connections with Verrocchio's style. Leaving aside works like the *Madonna of the Misericordia* and the *Deposition* [218], frescoes in the Ognissanti church in Florence that appear to date about 1473, but which are not very in-

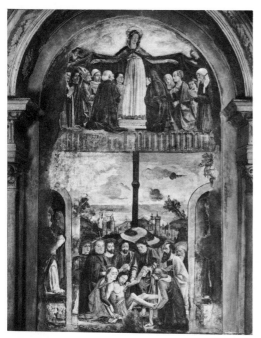

218. Domenico Ghirlandaio. *Deposition* and *Madonna of the Misericordia*, ca. 1473. Fresco. Florence, Ognissanti.

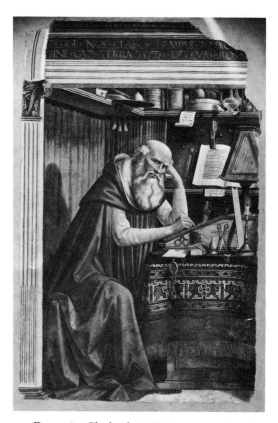

219. Domenico Ghirlandaio. *St. Jerome in His Study,* 1480. Fresco, 152 × 112 cm. Florence, Ognissanti.

formative in reconstructing Ghirlandaio's early style, we may turn directly to more fully developed and revealing examples, ones firmly documented and dated. The *St. Jerome in His Study* [219] was originally painted for the *tramezzo* (choir screen) of the church in direct confrontation with Botticelli's *St. Augustine in His Study* [130]. Ghirlandaio's fresco, not altogether a success, shows a physically present, richly detailed figure who is, however, without inner life or an emotional dimension. The still-life elements, painted in strong, local colors, appear like rigid decorative abstractions due to the complete absence of atmosphere in the painted room.

The *Last Supper* [220] is a more gripping painting, and the subject has greater narrative potential. It has suffered in comparisons with the more emblematic example by Andrea del

Castagno [115], which may have had some influence on Ghirlandaio, and the *Last Supper* painted by Leonardo da Vinci nearly two decades later in Milan [248]. Domenico produced a distinctive work, one that must have offered many more visual delights, especially in the treatment of the still life and the surfaces of things, before the heavy losses of paint that have occurred over the centuries. The landscape, the perspectival foreshortenings, and, on the whole, the manufacture have been skillfully crafted.

Ghirlandaio chose to organize his composition around a pre-existing console in the middle of the wall on the main axis. As a result, like

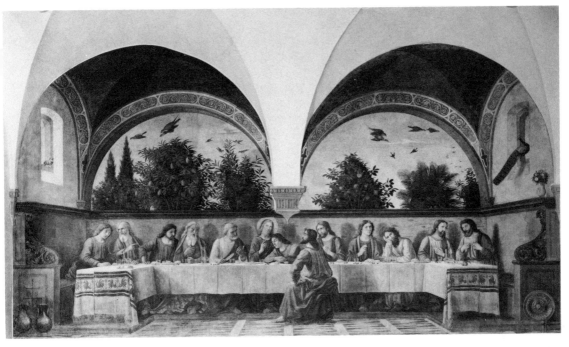

220. Domenico Ghirlandaio. *Last Supper*, 1480. Fresco, 177 × 812 cm. Florence, Ognissanti.

Castagno's figure of Christ, Domenico has pushed Christ off to one side, while John the Evangelist, who traditionally rests on Christ's bosom, was posed to fit exactly into the restricted space. The central group is completed by Judas to the right of the console and on the opposite side of the U-shaped table. All the Apostles are located parallel to the back wall at some distance from the picture plane and hence from the viewer. They are isolated, stiff, yet physically demanding figures requiring our full attention, one by one. A particularly appealing aspect of the fresco is the naturalistic treatment of details, including the variety of trees and birds and the many objects on the table. Modeled with descriptive, bright colors, the objects are set against either a pale sky or the off-white of the tablecloth and consequently stand out.

Following his frescoes in the Sistine Chapel and the painted *uomini famosi* in the Sala dei Gigli in Florence [222], where his part in the execution seems to have been shared with his shop, Ghirlandaio became engaged in the decoration of the Sassetti Chapel in Santa Trinita. Not only was a praiseworthy fresco cycle produced for Francesco Sassetti, chief of the Medici banking operations in Florence, but Ghirlandaio also painted a fine altarpiece, usually called the *Adoration of the Shepherds,* which is still in the chapel [223].

Painted on a square panel, the *Adoration* demonstrates the full range of Domenico's skills even better than the *Last Supper.* The superior preservation of the picture exposes its exceptional technical quality. A classically inspired sarcophagus with its finely wrought inscription and the piers that support the straw roof of the shed give the unabashed flavor of antiquity. The painting can be thought of as an Adoration of the Child in which Mary adores the newborn Child, as well

as an Adoration of the Shepherds, a conflation of motives found in Hugo van der Goes's *Portinari Altarpiece,* which had been set up in Sant'Egidio in 1483 [224]. In fact, the rugged realism in rendering the shepherds must also have resulted from an awareness of contemporary Netherlandish art, including the *Portinari Altarpiece.* Perhaps Ghirlandaio's Italian and more specifically Florentine orientation did not permit the complete surrender to the heightened realism that marks the Northern interpretations of such images. His peasants maintain a restrained demeanor and have a physical dignity common to all his figures, regardless of their social status.

Two other scenes are found integrated into the painting: the Annunciation to the Shepherds at the upper left and the Journey of the Magi, whose train is shown winding around the side of the hill and passing through a triumphal arch. There is also a view of a city in the middle ground and a gradually rising mountain in the extreme distance. This painting has everything that a contemporary merchant-patron could hope for, even an ox and an ass, conventional references to the Nativity. What is lacking is an elusive dimension—a "poetry" or "spirit"—to make this sparkling picture a masterpiece.

The frescoes on the walls of the Sassetti Chapel reveal a similar excellence of execution. Ghirlandaio offers the Florentine viewer

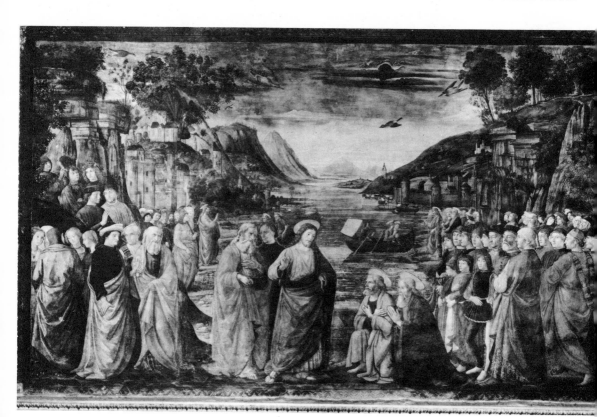

221. Domenico Ghirlandaio. *Calling of Peter and Andrew,* 1481–82. Fresco. Rome, Vatican, Sistine Chapel.

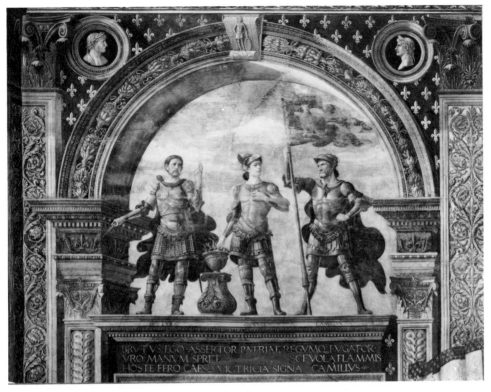

222. Domenico Ghirlandaio. *Uomini Famosi: Brutus, Scaevola, and Camillus,* ca. 1482–85. Fresco. Florence, Palazzo Vecchio, Sala dei Gigli.

familiar cityscapes that must have been particularly pleasing; for example, the view of the Ponte Santa Trinita and the façade of the very church where the frescoes are located, not to mention Sassetti's palace, challenge the meaning of artistic reality and also give the painter an opportunity to display his talents. A typographical reference to Florence is found in the fresco of *Pope Honorius Establishing the Rules of the Franciscan Order* [225]. Here we see the Loggia dei Lanzi and the Palazzo della Signoria with its tall embankment (long since removed) upon which stood the symbolic Florentine lion *(marzocco)* through the open arches.

Ghirlandaio had to contend with a pre-existing Gothic lunette when creating the compo-

sition. He nullified the pointed arch of the chapel's structure by locating a massive painted round arch beneath it, and he stressed the horizontal. The theme of the fresco is illustrated on the second plane, where the pope at the right hands the kneeling St. Francis and his followers the papal bull that recognizes their order. In keeping with the Florentine architecture behind, a series of easily recognizable contemporary portraits is placed prominently in the front plane. The unmistakable profile of Lorenzo de' Medici is between two older men on the right, the one nearest the viewer representing the patron, old Sassetti himself. In a device already found in a preparatory drawing [226], a group of figures pour into the scene from a stair beneath street

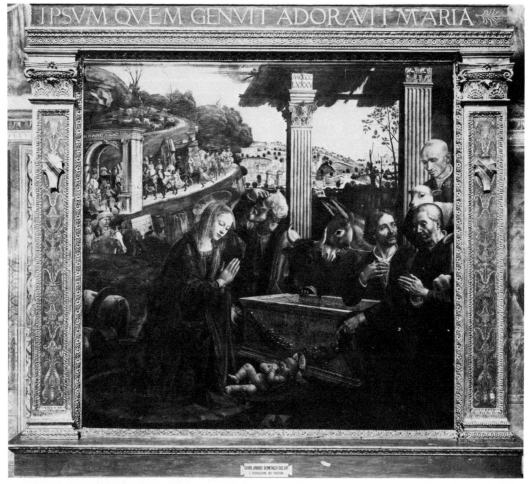

223. Domenico Ghirlandaio. *Adoration of the Shepherds*, 1485. Wood panel, 167 × 167 cm. Florence, Santa Trinita, Sassetti Chapel.

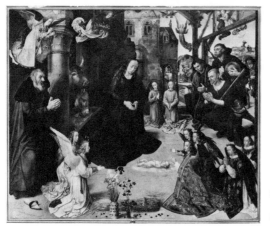

224. Hugo van der Goes. *Adoration of the Shepherds (Portinari Altarpiece)*, ca. 1480. Wood panel, 253 × 304 cm. Florence, Uffizi.

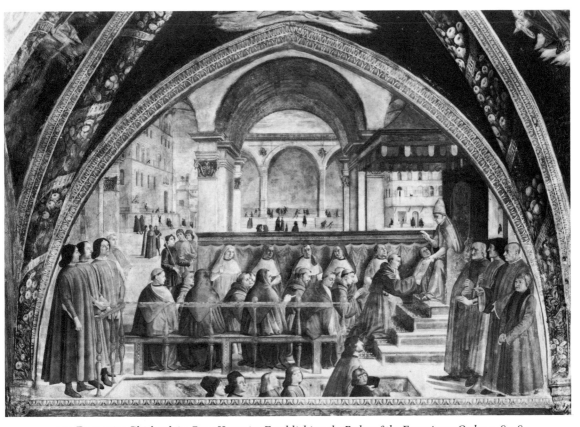

225. Domenico Ghirlandaio. *Pope Honorius Establishing the Rules of the Franciscan Order*, 1484–85. Fresco. Florence, Santa Trinita, Sassetti Chapel.

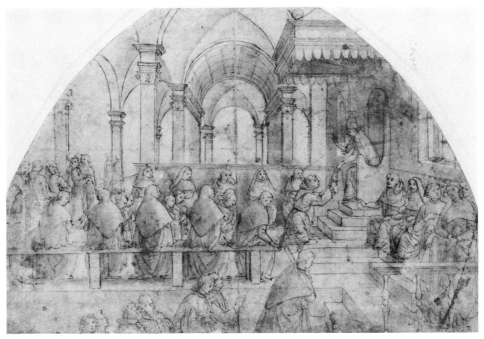

226. Domenico Ghirlandaio. Preparatory drawing for *Pope Honorius Establishing the Rules of the Franciscan Order*, ca. 1483. Pen and bister, 25 × 37 cm. Berlin, Kupferstichkabinett.

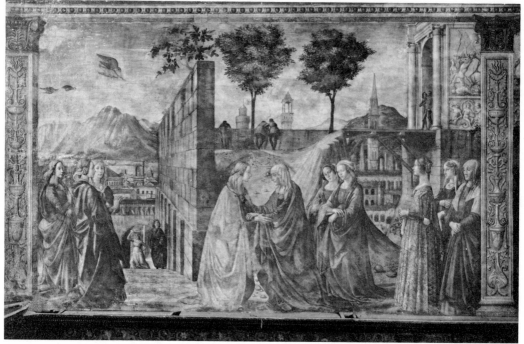

227. Domenico Ghirlandaio. *Visitation*, 1486–90. Fresco. Florence, Santa Maria Novella, choir.

level, headed by the humanist Angelo Poliziano, tutor of the Medici children. Ghirlandaio here echoes the effect previously obtained by Mantegna in the *Crucifixion* for the predella of the *San Zeno Altarpiece* [184] and by Filippo Lippi in the *Coronation* [84]. Ghirlandaio's dignified figures stand easily, betraying self-confidence and self-satisfaction much as one might imagine from Ghirlandaio's rich clients.

Ghirlandaio's gift for portraiture can also be observed in the far more ambitious cycle he undertook for the massive Gothic choir of Santa Maria Novella. The scenes on the left wall treat the life of Mary, those on the right the story of John the Baptist. The events are to be read chronologically from the bottom zone upward, which is to say in the contrary order in which they were presumably painted. Portraits abound, particularly on the lowest zone,

the one most accessible to the spectator, where Ghirlandaio himself probably participated more fully. In the *Visitation* [227], Mary encounters her cousin Elizabeth before the births of Christ and John; the spatial excitement created by shifting the ground levels, already demonstrated in the *Pope Honorius* fresco in Santa Trinita, is further exploited here. The two women, as heavily draped as they are undemonstrative, meet in the center of the composition close to the picture plane. Groups surround the pair but at some distance. On the left, in the middle plane, a woman supporting a burden on her head labors up the slope to the zone of the main action. Below her lie a city and in the distance high mountains. In the center left is a still higher level with figures leaning over a low parapet looking down on the city. On the right, Ghirlandaio has placed a triumphal arch

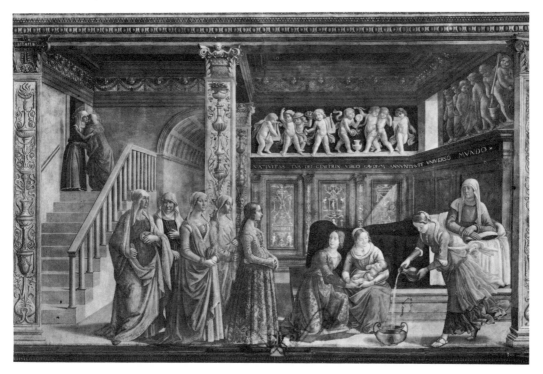

228. Domenico Ghirlandaio. *Birth of the Virgin*, 1486–90. Fresco. Florence, Santa Maria Novella, choir.

229. Domenico Ghirlandaio. Detail of 228.

obliquely in space and a rather precarious bridge.

These spatial intricacies heighten the narrative, which in itself has limited dramatic possibilities. The arch has finely rendered, imitation classical marble reliefs and is a reminder of Domenico's antiquarian and archaeological interests. On the other hand, his compositions and the individual figure types, poses as well as heads, have virtually nothing to do with antiquity; Ghirlandaio's commitment to antiquity as a vital inspiration for his paintings is relegated to theatrical props and learned visual references. Nevertheless, he was responsible for an important body of drawings after the antique known as the *Codex Escorialensis.*

Probably the most admired of Ghirlandaio's frescoes is the *Birth of the Virgin* [228], in which his unique skills come together successfully. In a clearly definable stage setting, the aged St. Anne watches from her bed as the handmaidens prepare to wash the babe while family members look on. Once again specific portraits enliven the scene [229]. The architectural interior is pure fantasy, stylistically *all'antica,* while the frieze of *putti* demonstrates Ghirlandaio's awareness of both ancient sculpture and the art of his *quattrocento* contemporaries and predecessors. He actually signed this fresco in the feigned intarsia decoration at the back wall, while up the steps two women embrace in an action that repeats the *Visitation.*

In examples such as these we can observe Ghirlandaio at his best, within the second or middle stage of his development, the only one that can be safely defined. Ghirlandaio died in 1494 at the age of forty-five. In his pictures, he was somewhat dry and humorless, serious and objective, but he consistently produced well-crafted works. He was a distinguished portrait painter, although the solid figures in his frescoes are psychologically opaque. He had the most active shop in Florence during the

1480s and was in fact the teacher of Michelangelo, although he preferred to deny it. Unlike Pollaiuolo and even Verrocchio, Ghirlandaio was never taken with the study of anatomy, and unlike Signorelli he was never fully engaged by the nude figure.

LUCA SIGNORELLI

The reputation of Luca Signorelli (ca. 1450–1523) since the mid-sixteenth century has rested extensively on the connection between his art and the development of Michelangelo, with a particular emphasis on Michelangelo's reliance upon the older master's inventions and a shared predisposition to render to the nude. Evidence that Michelangelo had actually lent Signorelli a substantial sum of money further supports a personal rapport. Seen within the context of monumental painting of the second generation, Signorelli's contribution is also substantial. According to the mathematician Luca Pacioli, Signorelli was a disciple of Piero della Francesca—Pacioli's own teacher—and since he wrote while Signorelli was still active, the contention seems well-founded; probable suggestions place Signorelli's birth around 1450 in Cortona, a town on the border between Tuscany and Umbria.

A poorly preserved fresco fragment datable to 1474 is his first extant work (Città di Castello, Pinacoteca Communale). Signorelli was active in and around Florence during the next decade: in 1482 he was commissioned to paint the doors of a wardrobe frontal in Lucigniano (lost), and shortly after he frescoed the small Cappella della Cura in the Basilica of the Santa Casa in Loreto, somewhat more distant from Florence in the Marches. Signorelli probably had a share in the frescoes on the walls of the Sistine Chapel around 1482–83 [148]. In 1484 he dated an altarpiece for the Cathedral of Perugia (Museo del Duomo). In the same year he was paid by the officials of Cortona to pro-

ceed to Gubbio to negotiate with Francesco di Giorgio Martini about building the Madonna del Calcinaio, a centrally planned church outside Cortona designed by the Sienese painter and architect (see Chapter 5).

In 1485 Luca was commissioned to do an altarpiece in Spoleto (lost or never finished). The *Annunciation* of the Galleria Communale of Volterra is signed and dated 1491. In the same year he was invited to attend a meeting of artists to select the best design for the new façade of the Florentine Cathedral, significant evidence of Signorelli's standing in the Florence of Lorenzo de' Medici. He did not, in fact, attend the meeting. He was recorded back in Città di Castello in 1493 and in the following year painted a standard for Urbino (Ducal Palace). In 1497 Luca began work on the cycle of frescoes for the abbey of Monte Oliveto illustrating the life of St. Benedict and thereby gained a reputation in nearby Siena. There in 1498 he painted the altarpiece for the Bichi Chapel in Sant'Agostino, in combination with a wooden sculpture (Berlin-Dahlem, Staatliche Museen) and a predella now divided among various collections.

His work in Siena was followed by two commissions, first to finish the vaults begun by Fra Angelico for the large San Brizio Chapel in the Cathedral of Orvieto in 1499 and for the walls of that chapel in 1500, which he finished at the latest by 1503 or 1504. In the years that followed, Signorelli was back in Siena, then again in the Marches and Rome, but he always maintained close ties with his native Cortona, where he frequently served on public councils and where he continued to paint. He produced the *Institution of the Eucharist* [239] in 1512; he died eleven years later in Cortona.

‡

Luca's training and early career are hazy because of the limited number of early pictures. The small, signed *Flagellation* [230], made originally as a processional banner and once backed by a *Madonna and Child* (now separated), was for a church in Fabriano and is probably one of his earliest surviving works, perhaps datable to 1480. The connections with Piero della Francesca's art, including the eloquently painted version of the same subject [231], are not overriding, except for a formal, measured balance in composition; by the age of thirty predictably the specific lessons learned from his master had been thoroughly digested and the period of imitation, if there was one, had long since passed. The poses are directly derived from antique sources both in the foreground group and the imitation reliefs behind, with, however, a Florentine mediation like Antonio del Pollaiuolo's Villa della Gallina frescoes [215], which relate to Signorelli's dancing tormentors of Christ. Signorelli stresses the sturdy outline of his figures, probably applied during the final resolution of the painting, in order to accentuate the forms themselves, while thickening the limbs.

The *Madonna and Child with Saints*, which once had an inscribed date of 1484, was commissioned for the Cathedral of Perugia by a bishop from Cortona [232]. By this period traces of Luca's training and even his first mature manner are obscured; reflections of Piero della Francesca continue to be rare and are mainly discernible in the Child, a massive figure of exceptional gravity and seriousness. The Madonna and Child are placed high in the pictorial field on a narrow, rather fragile throne, which makes them by comparison appear even more solid. Sts. John the Baptist and Lawrence are on the same elevated zone, with St. Onophrius and a bishop, perhaps the donor himself, beneath. In the center a Pollaiuolesque angel, almost certainly based on a life study, tunes a lute. In seeking possible sources for Signorelli's art as seen here, we must also imagine a connection with Perugino, especially for the St. John. Signorelli

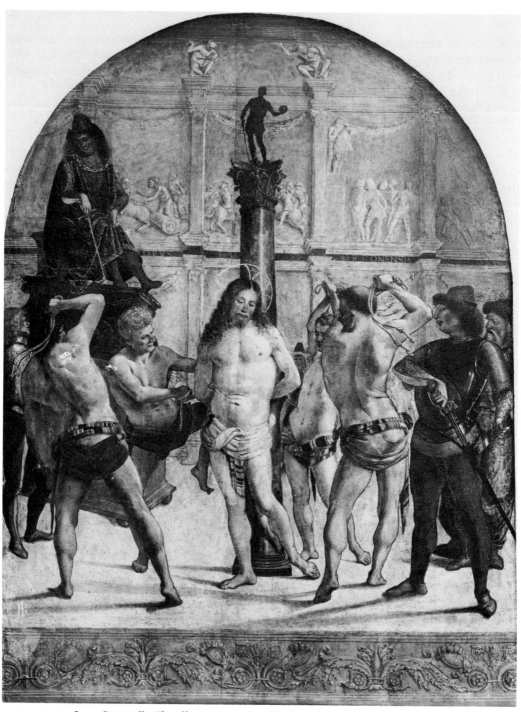

230. Luca Signorelli. *Flagellation*, ca. 1480. Wood panel, 80 × 60 cm. Milan, Brera.

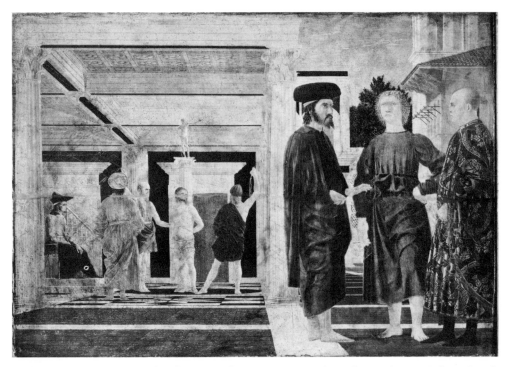

231. Piero della Francesca. *Flagellation of Christ,* ca. 1450. Wood panel, 59 × 81.5 cm. Urbino, Ducal Palace.

and Perugino were both Umbrians whose life-spans overlapped, and they were influential over much of Italy. The piling up of figures in the composition reflects Perugino, but it also occurs among Ferrarese painters like Cosmè Tura, and becomes especially important in Venice.

Notwithstanding the connections, Signorelli's painting in Perugia (Perugino's home territory, of course) is distinct and independent, with its cool, pale background virtually without landscape references. The transparent glass vessels containing wild flowers—a reference to Mary—and other superb still-life devices need not be derived from Netherlandish models directly (as is often suggested), because by the 1480s such elements had long since be-

come commonplace among Italian artists. Luca here is already a master of the nude, as demonstrated by his handling of the Child and the youthful angel but also by the emaciated hermit St. Onophrius—hints of his future figural preferences.

The memorable *Madonna and Child* [233] painted, as circumstantial evidence suggests, for the Medici along with the famous, now destroyed *School of Pan* [234] chronicle Signorelli's adherence to classical models, especially for the nudes in the background of the *tondo,* with its fictive marble frame superimposed on a rectangular picture. Luca must have been a student of ancient sarcophagi as well as of freestanding statuary and very likely also knew small Roman and Etruscan bronzes

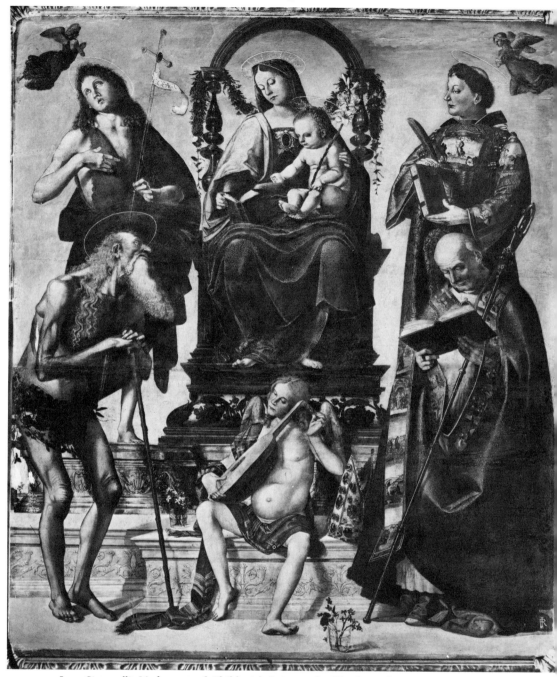

232. Luca Signorelli. *Madonna and Child with Saints*, 1484. Wood panel, 221 × 189 cm. Perugia, Museo del Duomo.

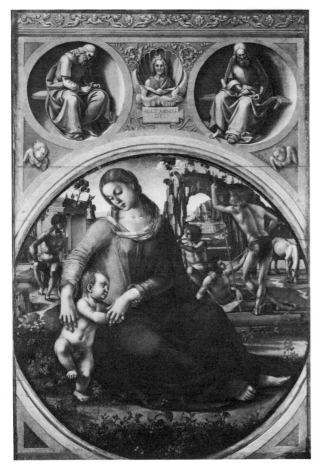

233. Luca Signorelli. *Madonna and Child*, late 1480s. Wood panel, 168 × 115 cm. Florence, Uffizi.

and painted vases. At the same time, he was aware of the sculpture of Donatello and Verrocchio. Landscape, as with Michelangelo, had little interest for Luca, although in the Uffizi *Madonna* the flowers and plants are presented affectionately, and in the rocky cliff, open in the middle like a gigantic arched bridge, already a familiar motif in Mantegna's art, he expanded his formal vocabulary to meet the fierce competition in Florence.

The frescoes in the San Brizio Chapel of Orvieto Cathedral (a commission offered earlier to Perugino, whose price was considered too high by the church officials) comprise Signorelli's masterpiece. He first undertook to

finish the vaulting begun by Fra Angelico and Benozzo Gozzoli a half-century earlier with depictions in separate sections containing choirs of Apostles, Church Doctors, Virgin Martyrs, and Angels. The large wall frescoes are reserved for the *Antichrist* [235], the *End of the World*, the *Resurrection of the Dead* [236], the *Damned* [237], the *Saved* and, on the base level, imitation classical grotesques and portraits, including those of Virgil and Dante. The subject of the Last Judgment coincides with the half-millennium and the prophecies of doom that circulated widely before the year 1500. Luca apparently painted the vast cycle rapidly, making effective use of

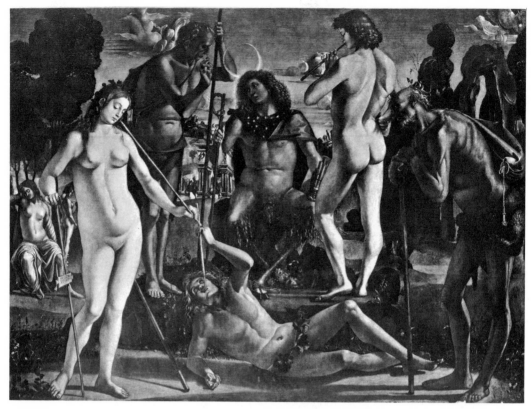

234. Luca Signorelli. *School of Pan* (destroyed), late 1480s. Wood panel, 194 × 257 cm. Formerly Berlin, Kaiser Friedrich Museum.

assistants. He reveals himself as particularly dedicated to a monumental style, an advocate of the expressive potentialities of the human figure, nude, or tightly dressed to allow a reading of the anatomy. The *Antichrist,* without nudes because of the iconographic requirements of the subject, is decidedly scenographic; more than a hundred figures are distributed across the flat landscape, dominated on the right by an imaginary structure composed of a classical temple attached to a square building with a towering dome. On the left in the distance is a city. Signorelli, like the slightly older Melozzo da Forlì, is challenged by arranging figures in difficult foreshortening —on the ground, flying in the air, twisting and

turning in unexpected positions. The central space is taken up by the Antichrist being counseled by the devil as he preaches from a small marble altar.

The other frescoes in Orvieto give Luca wider latitude in rendering the nude; in the *Resurrection of the Dead* the figures rise from the earth as skeletons or as full flesh-and-blood images in a wide variety of poses. In Luca's vision, the world is composed of beautiful young men and women, muscular, strong, thick-limbed, with well-formed hands and distinctive fingers, presented with generalized modeling [238]. They are convincingly three-dimensional and occupy the spaces they create by their fleshy presence. Color has a sec-

235. Luca Signorelli. *Antichrist*, 1500–1504. Fresco. Orvieto, Cathedral, San Brizio Chapel.

236. Luca Signorelli. *Resurrection of the Dead*, 1500–1504. Fresco. Orvieto, Cathedral, San Brizio Chapel.

237. Luca Signorelli. *Damned*, 1500–1504. Fresco. Orvieto, Cathedral, San Brizio Chapel.

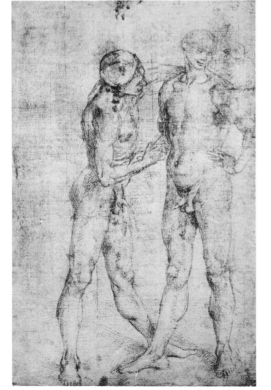

238. Luca Signorelli. Studies of nudes for the Orvieto frescoes, ca. 1500. Black charcoal, 41 × 26.5 cm. Florence, Uffizi.

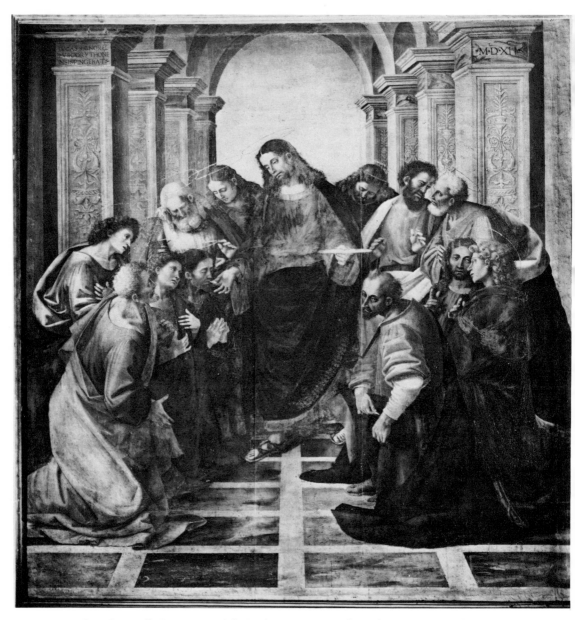

239. Luca Signorelli. *Institution of the Eucharist*, 1512. Wood panel, 270 × 240 cm. Cortona, Museo Diocesano.

ondary part in the total effect, but Luca often employs rich, sonorous, though metallic and sometimes stark color that can be decorative but never naturalistic. As in the case of the Schifanoia Palace frescoes in Ferrara, the Orvieto frescoes would have had a far more powerful, even inevitable impact on other artists were they not located in a provincial center like Orvieto, though it is on the road to Rome. Furthermore, they appeared old-fashioned soon after they were painted, having been so quickly followed by Raphael's frescoes in the Vatican *stanze* (series of rooms) and by Michelangelo's Sistine ceiling. Seen within the context of second generation painting, however, they are unique, attractive, and progressive.

Among his last works (and Luca outlived both Leonardo and Raphael), where a noticeable decline in quality is undeniable, the *Institution of the Eucharist* [239] retains the originality of his previous efforts. Christ, standing in the center high in the picture, is framed by the finely decorated piers and the arch of a Renaissance structure, open to the pale sky. He offers the holy wafer to the Apostles, who form a spatial funnel, revealing a multicolored marble floor. Judas, perhaps the finest figure in the painting, is subtly separated from the others; he turns away from Christ, putting the Host in a money sack where presumably he stores the pieces of silver, a sad and remorseful image.

Signorelli was one of the important models for the young Raphael as he was evolving his own artistic style, especially when he was in Città di Castello, on and off between 1500 and about 1503 or 1504. Unlike Raphael, and even Piero della Francesca, Signorelli was a great provincial master who remained provincial despite moments of glory and periods of soaring invention, as in the *Pan* or in the frescoes in Orvieto.

LEONARDO DA VINCI

Leonardo di ser Piero da Vinci (1452–1519) is sometimes displaced from his proper contemporary milieu. Although born in 1452, he is usually associated with Raphael, Titian, and Michelangelo, who together are credited with producing the fullest and most potent phase of Renaissance painting. Leonardo of the *Last Supper*, the *Battle of Anghiari*, and the *Mona Lisa*, Raphael of the Vatican *stanze*, Michelangelo of the Sistine ceiling, and Titian of the Frari altarpieces are celebrated as representative of a rare moment in the history of Renaissance painting. Leonardo, however, belongs to a generation before the others; he was born thirty-one years earlier than Raphael, who died only a year after Leonardo. When Michelangelo was three years old, Leonardo was already a promising painter with a significant commission from the Florentine Signoria for an altarpiece in their palace (which he failed to produce). However progressive and innovative, Leonardo should be studied within the context of his actual contemporaries, artists who experienced comparable cultural and political impulses and had similar training. As a point of reference, Leonardo was a nearly exact contemporary of Lorenzo de' Medici (born 1449), and not Lorenzo's son Giovanni de' Medici, who became Pope Leo X and who was born in 1475, the same year as Michelangelo.

Leonardo was, of course, Florentine by birth, from the outlying town of Vinci, and he was trained in Florentine workshops. He traveled widely, spent almost two crucial decades in Milan just before 1500, and was always open to whatever currents he found. While he should be placed among the monumental artists, he often betrays lyric traits, and on the continuum between lyric and monumental, Leonardo, like Giorgione, stands close to the middle.

The myth surrounding the artist, already growing during his lifetime, which has continued to snowball over four centuries, raises difficulties in evaluating Leonardo's art. If Raphael and especially Michelangelo were regarded as "divine," Leonardo has an unchallenged position as the super genius, the most universal of the *uomini universali*. His scientific investigations and his anatomical studies have proved to be astonishingly advanced, the former anticipating innumerable modern devices from the armored tank to the airplane, the diving suit to the helicopter. For the historian and the casual observer alike, such genius has tended to intimidate an objective approach to his painting.

At about the age of thirteen, Leonardo was placed in a workshop, very likely that of Andrea Verrocchio. We know that Leonardo was there in 1469 when the bronze ball for the Cathedral was being cast. He enrolled in the Confraternity of St. Luke in 1472. In 1476 he is mentioned as (still) residing with Verrocchio, and in 1478 he obtained a commission for an altarpiece in the Palazzo della Signoria. He contracted to paint an *Adoration of the Magi* [245] for the monks of San Donato a Scopeto in 1481, which remained unfinished, presumably because he left Florence for Milan, where in 1483 he was assigned to paint the *Madonna of the Rocks* [246]. Leonardo remained in Milan, working mostly at the court of Ludovico Sforza and in the refectory of Santa Maria delle Grazie, painting the *Last Supper* [248], until 1499. In that year, when his patron fled the city, Leonardo also left, stopping first at Mantua, where he did a portrait of Isabella d'Este [250], then moving on to Venice for a few months, and finally working his way back to Florence by 1500.

He obtained a commission for a St. Anne from the Servites (for their church of the Santissima Annunziata) soon after his arrival. Two years later Leonardo was appointed the official architect and engineer of Cesare Borgia, but in 1503 he was again in Florence, employed on a canal project for the government. He began the huge mural of the *Battle of Anghiari* in the Palazzo della Signoria in 1505 after working on the cartoon during the previous year in the Convent of Santa Maria Novella. In 1506 Leonardo was again in Milan, this time in the employ of the French, and he remained there except for trips to Florence until he left Lombardy permanently at the end of 1513 for Rome. Patronized there by Giuliano de' Medici, duke of Nemours, he was lodged in the Belvedere Palace. In 1516, after the death of Giuliano, Leonardo quit Rome and Italy for France, where he died at Amboise in 1519.

꙼꙼

A comprehensive evaluation of Leonardo's art is hampered by the small number of extant paintings. He failed to complete many commissions, and others have been lost or destroyed. Even among the handful of pictures that are widely accepted as by Leonardo, there are attribution problems, questions of collaboration with assistants, heavy restoration, mutilation, and other damage. With general agreement, the following partial list of works can be considered: the *Annunciation* [242], *Ginevra de' Benci* [243], the *Adoration of the Magi* [245], the *Madonna of the Rocks* (one version in Paris [246], another in London, [247]), the *Last Supper* [248], the *Madonna and Child with St. Anne* [255], *Bacchus* [256], and the *Mona Lisa* [251]. Of these, the *Last Supper* is a majestic wreck and the *Adoration* is barely half-finished—what is now visible is really underpainting. The *Battle of Anghiari*, a conception of capital importance for Leonardo's artistic ideas and his stylistic evolution, is known only through feeble, partial copies [252]. Thus, what we have left of Leonardo's paintings is so slight that the mystery surrounding his art is enhanced.

240. Leonardo da Vinci. *Landscape*, 1473. Pen and ink, 19 × 28.5 cm. Florence, Uffizi.

Hundreds, even thousands, of drawings and studies by Leonardo are to be found on the pages of his notebooks; some reflect lost or never executed compositions known only through copies. The bulk of his drawings, however, are related to areas of interest and experimentation other than painting and are not necessarily of artistic merit. An understanding of Leonardo's painting style is further confused by his *Treatise on Painting*, which like so many of his works, he left unfinished. It was put together from notes by his pupil and heir Francesco Melzi. The correlation between his ideas about painting expressed in the *Treatise* and his practice is not consistent, and sometimes he gives advice in the treatise that he himself never followed.

There is good reason to believe that Leonardo was Verrocchio's pupil, and in Verrocchio's shop he could have learned a great deal, since it produced diverse objects ranging from small painted Madonnas to over-life-size bronze sculpture. The first time Leonardo's hand can be seen with certainty is in a landscape drawing dated 1473 [240], in the *Annunciation* [242], and on parts of the *Baptism of Christ* [241], Verrocchio's most ambitious pictorial composition. Leonardo's share is probably confined to the kneeling angel on the extreme left and parts of the distant landscape.

A conception of Verrocchio's figural types as they may have affected the young Leonardo is best seen in three-dimensional examples. The bronze *David* (Florence, Bargello) is a self-

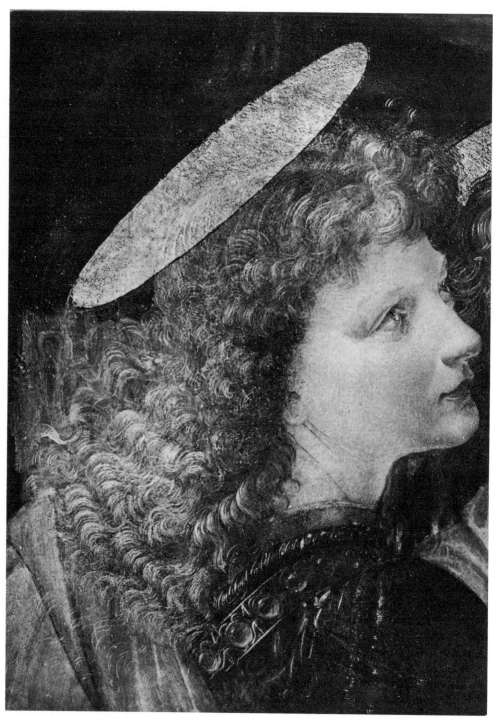

241. Leonardo da Vinci. Detail of 123.

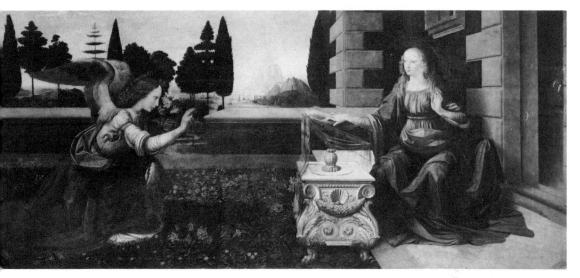

242. Leonardo da Vinci. *Annunciation*, ca. 1473. Wood panel, 104 × 217 cm. Florence, Uffizi.

confident, unperturbed, rather fragile youth who recurs as a type in Leonardo. His head is small in proportion to the rest of the body, especially the heavy legs. The quizzical expression approaching smugness reveals a faint smile not unlike those of the faces Leonardo will make a decade or so later. The head of the *David*, when seen in profile with its carefully arranged ringlets framing the face, is similar to Leonardo's angel in the *Baptism*, with its strong chin, tightly pressed lips, straight nose, and prominent brow. Leonardo softens and enlivens the hair, with locks flowing down the back of the neck. At this early stage of his development, Leonardo is occupied with the rendering of detail, seen here in the naturalistic treatment of the gems on the angel's right shoulder and the landscape directly above. The other areas of the painting, including the water and rocks in the foreground and the cliff behind St. John the Baptist, are by comparison mechanically painted and oddly unnatural.

The Uffizi *Baptism*, probably painted in the years between 1470 and 1473, raises the question of Leonardo's position in Verrocchio's shop. He was already a member of the confraternity of St. Luke by 1472 and was old enough to make a shop of his own. Apparently he still thought he had an advantage in continuing to stay with Verrocchio, or perhaps he was fearful of striking out for himself.

Leonardo's works of the 1470s, whether executed within the shop or independently, are difficult to arrange chronologically, but to a certain extent they all show dependence upon Verrocchio rather than a fulfilled personal expression, which we find first in the *Adoration of the Magi*. The early works, reflecting Verrocchio's shop style, include the *Annunciation* [242], the *Ginevra de'Benci* [243], the *Madonna with the Vase* (Munich, Alte Pinakothek), and the *Benois Madonna* [244]. I suggest that the chronology among them follows the order given, with Leonardo's share in the *Baptism* occurring toward the beginning of the group. We must also assume that Leonardo was working on more than one of these projects at the same time, since he worked slowly. The *Benois Madonna* is the most independent of this group of paintings; conse-

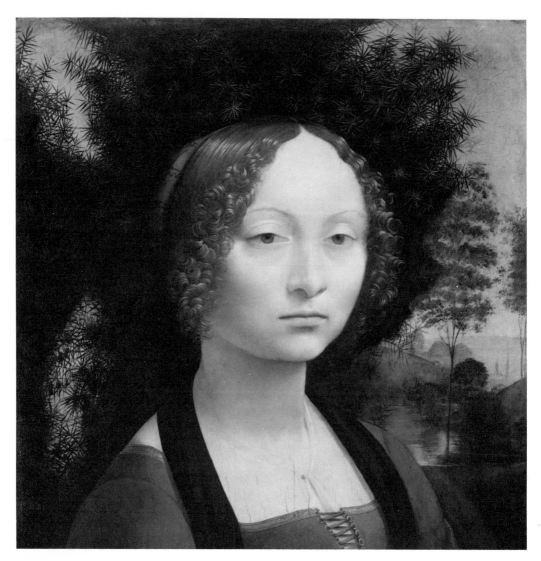

243. Leonardo da Vinci. *Ginevra de'
Benci*, ca. 1475. Wood panel,
38.2 × 36.7 cm. Washington, National
Gallery.

quently it was probably the last to have been painted. The light is handled more loosely and more expressively than in the others, although the condition of the painting makes sweeping claims precarious. On the other hand, the composition is forthright: the Child, seated on Mary's raised leg, is placed obliquely, arranged at right angles to Mary, who is also turned in space; the two are locked into a compact spatial block.

The painting that shows Leonardo's thorough liberation from Verrocchio and a declaration of artistic independence is the *Adoration of the Magi* [245]. The contract of 1481 called for its completion in two or two and one-half years. Although unfinished, it provides incomparable insights for understanding Leonardo's method, thanks in part to the related drawings. The underpainting, which was essentially all that was executed, records his working procedure. The popular subject is given a centralized composition and requires a spatial reading. The shift from a more conventional arrangement with figures all on the same plane is not entirely Leonardo's invention; Botticelli had used a similar solution earlier. Leonardo placed the main figures close to the picture's surface and hence to the spectator, building them into a pyramidal arrangement with Mary's head at the apex. Consequently, the three Magi and the Madonna and Child are separated from the other figures, even those contiguous to the geometrical construction, and while the others gesticulate and react vigorously, the principal actors perform their restrained roles slowly, silently. Mary is rendered as if the *Benois Madonna* had been turned around to face the spectator, and she seems to have the same idealized face.

Leonardo constructs form by building from light to dark but also from dark to light, sometimes pulling out secondary images from deep shadows. The light strikes the Child from the front, establishing an excited surface that

models the form, but the solution has yet to be fully resolved at the stage of execution in which he abandoned the painting. A preliminary study (Florence Uffizi) reveals more clearly the ruined or half-built structures, with the massive double stairway on the left, the shed at the right, and a battle, or more likely a joust, in between in the background.

The contract of 1483 for the *Madonna of the Rocks* (first version, Paris, [246]; second version, London, [247]) was entered into by Leonardo, together with the local painters Ambrogio and Evangelista de Predis, with the Confraternity of the Conception of the Virgin in San Francesco Grande, Milan, following the manufacture of the frame. The circumstances that caused two versions to be produced, their dates and chronologies, contain irresolvable problems, although it is generally agreed that the Louvre picture was the original commission which, for some unexplained reason, was replaced by the London picture. The second, London version exhibits a much greater share of shop assistance than the one in Paris.

The composition makes use of a pyramid, with the little St. John on the left, the Christ Child who blesses him and the angel at the right, and Mary, with extended arms, at the apex. Another set of relationships is also formulated: the left hand of Mary, sharply foreshortened and projecting toward the picture surface, the unforgettable pointing hand of the angel (dropped from the London version), and the head and body of the Christ Child form a secondary vertical axis parallel to the central one. The semicircular shape of the upper portion of the picture affects the forms of the rocks in the cavern-like space behind the sacred figures, which functions like an apsidal dome, similar to the architecture in Piero della Francesca's *Brera Altarpiece* [111] or Giovanni Bellini's *San Giobbe Altarpiece* [197].

In this painting Leonardo expresses his interest in nature, from the variety of plants and

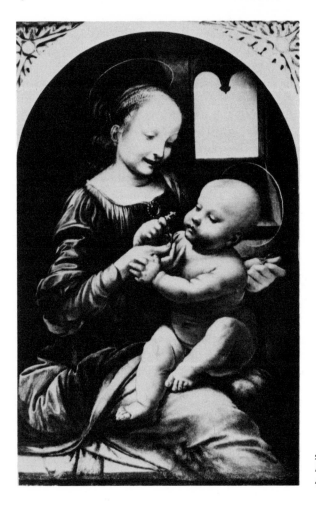

244. Leonardo da Vinci. *Benois Madonna*, ca. 1478. Wood panel, 49.5 × 31.5 cm. Leningrad, Hermitage.

flowers (which have symbolic references to Mary) to the atmosphere—including mist and air as seen from a distance—as well as in the surface of materials and their textures. He was aided in obtaining the desired effects by the oil medium and oil glazing. The softening of the edges of forms, the gradual shift from plane to plane, and the smoky, veil-like quality of the surface *(sfumato)* recall Netherlandish painting and one of its finest spokesmen in Italy, Antonello da Messina, Leonardo's older contemporary. The dramatic and expressive possibilities of shadow and the flickering light on the surface, which picks up the fingertips of Mary's extended hand, appear for the first time in Leonardo's art.

The color in the *Madonna of the Rocks* is the most elusive of the painting's puzzling and magical components. The expectation of compelling tonalities, deep sonorous reds and the transparent green of the angel's garment, is never quite fulfilled. The landscape is virtually monochromatic, either because the final glazes were never applied or because Leonardo wished to distinguish between the figures and the rest of the picture coloristically

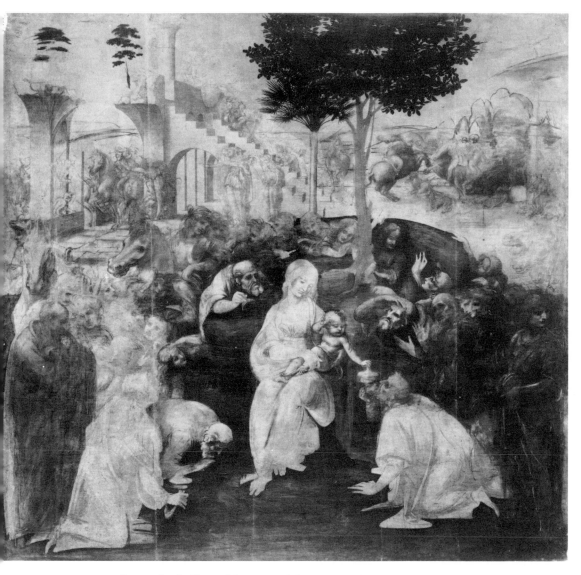

245. Leonardo da Vinci. *Adoration of the Magi* (unfinished), ca. 1482. Wood panel, 246 × 243 cm. Florence, Uffizi.

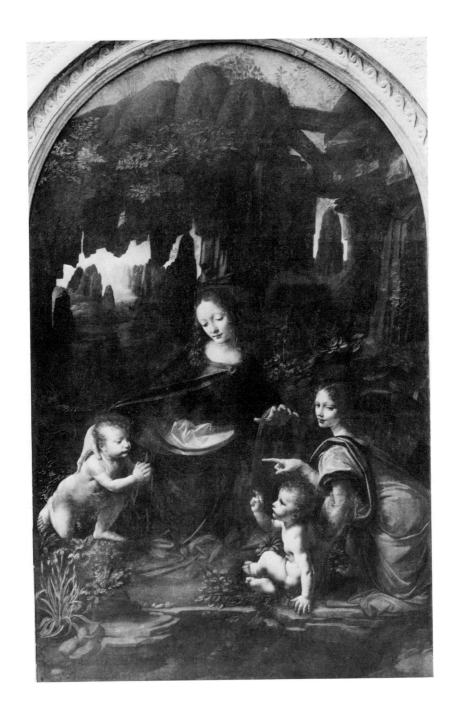

246. Leonardo da Vinci. *Madonna of the Rocks*, 1483–85 (?). Wood panel (transferred), 197 × 119.5 cm. Paris, Louvre.

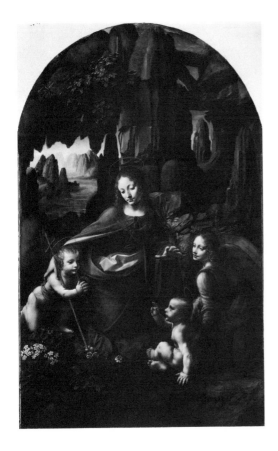

247. Leonardo da Vinci. *Madonna of the Rocks*, early 1500s. Wood panel, 189.5 × 120 cm. London, National Gallery.

as well as compositionally. Whatever color there is has a secondary role. In the *Madonna of the Rocks* Leonardo subordinates every-thing, including color, to the demands of the total interlocked composition, producing an easily readable and understandable icon of un-precedented complexity and unity.

The *Last Supper* [248] is among the most renowned and oppressive pictorial images of Western art. Begun around 1495 and men-tioned by a contemporary as finished in 1498, the mural was executed in the refectory of the Convent of Santa Maria delle Grazie in Milan. The room is about four times as long as it is wide, and the painting covers the entire width of one short wall, raised some feet about the pavement. Like previous *Last Suppers* by Cas-tagno and Ghirlandaio [115, 220], it was made

to be a constant reminder to the monks of Christ's momentous meal while they were at table, with Eucharistic references central to the picture's meaning. On the opposite wall was an older fresco that included the Crucifix-ion, which, in the unfolding of events, follows the Last Supper.

Since the *Battle of Anghiari* (undertaken along with Michelangelo's *Battle of Cascina* for a wall of the Palazzo della Signoria after Leonardo had returned to Florence) was never finished, and since the cartoon has long since been lost, the *Last Supper* alone repre-sents Leonardo's art on a grand scale. In it he emerges as the direct heir of Masaccio, whom he specifically admired, and of Filippo Lippi (as represented by the Prato frescoes) in the integrity of the figures and in the tightly com-

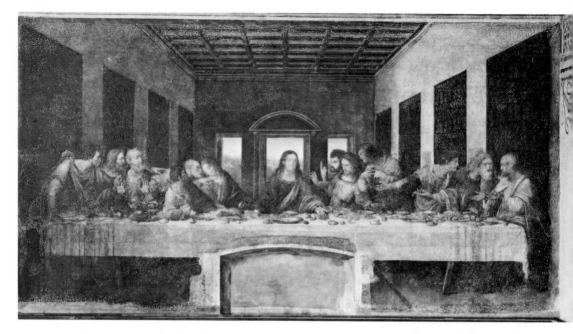

248. Leonardo da Vinci. *Last Supper*, ca. 1495–98. Fresco, 460 × 880 cm. Milan, Convent of Santa Maria delle Grazie, Refectory.

posed groups of majestic, serious Apostles, shown without anecdotal intent. For the sake of identification, the participants are, as usually believed, reading from left to right and organized into subgroups: Bartholomew, James Minor, Andrew; Judas, Peter, John the Evangelist; Thomas, James Major, Philip; and Matthew, Thaddeus, Simon. Christ is in the center, in a section all to himself, functioning much like the Christ in Masaccio's *Tribute Money* [77], alone in a crowd. Although following the *quattrocento* tradition of placing the long table parallel to the picture's surface, Leonardo includes Judas among the Apostles on the same side, yet subtly removes him from the others by his action.

The composition did not come easily to Leonardo, who in preparatory studies [249] had a more conventional arrangement for the figures. In one drawing he even labeled the various Apostles as if to keep them straight in his own mind. After arriving at the final com-

positional solution, he worked out the features of the individual participants, presumably utilizing studies from life to achieve their physiognomies. It is said that Leonardo could never finish the head of Christ, although judgment is difficult, given the disastrous condition of the painting. The *Last Supper*, restored more than half a dozen times over the centuries, had already begun to deteriorate soon after it had been completed, presumably because of the experimental mixed media Leonardo employed.

Besides the grouping of the figures, their restrained but expressive gestures, and the psychological interaction between individuals and groups, one should not underestimate the carefully integrated harmony of the "minds" of the figures with their physical appearance, as well as the importance of the space and the depiction of still life. The perspective operates best at some distance from the painting, rather than close by, because the coffered ceil-

ing is sharply foreshortened whereas Christ and the other figures are seen from a point of sight at about eye level. If the perspective and the resulting foreshortening are read literally, the room in which the meal occurs is deep, the doorway with the curved pediment enormous. The still-life elements in their original appearance, the bread and wine, the glasses, the plates, foods, and even the tablecloth, must have offered an attractive counterbalance to the severity and drama of the figures, representing, according to older commentaries, the moment of announcement by Christ of his betrayal.

The reactions of those present seem to move in waves, with Judas the antagonist leaning backward and away, and Peter angrily gripping the knife with which he will cut off the ear of a Roman soon afterward. Only John, mirroring Christ's demeanor, fails to react overtly. Christ, still in his role as teacher, completely relaxed and resigned, gestures toward the wine on his right and the bread on his left. In this mural, color seems to have functioned actively, with a more vigorous and aggressive application than in his glazed panel paintings. Blues and reds predominate and are played against the pale whiteness of the long horizontal cloth.

In the *Last Supper* Leonardo celebrates "decorum," the nobility of expression and gesture, the dignity of movement and pose. His figures are the embodiment of a disciplined constraint that becomes a hallmark of painting

249. Leonardo da Vinci. Studies for the *Last Supper*, ca. 1495. Pen, ink, and metalpoint, 27.8 × 20.8 cm. Paris, Louvre.

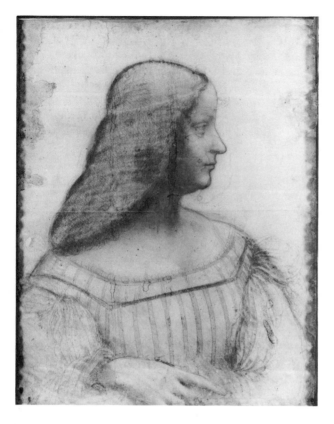

250. Leonardo da Vinci. *Isabella d'Este*, 1500. Black chalk with charcoal and pastel, 63 × 46 cm. Paris, Louvre.

among third generation monumental painters.

In contrast to the *Last Supper* and the *Battle of Anghiari,* Leonardo's portraits—the *Ginevra de'Benci,* the *Mona Lisa,* the *Lady with the Ermine* (Cracow, Czartoryski Museum), and the profile portrait drawing of Isabella d'Este [250]—were intended for the private enjoyment of his patrons and indicate a personal involvement between the painter and his sitter: all three were apparently done from life. The *Ginevra* is a work of the mid-1470s and reflects Verrocchio. Cut down at the bottom, the portrait of Ginevra, whose name is a variant of the juniper bush that surrounds her head, presumably once showed the hands.

The *Mona Lisa* [251], perhaps begun in 1503, after Leonardo's return to Florence, was never delivered to the patron since we know Leonardo still had it in France when he died. The painting has managed to survive overstudy, farfetched iconographical explanations, and romantic interpretations, retaining its power as an engaging and mysterious image. The subject, whose identity is not certain, is placed in an open loggia with the viewer looking over the shoulder of the painter in the deep shadows near a wall. Since the viewer's eyes are on the same level as the sitter's, everyone is, presumably, seated. The figural pose is a significant invention: Mona Lisa's imposing body is set obliquely in space; the head is turned nearly full face to the viewer with the left arm resting on an armrest, on a plane both close to the surface and parallel to it. The spatial zone occupied by the figure is estab-

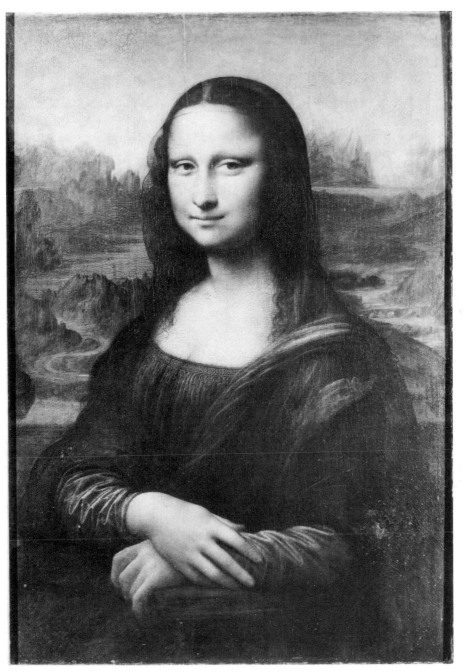

251. Leonardo da Vinci. *Mona Lisa*, begun ca. 1503. Wood panel, 77 × 53 cm. Paris, Louvre.

lished between the armrest and the low wall of the loggia. The highlighting of the face, the flesh above the bodice, and the magnificent hands produce a vertical focus within the picture. The puzzling background landscape, which can hardly refer to anything in Tuscany, has a high horizon only slightly below eye level, barely intruding upon the sitter's world. The picture has been frequently copied and interpreted. The power of its composition for portraiture was well understood by Raphael early on, and through him, as well as directly, the Mona Lisa pose has become standard even for modern-day photographers. In the half-light of the *Mona Lisa* the forms and the modeling are revealed with subtle nuances, but color has been sacrificed, for if objects are read with sharp focus when the eye of the beholder is in shadow, as must be presumed here, the color tends to lose its distinctness and each hue its identity.

After Leonardo left Milan at the end of 1499, he painted only sporadically. The *Battle of Anghiari* was commissioned in 1504 [252], and he immediately began to work on the cartoon for it in a special studio at Santa Maria Novella, actually beginning to paint (perhaps with encaustics) toward the middle of the following year. Soon he had to abandon the work because of demands for his services again in Milan. The painted version was hardly begun, and was covered over in the middle of the century; the cartoon, which was constantly studied and copied by other artists, has long since disappeared. Leonardo's plan for the entire composition is not known for certain, but the central section was an equestrian group usually referred to as the Battle for the Standard and is known from inept copies and copies after copies as well as engravings. The theme, and presumably that of Michelangelo's companion fresco of the *Battle of Cascina* [273], was drawn up by Machiavelli.

Leonardo, judging not only from copies and versions that have survived but also from studies and sketches he made for the fresco [253], distilled the battle into a combat between two pairs of cavalry officers whose energy and that of their mounts intertwine in agonized intensity, while a few figures beneath are also engaged in deadly struggle. The central figure, for which there exists a magnificent drawing of the head and upper torso, with the mouth wide open, brows knit, and with the arm raised to deliver a blow, is a study in the representation of human force, preceded by the studies of Antonio del Pollaiuolo.

The composition of the *Battle* as we know it is constructed within a parallelogram rather than a pyramid, and in this respect is related to the *Burlington House Cartoon* [254]. The heads of the two women in the *Cartoon*, mother and daughter, confront each other on the same level as the warriors in the *Battle*, but they are closer together. They converge obliquely and break through the implicit plane upon which they rest. The two children also converge by gesture and glance and appear more like twins than cousins; Mary and Anne are also very similar in type, as if two sides of the same personality, but Mary, awkwardly sitting on Anne's lap, is in an unresolved pose.

The *Burlington House Cartoon*, probably done just before he left Milan, is a predecessor of the *Madonna and Child with St. Anne* [255], which can be dated 1503–6, while Leonardo was in Florence. The composition, however, is less daring and innovative, with the figures built up within the pyramidal mass. The Child playing with the lamb appears as a variation of the Child playing with a cat in drawings made during Leonardo's first phase a quarter century before in Florence. The *St. Anne*, like the *Mona Lisa*, remained with Leonardo until his death, and he probably worked on it over the years, adding glazes, perfecting one area or another. Mary sits less ambigu-

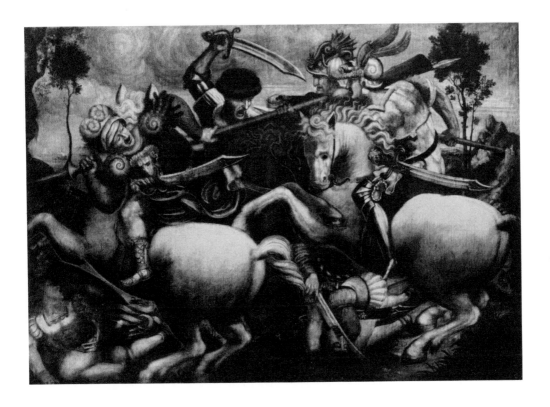

252. Leonardo da Vinci. *Battle of Anghiari* (destroyed), 1504–6. Sixteenth-century copy after. Florence, Horne Museum.

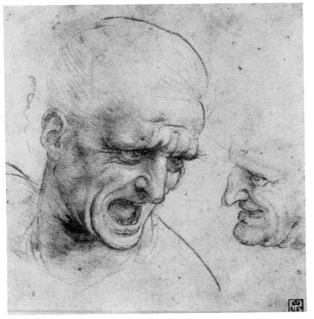

253. Leonardo da Vinci. Study of a head of a man shouting and of a profile, for the *Battle of Anghiari*, 1504. Black and red chalk, 19.2 × 18.8 cm. Budapest, Museum of Fine Arts.

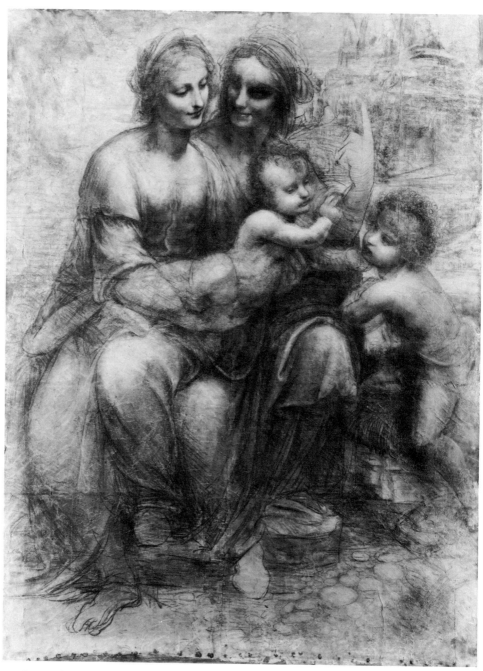

254. Leonardo da Vinci. *Madonna and Child with St. Anne and John the Baptist (Burlington House Cartoon)*, ca. 1499. Black chalk heightened with white, 141.5 × 104 cm. London, National Gallery.

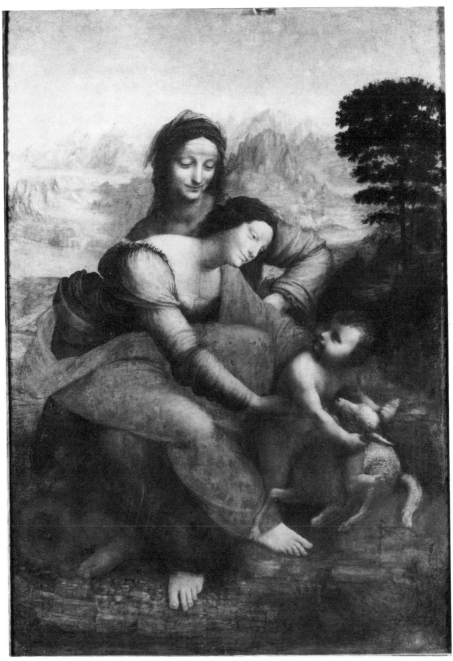

255. Leonardo da Vinci. *Madonna and Child with St. Anne*, 1503–6 (?). Wood panel, 168 × 112 cm. Paris, Louvre.

256. Leonardo da Vinci(?). *Bacchus,* ca. 1516. Canvas (transferred), 177 × 115 cm. Paris, Louvre.

forms takes place in the eye of the beholder rather than on the painted surface. Raphael, who was attuned to Leonardo's example, also seems to have benefited from this final phase of Leonardo's development, which he must have seen while Leonardo was in Rome, from 1513 to 1516. The expressive lights and darks were taken up by a group of Lombard painters, who imitated Leonardo's last manner, and by other North Italians, including Correggio, Lolto, Giorgione and Parmigianino, who incorporated Leonardesque elements into their own visual styles.

Leonardo, despite this new and emphatic *chiaroscuro,* never abandoned his commitment to a monumental interpretation of form: human figures with full, heavy limbs and columnar necks that support noble heads. If anything, in the late works, he tended to exaggerate in the direction of greater monumentality, as demonstrated by the *Bacchus* in the Louvre.

PIERO DI COSIMO

According to his father's tax return of 1480, Piero di Lorenzo, known as Piero di Cosimo (1461/62–1521?), was in the *bottega* of Cosimo Rosselli, a Florentine painter of considerable popularity and reputation during the second half of the *quattrocento.* From Rosselli Piero also took the name "di Cosimo," indicating a particular affection for his teacher. Since Piero was not salaried in 1480, it is likely that he had already achieved a degree of independence in the shop by this time, presumably after a period of training. Piero had a career of over forty years as a practicing painter, but his works are poorly documented and the facts surrounding his life are fragmentary and uninformative. He may have been in Rome in 1481 and 1482 with Cosimo Rosselli, who, as we have seen, was one of the masters active on the fresco decorations of the walls of the Sis-

ously on St. Anne's knees than in the *Cartoon;* turning to His mother the Child exchanges eye contact with Mary. The scene takes place on a knoll within a landscape, as in the *Madonna of the Rocks,* with Alpine peaks in the distance.

The dominant characteristic of both works and of the pictures Leonardo executed subsequently, including the *St. John the Baptist* and the *Bacchus* [256], is the degree to which *chiaroscuro* has taken over, becoming a salient stylistic and expressive end unto itself. Larger areas of shadow and light are laid out softly, operating on each other as if the artist has gone beyond the point of finishing. Most contours are obliterated, and the isolating of

tine Chapel. Piero di Cosimo was listed as head of the family with his brothers in 1498, and sometime between 1503 and 1505 he was inscribed in the Confraternity of St. Luke. He was among the artists and artisans who formed the commission to evaluate the various proposed sites for the placement of Michelangelo's marble *David,* and in the same year, 1504, he was entered in the painters' guild. In 1506 he was paid for a *Madonna* (not identified), in 1507 for festival decorations, and in 1510 he worked for Filippo Strozzi in his *camera* (room). Five years later he produced decorations for the triumphal entry of Leo X into Florence. From what is known, then, Piero di Cosimo appears to have spent almost his entire artistic life in Florence or nearby.

If the documents are practically of no help in establishing Piero's career and an acceptable chronology, Vasari's account of his life is among that author's most sympathetic biographies. Vasari, much taken with Piero's art, even owned a painting by the master. However helpful and rich Vasari's version of his life may be, with its heavy emphasis on Piero's eccentricities, it cannot be used as a substitute for contemporary documentation. Piero, some critics have suggested, moved from the orbit of Cosimo Rosselli to further training elsewhere. He seems at least to have made a careful study of Verrocchio, Filippino Lippi, and Ghirlandaio.

<div align="center">⁌</div>

The altarpiece of the *Visitation with Sts. Nicholas and Anthony Abbot* [257] can be dated to a period around 1489 to 1490, when the frame was provided. Made for the Capponi family chapel in Santo Spirito, the painting must be the starting point for any stylistic discussion of Piero's art. No doubt Piero painted many works before this one, but none is documented except for a signed and dated painting of the *Immaculate Conception* still in San

Francesco in Fiesole (1480), the inscription of which is not contemporary with the picture; it does betray a reliance upon Cosimo Rosselli.

In the background of the *Visitation* are two subthemes: the Adoration of the Child on the left and the Massacre of the Innocents on the right; on the façade of a distant church is represented still another subject, the Annunciation. By the time Piero painted this altarpiece he was obviously a fully developed and stylistically independent artist, and whatever he may have absorbed from his teacher or teachers is well integrated into his art. The carefully centralized, decisively plotted composition combines the meeting of Mary and Elizabeth with patron saints of the Capponi family in the same space. The saints occupy the bottom half of the panel and are closer to the spectator, with the Christological elements set in the upper zone, within a bright, high sky and diversified landscape. The buildings on both sides of the middle ground create a visual funnel leading to the infinite distance. On the raised stage-like platform on the right beside a withering tree unfolds the Massacre and behind it is a Romanesque city.

Piero's figural style here reflects a sculpturesque regard for massive draperies, robust proportions, vast expressive hands, and a dedication to figural volume, all ingredients he shares with monumental painters of the second generation. Since his life falls late in the period and since he presumably was active into the 1520s, Piero's art frequently overlapped the careers of the third generation painters, among them his own gifted pupils, Andrea del Sarto and probably Fra Bartolommeo, whom he outlived.

The intensified reality that is found in Piero's pictures, and the range of his fantasy, so much admired by Vasari, are seen in the *Visitation* and in part can be attributed to an acquaintance with Netherlandish art. A realism approaching surrealism *avant la lettre* is

257. Piero di Cosimo. *Visitation with Sts. Nicholas and Anthony Abbot*, ca. 1489–90. Wood panel, 184 × 189 cm. Washington, National Gallery.

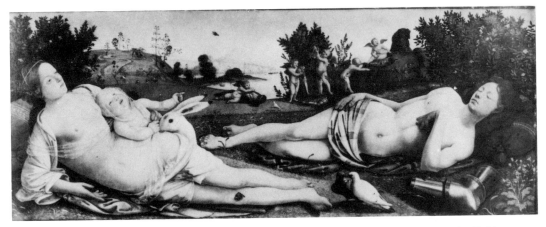

258. Piero di Cosimo. *Venus, Mars, and Cupid*, ca. 1490. Wood panel, 72 × 182 cm. Berlin-Dahlem, Staatliche Museen.

manifested here, for example in the treatment of the balls, attributes of St. Nicholas, on one of which the chapel's space is reflected, or in the precariously balanced account book, or in the bell and crutch of St. Anthony. The effects are achieved in part due to Piero's preference for oil painting over tempera, a preference that permitted *trompe l'oeil* qualities already favored by some Italian artists, whose origins are linked to currents found north of the Alps.

Piero seeks to build his forms with tonal contrasts. The profile of the Madonna against a bright sky has a thin edge of dark shadow that softens the outline. The modeling within the face is understated, with only the features drawn on a flattened plane. The juxtaposition of light and dark to heighten the distinction between forms is also found in other areas, including the cliff on the left against the pale sky. The color is bright, intense, unpredictable, while the viscous oil paint is often applied boldly, as in the beards and hair of the seated saints, creating brilliantly executed passages.

Another work that can be confidently considered to be by Piero di Cosimo is the *Venus,*

Mars, and Cupid [258] of about 1490, once owned by Vasari himself and enthusiastically described by him as follows:

> This master likewise painted a picture of a nude Venus, with a Mars also nude, the latter lying asleep in a meadow filled with flowers; hovering around them are cupids, who carry off the helmet, armlets, and other portions of the armor of Mars. There is a grove of myrtles and here there is a cupid alarmed at the sight of a rabbit: the doves of Venus are also depicted, with other emblems of love.

Piero's adherence to a monumental language is revealed in the treatment of the nude, especially in the robust *putti* located in the middle distance, posed easily and modeled with convincing volume. He was particularly conscious of a series of contrasts within this winning panel, which probably served as a *cassone* frontal: the two pigeons below, the reclining male and female figures, the foreground dominated by flesh and the landscape background, the playing of dark against light tones, where silhouettes are heightened by light areas added to the edges as seen on the lower border of the Venus or the arms of Mars. Piero

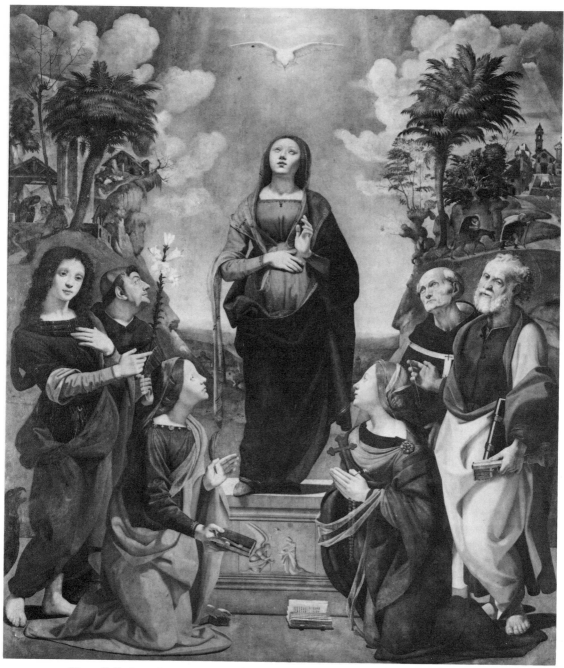

259. Piero di Cosimo. *Incarnation of Christ with Saints*, ca. 1505. Wood panel, 206 × 172 cm. Florence, Uffizi.

260. Piero di Cosimo. *Giuliano da San Gallo,* ca. 1500. Wood panel, 47.5 × 33.5 cm. Amsterdam, Rijksmuseum.

261. Piero di Cosimo. *Francesco Giamberti,* ca. 1500. Wood panel, 47.5 × 33.5 cm. Amsterdam, Rijksmuseum.

also sets lighter forms against dark, as in the branches behind the head of Venus, where the internal modeling is kept to a minimum. Typically, he is deeply aware of the interaction between the basic landscape elements and his narrative, so that figures or groups are relegated to specific pictorial areas with the background landscape echoing their arrangements, a usage also found in Leonardo and seen more pointedly in Piero's own *Incarnation of Christ with Saints* [259].

The three saints on either side in the *Incarnation* are set in front of cliffs which define their place in the composition, while above them the Adoration of the Child and the Flight into Egypt are represented in another scale. Mary, standing on an imitation marble altar which contains a bas-relief of the Annunciation, is isolated from the other figures by having only pale sky as a background with the white dove representing the Holy Spirit above, on axis. The clouds on either side echo the divisions of the groups as they continue the play of lights against darks. The altarpiece, mentioned by Vasari as in a chapel of the Santissima Annunziata, has been dated to about 1505, when Leonardo was back in Florence painting the *Battle of Anghiari,* since there are Leonardesque features such as the handling of St. John the Evangelist on the extreme left, where the contours and the surface are somewhat softened.

262. Piero di Cosimo. *Vulcan and Aeolus,* 1490s. Wood panel, 155.6 × 166.4 cm. Ottawa, National Gallery of Canada.

The portraits of *Giuliano da San Gallo* and *Francesco Giamberti* [260, 261] probably antedate the altarpiece. The same attention to detail in the portrait of Giuliano, primarily an architect, which includes calipers and a feather pen, instruments of his activity, and the more concentrated modeling in the face connect it with the head of St. Jerome in the *Incarnation.* The sitter appears to be about sixty years of age, although one must be cautious in estimating the age of a portrait subject. We must assume that it was sometimes the desire of the patron to be flattered by being depicted as more youthful than he was, and that painters often complied. Consequently, the apparent age of a subject is rarely a decisive factor for precisely dating a picture.

An important group of panels and canvases associated with Piero illustrates mythological subjects dealing with the early history of man. One example is the *Vulcan and Aeolus* [262]. None of the pictures of this type is documented or dated, but very likely they were part of the furniture decorations in private rooms, and their attribution to Piero is difficult to question. For the *Vulcan,* a somewhat abraded picture, a date in the 1490s is the most reasonable, before Leonardo's return to Florence. The subject matter has been related to the earliest manufacture of tools and buildings, and Piero shows an idyllic scene in which the wild animals and fowl appear unfrightened by the presence of man. The section showing the construction of the first house at the upper right, contrasted to the huts on the opposite side, is particularly effective. The composition appears to be disorganized and haphazardly constructed, as if reflecting the condition of the society represented. On the other hand, the figures are rendered with robust proportions, strong volumetric modeling, and convincing poses. In a picture such as this, Piero's appeal rests on the strength of his drawing, the power of his forms, and the intricacy of the landscape. Furthermore, the depth of his imagination and a facility for understanding the human condition are apparent in the interaction of his figures, both physically and psychologically.

THE THIRD GENERATION

The first two generations of Renaissance painters are often referred to collectively as representatives of the fifteenth century or the *quattrocento* style (with the notable exception of Leonardo). The third generation artists are associated with the sixteenth century or the *cinquecento* style. Giorgio Vasari, in the organization of his *Lives,* recognized that art prior to our third generation, which he called the third age, had attained a certain degree of accomplishment, guided by a study of both antiquity and nature; however, the figures of these earlier artists lacked a supreme perfection, especially in the feet, hands, hair, and beards. These painters, whom Vasari nevertheless admired, lacked the final grace achieved by painters of the third generation. Their art was characterized by a certain dryness that was only overcome by Vasari's older contemporaries, in a style which he called "modern."

In the various classifications of subject matter, the third generation painters elaborated upon their predecessors. In portraiture, for example, the small, tightly painted portraits of Piero della Francesca and Antonello da Messina have been expanded beyond mere likenesses, as it were, to obtain a new narrative dimension in the hands of Raphael, Titian, and Sebastiano del Piombo.

The finest achievement of the third generation painters was in the area of narrative painting. We have already seen how Masaccio, Filippo Lippi, Piero della Francesca, and Ghirlandaio had produced noble *storie* that conform to Alberti's description of such paintings from antiquity. Leonardo most of all, among all of the earlier painters, seems to have led the way toward the translation of Alberti's theoretical ideas into practice. The *Last Supper,* a subject that inherently has few narrative possibilities, is his own landmark example [248].

(However, the fresco may not have had an immediate influence upon third generation painters, located, as it was, in Milan, instead of on the Venice-Florence-Rome axis.) Leonardo's younger contemporaries of the next generation, Michelangelo, Raphael, and Titian, treated history painting with supreme perfection. Michelangelo first dealt with the narrative in the *Cascina* cartoon and later, more fully, in some of the Old Testament scenes from the Sistine ceiling. Most impressive in terms of the narrative is Michelangelo's *Flood* [281], where people of all ages, nude and clothed, standing, stooping, reclining, and bending, display a variety of emotions in humanity's desperate and unsuccessful struggle to survive the waters.

Raphael also painted in the highest tradition of the history picture in his frescoes in the Vatican *stanze.* Works such as the *School of Athens* [332] and the *Fire in the Borgo* [338] are demonstrations of his consummate skill in this category, where his treatment is more facile than Michelangelo's. In Titian's *Bacchus and Ariadne* [307] and the *Bacchanal of the Andrians* [306] the narrative elements depend upon ancient accounts, which he magisterially translated from literary to visual imagery. Even in a religious picture like the *Ecce Homo* [309], signed and dated 1543, the same powerful *historia* quality is maintained. Christ at the top of the stairs is presented to the public. Titian keeps the number of figures, of all ages and poses, some nearly nude, others clothed in exotic costumes or military armor, down to a manageable few. The emphasis is on readability, clarity, and restraint.

To begin the discussion of the third generation with Fra Bartolommeo may appear awkward, considering the unquestionably superior masters who belong to the same period—Michelangelo, Raphael, Titian, and Correggio, to name a few. However, Fra Bartolommeo was born earlier than the others. His career, moreover, provides a comfortable link between the second and third generations, emphasizing a continuity. As a pupil of Cosimo Rosselli, he is linked with another Rosselli student, Piero di Cosimo, who stands chronologically at the very end of the second generation. The boundaries between the generations are sometimes, as we have seen, fluid; Piero di Cosimo actually outlived Fra Bartolommeo, but there is no question that their artistic styles fit more comfortably in their respective generations.

The lyric painters were placed before the monumental ones for the first and second generations; this order has been reversed for the third generation because the transition between the generations is less disruptive in this way. The result is to end the book with the lyric painters of the third generation. Many of these lyric painters are also known as the early Mannerists and have been studied more particularly as the beginning of something new in the sixteenth century, Mannerism, than as the continuation of the previous style. Although

a stylistic term subject to disagreement among critics, Mannerism is considered to be a style that often ran counter to the Renaissance. It was an international development that was essentially anti-classical and anti-monumental. The artists sought deeply personal and eccentric variations of the same themes that occupied artists from the previous generation. They would either deny or exaggerate space, use blatantly unnaturalistic color, elongate or severely thicken their figures, and often made their imagery especially complex, ambiguous, and difficult to decipher. Mannerism stands between the Renaissance and the Baroque in the historical development of Italian art. In this book, the early Mannerists are treated within their generational context, as an extension and final statement of lyric painting of the Renaissance.

By beginning with Fra Bartolommeo, we acknowledge not only the continuing primacy of Florence at the beginning of the third generation, but also the interchange between the regions. He made an important trip to Venice, thereby transmitting the newest central Italian currents to the Veneto. At the same time, he came away with ideas obtained from Giovanni Bellini and perhaps Giorgione. Michelangelo was also, of course, a Florentine. Although his emotional allegiance was always toward his home city, he nevertheless spent nearly fifty years in Rome, which was to become the mecca for artists in the first quarter of the sixteenth century. Raphael was an Umbrian who spent three or four crucial years in Florence, but the bulk of his career transpired in Rome. Only Titian, among the giants of the third generation, avoided Rome except for a brief trip there in the 1540s. Still he did visit. All of the other artists that we shall study had a Roman experience, although it was not always positive. Painters such as Lorenzo Lotto were virtually unaffected by the new art they saw there; nor did the experience of ancient Roman sculpture seem important. Others, like Rosso, were overcome by the extraordinary artistic activity in the city, especially the works of Raphael in the Vatican *stanze* and Michelangelo's Sistine ceiling. Instead of expanding Rosso's art, the effect was probably negative and constricting. Beccafumi, likewise, was unable to cope with the new style as it unfolded in Rome at the end of the first decade of the sixteenth century. He quickly returned to Siena, where he tapped a profound personal expression.

Michelangelo, Raphael, and Titian are among the most studied Renaissance artists, and there is a reasonably large body of data and works associated with them. Michelangelo is the best-documented artist in this book; Giorgione is the least well documented. But it should be recognized that Vasari's accounts of third generation painters are almost universally more reliable than those for the earlier ones, precisely because he had a good deal of firsthand knowledge, and we can more confidently rely on him.

THE THIRD GENERATION:
THE MONUMENTAL CURRENT

Fra Bartolommeo, Michelangelo, Giorgione, Titian, Sebastiano del Piombo, Raphael, Andrea del Sarto

FRA BARTOLOMMEO

Bartolommeo di Paolo (1473–1517) was known as Baccio della Porta and as Fra Bartolommeo after he became a Dominican friar. He was a *garzone* running errands in the shop of Cosimo Rosselli in 1485 and 1486. An *Annunciation* in Volterra [263] is signed on the back and dates from 1497 but appears to be a collaborative effort with Mariotto Albertinelli (1474–1515), with whom he formed a partnership, perhaps by the mid-1490s. In 1499 Bartolommeo undertook to paint a *Last Judgment* for the cemetery chapel of Santa Maria Nuova, which was completed by Albertinelli when Bartolommeo took religious orders in 1500, after which he stopped painting for a time. Only in 1504 did Fra Bartolommeo accept another commission, to paint the *Vision of St. Bernard* for the Badia of Florence [265], which he finished three years later. He was in Venice for a few months in 1508 and obtained an assignment for a Dominican church on a nearby island, but it was never sent to its destination because of disputes over payment and was eventually sold to a church in Lucca. The

painting, *God the Father with Sts. Catherine of Siena and Mary Magdalen* [267], is dated 1509, the same year he painted a *Madonna and Child Enthroned with Sts. Stephen and John the Baptist* for the Cathedral of Lucca. In that year the partnership with Albertinelli, which had lapsed, was renewed and continued until 1512. During this three-year span a number of pictures were painted, including the signed and dated *Marriage of St. Catherine* [268] of 1511 and the *Madonna in Glory with Saints* for the high altar of the Besançon Cathedral of 1511/12.

Fra Bartolommeo seems to have been in Rome for a brief period in 1514, and his pictures for the following three years, until his death, reflect his experience of both ancient and modern works there. The *Salvator Mundi with Saints* [271] and the *Madonna della Misericordia* (Lucca, Pinacoteca) can be dated to 1516, when an inventory was made of his works—a unique document for any artist of the period.

❧

263. Fra Bartolommeo with Mariotto Albertinelli. *Annunciation*, 1497. Wood panel, 176 × 170 cm. Volterra, Cathedral.

Recently, scholars have tried to reconstruct Fra Bartolommeo's earliest manner, of which we have no true record. They seek to locate him in the orbit of Domenico Ghirlandaio and Leonardo (who may have left some pictures in Florence during his long Milanese stay) instead of Rosselli. The most efficient way to evaluate Fra Bartolommeo's first phase of development and to probe behind it to his training is to examine the much damaged fresco of the *Last Judgment* for Santa Maria Nuova, now removed from the cemetery wall and on view in the Museum of San Marco [264], and the drawings he made for it. Only the upper portion of the fresco was painted by him, although he must have designed the whole. Christ, encircled by cherub heads, raises His right hand in judgment; with His left he points toward the wound in His side. Immediately below, an angel holds instruments of the Passion. Saints arranged in segments of a semicircle that cuts into the pictorial space are seated on a cloud bank; flying angels sound their trumpets to signal the final moment. Fra Bartolommeo's composition is taken as a source for the upper zone of Raphael's *Disputa* [331] and is not irrelevant when considering Michelangelo's much later treatment of the *Last Judgment*, especially in Christ's gesture and pose [289].

Fra Bartolommeo, several years Michelangelo's senior and more exclusively a painter, was the oldest important exponent of the monumental current among third generation painters, although he, like Leonardo and Giorgione, stands toward the middle of the continuum between absolute lyric and monumental choices. He builds figures with decisive modeling and controlled drawing in the *Last Judgment*, which he painted in 1499 and 1500.

After a four-year pause, Fra Bartolommeo worked on the *Vision of St. Bernard* [265], which he finished in 1507. In it he modifies his monumental syntax, leaning, if only temporarily, toward more lyrical qualities than he revealed in the *Last Judgment*. The painter was

264. Fra Bartolommeo and Mariotto Albertinelli. *Last Judgment,* 1499/1500. Fresco, 340 × 360 cm. Florence, Museum of San Marco.

not immune to the immense appeal of Filippino Lippi's treatment of the same subject, which appears to be the starting point for Fra Bartolommeo's interpretation [139]. He aggrandizes the importance of Mary, who now dominates the spectator's attention rather than sharing it equally with Bernard, as in Lippi's picture. As she hovers above the

ground supported by a host of angels, Mary tenderly holds the Christ Child, who is not present in Lippi's version. Bernard is not shown as a scholar but as a mystic, dazed by what he has conjured up. The figure of Bernard remains in its plane and offers the conviction of an organic structure beneath the drapery, an image very much within the mon-

265. Fra Bartolommeo. *Vision of St. Bernard*, 1504–7. Wood panel, 220 × 213 cm. Florence, Pitti Palace.

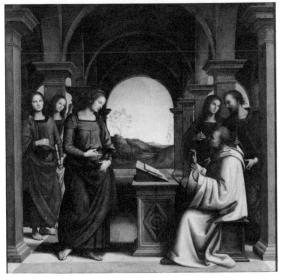

266. Pietro Perugino. *Vision of St. Bernard*, early 1490s. Wood panel, 173 × 170 cm. Munich, Alte Pinakothek.

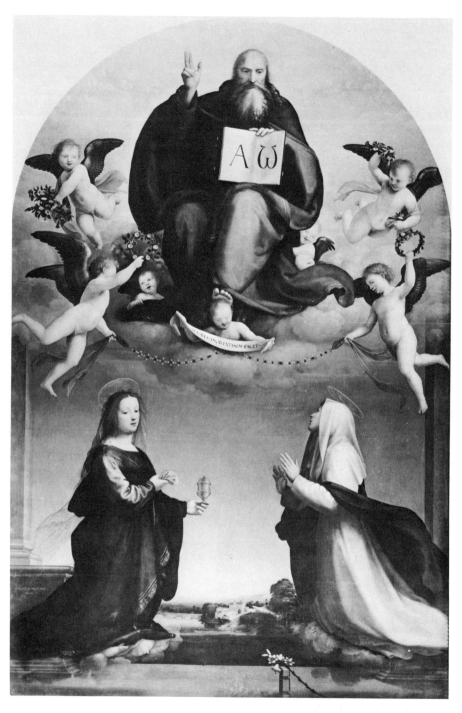

267. Fra Bartolommeo. *God the Father with Sts. Catherine of Siena and Mary Magdalen*, 1509. Wood panel (transferred), 361 × 236 cm. Lucca, Pinacoteca.

umental range, although the fragile proportions could suggest otherwise.

The painting offers other charms: a low, flat, deep landscape fills the central void; at the sides a rocky cliff (recalling Piero di Cosimo in treatment) is balanced by tall buildings. In the foreground the tiny *trompe l'oeil* tabernacle with the Crucifixion is a restatement of a device first introduced by Fra Angelico, Bartolommeo's predecessor as resident painter at the Convent of San Marco. The third generation master elaborates the pictorial pun by having one of Bernard's books lean against the tiny painting-within-a-painting. The softly modeled, somewhat generalized head of the saint recalls Perugino's *Vision of St. Bernard* [266], painted in the early 1490s, which appears to have been decisive for the Frate's interpretation—further evidence of the Umbrian painter's widespread influence.

Following the trip to Venice, Fra Bartolommeo produced the *God the Father with Sts. Catherine of Siena and Mary Magdalen* [267] in which critics have observed that the color and especially the light have points in common with the art of Giovanni Bellini. The figures are restrained in their gestures but fully evolved physically, as are the fine nude children who encircle the blessing Father. The women down below are arranged to provide a central void articulated by a low-lying landscape. They, like the Virgin in the *Vision of St. Bernard,* float above the ground, but their solidity is unchallenged. Here too is a *trompe l'oeil* element, this time a book close to the bottom of the picture; on it rests Catherine's attribute, lilies. The two saints are perfectly balanced yet sufficiently differentiated to offer diversity without discord. God the Father is stark, awesome, blatant, rhetorical. Little direct borrowing from either Leonardo or Raphael (who had come and gone from Florence) can be detected here, but they have a strong impact on the Frate's style in pictures that follow, as if a delayed reaction.

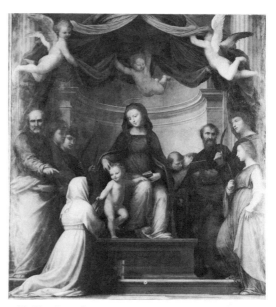

268. Fra Bartolommeo. *Marriage of St. Catherine,* 1511. Wood panel, 257 × 228 cm. Paris, Louvre.

The *Marriage of St. Catherine* [268], dated 1511, shows a shift in the painter's style. Cast shadow and a filmy softening screen of atmosphere function pictorially and expressively. These devices are attributable to the influence of Leonardo and were possibly reinforced by Bartolommeo's brief visit to Venice. The structure of the composition, the relation of the figures to the architecture, and the pose of the casually seated Mary and the standing Child bring to mind Raphael's *Madonna of the Baldacchino* (Florence, Pitti Palace), left incomplete in Florence in 1508. Enframed by the apsidal niche, Bartolommeo's Mary is isolated from the other actors; above, angels fuss with the canopy. Although the theme is not new, Fra Bartolommeo combines the typical altarpiece with the Madonna and saints with the more narrative subject of a betrothal. The Child and the kneeling, almost hidden Dominican St. Catherine are a subtheme within the

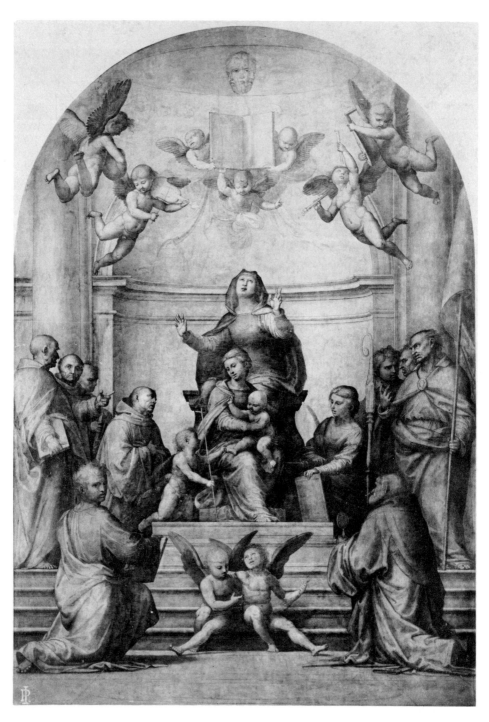

269. Fra Bartolommeo. *St. Anne Altarpiece,* begun 1510. Wood panel, 444 × 305
cm. Florence, Uffizi.

whole. They are not relegated to the background (as they might be in a painting by Piero di Cosimo), but are actually down front, closest to the viewer. The compositional system, with a centralized, stable group flanked by saints and reinforced by the shallow architectural backdrop, is perpetuated in two other larger commissions, the unfinished *St. Anne Altarpiece* [269], commissioned in 1510, and another version of the theme of the *Marriage of St. Catherine,* known as the *Pala Pitti* (Florence, Accademia, but once in the Pitti Palace).

Following a short trip to Rome in 1514, Fra Bartolommeo painted the enormous, even overblown *St. Mark the Evangelist* [270] in a manner defined by Michelangelo's Prophets on the Sistine ceiling, but at this point Bartolommeo also becomes more sensitive to Michelangelo's sculpture in Florence. Yet Michelangelo's body language, with its intense *contrapposto* and the power of the physical presence, is not easily achieved by the Frate, whose commitment to a monumental mode never goes that far.

His Roman trip and contact with the confident, accomplished frescoes of Raphael and Michelangelo in the Vatican seem actually to have precipitated an artistic crisis that Fra Bartolommeo was never to resolve fully. The *Salvator Mundi with Saints,* datable to 1516, the year before his death, is a glorification of the Mass [271]. The Apollonian Christ stands precariously with his arms outstretched on an altar shelf, surrounded by the Four Evangelists holding books. Below, *putti* enframe a circular view into a landscape like a porthole, with the covered chalice teetering precariously above and on an axis with Christ, who appears to rise from it. Firmly centralized and balanced, the figures betray quotations from Raphael, although the painter's resolutions are never quite as majestic as the conceptions promise. The shallow space is articulated by the flat, planar architecture and the grandiose

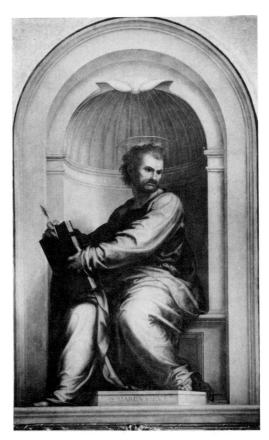

270. Fra Bartolommeo. *St. Mark the Evangelist,* ca. 1515. Wood panel, 340 × 212 cm. Florence, Pitti Palace.

niche. The four figures who stand on the raised platform are completely dominated by Christ. Fra Bartolommeo's figures fail to fully convince the spectator of their anatomical accuracy or of their physical presence. It is in the compositional inventions and the grand conceptions that the Frate made his most powerful contribution to Renaissance art. What he lacked in soaring artistic spirit he made up for in devotional earnestness.

MICHELANGELO

The life and work of Michelangelo Buonarroti (1475–1564), the most studied artist of the Ren-

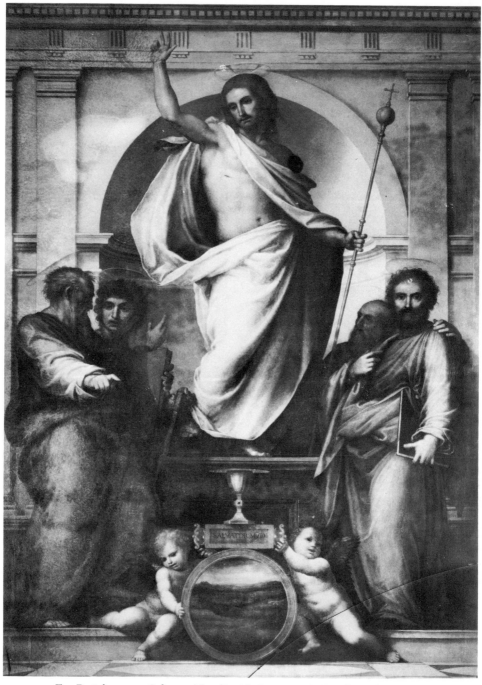

271. Fra Bartolommeo. *Salvator Mundi with Saints,* 1516. Wood panel (transferred), 283 × 201 cm. Florence, Pitti Palace.

aissance, are extremely well documented. He was the subject of semi-official biographies while still alive; letters by and to him have been collected; his poems provide autobiographical material; his remarks and observations were carefully recorded. The outlines of his life are familiar but may be rehearsed here with emphasis upon his career as a painter, although he was, perhaps, a sculptor most of all, at least earlier in his long career, and an architect toward the end of it. We know for certain that he was placed in the workshop of the brothers Domenico and Davide Ghirlandaio in 1488, immediately upon turning thirteen and following some schooling. He probably stayed there only two of the three years set forth in the contract, then moved the center of his activity to the Medici gardens and eventually the Medici household. After the death of Lorenzo de' Medici in 1492 and following the expulsion of the Medici from Florence in 1494, Michelangelo traveled to northern Italy and to Rome, working as a sculptor. Back in Florence he obtained the commission for the giant marble *David* from the Signoria in 1502, which he completed in 1504.

His earliest painting commissions were the *Battle of Cascina* for the Sala del Gran Consiglio of the Palazzo della Signoria, also of 1504, for which he completed only the cartoon (lost), and the *Doni Madonna* [272] of about the same time. In 1505 Michelangelo was hired to make the Tomb of Julius II in Rome, a demanding undertaking that was never really finished but upon which the artist worked on and off for over four decades. The same pope assigned Michelangelo to paint the vaulted ceiling of the Sistine Chapel in 1508, the whole of which was unveiled in 1512 [278]. After this exhausting project Michelangelo hardly painted at all, but is known to have supplied designs to other painters, including Sebastiano del Piombo, until 1536 when he began again in the Sistine Chapel, this time painting the *Last* *Judgment* on the altar wall [289]. This enormous fresco was finished in 1541.

During the years between the completion of the Sistine ceiling and the *Last Judgment,* Michelangelo spent much of his time in Florence working on the Medici tombs and other sculptural and architectural projects, and when the Medici were temporarily expelled, between 1527 and 1529, he assisted the revived but short-lived republic by supervising the fortifications of the city. After 1534, however, he never again returned to his native city, although he always remained loyal to Florence and the anti-Medician party.

In 1542, the year after he completed the *Last Judgment,* Michelangelo began the frescoes in the Pauline Chapel in the Vatican, which he finished only in 1550 [290, 291]. During the later part of his life Michelangelo was concerned with St. Peter's and its dome, as chief architect of the works; he also designed the new piazza of the Capitol and the fine palaces there. Even during the very last years of his long career Michelangelo continued to do some sculpture and continued to draw. His activity as a painter can be centered around the *Battle* cartoon and the Sistine ceiling in the period up to 1512, then the *Last Judgment* and the Pauline Chapel frescoes in the 1530s and 1540s.

⁘

Efforts to isolate Michelangelo's possible contributions to Ghirlandaio's frescoes in the choir of Santa Maria Novella have proved fruitless, leaving the *Doni Madonna* as his first surviving essay as a painter [272]. This harshly rendered *tondo* for a Florentine patron, the same merchant who commissioned Raphael a year or two later to paint portraits of himself and his wife, uses a format developed during the previous half-century for pictures destined for private devotion. Michelangelo must also have designed the magnificent wood

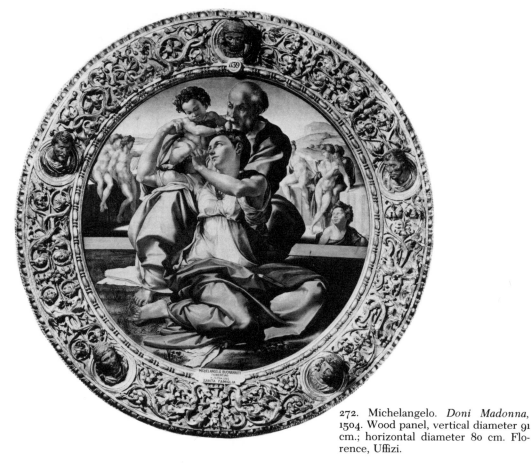

272. Michelangelo. *Doni Madonna*, 1504. Wood panel, vertical diameter 91 cm.; horizontal diameter 80 cm. Florence, Uffizi.

frame with the small carved busts. The theme is the Holy Family, expanded to include the little St. John the Baptist behind the parapet on the right and the much-discussed male nudes in the background. Their meaning is unclear, although as a tour de force they permitted the artist to demonstrate his skill in a genre—the nude—in which he was peerless, even in confrontation with the aging Leonardo, who was triumphantly back in Florence in the very years when this picture was being produced.

Compositionally, Michelangelo established a compact, vertically oriented rectangular block; it fills the foreground and only subtly and almost reluctantly conforms to the circular frame. A low wall forms a decisive horizon-

tal band to counter the verticality of the principal group and separates the foreground from the background. The carefully studied and tightly painted draperies are an exercise in *chiaroscuro,* using a single color for each separate unit. These draperies betray his awareness of Leonardo, as does the conception of Mary to a certain extent. A Signorelli *Madonna and Child* [233] has often been cited as influential for Michelangelo's picture. Both are circular compositions and both have nude men in the backgrounds. The muscular anatomy of Michelangelo's figures and Mary's thick forearm that supports the Child (who, like Mary, is in vigorous *contrapposto*) are characteristic of Michelangelo's figural style. If somewhat cold, dry, and mechanical, this

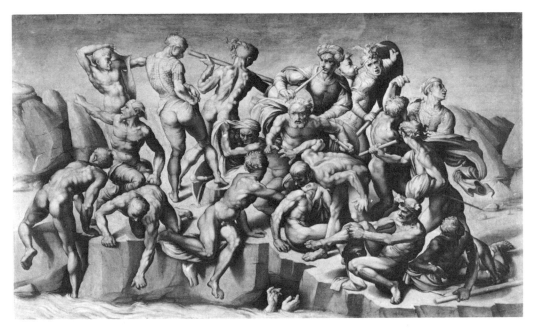

273. Michelangelo. *Battle of Cascina*, 1504–5. Early 16th-century copy of central section. Grisaille on paper, 76.2 × 132 cm. Norfolk, Holkham Hall (Collection Earl of Leicester).

tempera picture is also his only extant essay as a panel painter; all the other painted works by him are frescoes.

At about the same time as the *tondo*, Michelangelo, having finished and delivered the marble *David* (Florence, Accademia), was commissioned to paint the *Battle of Cascina* for the Sala del Gran Consiglio of the Palazzo della Signoria. He finished the cartoon by 1505 but never got beyond some preliminary preparations of the wall before he was called away from Florence. Nonetheless, the composition quickly became famous and was one of Michelangelo's most influential works. Studied and copied by artists for decades, it was, one might say, consumed by them. The central portion is known from a grisaille copy [273] and from engraved sections and drawn copies

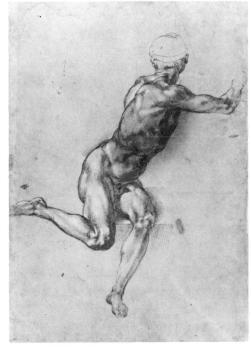

274. Michelangelo. Figure study for the *Battle of Cascina*, ca. 1504. Ink and wash, 41.2 × 28.1 cm. London, British Museum.

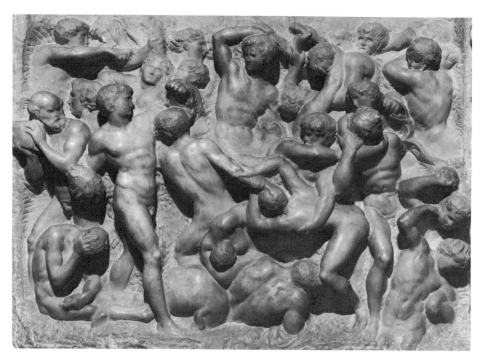

275. Michelangelo. *Battle Relief,* ca. 1491. Marble, 84.5 × 90.5 cm. Florence, Casa Buonarroti.

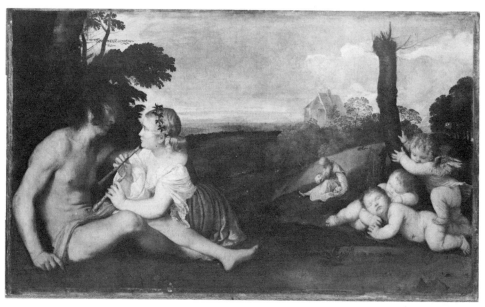

276. Titian. *Three Ages of Man,* ca. 1512–13. Canvas, 90.2 × 151.2 cm. Edinburgh, National Gallery of Scotland.

as well as from Michelangelo's own preparatory drawings for the cartoon [274]. The scene depicts a battle in which the Florentines defeated the Pisans in 1364, and in the strict Albertian sense Michelangelo has constructed a historical narrative painting with over-life-size figures of great power.

Like the marble *David*, and in contrast to Leonardo's *Battle of Anghiari* [252], the *Battle of Cascina* does not depict the moment of battle, much less of victory, but a previous action; the results are not implied in the picture. Judging from the copy, the three compressed rows of figures are crowded into a shallow space, recalling Pollaiuolo's *Battle of Ten Nudes* [217] but more specifically Michelangelo's own *Battle Relief* [275], carved when he was about sixteen. Many of the figural motives were to become fixed types in Michelangelo's art and are found scattered among the Sistine ceiling decorations. The *Battle of Cascina* also provided painters with a catalogue of figural poses that were copied and adopted assiduously. Even Titian used one of Michelangelo's inventions for the *Cascina* cartoon in his *Three Ages of Man* [276].

According to an actual account of the battle, soldiers of the Florentine army were bathing in the Arno River near Pisa because of the extreme heat of the afternoon. One of the Florentines was struck by the danger of a possible surprise attack and had the alarm sounded as a test. Michelangelo shows the reaction of all involved in their different states of undress, activity, and movement.

Even before completion, the importance of the frescoes of the Sistine Chapel ceiling was widely acknowledged [277, 278, 279]. They occupied Michelangelo between 1508 and 1512 with some interruptions; he apparently painted the ceiling for a total of twenty-two months. Approximately half of the ceiling was unveiled in mid-1510, but what was actually finished is not certain: either the entire central zone with the nine histories, beginning chronologically with the *Separation of Light from Darkness* over the altar through the *Drunkenness of Noah* over the entrance, but without the accompanying segments, that is, the Prophets and Sibyls, spandrel narratives and lunettes with the ancestors of Christ; or half of the whole ceiling up to the *Creation of Eve*, with its entire decoration (but not the lunettes, which, in any case, are on the side walls). Under any circumstances the Noah scenes were painted first, followed by those depicting Adam and Eve and finally the Creation subjects showing God; that is, Michelangelo, working backwards chronologically with respect to the biblical text, began at the entrance and proceeded toward the altar. The orientation of the chapel, contrary to the usual custom, is east to west with the altar on the west.

The existing decoration in the chapel, provided by Sixtus IV and presumably thought out by the pope himself, was a predetermined factor for the iconography and to a lesser extent even for the structure of the ceiling frescoes, although it is only fair to say that the elaborate program eventually worked out by Michelangelo is theologically and philosophically complex, and at least half a dozen explanations have been suggested by modern scholars. The Old Testament subjects should be understood as parallel to the New Testament ones. The theme of generation, already stressed in the zone below in the fifteenth-century cycle, as testified by the *tituli* (inscriptions) that accompany the individual scenes, is continued by Michelangelo. The chapel was dedicated to the Assunta (Assumption of the Virgin), painted on the altar wall by Perugino, who also made the culminating scenes of the *Nativity* and its Old Testament counterpart, the *Finding of Moses*, all of which later gave way to Michelangelo's *Last Judgment*.

A basic feature of the chapel itself, so obvi-

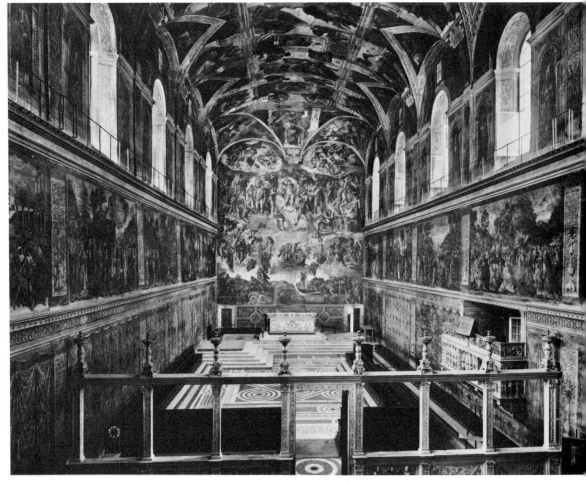

277. General view of the Sistine Chapel, looking toward the altar. Rome, Vatican.

ous that it is sometimes ignored, is the papal function, as the pope's chapel and the location of the elections of new popes. Furthermore, the building was in some respects a personal monument to the Della Rovere family, since Sixtus IV saw to its actual construction and the frescoes beneath the vaults, and his nephew Julius II commissioned the ceiling decoration. Oak leaves and acorns abound, heraldic symbols of the family whose name means literally "from the oak."

In planning the architectural design Michelangelo first had to accommodate his pro-

gram to the pre-existing building, including the windows, which were the source of light for his decoration. The wreath of openings still provides the principal viewing light. Michelangelo devised a long central area framed by a fictive marble cornice and separated into nine sections by broad pilaster strips bent across the ceiling, also in imitation white marble. Sections of alternating dimensions are framed between wider and narrower bands. Within them Michelangelo varied the size of the actual narratives, giving only the smaller ones a marble frame. Four male nudes *(ig-*

278. Michelangelo. Sistine Chapel ceiling, 1508–12. Rome, Vatican.

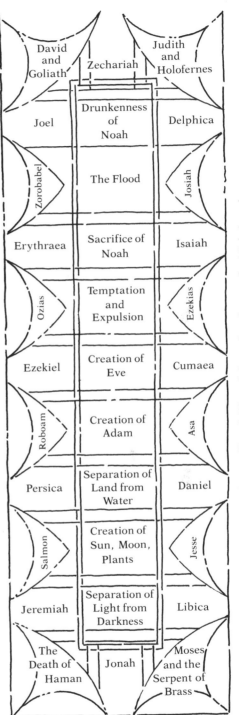

David and Goliath	Zechariah	Judith and Holofernes
Joel	Drunkenness of Noah	Delphica
Zorobabel	The Flood	Josiah
Erythraea	Sacrifice of Noah	Isaiah
Ozias	Temptation and Expulsion	Ezekias
Ezekiel	Creation of Eve	Cumaea
Roboam	Creation of Adam	Asa
Persica	Separation of Land from Water	Daniel
Salmon	Creation of Sun, Moon, Plants	Jesse
Jeremiah	Separation of Light from Darkness	Libica
The Death of Haman	Jonah	Moses and the Serpent of Brass

279. Vatican, Sistine Chapel. Plan of the ceiling frescoes by Michelangelo

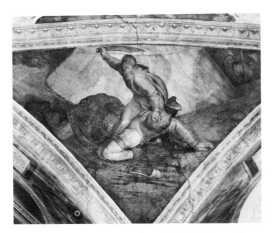

280. Michelangelo. *David and Goliath*, 1508–12. Fresco. Rome, Vatican, Sistine Chapel.

nudi), among the most admired elements of the ceiling, ostensibly support ribbons attached to large medallions painted to look like bronze. Twenty in all, they are in different poses, producing, together with the Prophets and Sibyls, a "handbook" of alternatives for the seated figure for later artists. At the corners of the ceiling Michelangelo has painted four salvation subjects, including *David and Goliath* [280] and *Judith and Holofernes.* Triangular-shaped compartments are repeated in a continuous band along the entire border of the ceiling; they contain bronze-colored nudes that alternate with the renowned Prophets and Sibyls set into marble thrones which, in turn, have paired marble *putti* in a variety of poses and positions that expand

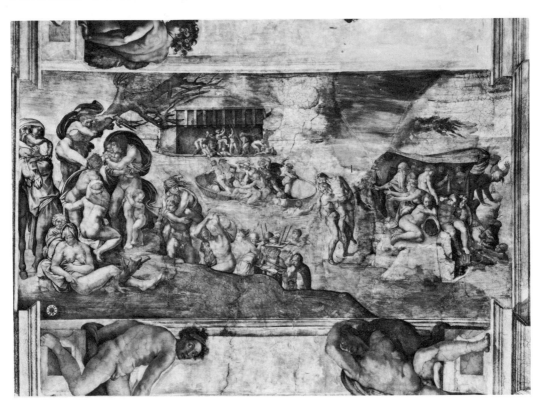

281. Michelangelo. *Flood*, 1508–12. Fresco. Rome, Vatican, Sistine Chapel.

upon the tradition of Donatello and Luca della Robbia. The ancestors of Christ are painted on the flat side walls, the only section of the decoration that did not require the visual adjustments posed by painting on a curved surface.

Only a few examples from the Sistine ceiling need be discussed in order to obtain insight into the style of the artist, who was here at the height of his powers. Critics have long noticed that there is an expansion of figure size and of monumentality in the proportions from the earlier to the later phases of the ceiling—that is, from the Noah and Adam and Eve scenes and their accompanying Prophets and Sibyls to those subsequent sections depicting God the Father. The multifigured second history, the *Flood,* is compositionally intricate [281]. A windblown stage that has the ark of Noah—a large rectangular float with a pyramidal roof—in the distance is the most panoramic treatment found in Michelangelo's entire oeuvre. Three other foci include the diagonally established hill at the left foreground, the outcropping of rock on the right, and the circular boat

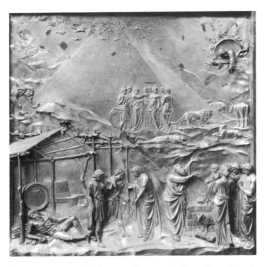

282. Lorenzo Ghiberti. *Gates of Paradise* (Noah scene), ca. 1428. Bronze relief, 79.4 × 79.4 cm. Florence, Baptistery.

in the middle ground. These areas are unified by intervening figures and the direction of their movements, as in the group that forms a central stress from the middle distance upward and toward the picture surface, moving up the hill to apparent safety, a device that may be traced back to Mantegna's early work but is also found in Ghirlandaio's frescoes at Santa Maria Novella. Michelangelo's actors are presented with the fullest physical conviction, their weighty, usually nude bodies drawn with insistent anatomical exactitude. Color, although assured and attractive, is largely an aid in reading the individual forms and their groups instead of having an important independent function.

Uccello's fresco in the cloister of Santa Maria Novella and Ghiberti's panel from the *Gates of Paradise* [282] are often specifically mentioned as sources for Michelangelo's conception of the *Flood.* Individual figures have been adopted from Roman sarcophagi, but early *quattrocento* sculpture offered Michelangelo other insights; no precedent exists for the narrative richness and psychological depth of the painting. The struggle of the individual against nature is treated with a poignancy that suggests autobiographical connotations: a father who carries his dead son, a mother shielding her infant, lovers embracing to give courage to one another, refugees seeking to salvage prized possessions. Others fight savagely for protection from the rising waters either by attaching themselves to the ark (as in Uccello's picture) or by crowding into a boat that will soon tip. Our knowledge that the superhuman efforts are inevitably to fail makes Michelangelo's tragedy all the more frightful. Hope lies only in the ark (that is, the church), and here we see the dove high in the structure with Noah leaning out from the side on exactly the central axis of the painting. Although the individual figures and groups have the effect of sculptural masses or at the least

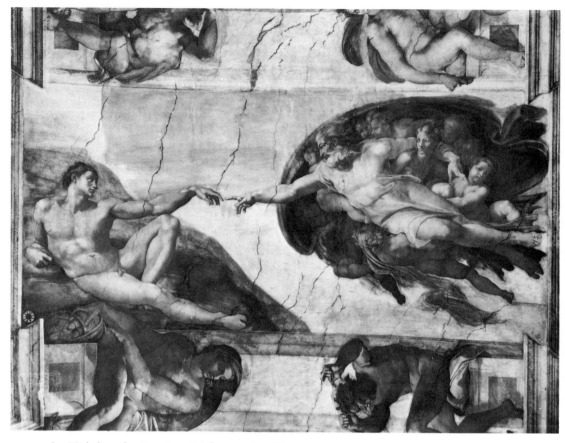

283. Michelangelo. *Creation of Adam*, 1508–12. Fresco. Rome, Vatican, Sistine Chapel.

high reliefs, the *Flood* remains purely two-dimensional, which is to say, pictorial. Remarkably, Michelangelo was able to move from sculpture to painting by means of his impeccable draftsmanship, which always lies behind the forms.

The *Creation of Adam,* less spatial, shows a still more monumental scale [283]. God the Father is surrounded by a sweeping wine-colored mantle in which nude children and youths accompany and support the hovering body. Adam records Michelangelo's relation to the antique; here he achieves a type that recalls Greek fifth-century statuary, although his actual sources may have been later gems,

cameos, and even Early Christian ivories, or some unlikely combination of antiquities. These somewhat indirect sources were filtered through the experience of modern masters Michelangelo admired, especially Donatello, Jacopo della Quercia, Masaccio, and Niccolò dell'Arca, whose marble sculpture he had studied in Bologna. Monumental examples of ancient sculpture, including the *Torso Belvedere* [284] and the recently rediscovered (1506) *Laocoön* [285], were also part of his visual environment.

Adam, whose pose echoes the diagonal stretch of barren land upon which he rests, is flattened out on a plane parallel to the pic-

284. *Torso Belvedere,* c. 50 B.C. Marble. Rome, Vatican Pinacoteca.

285. *Laocoön* (restored), mid 1st cen. B.C. Marble, h. 242 cm. Rome, Vatican.

ture's surface, an effect most noticeable in the torso. The body gradually comes alive by means of God's intense glance and approaching touch, but Adam is still without the power of independent movement. From the hands alone it is also clear that man has been fashioned in God's image. The expanded size and the stress on the contours of Adam may have been Michelangelo's response to an increased awareness of the spectator on the floor below, who could have lost track of the complexities and detail in the *Flood.* Here the protagonists, each treated as lighted masses against a dark ground, are easily readable. Symbolically the nude Adam refers to Christ, the second Adam, and his martyrdom; Adam's left hand, still lifeless, recalls the same hand of Christ in Michelangelo's *Pietà* in St. Peter's, made a decade before.

The segment that contains the *Creation of Eve* [286] reveals how the various elements in the central section of the ceiling interact. The *ignudi* are paired when properly read from the side axis, unlike the *Creation of Eve* scene, which is meant to be viewed facing away from the altar. Consequently from below there are three principal views of the segment: from the altar facing toward the entrance wall and from the right and left "aisles," which is also the proper position to see the *Cumaean Sibyl* and the *Prophet Ezekiel,* who occupy the same segment in a lower zone.

The torsos of the *ignudi* on the left of the *Creation of Eve* are similar but reversed. It is the arrangement of the arms and legs that makes the body language of each one distinct. The figures encroach slightly upon the composition of the scene from Genesis, thereby locating themselves on a plane in front of the frame for the scene. Michelangelo uses the natural

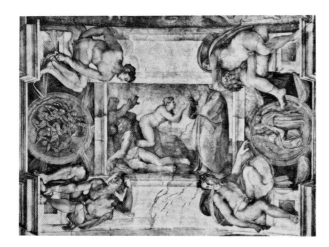

286. Michelangelo. *Creation of Eve*, 1508–12. Fresco. Rome, Vatican, Sistine Chapel.

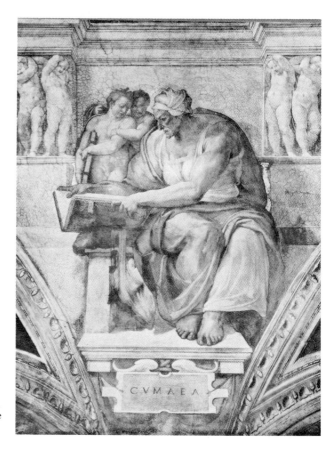

287. Michelangelo. *Cumaean Sibyl*, 1508–12. Fresco. Rome, Vatican, Sistine Chapel.

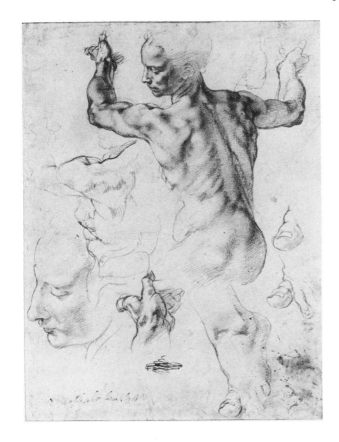

288. Michelangelo. Studies for the *Libyan Sibyl*, 1508–12. Red chalk, 29 × 21.2 cm. New York, Metropolitan Museum of Art.

light source of the windows, which is integrated into the paintings, to produce a unifying condition for the fictive world and make the composition of the whole more comprehensible. The *Creation of Eve,* like the *Flood* and the *Creation of Adam,* is organized by a diagonal outcropping of land, with the reclining Adam following the more distant contour. Eve seems to be lifted out of Adam's side merely by the gesture of God, whose ponderous form expands beyond the available pictorial space. The pure physical presence of all the figures, the way they are posed, their convincing occupation of space, and how they function according to the forces of nature are characteristic of Michelangelo's image-making. Design elements, surface play, and inter-

est in detail are virtually eliminated. Michelangelo speaks the language of the figure, a dialect of the body charged with an awareness of human emotions and physical strength. The *terribilità* (fiery intensity) of his figures is characteristic not merely of his art, but of his own personality.

The ponderous *Cumaean Sibyl* is a grotesque seer of such size as to be virtually immobilized as she turns her tiny head from an opened book [287]. Behind her, flesh-colored children assist; the throne, with gilded balustrades, has marble *putti* who function as supports for the cornice; they are created as reversed pairs, probably having been produced from the same cartoon.

Michelangelo's style underwent certain

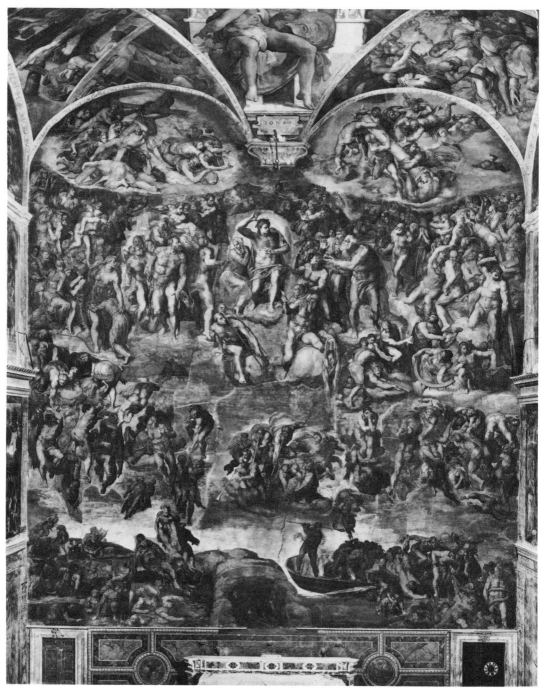

289. Michelangelo. *Last Judgment*, 1536–41. Fresco. Rome, Vatican, Sistine Chapel.

modifications in the nearly four years from the beginning of the Sistine ceiling decorations to the end of the work [288]. But the later, more gigantic images need not be attributed to a radical shift in style; they are those more closely related to the altar, just as the larger figures in the *Last Judgment* are near Christ. The change, in any case, is slight. The ceiling as a whole is a heterogeneous work that efficiently illustrates the supremacy of painting over sculpture in the terminology of Leonardo's *paragone,* and by a master who was, ironically, foremost a sculptor. It is almost superfluous to state what is generally known: the Sistine ceiling is a triumph of monumental painting by a third generation master.

Evaluation of the *Last Judgment,* on the other hand, has caused difficulties [289]. Painted more than twenty years later, the enormous fresco on the altar wall is seen as either a summation of the Renaissance style or as evidence of Michelangelo's adherence to Mannerism. Some critics have even considered the *Last Judgment* Baroque, or at least proto-Baroque, and in any case, as a forward-looking statement. On the other hand, what Michelangelo has painted is in no way in violation of his early figural style, and many poses and motives may be traced back at least to the *Battle* cartoon. Furthermore, the immense size of the *Last Judgment* is important for understanding its evolution, since it is one of the largest wall decorations organized as a single composition up to this time. In order to make room for it Michelangelo had to eliminate two of his own lunettes, fill in pre-existing windows, and cover over Perugino's frescoes.

He divided the surface into three layers or zones of activity, plus the lunettes, strung out horizontally; in this way he roughly connected his fresco with the pre-existing decoration on the side walls. The *Last Judgment* is also divided vertically by a central axis created by the figure of Christ and by horn-blowing angels. Consequently, if we include the some-

what isolated lunettes, he established eight compartments, which, reading from the lower left, upward, across, and then downward, are: (1) the bodies of the chosen rising from their tombs; (2) the elect ascending; (3) a choir of holy figures; (4) angels showing the Cross and the crown of thorns; (5) angels holding the column of the Flagellation; (6) a choir of holy figures; (7) the fallen descending; (8) Hell and the damned, with Charon and Minos.

Plans for the *Last Judgment* and apparently even some of the cartoons were prepared before Clement VII (Medici) died in 1534, and the project was enthusiastically continued by the Farnese pope Paul III, who was a devoted admirer of Michelangelo's. The artist responded with all his energy, producing a fresco with hundreds of figures in almost as many poses and postures. They were painted for the most part nude or scantily clothed; the draperies were added by order of a succeeding pope, including a billowing dress for the once entirely nude St. Catherine.

In addition to the zones already described, the composition of the vast fresco has a circular movement, although the geometry is only approximate; a clockwise flow has been observed, rising from the upraised right hand of Christ and down his left (that is, the picture's right) and serving to connect the horizontal zones. Rational perspective and scale do not pretend to operate here; no architectonic frame has been created to establish limits; no module can be determined. Christ, unquestionably the absolute central focus, is in size threatened from above by the gargantuan *Jonah,* part of Michelangelo's earlier cycle; saints on either side, bulky, slow-moving images, vie for the viewer's attention. Christ's traditional gesture with the right palm exposed, the left down, sets the entire machine in motion, unfolding the final chapter in the history of humanity as the inevitable conclusion to the Creation on the ceiling.

Michelangelo's conception of the human

290. Michelangelo. *Conversion of St. Paul,* 1542–45. Fresco, 625 × 661 cm. Rome, Vatican, Pauline Chapel.

figure, its dignity and expressive potentialities, has not altered radically from the time of the ceiling, or even from the *Battle* cartoon, although he has thickened the internal proportions, broadened the shoulders, expanded the waists. Rather, we notice an evolution of the technique in the way in which forms are produced, depending less on outline and contour in the *Last Judgment* than previously. Michelangelo is now more dependent upon building forms with light and deep shadow, recalling Leonardo but also paralleling the approach of Titian, which he could easily have learned about through his friend Sebastiano del Piombo. If the interaction and excitement of light and shadow have substantially increased in the *Last Judgment,* the color is composed of somber muddy tonalities—grays, browns, and deep flesh tones calibrated only

by a deep blue shadowy sky.

In the *Last Judgment* Michelangelo's own fears and religious convictions are fixed within this unique vehicle; and, as if to reiterate a deep personal involvement, his own portrait appears within the flayed skin of St. Bartholomew (seated on a rock directly beneath Christ, on the right), peering glumly toward the descending masses on the irreversible road to Hell.

Michelangelo had a final opportunity to paint for the same Farnese patron in the Pauline Chapel of the Vatican, where he made a pair of frescoes facing one another. They, together with the *Last Judgment,* represent his *ultima maniera.* The earlier, painted between 1542 and 1545, is usually considered to be the *Conversion of St. Paul* [290]; the later, the *Crucifixion of St. Peter* [291], took from 1546 to

291. Michelangelo. *Crucifixion of St. Peter*, 1546–50. Fresco, 625 × 661 cm. Rome, Vatican, Pauline Chapel.

1550. Assistants must have assumed a significant share in the painting since in 1550 Michelangelo turned seventy-five. But perhaps still more important for understanding these late paintings is the shift in scale and the difference in viewing point they require as distinct from the Sistine ceiling and the altar wall. Here the figures are almost life-size, and the rapport between viewer and painted image is much more intimate.

Of the two, the *Crucifixion of St. Peter* is the more rewarding as a unified composition and in its rarefied and accentuated color, richer certainly than the *Last Judgment,* with pale greens and violets setting off the flesh tones. A worker is preparing the hole for the cross upon which Peter is already affixed with four (not Christ's three) nails for the upside-down crucifixion. The figures supporting the cross

are turning their heavy burden. We may assume that it will be set up so that Peter will have his back to the spectator in the chapel. Gravity pulls Peter's body down, and his face is awkwardly turned outward with an expression of intensity associated with his fiery nature. Through the nearly axial location of Peter's head and two figures, one digging, the other gesticulating, a central stress is established that is countered by the sweeping though unarticulated landscape and the disposition of the figures in the second plane. Michelangelo was the consummate master of the human figure, but his skill with animals, unlike Leonardo's, as in the awkward horse on the left, was wanting.

After a span of half a century Michelangelo's personal style did not change markedly. Each of the main painting assignments, the *Cascina,*

the Sistine ceiling, the *Last Judgment,* and the Pauline Chapel frescoes, had different functions and was to be seen in different contexts by the patron and the spectator. In them all, the monumental style of the third generation of Renaissance painting remains undiluted. His visual experience, especially with ancient statuary, continually increased, reinforcing what had always been a component of his style. He was probably familiar with Titian's paintings even before his visit to Rome in 1545, and some exchanges (and not only from Michelangelo to Titian) should be assumed. Equally important, Michelangelo's own private torments seem to have remained with him and even to have intensified, but through it all his painting style remained consistent with his first paintings, the *Doni Madonna* and the cartoon for the *Battle of Cascina.*

GIORGIONE

Ranked by the humanist Baldassare Castiglione among the finest painters of the time soon after his premature death—along with Mantegna, Raphael, Leonardo, and Michelangelo —Giorgio da Castelfranco, better known as Giorgione (1477?–1510), was born in Venetian territory. He went to Venice at an uncertain date. Little factual material has been preserved about him and about his art from contemporary sources and documents, making his biography something of a mystery and creating puzzles about his art. Assumed to have been born about 1477 or 1478, he falls naturally into the company of third generation painters. There are, however, remarkably few works certainly by his hand, and even those that are overwhelmingly accepted by critics are limited. By taking a restrictive point of view and by considering only the few autograph paintings or those widely admitted to his oeuvre, we can see that he remains one of the most fascinating and influential painters of his gen-

eration, although he died at the age of thirty-two or thirty-three. He is here among the monumental artists, although he could just as easily be located in the lyric current; in fact, he, like Leonardo da Vinci, whom Giorgione seems to have imitated to a certain extent, stands at about the center of the continuum between the two currents.

The first time Giorgione's name occurs in extant documents is only in 1507, when at about thirty he was commissioned to do a picture for the Doges' Palace in Venice, which he completed and delivered the following year; this work is lost. In the same year, 1508, Giorgione finished some frescoes for the exterior of the Fondaco dei Tedeschi (only partially and very poorly preserved). In an appeal over the payments, Giovanni Bellini was charged with selecting a committee of artists to evaluate his work; they awarded Giorgione 130 ducats. Bellini is usually assumed to have been the teacher of Giorgione, as he is also thought to have been the master of Sebastiano del Piombo and Titian. Like Perugino and Raphael, the master outlived the pupil, for Giorgione was already dead by October 25, 1510, as is revealed in a letter written by Isabella d'Este, who sought a picture from Giorgione's estate. Despite Giorgione's short life-span, he left the ineradicable stamp of his personal style upon many other painters; among the most gifted were Sebastiano del Piombo and Titian, but there were a host of talented lesser masters— the "Giorgioneschi"—who produced a vast number of paintings in his poetic manner.

Only a single picture bears a date and a specific reference to Giorgione, the so-called *Laura* [292]; but by combining the meager documentation and notices by local writers and by Vasari, an oeuvre has been reconstructed with reasonable certainty. Among the works taken to be early and which have

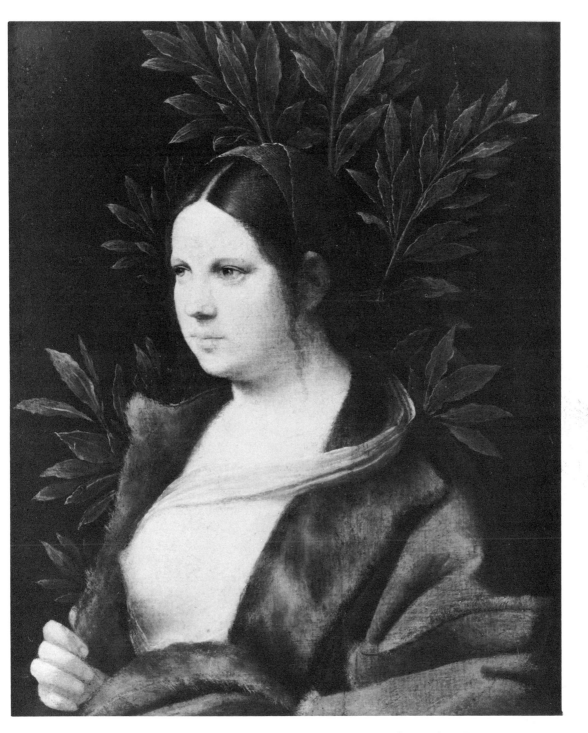

292. Giorgione. *Laura,* 1506. Canvas, 41 × 33.5 cm. Vienna, Kunsthistorisches Museum.

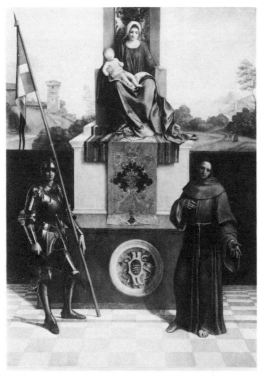

293. Giorgione. *Castelfranco Altarpiece,* 1500–1502(?). Wood panel, 200 × 152 cm. Castelfranco, San Liberale.

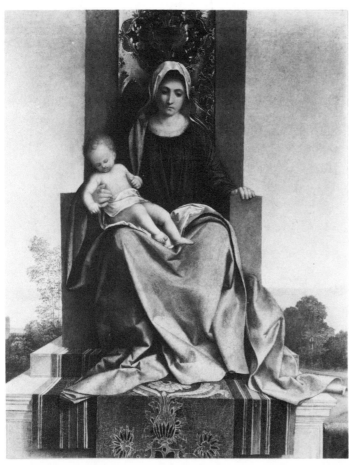

294. Giorgione. Detail of 293.

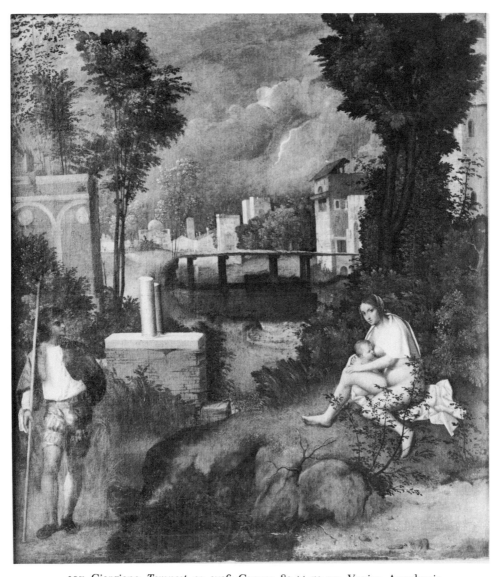

295. Giorgione. *Tempest*, ca. 1506. Canvas, 82 × 73 cm. Venice, Accademia.

received not only general acceptance but also form the basis for any discussion of the master is the smallish *Castelfranco Altarpiece* [293, 294], which must have been painted in his native town shortly after 1500. The motionless, elongated saints share the focus with Mary, who is seated high above the checkered floor with the sleeping infant, and with the soft, lacy landscape. Reflections of *quattrocento* Umbrian painting seem to have been united with the more generic Venetian qualities typified by Giovanni Bellini, who was himself impressed by Umbrian examples. The overall design of the work and the treatment of the painted surface also recall Antonello da Messina, who, as has been suggested, had been sensitive to Piero della Francesca's art. Perugino, who was in Venice in the 1490s, may have left a mark on Giorgione, especially in the poses and the positioning of the figures and the treatment of the landscape. The small heads and minute features of the faces, their aloofness and self-absorption, puzzle and engross the spectator. The geometric decorations, the squares on the floor, the circular frame of the coat of arms, and the firm rectangles of the throne are contradicted by the soft handling, the warm light, and the fragility of the images.

The *Laura* of 1506 has been altered over the centuries, first transposed into an oval picture and then restored back to a rectangular one. Originally the figure extended below the waist, and there was more space above. The effect was one of much less immediacy for the viewer than is the case today in its cut-down version and was more in keeping with the remoteness of Giorgione's images as we know them. Like all of Giorgione's pictures, enigmatic aspects persist; the subject is unspecific, although the artistic intention is the presentation of the surface beauty, the soft flesh juxtaposed against the fur of the luxurious garment, the dark eyes, shining and alert, the thin veil enticingly but gently winding around the exposed breast. The laurel branches, which give their name to the figure, are painted with considerable realism and permit the head to be silhouetted before a neutral gray-green halo of leaves, isolated from the deep-toned background, not unlike Leonardo's *Ginevra de'Benci* [243]. Leonardo's influence has often been noted in Giorgione's art, most particularly in the softening of the contours. Leonardo was in Venice for a few months early in 1500, and even if Giorgione did not meet him, Leonardo's works, methods, and reputation must have been familiar to the painters in Venice.

Close in style to the *Laura*, and sharing the same model for one of the figures, is the *Tempest* [295], also known as the *Gypsy and the Lady*, a more elaborate but unspecifically defined subject, at least so far, despite erudite efforts to unravel its meaning. Some observers have even come to the conclusion that no fixed mythological references are intended, particularly in view of the radical *pentimento* known through X rays, in which the male figure on the left is painted over an image of a female bather. The storm with the high, menacing clouds is pointed up by a bolt of lightning near the central axis, but the effect is one of a momentary, accidental event, that of coming upon the beautiful full-bodied bather at the right, who is nursing her baby. The landscape and particularly the variety of leafy trees are painted with remarkable directness in which the potentialities of the oil medium are explored with facility; the picture is a precocious example of landscape painting where the figures are subservient to their natural surroundings.

Several works of great beauty associated with Giorgione involve the collaboration of another distinctive master. In the *Sleeping Venus* [296] a significant share has been assumed for Titian, especially in the landscape,

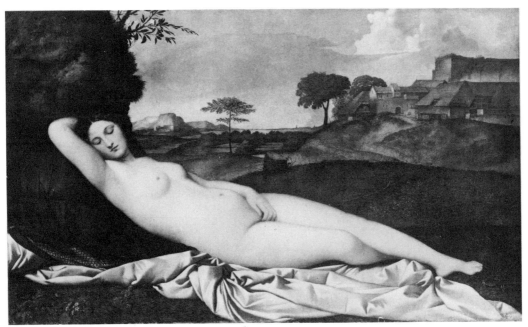

296. Giorgione. *Sleeping Venus,* ca. 1509. Canvas, 108.5 × 175 cm. Dresden, Staatliche Gemäldegalerie.

297. Titian. *Venus of Urbino,* 1538. Canvas, 119.5 × 165 cm. Florence, Uffizi.

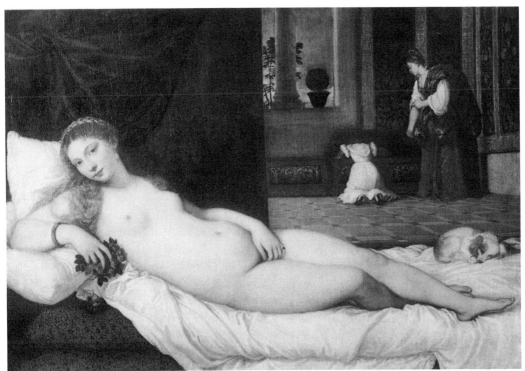

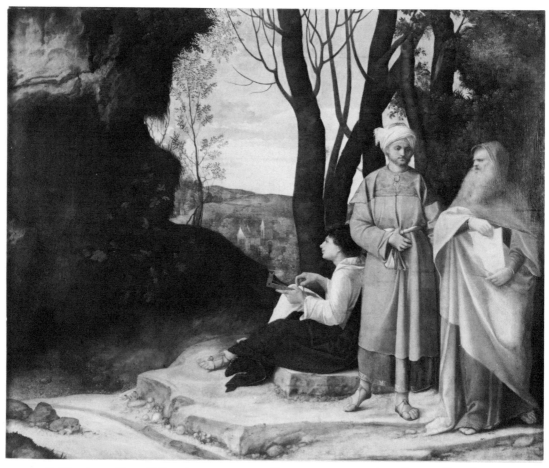

298. Giorgione. *Three Philosophers,* ca. 1509–10. Canvas, 123.5 × 144.5 cm. Vienna, Kunsthistorisches Museum.

where on the right a cupid has been painted out. The outstretched figure, stocky in proportions, is usually considered to be by Giorgione. The drawing is only approximate, with the outlines blurred to produce a gradual transition between the barely modeled flesh and the surrounding surface. But the edges are nonetheless legible, and they form a flattened lozenge-shaped, pale collage-like form lying close to the picture plane, a device favored over juxtapositions of darks and lights to conjure up an illusion of three-dimensionality. If compared with Titian's *Venus of Urbino* [297] the differences between the two become clear

since Titian has taken over the pose and the figural type almost verbatim from Giorgione; they are differences of temperament and personality more than of time passed. If the *Sleeping Venus* was actually completed by Titian, as is frequently assumed, the overall effect remains tightly connected with Giorgione's style, and one might also suppose that it falls chronologically near the end of his short career, for we should assume that it was left unfinished at his death.

The *Three Philosophers* [298] must also be a work of the last couple of years of Giorgione's life, since a near-contemporary source says

that it was begun by him and finished by Sebastiano del Piombo, a collaboration confirmed by stylistic analysis. The subject matter has long been a source of disagreement, but more recently most scholars call the picture the *Three Magi.* Whatever the precise theme, one can find three ages of man, three distinct temperaments, and three different nations. As with the *Tempest,* there are important *pentimenti,* more easily accomplished in the oil medium that Giorgione favored than with tempera. The present picture may also have been cut down on all sides, judging from a later copy. If there was an element of collaboration, and I find no reason to doubt it, the invention and the figure types, their poses, and the relation of one to another are Giorgione's. Sebastiano's role must have been limited literally to finishing the work, that is, giving it the final surface and unifying the elements. In the *Three Philosophers* the figures are rather weightless, silent images, placed somewhat unspecifically in space, haphazardly related, as it were, to the landscape. For example, the youngest figure, seated toward the center of the composition, is partly blocked out by the oriental with the deep red

garment, and his head, in profile, is apparently unrelated to the twin tree trunks behind it. The natural and private world Giorgione has created envelops us with its mystery and poetry, with its anti-scientific structure and even its rather unclassical choice of figural types and poses.

The *Fête Champêtre* [299] is a Giorgionesque picture of great beauty which has failed to find any consensus for an attribution among modern scholars, who waver between Giorgione and Titian, or, as a compromise, a joint work. The pastoral subject is also either purposely obscure or a *poesia* without a specific theme. We are confronted by two voluptuous female nudes juxtaposed with two finely dressed young men in this picture, which has been enlarged slightly from its original dimensions. Musical references are present, and the shepherd with his flock in the middle distance seems attracted by the song of the musicians in the foreground. The atmospheric landscape and the late afternoon light that flickers through the clouds and is caught by the bushy trees make for a haunting picture. Most of all it shows the power of Giorgione's style and provides a sensible prelude to Titian.

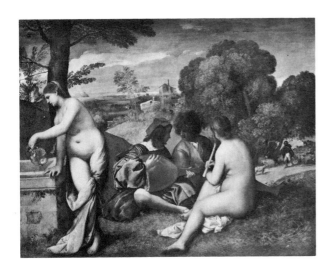

299. Giorgione (?). *Fête Champêtre,* 1510 (?). Canvas, 110 × 138 cm. Paris, Louvre.

TITIAN

Born in the mountainous village of Pieve di Cadore in Venetian territory, Tiziano Vecellio (1477?–1576), known in English as Titian, was the leading painter of Venice, and indeed of all Italy and Europe, for over half a century. Regarded as the finest exponent of color in painting, he is often seen in contradistinction to Michelangelo, the exemplar of drawing par excellence. Since Titian's birth date is not assured by firm documentation, his training is particularly difficult to reconstruct, although late contemporary sources suggest a period with Giovanni Bellini and a close collaboration with Giorgione. Titian, in a letter to his patron Philip II on August 1, 1571, gives his age then as ninety-five, which would locate the year of his birth at 1476 or 1477. Vasari in one place gives his birth date specifically as 1480, and a seventeenth-century biographer maintained that he was born in 1477; since he is known to have died in 1576, he may actually have lived ninety-nine years. On the other hand, many modern students have denied such an early date in favor of 1488–90, basing themselves on an assertion by Ludovico Dolce (1557) that Titian was not yet twenty when he worked on the frescoes (alongside Giorgione) for the Fondaco dei Tedeschi, and on a second statement by Vasari asserting that Titian was seventy-six when Vasari visited with him in Venice, apparently in 1566.

It is best to keep an open mind: Titian may have been a nearly exact contemporary of Giorgione (as I believe), or as many as ten years his junior. Under any circumstances, the first documentary evidence of Titian's activity as a painter dates from 1511, when he was paid for three frescoes for the Scuola di Sant'Antonio in Padua, after Giorgione had already died. He began painting a fresco to replace the fourteenth-century mural in the Sala del Gran Consiglio of the Doges' Palace in Venice two years later, although the project was not finished for several decades. In 1516 Titian was at the court of Ferrara and, perhaps, shortly before was commissioned to do the gigantic *Assumption* [303] for the main altar of the Frari church in Venice, which he completed in two years. In 1517 he became the official painter of Venice, succeeding Bellini, who had died the year before. He obtained another important commission for the Frari in 1519, this time the so-called *Pesaro Madonna* [304]. During the following year Titian dated an altarpiece for San Francesco in Ancona. In 1523 he was documented in Ferrara, and he also had contact with the Gonzaga court in Mantua.

Titian married in 1525 and in the following year completed the *Pesaro Madonna*. In Mantua, and in 1530 he attended the coronation of Charles V in Bologna, where he also did a portrait of the emperor. The connection between Titian and the Hapsburgs was to continue until his death. Also in 1530 he completed the esteemed *St. Peter Martyr Altarpiece* for Santi Giovanni e Paolo (destroyed by fire in 1867). In 1532 Titian began work for the Della Rovere of Urbino.

In 1533 he again painted Charles V and, in turn, was made a noble; in that year he was considered the first painter of the emperor. Titian finally finished the mural in the Sala del Gran Consiglio (destroyed in a fire in 1577) in 1538 and was present at an encounter between Paul III and Charles V in Ferrara, and painted a portrait of the pope. In 1545 he went to Rome, where he was received by the pope, court dignitaries, and his fellow artists, including Sebastiano del Piombo and Michelangelo. In the following year he was awarded Roman citizenship before returning to Venice. Further extensive travel is recorded, including a trip to Augsburg for the Diet held there in 1548 and again in 1550. By 1552 Titian began a long and continuous interchange with Prince Philip. In the following year he began a series of *poesie* for him.

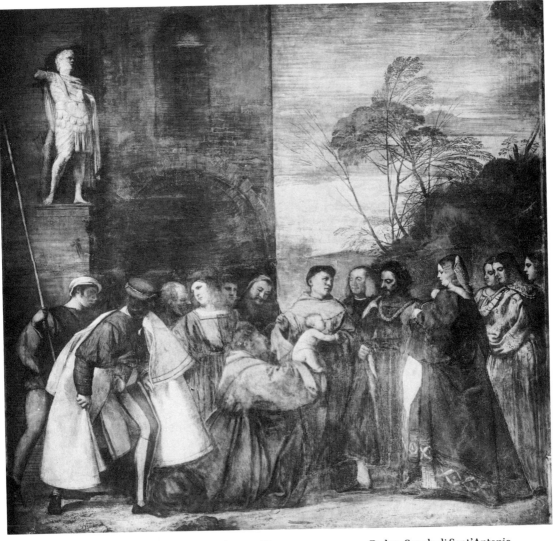

300. Titian. *Miracle of the Speaking Babe*, 1511. Fresco, 320 × 315 cm. Padua, Scuola di Sant'Antonio.

In 1555 Charles V abdicated in favor of his son, who became Philip II of Spain. Titian finished the *Rape of Europa* (Boston, Isabella Stewart Gardner Museum) for the new king in 1562 and two years later sent him the *Last Supper* (Escorial, San Lorenzo). The same year he obtained a commission for three ceiling paintings for the town hall of Brescia, which were installed by 1568. Titian, along with other Venetians, was elected a member of the Florentine Academy in 1566. Apparently he was actively painting during the final decade of his life and even in the last year. He died on August 27, 1576, and was buried in the Frari, which still houses two of his finest altarpieces.

✛

Although an ample number of works have been catalogued as early Titians, serious ques-

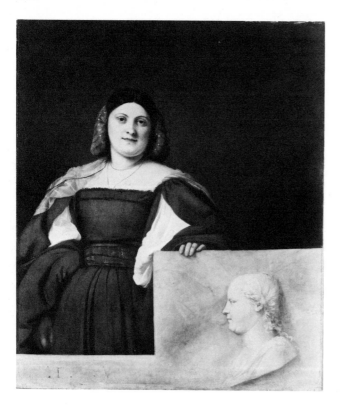

301. Titian. *La Schiavona,* ca. 1512. Canvas, 119.4 × 96.5 cm. London, National Gallery.

tions persist, especially about the Titian-Giorgione relationship, and the attribution of several of the finest works, like the Dresden *Sleeping Venus* [296] and the *Fête Champêtre* [299], vacillates between the two. For the purpose of defining Titian's larger contribution to Italian Renaissance painting, his first documented extant works, the frescoes in Padua that treat episodes in the life of St. Anthony, take us away from speculative provinces altogether. The largest of the three is the *Miracle of the Speaking Babe* [300] in which the newborn infant recognizes and speaks to his mother. Atypical of Titian, who worked primarily with oils on canvas, the fresco is already a self-confident demonstration of artistic independence, whatever his age when he painted it. Echoes of a collaboration or assistantship under Giorgione are found in some of the figures, including the elaborately dressed,

bearded man in the middle right, or the heads framed within the niche of the building on the left; the forms are softened where light functions to instill mood and expression. The figures, located on a narrow stage close to the picture surface, are in a frieze-like arrangement, including the four women on the left. They all derive from the same model, who is also the double subject of the portrait *La Schiavona* [301].

The proportions of the figures are monumental: sturdy, fully developed people act out in pantomime the triumph of Justice (which is the meaning of the theme), with a broken statue of a Roman emperor dominating the upper zone of the mural. Little connects this fresco specifically with what his contemporaries among monumental painters were doing in Tuscany, Umbria, or Rome, although in subsequent works Titian reveals some knowledge of

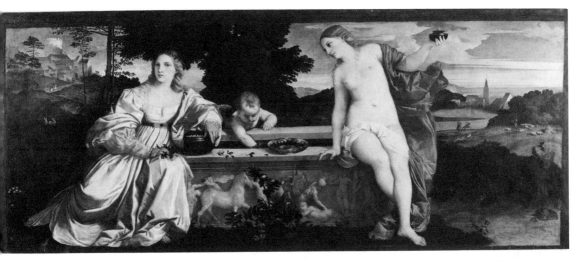

302. Titian. *Sacred and Profane Love,* ca. 1514. Canvas, 118 × 279 cm. Rome, Borghese Gallery.

Fra Bartolommeo, who was in Venice for a few months in 1508, as well as of Raphael and Michelangelo. Whatever he was able to obtain from them until later in his career must have come largely secondhand, via drawings, engravings, and copies.

Titian's paintings as he enters into a thoroughly personal, mature style, that is, once he had fully integrated the impulses from Giovanni Bellini and Giorgione, are representative of the third generation of monumental painters and parallel those by Raphael, Andrea del Sarto, or Michelangelo; and perhaps more than any of the others, Titian retained an unwavering allegiance to a monumental language throughout his long career. When younger artists had long since offered alternative solutions that had been accepted by informed patrons, Titian continued to paint in his accustomed style. No radical changes occur in his art from the middle of the second decade of the sixteenth century until his death sixty years later, although an ever expanded virtuosity in the medium of oil paint marks an internal development toward total freedom.

The *Sacred and Profane Love* [302], an oil painting probably done in 1514 to commemorate a marriage, has convincing volumetric figures in robust proportions painted still rather tightly. The work has close affinities with the *Fête Champêtre* in the Louvre. The limbs of the twin Venuses occupy a defined space in front of the wellhead and its relief *all'antica.* Cupid, between and behind them, seems the common bond. On either side of the canvas are landscapes that differ from one another, much as the figures do. Behind the nude Venus, or "sacred" love, is a soft meadow and a placid lake before a village dominated by a church tower with a mighty belfry; on the opposite side the terrain is more rigid and savage. An absence of tension characterizes Titian's expression here; the central group is without stress, and neither figure revels in her beauty or is embarrassed by it. Titian sees them as two kinds of love, as two sides of the same coin, although the precise meaning of this poetic work has so far escaped a fully convincing iconographic explanation.

The magnificent *Flora* (Florence, Uffizi) may be based on the same model as the two Venuses, or, more likely, on some ideal type

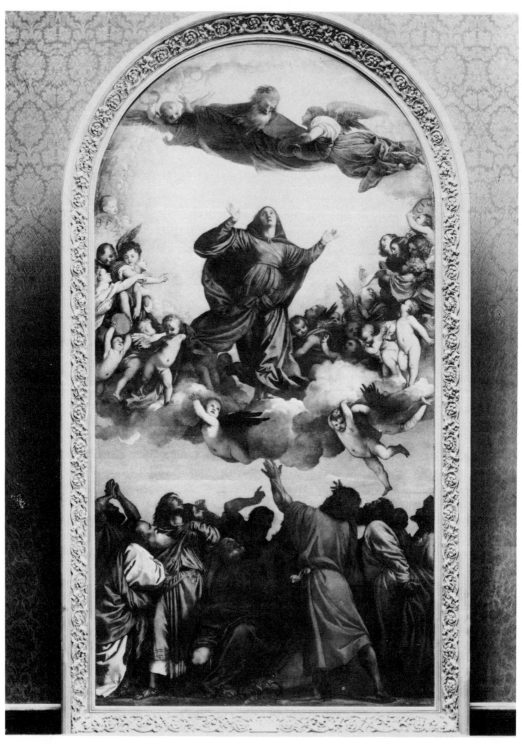

303. Titian. *Assumption*, 1516–18. Wood panel, 690 × 360 cm. Venice, Santa
Maria Gloriosa dei Frari.

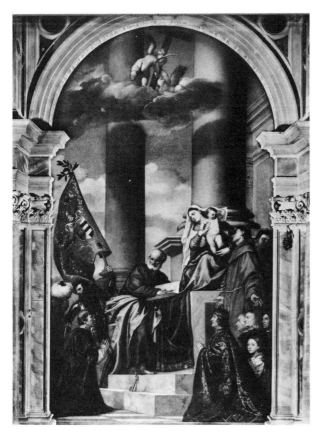

304. Titian. *Pesaro Madonna*, 1519–26. Canvas, 478 × 268 cm. Venice, Santa Maria Gloriosa dei Frari.

Titian had formulated. The smallish picture has a mysterious air. Flora's form is achieved without edge or silhouette but instead through the application of paint, as in the *Sacred and Profane Love*. The painted frieze in the Borghese picture demonstrates Titian's (and his patron's) interest in the antique. Unlike the archaeological commitment of Mantegna or Raphael, Titian freely and without compunction invents scenes to suit the requirements of the *poesia*.

In his first major religious commission in Venice, finished in remarkably rapid time, Titian's skill and originality with oil paint determine the nature of his art. The *Assumption* [303], finished in 1518 after about two years of work, is an altarpiece nearly twenty-three feet in height, which was created to fill the apsidal space of the late-fourteenth-century church.

Consequently, the stringent modeling of Carpaccio or even Giovanni Bellini gave way to a pliant, sure-handed, sweeping stroke that became ever more pronounced in Titian's art as the decades passed. The composition suggests a debt to Raphael's *Disputa* [331] with its three zones, although the stress within the Frari altarpiece is more specifically vertical, so that the *Madonna of Foligno* [360] and even the *Sistine Madonna* [336], both of which predate Titian's picture, might also be recalled. On the other hand, I should stress again that Titian's connection with specific Roman and Florentine stylistic tendencies was then indirect and filtered by local tradition.

Titian locates the figural activity in the *Assumption* close to the picture plane, establishing a shallow stage on which the figures are tightly compressed, a system that produces a

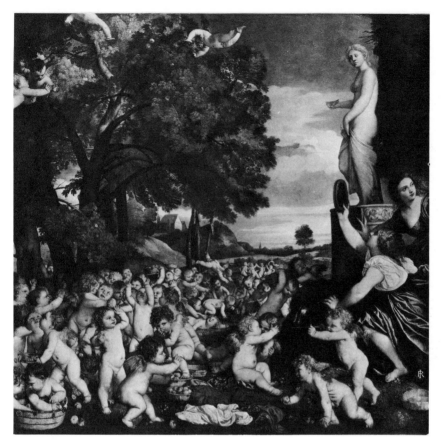

305. Titian. *Worship of Venus*, 1518–19. Canvas, 172 × 175 cm. Madrid, Prado.

demanding immediacy and makes it difficult to isolate single figures. The Apostles on ground level look and gesture upward to the heavenly cloud bank upon which Mary stands majestically, arms outstretched in an orant's gesture of prayer, like Raphael's Christ from the *Transfiguration* [340]. A vast family of infant and youthful angels support the clouds as they make music and pay homage to Santa Maria Gloriosa (to whom the Church of the Frari is dedicated), while above her hovers the greatly foreshortened God the Father.

The color, as always for Titian, has a determining function. If the deep reds, warm oranges, and sunny flesh tones, together with the gold behind the sacred images, are overpowering, *in situ* the effect of the brightly lighted soaring choir is a glowing, visionary, unfolding experience. Each zone is visually connected with the other by gesture, flying angels, and intense glances. Titian, the painter of Venuses, of sensual images and fleshy nudes, of intricate mythological scenes and imperial portraits, established with the *Assumption* a religious imagery that dominated much of the century's art, one that rejected the anecdotal for the supernatural, treated within a context of convincing visual logic.

For the same church Titian painted the *Pesaro Madonna* [304], in oil on canvas, and it

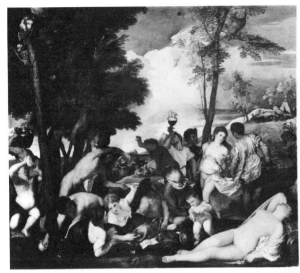

306. Titian. *Bacchanal of the Andrians,* 1523–24. Canvas, 175 × 193 cm. Madrid, Prado.

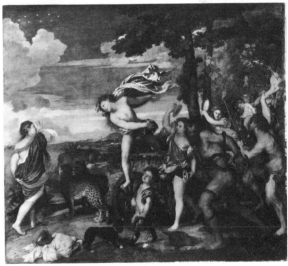

307. Titian. *Bacchus and Ariadne,* 1520–23. Canvas, 175 × 190 cm. London, National Gallery.

too has remained there ever since. Completed in 1526, this *pala* (altarpiece) is also ample in size, nearly sixteen feet high. Members of the patron Jacopo Pesaro's family, placed in the traditional attitude of donors close to the spectator in the lowest zone, are in profile except for a handsome youth who stares vacantly out of the painting. The sacred figures are higher in the pictorial field: St. Peter is located near the central axis, and above him and to the

right are Mary and the Child set into a slowly rising diagonal, with Sts. Francis and Anthony of Padua serving to connect them with the front plane. A majestic columnar temple is set obliquely behind the figures. Within the crown of the altarpiece two angels on a dark cloud raise a cross to forecast the Child's future. Spatially, one orthogonal thrust moves from right to left, created by the columns and especially their bases, and another up the

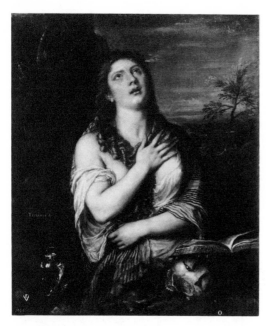

308. Titian. *Penitent Magdalen*, ca. 1531–33. Wood panel, 84 × 69 cm. Florence, Pitti Palace.

steps, from Jacopo Pesaro on the left to St. Peter and then to Mary and Christ. Landscape is suppressed except for generalized clouds in this visionary tableau, which harmoniously combines an immediacy of the here and now, expressed by the family portraits, with a heavenly apparition. In this recently cleaned painting, the decisive color increases the visual excitement.

The commission for the *Pesaro Madonna* of 1519 coincides with the signed *Worship of Venus* [305] of 1518–19 for Alfonso d'Este of Ferrara's *camerino,* which eventually included works by his court painter Dosso Dossi, Giovanni Bellini's *Feast of the Gods,* and other paintings by Titian [306, 307]. Here Titian has reconstructed a classical painting on the basis of a literary description by Philostratus. It should be remembered that Renaissance painters had no significant examples of ancient painting upon which to base their works, unlike the sculptors and architects, so they had

to invent them. Diagonal movements have an important share in the structure of the composition, which is not out of harmony with that of the *Pesaro Madonna.*

In the *Worship of Venus* a powerful diagonal composed of an infinity of nude cupids carries the eye from the lower left toward the right leading to the base of the statue of Venus, who oversees the agitated scene, and further into the landscape. Natural elements have an important share in the picture, and one is more inclined to read the work as a landscape with figures than vice versa, despite the sheer number and variety of cupids and the diversity of their activities, which are mainly connected with the gathering of apples. Not only does Titian fittingly evoke the literary source of the picture, but he also shows his own pictorial inventiveness in creating so many different poses and attitudes in which children may be seen. Despite the number there is practically no repetition. Nor does the artist find any difficulty in rendering a pagan subject such as this one simultaneously with a Christian one; for Titian the subjects become merely different genres, without conflict in his mind.

The *Entombment* (Paris, Louvre) of about 1525–30 and the *Penitent Magdalen* [308] of about 1531–33 were apparently private devotional pictures commissioned by Federigo Gonzaga of Mantua and have the same poetic vision as do the mythological pictures. The full, nude Magdalen is like a Venus, but her contrition is reservedly expressed by the turn of her head and the pathetic upward glance. The beauty of the figure is matched by the magnificence of the painted surface: the deep golden flowing hair, an attribute of the Magdalen along with the ointment jar shown on the lower left, is painted with a technical bravura unrivaled until the seventeenth century. Titian here draws with the oil-laden brush to achieve the intricacies of the flowing hair.

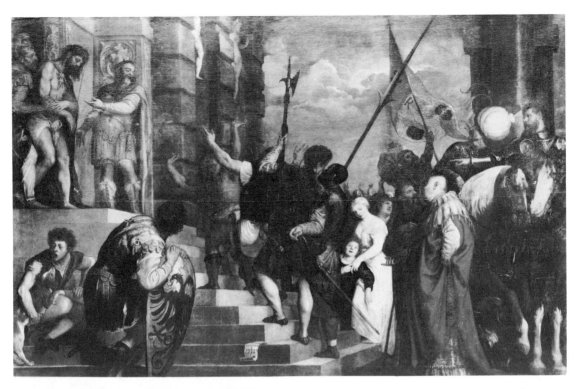

309. Titian. *Ecce Homo*, 1543. Canvas, 242 × 361 cm. Vienna, Kunsthistorisches Museum.

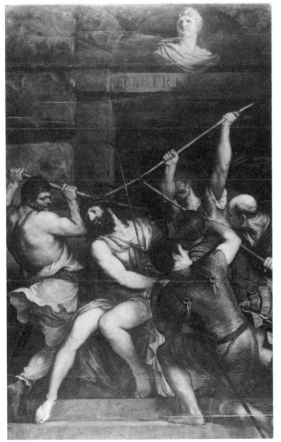

310. Titian. *Christ Crowned with Thorns*, mid-1540s. Wood panel (transferred), 303 × 180 cm. Paris, Louvre.

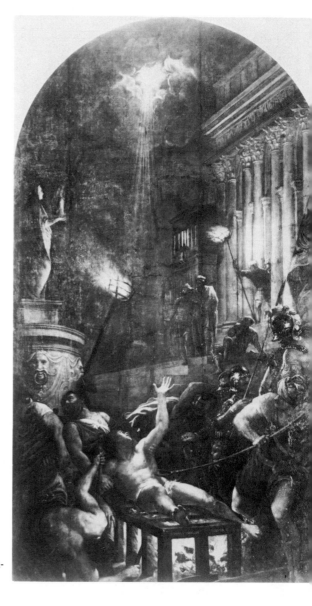

311. Titian. *Martyrdom of St. Lawrence*, 1550s. Canvas, 500 × 280 cm. Venice, Chiesa dei Gesuiti.

Somewhat incongruously, the nude *Venus of Urbino* (Florence, Uffizi), painted a few years later in 1538, is less sensuous though more erotic in implication than this *Magdalen*. She lies on the raised soft pillows of an inviting bed, her right hand lightly holding roses. This is apparently a marriage picture; in the middle ground a servant searches in a carved *cassone* for clothes for the woman, while a small dog, perhaps representing the

fidelity of the wife-Venus, is curled up on the bed. The planar relationships are more geometric here than is customary for Titian and may be followed with regularity into depth, from the edge of the bed to the figure itself, slightly flattened, then to the green hanging on the left in another plane behind her, and finally to the back wall.

Equally readable, although with a much shallower space, are the *Ecce Homo* [309] and

312. Raphael. *Liberation of St. Peter from Prison*, 1512–13. Fresco, base 660 cm.
Rome, Vatican, Stanza d'Eliodoro.

the *Christ Crowned with Thorns* [310]. The latter dates to the mid-1540s and was originally painted on a panel, an unusual support for Titian, and subsequently transferred to canvas. The three steps emphasize the picture plane, which is echoed by the heavily rusticated palace in a parallel plane behind; within the dark doorway the space is less specific. The composition, which at first may appear to be comfortably centralized, has a complicated balance in which four soldiers on the right are counterpoised with Christ and the aggressive barebacked figure holding a staff on the left. All these figures form a snugly compact group around the agonized Christ. A haughty bust of the emperor Tiberius Caesar, which establishes a vertical axis with three of the tormentors, makes a mockery of pagan justice. This painting, signed on the steps beneath Christ's left foot, must have had powerful meaning for Titian, who took up the composition again toward the end of his life [316], an expressionistic reduction of the earlier version of the subject.

The *Martyrdom of St. Lawrence* [311] was painted in the 1550s, after Titian's visit to Rome, and underscores his continuing, even renewed, commitment to classical monumentality. Massive, muscular bodies, nude or partly nude, are rendered in the weighty proportions of his earlier paintings. Never a true student of anatomy and never taken with drawing directly from the model as an experience for its own sake, Titian was criticized especially by Vasari for the lack of correctness of his figures. Titian seeks to capture the appearance of forms, giving clues necessary for an effective reading.

The martyred Early Christian saint on his fiery grill is placed obliquely in the shallow front plane, where most of the action is packed. A diagonal movement up the steps in the middle ground leading to a massive temple front, more Renaissance Roman than ancient Roman in style, is countered by the recession that moves sharply to the left. A goddess, perhaps Vesta, on a high pedestal balances these movements. A counterplot to the

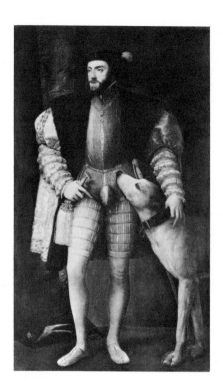

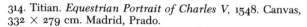

313. Titian. *Charles V with a Dog*, 1533 (?). Canvas, 192 × 111 cm. Madrid, Prado.

314. Titian. *Equestrian Portrait of Charles V*, 1548. Canvas, 332 × 279 cm. Madrid, Prado.

painting's main theme of Lawrence's and consequently Christianity's victory over pagan beliefs is the pictorial one: an exposition of different kinds of light within a night scene. It may be Titian's response to Raphael's *Liberation of St. Peter from Prison* [312]. This interest in varying light sources is manifested in the intensely burning coals beneath the gridiron, the flickering light from the torches, and the heavenly light breaking through the dark sky above, which picks up Lawrence's outstretched hand and his body, drawing away the pain of the fire below.

Titian was one of the finest and most sought-after portrait painters. Early, he carried on a tradition associated with Giorgione but soon developed types that are personal, new, and which become canonical in subsequent decades. His standing portrait of *Charles V with a Dog* [313], apparently executed in 1533 and based on an Austrian prototype, or the portrait of the same emperor made in 1548, demonstrates his powers in this category. The *Equestrian Portrait of Charles V* [314] of 1548 has a military aura and, in fact, commemorates an actual battle in which the emperor led his forces to victory over the Protestant League at Mühlberg the year before. Consequently he is represented as the defender of the Catholic faith. The power of this image and its significance are established without the aid of any symbols whatsoever, and no other actors or

subplots, even in the extreme distance, compete with the majesty of the fully armored emperor. The type is related to the condottiere monuments, both sculpted and painted, from the previous centuries, including Castagno's *Niccolò da Tolentino* [119] and Verrocchio's *Colleoni* [122] in Venice, although Titian made a flesh-and-blood image that manages to be imperial yet remain human. The warm lacy landscape, the prancing nervous steed, and the dignified rider all betray an analogous sensitivity. It should be noted that once again the principal form—an equestrian group—is placed in the foreground, parallel to the picture plane.

In the special genre of the group portrait Titian also made an important contribution. Combining the full-length standing figure that he was instrumental in popularizing in Italy with the seated papal image that Raphael had developed in his portraits of *Julius II* (London, National Gallery) and of *Pope Leo X with Two Cousins* [342], Titian's *Pope Paul III and His Grandsons* [315] was left unfinished during his trip to Rome in 1545–46. Also like Raphael's *Pope Leo X,* Titian's portrait is a harmony in reds. But Titian's is an unfolding narrative in comparison with Raphael's more static painting; the figures interact with one another in pose and glance, transforming group portraiture into narrative painting.

Gradually over the decades Titian loosened his pictorial technique, ever more freely and mysteriously applying the viscous oil paint onto canvas in rapid strokes that remain strokes, only to transform themselves into the forms represented. Vasari described the process with the critical eye of a Michelangelo follower, but he could not hide his admiration and amazement. He noted that the late works (but, of course, before 1568, when the second edition of the *Lives* was published) were quite different from those made when the painter was young. Vasari observed: "The early works are executed with a certain refinement and

incredible care, and are made to be seen up close and from a distance; but the late ones, made with strokes [*colpi*] boldly applied and with blobs, [are executed] in such a way that up close nothing can be seen, but from a distance they appear perfect." It is almost superfluous to remark how such a description might be applied to Monet.

Extreme examples of his *ultima maniera* are the *Nymph and Shepherd* (Vienna, Kunsthistorisches Museum) and the *Christ Crowned with Thorns* [316]. To a late follower of Titian is ascribed the further description of Titian's working method: "For the final touches he would blend the transitions from highlights to half-tones with his fingers, blending one tint with another, or with a smear of his finger he would apply a dark accent in some corner to strengthen it, or with a dab of red, like a drop

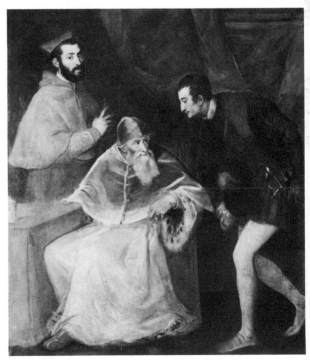

315. Titian. *Pope Paul III and His Grandsons (Alessandro Cardinal Farnese and Ottavio Farnese)* (unfinished), 1546. Canvas, 200 × 173 cm. Naples, Capodimonte Museum.

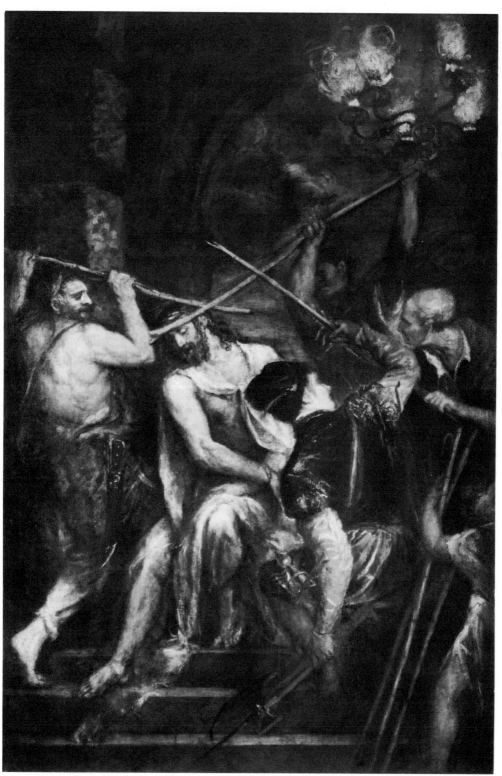

316. Titian. *Christ Crowned with Thorns*, ca. 1570–76. Canvas, 280 × 181 cm. Munich, Alte Pinako-thek.

of blood, he would enliven the surface. . . . In the final stages he painted more with his fingers than with the brush." The Vienna canvas, in Titian's studio at the time of his death and consequently a work of his extreme old age, is as sensual as any of his mythological subjects, and the nymph, in fact, reverts back to a pose invented by Giorgione seven decades before. The composition and forms are still thoroughly in the monumental style of the third generation, carrying that stylistic language far into the sixteenth century. Titian, as was his custom, here chose youthful models, ones of great natural beauty and physical perfection. He is unsculptural in rendering the fleshy nudes, nor does his architecture pretend to be buildable. But, incongruously, the forms Titian represents are convincingly present and strongly physical. If there is little psychological interaction between the lovers in this picture, or between either of them and the spectator (and the painter), the rapport between that which is depicted, the total *poesia,* and the means of the depiction, the oil paint on rough canvas that irregularly licks up the pigment, was never more tightly united.

SEBASTIANO DEL PIOMBO

Sebastiano di Luciano, known as Sebastiano Veneziano or after receiving a papal sinecure in Rome (1531) as Sebastiano del Piombo (ca. 1485–1547), is one of the most dramatic examples of an artist with a strong local orientation (in Venice) who shifted centers and modified his expression to conform to the style of his new home (Rome). According to Vasari, who was personally acquainted with him, Sebastiano began his career as a musician before he became an apprentice in Giovanni Bellini's shop; later he was associated with Giorgione. In 1511 he was summoned to Rome by the wealthy Sienese merchant Agostino Chigi, who was a patron of Raphael and Peruzzi.

Once in the papal city, Sebastiano stayed there for the remainder of his life with the exception of a two-year trip to Venice following the Sack of Rome. He served as one of the most important vehicles by which the new Venetian style of Giorgione was transmitted to Rome, where it was received with great enthusiasm.

After working at Chigi's villa, the Farnesina, where he came into direct contact with Raphael, Sebastiano apparently gravitated toward Michelangelo's orbit. An extensive correspondence between the two artists still exists, and Michelangelo is said to have supplied drawings and sketches for Sebastiano's paintings. In addition, Michelangelo was godfather to Sebastiano's son (born in 1520). A *Deposition* [318] is signed and dated 1516, the same year Sebastiano undertook the decoration of the Borgherini Chapel in the Church of San Pietro in Montorio (Rome), where work on the frescoes lingered on until 1524. In 1517 Cardinal Giulio de' Medici, a cousin of Leo X and a future pope, commissioned the *Resurrection of Lazarus* [319] from Sebastiano for the Cathedral of Narbonne in competition with Raphael's *Transfiguration* [340]. Sebastiano finished his painting two years later; Raphael died before fully completing his altarpiece. Soon afterward, Sebastiano probably began the striking *Martyrdom of St. Agatha* [322], which is dated 1520, and the *Visitation* (Paris, Louvre), dated 1521. From the time of his arrival in Rome until the later 1520s, Sebastiano produced a large number of portraits, a genre in which he excelled. There is a noticeable slackening off of his productivity by 1531, when he obtained a fixed income and took holy vows. Thereafter, he virtually stopped painting. In 1532 mention is made of a *Nativity of Mary* for the Chigi Chapel in Santa Maria del Popolo, but it was left unfinished.

٠┼┼

317. View of the Sala di Galatea, with Sebastiano del Piombo's *Polyphemus* and the *Fall of Icarus* and Raphael's *Galatea*. Frescoes. Rome, Villa Farnesina.

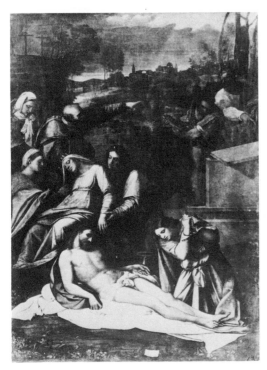

318. Sebastiano del Piombo. *Deposition*, 1516. Wood panel (transferred), 260 × 193 cm. Leningrad, Hermitage.

Of the Venetian works associated with Sebastiano, none is signed or documented, although indirect evidence and stylistic considerations permit convincing attributions. Older sources suggest a collaboration with Giorgione in the *Three Philosophers* [298], where Sebastiano's share was limited to the completion of the work, left unfinished at Giorgione's death. The organ shutters for the little Venetian church of San Bartolommeo al Rialto, where Dürer left an important altarpiece in 1506, seem to date from 1507 and 1508. On the outside face of the shutters (they are painted on both sides) there are paired saints in shadowy niches. The old pilgrim St. Sinibaldus on the right exemplifies not only the closeness of Sebastiano's style to Giorgione's at this time, but also their mutual dependence upon Giovanni Bellini, whose head of St. Zaccaria, from the altarpiece of

1505 [198], is a model for both Sebastiano's St. Sinibaldus and the oldest of Giorgione's *Three Philosophers*. The understatement achieved through the use of shadow for the sake of expression and mood, in which not only are the forms softened but the atmosphere is also charged with an ambiguous reality, leaves much to the viewer's imagination.

The shift from Venice to Rome brought Sebastiano into a very different artistic environment, where Italy's most powerful artists, with the exception of Titian, had been drawn by well-paying and abundant commissions. In the early sixteenth century, the monumental style was favored; there was a desire among the artists, and presumably their patrons as well, to come to terms with Roman antiquity. Sebastiano was quickly put to the test, working beside Raphael on the frescoes for the Farnesina, where we can see his hand in the *Polyphemus* and in the lunette above depicting the *Fall of Icarus* of 1511 [317]. Sebastiano portrays the beautiful Icarus hovering over his father, while the feathers of his wax wings begin to melt from the heat of the sun. Sebastiano shows a certain insecurity with the medium of fresco and an uneasiness with human anatomy when compared to the self-confident Raphael, but he manages to inject a poetic mood through the use of soft modeling.

Sebastiano soon became personally and artistically associated with Michelangelo. In the *Deposition* [318] he incorporated figural types from Michelangelo, particularly the swooning Mary on the left, without sacrificing his own interest in landscape, and a mood evoking Giovanni Bellini and Giorgione. Although the painting of this picture coincides with Leonardo's stay in Rome (1513–16), there is little that bespeaks Leonardo except perhaps the flowery meadow in the front. The composition is constructed somewhat like Raphael's *Spasimo* (Madrid, Prado), painted around the same time. In addition, there are paraphrases of figures from the Stanza della Segnatura,

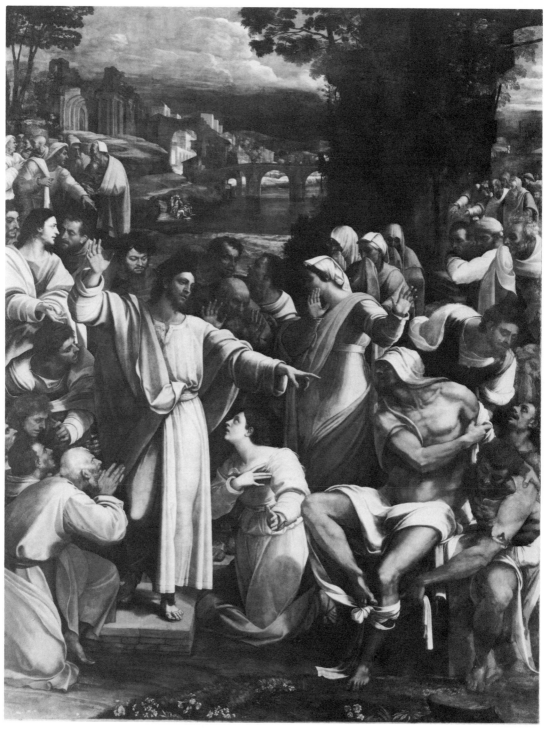

319. Sebastiano del Piombo. *Resurrection of Lazarus*, 1517–19. Wood panel (transferred), 381 × 289 cm. London, National Gallery.

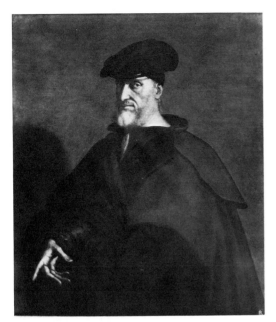

320. Sebastiano del Piombo. *Andrea Doria*, 1526. Wood panel, 153 × 107 cm. Rome, Galleria Doria-Pamphili.

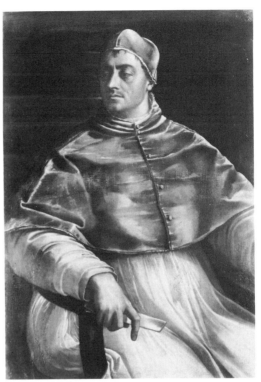

321. Sebastiano del Piombo. *Pope Clement VII*, 1526. Canvas, 145 × 100 cm. Naples, Capodimonte Museum.

particularly noticeable in the two figures in the middle distance on the right looking or gesturing downward. It is in the use of light, both for modeling form and for expression, that Sebastiano excels. The competition between Raphael and Sebastiano was extended to include the supporters of Michelangelo and those of Raphael. All Rome was alive with excitement over the *Resurrection of Lazarus* [319] and the *Transfiguration.* It is known that Michelangelo provided advice and possibly even drawings and sketches for Sebastiano's use.

The force of gesture, memorable in Michelangelo's *Creation of Adam* from the Sistine ceiling [283] and alluded to in the bald figure pointing in the *Deposition,* is monumentalized in Sebastiano's Christ in the *Resurrection of Lazarus.* The parchment-skinned figure of Lazarus is also Michelangelesque as he gradually begins to regain life after being

dead and buried for three days. Other insights obtained from Michelangelo include the woman with hands raised, who is a reversal of Adam in Michelangelo's *Expulsion.* Sebastiano was able to incorporate the best of several worlds: the powerful figures of Michelangelo (and Raphael, for that matter), with a sympathy for landscape and the more poetic use of *chiaroscuro* and color that are characteristic of his Venetian origins. In the *Resurrection of Lazarus,* despite the borrowings, Sebastiano still continues to be his own man. Some passages are of great beauty, and if the picture fails to attain the supreme level of Raphael's *Transfiguration,* the explanation lies not in the mismanagement of his sources, but in the fact that his artistic abilities could not sustain the heights of his towering contempo-

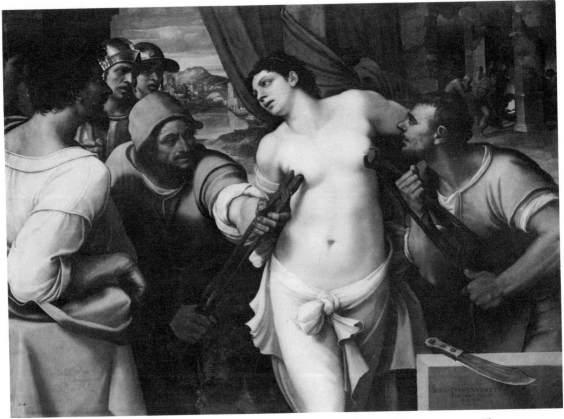

322. Sebastiano del Piombo. *Martyrdom of St. Agatha*, 1520. Wood panel, 131 × 175 cm. Florence, Pitti Palace.

raries, leading Sebastiano eventually to give up painting altogether. The death of Raphael, his most potent rival, in 1520, opened the field in Rome, but after a burst of activity, Sebastiano was unable to fill the gap, except in the area of portraiture.

The portrait of *Andrea Doria* [320], painted in 1526, shows the severe Genoese admiral standing magisterially behind a marble parapet on which is carved a Roman relief with marine iconography. Gesture takes control. What is absent here and in the distinctive portrait of *Pope Clement VII* [321], painted in the same year, are insights into the personality and inner emotions of the sitters. Based on Raphael's portrait of *Julius II* (London, Na-

tional Gallery), Clement is shown as a similar three-quarter-length figure. Sebastiano's sitter is not only more self-assured as he turns away from the axis of the torso, but the image is also more rhetorical than Raphael's introspective Julius. In Sebastiano's painting, the hand that holds a folded letter provides a strong visual focus that tends to compete with the head rather than supplement it, preventing, as does the dramatic expression, a rapport between subject and viewer. In another time, Sebastiano del Piombo might have ranked as the first painter of Italy, but the competition was too keen, and he seems to have been overcome by it.

RAPHAEL

With Raffaello Sanzio (1483–1520), known in English simply as Raphael, we are dealing with the model third generation monumental painter. Despite his short life of only thirty-seven years, he left a large body of works from almost every year of his career, so that his total contribution and far-reaching influence can be efficiently gauged. Furthermore, because of a widespread reputation already achieved in his lifetime, sufficient contemporary data have survived to permit the construction of a well-grounded chronology. Only the earliest period is less clear, and for it, as one might imagine, various and conflicting reconstructions have been offered. Born in Urbino, where his father had been painter and major-domo for the court, Raphael was an orphan at age eleven but must have had training as a painter because in 1500 he was commissioned together with an older painter for an altar-piece dedicated to St. Nicholas of Tolentino for a church in Città di Castello. Only fragments of the work, which was finished in 1501, survive (Naples, Capodimonte Museum), but drawings have also come down giving us insight into his earliest efforts as a draftsman.

The *Marriage of the Virgin* [323] is signed and dated 1504, representing the first incontrovertible independent example of his art. However, on the basis of Vasari's biography and on stylistic evidence, a substantial number of other works can be located between 1501 and 1504, although from a stylistic point of view they are not crucial for a broad understanding of Raphael's development. Raphael settled in Florence either by the end of 1504 or more likely early 1505, remaining there on and off until his transfer to Rome in 1508. He began painting the *stanze* in the Vatican Palace in 1509 for Julius II. The frescoes in the Stanza della Segnatura were finished in 1511 and are perhaps his most successful. In 1514 Raphael was appointed architect of St. Peter's,

and in the following year he was placed in charge of the ancient inscriptions of Rome and was executing the cartoons for the tapestries for the Sistine Chapel, which were finished in 1516. He was still painting in the Vatican in 1517, when he dated the *Oath of Leo III* in the Stanza dell'Incendio. In that same year he was commissioned to do the *Transfiguration* [340], not fully finished at his death in 1520.

‡

An appraisal of Raphael's early development should begin, in the context of this book, with the *Marriage of the Virgin* in Milan [323], leaving to one side the very early works that include controversial attributions and where there are few signs of a personal idiom. Indeed, even in the *Marriage*, finished at age twenty-one, Raphael's style is closely identified with the manner of his principal teacher Perugino, whose *Christ Handing the Keys to St. Peter* in the Sistine Chapel [149] was a model for the composition. The lyric qualities of Perugino's style, the lithe, elongated figures in a limited number of poses, tiny delicate features and limbs, the simple oval faces and an affection for deep, misty landscapes, are recalled. Raphael has effectively conquered the challenges of linear perspective, although the flow between foreground, middle ground, and distance is disjointed, much as it is in Perugino's prototype. The building, on the façade of which he prominently signed and dated the painting, made for a patron in Città di Castello, is a masterpiece of fantasy, although it is connected with the advanced architectural currents representative of Raphael's countryman and perhaps his mentor in Rome, Donato Bramante.

A break from Perugino's manner occurred only when Raphael settled in Florence. Leonardo's presence in that city, where he had returned in 1500, and his artistic example were unquestionably instrumental in the rapid modification of Raphael's art, as was Michelan-

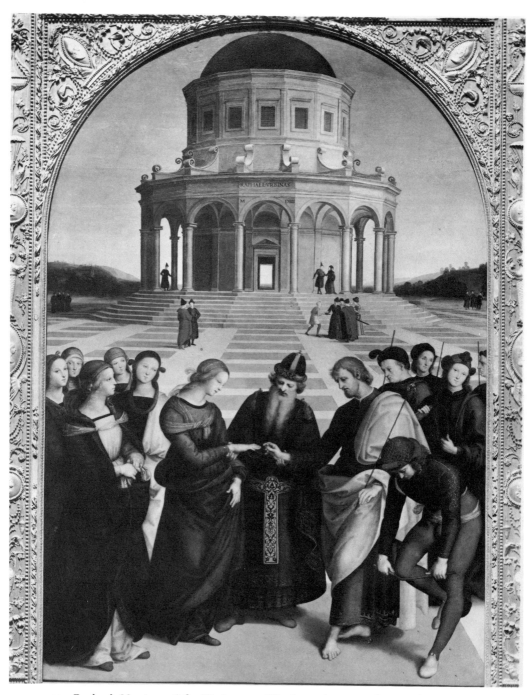

323. Raphael. *Marriage of the Virgin*, 1504. Wood panel, 170 × 118 cm. Milan, Brera.

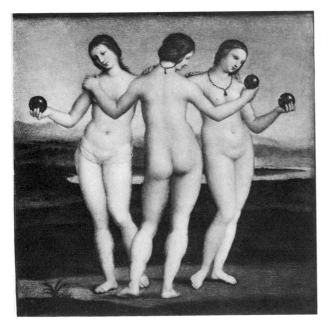

324. Raphael. *Three Graces,* ca. 1505–6. Wood panel, 17 × 17 cm. Chantilly, Musée Condé.

325. *Medici Venus,* 3rd cen. B.C. Marble. Florence, Uffizi.

gelo's example and the incalculable success of the just finished marble *David.* He retraced Florentine artistic developments, carefully examining the innovations of Masaccio and Donatello and quickly achieving independence from the style of Perugino; by 1505 we can conveniently see the beginning of his first phase. Raphael appears to have benefited from Leonardo's example in the little *Three Graces* [324], datable to 1505 or 1506. These nudes have the same proportions as some of Leonardo's female figures, which in turn are based on classical prototypes [325]: thick trunks, heavy thighs, smallish heads. Raphael's nudes stand in convincing gravitational poses, occupying a marked spatial zone. By eliminating the decorative, purely surface, elements, Raphael achieves a monumentality that is natural to him and one that will continue to mark his art for the remainder of his life.

The *Entombment* [326] is signed and dated 1507, but the commission and planning of the

composition must have taken place several years before. Florentine elements abound, and he may even have painted the altarpiece, which was for a Perugian patron, in Florence. The pose of the seated figure on the right is a quotation from Michelangelo's *Doni Madonna* [272]; the dead Christ is closely related to the *Pietà.* Also related to Michelangelo are the generally muscular, thick-limbed participants, although the impulses from Luca Signorelli for several figures and for the color should not be overlooked. The figures are arranged in a horizontal frieze-like band, tightly packed in a shallow space near the picture plane. Behind on the right is Calvary with the vacant crosses and the ladder down which Christ has been carried. On the left the foreshortened mouth of the cave, which will serve as His tomb, indicates the final direction of the movement. The grieving women and particularly Mary may refer to the special circumstances that surround this Perugian assign-

326. Raphael. *Entombment,* 1507. Wood panel, 184 × 176 cm. Rome, Borghese Gallery.

327. Raphael. *Theological Virtues: Faith, Hope, and Charity* (predella panel, *Entombment*), 1507. Wood panel, 16 × 44 cm. each. Rome, Vatican Pinacoteca.

328. Raphael. *Madonna of the Goldfinch*, 1506–7. Wood panel, 107 × 77 cm. Florence, Uffizi.

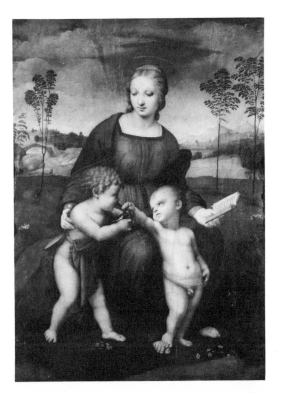

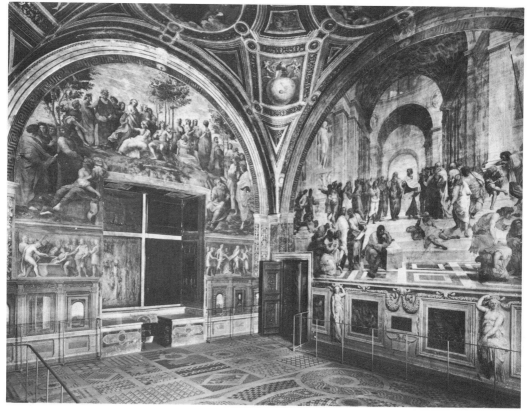

329. View of the Stanza della Segnatura, Vatican, Rome.

ment concerning the murder of Atalanta Baglioni's young son in a political plot. The low hills recall the reposeful Umbrian countryside.

Raphael has not fully harmonized all the elements in the intricate composition, and the proportions of the various figures are disjointed. Yet there are superb passages comprising single figures and groups, for example, the head of Christ, his limp arms and lifeless hands, and the Maries on the right. The predella [327], which has been separated from the main field, contains monochrome representations of the theological virtues done, evidently, toward the final stage of Raphael's activity on the altarpiece. The struggles with

poses and a self-consciousness have given way to a confident, facile execution.

The little *putti* are like the children in the *Madonna of the Goldfinch* [328] of about the same date, 1507. This *Madonna* delineates one aspect of Raphael's activity during his Florentine sojourn, the production of a number of small devotional pictures for private patrons. He must have found it difficult to obtain lucrative public and major private commissions because of his age and his non-Florentine origins, not to mention competition with Fra Bartolommeo, Leonardo, and Michelangelo. The pyramidal arrangement of Mary, the Christ Child, and the infant St. John is a meditation on Leonardo's inventions, with Raphael's

characteristically more delicate and less neurotic expression. Mary towers over the children but simultaneously protects them by glance, gesture, and physical mass.

Raphael fulfilled the stylistic implications demonstrated in his Florentine works later on in Rome, where he arrived in 1508. The Stanza della Segnatura frescoes include the ceiling and side walls of this papal chamber [329, 330]. The program for the room, which is closely tied to the person of Julius II (who appears in the frescoes), is probably Franciscan; there is a comfortable harmonization of Christian and classical thought. In addition to the ceiling with biblical and classical subjects and personifications, the side walls contain the famous frescoes, the *Disputa,* the *School of Athens,*

Parnassus, and the less well known *Gregory IX Approves the Decretals* as well as grisaille decoration *all'antica.*

Raphael has united three basic ingredients of his early maturity: (1) the native Umbrian qualities derived from Perugino especially but also from Signorelli and Pinturicchio and that recall the more distant Piero della Francesca; (2) the impact of what he saw and absorbed in Florence; and (3) the massive injection of impulses for his figural vocabulary that he found in Rome, ancient and modern. The *Disputa (Disputation over the Sacrament)* was the first of the larger scenes painted, and it represents not a dispute but an amplification of the meaning of the Eucharist, which rests on the altar on the central axis of the picture [331]. Pre-

330. Ceiling of the Stanza della Segnatura, 1508–9. Fresco. Rome, Vatican.

331. Raphael. *Disputa (Disputation over the Sacrament),* 1509–10. Fresco, base 770 cm. Rome, Vatican, Stanza della Segnatura.

cisely on the same axis, reading upward, is the white dove of the Holy Spirit, Christ with outstretched hands revealing His wounds, and God the Father holding a globe with His left hand while blessing with His right. The circle is important here because it is the shape of the wafer, then of the halo behind the seated Christ, and finally of the segmented circle at the top.

Raphael has very exactly regulated the path the eye should take in reading the *Disputa*. The figures at either end of the composition lean outward as if to establish points of entry and exit; the eye is then led by means of a turn of a body, a thrust of an arm, the direction of a glance. To a large degree the figures are identifiable. The four principals are Doctors of the Church, Gregory the Great and Jerome on the left side of the altar, Ambrose and Augustine on the opposite side. Standing on the right side of the painting Sixtus IV, uncle and patron of Julius II, is dressed in a golden cope and papal tiara. Directly behind him the unmistakable profile of Dante is to be seen. On the opposite side of the composition the most devout painter of the previous century, Fra Angelico, is included along with a likeness of Bramante.

The *School of Athens*, done in 1510 and 1511, marks the high point in Raphael's development and in the evolution of narrative painting in the Renaissance [332]. The clarity of expression, the rigorous composition, the satisfying architectural spaces, the descriptive, dignified color, and particularly the integrity of the individual figures as they relate to each other and to the space they occupy belong to the tradition first stated by Masaccio in the Brancacci Chapel.

The main action is concentrated in a zone atop four high marble steps, where the figures are arranged horizontally with a gradually increasing stress given to Plato and Aristotle, isolated by a distant arch on the central axis, much as Christ is separated from the Apostles

in Leonardo's *Last Supper* [248]. Below, individual personalities and groups are carefully orchestrated to add excitement, interest, and diversity to the overall composition. A classical structure is archaeologically reconstructed with coffered marble vaults, a great open dome, and marble reliefs and statues. The figures are conceived in various poses: running, standing, bending, sitting, and reclining; their expressions are restrained as they concentrate on activities of teaching or explicating, studying or meditating. As part of a carefully conceived program (though apparently not Raphael's invention), the *School of Athens* stands for Philosophy and is placed in conjunction with three others that represent Theology, Poetry, and Law. The cool crisp color, the clear sharp air, and the earthbound emphasis of the composition are elements consistent with the theme of the fresco. Raphael, as effectively as any painter of the Renaissance, was able to integrate meaning and form. And if Raphael's mode, like Michelangelo's, was basically figural, he located his actors more specifically within an environment, which he manipulated with facility.

In the *Parnassus*, the allegory of Poetry for the same program, a more elaborate landscape environment is established [333]. The figures are arranged in two zones that are above one another but are also on different spatial planes. The greatest writers of the ancient and modern worlds, accompanied by the nine Muses, are placed on either side of Apollo, who plays a viol atop the low hill. The lower central portion of the fresco is punctured by an actual window, as the *School of Athens* was with a door, and Raphael ably incorporated it into the fiction by establishing an imitation marble frame upon which Sappho rests. We are prepared for such optical play by Mantegna. As in the *School of Athens* and the *Disputa*, portraits of contemporaries are interspersed with historical personalities to form an expanded cycle of *uomini famosi* [117]. Ra-

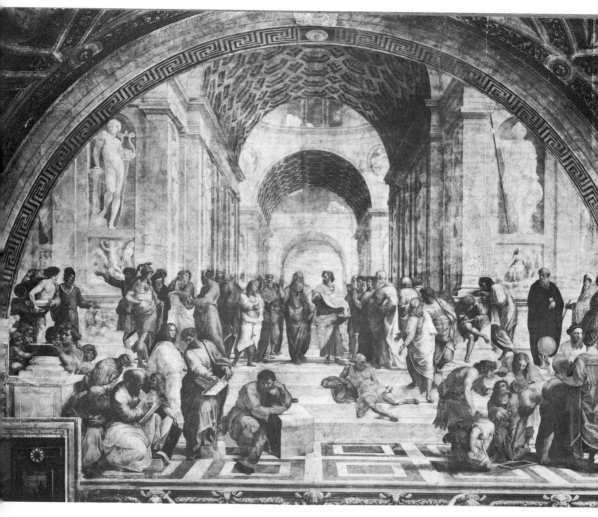

332. Raphael. *School of Athens*, 1510–11. Fresco, base 770 cm. Rome, Vatican, Stanza della Segnatura.

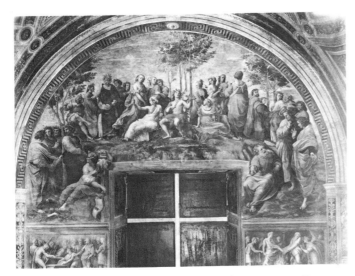

333. Raphael. *Parnassus*, ca. 1511. Fresco, base 670 cm. Rome, Vatican, Stanza della Segnatura.

334. Raphael. Study of Apollo for *Parnassus*, ca. 1511. Ink, 31.4 × 22.2 cm. Lille, Musée des Beaux-Arts.

phael's approach to constructing the figure can be examined in the nearly nude Apollo, who may have been based on a small Roman bronze representing Mars. But Raphael has confirmed and analyzed the figure and the pose in a drawing from a living model [334]. Much the same process may have been involved for many of the other figures, several of whom have poses borrowed from Roman sarcophagi. They are gracefully balanced, without tension.

Another example of classical imagery illustrated by Raphael is the *Galatea* [335], a fresco ordered by the Sienese Agostino Chigi for his Villa Farnesina, where Raphael had a share in the decoration along with Sodoma and Sebastiano del Piombo [317]. In this cen-

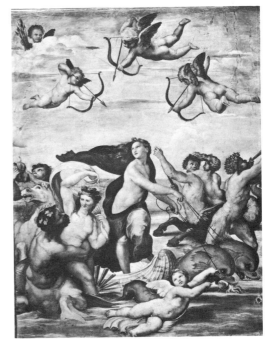

335. Raphael. *Galatea*, ca. 1512. Fresco, 294.5 × 223 cm. Rome, Villa Farnesina.

tralized composition, Raphael has made a fully three-dimensional scene quite unlike Botticelli's flat, decorative *Birth of Venus,* which it superficially resembles; all Raphael's figures are lustily present and volumetric. The text for Raphael's interpretation derives from antiquity via a poem by Poliziano; for the central figure Raphael has introduced a new, engaging pose. Galatea is being pulled by ferocious dolphins, and her torso and arms are pivoted from the main axis; at the same time she is centrally placed, standing in an exaggerated *contrapposto,* precariously maintaining her balance. The effect is that of what might be imagined as an ancient Roman narrative fresco, although they were not known in the Renaissance.

The famous *Sistine Madonna* [336] of 1512–13, contemporary with the *Galatea,* was made for the city of Piacenza in the Po Valley on commission from Pope Julius II (whose likeness is used for St. Sixtus), and marks the culmination of Raphael's first period. Among the most successful paintings of its kind, it should be read both spatially and diagramatically. Sts. Sixtus and Barbara are vigorously foreshortened, with Sixtus's extended hand functioning to lead the spectator into the painted world where Mary, erect, monumental, ever present, stands on a segment of a globe holding the Child. When the composition is read on the surface, the three principals establish a stable equilateral triangle with the lower corners cut away. This geometry offers an unalterable permanence to the heavenly apparition. The gravity of the forms and the restraint of the expression are humanized by the playful, slightly bored child-angels at the bottom. In this work, painted on canvas, the virtuosity of the brushwork, as in the head of the saint in profile, is apparent when seen close by, and the expanded color, daring golds and off-greens, rise to the demands of the expression. The painting, located in northern Italy, was

consequently available to painters who might otherwise not have known Raphael's art firsthand, but who would have been quickly receptive to the quotations from Leonardo cited by Raphael, including the head of St. Barbara.

In contrast to the conceptual subjects of the Stanza della Segnatura, the frescoes in the contiguous room are historical in nature and dramatic in expression. The *Expulsion of Heliodorus from the Temple* [337], painted in 1512–13, is based on an account in the Apocrypha. Because of his hatred for the high priest Onias, at the altar with a likeness of Julius II, Simon the Benjaminite, overseer of the temple, told the king about riches held in the temple. Heliodorus, shown on the ground at the right, was sent by the king to steal the treasures, but he was struck down by the fiery rider on a white horse who has miraculously answered Onias's prayers. Julius appears again at the left, this time as pope, with his entourage. Raphael has opened out the central space so that the main figure, in the middle ground, and his function are unmistakably clear. There is considerable movement in this fresco, especially on the right, where the angels are helping the horse and rider fly through space with immense force. We are drawn into the composition on the left mainly by the kneeling woman turning sharply into space toward a relaxed Onias, and then back out again on the other side. Raphael's figures are more muscular, thicker and heavier, that is, more Michelangelesque, than in the *School of Athens.*

Pope Julius II's death in 1513 coincides with the beginning of Raphael's second stylistic phase. He continued to be a favorite at the papal court, where he was patronized by the Medici pope Leo X, and he proceeded with work on the frescoes in the papal *stanze.* The *Fire in the Borgo* [338] in the Stanza dell'Incendio, which obtains its name from it, illustrates a fire that broke out before St. Peter's in

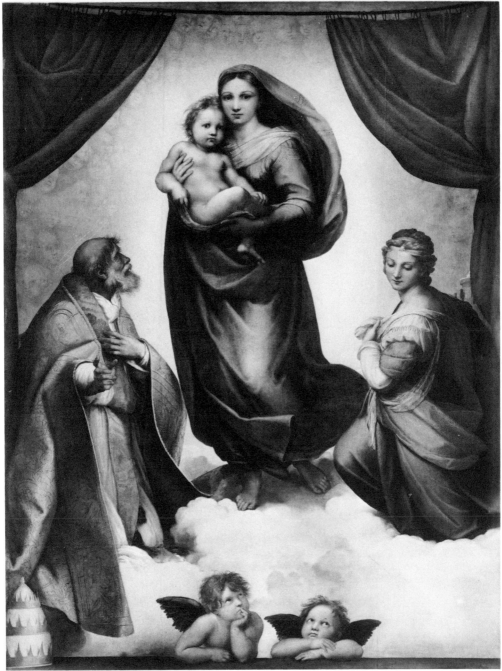

336. Raphael. *Sistine Madonna*, 1512–13. Canvas, 265 × 196 cm. Dresden, Staatliche Gemäldegalerie.

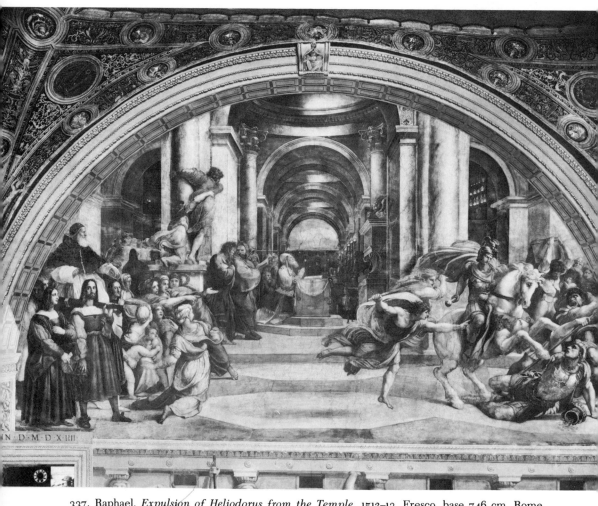

337. Raphael. *Expulsion of Heliodorus from the Temple*, 1512–13. Fresco, base 746 cm. Rome, Vatican, Stanza dell'Eliodoro.

338. Raphael. *Fire in the Borgo*, 1514–15. Fresco, base 670 cm. Rome, Vatican, Stanza dell'Incendio.

the ninth century during the reign of Leo IV. By the time this was being painted, in 1514–15, Raphael's expanded shop became extremely well-organized so that specialists worked on specific elements, a system that freed Raphael for his new architectural and archaeological responsibilities.

Both these facets of his interest are easily recognizable in the *Fire*. The increased spatial complexity is manifested by a centrally organized stage that rises slightly in the middle ground only to recede again in front of the old church façade in the distance, where the orthogonals converge. By this shifting of the ground level Raphael was able to avoid the pitfalls in spatial design of his own early *Marriage of the Virgin* [323]. Furthermore, the pope in the background is slightly off the central axis, in the contemporary building to the right. Toward the sides of the fresco other shifts occur. Figures are more directly paraphrased from ancient models than Raphael had done earlier. An increased interest in the expressive qualities of the nude and in depicting exaggerated musculature may reflect not merely Raphael's own response to Michelangelo's art, but that of his *garzoni* to it. The statuesque group on the lower left representing a young man carrying his old father from

the burning building is a visual commentary on a motive by Michelangelo from the *Flood* [281], where an old father supports his son. With all its excitement, complexities, and subplots, the *Fire in the Borgo* is comfortably readable, expanding and modifying ideas that had been treated in the Stanza della Segnatura.

Raphael and his shop painted ten large cartoons in 1514 and 1515 for tapestry weavers in Flanders. These tempera paintings on paper (London, Victoria and Albert Museum) depict scenes showing events in the lives of Sts. Peter and Paul and were commissioned by Leo for translation into tapestries to accompany the fifteenth-century frescoes on the walls and Michelangelo's ceiling fresco in the Sistine Chapel. In the *Miraculous Draught of Fishes* [339], the fishermen of the lake are disposed in two boats. An abundant catch fills the boat in which Christ sits as he calls upon Peter and Andrew to become fishers of men. The cartoon was so conceived by Raphael as to retain its strength as a composition even when reversed by the weavers. The majesty of the composition and the restrained reactions of the Apostles provide a measured balance between the power of the subject matter and the humble origins of the cast of characters.

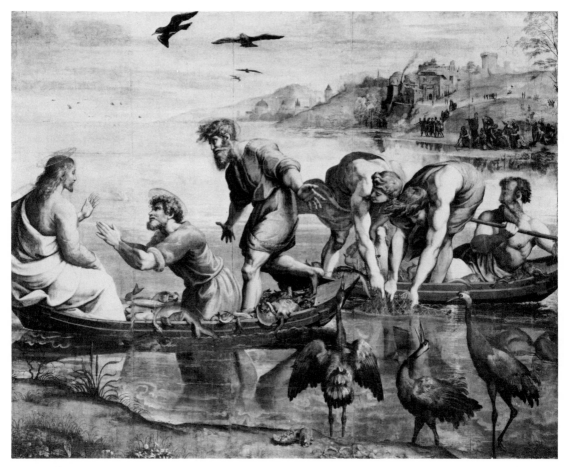

339. Raphael. *Miraculous Draught of Fishes,* 1516. Tempera on paper, 360 × 400 cm. London, Victoria and Albert Museum.

The qualities that may be isolated in the *Fire in the Borgo* are further developed in the *Transfiguration* [340], probably begun in 1518 and nearly finished at the time of the artist's death two years later. Commissioned by the pope's cousin Cardinal Giulio de' Medici (who became Pope Clement VII) for a French cathedral, it never reached its projected destination. In it Raphael shares with his contemporaries, including Titian and Correggio, a desire to reinterpret the traditional altarpiece as a narrative. In a first idea found among Raphael's extant drawings, he shows only the actual Transfiguration when Christ appears between Elijah and Moses with three Apostles on Mount Tabor. In the final resolution Raphael incorporates a subsequent biblical account of the Apostles' inability to heal a lunatic child (whom Christ exorcises), rarely depicted in art, and has it occupy the main field. The figures are disposed in the foreground near the viewer, in two closely compressed zones, with the central area left open. The apparition appears above and at some distance, so that the chronological separation of the two events is established not only vertically but spatially. The two incidents are visually united through gesture and movement. The light functions in

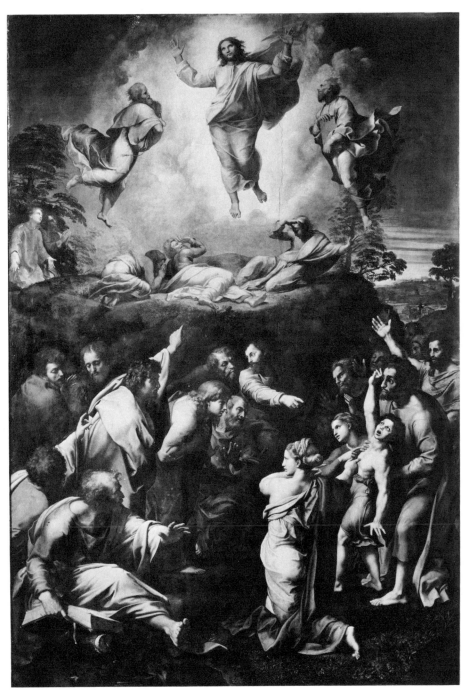

340. Raphael. *Transfiguration*, 1518–20. Wood panel, 405 × 278 cm. Rome,
Vatican Pinacoteca.

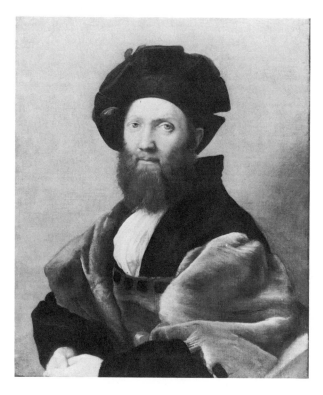

341. Raphael. *Baldassare Castiglione,* ca. 1515. Canvas, 82 × 66 cm. Paris, Louvre.

a dual role—that of creating volume through *chiaroscuro* and in expressively defining individual figures and segments. In this last work, finished after his death by Giulio Romano, Raphael's approach remains monumental. The deep, symphonic color increases the beauty of the entire work but never diminishes the integrity of the forms, the dignity of the heads, their facial expressions, and the decorum of their gestures. It represents the high point of his middle period; he never lived to have a late phase.

Raphael, like Titian, excelled in portraiture. Even in Florence he already had orders for portraits, and for the remainder of his career commissions continued to pour in. Two may be singled out, dating from his residence in Rome: the *Baldassare Castiglione* [341] and the *Pope Leo X with Two Cousins* [342]. The easy restraint and dignity of Castiglione's pose, hands folded (now only partially visible since the picture has been cut down), the body turned slightly in space, and the head moving almost imperceptibly to meet the viewer, are part of a formula adopted from Leonardo as exemplified by the *Mona Lisa.* The essentially undramatic, nonepisodic handling, a generalized light, and a near monochromy seem the suitable treatment for the author of the *Book of the Courtier,* himself an arch model of appropriate behavior in a Renaissance court. Raphael's untheatrical approach may be seen in contrast to Sebastiano del Piombo's portraiture.

Raphael also confronted the challenge of the group portrait, which he resolved with great success in the *Pope Leo X with Two Cousins,* painted during 1517 and 1518. These three Medici cousins are represented in a straightforward, unprettified manner, each

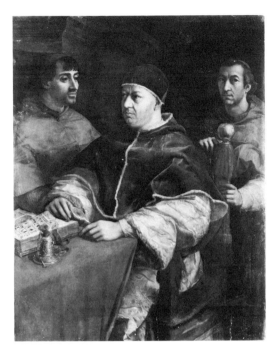

342. Raphael. *Pope Leo X with Two Cousins (Cardinals Giulio de' Medici and Luigi Rossi)*, 1517–18. Wood panel, 154 × 119 cm. Florence, Uffizi.

Raphael is perhaps the most satisfying because of the rationality of his compositions and the inevitability of his figures. He was a consummate draftsman on paper and in his paintings, giving a surety of form. His art became the backbone of academic instruction for centuries; nor did his reputation ever suffer the ups and downs of Michelangelo's.

ANDREA DEL SARTO

The Florentine Andrea di Agnolo (1486–1530), known as Andrea (or Andreino, "little Andrea") del Sarto because his father was a tailor *(sarto),* had a prominent position in the evolution of Italian painting during the twenty years before his premature death. Andrea was inscribed in the painters' guild in 1508, the first fixed date that has survived concerning his career as an artist. Beginning in 1509 he painted

with his own individualized physical characteristics. They are close in age and have an intangible likeness, although the pope's corpulence and the fact that he is seated allow him precedence, as his rank demands. Toward the end of his career, by normal standards at midcareer, Raphael exhibits an uncanny breadth of visual understanding. Northern art, which Michelangelo specifically disparaged, continues to have a vitality for him, and treatment of certain details, including the golden bell, the illuminated manuscript, and the reflection of a window on the luminous knob of the chair, rival Flemish practice [343]. Surface textures are keenly observed, and the color is an exercise in reds. None of these features diminishes the painting's monumentality: the sturdy although barely implied architecture, the figures solid, column-like, and permanent.

Of all the painters of the third generation,

343. Raphael. Detail of 342.

a series of scenes from the life of St. Philip Benizzi in the atrium of the Servite church, Santissima Annunziata, one of which bears the date 1510. In 1511 he received the commission to paint a *Last Supper* for the Convent of San Salvi outside the walls of Florence, but the work was not completed until almost fifteen years later. Also in the same year Andrea frescoed the *Journey of the Magi*, again for the atrium of the Annunziata. Payments for still another fresco, the *Birth of the Virgin* [344], are mostly from 1513 and 1514, a date found in the painting.

The *Madonna of the Harpies* [347], his most famous altarpiece, was completed three years later (1517), as attested to by the date in a cartouche within the picture. Previously, Andrea took part in the elaborate decorations for the entry of Leo X (Medici) into Florence in 1515. At the same time he began working on the fresco cycle in the cloister of the Scalzo, one of the many lay religious confraternities in Florence, which was to occupy him for the next eleven years. In 1518 Andrea obtained a sizable dowry from his wife Lucrezia's family, and soon after his marriage he went to France, where he worked for Francis I at Fontainebleau. He returned to Florence in 1519, and by 1521 he is registered at work, together with Pontormo (for a time his pupil) and Franciabigio, on paintings for the main *salone* (large room) of the Medici villa at Poggio a Caiano, but his work there was modified sixty years later. In 1524 there is record of a payment for the *Lamentation over the Dead Christ with Saints* [349], intended as an altarpiece for a country church outside Florence, that contains his characteristic monogram of two A's (for Andrea di Agnolo), one inverted over the other. Around this time, on commission, Andrea made a copy of Raphael's *Pope Leo X with Two Cousins*. He also painted the *Madonna del Sacco* [352], in the Chiostro dei Morti, part of the decorative complex at the

Santissima Annunziata, which is dated (but not signed) 1525.

Biographical information on the last five years of his life is scarce, due perhaps to the general disruption of political life in Italy and particularly the strife in Florence, highlighted by the brief restoration of a Republican government in 1527. Andrea died at the age of forty-four and was buried in the Compagnia delle Scalzo, where he had worked so diligently for such a long time. He was a prolific painter and had several close followers who imitated his art successfully, thereby leaving a large body of works that are associated with his name.

⁘

In 1514 the twenty-eight-year-old painter signed and dated the fresco of the *Birth of the Virgin* in the atrium of the Santissima Annunziata [344]. He was by then an experienced, successful master of some individuality. He had painted the *Journey of the Magi* and the frescoes illustrating the life of St. Philip Benizzi for the same location, the so-called Chiostro dei Voti, although these fail to fully achieve a stylistically personal statement. Instead, in the assignment done when he was in his mid-twenties, he appears heavily dependent on Mariotto Albertinelli, as well as on his presumed master, Piero di Cosimo (especially in the treatment of the landscape), and his collaborator, the slightly older Francesco Franciabigio. Andrea, it appears, was a slow starter like Leonardo and possibly Titian in achieving a personal language—the ingestion and digestion of what was available had a long maturative period before entering a first, independent phase.

The *Birth of the Virgin* is much freer of this network of stylistic components. Full-bodied, three-dimensional figures in sweeping, austere costumes are less fussy than those painted by Ghirlandaio thirty years earlier in a similar

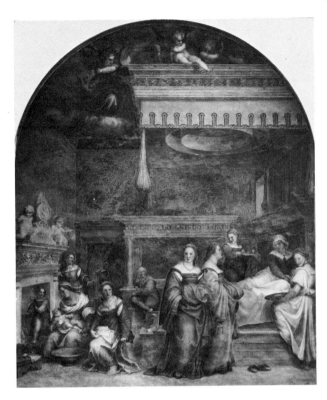

344. Andrea del Sarto. *Birth of the Virgin*, 1514. Fresco, 410 × 345 cm. Florence, Santissima Annunziata.

scene. In their simplicity, they revert back to the handling current of Masaccio and his generation, as well as to contemporaries like Fra Bartolommeo and Raphael. The *Birth of the Virgin* is reasonably uncrowded, so that the figures can move graciously in the expansive room, dominated by the bed and the high canopy, above which the angels rejoice. St. Anne is de-emphasized, as is her old husband Joachim, the only male in the painting. The infant Mary is shown being dried by the fireplace, where the symbol of the order of the Servi of Maria, the S and the lily, over the mantle constitute part of the sculptural decoration.

The two heavily draped women in the center, one in profile, the other facing out toward the spectator, have the dominant position. They are, besides, based on the same model, wearing identical, though diversely colored,

fine dresses. One of the characteristic features of Andrea's approach, as differentiated from that of Raphael's, which in many ways it approximates, is the softening of edges and the avoidance of outlining. The resulting *sfumato*, or at least a breaking down of contours, is associated both with Leonardo and the Venetians, particularly Giorgione, Titian, and Sebastiano del Piombo. This quality is particularly noticeable when comparing Andrea's approach to Michelangelo's manner in the nearly contemporary Sistine ceiling frescoes.

Andrea del Sarto proceeded slowly on the fresco decoration of the small cloister of the Compagnia delle Scalzo, begun in 1511. The work was for a confraternity dedicated to St. John the Baptist, of which he himself was a member. Because of eighteenth-century renovations, the original appearance of the project,

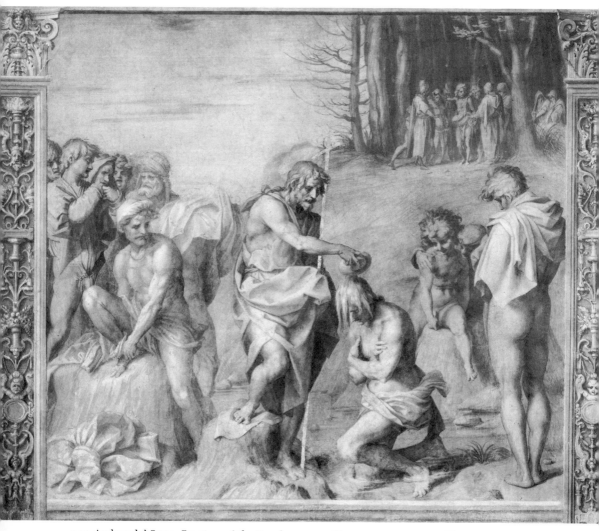

345. Andrea del Sarto. *Baptism of the People*, 1515–17. Fresco, 192 × 205 cm. Florence, Cloister of the Scalzo.

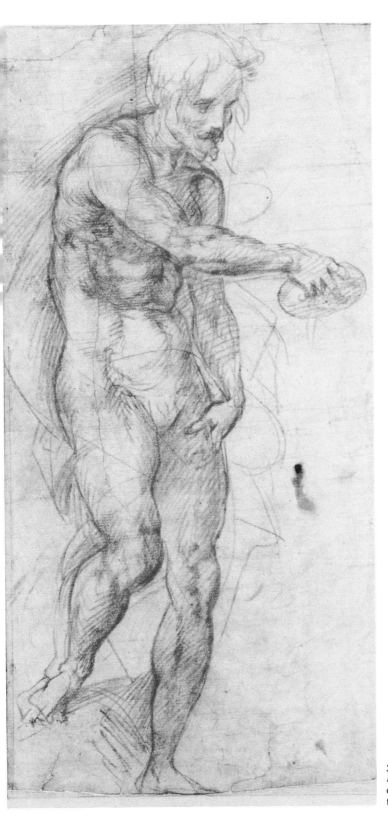

346. Andrea del Sarto. Study for the *Baptism of the People*, ca. 1515. Red chalk, 31.4 × 18.6 cm. Melbourne, National Gallery of Victoria.

which dealt with twelve scenes from the life of the saint, as well as four virtues and architectural elements, cannot be fully appreciated, even though a coherent iconographical and architectonic program had been defined from the outset. Among the most moving of the exceptionally fine group of narratives is the *Baptism of the People* [345], known to have been finished by early 1517 and therefore datable to 1515–17. The unusual procedure is a *chiaroscuro* monochrome, where a deep gray is either darkened or lightened to produce volumetric form. The visual effect is surprisingly luminous within the restricted means, recalling, in appearance, silverpoint drawings on paper.

The composition is based on V-shaped stresses, with the figures amassed in two shallow planes near the surface, reminiscent of Roman narrative sarcophagi, unusual in an artist who rarely is specifically dependent on ancient models. The absence of tension within and between the figures is exemplified by the pose of the Baptist, who comfortably pivots on his weight-bearing left leg to reach across to the kneeling neophyte, a magnificent youth. In a preparatory drawing for the St. John [346] this gracefulness is already integral, a clear alternative to the *terribilità* of Michelangelo, whose figural discoveries nevertheless had a certain appeal to Andrea, especially male nudes derived from the *Battle of Cascina* cartoon. Temperamentally, Andrea is closer to the sculptor Andrea Sansovino, with whom he had direct contact, and generically, as has been observed, to Raphael.

The *Madonna of the Harpies* [347], named for the sphinxes (not harpies, as Vasari maintained) on the base of the altar, also brings to mind Raphael and can be instructively compared with the slightly earlier *Sistine Madonna* [336]. The two works exhibit a parallel language of restraint and have a similar composition consisting of a standing Madonna

with a single saint on either side. Again a casual air dominates Andrea's picture; the playful Child is shown climbing on His mother's raised leg with an impish smile like the marble *putti* from both Donatello's and Luca della Robbia's reliefs for the *cantorie* (singing gallery) in the Florentine Cathedral (now in the Museo dell'Opera del Duomo). The stability of the composition, with three insistent verticals composed of the erect figures of St. Francis, Mary, and St. John the Evangelist, is reinforced by other verticals formed by the Christ Child and the angels. The scene occurs within a shallow stage, backed by an architectural prop arranged parallel to the picture plane. In the painting, made for a Franciscan church in Florence, the founder of the order looks out toward the viewer, as do the other figures, quite unlike Raphael's handling in the *stanze*. The reliance upon lightened and deeply shadowed areas functions to create a mood rather than having a specific dramatic purpose. The soft-spoken tonalities of Andrea's personal style are given added resonance by the loaded, sonorous, and quite original color, further diminishing a dependence upon outline drawing.

Culminating this first or youthful phase—following what appears to have been a long period of training and emerging independence—was Andrea's trip to France, where he produced the *Charity* [348]. Signed and dated 1518, this frequently restored picture was transferred from its original wood support to canvas in the eighteenth century. Executed for Francis I, who regarded charity as one of his personal devices, the seated, full-length Virtue also brings to mind early *quattrocento* examples, including Jacopo della Quercia's reliefs for the Sienese Fonte Gaia. The composition of the woman, much like a Madonna, retains a pyramidal format with two *putti* set in front of a landscape.

The Child sleeping on the ground in front,

347. Andrea del Sarto. *Madonna of the Harpies*, 1517. Wood panel, 208 × 178 cm. Florence, Uffizi.

348. Andrea del Sarto. *Charity*, 1518. Canvas (transferred), 185 × 137 cm. Paris, Louvre.

daringly close to the picture surface, is disruptive to the compositional equilibrium. Here, as elsewhere, Andrea del Sarto is never a true student of anatomy or even of the figure per se. He is far more interested in how a figure or an object appears to the eye or how it is read by the spectator, and in this respect he is closer to Titian and Venetian habits than to usual Florentine tradition. The meticulous *trompe l'oeil* details, including the foreshortened *cartellino* and the flora in the lower left, may reflect an absorption of Northern painting encountered in France and included as an accommodation to the taste of his royal patron. His return to Florence in 1519 marks the beginning of Sarto's middle stylistic period, which occupies the remainder of his abbreviated career.

The *Lamentation over the Dead Christ with*

Saints [349] has been associated with similar paintings by Perugino [350] and Fra Bartolommeo [351]. According to drawings, Andrea originally planned to place the dead Christ on the lap of Mary in a Pietà arrangement that was eventually modified in favor of the present solution. The painter has singled out the silently grieving Mary, isolated exactly in the middle of the altarpiece, with Christ, St. John, and St. Peter to the left and the Magdalen, St. Catherine, and St. Paul to the right. Viewed in conjunction with one another, the figures form the vertical bars of a gigantic letter M (possibly a hidden reference to Maria). The limited landscape elements are effectively incorporated into the structure of the painting. They echo the same muted restraint as do the actors, creating a sense of decorum that exemplifies all of Andrea's pictures. Individual figural types recall Fra Bartolommeo, but behind direct mediations is a congeniality of expression with Raphael. Painterly qualities prevail; the virtuoso treatment of color, the crisp handling of Mary's spotlighted cape, the outstretched arm and hand of St. Paul, and the cloth on which Christ is deposited reveal a commitment to accurately rendered appearance and, more basically, to the act of painting for its own sake.

Much admired by contemporaries and ever since, the *Madonna del Sacco* [352], named for the sack upon which St. Joseph leans, is a depiction of the Rest on the Flight into Egypt. The condition of the fresco, exposed to the weather for centuries, is poor. The picture, in an arched niche at the end of a long vista, has a sharply foreshortened, painted architecture. The Child straddles the right leg of His mother, forming an unbreakable unit, while St. Joseph appears somewhat peripherally, intent upon an open book. In scale the figures are small in relation to the pictorial field, and since there is no crowding of any kind, they demand our immediate perception without digression.

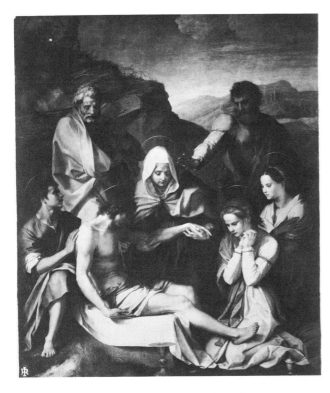

349. Andrea del Sarto. *Lamentation over the Dead Christ with Saints*, ca. 1524. Wood panel, 238 × 198 cm. Florence, Pitti Palace.

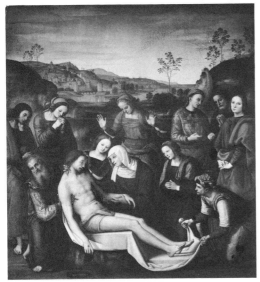

351. Fra Bartolommeo. *Lamentation over the Dead Christ*, ca. 1515–16. Wood panel, 152 × 195 cm. Florence, Pitti Palace.

350. Pietro Perugino. *Lamentation over the Dead Christ*, 1495. Wood panel, 214 × 195 cm. Florence, Pitti Palace.

352. Andrea del Sarto. *Madonna del Sacco*, 1525. Fresco, 191 × 403 cm. Florence, Santissima Annunziata, Chiostro dei Morti.

In addition to frescoes and altarpieces Andrea also designed façades for contemporary buildings in Florence, participated in creating decorations for festivals, produced drawings for the embroidery of ecclesiastical garments, and was called upon, from time to time, for portraits. All his work is defined by the same sense of measure and scale, weighted on the side of restraint, self-control, and understatement. He was described by Vasari as the "painter without mistakes," high praise to be sure, but also slightly damning.

THE THIRD GENERATION:
THE LYRIC CURRENT

Lorenzo Lotto, Correggio, Domenico Beccafumi, Rosso Fiorentino,
Jacopo Pontormo

LORENZO LOTTO

Among a small group of gifted masters whose art fits uncomfortably into their moment or perhaps any moment and with the productions of contemporaries, Lorenzo Lotto (ca. 1480–1557) was something of an itinerant loner. He was first documented in Treviso in 1503, but there is good evidence that he was born in Venice. His early training and formation are not known, although his mature career is essentially well-documented. In 1506 the altarpiece for Santa Cristina al Tivarone (Treviso) was already finished, the same year that Lotto signed and dated the *Assumption of the Virgin* in the Cathedral of Asolo. Also in 1506 he accepted an important commission at Recanati in the Marches, the Adriatic region in central Italy where he worked frequently during the remainder of his life and where he died. On this occasion he stayed in Recanati until 1508, continuing for half a century a pattern marked by frequent changes of residence.

In 1509 he is documented in Rome, where he obtained substantial payments for the dec-

oration of Julius II's rooms in the Vatican (not identified). At this time he must have been in contact with or at least aware of many progressive painters from Umbria and Tuscany who were actively employed by the pope, chief among them the slightly younger Raphael. Lotto was back in the Marches in 1512; he then settled in Bergamo, that prosperous Lombard town, where he remained until 1525. He was busily employed there with numerous commissions for altarpieces and fresco decorations, as well as designs for intarsia for Santa Maria Maggiore. Beginning in 1523 he appears to have maintained a residence in Venice and settled there by 1525, dwelling temporarily with the Dominican monks at Santi Giovanni e Paolo. In these years Lotto continued to execute assignments for patrons in the Marches, the Veneto, and Lombardy.

He recommended Jacopo Sansovino, the Florentine sculptor and eventually Venice's leading architect, for employment in Bergamo when Sansovino arrived in North Italy after the Sack of Rome in 1527. By 1532 Lotto was living in Treviso, but the length of his stay there is not known. He was in Iesi again in

1535 and in Ancona in 1538, where he began a book of accounts, kept until his death. He recorded all of his commissions and some personal remarks that reveal his tormented character. Once again a resident of Venice between 1540 and 1542, Lotto gave a small portrait of Martin Luther and his wife to a nephew with whom he was residing and who donated the pictures to a third party. The rendering of the subject at all raises questions about where Lotto's allegiances lay. There can be no doubt about the intensity of Lotto's religious convictions, however: he frequently lived in monastic institutions and joined a religious order near the end of his days. By far the largest segment of his work was done for churches.

In the decade of the 1540s Lotto continued to produce a large number of works in Treviso, Venice, and Ancona. In 1550 he even organized a sale of the pictures he had on hand in Ancona, but the results were disappointing to him. In 1552 he moved to the Sanctuary of the Santa Casa (Loreto), where he exchanged all his property for lodgings and maintenance, although he was still permitted to work for others as well. In the last years, when well into his seventies, he worked on decoration for the Church of the Santa Casa. He died in Loreto in 1557. Lotto seems to have been a sad, introspective, and disquieted person, bombarded with disappointments that prompted his frequent and presumably debilitating moves.

⊹

Lotto was extremely prolific, judging by the vast number of paintings mentioned in contracts, letters, and particularly in his books of accounts, in addition to the ample number of surviving pictures. A sample will suffice to indicate that there is a variation in style and in expression among Lotto's paintings even when dating from the same period in his career. This is due not so much to differing influ-

ences that may have appealed to him for approaching different problems, but to his own moody pattern of working. Lotto is most notably a painter in oils, but he is known to have done frescoes from time to time. He was an effective portrait painter of single busts, three-quarter-length figures, and groups. Although he occasionally painted mythological subjects, his main efforts were religious pictures, smaller altarpieces for churches, and works for private devotion.

The *Madonna and Child with St. Peter Martyr* [353], signed and dated 1503, is an authoritative index of Lotto's early work although instead of the little St. John we see today there was originally a bishop donor in profile, painted over in the seventeenth century. All scholars point to the connection of the composition with Giovanni Bellini (compare, for example, the Bellinesque picture in the Pierpont Morgan Library, New York). Lotto crowds the figural elements in the front plane and tends to de-emphasize their volume. The light and color is abstract and unnaturalistic. The power of this early work reveals an artist already testing his own individual language within an established mode, especially in the expression. The silent figures, isolated, self-absorbed, are within a landscape that evokes the surroundings of Treviso, where Lotto executed the painting. The color is deep, sonorous, and inviting, related not only to Bellini but also to Alvise Vivarini, who, many believe, was one of Lotto's teachers.

The same components are found in the *Santa Cristina al Tivarone Altarpiece* in a parochial church near Treviso [354]. The overall impression recalls Bellini's *sacra conversazione* in San Zaccaria [198], including even the mosaic in the curved apse. Lotto finished his picture by 1505–6, and in it he shows at least a distant reliance upon Antonello da Messina's *San Cassiano Altarpiece* [207], although Lotto also appears to have been engaged by the

353. Lorenzo Lotto. *Madonna and Child with St. Peter Martyr,* 1503. Wood panel, 55 × 87 cm. Naples, Capodimonte Museum.

powerful personality of Mantegna, who was an honored member of the artistic pantheon by the first years of the sixteenth century. Here Lotto is dependent upon Mantegna's *Madonna della Vittoria* [192], especially for the central group, which he transposes only slightly. Unlike either Mantegna or Bellini, Lotto diminishes the three-dimensional implications of his space; where there are the ingredients for illusionism, they are unfulfilled. The cutoff at the top is abrupt and uninformative; the puzzling open side on the right and the low horizon create unresolved spatial ambiguities. The figures stand easily, maintaining a presence more emblematic than actual, like those in Giorgione's contemporary *Castelfranco Altarpiece* [293], whose St. Liberale is compatible with Lotto's rendering of the same saint.

A more ambitious work than the *Santa Cristina* painting is the *Recanati Polyptych* [355], which originally had six compartments plus a predella (partially lost). It evokes the complex altarpieces of the previous half-century and earlier. Connections with Cima da Conegliano and especially Giovanni Bellini persist, particularly the *Frari Altarpiece.* There is also a continuous awareness of Mantegna's art, notably the *Pietà* set in the compartment above the enthroned Madonna. The bearded and mous-

tached Joseph of Arimathea, who stares out from behind Christ's left shoulder, is a direct paraphrase of a figure in Mantegna's *Presentation in the Temple* (Berlin-Dahlem, Staatliche Museen. The pathetic interpretation of the subject, with the two Maries at the right, one of whom is completely hidden by her blue garment, is deeply personal. Notwithstanding naturalistic elements, including the carefully observed draperies and the detailed body of the dead Christ, Lotto's dedication to abstract qualities vies with both naturalistic and narrative elements. If the Christ may be related to types found in Bellini, the final result is more tense, less balanced, with staccato rhythms. Some scholars have pointed to what they find as German qualities and more particularly the influence of Dürer, who was in Venice in 1506.

Lotto's stay in Rome had less effect upon his art than one might have expected. Although he shows an awareness of the masters he encountered there, Sodoma, Peruzzi, Bramantino, and especially Raphael, they hardly overwhelmed his art or seriously altered the course of his development. Most curiously, Lotto was wholly indifferent to the art of Michelangelo. The little *Holy Family* [356], a signed work, dated 1512 but heavily restored, does echo Raphael, but the composition is crowded, with the upper corners filled, producing a flattened

354. Lorenzo Lotto. *Santa Cristina al Tivarone Altarpiece,* ca. 1505–6. Wood panel, central scene 177 × 162 cm.; lunette 90 × 162 cm. Treviso, Santa Cristina al Tivarone.

355. Lorenzo Lotto. *Madonna and Child with Saints (Recanati Polyptych)*, 1508. Wood panel, 227 × 108 cm. Recanati, Pinacoteca.

356. Lorenzo Lotto. *Holy Family,* 1512. Canvas, 73 × 64 cm. Princeton, University Museum.

effect. The head of Joseph is identical with the image of Joseph of Arimathea in the *Recanati Polyptych.* Also noteworthy are the Leonardesque qualities in the head of Mary and especially in the angel, but the repainting does not permit secure generalizations. As usual, we can document certain borrowings, often specific details, but Lotto's art rarely looks like the works of any of the masters from whom he may have borrowed.

His activity in Bergamo, from 1512 to about 1525, was apparently the most stable of his adult career, when he remained fairly fixed in one place for an extended period. He must have come into contact with artistic currents emanating from nearby Milan and especially the figural inventions of Leonardo's followers. Lotto signed and dated 1516 a large altarpiece, the so-called *Pala of San Bartolommeo* in Bergamo (San Bartolommeo), an artificial invention in which he ineffectually sought to reproduce a progressive Roman *pala.* Lotto also

produced small pictures of greater delicacy and originality for private patrons. In one of the finest such works, the *Susanna and the Elders* [357], he combines a narrative in a genre setting with an extensive landscape outside a walled city. The elders gesture to the naked Susanna, falsely accusing her to her husband, who may be identified with the elegant gentleman entering the brick courtyard. The dishonest old judges are awkwardly posed as if their body postures and jerky movements reflect their distorted testimony. Susanna, in a popular story taken from the Vulgate, is in a kneeling Venus pose, one that Lotto may have achieved through Leonardo, but one that was widely known and reproduced in small bronzes in the Renaissance. The moralistic aspects of the story seem fitting for Lotto, while the informality of the narration suits his unclassical pictorial language.

The altarpiece for Santo Spirito in Bergamo, signed and dated 1521, is less appealing [358]. Here Lotto still relies on Leonardesque motifs, such as the little St. John wrestling with the lamb located beneath the throne. In this picture Lotto shows an increasing lack of interest in rendering the physical presence of the figures by sculpturesque modeling with *chiaroscuro.* The nude St. Sebastian, for example, who turns toward the enthroned Mary, limbs akimbo, is impossible to read anatomically. Decorative engagement, the oriental carpet, the bright unnaturalistic color, the active expressive potentialities in this *sacra conversazione* take control. The composition is anti-geometrical and unreconstructable, either on the surface or three-dimensionally. The vast circular movement of music-making angels in the clouds above may depend upon Raphael, but in appearance Lotto here, and frequently, has affinities with Correggio.

If there was no interchange between the two painters, and none is documented, they shared common roots, the deepest of them

357. Lorenzo Lotto. *Susanna and the Elders*, 1517. Panel, 60 × 50 cm. Florence, Pitti Palace.

358. Lorenzo Lotto. *Madonna and Child Enthroned with Sts. Catherine, Augustine, Sebastian, Anthony Abbot, and the Infant John the Baptist,* 1521. Canvas, 287 × 268 cm. Bergamo, Santo Spirito.

359. Correggio. *Madonna and Child with Saints (Madonna of San Francesco)*, 1514–15. Wood panel, 299 × 245 cm. Dresden, Staatliche Gemäldegalerie.

being Mantegna's art and Leonardo's veiled, smoky atmosphere. Both masters were in Rome early in their careers, during an explosive moment in the history of painting. Correggio died young, but Lotto's much longer career flourished mainly in provincial centers, where his art became increasingly anachronistic; his introspective rather pathetic interpretations became unbridled and in this way he shared with other painters of his generation a tendency toward deeply personal solutions.

CORREGGIO

Antonio di Pellegrino di Allegri, known as Correggio (1494?–1534), was the leading Emilian painter of the early *cinquecento*. He obtained his name from the town, located between Modena and Parma, where he was born. His birth date is uncertain; 1494 as an approximation is based on indirect evidence, including the knowledge that "he died young" and that both his parents outlived him. Correggio is first mentioned in documents in 1511, when he was a godfather at a baptism in his native town. Three years later he was asked to paint an important altarpiece for the Church of San Francesco in Correggio, a work he completed in the following year [359]. Although known to have been in Correggio until 1519, he must have passed at least a short period in Rome, probably before mid-1514, when the contract for the San Francesco altarpiece was signed, or immediately before he set out to paint it. In 1520 Correggio began an important fresco cycle that included the apse and the dome of San Giovanni Evangelista in Parma where he had taken up residence. Final payments for these frescoes were made early in 1524. In the meantime, he was commissioned to paint an altarpiece, the so-called *La Notte*, for Reggio Emilia in 1522 (Dresden, Staatliche Gemäldegalerie). In the same year he undertook the vast fresco decoration for

the Cathedral of Parma and in the year following was commissioned to paint an altarpiece for Sant'Antonio in Parma, the *Madonna and Child with Sts. Jerome and Mary Magdalen (Il Giorno)* [367], which was apparently delivered only in 1528. Consequently, by 1520 he had attained fame and lucrative patronage, which increased throughout the decade.

At the same time that the surfaces in the Cathedral of Parma were being prepared, Correggio was appointed with three others to offer opinions concerning the Steccata, another church in Parma. By 1526 a quarter of the decorations of the Cathedral are known to have been done. In 1528 a painting of the *Magdalen in the Desert* (lost) was referred to in a letter as "just finished." The second quarter of the Cathedral frescoes was finished in 1530, and in the same year the chapel where *La Notte* was placed had been completed. That year, 1530, appears on the frame of the *Madonna della Scodella* (Parma, Galleria). He returned to Correggio in 1532, if not before, without finishing the Parma frescoes; he died two years later, presumably at age forty.

·|·|·

The earliest documented painting by Correggio is the signed altarpiece for the Franciscan church in Correggio of 1514–15 [359]. There has been much speculation concerning Correggio's training and especially the identification of works that may predate this altarpiece, but the difficulties are considerable. He seems to have had a close connection with Mantegna's art, which is still apparent in the altarpiece (compare, for example, the *Madonna della Vittoria* [192]). The enthroned Madonna and the combination of figures, architecture, and landscape are also related to Mantegna's successor in Mantua, the Ferrarese painter Lorenzo Costa, but the more painterly qualities, the softening of edges and the dependence on atmospheric effects as

360. Raphael. *Madonna of Foligno*, 1511–12. Canvas, 301 × 198 cm. Rome, Vatican Pinacoteca.

sional space and gravitational conviction have given way, to a certain extent, to pictorial effects and surface excitement. Although the first extant example of his art, this painting is already close to achieving a fully expressive, original, and personal style, and whatever his precise training may have been, he was here a liberated, independent master. His stylistic debts also include Leonardo and even Raphael, whose art continues to influence Correggio throughout his life. With all of these various discernible sources, the altarpiece is an odd conglomeration of diverse stylistic components, confirming the opinion held by many critics that Correggio had made a trip to Rome. The reflections of Raphael, especially—most graphically the St. John the Baptist (compare the *Madonna of Foligno* [360])—suggest that the trip may have occurred in 1514.

The architectural elements retain the fantastic construction typical of late-fifteenth-century painting, enriched here by a combination of simulated reliefs at the base of the throne, showing scenes of Adam and Eve, the picture-within-a-picture in the oval (a seated Moses with the tablets), and the *putti* supporting the Virgin's throne. Mary, a dark form against a pale sky, silhouettes and isolates the light-toned Christ Child on her lap. Although the composition seems somewhat casual and unplanned, the central axis is stressed by the Child, the right foot of Mary, and the Moses image. The accompanying saints are arranged without a burdensome matching of attitudes. They do recall figures by other masters, especially the St. Catherine of Siena, who reminds me of Raphael's *St. Catherine of Alexandria* (London, National Gallery). Nevertheless, the painting hardly appears Raphaelesque in any significant sense.

The complexity of his artistic origins and the variety of stylistic strains in his art make it difficult to locate Correggio within a clear stylistic pattern. The explanation lies, perhaps, in

they alter the forms, also reveal an awareness of the late Giovanni Bellini (who was still alive the year that the picture was begun), and of Giorgione, already dead but whose influence on Emilian artists was considerable. We may never be able to ascertain precisely how these various elements were acquired by Correggio.

The composition is symmetrically balanced, a feature rarely found in his later works. The proportions of the figures are not rigorously consistent; smallish heads with delicate features still recall Perugino and, in any case, bear evidence of a lyric orientation, although like Giorgione and some others, Correggio's place on the lyric-monumental continuum is close to the center. Convincing three-dimen-

the provincial nature of his training and of the pictorial tradition of his birthplace and the areas of his main activity—Parma, Bologna, Reggio Emilia—at the beginning of the sixteenth century. He was surely drawn toward the best regional artists, the Ferrarese for the most part, and he was able to take the measure of the greatest of his contemporaries, from Leonardo to Raphael, Michelangelo, and Giorgione.

Among Correggio's altarpieces and religious paintings, the *Noli me tangere* [361], originally on panel but subsequently transferred to canvas, is undated and undocumented, but evidence supports the opinion that it was painted in Bologna, where Vasari saw it; it may be dated to around 1520. Christ is shown in His guise as gardener, with the straw hat and tools on the ground to His right as attributes. A deep-toned landscape competes with the figures—Mary Magdalen and Christ—who are located close to the picture's surface. The landscape, consequently, functions as a tapestry backdrop where, however, the main shapes—the hill on the left and the massive tree trunk on the right—echo and reinforce the figures.

The relation of Correggio's formal style to the ideas of his contemporaries is one of the most puzzling aspects of his art. Reflections and borrowings from Michelangelo may be isolated: the Magdalen is posed like the Eve of the *Fall* on the Sistine ceiling who in turn is related to Mary in Michelangelo's own *Doni Madonna* [272]; reverberations from Leonardo can be found in the execution and in the

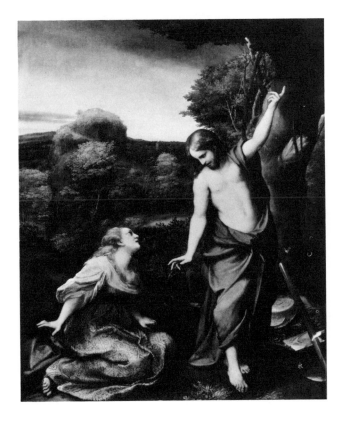

361. Correggio. *Noli me tangere*, ca. 1520. Canvas (transferred), 130 × 103 cm. Madrid, Prado.

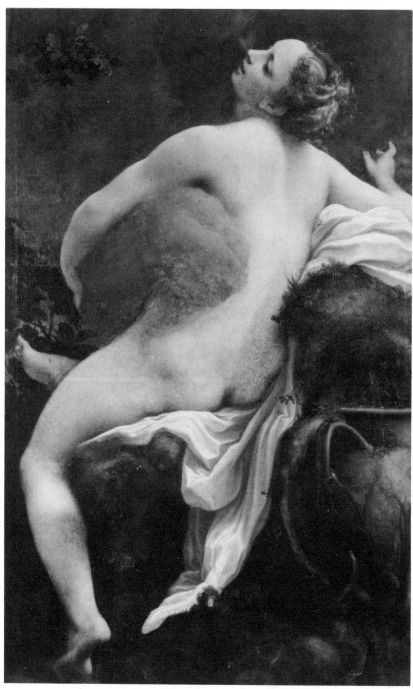

362. Correggio. *Jupiter and Io,* ca. 1532. Canvas, 163.7 × 70.5 cm. Vienna, Kunsthistorisches Museum.

softened contours as well as in the landscape, which also has similarities with Venetian practice. Raphael comes to mind, especially in the rendering of the head of Mary Magdalen, and one might even go further and locate points of contact with Ferrarese developments, especially Dosso Dossi. From such a listing the viewer might expect an eclectic potpourri of borrowings without homogeneity or sense. But more than most artists Correggio was able to learn from his gifted and innovative contemporaries while maintaining a high degree of independence. Perhaps his origins in a provincial center allowed him to seek inspiration more freely and open-mindedly wherever he might find it, without giving way to imitation or slavish copying.

Correggio produced a number of independent pictures for private patrons with classical subject matter having strong sensual and even erotic overtones. The *Jupiter and Io* [362], one of four compositions depicting the loves of Jupiter, was apparently presented by the duke of Mantua, Federigo Gonzaga, to Emperor Charles V in Spain, and perhaps was completed by 1532. Jupiter satisfies his desire for Io, according to the Ovidian account, under the guise of a cloud. In the painting the beautiful face of the god and his right hand are being transformed from gray mist to flesh as he embraces the ecstatic woman. The pose of Io, seen from behind, with the magnificent left leg carrying the eye vertically, is related to one of Raphael's *Three Graces* from the Farnesina, although a classical source may be the common link. The softness of flesh juxtaposed with the white sheet, the pale cool colors that play against the warm tones of the nude body, and the delicious contours fit the subject matter. This winning image had repercussions in subsequent painting, but no one surpassed the luxurious sensuality achieved by Correggio.

Along with smaller religious pictures, altarpieces, and allegorical paintings, Correggio excelled as a decorator. He painted the so-called Camera di San Paolo, a private chamber in a convent, with an exclusively classical program [363, 364]. The *Three Graces* gives an idea of the originality of the handling. Painted as imitation marble, the figures, in the softness of their flesh and in the flickering, slightly warm light, produce a more lifelike quality than might be expected. The composition is not based on the more commonly used classical prototype that motivated Raphael's little picture of the same subject; Correggio's interpretation is more erotic.

The two monumental cycles for churches in Parma offer another scale and are purely religious in subject. The earlier [365], produced between 1520 and 1523 in San Giovanni Evangelista, includes sections of the transepts, the apse, and the dome, where the decoration culminates. St. John's vision of the ascension of Christ surrounded by the Apostles is a huge narrative that translates analogous subjects treated as wall decorations, like those by Raphael for the Vatican *stanze,* into a circular and concave surface. St. John, on the longitudinal axis of the church at the zone above the huge cornice of the dome, is barely visible. The Apostles form a dark ring in sharp foreshortening that surrounds Christ, His arms outstretched and surrounded by billowing clouds that are transformed into angels in a golden atmosphere which, in turn, functions like a lantern, producing illumination in the otherwise unlighted dome. The nude Apostles, especially, reveal a closer affinity to Michelangelo's figures than to Raphael's; they are muscular creatures who move languidly in the pale clouds, interspersed with youths supporting and assisting them. The drawing of the dignified forms, however, does not ally itself with either Raphael or Michelangelo, revealing instead a connection with Venetian avant-garde developments.

If the individual figures share features

363. Correggio. Ceiling of the Camera di San Paolo (partial view), Parma.

364. Correggio. Detail of 363.

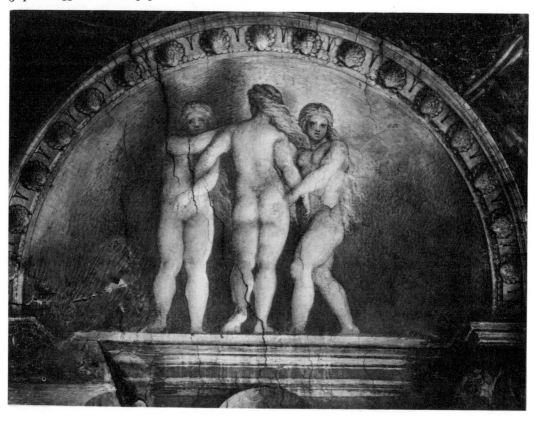

of the monumental current, Correggio under-stresses voluminousness as well as gravita-tional qualities in favor of a surface accentua-tion. The edge of a cloud and the undulating draperies vie with the poses and the move-ment of the figures. These frescoes, more than those in the subsequent cycle for the Cathe-dral of Parma, reveal Correggio's accommoda-tion of his own lyric inclinations to the Roman monumentality of Raphael and Michelangelo. Even the paired seated figures, Evangelists and Church Fathers for the pendentives, mon-umental in conception, are effectively flat-tened by means of elaborate draperies and ex-tensive still-life details; the mixed soft and pale colors de-emphasize the illusionism.

The cupola frescoes of the Cathedral (re-cently restored) are different in style and in effect, although they were produced within a matter of a few years from those at San Gio-vanni, and represent Correggio's middle pe-riod [366]. The contract for the Cathedral is dated 1522, and an ample share was painted by 1528 or 1529. Here, too, Christ is the center of the dome composition, although the spatial conception is more complex; the viewer is brought into an enormous funnel composed of whirling bodies leading the eye to a heavenly infinity. The scale and the proportions of the figures among themselves defy conventional visual rationality. In the zone of the drum, optically supported by squinches with gigantic painted saints, the Apostles stand on a painted cornice that hovers over a real one inter-spersed with circular windows. Above them are beautiful youths, nearly nude, as distinct from the heavily draped Apostles. A sea of figures, Old and New Testament personalities, encircle Christ in still another proportional scale. Mary is a principal participant who, as-cending to meet her Son, is supported by *putti*. The reading of the segments is not al-ways clear, and the color and light do not sim-plify it because, instead of accentuating the

form of the figures, Correggio stresses the vol-ume, the spatial implications, and the surface excitement. A shift in anatomical types may also be isolated, where exaggerations and elongations, along with difficult poses and foreshortenings, dominate, recalling Cor-reggio's follower Parmigianino.

These qualities of Correggio's art executed in the 1520s are readily studied in the *Ma-donna and Child with Sts. Jerome and Mary Magdalen* (*Il Giorno* ([367] probably cut down slightly on the sides and top), painted originally for a local church at the same time that he was working on the frescoes in the Cathedral. Considered his masterpiece among the altarpieces, the composition is built up as a remote variation of the pyramidal arrange-ments favored by Leonardo, broken by the dominating verticality of St. Jerome on the left. The *sacra conversazione* is transformed into an informal and incidental narrative that takes place in a landscape. A makeshift red canopy has been constructed in the fore-ground, where his figures are massed on a compact, constricted plane. Their poses are particularly hard to reconstruct because they are either figures covered by draperies that effectively hide their structure, or are in intri-cate unnatural positions. Even the partially nude Jerome is not easily read, with the sturdy right leg that appears disjointed from the trunk of his body. The pictorial effects derive from a masterly application of the oil paint, confident and elegant color, and idealized, refined faces.

In a fairly short lifetime Correggio left be-hind a large number of paintings and hun-dreds of square meters of frescoes. His resi-dence in the artistic backwaters of Emilia may have hampered the fullest flowering of his enormous gifts. Among the most attractive and inventive painters of the entire Renais-sance, Correggio had a strong influence on his immediate followers, like the eccentric Par-

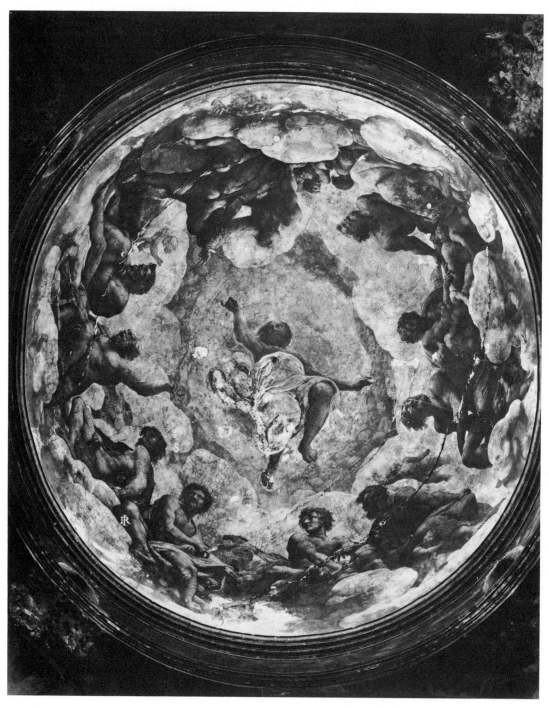

365. Correggio. *Vision of St. John,* 1520–23. Fresco, 940 × 875 cm. Parma, San Giovanni Evangelista, cupola.

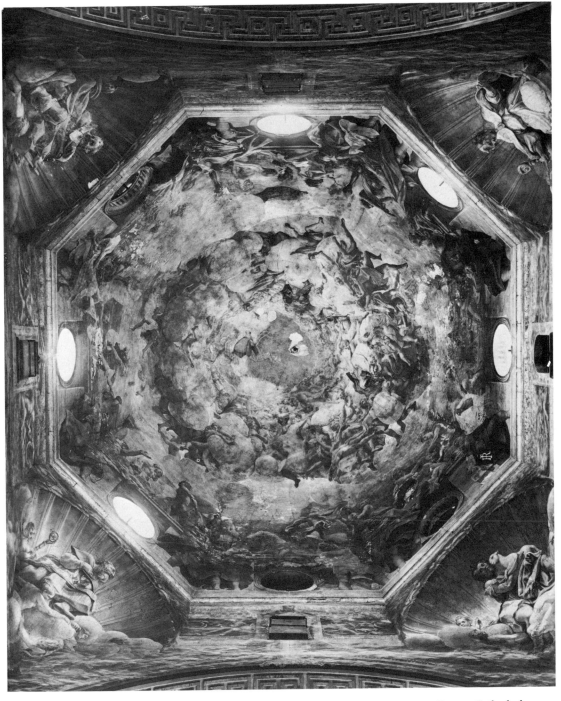

366. Correggio. *Assumption of the Virgin*, 1522–29(?). Fresco, 1093 × 1195 cm. Parma, Cathedral.

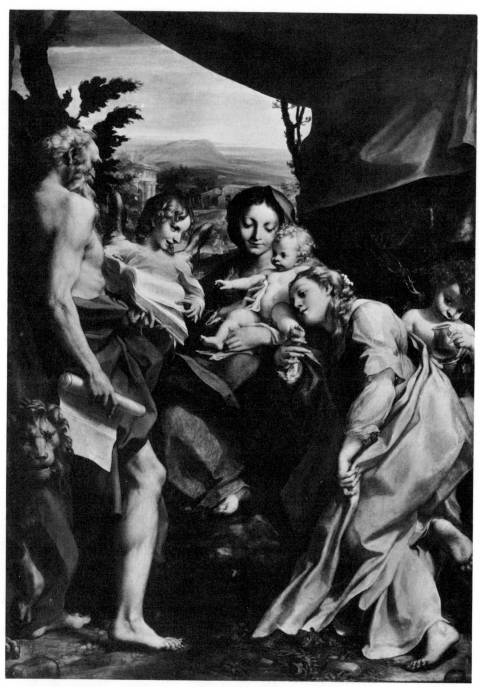

367. Correggio. *Madonna and Child with Sts. Jerome and Mary Magdalen (Il Giorno)*, ca. 1525–28. Wood panel, 205 × 141 cm. Parma, Pinacoteca.

migianino, and on the most distant ones, like Barocci and the Carracci from Bologna.

DOMENICO BECCAFUMI

Among the Sienese artists of the third generation, the most original was Domenico di Giacomo, known as Mecherino ("little Domenico") or more commonly as Domenico Beccafumi (ca. 1486–1551). Virtually nothing is known of his training, or of his birth date; he may have been self-taught. We can assume that he was fully aware of what was unfolding in nearby Florence during the period shortly after 1500, not to mention the particularly fascinating developments that were taking place in Siena itself. Among the older masters, Signorelli, Perugino, Pinturicchio, and possibly

the young Raphael were active there, or nearby; among his own contemporaries Michelangelo produced sculpture for the Piccolomini altar in the Cathedral. Vasari, who knew Beccafumi, described a trip to Rome, which perhaps took place between 1510 and 1512, where the Sienese painter might have seen not only Raphael's Stanza della Segnatura but the Sistine ceiling as well as his countryman Peruzzi's decorations in various Roman villas. Although unsubstantiated by documents, such a trip is quite possible and even likely judging from Beccafumi's pictures and from the fact that Rome lies less than two hundred miles south of Siena.

The earliest documented works by Beccafumi are for the Hospital of Santa Maria della Scala in Siena, comprising a triptych with

368. Domenico Beccafumi. *Meeting of Joachim and Anna at the Golden Gate*, 1514. Fresco. Siena, Hospital of Santa Maria della Scala.

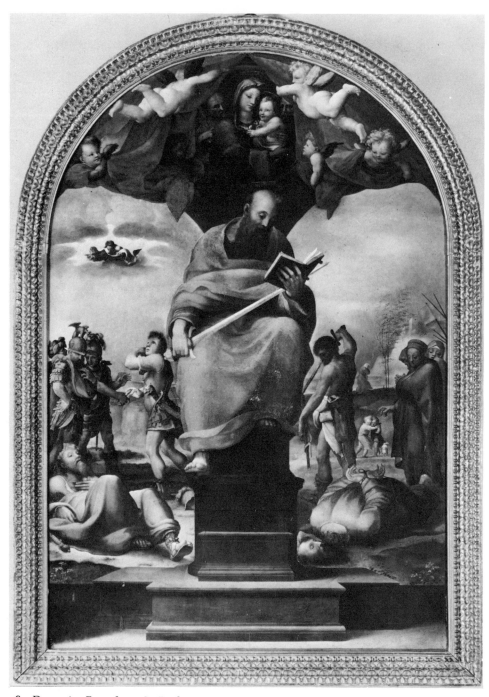

369. Domenico Beccafumi. *St. Paul*, ca. 1515. Wood panel, 190 × 150 cm. Siena, Museo dell'Opera del Duomo.

the *Trinity* [370], painted in 1513, and the *Meeting of Joachim and Anna at the Golden Gate* [368], a fresco finished in 1514 and still *in situ*. There is reason to believe that the *St. Paul* [369], made for the chapel connected with the Mercanzia, dates from 1515. Beccafumi was active designing pavement intarsia for the Cathedral beginning in 1519 and continued to supply drawings for the same extensive, indeed unparalleled, project until 1546. He is credited with introducing *chiaroscuro* effects into this kind of inlay, as well as the application of an analogous technique in wood-block printing. In 1529 he was commissioned to decorate the vault of the Sala del Concistoro in the Palazzo Pubblico, an assignment that dragged on until 1535 (repainted in the nineteenth century). The *Madonna and Saints* for the Confraternity of San Bernardino (Siena, Oratorio di San Bernardino) can be dated to 1537 on the basis of a payment document. Beccafumi was in Genoa at some point, apparently in the mid-1530s, and in Pisa from 1536 to 1541, where he executed various works including still extant Old Testament panels for the Cathedral. In 1544 he finished the frescoes in the apse of the Sienese Cathedral (much repainted), and he continued to work for that institution, producing eight angels cast in bronze and still attached to piers within the church.

A salient feature of Beccafumi's biography and artistic development was his decision to spend the bulk of his life in Siena with only relatively brief interruptions. If his painting shares impulses with Florentine contemporaries, including Albertinelli, Fra Bartolommeo, Rosso, and Pontormo, as well as the Roman works of Raphael and Michelangelo, Beccafumi remained always a provincial master who preferred to be the big fish (along with Sodoma) in the Sienese pond, rejecting more demanding challenges. (The same may be said of Pontormo, but the artistic condition of his "province" was richer, more varied, and had a more significant *quattrocento* pictorial tradition.) In Beccafumi we find a fluctuation in quality of execution as well as in invention and originality.

‡

Among the earliest documented works, the triptych with the central *Trinity* [370] and side panels containing the two St. Johns and Sts. Cosmas and Damian is not an altogether appealing ensemble; the ponderous side figures are in a different scale from the strongly axial *Trinity*. Nonetheless, it is here, and in the poorly preserved lunette fresco, *Meeting of Joachim and Anna at the Golden Gate* [368], that clues for understanding the stylistic origins of the master need be sought, bearing in mind Vasari's remark that Beccafumi was particularly taken with Perugino, who had two important commissions in Siena during the first decade of the *cinquecento*. In the *Trinity* the small faces of Christ and God the Father with their sweetened expressions evoke Perugino. There are also reverberations of Signorelli, who left important work in Siena at Sant'Agostino and in the Sienese territory at Monte Oliveto. The exaggerated anatomy of John the Baptist particularly recalls Signorelli. Although Beccafumi may have been as old as twenty-seven in 1513, he could have been somewhat younger (or older), since his birth date is only assumed, on the basis of conflicting evidence, to have been 1486. On the other hand, his painting of 1513 does not yet show a fully evolved personal style.

The *Stigmatization of St. Catherine of Siena* [371] is the finest example of his early achievement in which a full treatment of the expressive elements is combined with high technical mastery. An ingenious combination of a *sacra conversazione* and a narrative, it is usually dated around 1515 but quite possibly was made a little later. Beccafumi follows a spatial sys-

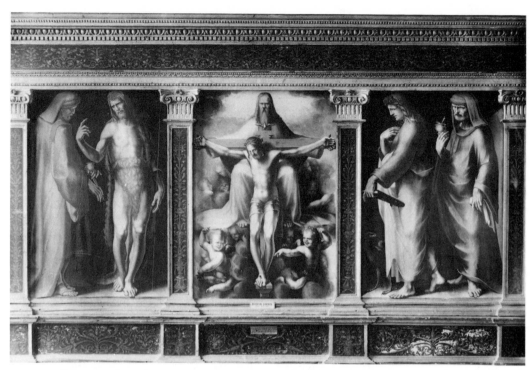

370. Domenico Beccafumi. *Trinity*, 1513. Wood panel, 152 × 228 cm. Siena, Pinacoteca.

tem often employed by Perugino and picked up by Florentines after 1500, with the open architecture set in front of a landscape with a distant low horizon; the floor is perspectively articulated. Above, in a cloud bank supported by *putti* and flying angels, is a half-length Madonna and Child. In this axial and balanced picture, painted in a closely modulated, detailed manner, the principal action unfolds in the middle ground beneath a domed vault and framed by an arch. St. Catherine, dressed in a pale habit, is on one knee before an under-life-size wooden crucifix, and she receives the wounds of the Crucifixion in much the same pose as does St. Francis, who is frequently represented in painting undergoing the same experience. The light, more than any other single element, threatens the visual logic, emanating from several unspecified sources

outside the painting. The attitude toward rendering anatomy, gravity, and weight, together with the treatment of the crackling surfaces of the draperies, clearly place Beccafumi in harmony with the lyric current as manifested by third generation painters, notwithstanding a somewhat monumental conception of St. Jerome on the right. Beccafumi's natural inclinations appear to oscillate, and in the Pisa panels of perhaps twenty years later he tends toward more monumental figures, although the overall style still remains within the lyric current.

In *Moses and the Golden Calf* of 1536–37 [372] the cramped, spatially compressed composition recalls Rosso. Individual figures, like the academic, sharply foreshortened, nude on the bottom left, or the active child in the center (ultimately a Raphaelesque invention) and

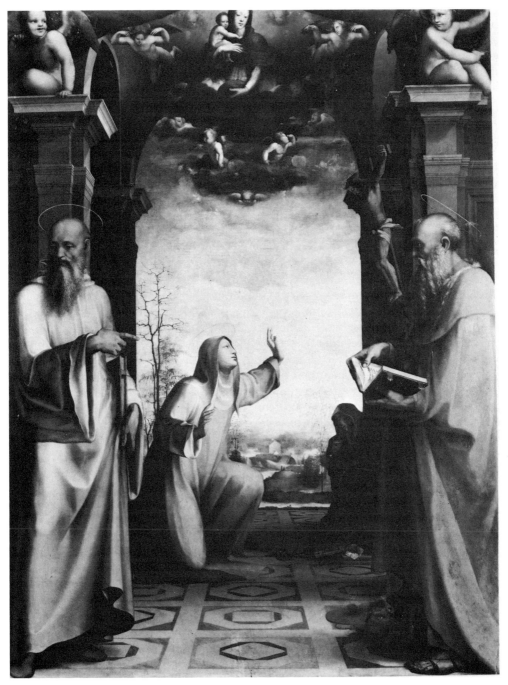

371. Domenico Beccafumi. *Stigmatization of St. Catherine of Siena*, ca. 1515. Wood panel, 208 × 156 cm. Siena, Pinacoteca.

the large seated woman who dominates the right side, although reminiscent of Florentine painting, also retain a sweetness of expression and delicacy of form that conform to the lyric Sienese painting of the previous century. Moses, to whom all of the other figures address their glances, is in a mannered, exaggerated *contrapposto* that serves to de-emphasize volume in favor of the silhouette; the potential drama of the subject is enhanced, but the result at the same time is idiosyncratic, as if Beccafumi had painted a series of marvelous individual details, independently and differently illuminated. When read singly and in conjunction with the delicately mixed pale tones, they provide a personal statement within the context of clearly discernible sources.

Once unified into the rectangle of a single tableau, the work remains oddly removed from the mainstream. Beccafumi repeats the dainty head of the woman in the foreground in a similar one behind her, and other types are also re-used. He rejects a precise, consistent scale: the angry Moses, ready to throw down the second tablet, overpowers in scale the secondary figures on the same plane, including the presumed self-portrait of the artist in profile next to the golden calf. The brazen idol, more like a miniature live calf than sculpture, is unexpectedly small in relation to the figures, thereby creating an uneasiness for the spectator. And if the effect of the whole is that of a noncomposition, the surface qualities, the virtuosity of application, the freshly painted passages of flesh, drapery, hair, and gold show Beccafumi at his best.

A picture described at some length by Vasari, and probably painted in the 1540s, is the *Fall of the Rebellious Angels* (first version [373]), which was painted at least after Michelangelo's *Last Judgment* [289], since there are paraphrases of it here. Furthermore, Michelangelo's Haman from the Sistine ceiling, or perhaps the drawing for it (London, British

Museum), is the basis for the male nude running frantically toward the spectator and away from Hell's fire. According to Vasari, who had harsh words for the picture, it was unfinished, and one might even guess that the painter was unable to resolve the compositional and spatial complexities he had created for himself, so that while the individual figures retain their power the overall effect is chaotic. Beccafumi actually delivered to the Carmine church in Siena another version of this theme, more readable but more banal, and less exciting.

ROSSO FIORENTINO

Giovanbattista di Jacopo, called il Rosso Fiorentino (1495–1540) because of his hair ("the red-headed Florentine"), was, according to Vasari, in addition to being handsome, an excellent musician and skilled in philosophy. Among the most original painters of his generation, Rosso does not appear to have been trained exclusively by one or another master in Florence; perhaps he moved about from shop to shop. The first fact we have is that Rosso became a member of the painters' guild in 1517, and in the same year he was commissioned to fresco an *Assumption of the Virgin* for the Santissima Annunziata [374], in the atrium where Pontormo and Andrea del Sarto had also painted. Four years later (1521) Rosso signed and dated his masterpiece, the large *Deposition from the Cross* made for the Cappella della Croce di Giorno in San Francesco in Volterra [375], which was moved to the Cathedral and is now in the local Pinacoteca.

Several other signed pictures have been preserved from these years when he was working in Florence; in 1524 he went to Rome and painted frescoes for the Cesi Chapel in Santa Maria della Pace. He remained in Rome, where he also supplied drawings for engravings, until 1527. Following the Sack, at which time he was manhandled, Rosso fled to

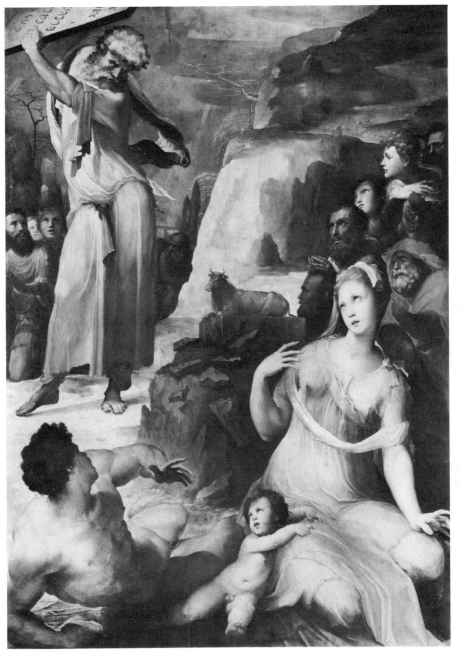

372. Domenico Beccafumi. *Moses and the Golden Calf*, 1536–37. Wood panel, 197 × 139 cm. Pisa, Cathedral.

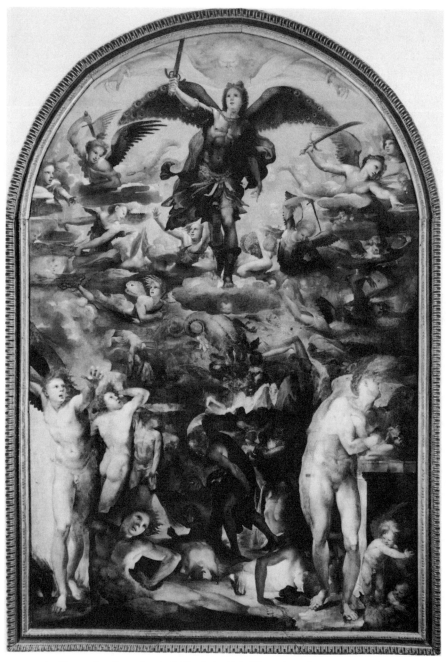

373. Domenico Beccafumi. *Fall of the Rebellious Angels*, 1540s. Wood panel, 347 × 224 cm. Siena, Pinacoteca.

Perugia and then to Borgo San Sepolcro. In Umbria Rosso was commissioned to paint the *Risen Christ* for the Cathedral of Città di Castello, a work that he finished only in 1530. In that year the painter left central Italy for Venice and soon settled in France, where he was patronized by King Francis I, on whose payroll his name appears under the year 1532. He became master of the stucco and painted decorations of the palace at Fontainebleau and was given a benefice in Paris, where he died five years later, still in the prime of life, rich, famous, and influential.

⁜

Like the other contemporary frescoes at the Santissima Annunziata, the *Assumption of the Virgin* [374] is in poor condition, and Rosso's picture can be deciphered only with difficulty. The figures, their internal proportions, and the treatment of the drapery recall Fra Bartolommeo most of all; at this point Rosso does not seem to have attained a fully liberated personal and identifiable manner. He was also beguiled by Andrea del Sarto's style, and thus he is clinging here to the monumentality of his older contemporaries that proved to be unnatural and ultimately uncharacteristic.

By the time he designed the *Deposition from the Cross* of 1521 for Volterra, Rosso's idiom had become thoroughly individual and even odd, and his lyric instincts were given free rein [375]. The *Deposition* has its closest connection to one of the same subjects produced in a curious collaboration by two leading lyric masters of the previous generation. The *Deposition* (Florence, Accademia), begun by Filippino Lippi and finished after his death by Perugino, predates Rosso's by nearly two decades. Rosso also arranged his characters

374. Rosso Fiorentino. *Assumption of the Virgin*, 1517. Fresco, 385 × 395 cm. Florence, Santissima Annunziata.

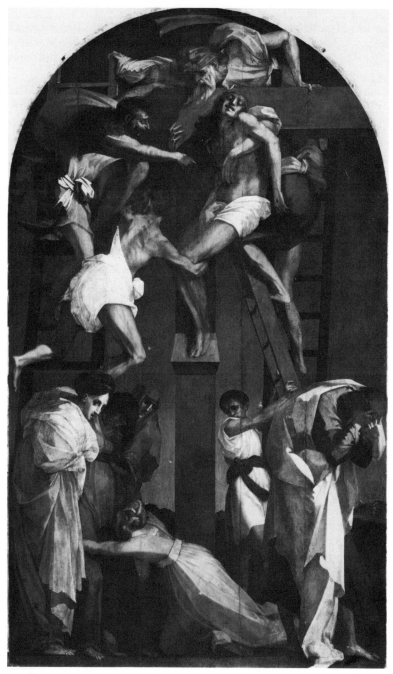

375. Rosso Fiorentino. *Deposition from the Cross*, 1521. Wood panel, 333 × 196 cm. Volterra, Pinacoteca.

376. Rosso Fiorentino. Detail of 375.

tion to its physical integrity. A word should be said about the remarkable quality of the paint, which was vigorously stroked onto the smooth wood surface with controlled brushwork that retains its identity while describing the forms [376].

The composition of the *Deposition* is dictated by the actual form of the *pala:* the arrangement of the figures who begin to lower the dead Christ from the Cross continues the movement of the arcuated top. The horizontal bar of the Cross acts to introduce the curved section and calibrate the vertical thrusts of the Cross and the three ladders. The spatial and visual ambiguities must have been sought consciously, and they are an important component of Rosso's formal expression.

The signed and dated *Dei Altarpiece* of 1522 [377], originally painted for the Dei family chapel in Santo Spirito, has been enlarged since Rosso's day, altering the composition beyond recognition. The elaborated flat architecture above the Madonna and Child with the ten accompanying saints is not part of the original; neither are additions on the sides and at the bottom. Rosso depends more on modeling to establish the figures, and he creates a more dramatic interaction between darker zones and flickering lights than in the previous examples. The figures remain elongated; they have smallish heads on massive draped bodies, except for St. Sebastian and the Christ Child. Rosso offers no psychological insight into their personalities or how they interact with their companions: they are unique, single images, each a whole unto himself. At this time Rosso must have been aware of forms and figural solutions by Michelangelo, who was active on the Medici tombs and on other Florentine projects in these years. The St. Sebastian has an air common to Michelangelo's *Bacchus* (then in Rome, however) but even more to his bronze *David* (lost but known through a drawing, Paris, Louvre). An even clearer borrowing can

calligraphically; they are laid out almost directly on the picture surface, eliminating any implication of convincing space. He substitutes expressive poses and gestures for volume, emphasizing the emotional content with thoroughly abstract, unnaturalistic color. Decorum in the vocabulary of Leonardo or Raphael is displaced by an exterior frenzy, and anything approaching a measured modular system has disappeared so that the scale and size perform a different function from that in, say, the *School of Athens*. Arms and legs are difficult to associate with the bodies they belong to, and single figures and groups are connected unpredictably. The drapery, painted with strong tones, is carefully and quite specifically rendered with a certain dryness and structurally has little to do with the figure to which it pertains, even operating in opposi-

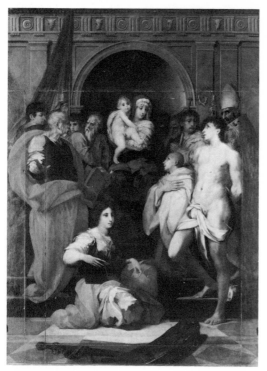

377. Rosso Fiorentino. *Dei Altarpiece,* 1522. Wood panel, 350 × 259 cm. Florence, San Lorenzo.

be signaled, one which refers back to Rosso's presumed origins: the saint kneeling beneath the Madonna on the right is unmistakably based on Fra Bartolommeo's St. Bernard from his *Vision of St. Bernard* [265].

A third picture from the Florentine years is the *Marriage of the Virgin* [378], dated 1523 and still in the Church of San Lorenzo. In manner it is close to the *Dei Altarpiece,* whose St. Catherine, seated in front of the enthroned Mary, reappears as a type in the seated old St. Anne, hands clasped in prayer, and her opposite, the young St. Apollonia, holding an open book; her transparent garment unexpectedly exposes the torso. The main action takes place on a platform up a set of steps, where the handsome bride and bridegroom, whose

heads are in profile, are being married by the priest. Painted with intense blond tonalities, the beardless Joseph is as youthful as Mary, contrary to traditional representations or, for that matter, Biblical tradition. There are frequent passages of exceptional virtuosity, as in the magnificent hair of Joseph or that of the disappointed suitor next to him. Rosso has moved, probably more than any other painter of his generation, to a deep, erratic individualization of the world he painted, with an anticonventional treatment of the human figure, of entire compositions, and of surface handling and color. He left Florence soon after the *Marriage of the Virgin* was painted, never to return, as if his explorations into a personal manner within the local usages of Florence had been exhausted.

The Roman experience, from 1524 to 1527, brought Rosso headlong into a difficult set of conditions that apparently threw his treatment of images into turmoil. Michelangelo's Sistine ceiling had a profound but negative effect upon Rosso, who sought to monumentalize his images in the Cesi Chapel frescoes. The heavy forms depicting the *Creation of Eve* [379] are specifically related to Michelangelesque prototypes from the ceiling, but they are not taken from the same subject (which Rosso could have done directly had he chosen to do so). Rosso also unmasks an awareness of another wave of Roman painting that had a basically monumental cast—the work of painters trained in Raphael's shop. Judging from the Cesi frescoes, which are the only works that can be securely associated with Rosso's Roman sojourn, the impact of Roman painting was not beneficial.

After leaving Rome, Rosso executed his last major Italian commission, the *Risen Christ* [380], sometimes (inaccurately) called the *Transfiguration,* in which he liberated himself from the weight of Michelangelo's presence, although the incongruously muscular child re-

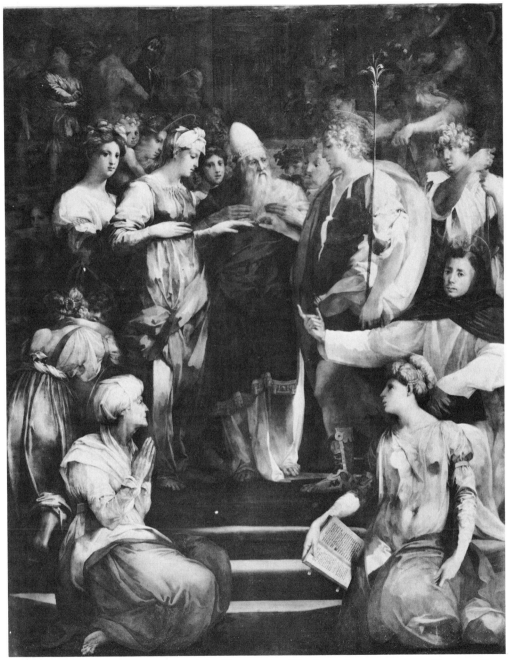

378. Rosso Fiorentino. *Marriage of the Virgin*, 1523. Wood panel, 325 × 150 cm. Florence, San Lorenzo.

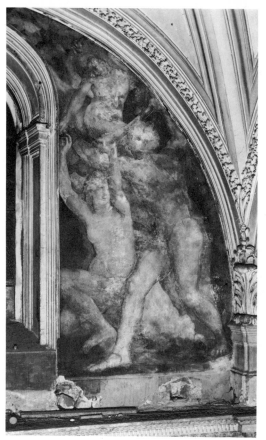

379. Rosso Fiorentino. *Creation of Eve*, 1524–27. Fresco. Rome, Santa Maria della Pace, Cesi Chapel.

Rosso's activity in France, centered in decorations for the royal palace at Fontainebleau, has not survived in sufficient quality and state of preservation to offer comprehensive judgment about his last decade. The Gallery of Francis I, where stories from the *Iliad*, the *Odyssey*, and from Ovid's *Metamorphoses* are used to allegorize the life of the French monarch, has been variously restored and the frescoes heavily repainted. Nor is his exact share in the stuccoes in the same palace known, although it is usually assumed that Rosso was in charge of their original design. It may be symptomatic of French art or merely a turn of fortune that allowed Rosso, who was something of a failure in Rome, to have great success in France. However, since his contributions in France fall outside of Italian art, they will not be discussed here.

JACOPO PONTORMO

Jacopo Carucci, known as Pontormo (1495–1557), from the village outside Florence where he was born, was one of the most original nonconformist painters of the Renaissance. After an apprenticeship, possibly with Piero di Cosimo as well as Albertinelli, at least according to Vasari, he is documented together with Rosso as a collaborator on the predella of Andrea del Sarto's *Annunciation* (Florence, Pitti Palace) of 1512. His art, like Rosso's, often seen as an aberration of the "pure" classical style of Michelangelo and Raphael, slipped into relative oblivion after his death but in more recent times has witnessed a favorable re-evaluation. However categorized, as an early Mannerist or a lyric third generation painter, Pontormo offers the modern viewer a deeply personal, eccentric, yet refined art based on skillful draftsmanship, the cultivated sensibilities of a unique colorist, and an imaginative feeling for form.

Temporary festival decorations for the Medici and other patrons were produced be-

calls him or, perhaps, Giulio Romano. The intensity of a personalized religiosity, aggravated by his experiences during the Sack of Rome, is expressed in a heightened mysticism and complexity. Only the isolated Christ, figuratively reminiscent of Pontormo, is easily read. The picture, trimmed on all four corners to create an imbalanced octagon, still maintains a centrality of composition. Action occurs on or close to the surface, and if certain figures recall Raphael directly, they have become ethereal apparitions.

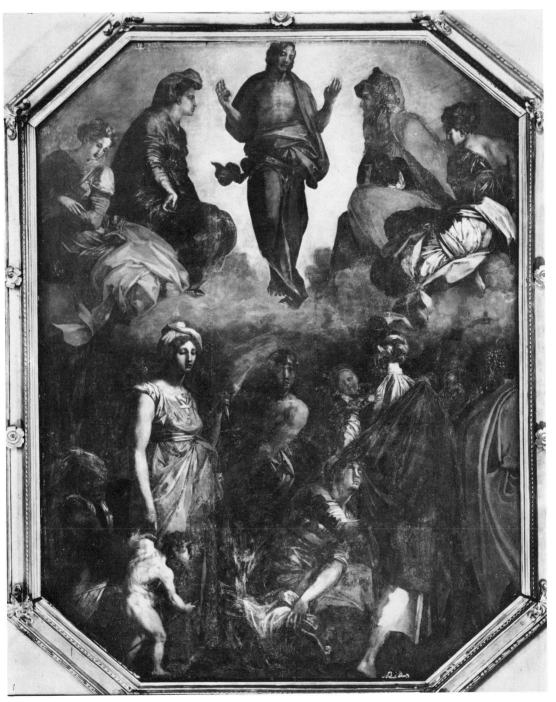

380. Rosso Fiorentino. *Risen Christ*, 1528–30. Wood panel, 348 × 258 cm. Città di Castello, Cathedral.

381. Jacopo Pontormo. *Visitation,* 1514–16. Fresco, 392 × 337 cm. Florence, Santissima Annunziata.

tween 1513 and 1515, comprising his earliest recorded works. The fresco depicting the *Visitation* for the Santissima Annunziata [381], documented between 1514 and 1516, is still visible there, in the atrium. The *Pucci Altarpiece* in San Michele Visdomini is dated 1518 [383]. Shortly afterward, between 1519 and 1521, Pontormo painted the *Vertumnus and Pomona* in fresco for the Medici country villa at Poggio a Caiano [384]. Two years later he was active on a fresco cycle for the Certosa at Galluzzo, near Florence, where he continued to work for the next several years. He dated a *Supper at Emmaus* (Florence, Uffizi) in 1525, the same year his name first appears in the Confraternity of St. Luke. Between 1527 and 1530 Pontormo made the *Madonna and Child with St. Anne and Other Saints* at the behest of the Florentine Signoria [390], partly overlapping work in the Capponi Chapel in Santa Felicita. In the following decade Pontormo was frequently employed by the Medici, and from 1546 until

his death on the first or second day of 1557, that is, for nearly eleven years, he worked on but failed to complete the choir frescoes for San Lorenzo (destroyed). It is noteworthy that Pontormo is not known to have traveled much and did not paint in Rome, as nearly all of his important contemporaries had done.

※

The *Visitation* in the courtyard of the Annunziata is the best example on a large scale of Pontormo's style immediately before achieving a fully evolved personal manner [381]. The detached fresco, begun when he was under twenty, is conceived like an altarpiece and echoes ideas set forth by Fra Bartolommeo and Andrea del Sarto [382], who were his first models. The action takes place in front of a curved exedra, showing Pontormo as close to the monumental idiom of his teachers and exemplars as he ever gets, in a situation closely parallel to Rosso's. In fact, the artist appears

382. Andrea del Sarto. *Visitation*, 1512. Wood panel, 181.5 × 181.5 cm. Florence, Pitti Palace.

383. Jacopo Pontormo. *Pucci Altarpiece*, 1518. Paper (transferred), 214 × 185 cm. Florence, San Michele Visdomini.

somewhat uncomfortable in what was in effect a competition with his successful older contemporaries. He demonstrates an awareness of the Stanza della Segnatura especially in the seated nude youth, who is like Raphael's Diogenes in the *School of Athens*. Pontormo's figure counterbalances the introspective woman leaning backward on the steps, whose structure shows a consciousness of types like Michelangelo's Eve from the *Fall* on the Sistine ceiling, connections that suggest an undocumented youthful trip to Rome.

Although Andrea del Sarto and Raphael had made an impression on the younger artist, his own more thoroughly independent style becomes apparent without disguise in the *Pucci Altarpiece* of 1518 [383]. Here we see a general flattening of the entire visual stage and even the figures, which was only a latent quality of the *Visitation*. Spatial implications

are now severely reduced, with all the figures packed into a shallow plane near the surface. The figural poses are easily read only in the silhouette, as with the young St. John the Baptist, a popular subject in Florentine pictures. The complex *contrapposto* of his placement creates a jagged zigzag played off the central axis, which is enhanced by a staff held by the infant Christ. Mary's seated position is also strongly contrapuntal as she gradually turns to the left from facing right, revealing a Leonardesque device carried to the edge of incomprehensibility. This painting, darkened over the centuries and obscured by old restorations and repaintings, now has little of the glowing qualities attributed to it by Vasari.

Pontormo shared with Andrea del Sarto and Franciabigio the commission for fresco decorations of the Medici villa at Poggio a Caiano, but only a portion of the work was ever done.

Pontormo's fresco in a large lunette, interrupted by a real circular window, was identified as *Vertumnus and Pomona* by Vasari [384]. The pastoral subject matter is fitting to the villa, and shows a small number of country people of all ages relaxing in nature, recalling poems by Lorenzo de' Medici, who had ordered the building of the villa. Many of the individual elements are treated with a keen naturalism, perhaps best exemplified by the sharply foreshortened dog on the left or the old man next to it. But instead of a cohesive space, the figures and the scrap of landscape float on the surface, and the modeling of individual figures, like the nude boys, has an abstract function and does not merely define form.

The frescoes in the Florentine Certosa (Galluzzo) illustrating scenes from the Passion are poorly preserved as the result of weathering in the courtyard for which they were painted. What is left reveals that Pontormo has increased the elongation of his figures, with the proportions of the head to the body of one to ten or even greater, a far cry from the seven to one ratio used by painters from Masaccio onward. Because of their condition it is not fruitful to examine the stylistic characteristics of these frescoes in detail, although Vasari's negative evaluation, in which he alludes disparagingly to the strong dependence on Dürer's prints, seems to be quite unjust. And if Pontormo depended on such sources, he had to transform them in size, scale, and medium, and, of course, he had to interject color. One is on firm ground when regarding the frescoes at the Certosa, done about 1523–25, as exceptionally original and magically personal. In

384. Jacopo Pontormo. *Vertumnus and Pomona*, 1519–21. Fresco, 461 × 990 cm. Poggio a Caiano, Villa Medici.

385. Jacopo Pontormo. *Christ Before Pilate,* ca. 1523–25. Fresco, 300 × 290 cm. Galluzzo, Certosa.

Christ Before Pilate [385], the distorted and truncated figures imply the impending Crucifixion. Christ in profile in the center, isolated from the crowded zones on either side, is more iconic than dramatic. He is awkwardly and irreverently tied by a stout cord, but, like Michelangelo's *Bound Slave* (Paris, Louvre), does not struggle.

For an appraisal of Pontormo's explicit mature style we should turn to the excellently preserved works in the Capponi (ex-Barbadori) Chapel in Santa Felicita, designed by Brunelleschi a century before. Pontormo, around 1525, began painting the *Deposition* for the altar [386, 387], still *in situ,* as well as the frescoes in the *cupoletta* or small dome (lost but known through drawings) and an *Annunciation* on a side wall [388, 389]. The *Deposition* is Pontormo's finest work, one of the supreme inventions of the entire Renaissance, and as if to underscore his authorship, his self-portrait on the extreme right commands our attention. Vasari describes the picture as representing the dead Christ taken from the Cross and being carried to burial. It has much in common both thematically and pictorially with Raphael's *Entombment,* which was then in Perugia [326]. Painted nearly twenty years later, Pontormo's picture appears as a vertically oriented interpretation of Raphael's horizontal picture, with the two subjects, the carrying of the body and the swooning Maries, combined. The elements of a Lamentation or Pietà, with the Virgin and the other Maries set into a second zone parallel to the base, and spatially a second plane, are behind those of an Entombment, composed of Christ and His two supporters. This exceptional work is intricate and subtle, with features that are sometimes bewildering. Suffice it to observe that there is no sign at all of the Cross in the picture. Vasari perceptively refers to Pontormo as that "brain" which is always investigating new concepts and extrav-

agant ways of proceeding, never content and never stopping his search.

Provision should be made—as is true of all painters, but especially Pontormo—for his extreme individualism, the personal quotient within the context of any broader and arbitrary ordering of the period. And with Pontormo the expressive aspects form such a dominant portion of his art that one is sometimes tempted to underestimate his connections with the style of contemporaries. The proportions of his figures, his relative disinterest in the effects of gravity and weight distribution, the emphasis on the edges and the resulting excitement of the silhouette, and the abstract anti-naturalistic but glowing color make his art a worthy extension of the language of Botticelli and Filippino Lippi, lyric masters of the previous generation. Within this context, the expression of individual figures and entire compositions also reflects his well-documented secretive eccentricities. His strange house was provided with a trap door so that Pontormo could pull up the mobile stairs without fear of unannounced or unwanted visitors.

The *Deposition* can be regarded as deeply personal on various levels. Pontormo has avoided the standard device used to imply three-dimensional, volumetric form: *chiaroscuro* modeling. Instead he depends (like Botticelli in the *Birth of Venus*) almost exclusively on precise outlining of the figures and a few internal details; the bodies are consequently unphysical, yet they fill most of the pictorial surface and demand uncompromised attention. Light and dark variations in the overall design are also reduced, and only on the ground level are some deep tonalities provided, the rest of the picture being dominated by those infectious pale tones, representing either flesh or drapery indiscriminately.

If in all his works little implication of atmospheric qualities in the space between the spectator and the image or in the distance is

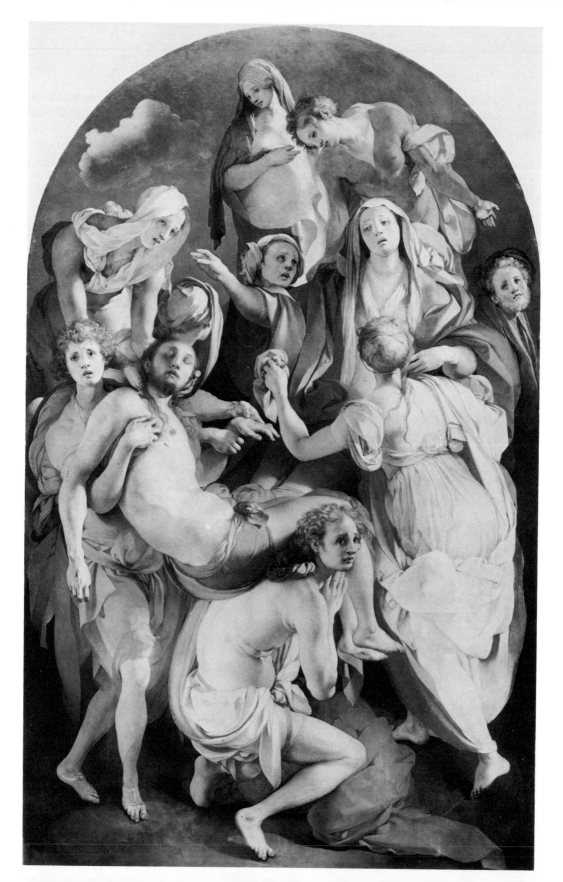

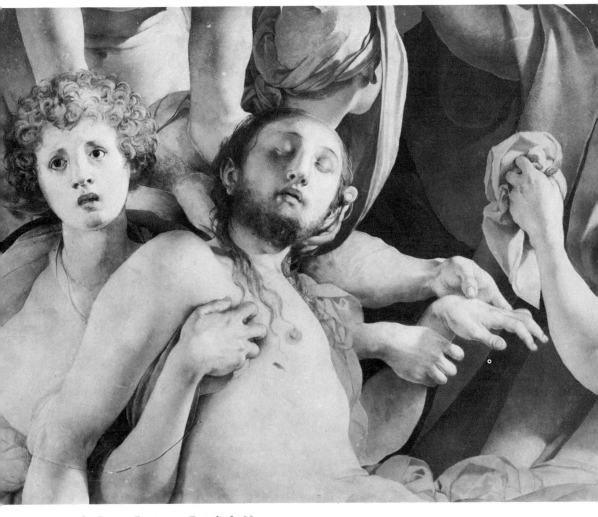

387. Jacopo Pontormo. Detail of 386.

386. Jacopo Pontormo. *Deposition,* ca. 1525. Wood panel, 313 × 192 cm. Florence, Santa Felicita, Capponi Chapel.

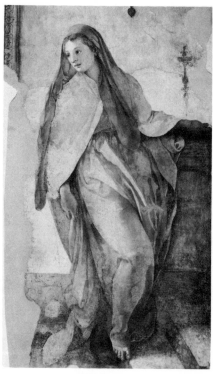

388. Jacopo Pontormo. Gabriel from the *Annuncia-tion*, ca. 1525. Fresco, 368 × 168 cm. (whole). Flo-rence, Santa Felicita, Capponi Chapel.

389. Jacopo Pontormo. Virgin Annunciate from the *Annunciation*, ca. 1525. Fresco, 368 × 168 cm. (whole). Florence, Santa Felicita, Capponi Chapel.

created, in the *Deposition* the scene is painted with relentless brightness, unchallenged by darks and completely uncompromised by soft-ening, quite the opposite solution to that of Leonardo or of Giorgione, but no less evoca-tive. The composition moves around a central axis that begins beside the exquisite foot of the crouching figure, who bears Christ's legs, and continues upward to the female figure at the top of the picture. Two lesser axes are parallel to the main one, passing through Christ's head on the left and Mary's on the right, providing a vertical counterpoint that ultimately leads out of the painting altogether to the fresco that once showed God the Father in the little dome of the chapel. A circular motion follow-ing the curved top involves nearly all the figures.

In order to appreciate the spatial complica-tions, with the three compressed planes neatly reinforced by the placement of the heads, the viewer must mentally reconstruct the nature of the terrain implied in the *Deposition*. Pon-tormo has arranged the participants on a rather sharply rising hill (Calvary?) much as a group portrait might be set up, in rows, each one slightly higher than the previous one. The changes in scale, the shifting poses, and the apparent instability of the figures are in this way at least partially explained. The porcelain color adds to the shocking effects of the total conception, but it too responds to Michelan-gelo's usage in the Sistine ceiling frescoes, al-though here it is made paler, more luminous, with mixed, thinned-out off-colors that hark back to late Gothic painting.

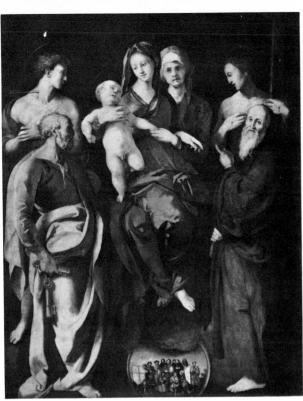

390. Jacopo Pontormo. *Madonna and Child with St. Anne and Other Saints,* ca. 1529. Wood panel, 228 × 176 cm. Paris, Louvre.

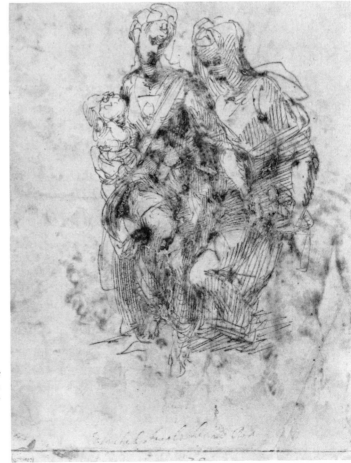

391. Michelangelo. *St. Anne with the Virgin and the Christ Child,* ca. 1505. Pen, 25.4 × 17.7 cm. Oxford, Ashmolean Museum.

The *Madonna and Child with St. Anne and Other Saints* [390] is probably datable to 1529, to a moment immediately following the completion of the decorations in Santa Felicita and before the final downfall of the popular government in Florence. Painted for a local church that no longer exists, the commission of the republican subject celebrating the expulsion of the duke of Athens in 1343 on St. Anne's day came from the government, whose members are actually represented within a disk at the bottom of the picture. The compositional challenge of arranging Anne, Mary, and the infant Jesus together had already occupied Masaccio and his predecessors in the fourteenth century, but also had more recently been taken up by Leonardo and Michelangelo, to whom Pontormo's solution comes the closest (see the drawing by Michelangelo [391]). Pontormo knew Michelangelo, who was in Florence at this time and who was a notorious anti-Medician partisan, and quotations and paraphrases from the older master can be traced from his earliest works. Pontormo elects to place the head of Mary on the same level as that of her mother, upon whose lap she sits, and, reading across the same zone, one also finds truncated images of St. Sebastian on the left and St. Philip (or the good thief?) on the right. Below, the fully articulated but heavily draped Sts. Peter and Benedict are silhouetted against the nude saints. It is typical of Jacopo's personal eccentricities that no more than one foot of any of the seven figures can be detected, which completely undermines the comprehensibility of their poses. Thus, once the rather monumentally conceived foreground figures have been formulated, they are flattened, the volume denied, and the distribution of weights completely concealed. The color is heavier than in the *Deposition* but not naturalistic, and the modeling is independent of the forms.

The small *Martyrdom of St. Maurice and the Theban Legion,* called by Vasari and some modern critics the *Eleven Thousand Martyrs* [392], contains quotations not only from Michelangelo's more recent productions (for example, the Medici tombs) but also harks back to the *Battle of Cascina* [273]. An overall bright tonality has been maintained in this picture, perhaps painted around 1531 as a study for a fresco. The Roman emperor's pose, with his muscular arm and distinctive gesture, is related to Michelangelo's statue of Giuliano de' Medici and to God the Father in the *Creation of Adam* from the Sistine ceiling [283]. He is on a raised platform on the plane nearest the viewer, while the nude figures below and to the left are much smaller, although on the same plane. But since they are nevertheless more distant, they are appropriately diminished. The terrain rises in the middle distance after a steep drop immediately behind the platform, where a battle unfolds, containing a direct borrowing from Michelangelo, once again from the *Battle of Cascina* cartoon, combined here with reflections from Leonardo's counterpart, the *Battle of Anghiari* [252].

At the very center of the panel is a drummer boy who also plays a flute with his left hand, while in the background on the left is a scene of baptism with angelic *putti* overhead, and on the other side crucified soldiers. The arbitrariness of the landscape and of the lighting are enhanced by the near absence of atmospheric effects. Pontormo seems to have taken this opportunity to treat the nude, mostly lean young men, in a variety of poses that demonstrate his controlled skill in figural draftsmanship. If dependent upon both Leonardo and Michelangelo for certain types and poses, Jacopo owes little to a direct study or contemplation of Roman art. Even when illustrating a purely ancient subject like the *Three Graces,* known from a magnificent drawing of about 1535 [393], his expression is entirely unclassi-

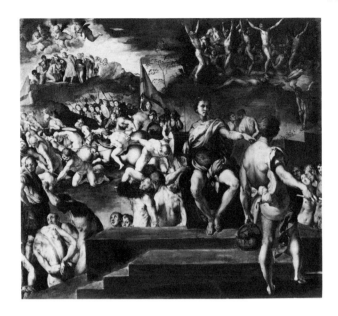

392. Jacopo Pontormo. *Martyrdom of St. Maurice and the Theban Legion*, ca. 1531. Wood panel, 65 × 73 cm. Florence, Pitti Palace.

cal as his forms are independent of direct classical prototypes.

Pontormo worked for Duke Cosimo de' Medici, decorating the choir of San Lorenzo, which was finished by his former pupil Angelo Bronzino after Pontormo's death. The entire cycle was covered over in the mid-eighteenth century, although a sensible reconstruction can be made of the original arrangement and some of the figural compositions by means of old engravings and Pontormo's preparatory drawings. From the drawings we see an increased preoccupation with Michelangelo; the Old Testament subjects for San Lorenzo parallel those of the Sistine ceiling. If Vasari's description is valid, Pontormo's frescoes were ultimately unintelligible, both thematically and artistically. The figures were without measurable proportions, the torsos being mostly large, and the legs, arms, and heads exceedingly small.

Although we are almost exclusively dependent on Vasari's account and modern attributions for Pontormo's portraiture, it is known to have been an important aspect of his art, and

he seems to have done many portraits. Based on a profile medal, the *Cosimo il Vecchio* [394] appears to date to the time of the *Pucci Altarpiece*, with dark tones and internal modeling in the face. The physical structure of the body is minimized. The highly refined *Portrait of a Halberdier* of about 1530 [395] is from the period of the *Madonna and Child with St. Anne*. Pontormo here shows an interest in the surface textures, the "feel" of material and objects, as well as a controlled use of light, and, most important of all, an insight into the essence of this sensitive youth. The small round face is dominated by the accentuated dark eyes set deeply into the oval sockets, rather close together, a common feature found in Pontormo's heads, painted or drawn.

As confirmed by such fine portraits as these, Pontormo was a rare painter and a rare mind; his sensibilities run counter to the more accessible art of Raphael, Michelangelo, and Titian, but his pictures are haunting images, and his drawings are among the best of the Renaissance. In the final analysis, his art is inseparable from what began during the first genera-

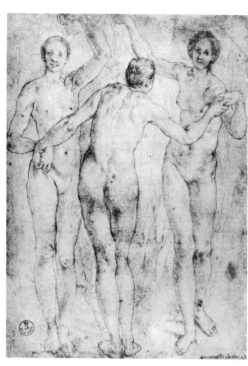

393. Jacopo Pontormo. *Three Graces,* ca. 1535. Sanguine, 49.5 × 21.3 cm. Florence, Uffizi.

395. Jacopo Pontormo. *Portrait of a Halberdier,* ca. 1530. Wood panel, 92 × 72 cm. New York, Chauncey Stillman Collection.

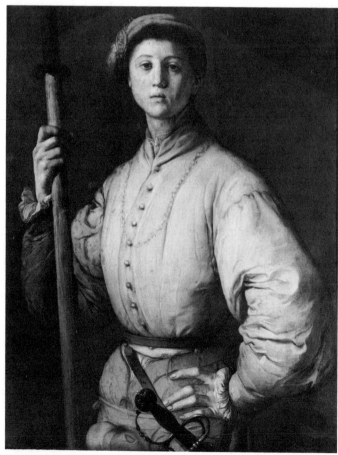

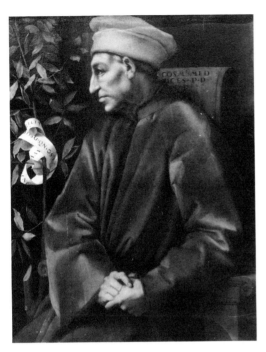

tion and is not the beginning of a new movement or trend. This is confirmed by the harmony which his painted decoration for the Capponi Chapel in Santa Felicita achieves with the Chapel's architecture which was originally designed for the Barbadori family by Filippo Brunelleschi back in the 1420s. In the century between the designing of the Chapel and Pontormo's decoration, the artistic assumptions of the Italian Renaissance remained the same, forming a coherent and unmistakable style.

394. Jacopo Pontormo. *Cosimo il Vecchio*, 1520 (?). Wood panel, 86 × 65 cm. Florence, Uffizi.

APPENDIX

The generational system into which the art of the leading painters of the Italian Renaissance has been organized is essentially modular, so that other painters born between about 1395 and about 1495 can be inserted into it without difficulty. Below are some of the better-known painters who have not been discussed. Whether they belong to the lyric or monumental current is also given, although, as we have seen, such indications are often relative and even indecisive for some painters. Following the names of these painters, I have also given their birth and death dates according to more recent authoritative studies and the name of the school to which they are usually associated.

The First Generation

Monumental

Lorenzo di Pietro called Vecchietta (1410?–1480), Sienese
Francesco Pesellino (1422–1457), Florentine

Lyric

Giovanni di Paolo (ca. 1400–1482), Sienese
Sano di Pietro (1406–1481), Sienese
Michele Giambono (ca. 1395–1462), Venetian
Antonio Vivarini (ca. 1420–1484?), Venetian
Benozzo Gozzoli (1420–1497), Florentine
Alesso Baldovinetti (ca. 1425–1499), Florentine

The Second Generation

Monumental

Vicenzo Foppa (1430?–1515?), Lombard
Donato Bramante (1444–1514), Umbrian/Lombard
Cosimo Rosselli (1439–1507), Florentine
Lorenzo di Credi (ca. 1459–1537), Florentine
Matteo di Giovanni (ca. 1435–1495), Sienese
Bartolomeo Montagna (ca. 1450–1523), Venetian
Francesco Francia (ca. 1450–1517), Emilian
Ercole de' Roberti (1456–1496), Emilian

Lyric

Marco Zoppo (1433–1478), Emilian
Francesco del Cossa (ca. 1436–1478), Emilian
Lorenzo Costa (1460–1535), Emilian
Carlo Crivelli (ca. 1435–ca. 1500), Venetian
Antoniazzo Romano (ca. 1435–after 1508), Roman
Benvenuto di Giovanni (ca. 1436–1518), Sienese
Neroccio de' Landi (1447–1500), Sienese
Francesco Botticini (1446–1498), Florentine
Ambrogio de Predis (ca. 1455–after 1508), Lombard

The Third Generation

Monumental

Giovanni Bazzi called Sodoma (ca. 1477–1549), Lombard/Sienese
Girolamo Savoldo (ca. 1480–after 1548), Lombard/Venetian
Girolamo Romanino (1484/87–1559), Lombard
Bernardino Luini (1480–before 1532), Lombard
Palma Vecchio (1480–1528), Venetian
Vincenzo Catena (ca. 1480–1531), Venetian
Giovanni Antonio de Sacchis called Pordenone (1483/84–1539), Venetian
Baldassare Peruzzi (1481–1536), Sienese
Dosso Dossi (ca. 1490–1542), Emilian

Lyric

Mariotto Albertinelli (1474–1515), Florentine
Francesco Franciabigio (ca. 1482–1525), Florentine
Francesco Ubertini called Bacchiacca (1494–1557), Florentine
Benvenuto Tisi called Garofalo (ca. 1481–1559), Emilian

BIBLIOGRAPHY

A. Sources and Documents

Alberti, L.B., *On Painting and On Sculpture, the Latin Texts of De Pictura and De Statua*, ed., trans., intro., and notes C. Grayson, London, 1972.

Cennini, C., *The Craftsman's Handbook (Il libro dell'arte)*, trans. D.V. Thompson, Jr., New York, 1954.

Chambers, D.S., ed., *Artists and Patrons in the Italian Renaissance*, Columbia, S.C., 1973.

Gaye, G., *Carteggio inedito d'artisti dei secoli XIV, XV, XVI*, 3 Vols., Florence, 1839–40.

Gilbert, C.E., *Italian Art: 1400–1500, Sources and Documents in the History of Art*, Englewood Cliffs, N.J., 1980.

Holt, E.G., ed., *Literary Sources of Art History*, Princeton, N.J., 1947 (paperback ed., *A Documentary History of Art*, 3 Vols., Garden City, N.Y., 1957–66).

Klein, R. and Zerner, H., *Italian Art: 1500–1600, Sources and Documents in the History of Art*, Englewood Cliffs, N.J., 1966.

Merrifield, M.P., *Original Treatises dating from the XIIth to XVIIIth Centuries on the Arts of Painting in Oil, Miniature, Mosaic, and on Glass; of Gilding, Dyeing, and the Preparation of Colors and Artificial Gems*, 2 Vols., London, 1849.

Müntz, E., *Les Collections des Medicis au XVe siècle; le musée, la bibliothèque, le mobilier*, Paris, 1888.

Schlosser-Magino, J., *La letteratura artistica*, trans. F. Rossi, 3rd Ital. ed. with notes by O. Kurz, Florence, 1956.

Vasari, G., *Le vite de' più eccellenti pittori, scultori ed architettori scritte da Giorgio Vasari*, ed. G. Milanesi, 9 Vols., Florence, 1878–85 (*Lives of the Most Eminent Painters, Sculptors and Architects*, trans. G. du C. De Vere, 10 Vols., London, 1912–15).

Vasari on Technique, ed. G.B. Brown, trans. L.S. Maclehose, New York, 1960.

B. Historical and Political Background

Baron, H., *The Crisis of the Early Italian Renaissance*, rev. ed., Princeton, N.J., 1966.

Brucker, G., *The Civic World of Early Renaissance Florence*, Princeton, N.J., 1977.

———, ed., *The Society of Renaissance Florence: A Documentary Study*, New York, 1971.

Burckhardt, J., *The Civilization of the Renaissance in Italy*, trans. S.G.C. Middlemore, Oxford, 1965.

Goldthwaite, R.A., *Private Wealth in Renaissance Florence: A Study of Four Families*, Princeton, N.J., 1968.

Guicciardini, F., *History of Italy and History of Florence*, ed. and abridged J.R. Hale, trans. C. Grayson, New York, 1964.

Hay, D., ed., *The Age of the Renaissance*, New York, 1967.

Kristeller, P.O., *The Classics and Renaissance Thought*, Cambridge, Mass., 1955.

———, *Renaissance Concepts of Man and Other Essays*, New York, 1972.

———, *Studies in Renaissance Thought and Letters*, Rome, 1956.

Machiavelli, N., *History of Florence and of the Affairs of Italy, from the Earliest Times to the Death of Lorenzo the Magnificent*, ed. F. Gilbert, New York, 1960.

Rubinstein, N., *Florentine Studies*, London, 1968.

———, *The Government of Florence under the Medici, 1434–1494*, Oxford, 1966.

Vespasiano da Bisticci, *Renaissance Princes, Popes and Prelates: Lives of Illustrious Men of the XVth Century*, trans. W. George and E. Waters, intro. M.P. Gilmore, New York, 1963.

C. General Studies

Ackerman, J.S., "Alberti's Light," in *Studies in Late Medieval and Renaissance Painting in Honor of Millard Meiss*, eds. I. Lavin and J. Plummer, Vol. I, New York, 1977, pp. 1–27.

———, "On Early Renaissance Color Theory and Practice," in *Studies in Italian Art and Architecture 15th through 18th Centuries*, ed. H.A. Millon, Cambridge, Mass. and London, 1980, pp. 11–40.

Berenson, B., *The Italian Painters of the Renaissance*, London, 1952.

Blunt, A., *Artistic Theory in Italy, 1450–1600*, Oxford, 1966.

Chastel, A., *The Flowering of the Italian Renaissance*, trans. J. Griffin, New York, 1965.

———, *Studios and Styles of the Italian Renaissance*, trans. J. Griffin, New York, 1966.

Crowe, J.A. and Cavalcaselle, G.B., *A History of Painting in Italy*, 2nd ed., ed. L. Douglas, 6 Vols., London, 1903–14.

———, *A History of Painting in North Italy*, ed. T. Borenius, 3 Vols., New York, 1912.

Davies, M., *The Earlier Italian Schools*, 2nd ed., National Gallery, London, 1961.

Degenhart, B. and Schmitt, A., *Corpus der italienischen Zeichnungen, 1300–1450*, Berlin, 1968–.

Dizionario biografico degli Italiani, 22 Vols. (through Cavallotti), Rome, 1960–.

Enciclopedia Cattolica, 12 Vols., Città del Vaticano, 1949–54.

Encyclopedia of World Art, 15 Vols., New York, 1959–68.

Freedberg, S.J., *Painting in Italy: 1500–1600*, Harmondsworth and Baltimore, 1970.

Friedlaender, W., *Mannerism and Anti-Mannerism in Italian Painting*, New York, 1957.

Gould, C., *The Sixteenth-Century Italian Schools (excluding the Venetian)*, National Gallery, London, 1975.

Hartt, F., *History of Italian Renaissance Art: Paint-*

ing, Sculpture, Architecture, 2nd ed., New York, 1979.

Marle, R. van, The Development of the Italian Schools of Painting, 19 Vols., The Hague, 1923–38.

Meiss, M., The Great Age of Fresco: Discoveries, Recoveries and Survivals, New York, 1970.

Ortega y Gasset, J., Man and Crisis, trans. M. Adams, New York, 1958.

Paatz, W. and E., Die Kirchen von Florenz, 6 Vols., Frankfurt am Main, 1940–54.

Pinder, W. Das Problem der Generation in der Kunstgeschichte Europas, 2nd ed., Berlin, 1928.

Pope-Hennessy, J., The Portrait in the Renaissance, New York, 1966.

Salmi, M., La miniatura italiana, Milan, 1954.

Shapley, F.R., Paintings from the Samuel H. Kress Collection, 2 Vols., London, 1966–68.

Shearman, J., Mannerism, Harmondsworth and Baltimore, 1967.

Smyth, C.H., Mannerism and Maniera, Locust Valley, N.Y., 1961.

Thieme, U. and Becker, F., Allgemeines Lexikon der Bildenden Künstler von der Antike bis zur Gegenwart, 36 Vols., Leipzig, 1907–47.

Venturi, A., Storia dell'arte italiana, 23 Vols., Milan, 1901–41.

Wolfflin, H., Classic Art, 2nd ed., London, 1953.

Zeri, F., Italian Paintings in the Walters Art Gallery, Baltimore, 1976.

D. Schools

Antal, F., Florentine Painting and Its Social Background, London, 1948.

Berenson, B., The Drawings of the Florentine Painters, 2nd ed., 3 Vols., Chicago, 1938.

——, Italian Pictures of the Renaissance: Central Italian and North Italian Schools, rev. and expanded ed., 3 Vols., London and New York, 1968.

——, Italian Pictures of the Renaissance: Florentine School, rev. and expanded ed., 2 Vols., London and New York, 1963.

——, Italian Pictures of the Renaissance: Venetian School, rev. and expanded ed., 2 Vols., London and New York, 1957.

Borsook, E., The Mural Painters of Tuscany from Cimabue to Andrea del Sarto, London, 1960.

Brandi, C., Quattrocentisti Senesi, Milan, 1949.

Causa, R., Pittura napoletana dal XV al XIX, Bergamo, 1957.

Florence and Venice: Comparisons and Relations, Acts of Two Conferences at Villa I Tatti in 1976–77 organized by Sergio Bertelli, Nicolai Rubinstein, and Craig Hugh Smyth, Vol. 1, The Quattrocento, Vol. 2, The Cinquecento, Florence, 1979–80.

Freedberg, S.J., Painting of the High Renaissance in Rome and Florence, 2 Vols., Cambridge, Mass., 1961.

Fremantle, R., Florentine Gothic Painters, London, 1975.

Gould, C., The Sixteenth Century Venetian School, National Gallery, London, 1959.

Levi d'Ancona, M., Miniatura e miniatori a Firenze dal XIV al XVI sècolo; documenti per la storia della miniatura, Florence, 1962.

Longhi, R., Officina ferrarese (1930; with additions, 1940; with new additions, 1940–55), Florence, 1956.

Nicolson, B., The Painters of Ferrara: Cosmè Tura, Francesco del Cossa, Ercole de' Roberti and Others, London, 1950.

Ottina Della Chiesa, A., Pittura lombarda del Quattrocento, Bergamo, 1959.

Pallucchini, R., La Pittura veneziana del Cinquecento, Novara, 1944.

Pope-Hennessy, J., Sienese Quattrocento Painting, Oxford and London, 1947.

[Posner], K. Weil-Garris, Leonardo and Central Italian Art: 1515–1550, New York, 1974.

Salmi, M., Paolo Uccello, Andrea del Castagno,

Domenico Veneziano, trans. J. Chuzeville, Paris, 1939.

Tietze, H. and Tietze-Conrat, E., *The Drawings of the Venetian Painters in the 15th and 16th Centuries,* New York, 1944.

Torriti, P., *La Pinacoteca Nazionale di Siena: i dipinti dal XII al XV secolo,* Genoa, 1977.

——, *La Pinacoteca Nazionale di Siena: i dipinti dal XV al XVIII secolo,* Genoa, 1978.

Vavalà, E.S., *Sienese Studies: The Development of the School of Painting in Siena,* Florence, 1953.

——, *Uffizi Studies: The Development of the Florentine School of Painting,* Florence, 1948.

Venturi, A., *La Pittura del Quattrocento nell' Emilia,* Verona, 1931.

Wilde, J., *Venetian Art from Bellini to Titian,* Oxford, 1976.

Zampetti, P., *La pittura marchigiana da Gentile a Rafaello,* Venice, n.d.

Zeri, F., *Italian Paintings, A Catalogue of the Collection of the Metropolitan Museum of Art: The Florentine School,* New York, 1971.

——, *Italian Paintings, A Catalogue of the Collection of the Metropolitan Museum of Art: The Sienese School,* New York, 1980.

——, *Italian Paintings, A Catalogue of the Collection of the Metropolitan Museum of Art: Venetian School,* New York, 1973.

E. Specialized Studies

Baxandall, M., *Painting and Experience in Fifteenth Century Italy,* Oxford, 1972.

Conti, A., *Storia del restauro e della conservazione delle opere d'arte,* Milan, 1973?.

Edgerton, S.Y., *The Renaissance Rediscovery of Linear Perspective,* New York, 1975.

Ettlinger, L.D., *The Sistine Chapel Before Michelangelo: Religious Imagery and Papal Politics,* Oxford, 1965.

Fanelli, G., *Firenze, Architettura e Città,* 2 Vols., Florence, 1973.

Gombrich, E.H., *The Heritage of Apelles: Studies in the Art of the Renaissance,* Oxford, 1976.

——, *Norm and Form: Studies in the Art of the Renaissance,* London, 1966.

——, *Symbolic Images: Studies in the Art of the Renaissance,* London, 1972.

Hatfield, R., *Botticelli's Uffizi 'Adoration': A Study in Pictorial Content,* Princeton, N.J., 1976.

Lee, R.W., *Names on Trees: Ariosto into Art,* Princeton, N.J., 1977.

——, *Ut Pictura Poesis: The Humanistic Theory of Painting,* New York, 1967.

Meiss, M., *The Painter's Choice: Problems in the Interpretation of Renaissance Art,* New York, 1976.

Panofsky, E., *Meaning in the Visual Arts,* New York, 1955.

——, *Renaissance and Renascences in Western Art,* Stockholm, 1960.

——, *Studies in Iconology: Humanistic Themes in the Art of the Renaissance,* Oxford, 1939.

Procacci, U., *Sinopie e affreschi,* Milan, 1961.

Salvini, R., *The Sistine Chapel,* appendix E. Camesasca, 2 Vols., New York, 1965.

Saxl, F., *Lectures,* London, 1957.

Seznec, J., *The Survival of the Pagan Gods: The Mythological Tradition and Its Place in Renaissance Humanism and Art,* Princeton, N.J., 1953.

Turner, R., *The Vision of Landscape in Renaissance Italy,* Princeton, N.J., 1966.

Weiss, R., *The Renaissance Discovery of Classical Antiquity,* New York, 1973.

White, J., *The Birth and Rebirth of Pictorial Space,* Boston, 1967.

Wind, E., *Giorgione's 'Tempesta' with Comments on Giorgione's Poetic Allegories,* Oxford, 1969.

——, *Pagan Mysteries in the Renaissance,* New Haven, Conn., 1958.

Wittkower, R. and M., *Born Under Saturn, The Character and Conduct of Artists: A Documented History from Antiquity to the French Revolution,* New York, 1963.

F. Monographs and Monographic Articles

Fra Angelico

Berti, L., Bellardoni, B., and Battisti, E., *Angelico a San Marco*, Rome, 1965.

Morante, E. and Baldini, U., *L'opera completa dell' Angelico*, Milan, 1970.

Pope-Hennessy, J., *Fra Angelico*, 2nd ed., Ithaca, N.Y., 1974.

Antonello da Messina

Bottari, S., *Antonello da Messina*, trans. G. Scaglia, Greenwich, Conn., 1955.

Fiocco, G., "Colantonio e Antonello," *Emporium*, Vol. 3, 1950, pp. 51–66.

Sciascia, L. and Mandel, G., *L'opera completa di Antonello da Messina*, Milan, 1967.

Fra Bartolommeo

Fahy, E., "The Beginnings of Fra Bartolommeo," *Burlington Magazine*, Vol. 108, 1966, pp. 456–63.

Gabelentz, H.V., *Fra Bartolommeo und die Florentiner Renaissance*, 2 Vols., Leipzig, 1922.

Knapp, F., *Fra Bartolommeo della Porta und die Schule von San Marco*, Halle an der Saale, 1903.

Beccafumi, Domenico

Briganti, G. and Baccheschi, E., *L'opera completa del Beccafumi*, Milan, 1977.

Ciaranfi, A.F., *Domenico Beccafumi*, Florence, 1966.

Sanminiatelli, D., *Domenico Beccafumi*, Milan, 1967.

Bellini, Giovanni

Dussler, L., *Giovanni Bellini*, Frankfurt am Main, 1935.

Ghiotto, R. and Pignatti, T., *L'opera completa di Giovanni Bellini*, Milan, 1969.

Robertson, G., *Giovanni Bellini*, Oxford, 1968.

Bellini, Jacopo

Joost-Gaugier, C.L., ed., *Jacopo Bellini: Fifty Drawings*, New York, 1980.

Moschini, V., *Disegni di Jacopo Bellini*, Bergamo, 1943.

Botticelli, Sandro

Ettlinger, L.D. and H.S., *Botticelli*, London, 1976.

Horne, H.P., *Allessandro Filipepi, commonly called Sandro Botticelli, Painter of Florence*, London, 1908.

Lightbown, R., *Botticelli*, 2 Vols., Berkeley, Calif., 1978.

Carpaccio

Cancogni, M. and Perocco, G., *L'opera completa del Carpaccio*, Milan, 1967.

Lauts, J., *Carpaccio: Paintings and Drawings*, London and New York, 1962.

Pignatti, T., *Carpaccio: Biographical and Critical Study*, trans. J. Emmons, New York, 1958.

Castagno, Andrea del

Horster, M., *Andrea del Castagno*, Ithaca, N.Y., 1980.

Richter, G.M., *Andrea del Castagno*, Chicago, 1943.

Salmi, M., *Andrea del Castagno*, Novara, 1961.

Correggio

Bevilacqua, A. and Quintavalle, A.C., *L'opera completa del Correggio*, Milan, 1970.

Ghidiglia Quintavalle, A., *Gli Affreschi del Correggio in S. Giovanni Evangelista a Parma*, Milan, 1962.

Gould, C., *The Paintings of Correggio*, Ithaca, N.Y., 1976.

Popham, A.E., *Correggio's Drawings*, London, 1957.

Toscano, G.M., *Nuovi Studi sul Correggio*, Parma, 1974.

Francesco di Giorgio

Weller, A.S., *Francesco di Giorgio, 1439–1501,* Chicago, 1943.

Gentile da Fabriano

Micheletti, E., *L'opera completa di Gentile da Fabriano,* Milan, 1976.

Ghirlandaio

Lauts, J., *Domenico Ghirlandajo,* Vienna, 1943.

Giorgione

Baldass, L. von, *Giorgione,* trans. J.M. Brown-John, New York, 1965.

Lilli, V. and Zampetti, P., *L'opera completa di Giorgione,* rev. ed., Milan, 1970.

Pignatti, T., *Giorgione,* trans. C. Whitfield, London, 1971.

Leonardo da Vinci

Beck, J., *Leonardo's Rules of Painting: An Unconventional Approach to Modern Art,* New York, 1979.

Clark, K., *The Drawings of Leonardo da Vinci in the Collection of Her Majesty the Queen at Windsor Castle,* 2nd ed., revised with the assistance of C. Pedretti, London, 1968–69.

———, *Leonardo da Vinci: An Account of His Development as an Artist,* rev. ed., Baltimore and Harmondsworth, 1967.

Heydenreich, L.H., *Leonardo da Vinci,* 2 Vols., New York, 1954.

Pedretti, C., *Leonardo: A Study in Chronology and Style,* Berkeley, Calif., 1973.

Richter, J.P., *The Literary Works of Leonardo da Vinci,* commentary C. Pedretti, Berkeley, Calif., 1977.

Wasserman, J., *Leonardo da Vinci,* New York, 1975.

Lippi, Filippino

Berti, L., *Filippino Lippi,* Florence, 1957.

Lippi, Fra Filippo

Marchini, G., *Fra Filippo Lippi,* Milan, 1975.

Pittaluga, M., *Filippo Lippi,* Florence, 1949.

Lotto, Lorenzo

Berenson, B., *Lorenzo Lotto,* London, 1956.

Caroli, F., *Lorenzo Lotto,* Florence, 1975.

Pallucchini, R. and Canova, G.M., *L'opera completa del Lotto,* Milan, 1975.

Mantegna

Kristeller, P., *Andrea Mantegna,* trans. S.A. Strong, London and New York, 1901.

Meiss, M., *Andrea Mantegna as Illuminator: An Episode in Renaissance Art, Humanism and Diplomacy,* New York, 1957.

Tietze-Conrat, E., *Mantegna: Paintings, Drawings, Engravings,* New York, 1955.

Masaccio

Beck, J., with Corti, G., *Masaccio: The Documents,* Locust Valley, N.Y., 1978.

Berti, L., *Masaccio,* University Park, Pa., 1967.

Volponi, P. and Berti, L., *L'opera completa di Masaccio,* Milan, 1968.

Masolino

Micheletti, E., *Masolino da Panicale,* Milan, 1959.

Toesca, P., *Masolino a Castiglione Olona,* Milan, 1946.

Melozzo da Forlì

Buscaroli, R., *Melozzo e il melozzismo,* Bologna, 1955.

Pantucci, M., *Melozzo da Forlì,* Milan, 1943.

Michelangelo

Beck, J., *Michelangelo: A Lesson in Anatomy,* New York, 1975.

Condivi, A., *The Life of Michelangelo*, ed. H. Wohl, trans. A.S. Wohl, Baton Rouge, La., 1976.

De Tolnay, C., *The Complete Works of Michelangelo*, 5 Vols., Princeton, N.J., 1943–60.

Hartt, F., *Michelangelo Drawings*, New York, 1971.

Hibbard, H., *Michelangelo*, New York, 1974.

Seymour, C., Jr., ed., *Michelangelo: The Sistine Ceiling*, New York, 1972.

Steinberg, L., *Michelangelo's Last Paintings, the Conversion of St. Paul and the Crucifixion of St. Peter*, New York, 1975.

Lorenzo Monaco

Siren, O., *Don Lorenzo Monaco*, Strassburg, 1905.

Perugino

Castellaneta, C. and Camesasca, E., *L'opera completa del Perugino*, Milan, 1969.

Venturi, L. et al., *Il Perugino*, 2 Vols., Turin, 1955.

Piero della Francesca

Battisti, E., *Piero della Francesca*, 2 Vols., Milan, 1971.

Clark, K., *Piero della Francesca*, New York, 1951.

Gilbert, C., *Change in Piero della Francesca*, Locust Valley, N.Y., 1968.

Longhi, R., *Piero della Francesca*, 3rd ed., Florence, 1964.

Piero di Cosimo

Bacci, M., *L'opera completa di Piero di Cosimo*, Milan, 1976.

——, *Piero di Cosimo*, Milan, 1966.

Douglas, R.L., *Piero di Cosimo*, Chicago, 1946.

Pinturicchio

Carli, E., *Il Pinturicchio*, Milan, 1960.

Schulz, J., "Pinturicchio and the Revival of Antiquity," *Journal of the Warburg and Courtauld Institutes*, Vol. 25, 1962, pp. 35–55.

Pisanello

Dell'Acqua, G.A. and Chiarelli, R., *L'opera completa del Pisanello*, Milan, 1972.

Paccagnini, G., *Pisanello*, trans. J. Carroll, London, 1973.

——, *Pisanello alla corte dei Gonzaga*, Milan, 1972.

Todorow, M.F., *I disegni del Pisanello e della sua cerchia*, Florence, 1966.

Pollaiuolo

Ettlinger, L.D., *Antonio and Piero Pollaiuolo: Complete Edition with Critical Catalogue*, Oxford and New York, 1978.

Pontormo

Berti, L., *L'opera completa del Pontormo*, Milan, 1973.

——, *Pontormo*, Florence, 1966.

Rearick, J.C., *The Drawings of Pontormo*, 2 Vols., Cambridge, Mass., 1964.

Raphael

Beck, J., *Raphael*, New York, 1976.

Dussler, L., *Raphael: A Critical Catalogue of his Pictures, Wall-Paintings and Tapestries*, trans. S. Cruft, London and New York, 1971.

Fischel, O., *Raphael*, trans. B. Rackham, London, 1964.

Pope-Hennessy, J., *Raphael*, New York, 1970.

Rosso Fiorentino

Barocchi, P., *Rosso Fiorentino*, Rome, 1950.

Carroll, E.A., *The Drawings of Rosso Fiorentino*, New York, 1976.

Andrea del Sarto

Freedberg, S.J., *Andrea del Sarto*, 2 Vols., Cambridge, Mass., 1963.

Shearman, J., *Andrea del Sarto,* 2 Vols., Oxford, 1965.

Sassetta

Carli, E., *Sassetta e il Maestro dell' Osservanza,* Milan, 1957.
Pope-Hennessy, J., *Sassetta,* London, 1939.

Sebastiano del Piombo

Dussler, L., *Sebastiano del Piombo,* Basel, 1942.
Pallucchini, R., *Sebastian Viniziano (Fra Sebastiano del Piombo),* Milan, 1944.
Volpe, C. and Mauro, L., *L'opera completa di Sebastiano del Piombo,* Milan, 1980.

Signorelli

Salmi, M., *Signorelli,* Novara, 1953.
Scarpellini, P., *Signorelli,* Milan, 1964.

Squarcione

Boskovits, M., "Una Ricerca su Francesco Squarcione," *Paragone,* Vol. 28, 1977, pp. 40–70.
Fiocco, G., "Il museo imaginario di Francesco Squarcione," *Atti e memorie dell' Accademia patavina,* Vol. 71, pt. 3, 1959, pp. 59–72.

Titian

Hope, C., *Titian,* London and New York, 1980.
Oberhuber, K., *Disegni di Tiziano e della sua cerchia,* Venice, 1976.

Pallucchini, R., *Profile di Tiziano,* Florence, 1977.
Panofsky, E., *Problems in Titian: Mostly Iconographic,* New York, 1969.
Rosand, D., *Titian,* New York, 1978.
Tiziano nel quatro centenario della sua morte, Venice, 1977.
Wethey, H.E., *The Paintings of Titian,* 3 Vols., London and New York, 1969–75.

Cosmè Tura

Malajoli, R., *L'opera completa di Cosmè Tura e i grandi pittori ferraresi del suo tempo: Francesco Cossa e Ercole de' Roberti,* Milan, 1974.
Ruhmer, E., *Tura: Paintings and Drawings,* London, 1958.
Salmi, M., *Cosmè Tura,* Milan, 1957.

Uccello

Parronchi, A., *Paolo Uccello,* Bologna, 1974.
Pope-Hennessy, J., *The Complete Work of Paolo Uccello,* 2nd ed., London, 1969.

Veneziano, Domenico

Wohl, H., *The Paintings of Domenico Veneziano ca. 1410–1461: A Study in Florentine Art of the Early Renaissance,* Oxford, 1980.

Verrocchio

Passavant, G., *Verrocchio: Sculpture, Paintings and Drawings,* trans. K. Watson, London and New York, 1969.

INDEX

Page numbers in boldface refer to illustrations.

Adoration of the Child, Lippi, Filippo, 113
Adoration of the Child, Perugino, 197
Adoration of the Magi, Fra Angelico and workshop, 120, **121**
Adoration of the Magi, Botticelli (Florence), 166, **168**, 169; (Washington), 182, **184**
Adoration of the Magi, Domenico Veneziano (attrib.), 129, **130**
Adoration of the Magi, Gentile da Fabriano *(Strozzi Altarpiece)*, 32, **33**, 34, 107, 182
Adoration of the Magi, Ghirlandaio, 265
Adoration of the Magi, Gozzoli, **66**
Adoration of the Magi, Leonardo da Vinci, 182, 286, 289, 291, **293**
Adoration of the Magi, Lippi, Filippino, 176, 182, **183**, **184**
Adoration of the Magi, Lorenzo Monaco, 36, **37**
Adoration of the Magi, Masaccio *(Pisa Altarpiece)*, 107, **107**
Adoration of the Shepherds, Ghirlandaio, 265, 267–68, **270**
Adoration of the Shepherds, Vander Goes *(Portinari Altarpiece)*, 267–68, **270**
Adoration of the Wood by the Queen of Sheba and the Meeting of the Queen of Sheba and Solomon, Piero della Francesca, **136**, 139, **140**
Aeneas Silvius Piccolomini Departs for Basel, Pinturicchio, 204, **205**; preparatory drawing by Raphael (?), 204, **205**
Agony in the Garden, Mantegna, 230
Albani Torlonia Polyptych, Perugino, **193**, 195
Alberti, Leon Battista, 5, 8, 22

Alberti, Leon Battista *(cont'd)*
 On Painting (and other writing), 5–6, 13, 20, 112, 167, 315
 perspective, theories of, 53, 66
 Tempio Malatestiano, Rimini, 132
Albertinelli, Mariotto, 392, 423, 434, 452
 Annunciation (and Fra Bartolommeo), 318, **319**
 Last Judgment (and Fra Bartolommeo), 318, **319**, **320**
Albertini, Francesco: *Memoria di Florentia*, 153
Alexander VI (Pope; Rodrigo de Borgia), 7, 201, 204
Alfonso I of Aragon, 76
Altarpiece of the Misericordia, Piero della Francesca *(Madonna della Misericordia)*, 130, 132, **133**, 134, 236
Altichiero, 79, 84
Ambrogio de Predis, 291, 452
anatomy. *See* figures, treatment of
Andrea del Castagno. *See* Castagno, Andrea del
Andrea del Sarto. *See* Sarto, Andrea del
Andrea Doria, Sebastiano del Piombo, **371**, 372
Angelico, Fra (Guido di Pietro; Giovanni Angelico), 5, 18, 21, 32, 54, 55, 57, 60, 62, 64, 66–67, 81, 113, 124, 127, 132, 157, 323
 Adoration of the Magi (and workshop), 120, **121**
 Annunciation (Cortona Altarpiece), 59, 60, 64, 129; (San Marco), **63**, 64
 J. Bellini painting attributed to, 88
 Chapel of Nicholas V, Vatican, frescoes, 55, 57, 64, **65**, 66–67
 Coronation of the Virgin, **64**, 66
 cross, Hospital of Santa Maria Nuova, 55, 57

461

Angelico, Fra *(cont'd)*
 Deposition from the Cross (and Lorenzo
 Monaco), 60, **61**, 62, 127
 and Domenico Veneziano, 57, 124, 125
 influence on: of Gentile da Fabriano, 35, 55; of
 Ghiberti, 30, 55; of Masolino, 55, 57, 60
 Linaiuoli Altarpiece, 55, 57, **58**, 60
 Orvieto Cathedral, San Brizio Chapel, frescoes,
 55, 190, 275, 279
 and Piero della Francesca, 57, 132
 in Raphael *stanze*, 381
 *St. Lawrence Distributing Alms to the Poor
 and the Infirm*, **65**, 67
 St. Peter Martyr Altarpiece, 55, **56**, 57
 San Domenico, Perugia, altarpiece, 55
 San Marco, Florence, frescoes, 55, **63**, 64, **64**,
 66
 San Marco Altarpiece, 62, **62**, 64
 Santa Trinita, Florence, frescoes, 60
 Santo Stefano al Ponte, Florence, Gherardini
 Chapel, frescoes, 55
 and Sassetta, 99
 *The Virgin and Child Enthroned with Angels
 and Sts. Cosmas and Damian, Lawrence,
 John the Evangelist, Mark, Dominic, Francis,
 and Peter Martyr*, 62, **62**, 64
 *The Virgin and Child with Sts. Dominic, John
 the Baptist, Peter Martyr, and Thomas
 Aquinas*, 55, **56**, 57
 workshop and assistants, 57, 67, 125, 132
Angelo Doni, Raphael, **196**, 197, 327
Annunciation, Fra Angelico *(Cortona
 Altarpiece)*, **59**, 60, 64, 129; (San Marco), **63**,
 64
Annunciation, Fra Bartolommeo and
 Albertinelli, 318, **319**
Annunciation, Bellini, J., 88, **89**, 90–91
Annunciation, Domenico Veneziano, **128**, 129
Annunciation, Leonardo da Vinci, 286, **289**, 291
Annunciation, Lippi, Filippino, 176, 178, **178**
Annunciation, Lippi, Filippo, **119**, 120
Annunciation, Martini, 90
Annunciation, Masolino, 45, **45**
Annunciation, Piero della Francesca, **136**, 141,
 141
Annunciation, Pinturicchio, 204, **206**
Annunciation, Pisanello, 76, 77, **77**, 79
Annunciation, Pontormo, 441, **444**
Annunciation, Sarto, Andrea del, 434
Annunciation, Signorelli, 275
Annunciation, Tura, 206, **207**, 209
Ansuino da Forlì, 223
Antichrist, Signorelli, 279, 280, **281**
antiquity, interest in and influence of, 3, 4, 5, 6,
 47, 53, 77, 88, 106, 134, 182, 185, 197, 204,
 222, 226, 228, 232, 239, 260, 264, 267, 274,
 275, 280, 315, 335–36, 344, 357, 369, 379,
 383, 384, 387

antiquity *(cont'd)*
 architecture, 3, 4, 27, 106, 194
 bronzes, 277, 407
 painting, 4, 5, 139, 197, 264, 279, 359
 sculpture, 3, 4, 28, 30, 31, 54, 88, 106, 134, 154,
 170, 234, 262, 277, 279, 335, 336, **337**, 344,
 354, 362, 371, 373, **375**, 383, 396
 themes, 3, 4, 197, 211, 415
 See also mythology and fable
Antonello da Messina (Antonello di Giovanni),
 158, 159, 250, 253–56, 315
 and Bellini, Giovanni, 243, 245, 254
 Ecce Homo, 250
 influence of, 219, 250, 254; on Carpaccio, 217,
 219; on Lotto, 403
 influence on: of Mantegna, 256; of
 Netherlandish painting, 250, 253, 256, 292
 Madonna and Child, **252**, 253
 and Piero della Francesca, 146, 253, 255, 256,
 344, 348
 St. Sebastian, **255**, 256
 Salvator Mundi, 250, **251**, 253
 San Cassiano Altarpiece, 245, 250, 253–55, **254**,
 403
 San Gregorio Polyptych, 250, **252**, 253, 254,
 256
 Trivulzio Portrait, 256, **256**
Antoniazzo Romano, 452
*Apparition of the Madonna to Sts. Anthony
 Abbot and George*, Pisanello, **80**, 81
April, Cossa, 211, **212**, 213
Arcangelo di Cola da Camerino, 57
architecture, depiction of, 15, 36, 54, 66, 79, 93,
 165, 167, 211, 216, 255, 257, 264, 291, 424
 Bartolommeo, Fra, 323, 325
 Bellini, Giovanni, 245, 246
 Carpaccio, 216, 220, 222
 Castagno, Andrea del, 147, 150
 Correggio, 411, 412
 Domenico Veneziano, 125, 127, 129
 Ghirlandaio, 269, 274
 Lippi, Filippino, 178, 182, 184
 Lippi, Filippo, 113, 117, 122, 123, 124
 Mantegna, 226, 228, 234, 235, 236, 239
 Masaccio, 102, 106, 107–08
 Masolino, 42, 45, 47, 93
 Perugino, 194, 195, 196
 Piero della Francesca, 132, 137, 139, 141, 142
 Pinturicchio, 202, 204
 Raphael, 373, 381, 391
 Signorelli, 280, 285
 Titian, 359, 363, 365
 See also perspective
Arrival of St. Ursula in Cologne, Carpaccio, 216,
 217, 219
Arte dei Linaiuoli: Fra Angelico altarpiece, 55,
 57, **58**, 60
Arte della Lana Altarpiece, Sassetta, **92**, 93

Arte della Seta, 260
Assumption, Titian, 285, 352, **356,** 357–58
Assumption of the Virgin, Correggio, 411, 417, 419
Assumption of the Virgin, Lotto, 402
Assumption of the Virgin, Masolino, 43
Assumption of the Virgin, Perugino, **191,** 331
Assumption of the Virgin, Rosso Fiorentino, 426, 429, **429**

Bacchanal of the Andrians, Titian, 316, **359,** 360
Bacchiacca (Francesco Ubertini), 452
Bacchus, Leonardo da Vinci, 286, 304, **304**
Bacchus, Michelangelo, 431
Bacchus and Ariadne, Titian, 316, **359,** 360
Baldassare Castiglione, Raphael, **390,** 390–91
Baldovinetti, Alesso, 125, 265, 451
Baptism of Christ, Piero della Francesca, 132, 134, **135,** 139
Baptism of Christ, Verrocchio, 160, **162,** 163, **163,** 165, 260; Leonardo's work on, 163, 165, 287, **288,** 289
Baptism of the People, Sarto, Andrea del, 393, **394,** 396; study for, **395,** 396
Barbadori Altarpiece, Lippi, Filippo *(Madonna Enthroned with Saints),* 113, **117,** 117–18, 120
Bardi Altarpiece, Botticelli, 166
Barocci, Federico, 421
Baroque painting, 5, 12, 24, 317, 341
Bartolommeo, Fra (Bartolommeo di Paolo; Baccio della Porta), 316–20 *passim,* 323, 325, 393, 423, 429
 Annunciation (and Albertinelli), 318, **319**
 God the Father with Sts. Catherine of Siena and Mary Magdalen, 318, **322,** 323
 influence of: on Pontormo, 437; on Rosso Fiorentino, 429, 432
 influence on, 317, 319, 323, 325
 Lamentation over the Dead Christ, 398, **399**
 Last Judgment (and Albertinelli), 318, 319, **320**
 Madonna and Child Enthroned with Sts. Stephen and John the Baptist, 318
 Madonna della Misericordia, 318
 Madonna in Glory with Saints, 318
 Marriage of St. Catherine, 318, 323, **323**
 Pala Pitti, 325
 as pupil: of Ghirlandaio, 274; of Piero di Cosimo, 305; of Rosselli, 316, 318, 319
 and Raphael, 18, 319, 323, 325
 St. Anne Altarpiece, **324,** 325
 St. Mark the Evangelist, 325, **325**
 Salvator Mundi with Saints, 318, 325, **326**
 Vision of St. Bernard, 318, 319–20, **321,** 323, 432
Battista Sforza, Piero della Francesco, 142, **142,** 146
Battle of Anghiari, Leonardo da Vinci, 18, 73, 285, 286, 295, 298, 300, 309, 331, 446; copies, 287, 300, **301;** studies for, 18, 300, **301**

Battle of Cascina, Michelangelo, 19, 295, 300, 316, 327, 329, 331, 342, 344, 396, 446; copies, 329, **329;** studies for, **329,** 331
Battle of Fornovo, 225
Battle of Love and Chastity, Perugino, 192, 197, 200, **200,** 239
Battle of San Romano: *Niccolò da Tolentino,* Castagno, Andrea del, 71, 73, 146–47, **152,** 154, 365
Battle of San Romano, Uccello, 67, 71, 73–75; (Florence), **72,** 73–74, **74,** 76; (London), **72,** 73; (Paris), 73, 74
Battle of Ten Nudes, Pollaiuolo, **264,** 264–65, 331
Battle Relief, Michelangelo, 19, **330,** 331
Beato Lorenzo Giustiniani, Bellini, Gentile, 213, **213,** 214–15
Beccafumi, Domenico (Domenico di Giacomo; Mecherino), 10, 317, 421, 423–24, 426
 Fall of the Rebellious Angels, 426, **428**
 influence on, of Perugino, 423, 424
 Madonna and Saints, 423
 Meeting of Joachim and Anna at the Golden Gate, **421,** 423
 Moses and the Golden Calf, 424, 426, **427**
 Palazzo Pubblico, Siena, frescoes, 423
 St. Paul, **422,** 423
 Siena Cathedral, painting and sculpture, 423
 Stigmatization of St. Catherine of Siena, 423–24, **425**
 Trinity, 421, 423, **424**
Bellini, Gentile, 16, 88, 213–16, 239
 Beato Lorenzo Giustiniani, 213, **213,** 214–15
 Cardinal Bessarion and Two Disciples, 213
 Doges' Palace, Venice, Sala del Gran Consiglio, painting, 213, 241
 and father, Jacopo, 92, 213, 214–15, 239, 241
 Procession of the Reliquary of the Cross in Piazza San Marco, **214,** 215–16
 St. Mark Preaching in Alexandria (and Giovanni Bellini), 214, **215**
 Sant'Antonio, Padua, Gattamelata Chapel, altarpiece, 88, 241
 Scuola Grande di San Giovanni Evangelista, Venice, painting, 214
 Scuola Grande di San Marco, Venice, painting and sculpture designs, 213, 214, **215**
 mentioned, 158, 217
Bellini, Giovanni (di Jacopo), 10, 13, 16, 20, 21, 24, 87, 88, 159, 216, 222, 223, 239–41, 243, 245–47, 249–50, 348
 and Antonello da Messina, 243, 245, 254
 Coronation of the Virgin, 241, **242,** 243
 Dead Christ with Mary and John, **240,** 241
 Doges' Palace, Venice, Sala del Gran Consiglio, painting, 213, 217, 241
 and father, Jacopo, 92, 239, 241
 Feast of the Gods (reworked by Titian), 241, **246,** 246–47, 360

Bellini, Giovanni *(cont'd)*
Frari Altarpiece, 241, 404
Fra Teodoro da Urbino, 241, **249**
Fugger Portrait, 240
Giorgione as pupil, 241, 246, 250, 344, 367
influence of, 158, 241; on Fra Bartolommeo,
 317, 323; on Correggio, 412; on Lotto, 403,
 404
Isabella d'Este's *studiolo*, painting, 239, 241
Madonna, 241
Madonna and Child (1504), 241; (1510), 241, **248**,
 249–50
Madonna degli Alberetti, 241, **248**, 249
and Mantegna, 16, 239, 240–41, 245–46
Mantegna's *Presentation in the Temple* copied,
 404
Pesaro Altarpiece, 241, **242**, 243
and Piero della Francesca, 243, 245
pupils and assistants, 241, 246, 250, 344, 367,
 369
Sacred Allegory, 247, **247**, 249
St. Mark Preaching in Alexandria (and Gentile
 Bellini), 214, **215**
San Giobbe Altarpiece, **244**, 245, 291
San Giovanni Crisostomo, Venice, altarpiece, 241
San Pietro Martire, Murano, altarpiece, 247
Sant'Antonio, Padua, Gattamelata Chapel,
 altarpiece, 88, 241
San Zaccaria Altarpiece, 241, **244**, 245, 247,
 369, 403
Scuola Grande di San Marco, Venice, painting,
 214
and Sebastiano del Piombo, 241, 246, 250, 344,
 367, 369
and Titian, 18, 241, 246, 250, 344, 352, 355
Woman with Mirror, 241
mentioned, 158, 239, 357
Bellini, Jacopo (di Niccolò), 4, 5, 16, 20, 32, 87–88,
 90–92
Annunciation, 88, **89**, 90–91
Crucifixion, 88
drawings, 76, 88, 91, 214
Lamentation, 91, 91–92
Madonna and Child, 88, **90**, 91
portraiture, 5; Lionello d'Este, 82, 88
as pupil of Gentile da Fabriano, 34, 35, 88, 91,
 213
San Michele, 88
Sant'Antonio, Padua, Gattamelata Chapel,
 altarpiece, 88, 241
Scuola Grande di San Giovanni Evangelista,
 Venice, painting, 213
tomb of Beato Lorenzo Giustiniani, 88
workshop, 213; and sons, Gentile and Giovanni,
 92, 213, 214–15, 239, 241
mentioned, 84, 157, 217
'Bene scriptisti de me, Thomas', Sassetta *(Arte
 della Lana Altarpiece)*, **92**, 93

Benois Madonna, Leonardo da Vinci, 289, 291,
 292
Benvenuto di Giovanni, 452
Bicci di Lorenzo, 57, 100
 San Francesco, Arezzo, frescoes, 130, 132, 136
Birth of St. John the Baptist, Pollaiuolo, 260
Birth of the Virgin, Ghirlandaio, **273**, 274,
 392–93
Birth of the Virgin, Sarto, Andrea del, 392–93,
 393
Birth of Venus, Botticelli, 167–68, 169–70, **170**,
 172, 384, 441
Blessing Christ, Melozzo da Forlì, 259, **259**
Bono da Ferrara, 223
Borgia, Cesare, 286
Botticelli, Sandro (Allesandro di Mariano
 Filipepi), 14, 16, 165–70, 172–73, 175–76, 178,
 181, 188, 291
Adoration of the Magi (Florence), 166, **168**,
 169; (Washington), 182, **184**
Bardi Altarpiece, 166
Birth of Venus, 167–68, 169–70, **170**, 172, 384,
 441
Florence Cathedral, façade project, 166
Fortitude, 165–66, **167**
influence of, on Lippi, Filippino, 176, 178, 182
influence on, 165, 166, 167
Lamentation, 173, **174**, 175
and Lippi, Filippo, 165, 166
Madonna del Magnificat, 172–73, **173**
Medici villa, Spedaletto, painting, 158–59, 265
Moses in Egypt and Midian, 172, **172**, 191
Mystic Nativity, 166, 175, **175**
Pisa Cathedral, frescoes, 165
Primavera, 167–69, **169**, 170, 172
St. Augustine in His Study, 165–66, 170, **171**,
 172, 266
Sistine Chapel, Vatican, frescoes, 166, 172, **172**,
 190, **191**, 265
Temptations of Christ, 172, **191**
in Verrocchio's workshop, 163, 165, 166, 167
mentioned, 158, 441
Botticini, Francesco, 452
Bound Slave, Michelangelo, 441
Bramante, Donato, 373, 381, 452
Bramantino, 404
Brancacci, Felice, 40
Brera Altarpiece, Piero della Francesca
 *(Madonna and Child with Saints, Angels,
 and Duke Federigo da Montefeltro)*, 142, **144**,
 239, 255, 291
Bronzino, Angelo, 24, 447
Brunelleschi, Filippo, 12, 13, 25, 26–27, 30, 31, 35,
 106, 129
Crucifix, 102, **102**
Florence Cathedral, dome, 22, 102
Hospital of the Innocents, Florence, 27, 47, **47**
and Masaccio, 30, 101, 102, 104, 112

Brunelleschi, Filippo *(cont'd)*
 perspective, theories of, 12, 26, 42, 53, 93, 102
 San Lorenzo, Florence, 27, 102
 Santa Felicita, Florence, Capponi Chapel, 441,
 449
Bruni, Leonardo, 146
Burial of the Wood, Piero della Francesca, 136,
 137, **137**
Burlington House Cartoon, Leonardo da Vinci
 *(Madonna and Child with St. Anne and
 John the Baptist),* 300, **302,** 304
Byzantine art, 22, 90

Calling of Peter and Andrew, Ghirlandaio, 190,
 191, 265, 267, **268**
Calling of St. Matthew, Carpaccio, 216–17
canvas (as painting support), 21, 52, 216, 245, 247
 large *(teleri),* 213, 216, 220
Caravaggio, 24
Cardinal Bessarion and Two Disciples, Bellini,
 Gentile, 213
Carnesecchi Madonna, Domenico Veneziano,
 125, **125,** 127
Carpaccio, Vittore (di Pietro), 216–17, 219–22
 Arrival of St. Ursula in Cologne, 216, **217,** 219
 Calling of St. Matthew, 216–17
 Dismissal of the English Ambassadors, **218,**
 219–20
 Disputa of St. Stephen, **221,** 222
 Doges' Palace, Venice, painting, 216
 influence on, 216, 217, 219, 222
 Meditation on the Passion of Christ, **220,** 222
 *St. Augustine in His Study (Vision of St.
 Augustine),* **219,** 221–22
 Scuola degli Albanesi, Venice, painting, 217
 Scuola di Santo Stefano, Venice, painting, 217
 Scuola Grande di San Giovanni Evangelista,
 Venice, painting, 214
 mentioned, 158, 357
Carracci (family), 24, 421
cartellino, paintings signed with, 115, 247, 253,
 256, 398
cartoons (for frescoes), 52
 polverello (transfer), 139
 reused and reversed, 139, 194, 197, 339
Castagno, Andrea del (Andrea di Bartolo), 13, 23,
 146–47, 150, 153–54, 165, 229, 253
 Crucifixion, 147, **148,** 150
 Deposition, 147, **148,** 149
 Famous Men (Uomini Famosi), **150, 151,**
 153–54, 267, **269** 383
 Farinata degli Uberti, **151,** 153, 154
 Florence Cathedral, stained-glass designs, 146
 influence of, on Mantegna, 229, 230
 influence on, 147
 Last Supper (Hospital of Santa Maria Nuova),
 147; (Sant'Apollonia), 147, **148, 149,** 150,
 153–54, 266, 267, 295

Castagno, Andrea del *(cont'd)*
 Madonna and Child, 153–54
 Madonna and Saints, 150
 Niccolò da Tolentino, 71, 73, 146–47, **152,** 154,
 365
 portrait of Leonardo Bruni, 146
 Resurrection, 147, **148**
 San Miniato fra le Torri, Florence, altarpiece,
 146
 Sant'Apollonia, Florence, frescoes, 147, **148,**
 149, 150, 153–54, 266, 267, 295
 Sant'Egidio, Florence, frescoes, 125, 147
 San Zaccaria, Venice, San Tarasio Chapel,
 frescoes, 146, **146,** 147
 Vasari on, 127, 146
 mentioned, 157, 158, 223
Castelfranco Altarpiece, Giorgione, 245, 255,
 346, 348, 404
Castiglione, Baldassare, 344, **390,** 390–91
Catena, Vincenzo, 452
Catholic Church, 3, 6, 7, 76
 and Protestant League, 364
 Protestant Reformation, 14, 24
Cavalcanti Annunciation, Donatello, 118, 120
Charity, Sarto, Andrea del, 396, 398, **398**
Charlemagne, 4
Charles V, 353, 415
 Titian portraits, 352, **364,** 364–65
Charles V with a Dog, Titian, 352, **364, 364**
chiaroscuro: intarsia, 423
 painting, 52–53, 104, 106, 117, 127, 129, 134, 143,
 163, 166, 245, 291, 295, 304, 307, 309, 328,
 342, 348, 371, **390,** 396, 407, 441
 See also light
Chigi, Agostino, 367, 383–84
Chigi family, 192
Christ and St. Thomas, Verrocchio, 160, **161,** 194
Christ Before Pilate, Pontormo, **440,** 441
Christ Crowned with Thorns, Titian (Munich),
 363, 365, **366;** (Paris), **361,** 362–63
Christ Handing the Keys to St. Peter, Perugino,
 191, 192, 193–95, **204,** 373
Cima da Conegliano, 254, 404
city views, 215–16, 268–69
classical art. *See* antiquity, interest in and
 influence of
Clement VII (Pope; Giulio de' Medici), 7, 341
 and Raphael, 259, 364, 365, 388, **390,** 391, **391**
 and Sebastiano del Piombo, 367, **371,** 372
Colantonio, 250
Colleoni, Verrocchio, 154, 160, **161,** 222, 365
color, use of, 15, 52, 53, 60, 64, 79, 153, 159, 188,
 197, 220, 241, 243, 307, 317, 323, 371, 498
 Angelico, Fra, 60, 64
 Bellini, Giovanni, 243, 245, 247
 Botticelli, 166, 169, 172, 173
 Correggio, 415, 417
 Gentile da Fabriano, 34, 111

color *(cont'd)*
 Ghirlandaio, 266, 267
 International Style, 36, 38
 Leonardo da Vinci, 292, 295, 297, 300
 Lippi, Filippino, 181, 184, 185
 Lippi, Filippo, 120, 124
 Lotto, 403, 407
 Mantegna, 223, 228
 Masaccio, 42, 109, 111
 Masolino, 42, 111
 Michelangelo, 328, 342
 Piero della Francesca, 141, 142, 243
 Pontormo, 437, 439, 444, 446
 Raphael, 375, 381, 384, 390, 391
 Rosso Fiorentino, 431, 432
 Sassetta, 95, 99
 Signorelli, 280, 285
 Titian, 352, 360, 365
 Tura, 210, 211
 Uccello, 21, 68
Compagnia delle Scalzo (Florence), 393, 396
composition and space, 14–15, 21, 87, 91, 165,
 188–89, 204, 211, 215–16, 256, 262, 317
 Angelico, Fra, 62, 64, 66–67, 127
 Bartolommeo, Fra, 319–20, 323, 325
 Beccafumi, 423–24
 Bellini, Giovanni, 243, 245, 246, 247, 249, 404
 Botticelli, 166, 167, 170, 172, 173, 175
 Brunelleschi, 12, 35
 Carpaccio, 216, 220, 221–22
 Castagno, Andrea del, 147, 150, 153
 Correggio, 412, 413, 415, 417
 Domenico Veneziano, 127, 129
 Gentile da Fabriano, 35, 93
 Ghirlandaio, 265, 266–67, 269, 272, 274
 Giorgione, 348, 351
 Leonardo da Vinci, 291–92, 295–96, 297–98,
 300, 304, 309, 417
 Lippi, Filippino, 62, 178, 182, 185
 Lippi, Filippo, 12, 117, 120
 Lotto, 403, 404, 407
 Mantegna, 21, 223, 226, 228, 229, 230, 235, 236,
 239, 404
 Masaccio, 12, 31, 104, 106, 107, 108, 111–12
 Masolino, 12, 42, 45, 47
 Melozzo da Forlì, 21, 257, 259
 Michelangelo, 257, 328, 331, 332, 334, 335, 336,
 337, 341, 342, 343
 Perugino, 193, 194, 197, 200
 Piero della Francesca, 132, 134, 137, 139, 142,
 143
 Piero di Cosimo, 305, 309, 311, 323
 Pontormo, 438, 441, 444, 446
 and proportion, 53, 117–18, 165, 216, 417
 Raphael, 373, 378, 379, 381, 384, 387, 388, 390,
 391
 Rosso Fiorentino, 431, 432, 434
 Sarto, Andrea del, 393, 396, 398

composition and space *(cont'd)*
 Sassetta, 93, 95, 99
 Signorelli, 275, 277, 280, 285
 and spectator's relationship to scene, 21, 60, 62,
 71, 87, 108, 120, 121, 139, 150, 168, 182, 204, 215,
 226, 235, 245, 249, 335, 337, 343, 398, 426,
 441
 Titian, 353, 354, 355, 357, 358, 359–60, 363,
 364, 365, 398
 and *tondo* form, 120, 172–73, 178, 277, 327, 328
 Uccello, 70, 74–75
 See also perspective
Confraternity of Corpus Domini (Urbino), 132
Confraternity of St. Luke (Florence), 55, 100, 160,
 176, 190, 286, 305, 353, 437
Confraternity of St. Luke (Rome), 257
Confraternity of San Bernardino (Siena), 423
Confraternity of San Giovanni Evangelista
 (Venice), 215
Confraternity of Santa Maria della Croce al
 Tempio, 60
Confraternity of the Conception of the Virgin
 (Milan), 291
Consecration of the Host, Justus van Ghent,
 75–76
Conversion of St. Paul, Michelangelo, 19, 327,
 342, **342**
Coronation of the Virgin, Fra Angelico, **64,** 66
Coronation of the Virgin, Bellini, Giovanni
 (Pesaro Altarpiece), 241, **242,** 243
Coronation of the Virgin, Lippi, Filippo, 113, 118,
 118, 120, 272
Coronation of the Virgin, Francesco di Giorgio
 (fresco), 186; (wood), 186, **187,** 188
Coronation of the Virgin, Sassetta, 93
Correggio (Antonio di Pellegrino di Allegri), 10,
 12, 20, 23, 24, 257, 316, 388, 407, 411–13, 415,
 417, 421
 Assumption of the Virgin, 411, 417, **419**
 Camera di San Paolo, Parma, ceiling, 415, **416**
 influence of, 417, 421
 influence on, 412, 413, 415; of Leonardo da
 Vinci, 304, 344, 412, 413, 415, 417; of
 Mantegna, 222, 239, 411; of Perugino, 200, 412
 Jupiter and Io, **414,** 415
 *Madonna and Child with Saints (Madonna of
 San Francesco),* **410,** 411–12
 *Madonna and Child with Sts. Jerome and
 Mary Magdalen (Il Giorno),* 411, 417, **420**
 Madonna della Scodella, 411
 Magdalen in the Desert, 411
 Noli me tangere, 413, **413,** 415
 La Notte, 411
 San Giovanni Evangelista, Parma, frescoes, 411,
 415, 417, **418**
 Vision of St. John, 415, 417, **418**
Cortona Altarpiece, Fra Angelico
 (Annunciation), **59,** 60, 64, 129

Cosimo il Vecchio de' Medici, Pontormo, 447, **449**
Cossa, Francesco del, 213, **452**
April, 211, **212**, 213
Costa, Lorenzo, 200, 411, **452**
Court, Mantegna, **233**, 234–35
Creation of Adam, Michelangelo, **336**, 336–37, 339, 379, 446
Creation of Adam, Uccello, **52**, 67, 68, **68**
Creation of Eve, Michelangelo, 337, **338**, 339, 432
Creation of Eve, Rosso Fiorentino, 426, 432, **434**
Creation of Eve, Uccello, 67, 68, **68**
Creation of the Animals, Uccello, **52**, 67, 68
Crivelli, Carlo, 84, **452**
Crucifix, Brunelleschi, 102, **102**
Crucifixion, Bellini, J., 88
Crucifixion, Castagno, Andrea del, 147, **148**, 150
Crucifixion, Mantegna *(San Zeno Altarpiece),* 230, **230**, 232, 269, 272
Crucifixion, Masaccio *(Pisa Altarpiece),* **106**, 107
Crucifixion of St. Peter, Michelangelo, 19, 327, 342–43, **343**
Cumaean Sibyl, Castagno, Andrea del, 153
Cumaean Sibyl, Michelangelo, 337, **338**, 339

Damned, Signorelli, 279, **283**
Dancing Nudes, Pollaiuolo, **263**, 264, 265
Dante Alighieri, 279, 381
David, Donatello, 27, **28**
David, Michelangelo (bronze), 431; (marble), 327, 329, 331, 375; committee on placement, 166, 176, 192, 305
David, Pollaiuolo, 263
David, Verrocchio, 287, 289
David and Goliath, Michelangelo, 334, **334**
Dead Christ with Mary and John, Bellini, Giovanni, **240**, 241
Death of Adam, Piero della Francesca, **136**, 137, **138**, 139
Death of St. Bernardine, Pinturicchio, **201**, 202, 204
decorative elements and detail, use of, 14, 15, 34, 42, 60, 79, 88, 90, 93, 99, 197, 204, 211, 255, 348, 379, 391, 415
 Ghirlandaio, 266, 267, 274
 Lippi, Filippino, 182, 184, 185–86
 Mantegna, 229, 234, 239
 Netherlandish painting, 219–20, 391, 398
Dei Altarpiece, Rosso Fiorentino, 431, 432, **432**
De Lazara Altarpiece, Squarcione, 84, **86**, 87
Deposition, Castagno, Andrea del, 147, **148**, **149**
Deposition, Ghirlandaio, 265–66, **266**
Deposition, Lippi, Filippino, and Perugino, 429
Deposition, Pontormo, 441, **442**, **443**, 444, 446
Deposition, Sebastiano del Piombo, 367, **369**, 369, 371

Deposition from the Cross, Fra Angelico and Lorenzo Monaco, 60, **61**, 62, 127
Deposition from the Cross, Rosso Fiorentino, 426, 429, **430**, **431**
Desiderio da Settignano, 122
 Marsuppini tomb, 154
Diamante, Fra, 113, 176
Dismissal of the English Ambassadors, Carpaccio, **218**, 219–20
Disputa (Disputation over the Sacrament), Raphael, 319, 357, 379, **380**, 381
Disputa of St. Stephen, Carpaccio, **221**, 222
Dolce, Ludovico, 352
Domenico di Bartolo, 114–15
 Madonna of Humility, **115**, 115
Domenico Veneziano (Domenico di Bartolommeo), 5, 20, 21, 64, 112, 123–24, 124–25, 127, 129–30, 132, 147
 Adoration of the Magi (attrib.), 129, **130**
 and Fra Angelico, 57, 124, 125
 Annunciation, **128**, 129
 Carnesecchi Madonna, 125, **125**, 127
 and Castagno, Andrea del, 146, 147
 Hospital of Santa Maria della Scala, Siena, frescoes, 115
 influence of, 130, 132, 147
 influence on, of Masaccio, 54
 and Lippi, Filippo, 113, 124
 Madonna and Child, 129–30, **131**
 Madonna and Child with Saints, 64, **126**, 127, 129
 Medici, Piero de', letter to, 113, 124–25
 St. John the Baptist in the Desert, **128**, 129
 St. Lucy Altarpiece, 64, 112, 125, **126**, 127, **128**, 129–30, 136, 150
 Santa Croce, Florence, frescoes, 129
 Sant'Egidio, Florence, frescoes, 125, 127, 147
 and Sassetta, 99, 125, 127
 mentioned, 157, 158
Donatello (Donato di Niccolò di Betto Bardi), 4, 13, 25, 27, 30, 31, 54, 60, 106, 210, 375
 Cavalcanti Annunciation, **118**, 120
 David, 27, **28**
 Feast of Herod, 47
 Florence Baptistery: doors, 27; tomb of John XXIII, 104
 Florence Cathedral: singing gallery, 396; stained-glass designs, 146
 Gattamelata, 71, 84, **153**, 154, 223
 influence of, 30, 279, 334; on Castagno, Andrea del, 147; on Francesco di Giorgio, 188; on Lippi, Filippo, 120, 122, 124; on Mantegna, 223, 226, 229; on Masaccio, 30, 101, 102, 104, 112
 Jeremiah, 147
 and Michelangelo, 334–35, 336
 Miracle of the Speaking Babe, 87
 Pazzi Madonna, 81, **81**

Donatello *(cont'd)*
 St. George, **225,** 226
 St. George and the Princess, **79,** 81
 St. Louis of Toulouse, 104, 129, **129,** 160, 229
 St. Mark, 27–28, **29,** 30
 Sant'Antonio, Padua, altar, 84, 87, 92, 104, 129,
 129, 160, 223, 228, 229
 Siena Cathedral, Baptistry, sculpture, 47, 93, 188
 Zuccone, 147
Doni Madonna, Michelangelo, 327–28, **328,** 344,
 375, 413
Dossi, Dosso, 452, 360, 415
drapery and costume, treatment of, 34, 36, 95,
 165, 169, 172, 189, 194, 209, 211, 247, 249, 305,
 392, 393, 404, 417, 424, 426, 441
 Lippi, Filippino, 178, 182, 184, 185
 Mantegna, 225, 229, 235
 Michelangelo, 316, 328, 341
 Rosso Fiorentino, 429, 431, 432
Drawing of a Horse, Pisanello, 82, **82**
Duccio di Buoninsegna, 20
 Maestà, 188
Dürer, Albrecht, 241
 influence of, 23, 404, 439
 San Bartolommeo al Rialto, Venice, altarpiece,
 369

Early Christian art, 4, 112, 336
Ecce Homo, Antonello da Messina, 250
Ecce Homo, Titian, 316, **361,** 362–63
End of the World, Signorelli, 279
Enthroned Madonna and Child with Angels,
 Tura, *(Roverella Altarpiece),* **209,** 210, 211
Entombment, Raphael, 375, **376,** 441
Entombment, Titian, 360
Equestrian Portrait of Charles V, Titian, **364,**
 364–65
Este, Alfonso d': Giovanni Bellini paintings, 241,
 246, 246–47, 359
 Titian paintings, 316, **358, 359,** 360
Este, Beatrice d': Tura portrait, 209
Este, Borso d', 206, 209
Este, Ercole d', 209
Este, Isabella d', 166, 236, 344
 Leonardo da Vinci portrait, 239, 286, 298, **298**
 studiolo, paintings for, 192, 197, 200, **200, 238,**
 239, 241
 Tura portrait, 209
Este, Lionello d', 82
 J. Bellini portrait, 82, 88
 Pisanello medal and portrait, 82, 83, **83,** 88
Este family, 76, 82, 206, 209, 247
Etruscan art, 4, 139, 264, 277, 279
Eugenius IV (Pope; Gabriele Condulmer), 7, 113
Evangelista da Predis, 291
Execution of St. James, Mantegna, 226, **227,** 228
Expulsion, Masaccio, **39,** 108–09, **110**
Expulsion, Michelangelo, 108, **110,** 371

Expulsion of Heliodorus from the Temple,
 Raphael, 384, **386**
Eyck, Jan van, 157, 219–20, 230, 250
 Lucca Madonna, 253, **253**

Fall, Masolino, **39,** 39–40, **40,** 41–42, 68
Fall, Michelangelo, 413, 438
Fall, Uccello, 67, **68**
Fall of Icarus, Sebastiano del Piombo, **368,** 369,
 384
Fall of the Rebellious Angels, Beccafumi, 426,
 428
Famous Men, Castagno, Andrea del, **150,** 153–54,
 383; *(Farinata degli Uberti),* **151,** 153, 154
Fancelli, Luca, 191
Farinata degli Uberti, Castagno, Andrea del
 (Famous Men), **151,** 153, 154
Feast of Herod, Donatello, 47
Feast of Herod, Masolino, 26, **46,** 47
Feast of the Gods, Bellini, Giovanni; reworked
 by Titian, 241, **246,** 246–47, 360
Federigo da Montefeltro, Piero della Francesco,
 142, **142,** 146
festive decorations, 6, 163, 184, 190, 206, 225, 236,
 250, 260, 275, 305, 434
Fête Champêtre, Giorgione and Titian, 351, **351,**
 354, 355
figures, treatment of, 15, 20, 21–22, 54, 57, 137,
 159, 163, 176, 188–89, 204, 210, 216, 256, 263,
 315, 317
 Angelico, Fra, 60, 62, 64, 66–67
 Antonello da Messina, 253, 255, 256
 Bartolommeo, Fra, 319, 320, 323, 325, 393, 429
 Beccafumi, 423, 424, 426
 Bellini, Giovanni, 222, 245, 246, 247, 249
 Bellini, Jacopo, 90–91, 92
 Botticelli, 166–70 *passim,* 172–73, 175, 181, 291
 Carpaccio, 216, 219, 221
 Castagno, Andrea del, 147, 150, 153, 229
 Correggio, 23, 411, 412, 413, 415, 417
 Domenico Veneziano, 127, 129
 Gentile da Fabriano, 34, 90–91, 93
 Ghiberti, 27, 30
 Ghirlandaio, 265, 266, 268, 272, 274
 Giorgione, 348, 351, 363, 367
 International Style, 27, 36, 38
 Leonardo da Vinci, 159, 286, 289, 291, 295, 296,
 297–98, 300, 304, 328, 375, 438
 Lippi, Filippino, 176, 178, 181, 182, 184, 185
 Lippi, Filippo, 113, 115, 117, 118, 120–24 *passim*
 Lotto, 403, 404, 407
 lyric painting, 14
 Mantegna, 223, 226, 228, 229, 230, 236, 239,
 256
 Masaccio, 21, 68, 104, 106, 107, 108–09, 112, 115,
 120, 393, 439
 Masolino, 39, 42–43, 91, 93
 Melozzo da Forlì, 257, 259

figures *(cont'd)*
 Michelangelo, 274, 325, 328, 331, 332, 336–37,
 339, 341–42, 343, 371, 373, 381, 396, 426
 Perugino, 193, 194–95, 196, 197, 200
 Piero della Francesco, 132, 134, 139, 141, 142,
 143
 Piero di Cosimo, 305, 307, 309, 311
 Pisanello, 79, 81, 91
 Pollaiuolo, 159, 256, 262, 263, 264–65, 274, 300
 Pontormo, 438, 439, 441, 444, 446, 447, 449
 proportion, 20, 109, 117, 185, 216, 230, 249,
 334–35, 354, 362, 378, 412, 439
 Raphael, 21, 369, 371, 375, 378, 381, 383, 384,
 387, 390, 391, 392, 393, 424
 Rosso Fiorentino, 429, 431, 432, 434
 Sarto, Andrea del, 392–93, 396, 398
 Sassetta, 93, 99, 188
 Sebastiano del Piombo, 369, 371, 372
 Signorelli, 274, 275, 277, 279, 280, 285
 Squarcione, 87
 Titian, 21, 316, 348, 354, 355, 357–65 *passim*,
 367
 Tura, 209, 210, 211
 Uccello, 67–68, 70, 74, 75, 76
 Verrocchio, 159, 163, 274, 289
 See also antiquity, interest in and influence of
Filarete, Antonio, 157
 Treatise on Architecture, 157, 158
Finding of Moses, Perugino, 191, 331
Fire in the Borgo, Raphael, 316, 384, 387, **387**,
 388
Flagellation, Signorelli, 275, **276**
Flagellation of Christ, Piero della Francesca,
 275, **277**
Flight into Egypt, Gentile da Fabriano *(Strozzi
 Altarpiece)*, 32, 34–35, **35**
Flood, Michelangelo, 316, **334**, 335–36, 337, 339,
 387
Flood and the Recession of the Waters, Uccello,
 67, 68, **69**, 70–71, 74, 335
Flora, Titian, 355, 357
Foppa, Vicenzo, 452
foreshortening, 93, 117, 129, 166, 182, 188, 194, 211,
 256, 264, 266, 280, 417, 439
 Beccafumi, 424, 426
 Bellini, Jacopo, 84, 88, 90
 Carpaccio, 217, 222
 Castagno, Andrea del, 153, 253
 Leonardo da Vinci, 291, 296–97
 Mantegna, 226, 257
 Masaccio, 106–07, 108
 Masolino, 88, 93
 Melozzo da Forlì, 257, 259, 280
 Pisanello, 81, 84
 Sarto, Andrea del, 398, 401
 Squarcione, 84, 87
 Uccello, 71, 74
Fortitude, Botticelli, 165, 166, **167**

Fortitude, Temperance, and Ancient Heroes,
 Perugino, 197, **199**
Founding of Santa Maria Maggiore, Masolino
 (Santa Maria Maggiore Altarpiece), 43, **44**,
 45, 93
Founding of Santa Maria Maggiore, Sassetta
 (Madonna of the Snow Altarpiece), 93, **96**
Four Evangelists, Lippi, Filippo, 121
Four Saints Altarpiece, Lippi, Filippino, 176, **177**,
 178
Francesco delle Opere, Perugino, **196**, 196–97
Francesco di Giorgio (Martini), 158, 186, 188–90
 Coronation of the Virgin (fresco), 186; (wood),
 186, **187**, 188
 Florence Cathedral, façade project, 186
 and Leonardo da Vinci, 186
 Madonna del Calcinaio, Cortona, architecture,
 186, 275
 Milan Cathedral, dome, 186
 Nativity, 186, 188–90, **189**
 St. John the Baptist, 186
 Sant'Agostino, Siena, Bichi Chapel, frescoes
 (attrib.), 186
 Siena Cathedral, high altar, 186
Francesco Giamberti, Piero di Cosimo, **309**, 311
Francia, Francesco, 452
Franciabigio, Francesco, 392, 438, 452
Francis I, 392, 396, 429, 434
Frari Altarpiece, Bellini, Giovanni, 241, 404
Fra Teodoro da Urbino, Bellini, Giovanni, 241,
 249
Frederick II, 4
Frederick III, 213
fresco (technique), 21, 51–52
 cartoons, 52; *polverello* (transfer), 139; reused
 and reversed, 139, 194, 197, 339
 sinopia, 51–52, **52**, 147, **149**
Fugger Portrait, Bellini, Giovanni, 240
Funeral of St. Stephen, Lippi, Filippo, 122–23,
 123, **124**
furniture, painting for and painting on, 8, 62,
 125, 129, 274, 307, 309, **310**, 311

Gaddi, Agnolo: *Story of the True Cross*, 136
Galatea, Raphael, **368**, 383, 383–84
Garofalo (Benvenuto Tisi), 452
Gates of Paradise, Ghiberti, 27, 32, 55, 62, 137,
 260; Genesis scene, 68; Noah scene, 335, **335**
Gattamelata, Donatello, 71, 84, **153**, 154, 223
Gentile da Fabriano (Gentile di Niccolò), 5,
 25–26, 27, 32, 34–35, 36, 68, 84, 90–91, 93,
 106, 111, 159, 204
 Adoration of the Magi, 32, **33**, 34, 107, 182
 Doges' Palace, Venice, frescoes, 32, 76
 and Domenico Veneziano, 125
 Flight into Egypt, 32, 34–35, **35**
 influence of, 26, 32, 35, 42, 55
 Madonna and Child Enthroned, 32

Gentile da Fabriano *(cont'd)*
　Madonna dei Notai, 32
　Madonna Enthroned, 35
　Pilgrims at the Tomb of St. Nicholas of Bari,
　　35, **36**
　and Pisanello, 35, 76, 77, 79
　Polyptych of Valle Romita, 32
　Quaratesi Altarpiece, 32, 35, **36**
　San Giovanni in Laterano, Rome, frescoes, 32
　Strozzi Altarpiece, 32, **33**, 34–35, **35**, 107, 182
　workshop and pupils, 26, 34, 35, 88, 91, 213
Ghiberti, Lorenzo, 25, 27, 30, 31
　Angelico's *Linaiuoli Altarpiece,* frame for, **58**
　Florence Baptistery, doors, 27, 32, 55; *Gates of*
　　Paradise, 27, 62, 68, 137, 260, 335, **335**
　Florence Cathedral, stained-glass designs, 146
　influence of, 30, 32, 55, 335; on Francesco di
　　Giorgio, 188; on Masaccio, 112; on Uccello, 67,
　　68
　St. John the Baptist, 27–28, **29**, 30
　Siena Cathedral, Baptistery, font, 93
Ghirlandaio, Benedetto, 265
Ghirlandaio, Davide, 265, 327
Ghirlandaio, Domenico (Domenico di Tommaso
　di Currado), 265–69, 272, 274, 315
　Adoration of the Magi, 265
　Adoration of the Shepherds, 265, 267–68, **270**
　Badia a Settimo, altarpieces, 265
　Birth of the Virgin, **273**, 274, 392–93
　Calling of Peter and Andrew, 190, **191**, 265,
　　267, **268**
　Codex Escorialensis, 274
　Deposition, 265–66, **266**
　Florence Cathedral: façade project, 166; mosaic
　　decorations, 265
　influence on, 265; of Verrocchio, 165, 265
　Last Supper (Florence), 150, 265, 266–67, **267**,
　　295; (Passignano), 265
　Library of Sixtus IV, Vatican, frescoes, 265
　Madonna of the Misericordia, 265–66, **266**
　Medici villa, Spedaletto, painting, 265
　and Michelangelo, 19, 265, 274, 327, 335
　Ognissanti, Florence, frescoes, 150, 166, 172,
　　265–66, **266**, 266–67, **267**, 295
　Palazzo della Signoria, Florence, Sala dei Gigli,
　　frescoes, 265, 267, **269**
　Pope Honorius Establishing the Rules of the
　　Franciscan Order, 269, **271**, 272; preparatory
　　drawing, 269, **271**
　St. Jerome in His Study, 166, 172, 265, 266, **266**
　Santa Maria Novella, Florence, frescoes, 184,
　　265, 272, **272**, **273**, 274, 327, 365, 383
　Santa Trinita, Florence, Sassetti Chapel,
　　frescoes, 120, 265, 268–69, **271**, 272
　Sistine Chapel, Vatican, fresco, 190, **191**, 265,
　　267, **268**
　Uomini Famosi: Brutus, Scaevola, and
　　Camillus, 267, **269**

Ghirlandaio, Domenico *(cont'd)*
　Visitation, 272, **272**, 274
　workshop, pupils, and assistants, 19, 265, 267,
　　274, 327
　mentioned, 158, 217, 319
Ghirlandaio, Ridolfo, 265
Giambono, Michele, 451
Ginevra de' Benci, Leonardo da Vinci, 286, 289,
　290, 291, 298, 348
Giorgione (Giorgio da Castelfranco), 12, 13, 17, 20,
　241, 243, 285, 317, 319, 344, 348, 350–51, 364,
　393, 413, 444
　and Carpaccio, 216, 222
　Castelfranco Altarpiece, 245, 255, **346**, 348,
　　404
　Fête Champêtre (and Titian), 351, **351**, 354, 355
　Fondaco dei Tedeschi, Venice, frescoes, 217,
　　344
　influence of, 344; on Correggio, 412, 413
　influence on: of Antonello da Messina, 254,
　　255, 348; of Leonardo da Vinci, 304, 344,
　　348, 412, 413, 415, 417; of Mantegna, 239; of
　　Perugino, 200, 348
　Laura, 344, **345**, 348
　as pupil of Giovanni Bellini, 241, 246, 250, 344,
　　367
　and Sebastiano del Piombo, 344, 350–51, 367,
　　369
　Sleeping Venus (and Titian), 348, **349**, 350, 354
　Tempest, **347**, 348, 351
　Three Philosophers (and Sebastiano del
　　Piombo), **350**, 350–51, 369
　and Titian, 18, 344, 348, 350, 351, 352, 354,
　　355, 363, 367
Giorno, Il, Correggio *(Madonna and Child with*
　Sts. Jerome and Mary Magdalen), 411, 417,
　420
Giotto, 20, 265
　influence of, 54, 100
　Lamentation, 54, **54**
　Santa Croce, Florence, frescoes, 112
Giovanni di Paolo, 451
Giovanni Pisano, 27
Girolamo da Cremona, 188
Giuliano da San Gallo, Piero di Cosimo, **309**, 311
God the Father with Prophets and Sibyls,
　Perugino, 197, **199**
God the Father with Sts. Catherine of Siena and
　Mary Magdalen, Fra Bartolommeo, 318, **322**,
　323
Goes, Hugo van der: *Adoration of the Shepherds*
　(Portinari Altarpiece), 268, **270**
gold and gold leaf, use of, 34, 35, 60, 62, 132
goldsmiths, 26, 27, 260
Gonzaga, Federigo, 360, 415
Gonzaga, Francesco, 225, 235, 236, 239
Gonzaga, Ludovico, 225
Gonzaga, Ludovico III, 235

Gonzaga family, 76, 225, 235, 236, 352
Gothic art, 4, 5, 27, 34, 36, 38, 53, 77, 92, 444
Goya, Francisco de, 236
Gozzoli, Benozzo, 67, 451
 Adoration of the Magi, 66
Orvieto Cathedral, San Brizio Chapel, frescoes, 279
Greek art. *See* antiquity, interest in and influence of
Gregory IX Approves the Decretals, Raphael, 379
Guarino Veronese, 81

Hercules and Antaeus, Pollaiuolo (painting), **262**, 263, 264; (sculpture), **262**, 263–64
Holy Family (as theme), 327
Holy Family, Lotto, 404, 407, **407**
humanism, 3, 197, 211, 213

Immaculate Conception, Piero di Cosimo, 305
Incarnation of Christ with Saints, Piero di Cosimo, **308**, 309
Innocent VIII (Pope; Giovanni Battista Cibo), 7, 190, 225
 tomb by Pollaiuolo, 260
Inscription with Putti, Mantegna, 235, **235**
Institution of the Eucharist, Signorelli, 275, **284**, 285
International Style, 27, 36, 38, 53, 77
Isabella d'Este, Leonardo da Vinci, 239, 286, 298, **298**
Italian language: Florentine dialect, 16, 22; Venetian dialect, 22

Jacopo di Voragine: *Golden Legend*, 136, 184
Jeremiah, Donatello, 147
Journey of the Magi, Sarto, Andrea del, 392
Judgment and Martyrdom of St. Peter, Lippi, Filippino, 15, **39**, **181**, 182
Judith and Holofernes, Michelangelo, 334
Julius II (Pope; Giuliano della Rovere), 7, 384, 402
 and Michelangelo, 327, 332
 and Raphael, 365, 372, 373, 379, 384, 402
Julius II, Raphael, 365, 372
Jupiter and Io, Correggio, **414**, 415
Justus van Ghent, 132
 Consecration of the Host, 75–76

Lady with the Ermine, Leonardo da Vinci, 298
Lamentation, Bellini, J., **91**, 91–92
Lamentation, Botticelli, 173, **174**, 175
Lamentation, Giotto, 54, **54**
lamentation over the dead Christ (as theme), 137
Lamentation over the Dead Christ, Fra Bartolommeo, 398, **399**
Lamentation over the Dead Christ, Perugino, 398, **399**

Lamentation over the Dead Christ with Saints, Sarto, Andrea del, 393, 398, **399**
landscape, treatment of, 4–5, 14, 15, 20, 36, 53, 57, 62, 76, 159, 165, 189, 204, 209, 266, 279, 424
 Angelico, Fra, 5, 60, 62, 124
 Bartolommeo, Fra, 323, 325
 Bellini, Giovanni, 159, 245, 246, 249
 Botticelli, 168–69, 172
 Carpaccio, 216, 219, 222
 Correggio, 23, 411, 413, 415
 Gentile da Fabriano, 5, 34–35, 93
 Giorgione, 348, 350, 351
 Leonardo da Vinci, 142, 279, 287, 289, 291, 292, 300, 304, 309
 Lippi, Filippino, 178, 181, 182
 Lippi, Filippo, 113, 124
 Lotto, 403, 407
 Mantegna, 226, 228, 230, 235, 236, 239, 279
 Masaccio, 107, 111
 Masolino, 5, 43, 45, 47, 93
 Michelangelo, 279, 343
 Netherlandish painting, 23, 226
 in oil, 245
 Perugino, 195, 196, 197, 200
 Piero della Francesca, 134, 137, 141, 142, 143
 Piero di Cosimo, 309, 311, 323
 Raphael, 373, 375, 381
 Sarto, Andrea del, 392, 398
 Sassetta, 93, 99
 Sebastiano del Piombo, 369, 371
 Titian, 355, 360, 365
Landscape, Leonardo da Vinci, 287, **287**
Laocoön, 336, **337**
Last Judgment (as theme), 280
Last Judgment, Fra Bartolommeo and Albertinelli, 318, 319, **320**
Last Judgment, Michelangelo, 19, 190, 319, 327, **340**, 341–42, 343, 344, 426
Last Supper, Castagno, Andrea del (Hospital of Santa Maria Nuova), 147; (Sant'Apollonia), 147, **148**, **149**, 150, 153–54, 266, 267, 295
Last Supper, Ghirlandaio (Florence), 150, 265, 266–67, **267**, 295; (Passignano), 265
Last Supper, Leonardo da Vinci, 18, 150, 266, 285, 286, 295–96, **296**, 297–98, 315–16, 381; studies for, **296**, **297**
Last Supper, Sarto, Andrea del, 150, 392
Last Supper, Titian, 353
Laura, Giorgione, 344, **345**, 348
Leo X (Pope; Giovanni de' Medici), 4, 7, 285, 305, 392
 Raphael paintings, 259, 364, 365, 384, 387, 390–91, **391**, 392
Leonardo da Vinci, 10, 11, 14, 16, 18–19, 142, 158, 163, 175, 279, 285–87, 289, 291–92, 295–98, 300, 304, 319, 328, 369, 392, 393, 431, 444
 Adoration of the Magi, 18, 286, 289, 291, **293**

Leonardo da Vinci *(cont'd)*
Annunciation, 286, **289,** 291
Bacchus, 286, 304, **304**
Battle of Anghiari, 18, 73, 285, 286, 295, 298,
300, 309, 331, 446; copies, 287, 300, **301;**
studies for, 18, 300, **301**
Benois Madonna, 289, 291, **292**
drawings, 159, 286, 287, 291, 304
figures, 159, 286, 289, 291, 295, 296, 297–98,
300, 304, 328, 375, 438
and Francesco di Giorgio, 186
Ginevra de' Benci, 286, 289, **290,** 291, 298, 348
influence of, 176; on Fra Bartolommeo, 319,
323; on Giorgione, 304, 344, 348, 412, 413,
415, 417; on Lombard painters, 11, 304; on
Lotto, 407, 411; on Piero di Cosimo, 309; on
Pontormo, 446; on Raphael, 18, 300, 304,
373, 378, 384
influence on: of Masaccio, 100, 295; of Milanese
painters, 11; of Piero della Francesca, 146
Isabella d'Este, 239, 286, 298, **298**
Lady with the Ermine, 298
Landscape, 287, **287**
Last Supper, 18, 150, 266, 285, 286, 295–96,
296, 297–98, 315–16, 381; studies for, 296, **297**
Madonna and Child with St. Anne, 286, 300,
303, 304, 446
*Madonna and Child with St. Anne and John
the Baptist (Burlington House Cartoon),* 300,
302, 304
Madonna of the Rocks (London), 286, 291–92,
295, **295;** (Paris), 286, 291–92, **294,** 295, 304
Madonna with the Vase, 289
and Michelangelo, 328, 342, 343
Mona Lisa, 285, 286, 298, **299,** 300, 304, 390
notebooks, 100, 287
on Pollaiuolo's *Battle of Ten Nudes,* 264–65
pupils and assistants, 286, 287, 291
St. John the Baptist, 304
and Verrocchio, 13, 18, 163, 165, 166, 286, 287,
289, 291, 300
Verrocchio's *Baptism of Christ,* work on, 163,
165, 287, **288,** 289
writing, 5; *Treatise on Painting,* 159, 287
mentioned, 158, 344, 413
Liberale da Verona, 188
Liberation of St. Peter from Prison, Raphael,
363, 364
Liberius, Pope, 45
Libyan Sibyl, Michelangelo (studies for), 339,
339, 341
light, awareness and use of, 5, 34, 52, 53, 57, 106,
150, 159, 188, 210, 216, 229, 257, 323, 396, 431
Angelico, Fra, 57, 60, 62, 64, 132
Antonello da Messina, 243, 253, 256
Beccafumi, 424, 426
Bellini, Giovanni, 243, 245, 247, 249–50
Carpaccio, 220, 222

light *(cont'd)*
Correggio, 415, 417
Domenico Veneziano, 127, 129
Giorgione, 348, 350, 351, 444
Leonardo da Vinci, 291, 292, 300, 304, 342, 444
Lippi, Filippino, 178, 181
Lippi, Filippo, 117, 120, 122
Lotto, 403, 407
Masaccio, 104, 106, 107
Masolino, 39, 108
Michelangelo, 328, 332, 337, 339, 342
Piero della Francesca, 132, 141, 143, 243
Piero di Cosimo, 307, 309
Pontormo, 441, 444, 446, 447
Sassetta, 99, 132
Sebastiano del Piombo, 369, 371
Titian, 342, 354, 357, 364
Venetian painting, 22, 219, 241
See also *chiaroscuro*
Linaiuoli Altarpiece, Fra Angelico, 55, 57, **58,** 60
Lionello d'Este, Pisanello, 83, **83,** 88
Lippi, Filippino, 62, 113, 176, 178, 181–82, 184–86
Adoration of the Magi, 176, 182, **183,** 184
Annunciation, 176, 178, **178**
Deposition (and Perugino), 429
Florence Cathedral, façade project, 176
Four Saints Altarpiece, 176, **177,** 178
influence of, 176, 178; on Fra Bartolommeo,
319; on Sarto, Andrea del, 393
influence on: of Botticelli, 176, 178, 182; of
Melozzo da Forlì, 182
Judgment and Martyrdom of St. Peter, 15, 39,
181, 182
Marriage of St. Catherine, 176
*Raising of the Son of Theophilus and St. Peter
Enthroned* (and Masaccio), 15, 39, 41, **180,**
181–82
*St. Philip Driving the Dragon from the
Temple,* 184–86, **185**
Santa Maria del Carmine, Florence, Brancacci
Chapel, frescoes, 15, 39, 40, 41, 107, **180,** 181,
181–82
Santa Maria Novella, Florence, Strozzi Chapel,
frescoes, 176, 184–86, **185**
Santa Maria sopra Minerva, Rome, Caraffa
Chapel, frescoes, 176, **181,** 182
Virgin in Glory, **181,** 182
Vision of St. Bernard, 178, **179,** 181, 319–20
mentioned, 158, 190, 441
Lippi, Fra Filippo (Filippo di Tommaso di
Lippo), 12, 18, 20, 84, 112–15, 117–18, 120–24,
146, 176, 178, 315
Adoration of the Child, 113
Annunciation, 119, 120
Barbadori Altarpiece, 113, **117,** 117–18, 120
and Botticelli, 165, 166
Coronation of the Virgin, 113, 118, **118,** 120, 272
and Domenico Veneziano, 113, 124

Lippi, Fra Filippo *(cont'd)*
Four Evangelists, 121
Funeral of St. Stephen, 122–23, **123**, **124**
influence of, 120; on Francesco di Giorgio, 188;
on Mantegna, 230
influence on, 115, 120, 124, 122
Madonna and Child with Saints (attrib.),
113–14, **115**
Madonna Enthroned with Saints, 113, **117**,
117–18, 120
and Masaccio, 54, 113, 114, 115, 120
Prato Cathedral, frescoes, 113, 120–23, **122**, **123**,
124, **124**, 136, 165, 295
Rules of the Carmelite Order, 113, **114**
St. Bernard's Vision of the Virgin, 113
St. Luke, 121–22, **122**
Santa Maria del Carmine, Florence, frescoes,
112, 113
Spoleto Cathedral, frescoes, 113
Stoning of St. Stephen, 122
Tarquinia Madonna, 62, 87, 113, 115, **116**, 117,
125, 253
mentioned, 157, 223, 260
Lombardi, Pietro, 245
Lorenzetti, Ambrogio, 20, 93
Lorenzetti, Pietro, 20, 93
Lorenzo di Credi, 160, 165, 166, 452
Lorenzo Monaco (Piero di Giovanni), 5, 25–26,
27, 35, 36, 38, 60
Adoration of the Magi, 36, **37**
Deposition from the Cross (and Fra Angelico),
60, **61**, 62, 127
influence of, 26, 32
Santa Trinita, Florence, frescoes, 36
Lotto, Lorenzo, 5, 317, 402–04, 407, 411
Assumption of the Virgin, 402
Holy Family, 404, 407, **407**
influence on, 222, 403–04, 407, 411
*Madonna and Child Enthroned with Sts.
Catherine, Augustine, Sebastian, Anthony
Abbot, and the Infant John the Baptist,* 407,
409
Madonna and Child with St. Peter Martyr,
400, 403
Madonna and Child with Saints, 404, **406**
Pala of San Bartolommeo, 407
Recanati Polyptych, 404, **406**, 407
Santa Cristina al Tivarone Altarpiece, 402,
403–04, **405**
Santa Maria Maggiore, Bergamo, intarsia, 402
Susanna and the Elders, 407, **408**
Lucca Madonna, Eyck, Jan van, 253, **253**
Luini, Bernardino, 452
Luther, Martin, 403
lyric painting, characteristics of, 14

Machiavelli, Niccolò, 300
Madonna, Bellini, Giovanni, 241

Madonna, Piero di Cosimo, 305
Madonna and Child (as theme), 6
Madonna and Child, Antonello da Messina *(San
Gregorio Polyptych),* **252**, 253
Madonna and Child, Bellini, Giovanni (1504),
241; (1510), 241, **248**, 249–50
Madonna and Child, Bellini, J., 88, **90**, 91
Madonna and Child, Castagno, Andrea del,
153–54
Madonna and Child, Domenico Veneziano,
129–30, **131**
Madonna and Child, Mantegna *(San Zeno
Altarpiece),* **229**, 229–30
Madonna and Child, Signorelli, 277, 279, **279**,
328
Madonna and Child, Squarcione, 84, **85**, 87
Madonna and Child Enthroned, Gentile da
Fabriano, 32
Madonna and Child Enthroned, Masaccio *(Pisa
Altarpiece),* **105**, 106, 114, 255
*Madonna and Child Enthroned with Sts.
Catherine, Augustine, Sebastian, Anthony
Abbot, and the Infant John the Baptist,*
Lotto, 407, **409**
*Madonna and Child Enthroned with Sts.
Stephen and John the Baptist,* Fra
Bartolommeo, 318
Madonna and Child with St. Anne, Leonardo da
Vinci, 286, 300, **303**, 304, 446
Madonna and Child with St. Anne, Masaccio
and assistants, 100–01, **102**
*Madonna and Child with St. Anne and John the
Baptist,* Leonardo da Vinci *(Burlington
House Cartoon),* 300, **302**, 304
*Madonna and Child with St. Anne and Other
Saints,* Pontormo, 437, **445**, 446, 447
Madonna and Child with St. Peter Martyr,
Lotto, **400**, 403
Madonna and Child with Saints, Correggio
(Madonna of San Francesco), **410**, 411–12
Madonna and Child with Saints, Domenico
Veneziano *(St. Lucy Altarpiece),* 64, **126**,
127, 129
Madonna and Child with Saints, Lippi, Filippo
(attrib.), 113–14, **115**
Madonna and Child with Saints, Lotto *(Recanati
Polyptych),* 404, **406**
Madonna and Child with Saints, Signorelli,
274–75, **278**
*Madonna and Child with Saints, Angels, and
Duke Federigo da Montefeltro,* Piero della
Francesca *(Brera Altarpiece),* 142, **144**, 239,
255, 291
*Madonna and Child with Sts. Jerome and Mary
Magdalen,* Correggio *(Il Giorno),* 411, 417,
420
Madonna and Saints, Beccafumi, 423
Madonna and Saints, Castagno, Andrea del, 150

Madonna degli Alberetti, Bellini, Giovanni, 241, **248**, 249
Madonna dei Notai, Gentile da Fabriano, 32
Madonna della Misericordia (as theme), 236
Madonna della Misericordia, Fra Bartolommeo, 318
Madonna della Misericordia, Piero della Francesca *(Altarpiece of the Misericordia),* 132, **133**, 134, 236
Madonna della Scodella, Correggio, 411
Madonna della Vittoria, Mantegna, 225, 236, **237**, 239, 404, 411
Madonna del Magnificat, Botticelli, 172–73, **173**
Madonna del Sacco, Sarto, Andrea del, 392, **400**
Madonna Enthroned, Gentile da Fabriano, 35
Madonna Enthroned with Saints, Lippi, Filippo *(Barbadori Altarpiece),* 113, **117**, 117–18, 120
Madonna Enthroned with Sts. John the Baptist and Sebastian, Perugino, 191, **194**, 195, 196
Madonna in Glory with Saints, Fra Bartolommeo, 318
Madonna of Foligno, Raphael, 357, 412, **412**
Madonna of Humility, Domenico di Bartolo, 115, **115**
Madonna of San Francesco, Correggio *(Madonna and Child with Saints),* **410**, 411–12
Madonna of the Baldacchino, Raphael, 323
Madonna of the Chair, Raphael, 253
Madonna of the Goldfinch, Raphael, **377**, 378–79
Madonna of the Harpies, Sarto, Andrea del, 392, 396, **397**
Madonna of the Misericordia, Ghirlandaio, 265–66, **266**
Madonna of the Rocks, Leonardo da Vinci (London), 286, 291–92, 295, **295**; (Paris), 286, 291–92, **294**, 295, 304
Madonna of the Snow Altarpiece, Sassetta, 93, **94**, 95, **95**, 99; *Founding of Santa Maria Maggiore,* 93, **96**
Madonna of the Stairs, Michelangelo, 19
Madonna with Sts. John the Baptist and Donatus, Verrocchio and workshop, 160, **164**, 165
Madonna with the Vase, Leonardo da Vinci, 289
Maestà, Duccio di Buoninsegna, 188
Magdalen in the Desert, Correggio, 411
Mainardi, Bastiano, 265
Mannerism, 10, 24, 316–17, 341
Mantegna, Andrea, 10, 13, 16, 20, 21, 24, 88, 92, 120, 123, 146, 158, 204, 211, 223, 225–26, 228–30, 232, 234–36, 239, 260, 279
 Agony in the Garden, 230
 and Bellini, Giovanni, 16, 239, 240–41, 245–46
 Court, **233**, 234–35
 Crucifixion, 230, **230**, 232, 269, 272
 Ducal Palace, Mantua, Camera degli Sposi, frescoes, 6, 153, 197, 211, 225, 229, **231–36**, 234–36, 257, 381

Mantegna, Andrea *(cont'd)*
 Eremitani, Padua, Ovetari Chapel, frescoes, 137, **224**, 226, **227**, 228
 Execution of St. James, 226, **227**, 228
 influence of, 188, 222, 335; on Antonello da Messina, 256; on Carpaccio, 217, 222; on Correggio, 222, 239, 411; on Giorgione, 239; on Lotto, 222, 403–04, 407, 411; on Melozzo da Forlì, 257; on Raphael, 239; on Titian, 222, 239; on Tura, 210
 influence on, 223, 357; of Castagno, Andrea del, 229, 230; of Donatello, 223, 226, 229; of Lippi, Filippo, 230; of Piero della Francesca, 223, 230, 235
 Inscription with Putti, 235, **235**
 Madonna and Child, **229**, 229–30
 Madonna della Vittoria, 225, 236, **237**, 239, 404, 411
 Meeting, 235, **236**
 oculus, 232, 234, 235
 Parnassus, 197, 200, **238**, 239
 Presentation in the Temple, 404; Giovanni Bellini's copy, 404
 as pupil of Squarcione, 84, 87, 223, 225–26
 Resurrection, 230
 St. James Led to Execution, **224**, 226
 St. Sebastian, **231**, 232, 234
 Santa Sofia, Padua, altarpiece, 225
 San Zeno Altarpiece, 226, **228**, 228–30, **229**, **230**, 232, 235, **243**, 243, 269, 272
 Servants with Horse and Dog, **234**, 235
 Triumphs of Caesar, 236
 mentioned, 217, 344
Marriage of St. Catherine, Fra Bartolommeo, 318, 323, **323**
Marriage of St. Catherine, Lippi, Filippino, 176
Marriage of the Virgin, Raphael, 17, 373, **374**, 387
Marriage of the Virgin, Rosso Fiorentino, 432, **433**
Martin V (Pope; Oddone Colonna), 3, 7, 32, 112
Martini, Simone, 20, 93
 Annunciation, 90
Martyrdom of St. Agatha, Sebastiano del Piombo, 367, **372**
Martyrdom of St. Lawrence, Titian, **362**, 363–64
Martyrdom of St. Maurice and the Theban Legion, Pontormo, 446–47, **447**
Martyrdom of St. Sebastian, Pollaiuolo, 260, **261**, 262, 263, 264
Mary Magdalen, Perugino, **195**, 196
Masaccio (Tommaso di ser Giovanni), 10, 12, 13, 14, 16, 17, 20–26 *passim,* 41, 45, 53–54, 57, 100–02, 104, 106–09, 111–12, 123, 132, 147, 241, 265, 315, 375
 Adoration of the Magi, **107**, 107
 and Brunelleschi, 30, 101, 102, 104, 112
 Crucifixion, **106**, 107

Masaccio *(cont'd)*
Expulsion, **39**, 108–09, **110**
figures, 21, 68, 104, 106, 107, 108–09, 112, 115, 120, 393, 439
Finding of the Son of Theophilus and St. Peter Enthroned (and Filippino Lippi), 15, **39**, 41, **180**, 181–82
influence of, 54, 100, 112, 115; on Leonardo da Vinci, 100, 295; on Michelangelo, 100, 108, 336
influence on: of Donatello, 30, 101, 102, 104, 112; of Gentile da Fabriano, 35; of Ghiberti, 112; of Giotto, 100; of Nanni di Banco, 31
and Lippi, Filippo, 54, 113, 114, 115, 120
Madonna and Child Enthroned, **105**, 106, 114, 255
Madonna and Child with St. Anne (and assistants), 100–01, **102**
People Giving Their Goods to St. Peter and the Death of Ananias, **39**, 108, **109**
Pisa Altarpiece, 100, 101, **105**, 106, **106**, 107, **107**, 114, 115, 127, 255
St. Peter Baptizing the Neophytes, **39**, 43, **43**, 108–09, **111**
St. Peter Healing with His Shadow, **39**, 108, **109**
San Giovenale Altarpiece, 100–01, **101**
Santa Maria del Carmine, Florence, Brancacci Chapel, frescoes, 15, 21–22, 25, 31, **39**, 40, 41–42, 43, **43**, 53, 57, 100, 101, 106, 107, 108–09, **109**, **110**, **111**, 111–12, 113, 134, 136, 137, **180**, 181–82, 229, 295, 381
Tribute Money, 22, 31, **39**, 41–42, 108, **111**, 111–12, 137, 229, 295
Trinity, 42, 100, 101–02, **103**, 104, **104**, 106, 107
mentioned, 157, 158, 159
Masolino (da Panicale; Maso, or Tommaso di Cristofano Fini), 5, 12, 25–26, 27, 36, 39–43, 45, 47, 88, 91, 111, 241
Annunciation, 45, **45**
Assumption of the Virgin, 43
Castiglione Olona, Collegiata, frescoes, 26, **46**, 47
Fall, **39**, 39–40, **40**, 41–42, 68
Feast of Herod, 26, **46**, 47
Founding of Santa Maria Maggiore, 43, **44**, 45, 93
influence of, 26, 32, 39; on Fra Angelico, 55, 57, 60; on Pisanello, 77; on Uccello, 68, 73
influence on, of Gentile da Fabriano, 35, 42
Pietà, **38**, 39
Resurrection of Tabitha and the Healing of a Cripple, **39**, 41, 41–42, 108
St. Peter Preaching, **39**, **42**, 43, 108
Sts. Peter and Paul, 43, 57, **58**
San Clemente, Rome, Chapel of the Sacrament, frescoes, 26, 45, **45**
San Fortunato, Todi, fresco, 26

Masolino *(cont'd)*
Santa Maria del Carmine, Florence, Brancacci Chapel, frescoes, 25, 26, **39**, 39–43 *passim*, **40**, **41**, **42**, 47, 57, 68, 107, 108
Santa Maria Maggiore Altarpiece, 26, 43, **44**, 45, 57, **58**, 93
Story of the True Cross, 39, 136
mentioned, 157, 159
Master of Flémalle, 253
Matteo di Giovanni, 452
medals, 76–77, 82, **83**, 186
Medici, Carlo de', 123
Medici, Cosimo de' ("Il Vecchio"), 62, 167
Pontormo portrait, 447, **449**
Medici, Cosimo I de', 447
Medici, Giovanni de' (1424–63): Verrocchio tomb, 160
Medici, Giovanni de' (1475–1521). *See* Leo X
Medici, Giuliano de', 286, 446
Medici, Giulio de'. *See* Clement VII
Medici, Lorenzo de' ("Il Magnifico"), 73, 158–59, 166, 167, 184, 260, 265, 269, 275, 285, 327, 438
Medici, Piero de': and Domenico Veneziano, 113, 124–25
Verrocchio tomb, 160
Medici, Piero di Cosimo de', 260
Medici family, 73, 327
as patrons, 62, 64, 71, 73, 113, 158–59, 160, 163, 166, 167, 184, 265, 277, 279, 327, 392, 431, 434, 438, 439, 446
Medici Venus, 170, 373, **375**
Meditation on the Passion of Christ, Carpaccio, **220**, 222
Meeting, Mantegna, 235, **236**
Meeting of Joachim and Anna at the Golden Gate, Beccafumi, **421**, 423
Melozzo da Forlì, 21, 158, 159, 182, 256–57, 259, 280
Blessing Christ, 259, **259**
Sixtus IV Appointing Platina as Prefect of the Vatican Library, 257, **258**, 259
Melzi, Francesco, 287
Menabuoi, Giusto de', 84
Mercanzia (Florence), 104, 160, 165
Michelangelo (Buonarroti), 4, 10, 12, 13, 16, 18, 19, 20, 22, 24, 52, 175, 279, 285, 286, 316, 317, 325, 327–29, 331–32, 334–37, 339, 341–43, 391, 392, 434
Bacchus, 431
Battle of Cascina, 19, 295, 300, 316, 327, 329, 331, 342, 344, 396, 446; copies, 329, **329**; studies for, **329**, 331
Battle Relief, 19, **330**, 331
Bound Slave, 441
Conversion of St. Paul, 19, 327, 342, **342**
Creation of Adam, **336**, 336–37, 339, 371, 446
Creation of Eve, 337, **338**, 339, 432

Michelangelo *(cont'd)*
Crucifixion of St. Peter, 19, 327, 342–43, **343**
Cumaean Sibyl, 337, **338**, 339
David (bronze), 431; (marble), 327, 329, 331, 375; committee on placement, 166, 176, 192, 305
David and Goliath, 334, **334**
and Donatello, 334–35, 336
Doni Madonna, 327–28, **328**, 344, 375, 413
Fall, 413, 438
figures, 274, 325, 328, 331, 332, 334–35, 336–37, 339, 341–42, 343, 371, 373, 381, 396, 426
Flood, 316, **334**, 335–36, 337, 339, 387
and Ghirlandaio, 19, 265, 274, 327, 335
Giuliano de' Medici, statue of, 446
influence of, 176, 317, 329, 331; on Fra Bartolommeo, 325; on Correggio, 413, 415; on Pontormo, 438, 446, 447; on Raphael, 18, 373, 375, 387; on Rosso Fiorentino, 431, 432
influence on, 335, 336, 342, 344; of Masaccio, 100, 108, 336; of Uccello, 71, 335
Judith and Holofernes, 334
Julius II, tomb, 327
Last Judgment 19, 190, 319, 327, **340**, 341–42, 343, 344, 426
and Leonardo da Vinci, 328, 342, 343
Libyan Sibyl, studies for, 339, **339**, 341
Madonna of the Stairs, 19
Medici tombs, 327, 431, 446
Pauline Chapel, Vatican, frescoes, 19, 327, **342**, 342–43, **343**, 344
Piccolomini altar, Siena Cathedral, 204, 421
Pietà, 337, 375
Prophet Ezekiel, 337
St. Anne with the Virgin and the Christ Child, **445**, 446
and Sebastiano del Piombo, 14, 327, 342, 367, 371
and Signorelli, 274, 328
Sistine Chapel, Vatican, frescoes, 6, 19, 71, 108, **110**, 121, 122, 190, 234, 257, 285, 316, 317, 319, 325, 327, 331, 332, **332**, **333**, 334, 334–37, **336**, **338**, 339, **339**, **340**, 341–42, 343, 344, 387, 393, 413, 426, 432, 438, 444, 446, 447
Temptation and Expulsion, 108, **110**, 371
and Titian, 331, 342, 343, 352, 355
writing, 325, 327
mentioned, 352, 354, 404, 413, 423, 447
Michele da Firenze, 79
Michelozzo di Bartolommeo, 64, 104, 129
miniatures and illuminations, 79, 115, 228
Miracle of the Speaking Babe, Donatello, 87
Miracle of the Speaking Babe, Titian, **353**, 354
Miraculous Draught of Fishes, Raphael, 387–88, **388**
Mona Lisa, Leonardo da Vinci, 285, 286, 298, **299**, 300, 304, 390
Montagna, Bartolomeo, 452

Montefeltro, Federigo da, 157, 186
Piero della Francesca paintings, 142, **142**, **143**, **144**, 146, 239, 255, 291
monumental painting, characteristics of, 14–15
Moses and the Golden Calf, Beccafumi, 424, 426, **427**
Moses in Egypt and Midian, Botticelli, 172, **172**, **191**
Mystic Nativity, Botticelli, 166, 175, **175**
mythology and fable, 6, 168–70, 234, 236, 239, 246–47, 249, 260, 263, 264, 265, 307, 309, 311, 358, 359–60, 367, 369, 403, 434

Nanni di Banco, 13, 25, 30–31, 54, 112, 121–22
Quattro Santi Coronati, 31, **31**
Nanni di Bartolo (Il Rosso), 76, 77
narrative painting, 5–6, 20, 21, 22, 26, 47, 112, 137, 143, 204, 210, 215, 219, 220–21, 222, 235, 257, 259, 265, 266, 274, 309, 315–16, 331, 335, 381, 383, 388, 396, 404, 407, 415, 417, 423
narrative reliefs, 30, 47
Nativity (as theme), 143
Nativity, Francesco di Giorgio, 186, 188–90, **189**
Nativity, Perugino, 191, 331
Nativity, Piero della Francesca, 142–43, **145**, 146
Nativity of Mary, Sebastiano del Piombo, 367
nature and naturalistic elements, 4–5, 14, 27, 34, 62, 70, 71, 81, 204, 226, 230, 267, 289, 291–92, 307, 315, 348, 360, 404, 439. *See also* landscape; light
Neroccio de' Landi, 186, 452
Netherlandish painting, knowledge and influence of, 23, 34, 115, 120, 141, 178, 210–11, 216, 226, 230, 250, 253, 256, 268, 292, 305
detail, 219–20, 391, 398
still-life elements, 23, 277
Niccolò da Tolentino, Castagno, Andrea del, 71, 73, 146–47, **152**, 154, 365
Niccolò dell'Arca, 211, 336
Nicholas V (Pope; Tommaso Parentucelli), 7, 66
Angelico frescoes for chapel and study, 55, 57, **65**
Noli me tangere, Correggio, 413, **413**, 415
Notte, La, Corregio, 411
nude, treatment of. *See* figures
Nymph and Shepherd, Titian, 365, 367

Oath of Leo III, Raphael, 373
oil paint, use of, 21, 52, 146, 216, 243, 245, 250, 292, 351, 355
and tempera, combination, 243
and *trompe l'oeil,* 307
Ovid, 6, 247, 415, 434

Pacioli, Luca, 132, 274
painters' guild (Florence; Medici e Speziali), 26, 32, 36, 67, 100, 146, 305, 391, 426
painters' guild (Padua), 84

painters' guild (Perugia), 201
Pala of San Bartolommeo, Lotto, 407
Pala Pitti, Fra Bartolommeo, 325
Palma Vecchio, 452
Parmigianino, 24, 304, 417, 421
Parnassus, Mantegna, 197, 200, **238,** 239
Parnassus, Raphael, 379, 381, 383, **383**; study for, 383, **383**
patronage, 6, 8. *See also individual patrons*
Paul III (Pope; Alessandro Farnese), 7, 341, 342
 Titian paintings, 352, **365**
Pazzi Madonna, Donatello, 81, **81**
Penitent Magdalen, Titian, 360, **360,** 362
pentimenti, 250, 351
People Giving Their Goods to St. Peter and the Death of Ananias, Masaccio, 39, 108, **109**
perspective, treatment of, 20, 21, 27, 53, 57, 62, 84, 159, 166, 188, 211, 215, 249, 266, 296–97, 305, 373
 Alberti, 53, 66
 Bellini, Jacopo, 84, 88, 90
 Brunelleschi, 12, 26, 42, 53, 93, 102
 Carpaccio, 217, 221
 Domenico Veneziano, 125, 129
 Lippi, Filippo, 112, 117, 120, 122
 Mantegna, 223, 226
 Masaccio, 12, 26, 42, 102, 107, 108, 112
 Masolino, 12, 39, 42, 45, 47
 Melozzo da Forlì, 159, 257
 Michelangelo, 334, 341, 342
 Piero della Francesca, 132, 137, 141
 Pisanello, 77, 79, 84
 quadratura, 234–35, 257
 Uccello, 21, 67, 71, 74, 75, 76, 257
 See also foreshortening
Perugino, Pietro (Pietro di Cristofano Vannucci), 20, 190–97, 200, 206, 279
 Adoration of the Child, 197
 Albani Torlonia Polyptych, **193,** 195
 Assumption of the Virgin, 191, 331
 Battle of Love and Chastity, 192, 197, 200, **200,** 239
 Christ Handing the Keys to St. Peter, 191, 192, 193–95, 204, 373
 Collegio di Cambio, Perugia, frescoes, 191, 197, **199,** 204
 Doges' Palace, Venice, painting, 191
 Finding of Moses, 191, 331
 Florence Cathedral, façade project, 166
 Fortitude, Temperance, and Ancient Heroes, 197, **199**
 Francesco delle Opere, **196,** 196–97
 God the Father with Prophets and Sibyls, 197, **199**
 influence of, 190, 200, 323; on Beccafumi, 423, 424; on Correggio, 200, 412; on Giorgione, 200, 348; of Signorelli, 275, 277
 influence on: of Florentine painting, 202; of Verrocchio, 165, 194

Perugino, Pietro *(cont'd)*
 Lamentation over the Dead Christ, 398, **399**
 Lippi's *Deposition* completed by, 429
 Madonna Enthroned with Sts. John the Baptist and Sebastian, 191, **194,** 195, 196
 Mary Magdalen, **195,** 196
 Nativity, 191, 311
 and Raphael, 17, 18, 195, 197, 200, 373, 375, 379
 St. Sebastian, **195,** 196
 Sant'Agostino, Siena, altarpiece, 192
 Sistine Chapel, Vatican, frescoes, 166, 172, 190, **191,** 192, 192–95, 200–01, 204, 265, 331, 341, 373
 Stanza dell'Incendio, Vatican, fresco, 192
 Transfiguration, 197
 Vision of St. Bernard, **321,** 323
 mentioned, 158, 217, 344, 412, 421
Peruzzi, Baldassare, 367, 404, 421, 452
Pesaro, Jacopo, 359, **360**
Pesaro Altarpiece, Bellini, Giovanni *(Coronation of the Virgin),* 241, **242,** 243
Pesaro Madonna, Titian, 285, 352, **357,** 358–60
Pesellino, Francesco, 125, 157–58, 451
Petrarch, 6, 150
Petrucci, Pandolfo, 202
Philip II, 352, 353
Pico della Mirandola, Giovanni, 206
Piero della Francesca (Piero di Benedetto Franceschi), 5, 13, 14, 20, 99, 123–24, 130, 132, 134, 136–37, 139, 141–43, 146, 241, 243, 285, 315
 Adoration of the Wood by the Queen of Sheba and the Meeting of the Queen of Sheba and Solomon, 136, 139, **140**
 Altarpiece of the Misericordia, 130, 132, **133,** 134, 236
 and Fra Angelico, 57, 132
 Annunciation, **136,** 141, **141**
 and Antonello da Messina, 146, 253, 255, 256, 344, 348
 Baptism of Christ, 132, 134, **135,** 139
 Battista Sforza and *Triumph of Battista Sforza,* 142, **142,** 143, 146
 and Bellini, Giovanni, 243, 245
 Brera Altarpiece, 142, **144,** 239, 255, 291
 Burial of the Wood, **136,** 137, **137**
 Death of Adam, **136,** 137, **138,** 139
 Federigo da Montefeltro and *Triumph of Federigo da Montefeltro,* 142, **142,** 143, 146
 Flagellation of Christ, 275, **277**
 influence of, 146, 147; on Mantegna, 223, 230, 235
 influence on, 54, 134, 202; of Domenico Veneziano, 130, 132
 Madonna and Child with Saints, Angels, and Duke Federigo da Montefeltro, 142, **144,** 239, 255, 291
 Madonna della Misericordia, 132, **133,** 134, 236

Piero della Francesca *(cont'd)*
Nativity, 142–43, **145,** 146
St. Jerome, 130
*St. Sigismond and Sigismondo Pandolfo
 Malatesta,* 130, 132, **134**
San Francesco, Arezzo, frescoes, 132, **136,**
 136–37, **137, 138,** 139, **140,** 141, **141**
Sant'Agostino, Borgo San Sepolcro, polyptych,
 132
Sant'Egidio, Florence, frescoes, 125, 130, 147
and Signorelli, 146, 274, 275
writing on perspective and mathematics, 132
mentioned, 158, 211, 223, 379
Piero di Cosimo (Piero di Lorenzo), 158, 190,
 304–05, 307, 309, 311, 323, 434
Francesco Giamberti, **309,** 311
Giuliano da San Gallo, **309,** 311
Immaculate Conception, 305
Incarnation of Christ with Saints, **308,** 309
influence on, 305, 309
Madonna, 305
as pupil of Rosselli, 305, 316
and Sarto, Andrea del, 305, 392
Venus, Mars, and Cupid, 307, **307,** 309
*Visitation with Sts. Nicholas and Anthony
 Abbot,* 305, **306,** 307
Vulcan and Aeolus, **310,** 311
Pietà, Castagno, Andrea del, 146
Pietà, Masolino, **38,** 39
Pietà, Michelangelo, 337, 375
Pietà, Tura *(Roverella Altarpiece),* 210, **210,** 211
Pilgrims at the Tomb of St. Nicholas of Bari,
 Gentile da Fabriano *(Quaratesi Altarpiece),*
 35, **36**
Pinturicchio (Bernardino di Betto [Benedetto]),
 190, 197, 200–02, 204, 206, 234
Aeneas Silvius Piccolomini Departs for Basel,
 204, **205**
Annunciation (with self-portrait), 204, **206**
Borgia apartments, Vatican, frescoes, 201, **203,**
 204
Death of St. Bernardine, **201,** 202, 204
Orvieto Cathedral, frescoes, 201
Palazzo dei Priori, Perugia, painting, 201
Santa Maria in Aracoeli, Rome, Bufalini
 Chapel, frescoes, 201, **201,** 202, 204
Santa Maria Maggiore, Spello, Baglioni Chapel,
 frescoes, 202, 204, **206**
Siena Cathedral, Piccolomini Library, frescoes,
 202, 204, **205**
Sistine Chapel, Vatican, frescoes (and
 Perugino), 200–01
Susanna and the Elders, **203,** 204
mentioned, 158, 190, 379, 421
Pisa Altarpiece, Masaccio, 100, 101, 115, 127;
 Adoration of the Magi, 107, **107;** *Crucifixion,*
 106, 107; *Madonna and Child Enthroned,*
 105, 106, 114, 255

Pisanello, Antonio, 4, 5, 10, 14, 20, 32, 68, 76–77,
 79, 81–82, 87–88, 91, 204
Annunciation, 76, 77, **77,** 79
*Apparition of the Madonna to Sts. Anthony
 Abbot and George,* **80,** 81
Doges' Palace, Venice, frescoes, 76
Drawing of a Horse, 82, **82**
and Gentile da Fabriano, 35, 76, 77, 79
Lionello d'Este, 83, **83,** 88
medals, 76–77; Lionello d'Este, 82, **83**
St. George, the Princess, and the Dragon, **78,**
 79, 81
San Giovanni in Laterano, Rome, frescoes, 76
Study of Head, **78,** 81
mentioned, 84, 157, 158, 159
Pisano, Andrea, 30
Pisano, Giovanni, 27, 30
Pius II (Pope; Enea Silvio Piccolomini), 7, 132, 204
Pinturicchio frescoes, 202, 204, **205**
Pizolo, Niccolò, 84
Pliny, 4
Poliziano, Angelo, 6, 113, 272, 384
Pollaiuolo, Antonio del (Antonio di Jacopo Benci),
 10, 20, 21, 158, 159, 163, 188, 256, 260, 262–65,
 274, 300
Battle of Ten Nudes, **264,** 264–65, 331
Birth of St. John the Baptist, 260
Dancing Nudes, **263,** 264, 265
David, 263
goldsmith and sculptor, 260, 262
Hercules and Antaeus (painting), **262,** 263,
 264; (sculpture), **262,** 263–64
Martyrdom of St. Sebastian, 260, **261,** 262, 263,
 264
Putto, **263,** 264
St. James between Sts. Vincent and Eustace,
 177, 178
tomb of Innocent VIII, 260
tomb of Sixtus IV, 260
Villa della Gallina, Arcetri, frescoes, **263,** 264,
 265, 275
Pollaiuolo, Piero del, 158, 165, 166, 260
Polyphemus, Sebastiano del Piombo, **368,** 369,
 383
Polyptych of Valle Romita, Gentile da Fabriano,
 32
Pontormo (Jacopo Carucci), 10, 14, 24, 175, 423,
 434, 437–39, 441, 444, 446–47, 449
Annunciation, **441,** 444
Certosa, Galluzzo, frescoes, 437, 439, **440,** 441
Christ Before Pilate, **440,** 441
Cosimo il Vecchio, 447, **449**
Deposition, 441, **442,** 443, 444, 446
influence on: of Fra Bartolommeo, 437; of
 Leonardo da Vinci, 446; of Michelangelo,
 438, 446, 447; of Raphael, 438, 441
*Madonna and Child with St. Anne and Other
 Saints,* 437, **445,** 446, 447

Pontormo *(cont'd)*
 Martyrdom of St. Maurice and the Theban Legion, 446–47, **447**
 Portrait of a Halberdier, 447, **448**
 Pucci Altarpiece, 437, 438, **438**, 447
 and Rosso Fiorentino, 434, 437
 San Lorenzo, Florence, frescoes, 437, 447
 Santa Felicita, Florence, Capponi Chapel, frescoes, 437, 441, **444**, 449
 and Sarto, Andrea del, 392, 434, 437, 438, 439
 Supper at Emmaus, 437
 Three Graces, 446–47, **448**
 Vertumnus and Pomona, 392, 438, 439, **439**
 Visitation, 426, **436**, 437–38
Pope Clement VII, Sebastiano del Piombo, **371**, 372
Pope Honorius Establishing the Rules of the Franciscan Order, Ghirlandaio, 269, **271**, 272; preparatory drawing, 269, **271**
Pope Leo X with Two Cousins (Cardinals Giulio de' Medici and Luigi Rossi), Raphael, 259, 365, 390–91, **391**; Andrea del Sarto copy, 392
Pope Paul III and His Grandsons (Alessandro Cardinal Farnese and Ottavio Farnese), Titian, 259, 365, **365**
Pordenone (Giovanni Antonio de Sacchis), 452
Portinari Altarpiece, van der Goes *(Adoration of the Shepherds)*, 268, **270**
Portrait of a Halberdier, Pontormo, 447, **448**
portraiture, 5, 8, 20, 23, 42–43, 60, 62, 120, 167, 182, 222, 230, 279, 311, 342, 364, 401, 426
 Antonello da Messina, 253, 256, 315
 Bellini, Gentile, 214, 216
 Bellini, Giovanni, 216, 246
 Bellini, J., 5, 82, 88
 Domenico Veneziano, 5, 129
 equestrian portraits, 71, 364
 Ghirlandaio, 269, 272, 274
 Leonardo da Vinci, 298, 300
 Lotto, 5, 403
 Mantegna, 225, 236, 257
 Melozzo da Forlì, 257, 259
 Perugino, 193, 196–97, 204
 Piero della Francesca, 5, 315
 Pinturicchio, 197, 204, 206
 Pisanello, 5, 81, 83
 Pontormo, 441, 446, 447
 Raphael, 5, 315, 364, 365, 378–79, 381, 384, 390–91
 Sebastiano del Piombo, 5, 315, 367, 372, 390
 self-portraits, 120, 167, 193, 197, 204, 216, 230, 342, 426, 441
 Titian, 5, 315, 352, 354, 358, 360, 364–65, 390
Presentation in the Temple, Mantegna, 404; Giovanni Bellini copy, 404
Primavera, Botticelli, 167–69, **169**, 170, 172
Procession of the Reliquary of the Cross in Piazza San Marco, Bellini, Gentile, **214**, 215–16

Profanation of the Host, Uccello, 67, **75**, 76
Prophet Ezekiel, Michelangelo, 337
Protestant League, 364
Protestant Reformation, 14, 24
Pucci Altarpiece, Pontormo, 437, 438, **438**, 447
Pugliese, Francesco del, 181
Putto, Pollaiuolo, **263**, 264

quadratura, 234–35, 257
Quaratesi Altarpiece, Gentile da Fabriano, 32, 35; *Madonna Enthroned*, 35; *Pilgrims at the Tomb of St. Nicholas of Bari*, 35, **36**
Quattro Santi Coronati, Nanni di Banco, 31, **31**
Quercia, Jacopo della, 115, 336
 Fonte Gaia, Siena, 396
 Siena Cathedral, Baptistery, font, 93

Raising of the Son of Theophilus and St. Peter Enthroned, Lippi, Filippino, and Masaccio, 15, **39**, 41, **180**, 181–82
Rape of Europa, Titian, 353
Raphael, 5, 10, 12, 13, 14, 16, 17–18, 20, 24, 123, 146, 159, 175, 206, 236, 285, 286, 315, 316, 317, 367, 373, 375, 378–79, 381, 383–84, 387–88, 390–91, 434
 Angelo Doni, **196**, 197, 327
 Baldassare Castiglione, **390**, 390–91
 and Fra Bartolommeo, 18, 319, 323, 325
 Disputa (Disputation over the Sacrament), 319, 357, 379, **380**, 381
 Entombment, 375, **376**, 441
 Expulsion of Heliodorus from the Temple, 384, **386**
 figures, 21, 369, 371, 375, 378, 381, 383, 384, 387, 390, 391, 392, 393, 424
 Fire in the Borgo, 316, 384, 387, **387**, 388
 Galatea, **368**, **383**, 383–84
 Gregory IX Approves the Decretals, 379
 influence of, 317; on Correggio, 412, 413, 415; on Lotto, 404, 407; on Pontormo, 438, 441
 influence on, 379, 391; of antiquity, 357, 373, 379, 381, 383, 384, 387; of Florentine art, 202, 373, 375, 379; of Leonardo da Vinci, 18, 300, 304, 375, 378, 384; of Mantegna, 239; of Michelangelo, 18, 373, 375, 387; of Signorelli, 285, 375, 379
 Julius II, 365, 372
 Liberation of St. Peter from Prison, 363, **363**
 Madonna of Foligno, 357, 412, **412**
 Madonna of the Baldacchino, 323
 Madonna of the Chair, 253
 Madonna of the Goldfinch, **377**, 378–79
 Marriage of the Virgin, 17, 373, **374**, 387
 Miraculous Draught of Fishes, 387–88, **388**
 Oath of Leo III, 373
 Parnassus, 379, 381, 383, **383**; study for, 383, **383**

Raphael *(cont'd)*
and Perugino, 17, 18, 195, 197, 200, 373, 375, 379
Pinturicchio's *Aeneas Silvius Piccolomini Departs for Basel,* preparatory drawing, 204, **205**
Pope Leo with Two Cousins (Cardinals Giulio de' Medici and Luigi Rossi), 259, 365, 390–91, **391**; Andrea del Sarto copy, 392
St. Catherine of Alexandria, 412
and Sarto, Andrea del, 393, 398
School of Athens, 22, 316, 379, 381, **382**, 384, 431, 438
and Sebastiano del Piombo, 367, 369, 371, 372, 384
Sistine Madonna, 253, 357, 384, **385**, 396
Spasimo, 369
tapestry cartoons, 373, 387
Theological Virtues: Faith, Hope, and Charity, 377, 378
Three Graces, 17, 375, **375**, 415
and Titian, 354–55, 357, 363, 364–65
Transfiguration, 17–18, 358, 367, 371–72, 373, 388, **389**, 390
Vatican frescoes, 285, 316, 317, 325, 373, 378–79, 384, 415; Stanza d'Eliodoro, 363, **363**, 384, **386**; Stanza della Segnatura, 18, 22, 197, 234, 316, 319, 357, 371, 373, **378**, 379, 379, **380**, **382**, **382**, 383, **383**, 384, 387, 431, 438; Stanza dell'Incendio, 192, 316, 373, 384, 387, 388, **388**
Villa Farnesina, Rome, frescoes, **368**, 369, **383**, 383–84
workshop and assistants, 17, 387, 432
mentioned, 157, 344, 354, 413, 421, 423, 447
Recanati Polyptych, Lotto, 404, 407; *Madonna and Child with Saints,* 404, **406**
Rembrandt, 19
Resurrection, Castagno, Andrea del, 147, **148**
Resurrection, Mantegna *(San Zeno Altarpiece),* 230
Resurrection of Lazarus, Sebastiano del Piombo, 367, **370**, 371–72
Resurrection of Tabitha and the Healing of a Cripple, Masolino, 39, **41**, 41–42, 108
Resurrection of the Dead, Signorelli, 279, 280, **282**, 285
Risen Christ, Rosso Fiorentino, 429, 432, 434, **435**
Rizzo, Antonio, 214
Robbia, Luca della: Florence Cathedral, singing gallery, 396
influence of, 120, 124, 134, 334–35
Roberti, Ercole de', 158, 213, 452
Roman art, 3, 30, 31, 77, 154, 194, 317, 335, 354, 369, 371, 383, 396. *See also* antiquity, interest in and influence of
Romanino, Girolamo, 452

Romano, Giulio, 24, 390, 434
Rosselli, Cosimo, 304, 305, 452
Sistine Chapel, Vatican, frescoes, 166, 190, **191**, 265, 304–05
workshop and pupils, 304, 305, 316, 318, 319
Rossellino, Bernardo, 122
Rosso, Il (Nanni di Bartolo), 76, 77
Rosso Fiorentino (Giovanbattista di Jacopo), 10, 175, 423, 424, 426, 429, 431–32, 434
Assumption of the Virgin, 426, 429, **429**
Creation of Eve, 426, 432, **434**
Dei Altarpiece, 431, 432, **432**
Deposition from the Cross, 426, 429, **430**, **431**
influence on, 317, 429, 431, 432
Marriage of the Virgin, 432, **433**
and Pontormo, 434, 437
Risen Christ, 429, 432, 434, **435**
Rovere family, 259, 332, 352
Melozzo da Forlì painting, 257, **258**
See also Julius II; Sixtus IV
Roverella Altarpiece, Tura, 210; *Enthroned Madonna and Child with Angels,* **209**, 210, 211; *Pietà,* 210, **210**, 211
Rucellai, Giovanni, 8
Rules of the Carmelite Order, Lippi, Filippo, 113, **114**

Sack of Rome, 14, 367, 426, 434
sacra conversazione (as theme), 21, 127
Sacred Allegory, Bellini, Giovanni, 247, **247**, 249
Sacred and Profane Love, Titian, 355, **355**, 357
Sacrifice of Noah, and the Drunkenness of Noah, Uccello, 67, 68, **70**, 71, 74
St. Anne Altarpiece, Fra Bartolommeo, **324**, 325
St. Anne with the Virgin and the Christ Child, Michelangelo, **445**, 446
St. Augustine in His Study, Botticelli, 165–66, 170, **171**, 172, 266
St. Augustine in His Study, Carpaccio *(Vision of St. Augustine),* **219**, 221–22
St. Bernard's Vision of the Virgin, Lippi, Filippo, 113
St. Catherine of Alexandria, Raphael, 412
St. Francis in Ecstasy, Sassetta, 93, **97**, **98**, 99, 132
St. George, Donatello, **225**, 226
St. George and the Princess, Donatello, 79, 81
St. George and the Princess, Tura, 206, **208**, 209–10
St. George, the Princess, and the Dragon, Pisanello, **78**, 79, 81
St. James between Sts. Vincent and Eustace, Pollaiuolo, **177**, 178
St. James Led to Execution, Mantegna, **224**, 226
St. Jerome, Piero della Francesca, 130
St. Jerome in His Study, Ghirlandaio, 166, 172, 265, 266, **266**
St. John the Baptist, Francesco di Giorgio, 186

St. John the Baptist, Ghiberti, 27–28, **29**, 30
St. John the Baptist, Leonardo da Vinci, 304
St. John the Baptist in the Desert, Domenico Veneziano *(St. Lucy Altarpiece)*, **128**, 129
St. Lawrence Distributing Alms to the Poor and the Infirm, Fra Angelico, **65**, 67
St. Louis of Toulouse, Donatello, 104, 129, **129**, 160, 229
St. Lucy Altarpiece, Domenico Veneziano: *Annunciation*, **128**, 129; *Madonna and Child with Saints*, 64, **126**, 127, 129; *St. John the Baptist in the Desert*, **128**, 129
St. Luke, Lippi, Filippo, 121–22, **122**
St. Mark, Donatello, 27–28, **29**, 30
St. Mark Preaching in Alexandria, Bellini, Gentile, and Giovanni, 214, **215**
St. Mark the Evangelist, Fra Bartolommeo, 325, **325**
St. Paul, Beccafumi, **422**, 423
St. Peter, Uccello, 67
St. Peter Baptizing the Neophytes, Masaccio, 39, 43, **43**, 108–09, 111
St. Peter Healing with His Shadow, Masaccio, 39, 108, **109**
St. Peter Martyr Altarpiece, Fra Angelico *(The Virgin and Child with Sts. Dominic, John the Baptist, Peter Martyr, and Thomas Aquinas)*, 55, **56**, 57
St. Peter Martyr Altarpiece, Titian, 352
St. Peter Preaching, Masolino, 39, **42**, 43, 108
St. Philip Driving the Dragon from the Temple, Lippi, Filippino, 184–86, **185**
St. Sebastian, Antonello da Messina, **255**, 256
St. Sebastian, Mantegna, **231**, 232, 234
St. Sebastian, Perugino, **195**, 196
St. Sigismond and Sigismondo Pandolfo Malatesta, Piero della Francesca, 130, 132, **134**
Sts. Peter and Paul, Masolino *(Santa Maria Maggiore Altarpiece)*, 43, 57, **58**
Salvator Mundi, Antonello da Messina, 250, **251**, 253
Salvator Mundi with Saints, Fra Bartolommeo, 318, 325, **326**
San Cassiano Altarpiece, Antonello da Messina, 245, 250, 253–55, **254**, 403
San Giobbe Altarpiece, Bellini, Giovanni, **244**, 245, 291
San Giovenale Altarpiece, Masaccio, 100–01, **101**
San Gregorio Polyptych, Antonello da Messina *(Madonna and Child)*, 250, **252**, 253, 254, 256
San Marco Altarpiece, Fra Angelico *(The Virgin and Child Enthroned with Angels and Saints)*, 62, **62**, 64
San Michele, Bellini, J., 88
Sano di Pietro, 451
Sansovino, Andrea, 396

Sansovino, Jacopo, 396, 402
Santa Cristina al Tivarone Altarpiece, Lotto, 402, 403–04, **405**
Santa Maria Maggiore Altarpiece, Masolino, 26, 43; *Assumption of the Virgin*, 43; *Founding of Santa Maria Maggiore*, 43, **44**, 45, 93; *Sts. Peter and Paul*, 43, 57, **58**
Santi, Giovanni, 157–58, 159, 190, 223, 373
San Zaccaria Altarpiece, Bellini, Giovanni, 241, **244**, 245, 247, 369, 403
San Zeno Altarpiece, Mantegna, 226, **228**, 228–30, 232, 235, 243; **243**; *Agony in the Garden*, 230; *Crucifixion*, 230, **230**, 232, 269, 272; *Madonna and Child*, **229**, 229–30; *Resurrection*, 230
Sarto, Andrea del (Andrea di Agnolo), 355, 391–93, 396, 398, 401
Annunciation, 434
Baptism of the People, 393, **394**, 396; study for, **395**, 396
Birth of the Virgin, 392–93, **393**
Charity, 396, 398, **398**
influence of, on Rosso Fiorentino, 429
Journey of the Magi, 392
Lamentation over the Dead Christ with Saints, 393, 398, **399**
Last Supper, 150, 392
Madonna del Sacco, 392, **400**
Madonna of the Harpies, 392, 396, **397**
Medici villa, Poggio a Caiano, frescoes, 392, 438
and Pontormo, 392, 434, 437, 438, 439
as pupil of Piero di Cosimo, 305, 392
and Raphael, 393, 398
Raphael's *Pope Leo X with Two Cousins* copied, 392
Santissima Annunziata, Florence, frescoes, 392–93, **393**, **400**, 426
Visitation, **437**
Sassetta (Stefano di Giovanni di Consolo), 16, 92–93, 95, 99, 132, 188, 204
Arte della Lana Altarpiece, **92**, 93
'Bene scriptisti de me, Thomas', **92**, 93
Coronation of the Virgin, 93
and Domenico Veneziano, 99, 125, 127
Founding of Santa Maria Maggiore, 93, **96**
Madonna of the Snow Altarpiece, 93, **94**, 95, **95**, **96**, 99
St. Francis in Ecstasy, 93, **97**, **98**, 99, 132
Siena Cathedral, designs for font, pavement, and stained glass, 93
Sassetti, Francesco: Ghirlandaio frescoes, 120, 267, **270**, **271**
Saved, Signorelli, 279
Savoldo, Girolamo, 452
Savonarola, Girolamo, 173
Schiavona, La, Titian, 354, **354**
Schiavone, Giorgio, 84

School of Athens, Raphael, 22, 316, 379, 381, **382**, 384, 431, 438
School of Pan, Signorelli, 277, 279, **280**, 285
scientific interests, 8, 159, 286
sculpture (Renaissance), 4, 12, 13–14, 20, 26, 27–28, 30, 54, 211, 245
 influence on painting, 81, 84, 87, 117, 120, 121–22, 123, 129, 147, 154, 335
Sebastiano del Piombo (Sebastiano di Luciano; Sebastiano Veneziano), 5, 315, 367, 369, 371–72, 390, 393
 Andrea Doria, **371**, 372
 and Bellini, Giovanni, 241, 246, 250, 344, 367, 369
 Deposition, 367, 369, **369**, 371
 Fall of Icarus, **368**, 369, 383
 and Giorgione, 344, 350–51, 367, 369
 Giorgione's *Three Philosophers* completed, **350**, 350–51, 369
 Martyrdom of St. Agatha, 367, **372**
 and Michelangelo, 14, 327, 342, 367, 371
 Nativity of Mary, 367
 Polyphemus, **368**, 369, 383
 Pope Clement VII, **371**, 372
 and Raphael, 367, 369, 371, 372, 384
 Resurrection of Lazarus, 367, **370**, 371–72
 San Bartolommeo al Rialto, Venice, organ shutters, 369
 San Pietro in Montorio, Rome, Borgherini Chapel, frescoes, 367
 and Titian, 352
 Villa Farnesina, Rome, frescoes, 367, **368**, 369, 383
 Visitation, 367
Servants with Horse and Dog, Mantegna, **234**, 235
Sforza, Ludovico ("Il Moro"), 158, 286
sfumato, 292, 393
Sigismund, 3
Signorelli, Luca, 190, 274–75, 277, 279–80, 285
 Annunciation, 275
 Antichrist, 279, 280, **281**
 Damned, 279, **283**
 End of the World, 279
 Flagellation, 275, **276**
 Florence Cathedral, façade project, 275
 influence of, 277; on Raphael, 285, 375, 379
 influence on, 202; of Perugino, 275, 277
 Institution of the Eucharist, 275, **284**, 285
 Madonna and Child, 277, 279, **279**, 328
 Madonna and Child with Saints, 274–75, **278**
 and Michelangelo, 274, 328
 Monte Oliveto, frescoes, 275, 423
 nude studies, **283**, 285
 Orvieto Cathedral, San Brizio Chapel, frescoes, 55, 57, 190–91, 275, 279–80, **281**, **283**, 285
 and Piero della Francesca, 146, 274, 275
 Resurrection of the Dead, 279, 280, **282**, 285

Signorelli, Luca *(cont'd)*
 Sant'Agostino, Siena, Bichi Chapel, altarpiece and sculpture, 275, 423
 Santa Casa, Loreto, frescoes, 259, 274
 Saved, 279
 School of Pan, 277, 279, **280**, 285
 Sistine Chapel, Vatican, frescoes, 191, 274
 mentioned, 158, 190, 217, 421
sinopia (for frescoes), 51–52, **52**, 147, **149**
Sir John Hawkwood, Uccello, 67, 71, **71**, 147, 154
Sistine Madonna, Raphael, 253, 357, 384, **385**, 396
Sixtus IV (Pope; Francesco della Rovere), 7, 190, 265, 331, 332, 381
 Melozzo da Forlì fresco, 257, **258**, 259
 tomb by Pollaiuolo, 260
Sixtus IV Appointing Platina as Prefect of the Vatican Library, Melozzo da Forlì, 257, **258**, 259
Sleeping Venus, Giorgione and Titian, 348, **349**, 350, 354
Sodoma (Giovanni Bazzi), 383, 404, 423, 452
space, treatment of. *See* composition and space
Spasimo, Raphael, 369
Squarcione, Francesco di ser Giovanni, 84, 87–88, 113, 157, 210
 De Lazara Altarpiece, 84, **86**, 87
 Madonna and Child, 84, **85**, 87
 as teacher, 84, 87, 223, 225–26
Stefano da Verona, 76, 91
Stigmatization of St. Catherine of Siena, Beccafumi, 423–24, **425**
still life and still-life elements, 5, 15, 23, 64, 87, 159, 182, 266, 277, 296, 297
Stoning of St. Stephen, Lippi, Filippo, 122
Story of the True Cross, Gaddi, 136
Story of the True Cross, Masolino, 39, 136
Strozzi, Filippo, 176, 305
Strozzi, Palla, 32, 34, 60
Strozzi Altarpiece, Gentile da Fabriano, 32, 34–35; *Adoration of the Magi*, 32, **33**, 34, 107, 182; *Flight into Egypt*, 32, 34–35, **35**
Study of Head, Pisanello, **78**, 81
Supper at Emmaus, Pontormo, 427
Susanna and the Elders, Lotto, 407, **408**
Susanna and the Elders, Pinturicchio, **203**, 204
symbolism. *See* iconography and symbolism

Tarquinia Madonna, Lippi, Filippo, 62, 87, 113, 115, **116**, 117, 125, 253
tempera, use of, 21, 43, 51, 52, 243
 and oil, combination, 243
Tempest, Giorgione, **347**, 348, 351
Temptation and Expulsion, Michelangelo, 108, **110**, 371
Temptations of Christ, Botticelli, 172, **191**
Theological Virtues: Faith, Hope, and Charity, Raphael, **377**, 378

Three Ages of Man, Titian, **330,** 331
Three Graces, Pontormo, 446–47, **448**
Three Graces, Raphael, 17, 375, **375,** 415
Three Graces, Tura, 213
Three Philosophers, Giorgione and Sebastiano del
 Piombo, **350,** 350–51, 369
Tintoretto, 24
Titian (Tiziano Vecellio), 4, 12, 13, 14, 16, 18,
 19, 20, 21, 24, 123, 241, 247, 285, 315, 316,
 317, 352–55, 357–60, 362–65, 388, 390, 392,
 398
 Assumption, 285, 352, **356,** 257–58
 Bacchanal of the Andrians, 316, **359,** 360
 Bacchus and Ariadne, 316, **359,** 360
 and Bellini, Giovanni, 18, 241, 246, 250, 344,
 352, 355
 Bellini's *Feast of the Gods* reworked, 241, **246,**
 246–47, 360
 Brescia town hall, painting, 353
 Charles V with a Dog, 352, 364, **364**
 Christ Crowned with Thorns (Munich), 363,
 365, **366;** (Paris), **361,** 362–63
 Doges' Palace, Venice, Sala del Gran Consiglio,
 fresco, 352
 Ecce Homo, 316, **361,** 362–63
 Entombment, 360
 Equestrian Portrait of Charles V, **364,** 364–65
 Fête Champêtre (and Giorgione), 351, **351,** 354,
 355
 Flora, 355, 357
 Fondaco dei Tedeschi, Venice, frescoes, 352
 and Giorgione, 18, 344, 348, **350,** 351, 352, 354,
 355, 363, 367
 influence on, 357; of Mantegna, 222, 239
 Last Supper, 353
 Martyrdom of St. Lawrence, **362,** 363–64
 and Michelangelo, 331, 342, 343, 352, 355
 Miracle of the Speaking Babe, **353,** 354
 Nymph and Shepherd, 365, 367
 painting technique, 21, 245, 354, 355, 360, 365,
 367, 393
 Penitent Magdalen, 360, **360,** 362
 Pesaro Madonna, 285, 352, **357,** 358–60
 *Pope Paul III and His Grandsons (Alessandro
 Cardinal Farnese and Ottavio Farnese),* 259,
 365, **365**
 Rape of Europa, 353
 and Raphael, 354–55, 357, 363, 364–65
 Sacred and Profane Love, 354, **355,** 357
 St. Peter Martyr Altarpiece, 352
 San Francesco, Ancona, altarpiece, 352
 La Schiavona, 354, **354**
 Scuola di Sant'Antonio, Padua, frescoes, 352,
 353, 354
 Sleeping Venus (and Giorgione), 348, **349,** 350,
 354
 Three Ages of Man, **330,** 331
 Venus of Urbino, 348, **349,** 350, 362

Titian *(cont'd)*
 Worship of Venus, **358,** 360
 mentioned, 369, 447
Tornabuoni family, 265
Torso Belvedere, 336, **337**
Transfiguration, Perugino, 197
Transfiguration, Raphael, 17–18, 358, 367, 371–72,
 373, 388, **389,** 390
Tribute Money, Masaccio, 22, 31, **39,** 41–42, 108,
 111, 111–12, 137, 229, 295
Trinity, Beccafumi, 421, 423, **424**
Trinity, Masaccio, 42, 100, 101–02, **103,** 104, **104,**
 106, 107
Triumph of Battista Sforza, Piero della
 Francesca, 142, **143**
Triumph of Federigo da Montefeltro, Piero della
 Francesco, 142, **143**
Triumphs of Caesar, Mantegna, 236
Trivulzio Portrait, Antonello da Messina, 256,
 256
trompe l'oeil, 5, 62, 74, 120, 197, 229, 234, 236,
 253, 307, 323, 398
Tura, Cosmè (di Domenico), 158, 206, 209–11, 213,
 277
 Annunciation, 206, **207,** 209
 Enthroned Madonna and Child with Angels,
 209, 210, 211
 Este family portraits, 209
 Pietà, 210, **210,** 211
 Roverella Altarpiece, **209,** 210, **210,** 211
 St. George and the Princess, 206, **208,** 209–10
 San Domenico, Ferrara, altarpiece, 206
 Schifanoia Palace, Ferrara, Sala dei Mesi,
 frescoes, 206, 209, 211, 213
 Three Graces, 213
Uccello, Paolo (Paolo di Dono), 5, 10, 21, 32,
 67–68, 70–71, 73–76, 132, 146, 257
 Battle of San Romano, 67, 71, 73–75;
 (Florence), **72,** 73–74, **74,** 76; (London), **72,**
 73; (Paris), **73,** 74
 Creation of Adam, **52,** 67, 68, **68**
 Creation of Eve, 67, 68, **68**
 Creation of the Animals, **52,** 67, **68**
 Fall, 67, **68**
 Flood and the Recession of the Waters, 67, 68,
 69, 70–71, 74, 335
 Florence Cathedral, designs for clock face and
 stained glass, 67, 146
 influence of, 84; on Castagno, Andrea del, 147;
 on Michelangelo, 71, 335
 influence on, 67, 68, 73
 Profanation of the Host, 67, **75,** 76
 *Sacrifice of Noah, and the Drunkenness of
 Noah,* 67, 68, **70,** 71, 74
 St. Peter, 67
 San Miniato al Monte, Florence, frescoes, 68
 Santa Maria Novella, Florence, Green Cloister,
 frescoes, **52,** 67–68, **68, 69, 70,** 70–71, 74, 335

Uccello, Paolo *(cont'd)*
 Sir John Hawkwood, 67, 71, **71**, 147, 154
 mentioned, 157, 158, 223
Uomini Famosi: Brutus, Scaevola, and Camillus,
 Ghirlandaio, 267, **269**

Vaga, Perino del, 24
Vasari, Giorgio, 24
 Lives, 9, 16, 26, 315, 317; on Beccafumi, 421,
 423, 426; on Castagno, Andrea del, 127, 146;
 on Correggio, 413; on Domenico di Bartolo,
 114; on Domenico Veneziano, 127; on
 Giorgione, 344; on Leonardo da Vinci, 163;
 on Lippi, Filippino, 182, 184; on Piero di
 Cosimo, 305, 307, 309; on Pinturicchio, 201;
 on Pollaiuolo, 260; on Pontormo, 434, 438,
 439, 441, 446, 447; on Raphael, 373; on Rosso
 Fiorentino, 426; on Sarto, Andrea del, 396,
 401; on Sebastiano del Piombo, 367; on
 Sistine Chapel wall frescoes, 190; on Titian,
 352, 363, 365; on Uccello, 68
Vecchietta (Lorenzo di Pietro), 186, 451
Velázquez, 236
Venus, Mars, and Cupid, Piero di Cosimo, 307,
 307, 309
Venus of Urbino, Titian, 348, **349**, 350, 362
Vermeer, Jan, 219–20
Verrocchio, Andrea (di Michele di Francesco di
 Cioni), 18, 20, 22, 158, 159, 160, 163, 165, 260,
 274
 Baptism of Christ, 160, **162**, 163, **163**, 165, 260;
 Leonardo da Vinci's work on, 163, 165, 287,
 288, 289
 Christ and St. Thomas, 160, **161**, 194
 Colleoni, 154, 160, **161**, 222, 364
 David, 287, 289
 influence of, 165, 279; on Francesco di Giorgio,
 188; on Perugino, 165, 194
 and Leonardo da Vinci, 13, 18, 163, 165, 166,
 286, 287, 289, 291, 300
 *Madonna with Sts. John the Baptist and
 Donatus* (and workshop), 160, **164**, 165
 Pistoia Cathedral, Forteguerri cenotaph, 160

Verrocchio, Andrea *(cont'd)*
 San Lorenzo, Florence, Medici tomb, 160
 workshop and assistants, 160, 163, 165, 166, 167
Vertumnus and Pomona, Pontormo, 392, 438,
 439, **439**
Virgil, 279
*Virgin and Child Enthroned with Angels and
 Sts. Cosmas and Damian, Lawrence, John
 the Evangelist, Mark, Dominic, Francis, and
 Peter Martyr, The,* Fra Angelico *(San Marco
 Altarpiece),* 62, **62**, 64
*Virgin and Child with Sts. Dominic, John the
 Baptist, Peter Martyr, and Thomas Aquinas,
 The,* Fra Angelico *(Saint Peter Martyr
 Altarpiece),* 55, **56**, 57
Virgin in Glory, Lippi, Filippino, **181**, 182
Vision of St. Augustine, Carpaccio *(St. Augustine
 in His Study),* **219**, 221–22
Vision of St. Bernard, Fra Bartolommeo, 318,
 319–20, **321**, 323, 432
Vision of St. Bernard, Lippi, Filippino, 178, **179**,
 181, 319–20
Vision of St. Bernard, Perugino, **321**, 323
Vision of St. John, Correggio, 415, 417, **418**
Visitation, Ghirlandaio, 272, **272**, 274
Visitation, Pontormo, 426, **436**, 437–38
Visitation, Sarto, Andrea del, **437**
Visitation, Sebastiano del Piombo, 367
*Visitation with Sts. Nicholas and Anthony
 Abbot,* Piero di Cosimo, 305, **306**, 307
Vivarini, Alvise, 217, 254, 403
Vivarini, Antonio, 451
Vulcan and Aeolus, Piero di Cosimo, **310**, 311

Weyden, Rogier van der, 157, 211, 250
Woman with Mirror, Bellini, Giovanni, 241
wood (as painting support), 51, 52, 245
workshops, 16, 17
 and signed paintings, 216
Worship of Venus, Titian, **358**, 360

Zoppo, Marco, 84, 452
Zuccone, Donatello, 147